Brazil Body & Soul

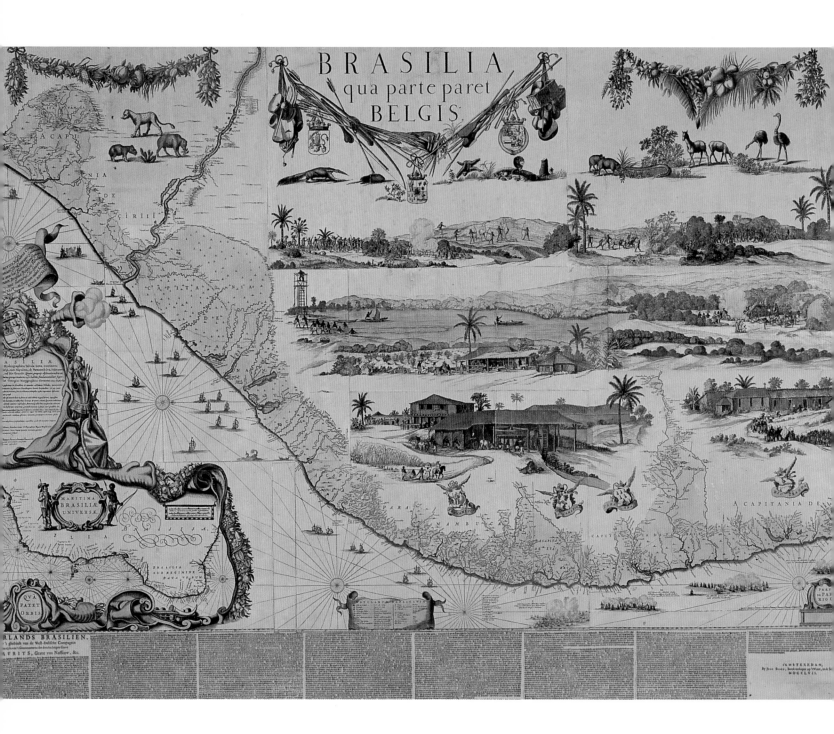

Brazil Body & Soul

Edited by Edward J. Sullivan

Curated by Edward J. Sullivan,
Germano Celant, Julian Zugazagoitia, Nelson Aguilar,
Emanoel Araújo, and Mari Marino

Guggenheim MUSEUM

Published on the occasion of the exhibition
Brazil: Body and Soul

The Solomon R. Guggenheim Museum
gratefully acknowledges the assistance of
BrasilConnects.

This exhibition has been made possible
through the generosity of the Friends of
 BrasilConnects

Solomon R. Guggenheim Museum, New York
October 11, 2001–January 27, 2002
Guggenheim Museum Bilbao
March 23–September 29, 2002

ISBN 0-89207-251-2 (softcover)
ISBN 0-8109-6933-5 (hardcover)

Guggenheim Museum Publications
1071 Fifth Avenue
New York, New York 10128

Hardcover edition distributed by
Harry N. Abrams
100 Fifth Avenue
New York, New York 10011

Design: Tsang Seymour Design, Inc., New York
Production: Melissa Secondino, Tracy Hennige
Editorial: Meghan Dailey, Elizabeth Franzen,
 Beth Huseman, Edward Weisberger; and
 Kristin M. Jones, Jennifer Knox White, Jonathan
 Raymond, Rachel Shuman, Bennett Simpson
Translations: Regina Alfarano, David Auerbach/Eriksen
 Translations, Michael Reade, Stephen Sartarelli
Printed in Germany by GZD

Frontispiece: Johanes Blaeu after George Markgraf,
Brasilia que parte paret Belgis, 1647. Etching on paper,
117 x 180 cm. Collection of Beatriz and Mário Pimenta
Camargo

Contents

BrasilConnects is an independent not-for-profit organization that celebrates, preserves, and supports Brazil's most treasured cultural and ecological assets. There is no better way to understand the essential features of a country than through its art. Art transcends all social, political, and ideological discourses. An engagement with art is a unique experience that teaches us something profound about what we are looking at. Art touches each one of us in a unique way and we must draw our own conclusions as to its meanings.

We have entered into a joint project with the Guggenheim Museum. The two institutions share similar interests in promoting knowledge through the arts and appreciation of the diversity of expressions. The exhibition *Brazil: Body and Soul* has been organized with the intention of conveying some of the salient points that distinguish our rich culture. We wish to foster an understanding of the arts of Brazil in order to challenge some of the stereotypes held by those less familiar with our country. As visitors to the exhibition will quickly realize, Brazil is much more than Carnival or soccer.

Brazil: Body and Soul partakes of the spirit of the large-scale exhibition *Mostra do redescubrimiento: Brasil 500 anos*, held in Brazil in 2000 to celebrate the first contacts with Europe five hundred years ago. The huge success of that exhibition in Brazil inspired pride in ourselves and revealed the country to an international audience.

Today, the Guggenheim Museum is set to bring the spirit of Brazil to a wider, global audience in its historic landmark, the Frank Lloyd Wright building on New York's Fifth Avenue and in the Frank Gehry masterpiece in Bilbao, Spain.

Brazil: Body and Soul was brilliantly conceived by an international team of curators. They established the concept after extensive research and a careful selection of the pieces from all regions of the country. Their efforts were undertaken in the spirit of the great German writer Friedrich von Schiller who stated that aesthetics can be as effective as ethics for bringing societies together.

— Edemar Cid Ferreira, Chairman, BrasilConnects

The year 2000 witnessed the celebrations of the five-hundredth anniversary of the first contact between Brazil and Europe. This event, which commemorated the beginnings of the modern nation, was widely celebrated throughout the country. It was a time to recall the great importance of the diversity of Brazil's cultural, racial, and ethnic components. Multiculturalism is one of the most important features of Brazilian society. It shares this characteristic with the United States. Therefore it is appropriate that the arts of Brazil be celebrated in the United States by a major exhibition organized by the Guggenheim Museum in New York that stresses the richness and complexity of our civilization.

The large-scale exhibition *Mostra do redescubrimiento: Brasil 500 anos* held in São Paulo in 2000 examined the multiplicity of Brazilian artistic production from the indigenous to the contemporary and the public responded with overwhelming enthusiasm. We hope that the American public will react with a similar positive feeling. *Brazil: Body and Soul* is an original project organized by the Guggenheim Museum. Conceived by an international team of curators, it explores two of the key moments in the development of the visual arts in the country: the Baroque and the Modern. Baroque art represents the deepest roots of Brazil's national artistic identity while Modern and contemporary art evidence the dynamism and constant growth of the nation's visual culture.

Brazil: Body and Soul is the largest and most comprehensive exhibition of Brazilian art ever carried out abroad. It is with great pleasure that I congratulate the Guggenheim Museum and BrasilConnects on this excellent initiative, which will contribute in a unique way to the dissemination of Brazilian culture in the United States.

— Rubens Antonio Barbosa, Ambassador of Brazil in the United States of America

Brazil: Body and Soul is an exhibition that honors both Brazil and New York. It is an exhibition with a sense.

What does sense sense?

Sense is the meaning of life. It is the most special power of our body through which we are conscious of things. I invoke the spirit of a poem by Fernando Pessoa, the Portuguese poet, to say it:

When I have sense of what to sense appears,
Sense is sense ere 'tis mine or mine in me is.
When I hear, Hearing, ere I do hear, hears.
When I see, before me abstract Seeing sees.
I am part soul part I in all touch
Soul by that part I hold in common with all.

The exhibition you are about to sense is the body and soul of Brazil, a country we hope can be understood here through the history of its own creation by the Brazilian people.

Brazil and the United States of America have existed in the same hemisphere, during the same span of history. Their respective development patterns have been different however; their origin obeys distinctive influences and hence their heritage. But art and human expression are "that part" we "hold in common."

Works of art brought from different parts of our country, arising from the ages, are exhibited here as our common sense. The sense to sense. This exhibition is about humanity.

As the Consul General of Brazil in New York from the exhibition's very inception, I am grateful to have witnessed the efforts of Edemar Cid Ferreira and his team at BrasilConnects joining senses with the Guggenheim to give us such a marvelous gift.

— Flávio Miragala Perri, Consul General of Brazil in New York

Foreword

Thomas Krens

Brazil is a country of extraordinary achievements, startling paradoxes, and enormous potential, and *Brazil: Body and Soul* captures the nation's essence by establishing a dialogue between two key periods of its artistic production: the Baroque and the Modern. This unique exhibition presents the complexity and richness of Brazilian culture by exploring deeply rooted expressions. The integration of body and soul—physical and spiritual, matter and inspiration—so integral to Brazilian art is crystallized in masterpieces that arose from traditions linked to African-related rituals, Christian religious processions, and secular celebrations such as Carnival. Indigenous arts, beginning with a historic Tupinambá feather cape from the sixteenth or seventeenth century and including more recent objects, attest to a living and dynamic tradition. The prevalence of Afro-Brazilian culture is highlighted along with popular art forms, and contemporary artists bring a sense of

renewal with works that synthesize the past and point to the future.

Brazil and the United States share common traits and also have compelling differences. Both nations experienced colonization and have had complex relationships with their indigenous peoples. The identities of both have been deeply shaped by the legacy of the involuntary migration and servitude of Africans, and both may be characterized as multiethnic societies that have assimilated immigrants from all parts of Europe and more recently Asia. Today, cultural diversity is a value shared by these democracies.

The idea of presenting a show devoted to Brazil was a natural one given the Guggenheim's global program. We are in the midst of planning an ambitious museum designed by Frank Gehry for lower Manhattan, which will join our existing facilities in New York: the landmark Frank Lloyd Wright building on Fifth Avenue and the Guggenheim Museum SoHo.

In Las Vegas, we recently opened the Guggenheim Hermitage Museum and the Guggenheim Las Vegas—both designed by Rem Koolhaas—bringing exhibitions to an audience in one of the world's fastest growing cities. This activity is complemented by the continued improvements of the Peggy Guggenheim Collection in Venice, the success of the Guggenheim Museum Bilbao designed by Gehry, and the Deutsche Guggenheim Berlin. The Guggenheim is an international institution not only in terms of buildings and locations but also through a commitment to expanding its programming, reflected both in the growth of the permanent collection and in the depth of special exhibitions. A multifaceted, multilingual, global culture is emerging in an increasingly interconnected, internet-linked world. Africa, Asia, and South America all sustain vibrant cultures, past and present, that must be engaged.

The Guggenheim has set high standards for addressing non-Western cultures with major scholarly exhibitions. Most recently, in 1998, *China: 5,000 Years* and its companion exhibition, *A Century in Crisis*, surveyed traditional and Modern Chinese art. Also in the 1990s, we presented *Japanese Art After 1945: Scream Against the Sky* and *Africa: The Art of a Continent*. With regard to Europe, the arts of a single country were highlighted in *The Great Utopia: The Russian and Soviet Avant-Garde, 1915–1932* and *The Italian Metamorphosis, 1943–1968*, among other exhibitions. The Guggenheim's commitment to Latin American art goes back to the groundbreaking 1965 exhibition *The Emergent Decade: Latin American Painters and Painting in the 1960's*, but *Brazil: Body and Soul* is our first show devoted to the art of a single Latin American country. The idea of addressing such a culture at this time first came to mind because of Marifé Hernandez, who, with her passion for and vision of Brazil, focused our attention on Brazil's celebrations in 2000, marking the quincentennial of the first contact between the Portuguese and indigenous

Brazilians. A key feature of these celebrations was the extraordinary, and extraordinarily popular, exhibition *Mostra do redescubrimiento: Brasil 500 anos*. Held at the Ibirapuera Park in São Paulo, it occupied every *Bienal* building, including the newly restored Oca and the Pinacoteca, all masterpieces designed by architect Oscar Niemeyer. This encyclopedic presentation of Brazilian art and culture was the vision of Edemar Cid Ferreira, Chairman of BrasilConnects, and we are grateful to him for having transmitted his passion to us. The impact of discovering the country in his company and the experience of *Mostra do redescubrimiento: Brasil 500 anos* were determining factors for us in producing the most comprehensive exhibition of Brazilian art ever presented outside of Brazil. The assistance of BrasilConnects, the dedication of its staff, whose names appear in the Project Team, and the generosity of the Friends of BrasilConnects were essential in making *Brazil: Body and Soul* a reality. BrasilConnects is a not-for-profit organization dedicated to the celebration and preservation of Brazil's cultural and ecological treasures, and we salute them for their worthy mission.

This exhibition would not have been possible without the support of officials of the Brazilian government. We are especially grateful to Fernando Henrique Cardoso, President of the Federative Republic of Brazil, who received us when we were first thinking about this project and has continually given his support and encouragement. Our deep appreciation goes to Marco Antonio de Oliveira Maciel, Vice-President of the Federative Republic of Brazil, for his commitment to this project and support for bringing the main altar of the church of the São Bento de Olinda monastery from his native region of Pernambuco. We are grateful for the help and assistance of Francisco Correa Weffort, Minister of Culture, and his staff and the unprecedented cooperation of Celso Lafer, Minister of Foreign Affairs. In the United States, we benefited from the constant support of

Rubens Antonio Barbosa, Ambassador of Brazil to the United States of America. We were guided and assisted in many ways by Flávio Miragala Perri, Consul General of Brazil in New York, whose personal passion for culture provided many insights.

The Guggenheim has been fortunate in having a team of six curators who defined and structured the suggestive narrative of *Brazil: Body and Soul*. We are indebted to them for the dedication, expertise, and perspective each brought to the exhibition as well as its accompanying publication and many programs. They were led by Guest Curator Edward J. Sullivan, who is Professor and Chairman of the Department of Fine Arts of New York University and an eminent scholar of Latin American art. His uncompromising eye and profound historical knowledge enriched the project. For the high quality of the publication he edited, we are grateful to him as well as all the scholars who contributed essays. Our appreciation also goes to Patrick Seymour and Laura Howell of Tsang Seymour Design for their sensitive design of the book. Germano Celant, Senior Curator of Contemporary Art, was instrumental in choosing the collision of universes that this exhibition brings together: historical and contemporary, popular and conceptual, traditional and experimental. Julian Zugazagoitia, Project Manager for this exhibition and Executive Assistant to the Director, handled the overall task of transforming curatorial ideas into the reality of *Brazil: Body and Soul*. With indefatigable energy he managed all the challenges of this complex endeavor.

The project benefited greatly from Curatorial Advisor Nelson Aguilar's experience as chief curator of *Mostra do redescubrimiento: Brasil 500 anos* and former curator of two editions of the São Paolo *Bienal*. His interpretations of Modern and contemporary movements and perception of how they contrast with the past were essential to articulating the concepts of the exhibition and catalogue. His skills were instrumental in obtaining the loans

of masterpieces that otherwise could not have been secured. Not only is Emanoel Araújo responsible for the rebirth of the Pinacoteca do Estado do São Paolo as a world-class institution, of which he is the Director, but he is also a talented contemporary artist (however, he refused requests to have his art included in our exhibition because he is a Curatorial Advisor). His exploration and redefinition of the prevalence of Afro-Brazilian traditions in the arts of Brazil began a new chapter in the scholarly approach to the nation's art history and greatly influenced our project. His efforts were indispensable in obtaining loans of wonderful objects. The presentation of treasures from the Baroque period, with the regional specificity that we are able to present, could not have been achieved without the dedication and talent of Curatorial Advisor Mari Marino, who is Director of the Museu de Arte Sacre de São Paolo. The excellence of the Baroque selections was made possible by her connoisseurship and years of experience.

The curatorial team benefited from the constant dialogue and guidance that Lisa Dennison, Deputy Director and Chief Curator, provided throughout the process of conception, selection of objects, and design of the exhibition. Charmaine Picard, Curatorial Project Assistant, has assured in the most swift and dedicated way the general coordination of the exhibition and its multiple programs within the Guggenheim and with BrasilConnects. The BrasilConnect staff both in São Paolo and New York distinguished itself with its high degree of commitment and professionalism. We thank in particular Emilio Kalil, Project Director, and Maria Paula Armelin, Project Manager, for their dedication. We are also grateful to Fausto Godoy, BrasilConnect's former Coordinator of International Relations, for starting the project with that organization.

The complexity of this exhibition presented special challenges and the magnificent outcome is the result of the work of all the departments of the Guggenheim.

We thank in particular the personnel listed in the Project Team. Special thanks go to Jane DeBevoise, Deputy Director for Program Administration and Operations, Roy Eddey, Chief Financial Officer, and Karen Meyerhoff, Managing Director for Exhibitions, Collections, and Design. We also thank our colleagues at the Guggenheim Museum Bilbao for their presentation of the exhibition.

Lenders from all regions of Brazil—private individuals, cultural institutions, artists, religious groups—recognized the importance of *Brazil: Body and Soul* and contributed to its success by allowing precious works from their collections to travel to the exhibition venues in New York and Bilbao. A separate page is devoted to the list of lenders, but we would like to take this opportunity to offer them our gratitude for their generosity and cooperation, without which this exhibition would not have been possible.

We would like to single out the Benedictine Order in Olinda for its loan of their church's main altar, one of the most beautiful treasures of the Brazilian Baroque. When Edemar Cid Ferreira first identified the main altar of São Bento de Olinda as an object for inclusion in the exhibition, the need for its conservation was of primary importance, and it was an honor to be part of what became BrasilConnect's first conservation effort. The Guggenheim is grateful to Dom Bernardo Alves de Souza and the monks of São Bento de Olinda; Carlos H. Heck, President of the Instituto do Patrimônio Histórico e Artístico Nacional (IPHAN); Roberto Cesar de Hollanda Cavalcanti, Head of the Protection Department, IPHAN; Fernando de Melo Freyre, President, Fundação Joaquim Nabuco; and Frederico Edualdo Pernambucano de Mello, Director, Foundation Joaquim Nabuco, as well as all the personnel who made the conservation and unique presentation of this altar possible. The presentation of this monumental altar also required enormous effort from the Guggenheim staff, in particular the Conservation Department under the leadership of Paul M. Schwartzbaum, Chief Conservator/Technical Director International Projects, and Stephen Engelman, Technical Designer. To all of them, our admiration and gratitude.

The altar rises from the ground floor of the museum's rotunda, initiating the exhibition's fundamental dialogue between the Baroque and the Modern. The selection of contemporary artists suggests many of Modernism's artistic strategies and visual vocabularies. We thank each artist for participating in this exhibition. Their works establish vital parallels with the art of the past and constitute critical links in the continuing, fluid narrative of artistic expression in Brazil.

The exhibition's unique setting was designed by Jean Nouvel. He brought this presentation to another level of sophistication by transforming the museum into a negative of itself, dematerializing the white architecture of Frank Lloyd Wright by using shades of gray and black. The dialogue between the Baroque and the Modern is therefore enhanced and dialectically exposed. Our thanks to Jean Nouvel, Jean Charles Zébo, Martine Arrivet, and Hala Warde for conceiving this design in close collaboration with the Guggenheim's exhibition design staff, in particular, Sean Mooney, Exhibition Design Manager, Ana Luisa Leite, Senior Exhibition Design Coordinator, and Bernardo Zavatini, Project Exhibition Designer.

The cultural achievements of Brazil have been too little known, especially in the English-speaking world, and we hope this presentation will help rectify this situation. By exhibiting masterpieces of Brazilian art that have seldom been seen in such depth outside of Brazil, *Brazil: Body and Soul* has endeavored to capture the essential nature of an extraordinary country. We salute this great nation and thank all, in particular BrasilConnects and the Friends of BrasilConnects, who made this project possible.

Special Thanks

In addition to those named in the Foreword, Project Team, and Lenders to the Exhibition, the following individuals deserve recognition.

Marisa Abate
Dom Geraldo Magella Agnello
Coronel Ary de Aguiar Freire
Antonio Ivo de Almeida
Miriam Almeida
Oscar Americano Neto
Sylvia Athaide
Cordelia and Antônio José Barros de
 Carvalho e Mello Mourão
Ricardo Aquino
Ana Helena Americano Araújo
Francisco de Assis Portugal Guimarães
Roland Augustine
Fatima Bercht
Jones Bergamin
Roberto Bicca de Alencastro
Tanya Bonakdar
Carlos Bratke
Maria Aparecida Silva Brecheret
Victor Brecheret Filho
Maria Regina Nascimento Brito
Noêmia Buarque de Hollanda
Pedro Buarque de Hollanda
Joaquim Canuto de Santana
Dom José Cardoso Sobrinho
Luís Augusto Carsalade de Lima
Sérgio Chamma
Ana Maria Chindler
Alvaro Edwards Clark
Fernando Cocchiarale
José Teixeira Coelho Netto
Peter Cohn
Antônio Carlos Curiati
Monsenhor Ademar Dantas
Luís Fernando Dias Duarte
Berete Due
Vilma Eid
Fanny Feffer
Júlio de Franco Neves

Domingos Giobbi
Raquel Glezer
Renato Magalhães Gouveia Júnior
Angela Gutierrez
Ben Hartley
Zeev Chalom Horovitz
Alfons Hug
Walter Siqueira Lazzarini
Ingrid Lee
Susana Torruella Leval
José Carlos Levinho
Lawrence Luhring
Heloisa Aleixo Lustosa
Peter Mann de Toledo
Dom Irineu Marinho
Cremilda Martins de Albuquerque
Thais de Mello Lima
Paula Montero
Rui Mourão
Paulina Nemirovsky
César Oiticica
Guillermo Ovalle
Paula Pape
Peter Pentz
Heitor Reis
Maria Izabel Branco Ribeiro
Myriam Andrade Ribeiro de Oliveira
Reinaldo Roels Jr.
Mercedes Rosa
Ricardo Sardenberg
Pedro Paulo de Sena Madureira
Brent Sikkema
Antonio Manuel da Silva Oliveira
Nancy Spector
Benjamin Steiner
Alessandra Villaça
Espen Waehle
Arno Wehling
Roberto Zarzur

Project Team

Guggenheim Museum

CURATORIAL

Edward J. Sullivan, *Guest Curator*

Germano Celant, *Senior Curator of Contemporary Art*

Julian Zugazagoitia, *Project Manager*

Nelson Aguilar, *Curatorial Advisor, Twentieth Century*

Emanoel Araújo, *Curatorial Advisor, Baroque and Popular Arts*

Mari Marino, *Curatorial Advisor, Baroque Art*

Charmaine Picard, *Project Curatorial Assistant*

Elissa Kwon, *Administrative Assistant*

Camila Henman Belchior, *Intern*

Lucimara Anselmo Santo Letelier, *Intern*

Carolina Silva, *Intern*

ART SERVICES AND PREPARATIONS

Scott Wixon, *Manager of Art Services and Preparations*

Mike Asente, *Assistant Manager of Art Services*

David Bufano, *Senior Museum Technician*

Barry Hylton, *Senior Exhibition Technician*

Mary Ann Hoag, *Lighting Designer*

Richard Gombar, *Construction Manager*

Michael Sarff, *Assistant Construction Manager*

James Nelson, *Chief Preparator*

Derek DeLuco, *Technical Specialist*

Jeffrey Clemens, *Associate Preparator*

Jeffrey Britton, *Associate Preparator*

Elizabeth Jaff, *Associate Preparator for Paper*

Thomas Radloff, *Art Handler*

Elizabeth Martin, *Art Handler*

Hans Aurandt, *Art Handler*

CONSERVATION

Paul M. Schwartzbaum, *Chief Conservator/Technical Director International Projects*

Nathan Otterson, *Assistant Conservator, Sculpture*

EDUCATION

Kim Kanatani, *Gail Engelberg Director of Education*

Pablo Helguera, *Senior Education Program Manager, Public Programs*

Sharon Vatsky, *Senior Education Program Manager, School Programs*

Rosanna Flouty, *Education Production Coordinator*

EXHIBITION AND COLLECTION MANAGEMENT AND DESIGN

Karen Meyerhoff, *Managing Director for Exhibitions, Collections, and Design*

Marion Kahan, *Exhibition Program Manager*

Sady Cohen, *Exhibition Management Assistant*

Paul Kuranko, *Media Arts Specialist*

Sean Mooney, *Exhibition Design Manager*

Ana Luisa Leite, *Senior Exhibition Design Coordinator*

Bernardo Zavattini, *Project Exhibition Designer*

Melanie Taylor, *Project Exhibition Designer*

Greg Pitts, *Project Design Associate*

Andrea Claire, *Project Design Coordinator*

Angelo Morsello, *Exhibition Design Assistant*

Marcia Fardella, *Chief Graphic Designer*

Concetta Pereira, *Production Coordinator*

Ana Linnemann, *Graphic Designer*

Christine Sullivan, *Graphic Designer*

Ursula Rothfuss, *Graphic Designer*

EXTERNAL AFFAIRS

Melanie Forman, *Director of Development*

Helen Warwick, *Director of Membership*

Kendall Hubert, *Director of Corporate Communications and Sponsorship*

Jennifer Sancton, *Manager of Exhibition Sponsorship*

Gina Rogak, *Director of Special Events*

Stephen Diefenderfer, *Special Events Manager*

Peggy Allen, *Development Coordinator*

FABRICATION

Peter Read, *Manager of Exhibition Fabrications and Design*

Stephen Engelman, *Technical Designer*

David Johnson, *Chief Framemaker*

Kirk Anders, *Senior Cabinetmaker*

Michael Goitia, *Cabinetmaker*

FILM AND MEDIA ARTS

John G. Hanhardt, *Senior Curator of Film and Media Arts*

Maria-Christina Villasenor, *Associate Curator of Film and Media Arts*

Robert Stam, *Guest Curator*

Ismael Xavier, *Guest Curator*

Rajendra Roy, *Program Manager, Film and Media Arts*

Kevin Murphy, *Administrative Assistant, Film and Media Arts*

FILM AND VIDEO PRODUCTION

Ultan Guilfoyle, *Director of Film and Video Production*

Alice Bertoni, *Assistant Producer, Film and Video Production*

FINANCE

Patrick McNamara, *Controller*

GLOBAL PROGRAMS, BUDGETING AND PLANNING

Anna Lee, *Director of Global Programs, Budgeting and Planning*

Christina Kallergis, *Financial Analyst, Global Programs, Budgeting and Planning*

LEGAL

Gail Aidinoff Scovel, *General Counsel*

Don Millinger, *Special Counsel*

Brendan Connel, *Assistant General Counsel*

Maria Palante, *Associate General Counsel*

Amanda Estrine, *Associate for Rights and Research*

Amy Gilday, *Assistant to the General Counsel*

MARKETING

Laura Miller, *Director of Marketing*

Sandra Kopp, *Senior Marketing Manager*

PHOTOGRAPHY

David M. Heald, *Head Photographer*

Ellen Labenski, *Associate Photographer*

Kim Bush, *Manager of Photography and Permissions*

PUBLIC AFFAIRS

Betsy Ennis, *Director, Public Affairs*

Shannon Leib, *Assistant Publicist*

Sasha Nicholas, *Public Affairs Coordinator*

PUBLICATIONS

Anthony Calnek, *Managing Director and Publisher*

Meghan Dailey, *Associate Editor*

Elizabeth Franzen, *Manager of Editorial Services*

Tracy Hennige, *Production Assistant*

Beth Huseman, *Assistant Editor*

Elizabeth Levy, *Managing Editor/Manager of Foreign Editions*

Laurel Ptak, *Assistant Editor*

Carey Ann Schaefer, *Assistant Editor*

Melissa Secondino, *Associate Production Manager*

Edward Weisberger, *Editor*

REGISTRAR

Meryl Cohen, *Head Registrar*

Carolyn Padwa, *Registrar*

Elissa Myerowitz, *Assistant Registrar*

RETAIL OPERATIONS

Peter Capriotti, *Manager of Retail Operations*

Gian Leoncavallo, *Merchandise and Marketing Assistant*

SECURITY

Thomas Foley, *Director of Security*

STRUCTURAL ENGINEERING

Ramon Gilsanz Consulting Engineers

Ramon Gilsanz

Vicki Arbitrio

Raul Maestre

VISITORS SERVICES

Stephanie King, *Director Visitor Services*

BrasilConnects

Edemar Cid Ferreira, *Chairman*
Pedro Paulo de Sena Madureira,
 Vice Chairman
Beatriz Pimenta Camargo, *Director*
Julio Landmann, *Director*
René Parrini, *Director*
Nelson Aguilar, *Chief Curator*
Franklin Espath Pedroso,
 Associate Chief Curator
Emilio Kalil, *Project Executive Director*
José Pascowitch, *Environment Executive*
 Director
Júlio Cesar Bin, *Marketing and*
 Communication Executive Director
Marco F. Simões, *Business Development*
 Executive Director
Raul Félix, *Finance and Administration*
 Executive Director
Helena Gasparian, *Coordinator of*
 International Relations

EXHIBITION TEAM

Nelson Aguilar, *Curatorial*
Emanoel Araújo, *Curatorial*
Mari Marino, *Curatorial*
Emilio Kalil, *Project Director*
Robson Outeiro, *Assistant*
Silvana Marani Lopes, *Assistant*
Franklin Espath Pedroso, *Project Coordinator*
Maria Paula Armelin, *Project Manager*
Claudia Vendramini, *Collaborator*
Claudia Regina da Silva, *Project Assistant*
Sérgio A. Dossantos, *Assistant for*
 Photography
Alessandra Batchelder, *Transport*
 Coordination
Daniela V. Coelho, *Transport Assistant*

BRASILCONNECTS U.S.A.

Adam Segall, *U.S. Executive Director*
Rosemary Otero, *U.S. Director*
Volga Khan, *Executive Assistant*

Conservation of Main Altar, São Bento de Olinda

BENEDICTINE ORDER, MOSTEIRO DE SÃO BENTO DE OLINDA

Dom Bernardo Alves de Souza

INSTITUTO DO PATRIMÔNIO HISTÓRICO E ARTÍSTICO NACIONAL

Carlos H. Heck, *President*
Roberto Cesar de Hollanda Cavalcanti,
 Head of the Protection Department
Luiz Antonio Cruz Souza
Antonio Fernando dos Santos
Eliane Maria Silveira Fonseca Carvalho

FUNDAÇÃO JOAQUIM NABUCO

Fernando de Melo Freyre, *President*
Frederico Eduardo Pernambucano de Mello
Pérside Omena Ribeiro
José Floriano de Arruda Neto
Jairson Alves da Rocha
Iramarai José Vilela de Freitas

Arquitecture Jean Nouvel (AJN)

Jean Nouvel
Jean Charles Zébo
Martine Arrivet
Hala Warde

Lenders to the Exhibition

INDIVIDUALS

Ricard Akagawa

Mr. and Mrs. Luíz Antônio de Almeida Braga

Ladi Biezus

Geneviève and Jean Boghici

Luiz Buarque de Hollanda

Mr. and Mrs. José M. Carvalho

Pedro Ramos de Carvalho

Claudio Cesar and Lynn Steiner Cesar

Ario Dergint

Sérgio Sahione Fadel

Simone Fontana

Marta and Paulo Kuczynski

Adolpho Leirner, São Paulo

Gerard Loeb

Antonio Maluf

Antonio Manuel

Mastrobuono Collection

Marcelo de Medeiros

Mestre Didi

Orandi Momesso

Vik Muniz

Diógenes Paixão

Lygia Pape

Sandra Penna

Patricia Phelps de Cisneros, Caracas

Beatriz and Mário Pimenta Camargo

João Maurício de Araújo Pinho,
 Rio de Janeiro

Marilisa Rodrigues Rathsam

Ronaldo Rego

Miguel Rio Branco

Eugênio Pacelli Pires dos Santos

Raquel Silveira, São Paulo

Tunga

Paulo Vasconcellos

Franz Weissmann

Renato Whitaker

Zellmeister Collection

Anonymous lenders

GALLERIES

D'Amelio Terras Gallery, New York

Galeria André Millan, São Paulo

Galeria Fortes Vilaça, São Paulo

Galeria Oliva Araúna, Madrid

Lehman Maupin Gallery, New York

INSTITUTIONS

Acervo Artístico/Cultural dos Palácios do
 Governo do Estado de São Paulo

Arquidiocese de Olinda e Recife, Convento
 de Santo Antônio, Pinacoteca de
 Igarassu

Arquidiocese São Salvador da Bahia
 (Catedral Basílica, Salvador)

Associação Cultural do Mundo de
 Lygia Clark

Atração Escritório de Arte, São Paulo

5a. Superintendência Regional/Instituto
 do Patrimônio Histórico e Artístico
 Nacional/Ministério de Cultura,
 Pernambuco

Confraria/Igreja Nossa Senhora dos
 Homens Pretos de Olinda

El Museo del Barrio, New York

Fundação Cultural do Estado da Bahia,
 Museu de Arte Moderna da Bahia,
 Salvador

Fundação José e Paulina Nemirovsky,
 São Paulo

Fundação Maria Luisa e Oscar Americano,
 São Paulo

Fundação Pierre Chalita, Alagoas

Solomon R. Guggenheim Museum,
 New York

Hélio Oiticica Collection, Projeto Hélio
 Oiticica, Rio de Janeiro

Igreja Nossa Senhora do Carmo de
 Olinda–5a Superintendência
 Regional/Instituto do Patrimônio
 Histórico e Artístico
 Nacional/Ministério de Cultura,
 Pernambuco

Instituto do Patrimônio Histórico e
 Artístico Nacional/Ministério de
 Cultura, Museu da Inconfidência,
 Ouro Prêto

Instituto Histórico e Geográfico Brasileiro,
 Rio de Janeiro

Irmandade da Santa Cruz dos Militares,
 Rio de Janeiro

The Metropolitan Museum of Art,
 New York

Mosteiro de São Bento de Olinda, Olinda

Museu Bispo do Rosario/Instituto
 Municipal, Colônia Juliano Moreira,
 Prefeitura Rio de Janeiro

Museus Castro Maya–Instituto do
 Patrimônio Histórico e Artístico
 Nacional/Ministério de Cultura,
 Rio de Janeiro

Museu de Arqueologia e Etnologia,
 Universidade de São Paulo

Museu de Arte Brasileira–Fundação
 Armando Alvares Penteado,
 São Paulo

Museu de Arte Contemporânea da
 Universidade de São Paulo

Museu de Arte da Bahia, Salvador

Museu de Arte de São Paulo Assis
 Chateaubriand, São Paulo

Museu de Arte Moderna do Rio de Janeiro

Museu de Arte Sacra da Universidade
 Federal da Bahia, Salvador

Museu de Arte Sacra de São Paulo

Museu do Índio, Rio de Janeiro

Museu do Oratório, Ouro Prêto

Museu Mineiro–Superintendência de
 Museus/Secretaria de Estado da
 Cultura, Minas Gerais

Museu Nacional da Universidade Federal
 do Rio de Janeiro

Museu Nacional de Belas Artes,
 Rio de Janeiro

Museu Paraense Emílio Goeldi–Conselho
 Nacional de Desenvolvimento
 Científico e Tecnológico/Ministério
 da Ciência e Tecnologia, Belém

National Museum of Denmark,
 Copenhagen

Pé de Boi Galeria de Arte Popular,
 Rio de Janeiro

Pinacoteca do Estado de São Paulo

The Solomon R. Guggenheim Foundation

Brazil: Body and Soul

Edward J. Sullivan

Dreamscapes

In 1436, Venetian cartographer Andrea Bianco published his map of the world as it was then known. On it was an island designated the "I. de Brazi." This was the first time that this quasi-mythical place was located on a scientific document. "Brazi" or "Brasi" was the name given to the island that was thought to be the source of brazilwood, a variety of red-dye-producing wood that had been known in Europe since at least the Middle Ages and possibly as far back as antiquity. The "Brazi" that Bianco indicated on his map is actually part of the Atlantic island chain of the Azores and was later renamed Terceira. Yet the legendary island of Brazi continued to exist in the imagination of many writers, and on other maps was even located in the mid-Atlantic, off the coast of Ireland. By the nineteenth century Brazi was finally declared to be as mythical as Atlantis. But the legend of this island may have contributed to the naming of Brazil,

when the wood was found there after the European "discovery" of this immense South American country. Thus, even Brazil's onomastic origins are bound up in notions of enigma, myth, and utopia.

The mirage of Brazil entered the dreamscape of the Western world soon after it was first sighted in April 1500 by Portuguese explorer Pedro Álvares Cabral. Exotic products including vegetable, animal, and mineral as well as human specimens were brought to Europe, where they became testimonies to the existence of the legendary. Tracts were written throughout Europe based on the accounts of travelers (many of whom never left the comfort of their homes) describing this strange utopia. Every paradise has its contradictions, and that of Brazil was its cannibalism. Early writings on the country emphasized the many peculiar practices of the indigenous peoples, yet the custom that was most avidly remarked upon was the

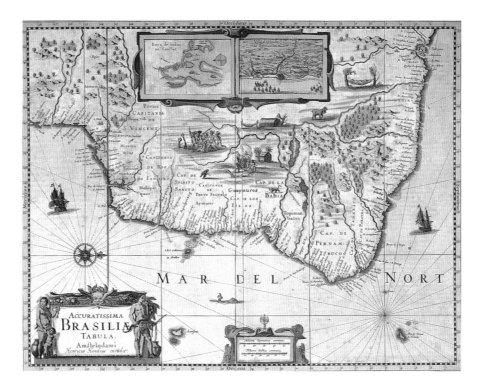

habit of eating other humans. While the extent of real instances of cannibalism is debatable, the metaphoric potential of the act laid the foundation for philosophical discussions about the Brazilian character throughout the twentieth century.

Brazil has continued to exist as an enigma and a dream. With its vast mineral wealth and its potential as a center for sugar, tobacco, and, later, coffee production, the country inflamed the imaginations of generations of industrialists from the colonial era onward. Nineteenth-century rubber barons in Manaus followed this dream when they erected a legendary opera house on the banks of the Amazon, and modern-day mega-capitalists revel in the fantasy of the country's economic and technological possibility. For generations, Rio de Janeiro has been the site of fantasies, both erotic and aesthetic, its Carnival serving as the allegorical fulfillment of hedonistic reverie. These dreams have eclipsed the primal nightmares that share equally in the Brazilian imaginary. The ravishing of the rain forests for their abundance, the violation of the cities by drug violence, and the massacre of homeless children are also components of the reality of modern Brazil.

The legacy of Brazilian visual culture is the subject of both this book and the exhibition it accompanies. This project, a quixotic undertaking, is the result of the labor of a considerable number of individuals in Brazil, the United States, and Europe. Its scope is expansive, and the following remarks are by way of an introduction to its dense sweep. Any introduction is merely a guide, a shorthand schema for understanding a larger, more richly complex entity, and this essay is no exception. The exhibition inevitably raises more questions than it can hope to answer, and these remarks are merely intended to be rudimentary guidelines for some of these historical and theoretical issues. However, there are inevitable gaps in this as in all such projects—for example, some works could not travel, or the curatorial concept did not allow for the inclusion of certain artists or phases of artistic development. I will therefore take advantage of this introductory format to include a few comments on aspects of Brazilian art that are not treated elsewhere in this publication and exhibition.

Any large-scale exhibition of the art of a single country poses many serious curatorial questions. Indeed, should there

be exhibitions that attempt to define the characteristics of the visual culture of a nation? Can such definitions be valid? What curatorial practices and strategies should be employed so that the art on display does not become subsumed into questionable ideological paradigms? What are the economic or political implications of an exhibition such as this, if we consider that most of what we think of as "art" is created as a commodity or becomes such when it is displayed outside its immediate context? How can we create an exhibition that will present as culturally sensitive a view as possible? These and many other questions have been at the core of the planning of *Brazil: Body and Soul*. This project has been undertaken not as an exercise in didactic thoroughness but with the intention of presenting, to a wide public, intimations of the diverse cultural strands that have comprised the fabric of visual expression in Brazil over the course of several centuries.

Before proceeding with a further examination of these points, it might be helpful to ask another question: Why should there be a large-scale show of Brazilian art now, and in the city of New York, with an accompanying publication that deals with so many aspects of Brazilian visual culture? Anyone familiar with the history of exhibitions and scholarship in the field of Latin American art within recent decades is aware that there has been a steady stream of articles and books written and exhibitions organized on virtually every aspect of art from Latin America, from ancient to Modern.[1] Much of this critical investigation has been undertaken out of a sincere desire to analyze and promote forms of art that until recently were marginalized by the Eurocentric discipline of art history. Some projects, however, have been driven more by financial motivations and the wish to take advantage of a burgeoning market for the art of the regions that extend from Mexico to the Southern Cone and into the Caribbean. Still others have grown out of a desire to profit from the potential economies of so-called developing nations.

While Brazilian art and artists have certainly figured prominently in a number of these exhibition projects, there is proportionately less known about Brazil's artistic development as a whole. Contemporary Brazilian artists participate in individual and group shows in the principal museums and galleries of the United States and Europe—and often not as "Brazilian" but as "contemporary" artists. Nonetheless, there is relatively little familiarity outside Brazil with the Brazilian Baroque or the modernizing movements of the 1920s and 1930s, even though exhibitions of Brazilian art have been organized internationally since the 1940s.[2] We might point to the linguistic isolation of Brazil, a Portuguese-speaking country enclosed within a predominantly Spanish-speaking continent, as a partial explanation for this lack of critical attention on the part of non-Brazilians. Portuguese language is rarely taught as part of a secondary-school or university curriculum in most countries, and thus much of the literature on Brazilian art history remains inaccessible to many.

In the United States, the years from the 1920s to 1940s witnessed a growth of interest in Latin American cultures. There was increased travel to Latin America, especially to Mexico and Cuba, the closest and most easily accessible countries to the United States.[3] Artistic interchange between the continents became more common, and the arts of Latin America assumed a more significant role in the exhibition policies of cultural venues in the United States, especially those in New York. Much of this was prompted by rapidly developing United States involvement in the politics and economies of the nations of Latin America, especially during the years prior to and during World War II. The Museum of Modern Art in New York, through the intervention of the Rockefeller family, who had significant

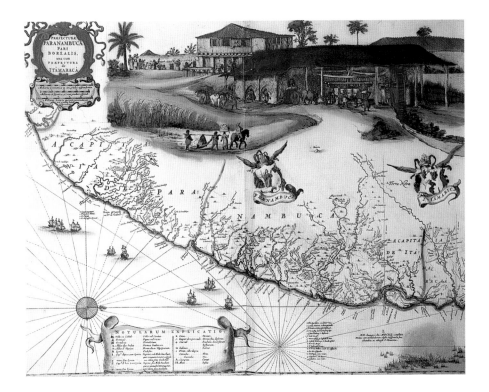

Map of Northeast Brazil from Frederick de Wit, *Atlas Maior* (Amsterdam, ca. 1700). The New York Public Library

cultural and business interests in the region, became one of the country's most important repositories of Latin American art. Although much of the museum's Latin American collection has not been on view for many years, many significant exhibitions on the subject were presented there in the 1940s, including *Twenty Centuries of Mexican Art*, in 1940, and *Modern Cuban Painters*, organized by Alfred H. Barr, Jr., in 1944. While Brazil was by no means absent from the museum's Latin American panorama, it was acknowledged in a somewhat less extensive way. An exception to this was the 1940 exhibition devoted to the work of Cândido Portinari (1903–1962), who had become known in the United States five years earlier when he was awarded an honorable mention at the Carnegie International exhibition in Pittsburgh for his painting *Coffee* (1935, cat. no. 240). A second exception was the 1943 exhibition *Brazil Builds: Architecture New and Old 1652–1942*.[4] Architecture was the aspect of Brazilian culture that aroused the most attention among New Yorkers in the mid-twentieth century, and the exhibition was an important event for the diffusion of knowledge about both traditional building practices in Brazil and the

great names of the contemporary period, especially Lúcio Costa (1902–1998) and Oscar Niemeyer (b. 1907).[5]

Since the 1940s, however, there have been relatively few comprehensive shows of Brazilian art or architecture in New York. *Brazil Projects*, presented at P.S.1 in 1988,[6] and a handful of smaller exhibitions in the 1990s focused on contemporary Brazilian art.[7] Other parts of the United States have had less exposure to Modern and contemporary Brazilian art, and the historical periods have been represented even more rarely.[8] In Europe, on the other hand, there have been several important shows of Brazilian art organized over the last fifteen years, and their catalogues have offered valuable information on a variety of time periods.[9] It is hoped that *Brazil: Body and Soul* will provoke greater curiosity about Brazilian culture. If it functions as a catalyst for in-depth exhibitions of the work of individual artists or movements, or serves as a stimulus for further specialized scholarly studies, it will have served a worthwhile purpose.

So many of our stereotypes come from the movies, and clichéd notions about Brazil have permeated Hollywood cinema since the early twentieth century.[10]

Even silent movies such as *Charley's Aunt* (1925) included eccentric Brazilian characters. But it was in the 1930s, with the growth of capital investment by the United States in Latin America and the beginning of Franklin D. Roosevelt's Good Neighbor policy that the deformation of Brazil (and the rest of Latin America) in Hollywood movies began in earnest. The 1933 musical *Flying Down to Rio*, with Ginger Rogers and Fred Astaire, transformed this Brazilian city into a world-renowned romantic vortex, an image that was fostered by many later Hollywood films, including the 1961 *Breakfast at Tiffany's*, in which the heroine, Holly Golightly (played by Audrey Hepburn), falls in love with a man from Rio. Even though she never makes the trip to Brazil (although her character in Truman Capote's 1958 novella does), she imagines Rio as the epitome of glamour, romance, and freedom. Alfred Hitchcock gave the city a new spin, using Rio as a site for Nazi spies in his 1946 film *Notorious*.

Ironically, the principal Brazilian character in *Flying Down to Rio* was played by a Mexican star, Dolores del Rio. But certainly the most famous case of cultural schizophrenia in the movies was that of Carmen Miranda. Born in Portugal and raised in Brazil, Miranda served as the generic, all-purpose latina bombshell in films throughout her career. In *The Gang's All Here* (1943), she became the "lady in the tutti-frutti hat."[11] Other films—often reviled by Brazilian audiences as representing Yankee ignorance and stereotyping of Latin America—found her in Cuba (*Week-End in Havana*, 1941) and even Colorado (*Springtime in the Rockies*, 1942). In 1945, a Carmen Miranda look-alike, along with Daffy Duck and his Brazilian counterpart, the parrot José or Joe Carioca, appeared in one of Walt Disney's Good Neighbor cartoons, *The Three Caballeros*. As George Hadley-García has pointed out, "Miranda's rise and fall parallels that of the Good Neighbor Policy."[12]

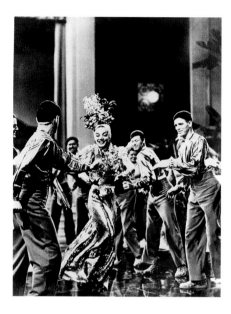

Carmen Miranda in *A Night in Rio*, 1941. Directed by Irving Cummings for Twentieth-Century Fox

Not all romanticized or fatuous views of Brazil have come from Hollywood, however. The French-Italian coproduction *Black Orpheus* (1959) purged the *favelas* of Rio of much of their misery and despair, presenting their protagonists as happy (if, ultimately, tragedy-stricken) inhabitants of a world of music and dance.

Other stereotypes about Brazil exist in the popular imagination, most of these deriving from television. Soccer is seen as the national preoccupation, Carnival the national orgy, and violence the norm. I do not believe that anyone would contest the existence of these elements in a greater or lesser measure in Brazilian society, yet they stand in the minds of many as the defining characteristics of the country, thanks to the overwhelming power of the mass media. Contrasting these truisms with other levels of cultural perception is a prerequisite to a more profound engagement with the realities of the country.

Brazil: Body and Soul does not pretend to present a complete panorama. It concentrates instead on two principal areas of Brazil's art history: the Baroque and the twentieth century. Yet within these divisions there is both flexibility and the desire to suggest nuance and fluidity in the historical narrative. Indeed, an attempt to impose strict linearity on Brazilian history would be a serious mistake, as the

history of Brazil's cultural development is one of reflexive contrasts and undulating spirals in constant flux. This project attempts to intimate much of the infra-history of the nation, posing questions that reflect upon such philosophical dilemmas as center versus periphery, borrowing and re-invention, and national self-projection. One of the defining terms of the Brazilianness of twentieth-century art has been "*antropofagia*" (cannibalism), first used by critic and essayist Oswald de Andrade and painter Tarsila do Amaral in the late 1920s to indicate characteristics of hybridity and originality.[13] They advocated a revalorization of local cultural forms to create a distinctly Brazilian identity that would challenge the hegemony of foreign fashions. The recycling and reinvention they proposed characterizes many phases of Brazilian visual art. Resistance and acceptance, and the urge to appropriate combined with flexibility and resilience shape the individuality of Brazilian cultural patterns.

Beginnings

Brazil: Body and Soul begins with a consideration of the view from the outside. The first European representations of Brazil taken from life were made by the Dutch artists Frans Post (1612–1680) and Albert Eckhout (ca. 1610–ca. 1665), who arrived in Brazil around 1636. Yet their images were only the first of many.[14] The nineteenth century was the age of the traveler-reporter artist, and the work of such painters as the Englishman Charles Landseer (1799–1879), the German Johann Moritz Rugendas (1802–1858), and the American Martin Johnson Heade (1819–1904) not only described an exotic distant land but also defined romantic clichés about it. Their work encompasses a paradigmatic chapter in the story of art in Brazil.[15] In the twentieth century, the French photographer Pierre Verger (1902–1996) etched the appearance of Brazil's Northeast (especially the city of Salvador da Bahia) on our minds, and, more recently, the

German painter Anselm Kiefer (b. 1945) created a series of large-scale works suggesting the dehumanization and alienation of the modern Brazilian city.

Eckhout came to Brazil in the retinue of the German count Johan Maurits van Nassau-Siegen, who was named governor of the short-lived Dutch colony in Brazil's Northeast by the Dutch West India Company. This artist executed an extraordinary series of virtually life-size anthropological portraits of the inhabitants of the country, including the eight works that portray members of two indigenous groups, an African man and woman, and a male-female pair of mixed race (cat. nos. 16–23). In addition, he depicted a group of Tapuya Indians engaged in a lively dance (cat. no. 15) and painted a series of evocative still lifes of the fruits and flowers of Brazil, both native and introduced (e.g., cat. nos. 24–27). All of these paintings decorated the main hall of the count's Vrijburg Palace and are now in the collection of the National Museum of Denmark in Copenhagen. Post, who also came to Brazil as an artist in the count's court, depicted the topography in the region of Recife and Olinda in what is now the state of Pernambuco. Only seven of the paintings he executed in Brazil are known to have survived, and one of these (cat. no. 28) is included in *Brazil: Body and Soul*. (His other existing Brazilian landscapes were painted later in Europe.) Described by art historian Luis Pérez Oramas as representing the "invention" of American landscape,[16] Post's paintings, as well as those by Eckhout, are important as documents of their time, establishing notions of place and personalizing the written accounts of European visitors to Brazil by presenting a firsthand description of what the artists witnessed.[17] However, like any distant view, they are distortions, the products of cultural voyeurism and the manifestations of scopophilic desires not only to record but to possess. These paintings, while essential to establishing Brazil as a tangible place in the minds of European

audiences, function equally as totems of desire and proprietorship.

This occasion also presents—in close proximity to the works of Eckhout and Post—a selection of the arts of indigenous peoples from both the past and the present. These objects, which include arrows, face and body masks, and feathered head pieces, cross conventional time lines as they continue to be made and used as integral components of the everyday rituals of indigenous groups. The most impressive object among these is a feathered cape of the Tupinambá people (cat. no. 1). In literal terms, this piece represents the type of object of desire coveted by wealthy sixteenth- and seventeenth-century European collectors of precious, exotic wares from those faraway places whose territories they had colonized. By placing such objects in their *wunderkammern*, or curiosity cabinets, the collectors could believe themselves to be the ritual possessors of the treasures of the newly discovered places across the ocean. The display of these objects in exhibitions illuminates the nature of acquisitiveness, proprietorship, and the actualization of colonial desires. We are both educated and blinded by their presence. While intellectually we may understand that the shaman who assumed the feathered mantle became a bird-man, a transformed being, an ethereal and sacred creature, we can never intuit the true significance of this or other ritual objects, for all of them are intimately connected to the creation mythologies and cosmological legends of the indigenous societies from which they come. As American and European curators and historians, we may transform these objects into "art" in the most banal, conformist sense by placing them into a context that makes them part of a linear historical narrative, yet they belong, at the same time, to a sphere that is far outside our realm of comprehension.

The indigenous objects in *Brazil: Body and Soul* are neither inert nor static. They each have a role in the "performance" of the lives of the peoples who created them. In confrontation with the depictions of Brazil by painters such as Post and Eckhout, they take on an active role as paradigms of the civilizations European artists have sought to depict and possess. In a larger context, the performative aspect of these objects, their inherent activity, adumbrates or parallels similar concepts of theatricality, absorption, and integration inherent in the conceptualization of other works of Brazilian art. Christian processions and other types of community-oriented observances of feast days or Semana Santa (the week preceding Easter Sunday), whether during the colonial period or in the present are, in essence, total works of art in which objects and the performance of them fuse into a whole, a totality in which spectator and activated object become equal participants in the performance of ritual. The interactive works of the Neo-Concrete artists such as Lygia Clark and Hélio Oiticica manifest a parallel engagement with concepts of theatricality and absorption. The creator, the object created, and the user/performer literally become one entity in an activated rite of celebration. Anthropologist Roberto DaMatta has broadened this discussion to include public ritual, both religious and secular. His reflections on Carnival, Independence Day parades, and other popular celebrations expand the depth and breadth of this notion of performativity.[18]

The Baroque

A significant percentage of the work in *Brazil: Body and Soul* is from the Baroque period. The use of the term "Baroque" presents both semantic and conceptual problems. It is rife with Eurocentric references and clichés regarding overabundance and decoration. Indeed, its linguistic origins may be traced to the sixteenth-century Portuguese word used as a derogatory description of an irregularly shaped pearl. "Baroque" has been employed in so many contexts that it has become virtually void of specific meaning, like many other

designations of artistic styles or chronological periods. Its use in a Latin American context has been long-debated. In a discussion about contemporary art, Brazilian art historian Paulo Herkenhoff recently referred to the Baroque as "a kind of alternate civilizing process."[19] I therefore use the term in a cautious but practical sense as a convenient label to characterize a long and complex historical process that began in the seventeenth century and reached (in some regions such as the interior state of Minas Gerais) well into the early decades of the nineteenth. The later phases of this period, after 1750 or so, should be more precisely delineated by the term "Rococo," but generally speaking I will employ the word "Baroque" to indicate Brazilian art of the colonial period.

Brazilian Baroque sculpture experienced an evolution that began with the seventeenth-century terra-cottas of Frei Agostinho da Piedade (?–1661) and other contemporaneous artists. Their work often displayed a hieratic stiffness in the poses of their subjects and the definition of their clothing. From around 1750, most sculpture demonstrated a Rococo tendency toward detail and ornamentation, although there are many differences in regional styles. The principal areas of artistic production during the Baroque included the present state of Rio Grande do Sul, where indigenous artists working in the Jesuit missions on the border with Paraguay and Argentina produced a distinctly rugged, powerful variety of sculpture. Examples from Minas Gerais generally demonstrated elegant proportions and the figures' garments were often painted in pastel colors. Sculpture from Bahia and the Northeast often portrayed a highly dramatic quality. The metropolitan school of Rio de Janeiro produced a sophisticated style of sculpture, often with references to contemporaneous European (especially Portuguese) models.[20]

In some regions of the country, a Neoclassical mode replaced the Baroque after around 1800, although this did not occur in Minas Gerais, which to this day preserves in many of its smaller cities and towns a distinctive spirit redolent of the intense spirituality expressed through its Baroque paintings, sculptures, and religious buildings. Minas Gerais was the home of Brazil's best-known Baroque artist, Antônio Francisco Lisboa (1738–1814), known by the nickname O Aleijadinho (The Little Cripple), which referred to the effects of the disease, possibly syphilis or leprosy, that debilitated him later in life.

The greatest proportion of Brazilian Baroque sculpture is religious, and many of these pieces were commissioned by the ecclesiastical orders. The theological concerns and specific devotions of these orders, including the Benedictines, Carmelites, Jesuits, and the Franciscans, informed the style and, most importantly, the iconographic content of many of these sculptures. What cannot be perceived in any reproduction of Baroque art, or even its presentation in the inherently decontextualized arenas of exhibition and publication, is the potency of the faith that these images supported. Its strong appeal to the senses, however, is a characteristic that may be intuited even within the setting of a museum.

Among the examples of Baroque sculpture in *Brazil: Body and Soul* are what we could term sculptures of public worship—pieces to be seen in the context of a church or chapel. There are also sculptures meant to be viewed as part of a processional group. During religious holidays, processions leave the church and travel along clearly defined routes through towns and cities. The carved wood images used in these processions are dressed in real clothing and often provided with hair and glass or painted eyes. The processions organized for Semana Santa are the best-known. As in other Catholic countries, particularly those of the Iberian peninsula, the participants in these processions carry platforms bearing figures depicting the suffering or dead Christ, the sorrowful

Virgin, and mourning saints. There is a dramatic physical interaction between image and worshiper in the performative ritual of the procession, with the sculptures evoking a high degree of devotion.

All Baroque religious imagery, whether from Europe or the Americas, is intended to convey the strength of Catholicism. In its third meeting (1562–63), the Council of Trent called for the reform of Mannerist art and the institution of greater clarity and vehemence of religious sentiment. The Baroque, which was in many senses a product of this decree, was predicated on a concept of intense engagement of the viewer with the image. This is true whether the image is meant to be perceived in a public or private forum. The larger-scale sculptures of the Baroque epoch represent an interactive participation between the worshiper and the object in a public setting such as a church or a chapel. Other, more private works embody the intimate, personal side of Brazilian spirituality, such as the small, portable oratories, or *oratórios*, with doors that open to reveal an image of Christ, the Virgin, or saints.[21] Oratories convey as convincingly as more monumental pieces the strength of faith and sense of communication with the divine that underlie Brazilian religious art. The oratory as a genre is not unique to Brazil; there are examples found also in Portugal, Spain, and other Latin American countries. But in Brazil, there are a surprisingly diverse number of categories and sizes to these private altars. Most are by anonymous artists, although such important figures as O Aleijadinho and the painter Manuel da Costa Ataíde (1762–1837) are recorded as having intervened in their creation. Some oratories contain not only Christian imagery but also that derived from Afro-Brazilian religions. This iconography syncretizes the Christian deity and saints with those of the West African pantheon of gods or spirits called *orixás*. The popular Afro-Brazilian saints such as Efigénia, Cosmos, Damian, and Elesbão are seen in many of them. These Afro-

Brazilian altars are quintessential testimonies to the multiplicity of racial elements in Brazil, as well as to the strength of the African presence and the significance of its forms of worship in many sectors of society.

What makes Brazilian Baroque art Brazilian? While up to now no one has attempted to define what has been articulated for English art by Nikolaus Pevsner or Mexican art by José Moreno Villa,[22] this is a question that naturally springs to the mind of virtually anyone who engages with this material. The many regional differences and evolving stylistic patterns from the seventeenth to the nineteenth centuries make easy characterization virtually impossible. However, there are certainly some iconographic singularities in the Brazilian Baroque, such as the many carvings of black saints. Another aspect that is particularly Brazilian about this art is the intensity, even theatricality of faith and the directness of communication that is established between the object and the beholder in so many instances. The power of this imagery transcends time and continues to provoke an emotional response today. A witness to any religious procession or church service on an especially important ecclesiastical holiday will become aware of this. Devotees of foreign cinema will remember a crucial scene from the recent Brazilian film *Central Station* (1998) that serves as a paradigm of both the power of images and the vehemence of collective devotion in Brazilian society. The heroine searches for the young boy who has accompanied her on a long bus trip from Rio de Janeiro to the Northeast. They find themselves in a small town, which also serves as an important pilgrimage site. It is the evening of a feast day and hundreds of worshipers have converged on the church, processing to the sanctuary with lighted candles while singing hymns. The heat, the crowds, and the furious pitch of their faith cause the heroine to faint. While this is a particularly dramatic, cinematographically driven episode, it

nonetheless presents a graphic suggestion of the intensity of the Brazilian popular devotional experience. Further, I submit that such fervor is heightened in the case of Brazilian festivals, processions, and other events of popular worship—as well as secular celebrations such as Carnival— by the hybridization that has occurred for centuries in the syncretization of religious sects and patterns of belief from European, indigenous, and African sources.

The fervor of popular faith is captured in the many ex-votos in Brazil: Body and Soul. These small wooden objects (whose name derives from the Latin for something offered or performed in fulfilment of a vow) are called milagres (miracles) in Brazil and are most commonly found in the Northeast. Milagres often take the form of body parts—heads, hearts, hands, stomachs, breasts—which signify that the person for whom the milagre was made had been cured of a malady specific to that area of the body. Ex-votos are donated to churches or chapels, or deposited in the "houses of miracles" found in the great pilgrimage centers. These sites are dedicated to saints or pious people known for their healing powers. Some of these centers are sanctioned by the Catholic church, others are not. Among the most outstanding pilgrimage centers in the Northeast of Brazil are São Francisco das Chagas in Canindé in the state of Ceará, Bom Jesús de Lapa in Bahia, and Nosso Senhor dos Passos in São Cristovão, state of Sergipe.

The making and use of ex-votos has been a common practice in many world cultures, but the particular forms taken by those from Brazil have roots in several of the visual traditions of the country. In one sense, these images may be affiliated with the sort of popular carvings characteristic of the Baroque period. However, as historian Lélia Coelho Frota states, "Indigenous Brazilians as well as those of African origin, both from societies skilled in woodworking, surely exerted great influence in establishing norms for the

portrayal of human figures in the milagres of Northeastern Brazil."[23] These images represent the convergence of multiple visual traditions and serve as receptacles of the pious zeal of the people who made and continue to make them.[24]

Much of the art in the Baroque section of Brazil: Body and Soul is anonymous, although certain pieces are by some of the masters of the seventeenth-, eighteenth-, and early-nineteenth-century visual traditions, such as Frei Agostinho da Piedade, Francisco Xavier de Brito (?–1751), and Valentim da Fonseca e Silva, known as Mestre Valentim (ca. 1750–1813). None of these artists is as well-known or embodies the same sense of dramatic directness of communication as O Aleijadinho, both a sculptor and an architect. His work in the region of Minas Gerais—whose towns attained legendary wealth in the late eighteenth century from its gold and diamond mines—defines an independent aspect of the local style, which was continued by his many disciples. O Aleijadinho's sculptures, as well as others attributed to him, most likely by his followers, may have been inspired in part by European religious prints imported into Brazil. They have a highly characteristic, even idiosyncratic appearance, sometimes reminding us, at least in the figures' faces, of the peculiarly theatrical saints and angels of Bavarian Rococo sculpture. His sculptures in the church and pilgrimage chapels at the sanctuary of Bom Jesus de Matozinhos in Congonhas do Campo, Minas Gerais, are his greatest masterpiece. They are part of a Gesamtkunstwerk in which the visitor/worshiper (pilgrim or modern tourist) plays an integral role as he or she visits the chapels situated on a hill that descends from the main church. In the chapels are life-size scenes of the Passion and Death of Christ.[25] The situation of the buildings and the quality and intensity of the light— intensely bright outside and profoundly vaporous in the interior of the chapels and the main church—contribute to the viewer's response to these sometimes

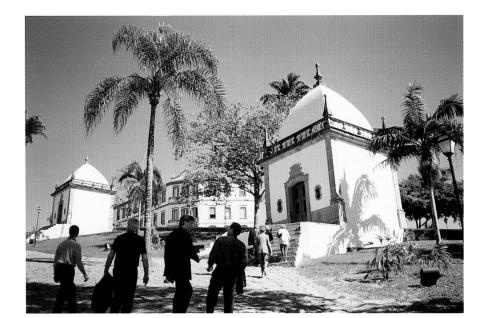

shockingly realistic and empathetic works. A rare example of monumental stone sculpture in the Brazilian Baroque tradition, O Aleijadinho's life-size soapstone images of Old Testament prophets on the double staircase of the church enhance the complexity and theatricality of the drama that unfolds around the viewer.

Among the greatest examples of Brazilian Baroque painting are the monumental wood ceilings painted mainly in the eighteenth century in churches throughout the country, the ultimate source of which may be found in the illusionistic ceiling paintings in many of the Baroque churches of Rome. The angled perspectives, elaborate use of architecture, and highly energized figure compositions of the Brazilian works are often astonishing in their complexity. Ataíde is the best-known artist of these ceilings, although they are often by unknown artists.

Painting on canvas or panel enjoyed a somewhat lesser development in Brazil than in other countries during the Baroque period. *Brazil: Body and Soul* has a small but important selection of paintings from the eighteenth century. Among the most unusual are two large wood panels from a series of four originally made for the church of São Cosme e São Damião in Igarassu, Pernambuco (now in

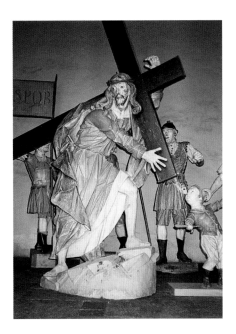 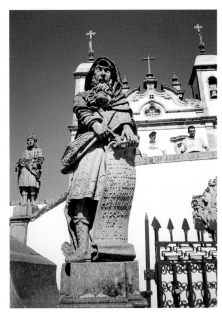

the Franciscan convent of Santo Antônio in the same town). *The Arrival of the Portuguese and Their Triumph over the Igarassu Indians in 1532* and *The Miracle that Spared the Town of Igarassu* (cat. nos. 121 and 122), by an anonymous painter working in 1729, are done in a style that by conventional standards could be described as unsophisticated, but their impact is dramatic and evocative. They were conceived as maps or narratives to be read from left to right and are accompanied by explanatory texts.

Secular painting is relatively rare in the Brazilian Baroque. While some portraits survive, there are fewer depictions of everyday life or historical scenes. *Fire at the Retreat of Nossa Senhora do Parto* and *Reconstruction of the Retreat of Nossa Senhora do Parto* (cat. nos. 133 and 134), two works circa 1789 by João Francisco Muzzi (born in Italy, active in Rio de Janeiro in the eighteenth century), offer extraordinarily important information about aspects of quotidian life in late-eighteenth-century Rio de Janeiro, such as dress, transportation, and construction practices. The Retreat of Nossa Senhora do Parto was an asylum or reformatory for women who were confined there by their fathers or husbands. It burned in late August 1789 and was quickly reconstructed according to plans devised by the sculptor/architect Mestre Valentim. *Reconstruction of the Retreat*

of Nossa Senhora do Parto includes a portrait of the Afro-Brazilian architect showing his plans to Viceroy Dom Luis de Vasconcelos.

Among other examples of eighteenth-century painting in *Brazil: Body and Soul* are two images of the life of Saint Benedito (cat. nos. 125 and 126). One depicts the saint praying in the company of other monks, while the other is a tender depiction of a vision in which the Virgin Mary appears to him, handing Benedito the infant Christ. Benedito is depicted as a man of color, and is thus one of the many so-called "black saints" in eighteenth- and nineteenth-century Brazilian art. There were numerous churches, brotherhoods, and church societies whose membership was restricted to slaves and former slaves, and many of these images were created to adorn their institutions. The presence of these black saints once again points to the theme of Africa in Brazil.

The impact of Africa on Brazilian consciousness and the presence of African material culture in Brazil is a subject that is inextricably woven into the country's history and collective consciousness. Slavery lasted in Brazil until the 1880s, barely one hundred years ago. The influence of Africa in terms of visual culture began in early colonial times, with the importation of slaves who fashioned sacred images through which

they could remember their past and integrate their forms of worship with their present situation.

Art historian Mariano Carneiro da Cunha states that African artisans participated in the creation of the wood sculptures of Brazilian Baroque churches as early as the sixteenth century, and suggests that Brazilian Baroque sculpture of later periods exhibits "African" characteristics, as in eighteenth-century depictions of angels or the Virgin Mary with dark skin.[26] Some of the outstanding artists of the Baroque phase of Brazilian art were of African descent, including O Aleijadinho and Mestre Valentim. African forms of Brazilian material culture survived beyond the Baroque period, however, and well into the nineteenth century. In *Brazil: Body and Soul*, there is a selection of ornate gold and silver jewelry as well as amulets or *balangandás*, which are gathered in multitudes and worn as bracelets or as adornments to clothing. A nineteenth-century painting (cat. no. 136) depicts a woman from Salvador da Bahia dressed in an elegantly severe black dress and splendidly bedecked with such accessories. There is a close stylistic proximity between these body adornments and those of the Yoruba, Fanti-Ashanti, and Baule peoples of West Africa, which may be understood in the context of resistance to European cultural and artistic hegemony in Brazil.[27]

The influence of Africa on twentieth-century Brazilian culture is equally important. Indeed, as in other Latin American societies such as Cuba, which also relied on slavery for its economic viability, Brazil's absorption of an African ethos was inevitable. Many of Brazil's most outstanding historians and cultural critics have underlined this dependency in their discussion of the elements that have shaped Brazilian consciousness. Gilberto Freyre and Darcy Ribeiro are among the most eloquent in their commentary on the multi-ethnicity of modern Brazil.[28] In our own attempts to comprehend the complexity of Brazilian visual culture from the colonial period to the present, an assessment of the significance of those artists who have absorbed and transformed African and Afro-Brazilian imagery, both sacred and secular, is indispensable.[29]

Toward Modernism

Brazil: Body and Soul was not envisioned as a comprehensive survey, and therefore many significant aspects of the country's cultural development have been omitted. Among the most obvious lacunae is the art of the nineteenth century. Although the Baroque survived into the first quarter of the nineteenth century, especially in provincial areas, this was a period of intense Europeanization in metropolitan centers. A watershed was reached in 1816 when a group of French artists, known as the French artistic mission, arrived in Rio de Janeiro at the invitation of the colonial government. The lessons learned by local artists from these Parisian painters, sculptors, and architects—some of whom had been trained in the atelier of Jacques-Louis David—radically changed the course of Brazilian art. One of the most significant of this group was Jean Baptiste Debret (1768–1848), a cousin of David.[30] His official composition depicting the 1822 coronation of Emperor Dom Pedro I reflects, in a rather stiff way, the French master's paintings of the crowning of Napoleon.

The Academia Imperial de Belas Artes in Rio de Janeiro was opened several years after the arrival of the French artistic mission. Its teaching methods, which were grounded in the conservative academic approach, marked artistic practice in Brazil through the nineteenth century and well into the early twentieth. Although the term "*antropofagia*" is usually associated with the modernizing events of the 1920s, we might also think of examining the art of the nineteenth century through an analogous prism, analyzing the appropriations of European sources by the Brazilians who emerged from the academic milieu. While there is much less of what we could conventionally call a "Brazilian

JEAN BAPTISTE DEBRET *Coronation of Emperor Dom Pedro I, December 1, 1822, in the Chapel of the Imperial Palace, Rio de Janeiro,* 1822. Oil on canvas, 340 x 640 cm. Ministério das Relações Exteriores–Palácio do Itamaraty, Brasília

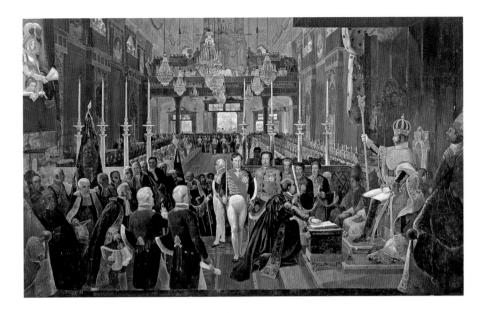

voice" in painting and sculpture from approximately 1820 to 1920, there are numerous instances of artists who created works in a spirit of cultural resistance from the strictures imposed upon them by European academic standards. From the middle to the late years of the nineteenth century, a number of distinct and significant artistic personalities emerged whose work is little known in an international arena but merits greater scholarly attention. Among these artists are Vítor Mierelles de Lima (1832–1903), important for his history paintings and landscapes, José Ferraz de Almeida Júnior (1850–1899), creator of realistic depictions of laborers and genre scenes, and Eliseu D'Angelo Visconti (1866–1944), who in his early phases utilized a Symbolist palette in a distinctly personal way. Each developed a distinguished body of work within the confines of the international hegemony of principally French artistic convention.

After Brazil gained independence from Portugal in 1822, the country was gradually opened to foreign exploration and, increasingly, the exploitation of natural resources on the part of nations such as France, Great Britain, and eventually the United States. From around 1840 to the 1870s, Brazil became the site of romantic desire expressed in the images of the numerous traveler-reporter painters and draftsmen who came to the country. The virgin territories of the wilderness appealed to legions of artists from all over Europe and from North America. Much of the history of Brazilian art during this period consists of the legacy of the foreign gaze directed at Brazil. Painters created idyllic vistas of the coastal regions, the Amazonian forests, and the "exotic" cities of Rio de Janeiro, Salvador da Bahia, and Recife. The most important North American artist in Brazil at this time was Martin Johnson Heade, who traveled there in 1863–64. A member of the Hudson River School of American romantic landscape painters, Heade created some of the most popular images of Brazilian flora and fauna of his day. His numerous depictions of hummingbirds in paradisaical surroundings were the result of his firsthand experience in the Brazilian rain forests, though he continued to paint hummingbirds throughout his life. He did not return to Brazil after his journey of 1863–64, but his experiences there marked his art in an indelible way for the rest of his career. It stimulated him to continue painting tropical places, even when at home in his studio.[31]

After the 1840s, photography also played a major role in creating a view of the remote, exotic, and desirable that came to form the conception of Brazil in the European and North American popular imagination. While early Brazilian

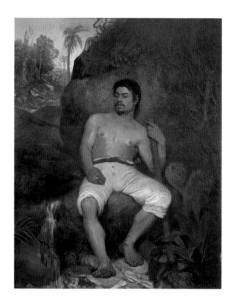

photographers such as Marc Ferrez (1843–1923) created images documenting the rise of the modern city and events of municipal and national importance, others concentrated on views of "picturesque" types, such as the Afro-Brazilian population of the Northeast, and places, such as the sensual landscape of Rio de Janeiro. Rapidly disseminated in newspapers and magazines, these images laid the foundation for the stereotypes of Brazil that later became standard fare in foreign cinematic representations of the country starting in Hollywood in the late 1920s.

The taste for European styles among bourgeois and upper-class consumers of art in Brazil's major cities was firmly established at the beginning of the twentieth century. The art markets in Rio de Janeiro and the rapidly developing city of São Paulo were decidedly conservative. After the 1910s, however, São Paulo became the most important site for artistic experimentation. It also became the center for coffee, Brazil's most important consumer product, and surpassed Rio de Janeiro in industrial production. Large-scale immigration from Europe, the Middle East, and Japan made the city grow rapidly after the turn of the century. In cultural terms, several events took place in São Paulo in the second decade of the new century that foreshadowed the transformations that would occur among the Brazilian artistic elite in

the 1920s. In 1913 (in both São Paulo and Campinas), Lasar Segall (1891–1957), a young artist from Lithuania, presented an exhibition of his paintings. Trained in Germany, Segall's art was redolent of the Expressionist use of color and bold drawing technique. Although his show attracted little attention, he became a critical member of the São Paulo avant-garde after his immigration to Brazil in 1923. In 1917, Anita Malfatti (1896–1964) showed her paintings in another exhibition that served as a harbinger of change in the Brazilian art world. Malfatti had trained in Berlin with Lovis Corinth, as well as in New York at the Art Students League and the Independent Art School of Homer Boss. She had become acquainted with such important cultural figures as Marcel Duchamp, Isadora Duncan, and Léon Bakst. Her 1917 exhibition in São Paulo elicited more commentary in the press than had Segall's, and when the conservative critic Monteiro Lobato referred to Malfatti's work in disparaging terms in a review entitled "A propósito da exposição Malfatti" (and, when reprinted two years later, renamed "Paranóia ou mistificação") the public took notice.[32] Malfatti had begun a promising career with paintings such as *Tropical* (1917, cat. no. 225), in which a lyrical scene of a woman proffering fruit is defined in bold, Expressionist colors. The adverse criticism of her 1917

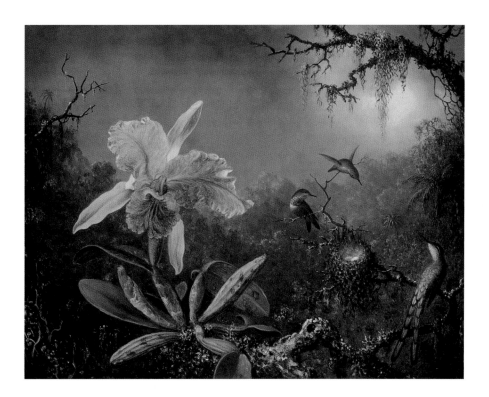

exhibition deeply affected her, however, and she reverted back to the traditional academic mode that defined her art for the rest of her life.

Brazil: Body and Soul presents a significant selection of art from the heroic age of Brazilian Modernism—the 1920s—and goes on to chart aesthetic changes through the mid-twentieth century. In Brazil, the radicalization of the art world (which admittedly was never as liberal as that of Paris for instance) gained momentum only after the *Semana de arte moderna* (Week of modern art), an arts festival that manifested the new spirit of experimentation.[33] Held at the Teatro Municipal in São Paulo in February 1922, it included not only painting and sculpture but also design, architecture, music, and poetry.[35] The event was a catalyst for new developments during the 1920s, a particularly open era in Brazilian culture and society. One of the principal organizers of the *Semana de arte moderna* was Emiliano Di Cavalcanti (1897–1976), whose career represents the essentially eclectic nature of Brazilian Modernism. Although his graphic art of the 1930s incorporated the stimulus of German Expressionist drawings and woodcuts, Di Cavalcanti began as a magazine

illustrator with a style similar to that of Aubrey Beardsley and other Art Nouveau draftsmen. By the 1920s, he had been in Paris, where he absorbed lessons from Picasso's Cubist and classical works. The latter served as one of the sources for Di Cavalcanti's most important paintings of the decade, including *Samba* (1925, cat. no. 238). This work is significant for several reasons. It is a large-scale representation of persons of mixed race, including Afro-Brazilians, performing a dance that may be understood as a symbol of Brazilian identity. The desire to represent national themes was one of the driving forces behind the art of this period. Brazilian-ness, or *brasilidade*, was, like national identity in the art of many other nations in Latin America at this time, a point of critical discussion. Latin American Modernists of the 1920s were aware of stylistic strategies from abroad, but sought to create new paradigms for national audiences. An image such as *Samba* may be considered as much an icon of national self-definition as a step in the development of Brazilian painting, even though its subjects, people of color, were painted by a Caucasian.

In discussing the artists of this period, comparisons with their European

counterparts inevitably arise. The debates regarding "influence," "originality versus imitation," and "periphery versus center" are inescapable. It is important to look at Modernism in Brazil and other parts of Latin America, especially during the 1920s, not as a consequence of or appendage to Parisian Cubism, Italian Futurism, or German Expressionism (all of which appealed in one measure or another to those artists who constituted the Modernist generation in São Paulo and elsewhere in Brazil), but as a distinct mode of vision that responded to specific local aesthetic and societal circumstances.[35] The sculptor Victor Brecheret (1894–1955), who was in Rome in 1916 and Paris in 1921, created one of Brazil's best-known public sculptures, an enormous granite monument to the *bandeirantes*, or explorers of Brazil's interior. Begun in 1936 and installed in São Paulo's Ibirapuera Park in 1953, this massive sculptural group—executed in a style that evidences Brecheret's interest in Art Deco—became one of the defining images of Brazilian history. The examples of Brecheret's work in *Brazil: Body and Soul* express his enthusiasm for religious subjects. A similar engagement with religion characterizes numerous examples of the work of Vicente do Rêgo Monteiro (1899–1970), who also spent many years in Paris—from 1911 to 1914 and again from 1920 to 1930. Rêgo Monteiro became fascinated with the indigenous cultures of Brazil and illustrated books dedicated to the history of their legends and religious beliefs. In works such as *The Adoration of the Magi* (1925, cat. no. 223), however, traditional Christian symbolism informs his painting. There is a pronounced sculptural quality to his images.

Brazil: Body and Soul also includes several key works by the best-known of Brazil's Modernists: Tarsila do Amaral (1886–1973). She spent a good deal of time in Paris during the 1920s, and did not participate in the *Semana de arte moderna* for this reason. Paris and the experience of Parisian Modern art were crucial to the

development of her visual vocabulary. Tarsila spoke of her studies of Cubism as her "military service," which she spent in the company of Constantin Brancusi, Albert Gleizes, Fernand Léger, and André Lhote.[36] The work of her first mature phase, the *Pau-Brasil* period of 1924–26 (named after the Portuguese term for brazilwood and reflecting the ideas of Oswald de Andrade's 1924 *Pau-Brasil* manifesto) demonstrates her appropriation and Brazilianizing of the ideas of Léger and of artists associated with the Purist movement, including Amédée Ozenfant and Le Corbusier. Purism, with its sculptural and architectural associations and emphasis on geometrical form, represented a quintessential strategy of the "return to order," the post–World War I rejection of what had been seen by some artists as the excesses of Parisian Cubism.[37]

The precursors of Tarsila's first mature phase are found in a number of canvases and drawings from 1923. Most outstanding is her *Black Woman* (1923, cat. no. 218), a depiction of an Afro-Brazilian female with exaggerated physical features—reminiscent of depictions of the *orixá* Yemanjá—against a stylized background composed of vertical zones of color bisected by an equally formalized banana-leaf pattern. Tarsila established her distinctive style only several years before her fortieth birthday, and although her paintings from the 1920s (the decade in which she produced her most emblematic pictures) are often considered to be icons of the Brazilian avant-garde, she was not necessarily a radical. The figure never disappeared from her work, and after the early 1930s her interests turned in the direction of social realism, influenced by her admiration for Soviet art and culture. However, it is the unique symbolic language she developed that distinguishes her art so forcefully.

A number of Tarsila's *Pau-Brasil* paintings have to do with cities and villages. In her images of São Paulo, the city is never

as dynamic nor as threatening as the urban depictions by the Italian Futurists, even though mechanization and the movement of motorized vehicles are suggested. Both her cityscapes and her renditions of country villages feature tubular forms and a lack of shading, but the outstanding element is color. The pinks, electric blues, and bright greens—colors characteristic of traditional Brazilian villages—might not be in conventional "good taste," Tarsila once remarked, but they express a Brazilian reality. It is important to assess her affinities with traditional Brazilian visual culture to understand the ornamental quality of her work as well as the idiosyncrasies of its iconography. Tarsila, her husband Oswald de Andrade, and their Swiss poet friend Blaise Cendrars gained firsthand knowledge of the then mostly forgotten Baroque towns of Minas Gerais during a 1924 journey that took them to Ouro Prêto for Semana Santa and to Rio de Janeiro for Carnival. Despite Tarsila's affinities for this early period of Brazilian visual history, Paulo Herkenhoff asserts that her art cannot be considered "Baroque," since her experience with contemporary French painting inhibited her from embracing the style's inherent theatricality.[38]

The "Baroque prevalence in Brazilian art," a concept discussed by art historian Leopoldo Castedo, is a protean and not easily definable theory.[39] Castedo believes in a pervasive receptivity—on the part of Brazilian painters, sculptors, and architects in more recent periods—to the complex visual and metaphoric characteristics exhibited by the art of the seventeenth and eighteenth centuries. I would be somewhat more cautious in my own assessment of this subject. During the 1920s, the era of the first modernizing projects in Brazilian art, artists sought to evoke the composite nature of national identity, and certainly the rich visual legacy of the Baroque period appealed to them, as did numerous manifestations of "popular" arts and practices, such as the Carnival in Rio de Janeiro witnessed by

Tarsila, Oswald, and Cendrars during their travels together. Yet I do not think it advisable to single out one particular element in this immense cultural amalgamation to explain the nature of the art of any individual era.

Tarsila's monumental canvas *Anthropophagy* (1929, cat. no. 234) is a summation not only of her *Antropofagia* period of 1928 and 1929, but of a philosophical attitude that defines the goals of this phase of modernization in Brazil. Just as Oswald's 1928 *Manifesto antropófago* is a verbalization of the longing for cultural consumption and transformation, Tarsila's painting presents these notions in the form of visual icons. The painting includes several pictorial types that she had previously depicted: the woman with the large breast derives from *Black Woman*, while the man with the enormous foot also appears in another canonical painting, *Abaporu* (1928), the title of which means "one who eats" in the Tupi Guarani language. In many ways, *Anthropophagy* represents the culmination of Tarsila's artistic accomplishments of the 1920s. Stylistically, there are still clear references to the volumetric forms and flat application of paint of Léger's art, but the tropical setting, the lemon-yellow sun, and the mythical figures are devoid of any direct references to foreign paradigms. In addition, *Anthropophagy* demonstrates Tarsila's interest in creating an atmosphere of subconscious reverie, which is present in many other canvases of the last two years of the 1920s. Several of the most important of these paintings are in the present exhibition, including *The Egg* (1928, cat. no. 233) and *Setting Sun* (1929, cat. no. 232). While both of these works contain innately Brazilian elements— the snake in *The Egg* is a particularly venomous serpent from the Amazon region, and the five animals in *Setting Sun* are *ariranhas*, or Amazonian otters—there is, as art historian Fatima Bercht points out, "an entirely unnaturalistic oneiric imagery that pervades [these canvases] . . . recalling

the work of Giorgio de Chirico, an artist admired by Amaral."[40]

Tarsila's work of the 1930s had a decidedly different character from that of the preceding decade. In social and economic terms, the 1930s were marked by the effects of the Great Depression, the rise of Fascism in Europe, and the consolidation of Soviet society and culture under Joseph Stalin. Throughout the Western world, a social consciousness manifested itself in art. Socialist Realism emerged in the Soviet Union to replace the artistic experimentation of earlier decades. In the muralism of Mexican artists such as Diego Rivera, in the art of the North American Regionalists such as Thomas Hart Benton, as well as in a considerable sector of Brazilian painting, images of the proletariat became increasingly popular. Tarsila made an extensive journey to the Soviet Union in 1931 and exhibited her art in Moscow during this trip. *Workers* (1933, cat. no. 235), which depicts an amalgamation of faces before a factory building, evidences her engagement with social themes. This painting may also be understood as an emblematic representation of the multiplicity of racial and ethnic types in Brazilian society and as a metaphor for the "new world order" in which the proletariat worker would prevail.

In Brazil, the 1930s were also marked by the presidency of Getúlio Vargas, who came to power in 1930 after taking control of the government by military coup. By 1937, Vargas had firmly established a dictatorship that came to be called the Estado Novo (New state). While not a fascist government in the sense of those developing concurrently in Italy and Germany, Vargas's Estado Novo attempted to promote a strong sense of nationalist pride among Brazilians. The work of Cândido Portinari epitomizes the development of social realism in Brazil that began during this period. In his *Coffee* of 1935, laborers serve as symbols of the strains of toil and the difficulties of economic hardship. Portinari was an accomplished muralist

and painted in many venues throughout Brazil and in the United States. His work includes murals for the Library of Congress in Washington, D.C., and the United Nations headquarters in New York. He was a controversial figure in his day, having been considered by some to be the "official painter" of the Vargas regime, and later in life was a staunch critic of the new tendencies of geometric art that began to gain popularity in the early 1950s.[41] His dedication to the figure was absolute, and his tolerance for experimental art was virtually nonexistent.

The subject of Surrealism and fantastic art in Latin America has engendered vigorous debates among scholars since the late 1980s. Many agree that it is problematic to connect the work of Latin American artists too closely with the orthodox Surrealism practiced in Europe in the circle of André Breton. Nonetheless, many members of the Surrealist movement traveled to the Americas (especially in the years preceding and during World War II) and found a receptive atmosphere in Mexico and several of the countries in the Caribbean. In some cases, they remained to become permanent participants in the artistic communities of their adopted homes. Surrealism—and, more broadly speaking, art whose fundamental characteristics include a sensitivity to fantasy and inventiveness—should also be examined with reference to Brazil. It is difficult to speak of a "Brazilian Surrealism" with any accuracy, except where an artist identified with a specific aspect of the Surrealist movement. Such was the case with sculptor Maria Martins (1894–1973), a much-appreciated artist in Brazil who in the 1940s was also well known among artistic circles in New York for her exhibitions at the Julien Levy and Valentine galleries. Her work was praised by, among others, Alfred H. Barr, Jr., who was instrumental in the purchase by the Museum of Modern Art of *The Impossible One* (1944), one of her best-known pieces. The undulating biomorphic forms of Martins's sculptures

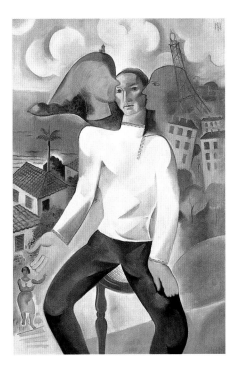

suggest sexual tensions and erotic couplings. One of the most evocative descriptions of Martins's work was written in 1947 by Breton:

> Maria, and behind her—or, rather, within her—this marvelous Brazil where, in this mid-twentieth century simultaneously infatuated with its derisory knowledge and terrified by it, the wings of the unrevealed still hover over vast spaces. That great doorway, hardly more than ajar yet upon the virgin regions where the unconsumed, brand-new forces of the future are lurking. Brazil, through which Maria's bronze eyes and unique vision, threads tomorrow's dreams with the lode of all its enigmas.[42]

Art historian Francis M. Naumann has examined Martins's close relationship with Marcel Duchamp over the course of many years, and suggests that the emotional and the professional connection between the two artists had significant consequences for the work produced by both, especially during the 1940s.[43]

The art of Alberto da Veiga Guignard (1896–1962) cannot be described with the same language as that applied to the

more transnational forms of Surrealism. The oneiric quality of Guignard's paintings places him in a category contiguous to those, like Martins, who embraced the symbolic and often self-referential vocabulary of quasi-abstract organic forms. Guignard, a native of the state of Rio de Janeiro, is known for his dreamy landscapes of the Baroque towns of Minas Gerais, where he lived and worked for many years in the later part of his life. In these paintings, there is a distinct quality of timelessness, as if the villages, with their tiny, brightly colored churches set against mountain landscapes, had never experienced the ravages of the years. A powerful stillness and tranquility characterizes one of his best-known paintings, the portrait *Léa and Maura* (1940, cat. no. 244). In this depiction of twins (one of whom, Léa, is the mother of the artist Tunga, whose work is also present in *Brazil: Body and Soul*), two women are shown seated on an elaborate sofa before a "Baroque" cityscape. The image underscores the communicative power of the decorative line, which is reiterated in each of the painting's details, such as the fabric of the sofa's seat, the carved wood, the curvilinear patterns of the sitters' dresses, and even their elaborate coiffeurs.

The development of Modern art in Brazil from the 1920s through the 1940s is infinitely more complex a history than can be outlined here, and *Brazil: Body and Soul* aims to present only a sampling of the most salient chapters in this narrative. A more textured analysis of the situation of Modernist painting would include a larger cast of characters. Of these additional artists it is important to at least mention Ismael Nery (1900–1934), Flavio de Carvalho (1899–1973), and Cícero Dias (b. 1907). Nery was an artist of the first Modernist generation who had one of the closest direct contacts with the European Surrealists. During his second trip to Europe, he met many artists in the circle of Breton. He was especially attracted to the work of Marc Chagall, which left an

indelible mark on his painting, as can be seen in his *Self-Portrait* (1927). In this image, Nery depicted himself being caressed by two faces against panoramas featuring Rio de Janeiro's Sugarloaf Mountain and Paris's Eiffel Tower. Equally open to transcribing psychic phenomena in concrete images that bear the indelible stamp of Surrealist biomorphism was Carvalho, who has a significant place in the history of Brazilian art as someone adept at painting and drawing as well as architecture. He was also a "performance artist" before the term existed, and his "actions" in São Paulo in the mid-1950s, in which he walked the streets of the city dressed in the clothing he had designed for the "*novo homem*" (new man), consisting of skirts and flowing, open shirts, anticipated Hélio Oiticica's *Parangolés* of the 1960s. The work of Dias demonstrates as much an affinity with the School of Paris, including Chagall, as an active interest in the visual potential of the decorative Baroque mode of the northeastern state of Pernambuco. The paintings and drawings of Dias (who spent much time in France after the late 1930s) are reminiscent of the type of artistic sensibility manifest in the writings of the author Jorge Amado, whose tales of sexual intrigue and improbable daily circumstances are also set in Recife (especially in Salvador da Bahia).

Discontinuities

The permutations of Modernism became even more varied during the 1940s. After World War II, conventional notions of center and periphery began to lose whatever tenuous meanings they had, and artistic pluralism widened the scope of the vocabularies of the visual arts. What Brazilian artists had articulated as anthropophagy, or aesthetic cannibalism, became the rule throughout the world as communication possibilities rapidly unfolded and the knowledge of what artists were doing in far-flung centers began to collapse the already vacuous concepts of artistic invention. The process of cultural globalization,

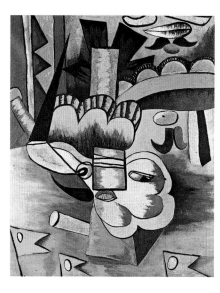

FLÁVIO DE CARVALHO *The Definitive Ascension of Christ*, 1932. Oil on canvas, 75 x 60 cm. Pinacoteca do Estado, São Paulo

which in the past decade has accelerated to an undreamed of extent, began in the 1940s and 1950s. Nonetheless, the strength of culturally and geographically specific approaches to image-making in Brazil accounted for the emergence of forms of art that, even in the increasingly Postmodern era of the late twentieth century, could still be unmistakably identified with the country.

Alfredo Volpi (1896–1988) was born in Lucca, Italy, but came to São Paulo with his family at the age of one. A self-trained painter, he worked outside the circles of the bourgeois intelligentsia, whose members patronized the pioneers from whose ranks many of the Modernist artists emerged. Volpi was, in a sense, a peripheral figure but one whose art, compelling in its own right, served as a harbinger for important developments in Brazilian painting in the 1950s. Volpi began as a house painter, and the experience of covering large areas with flat applications of paint remained in his imagination in a powerful way. It accounted, in part, for the innovations in his art starting in the 1940s. Until 1951, he was only able to paint part time because of economic constraints, and when he was finally able to pursue his art full time, he switched from conservative portrayals of traditional street scenes, country views, and portraits to depictions of house facades. Volpi is remembered for these paintings of facades, as well as for his

paintings of small flags or banners begun in the 1950s. The latter may be understood in terms of the performative aspect of Brazilian art, for flags and banners mark a mood of communal celebration. The inherent movement in these symbolic forms relate them to other artists' use of clothing or textiles as components of a public ritual. Little by little, Volpi reduced the aspects in his modest-sized canvases, until finally the strictly representational elements disappeared altogether and the works took on the look of abstract patterns, with fields of color punctuated only by a line or a square. However, his dedication to severe abstraction was interrupted from time to time by depictions of the Virgin and Child and of saints, doubtlessly inspired by the popular Baroque statuary he had seen in rural or urban churches. The trajectory of Volpi's career parallels that of other aesthetic circles in São Paulo and Rio de Janeiro in the early 1950s because of his intense engagement with geometric form. In 1953, at the second *São Paulo Bienal*, he shared the prize as Brazil's best painter with Di Cavalcanti. The work on exhibition at this *Bienal*— including examples of De Stijl, European Constructivism, and Italian Futurism, as well as Picasso's *Guernica*—certainly had a strong impact upon Volpi, who did not take up any particular artist's manner, but developed his own vision of geometrically based art.

During the 1950s, the art centers of Brazil—comprising not only São Paulo and Rio de Janeiro but also regional focal points of art production such as Belo Horizonte, Curitiba, Salvador da Bahia, and Recife, among others—experienced a growing pluralism. A variety of approaches to abstraction characterized the decade, including a vigorous form of gestural abstraction akin to French Tachisme and American Abstract Expressionism. Paintings by Antônio Bandeira (1922–1967) and Iberê Camargo (1914–1994) represent this approach to action painting. A large number of Japanese-Brazilian artists

(either immigrants from Japan or the sons and daughters of immigrants) brought another element of abstraction to Brazilian painting of the 1950s. Artists such as Tomie Ohtake (b. 1913) were deeply interested in transmitting a transcendental, meditative mood to their compositions. Influenced by their engagement with Asian philosophy as well as by their knowledge of contemporary developments in Japan, Ohtake, Manabu Mabe (1924–1997), and others produced a highly distinctive approach to lyrical nonfiguration. These tendencies are not represented in *Brazil: Body and Soul*, as the curators have decided to focus instead on Concrete and Neo-Concrete works from the same period.

Concrete art comprises a dramatic chapter in the history of the Constructivist innovation in Latin America, which began as early as the 1930s. Constructivist art had enjoyed a long period of development in Europe, and since the second decade of the twentieth century, geometrically based imagery had formed an important part of the artistic panoramas of both Eastern and Western Europe. Movements such as Russian Constructivism, De Stijl, and Neo-Plasticism, as well as the modes of painting, sculpture, architecture, and industrial arts taught at the Bauhaus all nourished a taste for rational nonobjectivity. In Latin America, Uruguayan artist Joaquín Torres-García introduced Constructivist art in 1934 after his return from a long period of residence in Paris and elsewhere in Europe. Artists in Montevideo and Buenos Aires reacted rapidly to this new stimulus, creating important bodies of work in a Constructivist manner in the 1940s and 1950s. The 1950s in Brazil was a period of democracy and relative economic prosperity, and it was within this climate of increased internationalism that Concrete art began to flourish.

The Concrete artists attempted to achieve dramatic effects through the use of highly distilled form. The geometric schemes of their works are usually very simple, with reduced elements playing off

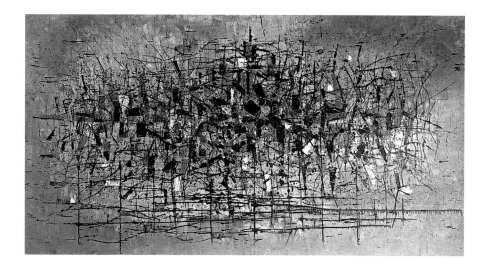

ANTÔNIO BANDEIRA *Untitled*, 1957. Oil on canvas, dimensions unknown. Collection of Ricard Akagawa

one another, creating tensions between planes and lines. One of the most important documents in the rise of Concrete art was the *Ruptura* manifesto written by Waldemar Cordeiro (1925–1973) and published in 1952. Cordeiro was one of the most outstanding artists of a group that consisted of, among others, Geraldo de Barros (1923–1998), Amílcar de Castro (b. 1920), Milton Dacosta (1915–1988), Luis Sacilotto (b. 1924), Ivan Serpa (1923–1973), and Mary Vieira (b. 1927). The development of Concrete art was an important manifestation of a greater engagement with international tendencies in Brazil. The establishment of the first *São Paulo Bienal* in 1951[44]—and the increased visibility of contemporary European art this provided, such as that of Swiss artist Max Bill, who won first prize at the inaugural *Bienal*— has been noted as an immediate stimulus for Brazilian artists by virtually everyone who has written about this subject.

The Brazilian Constructivist movements of the 1950s, 1960s, and 1970s had widespread consequences. Although orthodox histories of the Concrete and Neo-Concrete movements tend to concentrate on a handful of canonical figures, I believe that to comprehend this aspect of Brazilian art history in a more satisfactory way, it is necessary to look beyond the originators of these movements and take into account the art of those individuals who expanded not only the formal concerns but also the meanings of abstracted,

geometric form in Brazil. I refer specifically to several key artists who took visual cues from Concrete and Neo-Concrete art, but transformed it to conform with their interests in expressing ethical and religious beliefs deriving from Afro-Brazilian cultures. Rubem Valentim (1922–1991) created two- and three-dimensional totemic figures that appropriate the geometric language of Concrete art for spiritual reasons. He explained:

> My visual-graphic-sign language is related to the deep mystical values of an Afro-Brazilian culture (mixed-blood, animistic, fetishistic). With the weight of Bahia on my back, the culture experienced: with black blood in my veins—the atavism, with my eyes open to what is being done in the world . . . I try to transform into visual language the enchanted, magical, probably mystical world that is in constant flux inside of me.[45]

Brazil: Body and Soul includes several pieces of a series by Valentim, entitled collectively *Temples of Oxalá* (1977, e.g., cat. nos. 214.1–.3). These are imposing white relief sculptures featuring iconic forms that refer to an important *orixá* in the Nagô-Yoruba pantheon of deities. The work of Ronaldo Rego (b. 1935), a priest in the Umbanda religion,[46] is sometimes more explicit in depicting sacred rituals. His *Oratory* (1990s, cat. no. 213), for

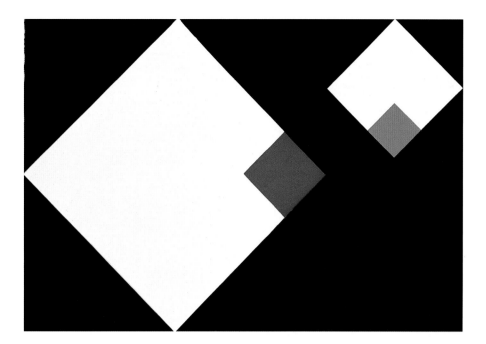

GERALDO DO BARROS *Concrete*, 1958.
Enamel on Eucatex, 49 x 71 cm. Collection of
Adolpho Leirner, São Paulo

example, recalls the intimate home altars of the Baroque period, while at the same time providing a site for the reaffirmation of the power of syncretism of African and Christian religions. Rego's art also demonstrates an interest in geometric form that parallels that of the Concrete and Neo-Concrete artists. In his colors, Rego makes reference to individual *orixás* as well as to life forces: red, for example, symbolizes the potency of life and is the color most associated with the deity Xangô.[47]

By the end of the 1950s, the geometric exactitude of Concrete art, as well as its intellectualized approach to image-making, caused this movement to be criticized and even rejected by some artists, who argued for the importance of greater dynamism and the possibility of physical engagement in works of art. It was in 1959, with the publication of poet Ferreira Gullar's *Manifesto neoconcreto* that the tenets of this new wave of Brazilian artistic development were formalized. Gullar's manifesto expressed the concepts that guided the production of artists such as Lygia Clark (1920–1988), Hélio Oiticica (1937–1980), Lygia Pape (b. 1929), Franz Weismann (b. 1914), and others in their search for forms of expression that would expand what they perceived as the rigidity

of the parameters of Concrete art. They were attracted to the phenomenological proposals of French philosopher Maurice Merleau-Ponty, and interactive engagement between the viewer and the work of art was an important goal. Again, we find here the performative, even theatrical element that is so crucial to an understanding of much Brazilian art throughout its history.

The careers of Clark and Oiticica are inextricably linked. Clark's work is characterized by a scintillating tension between the rigidly abstract and intimations of the organic. Her early training took place in Rio de Janeiro with the noted landscape artist and painter Roberto Burle Marx (1909–1993). Burle Marx's intense involvement with organic form doubtlessly inspired Clark, who constantly struggled to integrate the energy of life forces into her art. After creating a series of hard-edge abstract paintings such as *Egg* (1959, cat. no. 261), she moved on to produce three-dimensional metallic sculptures. In her *Trepantes* (Grubs; e.g., cat. nos. 270–72), she combined metal with wood or other substances such as rubber, setting up a tensions between the two surfaces and textures. Clark's series *Bichos* (Machine-animals; e.g., cat. nos. 263–65)—organic, free-form objects that may be installed

anywhere and in any configuration chosen by the viewer/participant—combine hints of living, breathing beings with the coolness of metal. Clark became a psychotherapist in her later years, and many of her therapeutic techniques were reflected in her work. For example, she created interactive objects (e.g., cat. nos. 266–69), including articles of clothing, that could be worn by the viewer/participant, temporarily altering his or her personality.

Clark both collaborated with and had strong affinities with Oiticica, who holds a position in the cultural consciousness of Brazil analogous to that maintained by Andy Warhol in the United States or Joseph Beuys in Western Europe. "Creator," "shaman," "rebel"—these are among the many apt terms that could be used to describe Oiticica's significance. Before his untimely death at the age of forty-three, he exhibited in relatively few galleries and museums and did not conceive of his work in the orthodox sense as art that could be commodified and put on display for viewers' pleasure. However, he did participate in the ground-breaking exhibition *Information*, presented at the Museum of Modern Art, New York, in the summer of 1970.[48]

After early study with the painter Ivan Serpa, Oiticica executed a series of *Metaschemes* in the late 1950s (e.g., cat. nos. 273–75), geometric forms painted in gouache on paper. In 1959, he made the transition from two to three dimensions. That year, he exhibited a series of reliefs at the first *Exposição neoconcreta* at the Museu de Arte Moderna in Rio de Janeiro, and the following year at *Konkrete Kunst*, organized by Max Bill and presented in Zurich. In November 1964, Oiticica wrote: "The discovery of what I call a *parangolé* [from a slang word referring to an animated situation or sudden confusion and/or agitation between people] marks a critical point and defines a specific position in the theoretical development of my entire experience of color-structure in space, principally in reference to a new definition of what

would be, in this same experience, the 'plastic object,' or, rather, the work."[49] Oiticica's *Parangolés* (e.g., cat. nos. 280–84), which take the form of a cape or other type of voluminous garment worn by a participant in an action, are related to the genres of experiential performative art that developed on the international scene in the 1960s. They also relate to a variety of pieces in *Brazil: Body and Soul*, including Clark's interactive objects and the Baroque processional sculptures dressed in garments for processions. What Oiticica was doing was to create an innately Brazilian form of Happenings or performance art, cannibalizing concepts from abroad in a latter-day anthropophagic fashion. There is much in the work of Oiticica that is specific to Brazil. His installation, or *penetrável*, entitled *Tropicália*, first presented at the Museu de Arte Moderna do Rio de Janeiro in April 1967, contained live macaws and native plants. Spectators walked through a labyrinth, stepping on various textures while becoming aware of the tropical scene. his was a wry commentary on Brazilian kitsch. The artist was intimately concerned with popular culture, having become immersed in it himself, gaining, for example, the rank of *passista* (principal dancer) in the samba school of Mangueira.[50]

To a New Millennium

In his *Parangolés*, Oiticica exploited the metaphorical possibilities of movement. By performing the secular rituals initiated

IVAN SERPA *Painting 178*, n.d. Oil on canvas, 97 x 130 cm. Collection of Ricard Akagawa

by the artist, the participant was absorbed not only by the cloth of the capes, but by their ceremonial significance. The textile pieces of Arthur Bispo do Rosario (1911–1989) achieved similar goals, yet they were conceived in an entirely different spirit. Bispo do Rosario was not trained as an artist and only began creating his prodigious body of work later in life. After many years of work in a variety of jobs, he became mentally ill and entered a series of institutions, finally arriving at the Colônia Juliano Moreira in Rio de Janeiro. There, he began to embroider garments with complex texts, adorning them with elaborate, mandala-like patterns that reflect an enigmatic religious fervor. Referring to the exhibition of Bispo do Rosario's work presented in the Brazilian pavilion at the 1995 Venice *Biennale*, Nelson Aguilar wrote:

The central piece of his work was the mantle for presentation he made for his encounter with God on Final Judgment Day. In the lining there are embroidered the names of hundreds of acquaintances. Bispo was to stand before the Creator in proxy for many compatriots. On the outside surface, glittering on the red fabric, burn the yellow threads with the power to obfuscate the divine court. The greatest designer of Christian art at the end of the millennium, this artist is also pagan for the carnivalesque liberty in which he weaves his raiment. He intends to crash the gates of Paradise dressed as an admiral of a seafaring power on the day of a big party.[51]

Bispo do Rosario's art has been characterized as "primitive," "naive," and "intuitive," yet such vague and ultimately condescending terms are questionable. The inclusion of this work within the trajectory of Modern art is a more productive way to view it, for its visionary quality parallels the utopian idealism embodied in other contemporary projects.

Brazilian art of the second half of the twentieth century presents an increasingly intricate series of multivalent patterns, all of which, taken together, form a more deeply nuanced picture of the visual narrative than appears in most survey texts. As with Bispo do Rosario, the work of artists that have been associated with popular manifestations should be included within this paradigm. Agnaldo Manoel dos Santos (1926–1962) and Geraldo Teles de Oliveira (known as GTO, 1913–1990), for example, reflect a commonality of both style and

spirit deriving from Afro-Brazilian visual traditions, yet I would by no means exclude their art from broader patterns within the Brazilian visual experience in modern times. Both Agnaldo dos Santos and GTO are known for their wood sculptures. In their unadorned, totemic appearance, those of dos Santos reflect an ongoing dialogue with the traditions of African wood carving, while GTO's complex arrangements of human figures create dynamic patterns that take on suggestions of organic growth.

It is important here to clarify what is meant by the term "Afro-Brazilian art." As art historian Marta Heloísa Leuba Salum states:

> Afro-Brazilian art is a contemporary phenomenon. It became known in the twentieth century, when it began to be recognized as encompassing any expression in the visual arts that recaptures, on one hand, traditional African aesthetics and religiosity and, on the other, the socio-cultural contexts of blacks in Brazil. . . . [The] works are representative of African-derived popular culture, and the rereadings of traditional African art.[52]

Afro-Brazilian art is as vital a component of black culture in Brazil as it is a critical ingredient in Brazilian visual culture as a whole. The art of Mestre Didi (b. 1917) is a key link in the understanding of these phenomena. His scepters and other ritual sculptures fashioned of vegetable fiber, leather, shells, and other materials connect manifestations of the Yoruba spirits with allusions to ancient myths of creation. They possess inherent power, both spiritual and visual, and are potent elements of contemporary artistic and religious experience.

Icons of a nonecclesiastical but no less powerful sort were created by sculptor Sérgio Camargo (1930–1990). Camargo took Constructivism into different directions from those followed by his fellow artists.

MIRA SCHENDEL *Untitled*, 1965. Oil on rice paper, dimensions unknown. Collection of Ada Schendel

His initial training took place in Buenos Aires under Emilio Pettoruti and Lucio Fontana. Later, in Paris, he made the acquaintance of Jean Arp, Brancusi, and Georges Vantongerloo. Camargo's large wood reliefs consist of flat surfaces covered with tubes, blocks, and other irregularly shaped forms, all of which—base and overlaid shapes—are painted white. (Camargo also worked in white and black marble.) An organic sensation is achieved that is complemented by the play of light over the volumetric surface, lending the work a highly sensuous quality.

The 1960s and 1970s is a difficult period to characterize in terms of Brazilian art history. An era of evolving artistic pluralism, it was also a time of military dictatorship, starting in 1964 and ending in 1985. Within this atmosphere of repression, the arts were stimulated to highly creative resistance, even though a harsh censorship ordinance of 1968 inhibited creativity in many ways. Absence, intimations of loss, and fragility are suggested in many of the works of Swiss-born Mira Schendel (1919–1988), whose exquisitely minimal markings on paper suggest a hermetic language. Other artists, such as Antônio Dias (b. 1944) and Antônio Henrique Amaral (b. 1935), expressed the unsettled atmosphere of the time in their strident images, which are related to international trends of Pop art and New Figuration .

Lygia Pape serves as an important link between the Neo-Concrete generation of the 1950s and 1960s and contemporary art at the turn of the millennium. Oiticica referred to Pape as a "permanently open seed" for her receptivity to new ideas and creation of constantly evolving forms.[53] *Book of Time* (1961, cat. no. 259) is composed of 365 pieces (representing the days of the year) that may be arranged in varying configurations. The "fabulous number of permutations that may arise with a single square format"[54] in this piece suggest the mutability of the object and the fluidity of time. Her *Tupinambá Cloak* (2000, cat. no. 305), a recent large-scale installation, brings *Brazil: Body and Soul* full circle, recalling the ancient Tupinambá feather cape that is the beginning focal point.

Regina Silveira (b. 1939) treats the themes of possession, power, and the contradiction of appearances. Probing social criticism is never very far from the surface of her deceptively simple pieces. In *The Saint's Paradox* (1994, cat. no. 306), a small statue of Santiago (Saint James the Apostle), who occupies an important place in religious iconography throughout the Americas,[55] rests on a pedestal in the center of the exhibition space with an enormous shadow cast behind him. The shadow is not his, however, but rather a distortion of the shadow that would be cast by Modernist Victor Brecheret's

bronze equestrian monument to the nineteenth-century Brazilian army officer the Duque de Caixas, which is situated in a prominent public square in downtown São Paulo. The subtle irony of this commentary on social, political, and economic relationships lends the work an immense power. The visual participation of the beholder is imperative here, as the work requires the viewer to rectify the skewed perspective of the shadow and its relationship to the small saint figure. In *Phantom* (1995, cat. no. 304), by Antonio Manuel (b. 1947), the viewer is even more physically engaged. Large and small pieces of carbon hang from thin strings within the exhibition space, creating a disorienting atmosphere of black substances that pierce the air and seem to threaten the viewer with their weight. The space of the gallery is altered, reordered according to the dictates of the artist, who demands physical engagement from his participants. But there is more to this installation than a simple play with space. Within the maze of hanging coal is a small photograph of an individual describing to the press a massacre of street children in Rio de Janeiro that he had witnessed. His face is shrouded by a cloth to hide his identity. As Paulo Herkenhoff explains, "Where violence imposes the law of silence, speech is an act of citizenship. Aroused from social amnesia this being now speaks and has

a memory. With his disposition, the child, anonymous, illuminates a social territory which, in the metaphor of the gallery, is peopled by coal."[56]

Accumulation, a multiplicity of materials (bronze, wood, glass), and juxtapositions of surfaces and magnetic tensions are all elements inherent in the work of Tunga (b. 1952). Many of his pieces carry with them intimations of the sacred, appearing to refashion Baroque sensibility. He plays with materiality, weight, and palpability. While his large-scale installations suggest inexorable mass, they also imply a profound sensuality. Indeed, references to body parts, skin, and hair are intrinsic to Tunga's visual vocabulary. Physical engagement with his work is inevitable, as the imposing presence of these pieces demands interaction. The viewer may walk around the colossal piece entitled *Scalp (Comb)* (1984–97, cat. no. 308), for example, observing the twists and turns of the hundreds of strands of "hair" that envelop the space in which the piece installed.

Literal interaction in the form of touch and smell are quintessential elements in the environmental works of Ernesto Neto (b. 1964). His pieces embrace the viewer in a total environment, a womblike chamber created out of nylon netting or flesh-colored Lycra and infused by odorous substances such as lavender and aromatic spices. The artist states that the organic shapes of his environments suggest "fertility, sexuality, touching and kissing."[57] Neto's art continues and connects with the traditions of Brazilian experiential art as represented in the past by Oiticica, Clark, and other members of the Neo-Concrete group.

The paintings and installations of Adriana Varejão (b. 1964) allude more directly to Brazil's visual history. She sometimes employs references to the Baroque tradition of tile decoration and visual quotations of architectural elements from the colonial period to ironically comment on the past. The survival of images in the collective consciousness

and the role they play in dreams or nightmares is at the root of much of her art, as is an urgent sense of corporeality, conveyed by the body fragments and extrusions of flesh that often punctuate her work. In *Folds* (2000–01, cat. no. 309), the artist gives the sense of a wall of an ancient building having just burst apart to reveal not the stuff of its construction but the viscera of the human body.

While Miguel Rio Branco (b. 1946) and Vik Muniz (b. 1961) are worlds apart in terms of their sensibilities, both artists' photography-based works demonstrate a concern for fragmentary appearances, the fleeting view, and chance occurrences that provoke a shock of recognition in the viewer. Rio Branco is a consummate colorist. His photographs are saturated in bright, even shocking tones, a veritable celebration and decomposition of the Baroque, to which he refers specifically in *Barroco* (1993, cat. no. 321). Muniz, who has been referred to ironically as a "low-tech illusionist,"[58] creates elaborate scenarios with the most ephemeral of materials (dust, thread, sugar), and then photographs these scenes. The process and the fugitive quality of the materials are emphasized as if to suggest a constant process of organic growth and decay. This is equally true of his *Aftermath* series (1998, e.g., cat. nos. 315–19), images of children at Carnival time. The photographs are, in fact, images of detritus found on the street that has been fashioned into "portraits" of the boys and girls.

Contemporary Brazilian artists have formed an integral part of international art culture in recent years. *Brazil: Body and Soul*, does not present a comprehensive overview of the developments of the past decade. The selection of contemporary artists is intended, instead, to suggest the multiplicity of artistic strategies employed today. Each piece sets up vital parallels with the art of the past, forming part of a fundamental dialogue with the continuing, fluid narrative of artistic expression in Brazil.

Notes

For their kindness, helpful suggestions, and encouragement, I would like to express my gratitude to my Brazilian friends and colleagues, especially Aracy Amaral, Marcelo Araujo, Paulo Herkenhoff, and Marcelo Montes Penha, as well as to my colleagues at the Guggenheim Museum, especially Charmaine Picard, Julian Zugazagoitia, Elizabeth Franzen, and Edward Weisberger.

1. Among the most important (if not always successful) large-scale exhibitions of Latin American Modern art that have been organized over the last fifteen years are: *Art of the Fantastic, Latin America, 1920–1987*, Indianapolis Museum of Art, 1987; *The Latin American Spirit: Art and Artists in the United States, 1920–1970*, The Bronx Museum of the Arts, New York, 1988; *Art in Latin America: The Modern Era, 1820–1980*, The Hayward Gallery, London, 1989; *Latin American Artists of the Twentieth Century*, The Museum of Modern Art, New York, 1993; and, most recently, the series of exhibitions known collectively as *Visiones del Sur*, held at various venues in Madrid in 2000–01, the most substantial of which were *Heterotopías. Medio siglo sin-lugar: 1918–1968*, Museo Nacional Centro de Arte Reina Sofía, and *Eztetykadelsueño*, Palacio de Cristal and Palacio de Velázquez. All of these exhibitions included information about Brazilian art and artists and were accompanied by significant catalogues.

2. In the United States, there have been no large-scale exhibitions devoted entirely to a wide panorama of Brazilian art. Small, focused shows such as *Ultramodern: The Art of Contemporary Brazil*, presented at the National Museum of Women in the Arts, Washington, D.C., in 1993, have been important for disseminating knowledge of Brazilian art in the United States, but the present exhibition is the first to address a wide variety of issues in Brazilian art history. The recent exhibition *Brésil Baroque. Entre Ciel et Terre*, shown at the Petit Palais, Paris, in 1999–2000, was a substantial exhibition of Brazilian Baroque art.

3. James Oles has studied this phenomenon with regard to Mexico. See his *South of the Border: Mexico in the American Imagination 1914–1947* (Washington, D.C.: Smithsonian Institution Press, 1993). There is no analogous study of the impact of travel and cultural relations between the United States and Brazil.

4. See Philip L. Goodwin, *Brazil Builds: Architecture New and Old 1652–1942*, exh. cat. (New York: Museum of Modern Art, 1943).

5. See *Portinari of Brazil*, exh. cat., with texts by Florence Horn and Robert C. Smith (New York: Museum of Modern Art, 1940). The catalogue was also issued as vol. 7, no. 6 of *Bulletin of the Museum of Modern Art*.

6. See *Brazil Projects*, exh. cat. (New York: P.S.1, 1988).

7. For example, see *Art from Brazil in New York*, exh. cat. (New York: LedisFlam and Galerie Lelong, 1995).

8. The only significant shows of Brazilian art that have been held in the United States outside New York are: *The Art of Brazil*, Tennessee Fine Arts Center, Nashville, 1975; and *Brazil: Crossroads of Modern Art*, Chicago Public Library Cultural Center, 1990.

9. Among the European exhibitions dedicated exclusively to Brazilian art are *Modernidade. Art Brésilien du 20e Siècle*, Musée d'Art Moderne de la Ville de Paris, 1987; *Brasilien. Entdeckung und Selbstdeckung*, Kunsthaus Zurich, 1992; *Brésil Baroque*, Petit Palais, Paris, 1999–2000; and *Brasil. De la antropofagia a Brasilia. 1920–1950*, IVAM Centre Julio González, Valencia, 2000.

10. See Sérgio Augusto, "Hollywood Looks at Brazil: From Carmen Miranda to *Moonraker*," in Randal Johnson and Robert Stam, eds., *Brazilian Cinema* (New York: Columbia University Press, 1982), pp. 351–61.

11. George Hadley-García, *Hispanic Hollywood: The Latins in Motion Pictures* (New York: Citadel Press, 1990), p. 113.

12. Ibid., p. 114.

13. Oswald de Andrade wrote the "Anthropophagic Manifesto" in 1928 and Tarsila do Amaral created her painting *Antropofagia* in 1929.

14. There had been many earlier visual representations of Brazil by European artists (mostly printmakers), but these artists had never traveled there. For the most part, their works concentrated on fantastical images of the land and its inhabitants. See Paulo Herkenhoff, ed., *O Brasil e os holandeses* (Rio de Janeiro: GMT Editores, 1999). See especially the essay by Ronald Raminelli, "Habitus Canibal. Os índios de Albert Eckhout," pp. 104–20.

15. See Ana Maria de Moraes Belluzzo, *O Brasil dos Viajantes* (São Paulo: Metalivros, 1994). On North American visitors to Brazil during this period, see Katherine E. Manthorne, "O Imaginário Brasileiro para o Público Norte-Americano do Século XIX," *Revista USP*, no. 30 (June–August 1996), pp. 60–71.

16. Luis Pérez Oramas, "Landscape and Foundation: Frans Post and the Invention of the American Landscape," in *Núcleo Histórico: Antropofagia e Histórias de Canibalismos*, exh. cat. (São Paulo: XXIV Bienal de São Paulo), pp. 107–10.

17. After returning to Europe, Post continued to paint nostalgic, more embellished caprices on the landscape of Brazil for the rest of his career.

18. Roberto DaMatta, *Carnivals, Rogues, and Heroes: An Interpretation of the Brazilian Dilemma* (Notre Dame, Indiana: University of Notre Dame Press, 1991).

19. Paulo Herkenhoff, "Brazil: The Paradoxes of an Alternate Baroque," in *Ultra Baroque: Aspects of Post Latin American Art*, exh. cat. (San Diego: Museum of Contemporary Art, 2000), p. 138.

20. The bibliography on Brazilian Baroque art is vast, and the most significant items are listed in the bibliographical section of this book. The most recent literature that summarizes the complexities of this area are found in the exhibition catalogues *Brésil Baroque* (Paris: Petit Palais, 1999) and *Arte Barroca* (São Paulo: Associação Brasil 500 Anos Artes Visuais, 2000). In the latter catalogue, see the especially helpful essay by Myriam Andrade Ribeiro de Oliveira, "A Imagem Religiosa no Brasil/The Religious Image in Brazil," pp. 37–79.

21. Oratories were particularly popular during the Baroque period, but they continued to be made into the twentieth century.

22. Sir Nikolaus Pevsner, *The Englishness of English Art* (Harmondsworth, England: Penguin, ca. 1964); and José Moreno Villa, *Lo mexicano en las artes plásticas* (Mexico City: El Colegio de México, 1948).

23. Lélia Coelho Frota, "The Ex-Voto of Northeastern Brazil: Its Antecedents and Contemporary Expression," in *House of Miracles: Votive Sculpture from Northeastern Brazil*, exh. cat. (New York: Americas Society, 1990), p. 29.

24. Another manifestation of the popular wood-carving traditions are the ship mastheads (*carrancas*) made during the nineteenth and early twentieth centuries for the boats (*barcas*) that plied the waters of the São Francisco River in the Northeast. These mastheads mainly take the form of lions' heads, designed as ritual protection of the cargo and passengers from bad weather and robbery. See Paulo Pardal, "Les Carrancas du Rio São Francisco," in *Brésil. Arts Populaires*, exh. cat. (Paris: Grand Palais, 1987), p. 54.

25. For this commission, O Aleijadinho worked with members of his atelier. For a discussion of the authorship of the individual figures, see Germain Bazin, *Aleijadinho et la sculpture baroque au Brésil* (Paris: Les Editions du Temps, 1963), and two books by Myriam Andrade Ribeiro de Oliveira: *Aleijadinho. Passos e profetas* (Belo Horizonte: Editora Itatiaia Limitada, 1985) and *O Santuário de Congonhas e a Arte do Aleijadinho* (Belo Horizonte: Edições Dubolso, n.d.).

26. Mariano Carneiro da Cunha, "Esboço histórico: o elemento negro nas artes plásticas," in Walter Zanini, ed., *História Geral da Arte no Brasil* (São Paulo: Instituto Walther Moreira Salles, 1982), vol. 2, pp. 989–90.

27. Carneiro da Cunha discusses the similarities of the styles of jewelry in Brazil and West Africa ("Arte afro-brasileira," in Zanini, ed., *História Geral da Arte no Brasil*, p. 1028).

28. See Gilberto Freyre, *The Master and the Slaves: A Study in the Development of Brazilian Civilization* (Berkeley: University of California Press, 1986), and Darcy Ribeiro, *The Brazilian People: The Formation and Meaning of Brazil* (Gainesville: University of Florida Press, 2000). These theories have not been accepted unquestionably. Indeed, Freyre's notion of "racial democracy" has been viewed as reductivist by, among others, Maria Lúcia Montes in her essay for this book.

29. See the discussions of the importance of African elements in Brazilian visual culture in Emanoel Araújo, ed., *A Mão Afro-Brasileira: significado da contribução artística e historica* (São Paulo: Tenenge, 1988). See also the essays in two recent exhibition catalogues: *Arte Afro-Brasileira/Afro-Brazilian Art* (São Paulo: Associação Brasil 500 Anos Artes Visuais, 2000) and *Negro de Corpo e Alma/Black Body and Soul* (São Paulo: Associação Brasil 500 Anos Artes Visuais, 2000).

30. The group also included the painter Nicholas-Antoine Taunay, the sculptor Auguste-Marie Taunay, and the architect Grandjean de Montigny.

31. See Theodore E. Stebbins, Jr., exh. cat., *Martin Johnson Heade* (Boston: Museum of Fine Arts, 1999), pp. 71–77.

32. *O Estado de São Paulo*, Dec. 20, 1917; reprinted (in French) in *Modernidade*, exh. cat. (Paris: Musée d'Art Moderne de la Ville de Paris, 1987), pp. 62–64.

33. The standard scholarly work on the Semana de Arte Moderna is Aracy Amaral's *Artes plásticas na Semana de 22* (São Paulo: Editora Perspectiva, 1970).

34. The one art form that was not represented to any great extent in the Semana was film.

35. See Edward J. Sullivan, "Notes on the Birth of Modernity in Latin American Art," in *Latin American Artists*, exh. cat. (New York: Museum of Modern Art, 1993), pp. 18–39.

36. Aracy Amaral, *Tarsila do Amaral* (São Paulo: Fundação Finambrás, 1998), p. 15.

37. The most recent scholarship on Purism is found in *L'Esprit Nouveau: Purism in Paris, 1918–1925*, exh. cat. (Los Angeles: Los Angeles County Museum of Art, 2001). See especially the essay "Purism in Paris, 1918–1925" by Carol S. Eliel. The best general study of the *retour à l'ordre* is found in Kenneth E. Silver, *Esprit de Corps: The Art of the Parisian Avant-Garde and the First World War* (Princeton: Princeton University Press, 1989).

38. Herkenhoff, "Brazil: The Paradoxes of an Alternate Baroque," p. 130.

39. Leopoldo Castedo, *The Baroque Prevalence in Brazilian Art* (New York: Charles Frank, 1964).

40. Fatima Bercht, "Tarsila do Amaral," in *Latin American Artists of the Twentieth Century*, p. 57.

41. On criticism of Portinari, see Annateresa Fabris, *Portinari, pintor social* (São Paulo: Editora Perspectiva, 1992), pp. 29–36.

42. André Breton, "Maria," in *Maria, Sculpture* (New York: Julien Levy Gallery, 1947; reprinted in *Maria: The Surrealist Sculpture of Maria Martins* (New York: André Emmerich Gallery, 1998), p. 42. See also Ingrid Schaffner and Lisa Jacobs, *Julien Levy: Portrait of an Art Gallery* (Cambridge, Mass,: MIT Press, 1998), p. 46.

43. Francis M. Naumann, "Marcel & Maria," *Art in America* 89, no. 4 (April 2001), pp. 98–110, 157.

44. There had been several other important exhibitions of abstract art in São Paulo before the first *Bienal*, such as that of Max Bill at the Museu de Arte de São Paulo in 1950.

45. Quoted in Kabengele Munanga, "Afro-Brazilian Art: What Is It, After All?" in *Arte Afro-Brasileira/Afro-Brazilian Art*, p. 106.

46. Umbanda and Candomblé are syncretistic religions that combine elements of African (principally Yoruba or—as in the case of Umbanda—Bantu) worship practices and deities with those of Christianity.

47. For a discussion of the symbolism connected with individual orixás, see Zeca Ligièro, "Candomblé is Religion-Life-Art," in Phyllis Galembo, ed., *Divine Inspiration: From Benin to Bahia* (Albuquerque: University of New Mexico Press, 1993), pp. 97–117.

48. See Kynaston McShine, ed., *Information*, exh. cat. (New York: Museum of Modern Art, 1970), p. 103.

49. See *Hélio Oiticica*, exh. cat. (Rotterdam: Witte de With Center for Contemporary Art, 1991), p. 85.

50. The title of *Tropicália* also refers to the cultural movement of the same name, which encompassed music, poetry, film, and other forms of cultural expression that incorporated aspects of high and low culture. This movement, founded by, among others, Gilberto Gil, Caetano Veloso, and Tom Zé, derived its inspiration from the antropofagia philosophy of appropriation and re-invention. The manifestations of Tropicália may also be seen as forms of cultural resistance created in opposition to the right-wing military coup of 1964.

51. *Imagem do Inconsciente/Images of the Unconscious*, exh. cat. (São Paulo: Associação Brasil 500 Anos Artes Visuais, 2000), p. 214.

52. Marta Heloísa Leuba Salum, "One Hundred Years of Afro-Brazilian Art," in *Arte Afro-Brasileira*, p. 112.

53. Quoted in Guy Brett, "The Logic of the Web," in *Lygia Pape*, exh. cat. (New York: Americas Society, 2001), unpaginated.

54. Ibid.

55. In Catholic imagery throughout the New World, St. James has been used as a symbol of the triumph of Christianity over indigenous religions.

56. Paulo Herkenhoff, *Density of Light: Contemporary Brazilian Photography* (São Paulo: Câmara Brasileira do Livro, 1994), p. 40.

57. Quoted in Katie Clifford, "Please Touch!," *Art News* 100, no. 5 (May 2001), p. 182.

58. Lilian Tone, "Vik Muniz: manipulador de positivos/Manipulator of Positives," in *Arte Contemporânea Brasileira: Um e/entre Outro/s*, exh. cat. (São Paulo: XXIV Bienal de São Paulo, 1998), p. 121.

Brazil in Historical Context

Michael M. Hall

After five centuries Brazilian assessments of the Portuguese conquest are often decidedly somber. The virtual destruction of the indigenous population, as well as a critical awareness of the ecological and social consequences of European domination, struck many in Brazil as reason enough to avoid any celebratory tone in the recent observances of the anniversary of Pedro Álvares Cabral's arrival in 1500. The date itself marks only a brief incident in the long history of European conquest. By the time the Portuguese reached Brazil they had already established a series of fortified trading posts along the West African coast, colonized Madeira and the Azores in the Atlantic, and reached India by sailing around the southern tip of Africa—a feat that would lead to a lucrative trade in spices and other Asian commodities. In fact, Cabral's expedition stayed only a few days before resuming its voyage to India, though one ship was sent back to Lisbon with news of the discovery in the

South Atlantic of what was initially thought to be a large island. The coastal Indian tribes that Cabral encountered, the Tupi-Guarani, may have numbered as many as 2,500,000 in 1500. They lived from fishing, hunting, and simple forms of agriculture, while engaging in ferocious warfare with neighboring villages. The Tupi-Guarani offered little of commercial interest, though the Portuguese did find valuable dyewood that, according to one theory, provided the name for the new colony. Initially called the Land of the True Cross, the area is said to have become known as Brazil on account of the red color of brazilwood, suggesting a *brasa*, or glowing coal.

The Portuguese, more concerned with profitable commercial activities elsewhere, took several decades to work out a successful formula for the colonization of Brazil. A few trading posts and occasional naval patrols failed to discourage French incursions. Faced in the 1530s with the need to

take effective possession of the new colony, the Portuguese government issued grants of royal authority to twelve proprietary captains who were to establish settlements along the coast. These hereditary captaincies faced a variety of problems that began with difficulties in raising capital and recruiting colonists and later included Indian attacks and hostilities among the Portuguese themselves. Only two captaincies were clearly successful, those at Pernambuco and São Vicente. In 1549 the king sent a royal governor to Bahia and charged him with helping to defend the captaincies as well as increasing crown revenues.

The most promising economic activity in the new colonies turned out to be sugar production, with which the Portuguese had considerable experience. The sugar mills they constructed in Brazil employed complex machinery and were among the most advanced and technically demanding operations of their time. The sugar industry also required a large and closely controlled labor force. Portuguese law permitted Indian enslavement under certain circumstances, notably the case of Indians captured in "just war" or rescued from execution by other tribes. For colonists in need of workers, war and rescue proved to be highly flexible concepts. Indian enslavement, however, failed to resolve the labor needs of the colony. Epidemics devastated the Indian population, which lacked immunity to measles, smallpox, influenza, and other contagious diseases introduced by the European invaders. Malnutrition and ill treatment made the effects of such epidemics especially lethal. The high death rate resulted in constant efforts to capture new contingents of slaves for the fields and mills. In resisting enslavement Indians often offset their disadvantages in armament, which may not have been great, by superior knowledge of the terrain and greater numbers. Their frequent attacks destroyed many Portuguese settlements, particularly in the early years of colonization. Indians

also proved to be less than entirely satisfactory slave laborers because they resisted their masters through frequent escapes, sabotage, malingering, and theft.

The recently formed Jesuit order, six of whose missionaries came out with the first royal governor in 1549, posed a further complication for the use of Indian slaves. The Jesuits, filled with the fervor of the Counter-Reformation, sought to place the Indian population under the control of their order. In practice, this came to mean confinement in isolated camps for purposes of religious indoctrination and labor service. This policy created intense conflict with settlers over the use of Indian labor and led to the expulsion of the order from several areas. The Jesuits showed fewer scruples regarding African slaves, whom the Portuguese had utilized in Europe and on Atlantic islands for some time before introducing them in considerable numbers to Brazil during the 1540s. Even the seventeenth-century Jesuit missionary and politician Antônio Vieira, outspoken in his defense of the Indians, argued that Christianization justified the enslavement of Africans. He advised such slaves to accept their condition as a means of salvation and considered escape from their masters a mortal sin. The Jesuits came to depend heavily on black slave labor in their extensive network of ranches and plantations and for other activities.

Although planters continued to use Indian slaves in sugar production for decades, and colonists elsewhere in Brazil employed them until at least the middle of the eighteenth century, those who could afford to do so bought African slaves. The use of African slaves was generally reported to be more profitable than the use of Indian slaves. The total number of slaves imported from Africa was very large indeed. According to recent estimates, Brazil received about 40 percent of the 15,000,000 or so Africans taken from their native lands and brought to the Americas. The Brazilian slave force depended on continuing imports from Africa because a

shortage of women and a high infant-mortality rate kept natural population growth low. Not only did this fact closely tie the fate of Brazil to the vicissitudes of the slave trade, but it also meant that recent arrivals constantly renewed African cultural influences.

During the more than 300 years of the trade, slavers brought Africans from different parts of the continent, including a significant number from Muslim areas. Such a long time period and such varied origins, as well as immense differences in the specific circumstances that slaves encountered over the vast territory of Brazil, raise doubts that Brazilian slavery was sufficiently homogeneous and distinct enough to set it off from slavery elsewhere. Nevertheless, especially when compared to the United States, some distinctions are quite striking. While few scholars today would defend the once popular notion that slavery took a peculiarly benevolent form in Brazil, there is no question that slaves there enjoyed greater potential access to freedom through self-purchase or manumission than those in North America. Slaves in Brazil also frequently escaped their captors and often formed *quilombos* (communities of fugitives), the most famous of which, Palmares, survived for most of the seventeenth century and resisted Dutch and Portuguese attacks until 1695. The significant number of slave conspiracies and revolts, particularly in the early nineteenth century, is remarkable. And through less spectacular forms of day-to-day resistance, slaves often managed to influence their living and working conditions for the better.

The Brazilian sugar economy declined from about the 1670s, badly hurt by increasing competition from French and British colonies in the Caribbean. However, sugar was not the only agricultural commodity exported from the colony. Other crops, particularly tobacco but also cotton, rice, and coffee would play important roles, as did cattle raising and cassava cultivation for the internal Brazilian market. During most of the colonial period the far northern and southern areas of Portuguese colonization participated only marginally in the export economy. For example, in São Paulo the small local population, composed in large part of people of mixed European and Indian origin, lived primarily from subsistence agriculture, selling foodstuffs to plantation areas, and profits from expeditions, called *bandeiras*, which ranged through the interior of South America in search of Indian slaves and mineral wealth.

When gold was discovered in Minas Gerais in the 1690s, the economy entered a new phase. The astounding rush that ensued, later intensified by the discovery of diamonds in the same region in the 1730s, drew immigrants from Portugal in great numbers and opened up a large part of the interior to settlement for the first time. The boom further stimulated the African slave trade, in the process harming the economy of older areas because of the transfer of slaves to Minas Gerais. The opulence of the mining districts became legendary and financed spectacular endeavors in architecture, decorative arts, sculpture, painting, and music. The sculptures of Antônio Francisco Lisboa, known as O Aleijadinho, are only the best known example of the remarkable artistic achievements in the mining region of eighteenth-century Minas Gerais.

Portugal's royal government adopted various heavy-handed tactics in its efforts to tax mining production, which not only created considerable resentment among the population but also may have brought little long-term economic benefit to Portugal. Mining activities began to decline by the middle of the eighteenth century, largely caused by the exhaustion of deposits, though oppressive regulation and taxation by the Portuguese government did not help.

The very notion of a unified "colonial Brazil" is something of a misnomer,

largely created by romantic and nationalist historiography in the nineteenth and twentieth centuries. In fact, the Portuguese discouraged links among their Brazilian possessions and tended to deal with each colony in Brazil as a separate entity. The governor-general, later viceroy, installed at Bahia exercised few powers beyond his own captaincy, and the situation did not change significantly when Portugal transferred the seat of government to Rio de Janeiro in 1763. In fact, for much of the colonial period the Portuguese ruled northern Brazil directly from Lisbon as an entirely distinct state. It is hardly accidental that British travelers often referred to the country as "the Brazils" well into the nineteenth century.

In competition with larger and more powerful nations one as small and poor as Portugal faced enormous obstacles in maintaining control over its vast Brazilian colonies. The Portuguese dislodged French settlements there with some difficulty, and from 1630 to 1654 they lost Pernambuco and adjacent areas to the Dutch. Portugal itself fell under Spanish domination between 1580 and 1640. The Portuguese never maintained the rigorous monopoly over colonial trade that mercantilist doctrine recommended, and English interlopers operated virtually at will for long periods. Portugal was obliged to grant significant advantages in colonial commerce to the English from the seventeenth century onward. It has often been argued that—because of the predominance of the English in Portuguese trade—Brazilian gold played an important role in the origins of the Industrial Revolution in England.

Attempts by the Marquês de Pombal, Portugal's virtual dictator between 1750 and 1777, to modernize Portuguese administration met with some success. His policies, continued by his immediate successors, accepted mercantilist doctrines and sought to stimulate manufacturing in Portugal while prohibiting it in Brazil. Through the creation of monopoly trading companies and other measures, Pombal managed to increase crown revenues and reduce Portugal's trade deficit, although the country continued to serve primarily as an entrepôt for commerce between Brazil and the more advanced economies of Europe, primarily England.

The relative weakness of the Portuguese state also had an impact on religious activities. Portugal secured effective control from the papacy over the church, which became in some ways more a Portuguese than a Roman institution. Ecclesiastical vigilance was generally slight. Until 1676 only one diocese existed, at Bahia, for all of Brazil, and only seven were created by the end of the colonial period. In 1759 when the crown ousted the Jesuits—by far the richest and most powerful of the religious orders in Brazil—there were fewer than 700 of them to expel. The secular clergy, scarce in number, ill prepared, and lax in the observance of vows, did little to strengthen the institutional church.

The Portuguese never installed a permanent Inquisition in Brazil but sent out a number of visitations by officials who took suspects back to Lisbon for trial and execution. These missions concerned themselves only occasionally with infractions by the clergy, although they investigated accusations of blasphemy, sodomy, witchcraft, and other activities condemned by the church. The investigators directed most of their attention to the so-called New Christians: descendants of Jews who had been forcibly converted to Catholicism in 1497 and were widely accused of practicing their ancestral religion in secret. New Christians occupied important positions in the Brazilian economy, though to what extent they retained aspects of Jewish religious observance is far from clear. Many investigations appear to have had more to do with political and economic matters than with questions of faith or religious practice.

Although the Portuguese government did not implement the Council of Trent's

rigorous administrative reforms aimed at centralization and clerical control, other aspects of the Counter-Reformation flourished in Brazil, in particular, commitment to the sacramental and outward trappings of the Catholic tradition. Processions, images, festivals, and feasts—all marked by Baroque pomp and sumptuousness and not always clearly separated from the profane—played a major role in Brazilian religious practice. The laity, through a variety of confraternities and brotherhoods, often organized such activities to encourage piety and religious sensibility and also perhaps to reduce tensions generated by the social divisions and ethnic diversity of Brazil. The much noted openness of Brazilian Catholicism to elements of African and indigenous religious practice was first evident in the colonial period. Vivid manifestations of popular faith, such as devotion to saints and the Virgin, often incorporated strong syncretic elements and took place at some distance from direct clerical control. While the institutional church may have been weak, popular religiosity was not.

By the end of the eighteenth century Brazil's population is thought to have been somewhat smaller than Portugal's 3,500,000 but was growing more rapidly. Slaves were the largest category in the colonial population: approximately 38 to 40 percent of the total. Whites numbered less than 30 percent, free blacks and mulattoes were perhaps a slightly smaller percentage, and Indians in areas under Portuguese control numbered about 5 percent. Racial prejudice within the free population reinforced rigid hierarchies of power and wealth, and free blacks and mulattoes suffered both legal disadvantages and widespread discrimination. Although Brazil remained overwhelmingly rural, several cities grew to significant size by the end of the colonial period. In both Bahia and Rio de Janeiro the populations approached 40,000 inhabitants around 1780, which made them substantial cities in the eighteenth-century Atlantic world;

for comparison, New York in 1775 had 20,000 inhabitants.

Portuguese policies considerably limited cultural life. No university, for example, was ever established in colonial Brazil, and Brazilians were expected to attend university in Coimbra, Portugal. The Portuguese permitted no printing presses in Brazil and restricted the circulation of books. Despite these obstacles many Brazilians were aware of the revolutionary events in North America and France toward the end of the eighteenth century, and they criticized Portugal's mercantilist policies, which restricted both trade and manufacturing in Brazil. Many of them resented the preference shown to the Portuguese-born for appointment to higher political and economic posts. Republican conspiracies in Minas Gerais in 1788–89 and Bahia in 1798 plotted independence for those regions, but the Portuguese strongly repressed both movements.

Brazilian independence came about primarily as a result of Napoleon's invasion of Portugal in 1807, which was part of his attempt to close Europe to commerce with England. Under British protection the Portuguese government, the royal family, and an enormous entourage embarked for Brazil, arriving there in 1808. This remarkable event forever changed Brazil's relation to Portugal. One of the government's first acts upon arrival was to open Brazilian ports to the trade of all friendly nations, which in practice primarily meant Great Britain. In 1815 Portugal, recently freed from French occupation, declared Brazil to be a kingdom with the same status as Portugal. From the Brazilian point of view the economic tie to Portugal now appeared largely irrelevant. Consequently, important interests in Portugal suffered considerably from the loss of their privileged position in Brazilian trade.

In 1820 a new government took power in Portugal. Liberal at home but deeply reactionary in regard to colonial questions, this government pressured the king,

João VI, to return from Rio de Janeiro. He did so the following year, after naming his elder son, Pedro, as regent in Brazil. Portuguese intransigence, and the attempt to recolonize Brazil by restricting trade and ordering the return of the rest of the government from Rio de Janeiro, precluded other possible outcomes, such as Brazilian autonomy within a union with Portugal. When the prince regent received an ultimatum to return to Lisbon, he declared the independence of Brazil on September 7, 1822, and was soon proclaimed emperor as Pedro I. The presence in Brazil of the heir to the Portuguese throne facilitated a peaceful and monarchical outcome to the crisis of 1820–22 and minimized the risks of popular participation in politics. As it happened, the large landowners who dominated political life managed to secure independence from Portugal while preserving their own power and the slavery on which it depended. Independence was thus the first of several remarkably conservative changes of regime in Brazilian history.

Pedro's continuing interest in the succession to the Portuguese throne, along with his various autocratic acts, strengthened growing anti-Portuguese sentiments and led to his abdication in 1831 in favor of his Brazilian-born son, later to become Pedro II. The empire continued to depend economically on slave labor and export agriculture. A boom in coffee production, beginning in the province of Rio de Janeiro in the 1830s but soon spreading to São Paulo, provided the basis for considerable political stability, especially when compared to the rest of Latin America in the nineteenth century.

The central government repressed, not without difficulty, a series of violent regional revolts during the 1830s and 1840s. These movements—in one of which Giuseppe Garibaldi, then in exile from Italy, participated—generally defended federalist principles against the marked centralization of the empire. Though some movements were republican and explicitly

secessionist, all avoided any significant involvement by slaves in their struggles. The political structure worked out after 1840 expressed a conservative version of nineteenth-century liberalism: regular elections—generally fraudulent, based on limited suffrage, and mostly indirect—selected members for a chamber of deputies with limited powers. Cabinets alternated in office, and the emperor reigned with dignity if little initiative in the use of his not insignificant authority.

Brazil abolished the slave trade in 1850 after decades of British pressure that this be done. By the 1880s, following some partial abolitionist measures, and faced with an increasingly unruly slave force, coffee planters in western São Paulo, the most dynamic region of the economy, systematized importing Italian immigrants to work on their plantations. Brazil finally abolished slavery with a minimum of disruption on May 13, 1888. It was the last country in the hemisphere to do so.

In 1889 military dissatisfaction, combined with growing federalist and republican sentiment, as well as the resentment of some planters over the abolition of slavery without compensation, resulted in a bloodless coup d'état that overthrew the monarchy. The republic proclaimed on November 15, 1889, hardly represented a dramatic rupture with the past. The São Paulo planters, who soon came to dominate the republic, established a federal system that assigned substantial powers to the states. Some states maintained their own armies, and that of São Paulo came to number 14,000 soldiers in the 1920s, about half as large as the federal army. The planters used the state to subsidize immigration in order to maintain cheap labor and, after 1906, to finance a valorization scheme to keep world coffee prices up by withholding part of the crop when necessary. This became the first successful effort by a producer of primary products to manipulate the price for its commodity.

The political system of the republic observed many of the forms of political

democracy, though suffrage remained highly restricted. In fact, local political bosses, often sustained by kinship networks, and state governors determined the outcome of elections. The state of São Paulo dominated the presidency, alternating control of the office with the oligarchy of the state of Minas Gerais. A free press operated for much of this republican period but posed little risk to those in power as illiteracy stood at 75 percent as late as 1920. Some industrialization took place, inadvertently aided by foreign exchange difficulties. By 1920 Brazil had 275,000 factory workers in an urban working class of roughly 1,000,000, compared to a rural labor force of over 6,000,000. The value of industrial production in the state of São Paulo passed that of agriculture toward the end of the 1930s. The rapidly growing city of São Paulo came to embody the dynamism and many of the tensions involved in Brazil's somewhat belated emergence into modernity. By 1920 the city had grown to 579,000 inhabitants, up from 240,000 in 1900. Half of the adult population in 1920 had been born abroad, primarily in Italy, Portugal, and Spain. The immigrant population actively participated in the general strikes that swept the city in 1917 and 1919, and the severe police repression emphasized the deportation of foreign-born militants.

The cultural movement that emerged in literature, music, and the visual arts responded in part to the strong class and ethnic tensions that marked São Paulo at that time. The young men and women who participated in the *Semana de arte moderna* (Week of modern art) in 1922 and gave impetus to the Modernist movement over the following decade were generally cosmopolitan and influenced by the French artistic vanguard that many knew first hand, as well as by Italian Futurism and other tendencies. Nonetheless, the São Paulo Modernists tended to be strongly nationalistic, and one of the movement's most striking characteristics was its interest in the rediscovery of Brazilian folklore

and popular traditions. The tensions between cosmopolitanism and nationalism, the latter often of an authoritarian strain, resulted in a cultural movement of some complexity in its politics as well as its aesthetics. The greatest writer of the group, Oswald de Andrade, became a militant communist during the height of Stalinism. Another participant in the *Semana de arte moderna*, the novelist Plínio Salgado, came to lead—with the support of many fellow Modernists—a Brazilian fascist movement of considerable importance. Salgado's fascists would probably have met with more success if the dictatorial government of the 1930s had not occupied most of the political space available for movements of the extreme Right.

The narrowly based government of the republic proved unable to meet demands for political and social inclusion from provincial oligarchies as well as the increasingly important middle and working classes. Throughout the 1920s young, nationalistic army officers further undermined the republic's fragile legitimacy. Discredited by the effects of the economic crisis of 1929, the government fell to a coup d'état supported by dissident regional oligarchies under the leadership of Getúlio Vargas. As head of a self-styled revolution Vargas led a heterogeneous coalition, united primarily in its desire to establish a strong centralized state. He governed for most of the 1930–45 period as a dictator, in a particularly repressive and brutal form after 1937. While not fascist per se, the regime adopted a number of corporatist measures and deployed a fair amount of the fascist-type kitsch and public theater common to many right-wing governments of the period.

Vargas strengthened the state apparatus considerably and embarked on a policy of industrialization in which large state-owned enterprises assumed a major role, most notably the Volta Redonda steel complex built in the early 1940s. The Vargas formula of protectionism and extensive state intervention—a formula

also followed by his successors—resulted in impressive industrial growth until the 1970s. The regime's much vaunted social reforms included a rudimentary system of social security and a minimum wage for urban workers, among other measures. The political benefits for Vargas, called the Father of the Poor, proved to be immense. After destroying much of the preexisting labor movement, his regime created a substantial union structure of its own. Although rigidly controlled by the government, the new system recognized important rights for workers and in later periods provided the basis for concrete gains as a result of hard struggles with employers and the state. Limited as Vargas's social measures may have been in practice, they offered workers new forms of recognition and fostered new expectations.

Despite the Axis sympathies of many in the government, including the president, pressure by the United States and a realistic assessment of Brazil's geopolitical situation led Vargas to take the country into World War II on the side of the Allies in 1942. Brazil furnished bases for the North African campaign and sent troops to fight in Italy. Toward the end of the war internal and external pressures forced the dictator to schedule elections. In October 1945, fearful that Vargas would cancel the elections or otherwise perpetuate himself in power, the military removed him from office. The subsequent regime's so-called redemocratization left most of the institutions and personnel from the dictatorship intact, including the newly elected president, General Eurico Gaspar Dutra, who was supported by Vargas.

In the presidential election of 1950 Vargas won handily and then governed for three and a half turbulent years. His creation of the state-owned petroleum monopoly, attempts to restrict profit remittances by foreign companies, and concessions to the labor movement, in particular the decision in 1954 to double the minimum wage, provoked truculent political and military conservatives to

launch a fierce campaign calling for Vargas's resignation. Amid an atmosphere of acute social tensions, widespread strikes, and dissatisfaction in the military over pay, came the revelation that a member of the president's entourage was responsible for an attempt to assassinate a leading political opponent. The military presented the president with an ultimatum to resign, and the 71-year-old Vargas committed suicide on August 24, 1954. His statist, nationalist, and populist legacy, however, continued to shape Brazilian political history into the next century.

Juscelino Kubitschek, winner of the 1955 presidential election, followed nationalist and industrializing policies devised for the most part in the last Vargas government. Kubitschek managed to secure a stable majority in congress and enough support in the armed forces to overcome military resistance to his taking office and to suppress two military revolts during his term. Despite some nationalist language and a break with the International Monetary Fund, the government showed great receptivity to foreign investment and enjoyed considerable success in attracting it. The automobile industry, installed during this period by European and North American firms, became the most famous example of Brazil's industrial achievements. Kubitschek's slogan "fifty years progress in five" expressed the hopefulness of Brazil in the late 1950s. His words were reinforced by Brazil's victory in the world soccer championship in 1958 and, above all, by the rapid construction of the spectacular new capital, Brasília, planned by Lúcio Costa and Oscar Niemeyer. Brazilian culture flourished particularly in film, theater, and popular music, much of it nationalistic and highly political.

The erratic Jânio Quadros, despite a strong electoral victory to succeed Kubitschek as president, was unable to reconcile congressional resistance to his program. His resignation in 1961 after only seven months in office, apparently intended as a political maneuver to

strengthen his power, was promptly accepted by congress and the armed forces. Quadros's departure provoked a serious crisis, as he intended, because the military regarded his vice president, João Goulart, the political heir of Vargas, as dangerously left wing. Since there was considerable support, even within the military, for allowing the constitutional successor to take office, a compromise was worked out by which Brazil changed to a parliamentary system of government.

Goulart became a president whose powers were supposed to be considerably reduced. In practice, few supported the parliamentary system, and he won an overwhelming victory in a 1963 plebiscite to restore full powers to the presidency. Nevertheless, he failed to secure congressional approval for even middle-of-the-road reform proposals and vacillated to such an extent that he lost the support of both the Center and the Left. A ferocious right-wing propaganda campaign calling for Goulart's overthrow accused him of communist sympathies and revolutionary plans. At the height of the Cold War and in the wake of the Cuban Revolution, such charges galvanized support from the armed forces and conservative business groups. Goulart took no illegal steps, but his ill-conceived and unsuccessful attempt to secure exceptional powers from congress to deal with the growing economic crisis was depicted as proof of dictatorial intent. His enemies alleged that the government's limited measures for agrarian reform and nationalization constituted a threat to private property. In the context of seemingly uncontrolled inflation, frequent urban strikes, and instances of peasant mobilization, forces in the military and their civilian allies began to organize the overthrow of the constitutional government. Reckless provocation by Goulart in pardoning petty officers for their participation in a naval revolt sealed his fate. The armed forces found such threats to military hierarchy and discipline intolerable, and the army, encouraged by the United

States government, deposed the president on March 31, 1964. Goulart's supposed revolutionary preparations proved to be a fantasy of his opponents; he tamely left office for exile in Uruguay.

The ensuing military dictatorship, quickly recognized by the United States, proclaimed itself the Revolution of 1964. The faction that first took power indicated a willingness to return government to civilian hands after the restoration of economic stability and the removal of leftists from congressional and other political offices, trade unions, the civil service, and universities. When the government's economic policies, in which rigid wage controls played a large part, proved to be unpopular and did not produce immediate positive effects, those within the military who opposed any steps toward democratic restoration gained the upper hand. The dictatorship lasted for twenty-one years under five successive military presidents.

The military regime generally sought to maintain a modicum of legality and to observe, after a fashion, some of the forms of political democracy. Given the government's unpopularity, however, even the semblance of elections required extensive manipulation. In one frequently used tactic, the government removed opposition figures from office on specious grounds and banned them from politics for ten years. Major executive posts—the presidency, mayoralties of large cities, and (between 1965 and 1982) state governorships—ceased to be chosen by direct election. A tame national congress was allowed to meet during most of the period since it posed little threat to the regime. It is hardly surprising that the leaders of the tolerated opposition seriously considered dissolving their party in the early 1970s. Government manipulation of electoral rules bordered on farce. Practically every election took place under regulations different from those in force at the preceding one, as the government sought to maximize the political weight of whatever support it could still muster in the more rural

and underdeveloped parts of the country. At least one of these devices, the substantial overrepresentation of states hastily created from scarcely populated former territories, continues to distort Brazilian politics up to the present.

Student demonstrations in 1968 as well as some strike activity by industrial workers and signs of insubordination by congress led the military to impose severe new controls over economic and political life, including rigid censorship of the media and the elimination of habeas corpus. This extremely repressive period, which lasted until 1974, also saw the growth of an urban guerrilla movement, whose most spectacular acts were the kidnapping of foreign diplomats, released in exchange for political prisoners held by the government. The dictatorship charged over 7,000 people in political cases, detained many more, tortured thousands, and killed between 300 and 400 of its opponents.

There was a short period of marked economic expansion in the early 1970s. After a degree of political liberalization in the middle of the decade, grassroots social movements, including some tied to the Catholic church, began to press for social justice, due process, and protection against state violence. Industrial workers struck on a large scale at the end of the decade, resisted considerable repression, and laid the basis for a new and autonomous labor movement. Brazilian civil society in the 1970s created a variety of new forms of political participation, which became more visible and influential in the following decade. Social movements emerged to advance women's issues, environmental concerns, rights for blacks and indigenous peoples, and specific issues such as housing and public health.

The transition to civilian rule proceeded slowly and not very smoothly between 1974 and 1985. The military government faced serious obstacles in 1975–76 to bringing the murderous security apparatus under control and headed off a coup d'état in 1977 by hard-line officers opposed to any liberalization of the regime. Nevertheless, between 1975 and 1979 the government ended censorship, eliminated most of the dictatorial powers instituted in the 1960s, and accepted a general amnesty leading to the release of political prisoners and the return of exiles.

Despite enormous demonstrations in major cities calling for direct presidential elections in 1984, the constitutional amendment to that effect narrowly failed to secure the required majority in congress. With the country experiencing economic stagnation, an enormous foreign debt, and skyrocketing inflation, the government lost control over the succession process and found itself formally supporting a presidential candidate for whom it had little sympathy. A substantial number of civilian politicians allied with the dictatorship ended up supporting the successful candidate of the moderate opposition, and these politicians would continue to play an essential part in all successive civilian governments. In fact, the transition to civilian rule turned out to be more conservative than expected because the indirectly elected president died before taking office and was replaced by his vice-president, José Sarney, a former leader of the government party.

Sarney's administration left a mixed legacy. Political liberties were observed, and the democratic transition was consolidated. After long deliberations a constituent assembly produced a new constitution at the end of 1988 that advanced social and political rights but has subsequently provoked neoliberal indignation for being overly statist. An unorthodox economic stabilization plan, despite enjoying initial success, collapsed disastrously at the end of 1986. Under severe balance of payments pressure the government suspended payment on the country's large foreign debt to private banks in 1987. With an annual inflation rate over 1,000 percent in 1988 and 1989, the government ended its term in some disgrace.

In 1989 Fernando Collor de Mello became the first directly elected president of Brazil in almost thirty years. The son of a northeastern political family, he had served as governor of Alagoas before being discovered by the powerful Globo television network, which actively promoted his presidential candidacy. Collor proved an effective and glamorous campaigner, depicting himself as a modernizing political outsider and winning support for his Thatcherite slogans even among the poor. In the runoff he faced Luís Inácio da Silva, known as Lula, who had led the automobile workers in several dramatic strikes. Collor, terrifying a large part of the middle class with the prospect of a government of the Left, won a solid popular majority.

Once in office Collor attempted a bizarre strategy for controlling inflation by freezing the bank accounts of individuals and firms. The plan was very unpopular, especially as it failed to reduce inflation. Collor's extravagant, individualist style offended some, and his open disdain even for allies in the conservative political establishment further isolated his government. When a series of corruption scandals involving Collor and his entourage became public, he was especially vulnerable because he had no significant political party behind him. Although business groups had strongly supported him in the presidential elections, by 1992 they were not inclined to save him. After unconvincing attempts were made to explain the vast sums of money at the disposal of Collor and his close associates, a movement to impeach the president swept the country. He resigned at the end of 1992 before being removed from office by the senate, which went ahead anyway and voted to deprive him of his political rights for eight years. The vice president, Itamar Franco, who served out the rest of Collor's term, was something of an economic nationalist with no interest in advancing market-oriented reforms.

Fernando Henrique Cardoso, a sociologist from the University of São Paulo who had entered politics in the 1970s, became Franco's finance minister. In this post he was responsible for the successful economic stabilization program that became the centerpiece of his presidential campaign in 1994. Leading a broad coalition of the Center and Right, Cardoso won an easy victory over Lula and proceeded to carry out a program of privatizations and market-oriented reforms. He managed to amend the constitution so as to permit his reelection, which was another substantial victory over Lula in 1998. Economic policy has kept inflation under control, though at the price of very high interest rates and relatively slow growth.

Brazil enters the new century with a population of 170,000,000, 81 percent of them now living in urban areas. The economy has been at times the ninth largest in the world, but in an international ranking of 92 countries by their equality of income distribution, Brazil ranks number 90, slightly better than South Africa. While some social indicators improved marginally during the 1990s, income distribution did not. A third of the population lives in poverty, about triple the percentage for other countries with similar levels of per capita income. As one recent study concludes, "Brazil on the threshold of the twenty-first century is not a poor country, but an extremely unjust and inequitable one, with many poor people."[1]

Notes

I am grateful to Silvia Lara, Anthony Pereira, and Paulo Sérgio Pinheiro for helpful comments.

1. Ricardo Paes de Barros, Ricardo Henriques, and Rosane Mendonça, "Desigualdade e pobreza no Brasil: Retrato de uma estabilidade inaceitável," *Revista brasileira de ciências sociais* 15, no. 42 (Feb. 2000), p. 141.

The Message of Brazilian Rituals: Popular Celebrations and Carnival

Roberto DaMatta

Brazil: Body and Soul, an exhibition and publication whose focus is art produced within the Brazilian context, influenced by the local lifestyles and landscapes, provides an excellent pretext for discussing historic, geographic, and sociocultural dimensions specific to Brazil, amid a dominant, globalized cosmopolitanism. Techniques and themes developed elsewhere reappear in Brazil's visual arts, blended and redefined, in the form of the cultural "mulatismo" that is so much a part of the country's artistic process in general and its symbolic universe in particular. Brazilian art leads us away from those notorious comparisons, such as indexes of violence or rates of income concentration, whereby the country tends to be denigrated—those figures that rank nations on scales of progress as being inferior or superior, advanced or backward, rich or poor. Instead, art allows us to enter into an enigmatic realm of ineffable things, things that are incomparable and

incommensurable. Comparisons must be made on the basis not of similarities but of contrasts, leading from the particular to the universal and not vice versa, as is the case with economic comparisons.

The possibility of talking about Brazil from a Brazilian perspective allows me to consider the message of Brazilian rituals, tracing what I think are their most important characteristics and their meaning within a social system that has always found a critical source of identity in its celebrations and ceremonies. Although Brazil as a nation-state changed its political regime, educational system, currency, and constitution several times, Brazil as a society and culture, with its religious rituals and, above all, its profane and orgiastic rituals, such as Carnival, remain relatively untouched. The people give meaning to life through age-old festivals that continue to be the dynamic center of the so-called popular culture and of the national soul.

In Brazil, through decades of great political and economic instability, it was rituals, not the constitution or the currency, that guaranteed social continuity, providing Brazilians of all social classes with a constructive, appealing sense of self-esteem. Thus, rituals have enormous importance as a major source of identity at all levels: individual and collective, public and domestic, local and national. While the elite has experimented with political regimes—from empire to republic, from civilian and military dictatorships to liberal democracy—imprinting upon society an indelible sense of failure that has only recently been modified, popular celebrations, Carnival in particular, have made use of parody and satire and their own inverted perspectives to rekindle Brazil's hopes as a society and culture.

Social Conviviality

In Brazil popular celebrations and civic commemorations, celebrating the things of this world, and religious rituals, dramatizing the "beyond," form a clear system, a "ritual triangle," as I have pointed out elsewhere.[1] Through the Semana da Pátria (Week of the nation), Holy Week, and the famous and irreverent Carnival (a national celebration lasting a minimum of four days), Brazilian society has established an idealized and balanced representation of itself, taking time to celebrate its civic, religious, and popular or profane dimensions.

In Latin America traditional commemorations, which originated from Iberian tradition and colonization, have been combined with modern civic ceremonies, which, beginning with regional independence movements, the various elites copied from revolutionary and republican Europe and from the individualistic and egalitarian social universe of the United States.

Given this background, to speak of Brazilian rituals implies discussing the ways in which two basic types of social conviviality interact in Brazil. One type is dominated by the market, individualism, and an abstract, universal, and political equality (a basic tenet of Western modernity: equality before the law, which theoretically exists for all) and is a dominant social premise of so-called developed nations. The other type, frequently referred to as traditional, is characterized by a hierarchical and relational worldview and is a dominant social premise of the so-called underdeveloped nations.

If the first set of values is dominated by individual autonomy and equality, the second is strongly linked to the idea that family and friends—relationships created and maintained at the *casa*, or home—are more important than the individual. There is a permanent confrontation between the two modes of social navigation: while Brazilians demand strong, impersonal rules to control public behavior, they reinforce their networks of personal relationships in order to be protected against the iron hand of state procedures.

It is my thesis that the "work" of Brazilian rituals is to bridge the gap between the two conceptions through the stylized plane of dances, songs, costumes, and parades. In order to understand what Brazilian celebrations are saying and doing, it must be understood that they carve out a special space by substituting an implicit relational—thus, magical—vision of the world for the modern social order based on individualism, preoccupied with segregating space and time, and founded in market-based rationalism and calculation. The relational vision is an emotional, intellectual, and cognitive orientation in which an affirmed disjunction between means and ends transforms and inverts well-established social routines, gender roles, and sacred values. Celebrations demand expending, license, and collective engagement.

The relational worldview has a set of values permeated by attitudes and gestures that are in direct contrast with the modern attitudes of daily routine. One of the most interesting transformations produced by Brazilian popular rituals is

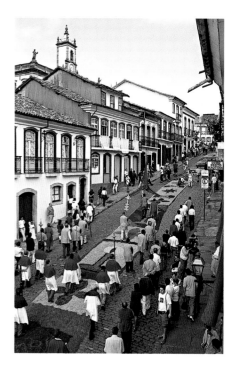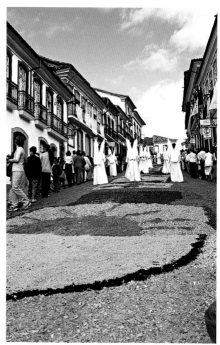

the shift from political, formal, or legal equality to what can be called substantive equality. In fact, all popular dramas—from saints' days to the orgiastic rites of Carnival—substitute a forgotten "moral equivalency" for the abstraction of "equality before the law." Here, one is dealing not with fundamental legal rights but with the basic, given moral equivalencies of death, suffering, misfortune, envy, desire, and physiological needs. As many celebrations dramatize, everyone—the most powerful and arrogant king, dictator, celebrity, millionaire, or president, as well as the most humble worker or peasant—has the right to the pleasure of singing, dancing, eating, drinking, lovemaking and, above all, laughter. The seldom studied pleasure of laughter, as Mikhail Bakhtin points out, relativizes seriousnessness and ridicules pomp and power.[2]

The "Popular"

When one speaks about Carnival and other Brazilian celebrations that lead to a relativizing, paradoxical, and ambiguous reading of social structure—especially of their attitude toward power structures and social order—one is speaking of a "popular" invested not by modern individualistic tradition, which has been transformed into a culture industry, or mass culture, but by an anti-individualistic and antimarket conception of the world. It is a "popular" in which everything is intertwined—nature with culture, this world with the beyond, the dead with the living, men with women, adults with children, work with leisure—by means of the visible and invisible links that celebrations invite us to experience, examine, understand. These links recreate a universe filled with human intentionality against the background of culture systems governed by the logic of compartmentalization, individualism, anonymity, and work as punishment and obligation.

The urban environment—an epitome of cruelty, indifference, and violence in Latin American—is miraculously humanized by celebrations. Streets and squares, emptied of murderous automobiles and buses, become dancing plazas, especially giving free rein to otherwise subordinate and marginal categories: the elderly, women, homosexuals, children, the poor. Rid of work, participants transform themselves into aristocrats, gods, and historical figures. The pompous discourse—the language of high finance and politics—that only a few can understand is replaced by the rhythmic singing and dancing that are

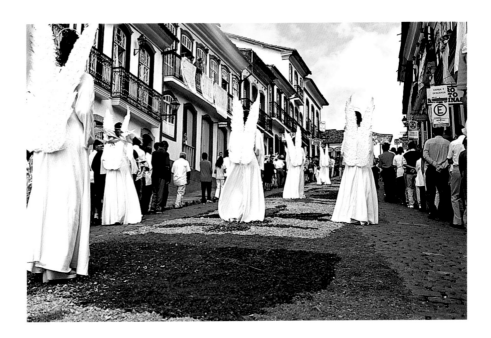

part of everyone's knowledge. Popular celebrations enable everyone to leave behind obligatory homes, families, and relationships by allowing a free association based on common interest and choice. Thus, clubs, *escolas, blocos, cordões*, which are voluntary and, in principle, free of the standard conditioning of gender, age, color, or social class, dominate Brazilian Carnival. It is the poor, the "ignorant," and the powerless, not the rich and powerful, who create the gathering. And it is their pomp and energy that awaken the envy and reactionary disdain of the upper classes, who wonder whether this celebratory effort would not be better applied elsewhere and whether the ritual's sensuality is not, in fact, immoral or excessive.

It is precisely the periodic and planned subversion of bourgeois austerity that creates and molds popular celebrations in Brazil. One of the most important elements is the abandonment of the capitalist linear logic according to which celebrations can only be legitimately held "after work," a cultural premise corresponding to the ascetic notion that we can only celebrate the accumulations produced by work. By going beyond this narrow relationship between leisure and work, popular celebrations propose a truce. They redefine the Edenic ideal of work as a celebration and joyous occasion.

These dimensions are expressed in the carnivalizing formula whereby standard social obligations and distinctions are temporarily abolished, allowing for symbolic changes of position, gender, residence, and status in general. Thus, in popular celebration, as Bakhtin reminds us, a precise separation can no longer be maintained between actors and spectators, producers and consumers, rich and poor, bosses and workers, blacks and whites—all are necessary for "making the party."

Order and Disorder

An obvious aspect of Brazilian rituals is their characterization as either a *festa* (celebration, party, or festivity), during which one is bound to laugh, dance, sing, eat, and be merry, or a *solenidade* (ritual or solemnity), which, in contrast, dramatizes seriousness and emphasizes bodily control, restraint, and discipline. Rituals can be divided into two fundamental modalities, according to the demands they make of our bodies, spirit, social status, and wallets. Thus, there are rituals of order, which legitimize, accentuate, reinforce, and exaggerate social positions, and orgiastic rituals, or rituals of disorder, which promote inversion, chaos, or even destruction of the morality that sustains society.

In practice these distinctions are muddled. In fact, the message of many

Brazilian rituals reveals a strange dialectic that expresses a double process. On one hand, there is the official sanctioning of Carnival, which has been domesticated as a show for the masses, where one pays admission to see the major parades, which are presided over by politicians and businessmen. On the other hand, there is the carnivalization of certain religious processions, when the Virgin or a saint becomes fused with certain Afro-Brazilian rites. The result of this mulatismo is a context in which sacred and profane, order and disorder, coexist in astonishing ambiguity, which, as I have suggested throughout my work, seems to characterize a fundamental aspect of Brazilian identity. The balance between rituals of order, which are dominant in societies considered to be developed, and rituals of disorder is striking in Brazil.

Rituals honoring local deities and events are commemorated side by side with national celebrations such as Independence Day and Carnival. It would be no exaggeration to say that there are as many rituals in Brazil as there are groups of people living in the country. One set of civic rituals helps to construct or read Brazil as a "nation-state." This class of celebration, which usually takes the form of a commemorative observance, is typified by commemorations of Independence and the Proclamation of the Republic, swearing-in ceremonies honoring newly-elected public officials, and celebrations of an industrial or commercial nature on both a national and international level: opening ceremonies for banks, factories, civic works, etc.; World Friendship Day, Valentine's Day, Labor Day, Mother's Day. Inspired by the French Revolution, British parliamentary practices, and American mass culture, these rituals are tied to the notion of society as a group of citizens aspiring toward equality, freedom, and social justice.

What is interesting in the case of Brazil is the combination of a set of modern civic commemorations, inspired by the bourgeoisie, with a vast range of popular celebrations—the blending, or "mulatization," of historic events with religious and popular values and dimensions that celebrate a transcendent view of life and society. There are celebrations that reinforce and venerate bourgeois order while others relativize it. Of the latter the most conspicuous example is Carnival, a celebration with many focal points and without a patron or defined nucleus. By accentuating sensuality, eroticism, seduction, grotesquerie, and the inversion of social structures, Carnival disturbs the bourgeois Christian and puritan order and way of thinking.

An Alternative Modernity

The case of Brazil reveals a ritual and a symbolic universe marked by an alternation between "popular" celebrations and civic and/or bourgeois commemorations. Celebrations honoring national rites of passage (Independence Day, the Proclamation of the Republic) and commemorations of an obvious commercial-capitalistic character, oriented toward the market (Valentine's Day, Mother's Day), follow a universalizing Western model. And there is the unsettling presence of popular festivities centered on the Passion of Christ or the ritualized death of animals, as in bullfights—not to mention the sense of chaos aroused by most Indian festivals—which offend the moral sensibility of those who consider them to be unethical, inhumane, or politically incorrect gatherings. The "accidental" tourist who witnesses a Brazilian celebration such as a *marujada*, a *congada*, a *reisado*, or Carnival, in which impoverished people launch an ironic/satiric commentary on the established power structure and political life, may be similarly disturbed. These celebrations put in motion dramas and characters so localized that they address and celebrate values the modern world does not want to know or seeks to forget or repress: the inevitability of death and suffering, the sense of violence inscribed

within religious and political codes, the arbitrariness of authority, the compassion that makes it possible to reconcile the extreme differences in economic circumstances and perceptions of the world among all sectors of the same society, and the power of women.

From an anthropological point of view it is interesting to observe that the dual agenda of rituals is testimony, not of an ill-constructed modernity or of an indigent and backward underdevelopment, but of an imaginative way of conjugating local aspects with the universalistic aspects imposed by the modern agendas originating, from top to bottom, as political and civilizing schemes.

The lesson of celebrations is to show how societies, having experienced the excesses famously illustrated in Pieter Brueghel the Elder's *The Fight Between Carnival and Lent* (1559), chose to harmonize Carnival and Lent. Thus, instead of proposing combat—between work and pleasure, seriousness and laughter, privacy and public life—they have decided upon a hybrid, inclusive truce. Essentially, I would like to believe that the message of Brazilian celebrations reveals a singular and alternative modernity for a social world that, while undoubtedly worried about economic growth, social order, and democratic institutions, is committed to the plight of the oppressed and faithful to a forgotten sense of human solidarity.

Translated from the Portuguese by David Auerbach.

Notes

1. See Roberto DaMatta, *Carnivals, Rogues and Heroes* (Notre Dame: University of Notre Dame Press, 1991).
2. See Mikhail Bakhtin, *La cultura popular en la edad media y en el renacimiento* (Madrid: Barral, 1974).

The Encou

nter

Reviewing Indigenous Arts

José António B. Fernandes-Dias

For over a century there has been a debate about how to organize, within Western descriptive categories, objects produced by non-Western peoples. Part of the issue is whether to affirm or negate the artistic status of these objects. According to the evolutionist paradigm that has developed since the Enlightenment, the answer to the question "what is the origin of art?" was ornamentation, considered the first artistic impulse to emerge once the basic needs to guarantee survival had been met. While there may have been consensus on the origin of art, there were diverging opinions regarding its initial form. Even if all agreed that ornamentation evolved into naturalist representation, some defended that it arose from the geometric desire to impose order, while others believed that it was driven by figurative principles: the more or less incipient attempt to represent natural forms. Since the second half of the nineteenth century, non-Western people were seen as manifesting what was consid-

ered the embryo of art forms. The debate was fueled in part by ethnographic material brought back from recently discovered lands in the South Seas, above all Polynesia. However, the often-cited works written by Karl von den Steinen upon his return from two expeditions to the Xingu region of Brazil in 1884 and 1887, added the graphic patterns of the peoples he encountered to the discussion. In any case, whether geometric or figurative in origin, and even if some scholars saw the ornamental sensibilities of "primitive forms" as deserving of admiration, the possibility that indigenous artifacts might be works of art was never considered. Art could only happen at more advanced stages of civilization; at most, the ornamental forms of "contemporary primitives" might be representative of what were the seeds of our art.[1]

This connection between non-Western ethnic objects and Western artist objects would only happen later, at the beginning of the twentieth century, on the

eve of great changes to European and American art that marked the Modernist revolution. At that time some tribal objects were suddenly perceived as works of art. The artists engaged in the avant-garde were the first to show an interest in these things and regarded them as an enormous resource of nonrealistic forms, employing them to create art that fell outside the classical canons of beauty, figurative illusion, and narrative. At the same time, the discipline of anthropology produced the first scholarly work on "primitive" art, a category that was named in the years following World War I. The boundaries and canonical criteria for "primitive" art were quickly established, largely determined by the aesthetic strategies defined by the successive "isms" of Modern art: Cubism, Expressionism, Surrealism. Two-dimensional imagery lost much of its dominance; the definition of artistic in "primitive" societies widened, and there was a growing interest in sculpture. Attention initially shifted to African examples and later to the Pacific Islands, where a profusion of significant nonrepresentational sculpture was to be found. Only then were these objects considered works of art as defined by the European and American Modernists. Even when studied by anthropologists in relation to the context of their creation, the objects were still subject to the criteria based on Western ideas of art: What are the principles of form and composition? What is the meaning of the iconography? Indigenous art from the Amazon, and the Americas in general, is notoriously absent from the main studies on "primitive" art, both those within the Modernist primitivist vein, following Robert Goldwater's seminal study in 1936, and also those that make reference to original context and production and usage, while examples of works from Africa and the Pacific Islands are everywhere.[2]

A third phase of this ongoing debate begins with the realization that many of these objects cannot be classified according to the Western system. Such a perceptual shift is the result of a greater visibility of the cultures that produce these objects on an international level and also within their respective countries. At the same time, there is a growing recognition that some objects are perceived as art because they are defined as art by the members of a specialized institution, the art world: artists, critics, gallerists, museums, patrons, and art schools.[3] However, in the majority of the societies where so-called indigenous art is produced, the institutions that establish the context for the production, circulation, and utilization of the objects are not those specializing in art but those that have a broader focus: cults of ancestors, societies of initiation, rites of puberty, barter systems, etc. For this reason, one cannot precisely speak of indigenous works or art in such institutional terms.

Should, therefore, indigenous practices remain outside Euro-American debates on art? For some scholars, the refusal to consider the art of indigenous peoples from Africa, the Americas, or the Pacific Islands as artistic is dangerously close to Eurocentric views that consider those peoples insufficiently developed to dedicate themselves to art. Such views have justified multiple forms of colonization and exploitation,[4] while others call attention to the risks of the opposing view: to call these objects art might lead to the misunderstanding that such works were produced out of naiveté, and their producers were incapable of recognizing the artistic qualities of their works.[5] Both are opposing versions of the same phenomenon—ethnocentrism—in which others are understood based on our perceptions of ourselves. One is segregationist and considers that others have no art, while the other is imperialist, projecting our criteria of art upon others to affirm that they too have art—as naive as they may be. In any case, to perceive other cultures according to our own criteria has negative consequences; we become unable

to understand these cultures at all. More than that, we lose perspective on our own ways of thinking and feeling, of acknowledging our limits and biases, and also of imagining how to overcome them.

The traditional arts have not been excluded from discussions of art per se. The formal and expressive wealth of indigenous forms continued to be acknowledged throughout the twentieth century. Beginning in the 1960s, however, the interest in such work was mostly because it symbolized an important issue in the Western debate regarding the role of the artist and the role of the art object in contemporary society, and the relationship between the artist and his/her surroundings. If during the course of the nineteenth century, European art lost much of its traditional public role (commemorative, decorative, liturgical, and educational), this loss was compensated by an auto-reflective retreat regarding art's own means and roles, in which its survival was justified by an insistence on its autonomy. However, such autonomy was always problematic. In some cases the works of art, freed from external representation, were granted powers equivalent to those of objects produced by traditional societies.[6] There are innumerable examples where the power of such art intervenes on daily life, from Pablo Picasso's exorcist-painting *Les Demoiselles d'Avignon*, inspired by his visits to the dusty galleries of the Musée Ethnographique du Trocadéro Museum in 1907, to the actions of Joseph Beuys that proposed spiritual healing, Elsewhere, self-reference is replaced by references to nonartistic cultural forms, thereby questioning our notions of culture and allowing art to be a part of that continuum; such is the case with Pop and Minimalism. There are also cases where the sociopolitics of the artistic endeavor as a process of production within particular social conditions is questioned. This might occur by analyzing the particular institution, its physical and architectonic settings, after the social, cultural, political, and historical

meanings associated with it. This is the case with site-specific and installation art. Or, it can be achieved by focusing on the viewer, who can no longer be restricted to a phenomenological outlook, given that he/she is also a social being defined by multiple differences. More recently, and more radically, many artists have used their work to explore the artistic dimensions of different voices within our society: women, sexual, or ethnic minorities, immigrants, the sick, etc., or they base their work on the personal and subjective experience of daily life in order to comment on or reconfigure its meaning by introducing new perspectives. The result is what has been called participant art, new public art, quasi-anthropological art.[7] Susan Hiller, an artist coming from a background in anthropology, offers insight:

> Artists *perpetuate* their culture by using certain aspects of it. Art activity is largely the result of socio-cultural conditioning; my personal production may appear enigmatic . . . but for it to be recognized to any degree it must, to a great extent, be mostly influenced by factors that condition everyone else— language, social structures. . . .

> Artists *change* their culture by emphasizing certain aspects of it that were perhaps previously ignored. The artist's vision may show hidden or repressed potentials. Artists may offer paraconceptual notions of culture by revealing the extent to which shared conceptual models are inadequate because they exclude or deny some part of reality. Artists everywhere operate skillfully within the very sociocultural contexts that formed them. Their work is received and recognized, to different degrees, within these contexts. They are specialist in their own culture.[8]

Some old certainties are shaken. Does having daily life as the content of a work, or being able to help in the development of a

community or the self-esteem of an individual, diminish or negate the artistic quality of these practices? To what extent can artists be involved with the members of the community in which they work? If the community is involved in the process of creation and utilization of the artworks, and it serves to promote social, personal, political, and economic changes, does that not challenge the artist's traditional need for distance from the subject and the power of creative authorship regarding the artwork? It may be true that we are at the end of an era in which individuals who recognize themselves as artists produce objects called art, whose only objective being exhibited and appreciated in specialized and separate spaces.[9]

There are other aspects to consider regarding the placing of indigenous objects within their original sociocultural context as their meaning, importance, and uses are obviously derived from indigenous culture. However, once they have been collected, studied, and placed in a museum, they enter the repertoire of Western culture. For this reason, one must be cautious in discussing context, which means not only the original cultural setting but also the historical and ethical circumstances in which they were gathered. More than that, "context" includes the multiple transformations of meaning that these objects have suffered in their travels before being digested by the West and placed into unfixed categories or exhibited in ways that are also in the process of change. They may have once been curiosities, documents portraying the development of human activity, or ethnographic and artist objects, as well as colonial trophies, instruments for preaching, artifacts, and decorative objects. Perhaps they were shown in curiosity cabinets, commercial establishments, missionary museums or museums of natural history, anthropology, or art, and perhaps in the living rooms of our houses.[10] Objects are promiscuous, as Nicholas Thomas astutely defines them: they move among disparate social and cultural domains, changing their meanings and objectives depending on context without ever compromising their essence.[11] It would be naive to assume that they are only one thing to be understood in one way, as their creators intended. Esther Pasztory warns us about the problems that result from the insistence on contextualization, which has been a common approach in studying non-Western art. To think that a culture can only be understood after extensive field studies or complete immersion in its way of life eliminates all but the specialized anthropologist. It is also "a very convenient way in which non-Western art is kept in its place, far from the practices of Western art, as wholly 'other.'"[12]

This idea is still dominant in anthropology and tends to fix the meaning of each object, removing it from the realm of interpretation, freezing it. The indigenous context can discredit this view if we replace the single, closed interpretation of the anthropologist with the multiple voices of a culture's own members; the process of interpretation becomes more open and is dependent on the skill of each interpreter and the conditions of interpretation. Recently, João Pacheco de Oliveira showed photos of Jurupixuna masks to present-day Ticunas. The two tribes were once neighbors, before the disappearance of the Jurupixunas. He notes that their own interpretations differed from those offered by outside academics. More important, the Ticunas disagreed among themselves about "the identity of the characters and the actions represented by the masks." The interpretations of each person were influenced by "their localization and family circle, and their age, official religion adopted and the knowledge they had of the "white man's" world. It was also noted that the disagreements regarding the identities represented by the masks did not cause any discomfort among them.[13]

One must be mindful of the fact that many of the traditional objects kept in museums and collections continue to be

produced for consumption and local use, while others are made strictly for sale. In some cases, the same object is used in the community and sold in regional, national, or international markets as a commodity. The objects can incorporate unusual material elements, iconographic motifs, techniques, or styles. This does not imply any loss of authenticity. It is necessary to overcome the stereotypical idea that these peoples are primitive and pure, or contaminated by progress; indigenous societies are at once tribal and modern, local and worldly. To consider their process of integration with the external world as the extinction of cultural diversity is to disregard the ability cultures have to select, adapt, and recontextualize external elements. Even when the objects are made for sale, geared to a market, it is not a passive process but one in which there is an appropriation of market mechanisms, the interpretation of public taste, and the attempt to gain some measure of control over how their image is presented to "whites." In cases where the objects are made to sell, it is evident that one cannot only take into account the indigenous cultural universe. It is interesting to note that contemporary indigenous societies are not entirely indifferent to the objects that are kept in museums, even when the objects are from a different group, as in the example of the Ticunas and the Jurupixuna masks. Above all, the objects are not viewed as necessarily functional and recontextualized in their original setting. They might be generically referred to as cultural relics that hold "an unequivocal historical value for the indigenous peoples."[14] These objects can also be reutilized within the context of indigenous people's current lives, as instruments of resistance and in the forging of their future.

James Clifford describes an incident when a curator from the Musée de l'Homme in Paris exhibited various fur coats from the collection to a Native American. One of the many visitors who saw the coats identified one as having belonged to the grandfather, who had

come to Paris with Buffalo Bill and was forced to sell the garment to pay for his return trip. Yet the fur coat had arrived in France a few centuries earlier to be included in a curiosity cabinet. The fact that the coat could not have belonged to his grandfather is irrelevant; rather than historical authenticity and the "legitimate" original cultural context, the reference was an interpretation of the visitor's era, the contemporary history of his ethnic group, and his stance about its future.[15] A similar incident occurred at the exhibition *Brasil+500 Mostra do redescobrimento* (2000) in São Paulo with a Tupinambá cape belonging to the collection of the National Museum of Denmark in Copenhagen.

Situations such as these indicate the need to accept the fact that a single object may be a different thing in different circumstances. Consequently, we must accept that different perceptions of the same object are legitimate, valid, and important to understanding it. The ethnological approach of the anthropologists and the approach of the art world are equally relevant. In an art exhibition or museum, objects should be viewed as artistic manifestations. Ultimately the problem is not that we observe these objects through our cultural lenses; rather, the difficulty arises when we assume that we think of these things in the same way as those who make and use them. For this reason, one must not try to reconcile the different meanings attributed to the objects. One must accept that an object can be simultaneously perceived in many ways: as artistic; as having a specific, traditional use in its society of origin; as an ethnographic object on display in a museum; and as something that evokes among the indigenous peoples an incomplete history of their fight for permanence and self-affirmation. Such a multifaceted perception enables us to approach these objects in a richer and more complex manner.

It is possible in an art exhibition to deepen our understanding of these objects

if, rather than insisting on placing them within a context, we consider them alongside our own artworks. The concepts and criteria of contemporary art offer good reasons to employ this approach to the indigenous arts of the Amazon. "Art" is not fixed and stable, and there is no need to maintain the parameters of the nineteenth century or of Modernism. It is important, both for the indigenous peoples and for us, to include their artworks in discussions of contemporary art and culture. Among other reasons, and as has been mentioned, the separation and the relation between art and other areas of life has been challenged by some of our recent artistic practices. Also, as we already know, unlike the traditional arts of Africa, the Pacific Islands, and certain groups from North America (above all from the Northwest coast of the Pacific), the works of the Amazon were not included in Modernist discussions of art in either its formal or semantic aspects. Therefore, this can widen our perception of what may be considered artistic about indigenous practices, beyond thinking about them as just decorative or beautiful objects, or objects that are supposed to have a particular concentration of symbolic and poetic value because of their ritual use. In the end, this is more in accordance with how the indigenous peoples classify their own objects. For them, the greater distinction is not between what is designated for daily use and what is used in rituals, but between objects that are culturally authentic and those that are of unknown or strange origin and are not appropriated.[16]

In this sense, Alfred Gell ironically asks what has characterized an anthropology of art? Is it not a particular, arbitrary and restricted field of study—the arts of the colonial and post-colonial periphery, of pockets of ethnic groups within national states, with their diverse minorities (female, sexual, popular, immigrational), alongside "primitive art" kept in museums—rather than a valid anthropological theory applicable to artistic manifesta-

tions in any cultural context? Is it not more the study of an "anthropological art," rather than an anthropological study of art?[17] He proposes a theory that would be valid for all art, one in which the focus on the properties of the objects, both formal and semantic, as well as the universe of art as an institution, might be replaced by a theory that would focus on human interaction, one in which the artistic objects are a permanent element:

> For anthropologists, the most sensible approach to works of art is in terms of a frame of reference . . . which is essentially identical to the one we apply to people. People are beautiful, ugly, interesting, boring, intelligible, incomprehensible, etc. and works of art are just fragments or emanations of people, with similar characteristics, which drift about in our ambience.[18]

> In order for the anthropology of art to be specifically anthropological, it has to proceed on the basis that, in relevant theoretical respects, art objects are the equivalent of persons, or more precisely, social agents.[19]

Not surprisingly, this perception is similar to the way of thinking of the indigenous societies of the Amazon, where there exists the prevailing idea of a universe in which everything has two dimensions: material-visible and energetic-invisible. Also prevalent is the notion of a general principle of transformation in which each thing can be many different things, depending from which domain of the universe it is viewed.[20] More generally:

> In many, perhaps all, non and protoliterate cultures of the world, objects are only superficially inanimate, they are so only as long as one does not direct a certain kind of attention towards them and does not "speak" to them. . . . But outward attention to the object, talking to it, enveloping it in ritual action

is also a way of taming its secret inner life, the danger represented by its hidden "intentions."[21]

We also treat as people the things we consider works of art. Thierry de Duve organized the exhibition *Voici. 100 ans d'art contemporain* at the Palais des Beaux-Arts in Brussels using a similar model based on the interactions generated by artistic objects themselves:

To say "here I am" is to introduce oneself. Only a living being with language is able to do that; inanimate things can not. And works of art are things. However, we attribute human qualities to them; we say they are alive; we believe that, when successful, they speak to us; we treat them with the respect we reserve to humans; we consider their destruction a barbaric act.[22]

Translated from the Portuguese by Michael Reade.

Notes

1. Frances Connelly, *The Sleep of Reason. Primitivism in Modern European Art and Aesthetics, 1725–1907* (University Park: Pennsylvania State University Press, 1995); and J. A. B. Fernandes-Dias, *From the Origin of Art to the Finality of Art. Amazonian Arts in the Art Discussions*, a talk presented at the Third Annual Conference on Amazonia, Center for Brazilian Studies, Oxford University, 2000.

2. J. A. B. Fernandes-Dias, *From the Origin of Art to the Finality of Art. Amazonian Arts in the Art Discussions*, a talk presented at the Third Annual Conference on Amazonia, Center for Brazilian Studies, Oxford University, 2000.

3. Arthur Danto, "The Artworld," *Journal of Philosophy*, no. 61 (1964), Georges Dickie, *Art and the Aesthetics: An Institutional Analysis* (Ithaca, N.Y.: Cornell University Press, 1974); J. A. B. Fernandes-Dias, "Arte e antropologia no século XX, Modos de relação," *Etnográfica*, vol. 1 (forthcoming).

4. Marianna Torgovnick, *Gone Primitive: Savage Intellects, Modern Lives* (Chicago: University of Chicago Press, 1990), p. 83.

5. Regarding William Rubin and the Museum of Modern Art's 1984 exhibition *Primitivism in Twentieth-Century Art*, see Thomas McEvilley, "Doctor Lawyer Indian Chief: 'Primitivism' in 20th Century Art," in Russell Ferguson, ed., *Discourses: Conversations in Postmodern Art and Culture* (Cambridge, Mass.: MIT Press; New York: New Museum of Contemporary Art, 1990).

6. Francesco Pellizzi, *Adventures of the Symbol: Magic for the Sake of Art* (New York: Cooper Union, 1986).

7. Nina Felshin, ed., *But is it Art? The Spirit of Art as Activism* (Seattle: Bay Press, 1995); Suzanne Lacy, ed., *Mapping the Terrain: New Genre Public Art* (Seattle: Bay Press, 1995); Hal Foster, *The Return of the Real* (Cambridge, Mass.: MIT Press, 1996); Alex Coles, ed., "Site-Specificity: The Ethnography Tum," in Alex Coles and Richard Bentley, *de-, dis-, ex-: Ex-cavating Culture* (London: Backless Books, 1996); J. A. B. Fernandes-Dias, "Arte e antropologia no século XX, Modos de relação," *Etnográfica*, vol. 1 (forthcoming).

8. Barbara Einzig, ed., *Thinking About Art: Conversations with Susan Hiller* (Manchester: Manchester University Press, 1996), pp. 23–24.

9. Arthur Danto, *After the End of Art: Contemporary Art and the Pale of History* (Princeton, N.J.: Princeton University Press, 1997).

10. J. A. B. Fernandes-Dias, "Arte, Arte Índia, Artes Indígenas," in Nelson Aguilar, ed., *Artes indígenas: Mostra do redescobrimento*, exh. cat. (São Paulo: Fundação Bienal de São Paol;: Associação Brasil 500 Anos Artes Visuais, 2000).

11. Nicholas Thomas, *Entangled Objects: Exchange, Material Culture and Colonialism in the Pacific* (Cambridge, Mass.: Harvard University Press, 1991).

12. Esther Pasztory, "Treason: Comments to Robert Faris Thompson," *Res*, special issue: *Tradition-Translation-Treason*, no. 32 (1977), p. 35.

13. João Pacheco De Oliveira, "Máscaras: objetos étnicos our recriação cultural?" *Os indios, nós* (Lisbon: CNCDP, 2000), pp. 210–13.

14. Gersem Santos Lucianos, "A diversidade cultural do alto rio negro," in *Arumã*, exh. cat. (Manaus: Museu Amazônico, 1994), p. 16.

15. James Clifford, "On Collecting Art and Culture," in *The Predicament of Culture: Twentieth-Century Ethnography, Literature and Art* (Cambridge, Mass., Harvard University Press), pp. 246–47.

16. Despite the diversity of indigenous arts and different contexts of its production and use, this is one of the aspects that is relevant in such contexts. Regarding the Wayana, see for example, Lúcia van Velthem, *O Belo é a Fera: A estética da produção e da predação entre os Wayana*, doctoral thesis, São Paulo, USP, 1995.

17. Alfred Gell, *Art and Agency: An Anthropological Theory* (Oxford: Clarendon Press, 1998), p. 1.

18. Gell, "Reply to Spring," *Journal of Material Culture*, 2, no. 1 (1997), p. 131.

19. Gell, *Art and Agency*, p. 7.

20. See Gerardo Reichel-Dolmatoff, *Beyond the Milky Way: Hallucinatory Imagery of the Tukano Indians* (Los Angeles: University of California Press, 1978); David Guss, *To Weave and To Sing: Art, Symbol, and Narrative in the South American Rain Forest* (Berkeley: University of California Press, 1989); Barbara Braun, ed., *Arts of the Amazon* (London: Thames and Hudson, 1995); Jean Langdon, ed., *Xamanismo no Brasil: Novas perspectivas* (Florianopolis: Editora da UFSC, 1996).

21. Francesco Pellizzi, "Editorial," *Res*, special issue: *Tradition-Translation-Treason*, no. 32 (1977).

22. Thierry De Duve, *Voici: 100 ans d'art contemporain*, exh. cat., Palais des Beaux-Arts, Brussels (Brussels: Ludion, 2000), p. 7.

Albert Eckhout and Frans Post: Two Dutch Artists in Colonial Brazil

Rebecca Parker Brienen

Celebrated in Brazil, but a well-kept secret in the rest of the world, the "*tempo dos flamengos*" is the period from 1630 to 1654 during which the Dutch, under the aegis of the Dutch West India Company (WIC), colonized part of the northeastern coast of Brazil.[1] The WIC was established in 1621 for the purpose of trade, conquest, and colonization in the Americas and Africa. While little came of the WIC's goal of establishing a Brazilian empire based on the cultivation and export of sugar, this short period nonetheless resulted in the first artistic and scientific studies of Brazil by Europeans. The German count Johan Maurits van Nassau-Siegen was named governor-general of the Dutch colony (hereafter Dutch Brazil) by the directors of the WIC in 1636 and sailed to Brazil on October 25 of that same year.[2] The count was a well-known figure in the Netherlands, an officer in the Dutch army and a frequent visitor in The Hague at the court of his cousin, the Dutch stadholder Prince Frederick Henry.[3] With this appointment, it was hoped that Johan Maurits would provide the strong leadership that the young colony so desperately needed.

On his arrival, Johan Maurits fashioned himself the ruler of a New World empire, initiating building projects—including two palaces and Mauritsstad, the new capital of the colony—and gathering talented artists and scientists at his Brazilian court, some of whom he brought with him from the Netherlands. The body of work produced for Johan Maurits in Dutch Brazil constitutes one of the richest and most important resources documenting the encounter with and colonization of the New World during the seventeenth century. As Rüdger Joppien notes in his seminal essay on the count and his artists, it would not be until the voyages of Captain James Cook in the eighteenth century that a similarly extensive pictorial record would be made of non-European lands and their peoples.[4]

Before leaving the Netherlands, the count acquired the services of two young Dutch painters, Frans Post (1612–1680) and Albert Eckhout (ca. 1610–ca. 1665), who most likely sailed with him to Brazil in 1636. Although the Portuguese and other Europeans had been trading with Amerindians and colonizing areas of Brazil for over one hundred years before the Dutch arrived, Eckhout and Post were the first trained European artists to make images in Brazil. Contracts describing their duties have not been found, but it is known that Post made numerous drawings of the Brazilian countryside, images of Dutch forts and battles with the Portuguese, and a number of landscape paintings. Eckhout occupied his time by making still-life paintings, portraits (including life-size images of the various ethnic groups encountered by the Dutch in Brazil and Africa), and hundreds of drawings and oil studies of Brazilian flora and fauna.

Other important figures at Johan Maurits's court in Brazil include the Dutch physician Willem Piso (1611–1678) and Georg Marcgrave (1610–ca. 1644), a German cartographer, natural historian, and the first astronomer in the New World. Piso and Marcgrave's *Historia naturalis Brasiliae* (1648) was the first natural history of Brazil. This important work in the history of New World science, authoritative until the nineteenth century, contains a number of illustrations based on images by Eckhout and Marcgrave, suggesting that in Dutch Brazil the boundaries between art and science were fluid. Similarly, the published versions of Marcgrave's 1643 map of Brazil, included in Caspar Barlaeus's 1647 history of Dutch Brazil, *Rerum per octennium in Brasilia*, and reproduced as a wall map by Johannes Blaeu in 1646, include decorative vignettes attributed to Post.

In a letter to King Louis XIV of France written in 1679, Johan Maurits asserted that the works made by his artists created a "portrait" of Brazil's peoples, animals, birds, fish, and fruits.[5] Indeed, praised for their "accuracy" and often called "docu-ments," the images by Post and Eckhout allow us a unique view of this important period in the history of Brazil. Nonetheless, their works are like much seventeenth-century Dutch art and represent a mixture of "naturalistic and conventionalized descriptions of human situations and of nature."[6] While the use of a naturalistic style suggests that they reflect reality, these images are actually carefully constructed works of art. Furthermore, the subject matter of Post's and Eckhout's works—the peoples, natural products, and landscape of Brazil—is hardly disinterested. Most likely displayed in the count's Brazilian Vrijburg Palace (completed ca. 1642) and Boa Vista (completed 1643), the paintings by Post and Eckhout formed the backdrop for receptions, banquets, and other formal occasions. Collectively, they offered a view of a beautiful, fertile, well-ordered, and conquered Brazil that was pleasing to the count and allowed him to possess the country "body and soul."

Albert Eckhout

Albert Eckhout[7] was born circa 1610 to Alberdt Eeckholdt (more commonly Eeckholt) and Marryen Roeleffs in Groningen, in the northern Netherlands.[8] Nothing is certain about his training, although he may have been a student of his uncle, Gheert Roeleffs, who is described in an archival document as a painter. After the deaths of both of his parents between 1621 and 1629, Eckhout had to support himself financially during this period. By the time he moved to Amsterdam in the 1630s, drawn like so many other artists to this bustling commercial and artistic center, Eckhout had received training in still life, portraiture, and landscape painting. Once in Amsterdam, he may have joined another painter's atelier. It is unclear how Eckhout, at that time still a young and inexperienced painter, gained Johan Maurits's favor, but it is likely that he was introduced to the count via Frans Post's brother Pieter Post or via Jacob van Campen, both

of whom were painter-architects working on the Mauritshuis (completed 1644), Johan Maurits's palace in The Hague and now a museum.

Still Lifes and Ethnographic Portraits for the Vrijburg Palace

Eckhout's only surviving paintings from Brazil include twelve still lifes, eight ethnographic portraits, and one painting of dancing Tapuya Indians, all now in the collection of the National Museum of Denmark in Copenhagen.[9] It is likely that these paintings, along with a now lost life-size image of Johan Maurits with "Brazilian" (Tupinambá) Indians (*Johan Maurits with Brazilians*, ca. 1642–44), formed a cycle of works that decorated the main "princely hall" of the Vrijburg Palace, the count's official residence in Dutch Brazil, and thus were intended both to enhance and reflect the count's position as colonial governor.[10]

The eight life-size ethnographic portraits (cat. nos. 16–23), most of which were completed in 1641, represent a pair of black Africans, two pairs of Amerindians, and a pair of mixed racial background, the first known paintings of a mulatto man and a *mameluca*.[11] Although the original placement of the images is not known for certain, it is probable that instead of hanging in male/female pairs, the paintings of the men and women faced each other from the opposite sides of the room, while the two paintings with a horizontal format, *Tapuya Dance* (ca. 1641; cat. no. 15) and *Johan Maurits with Brazilians*, were placed at opposite ends of the hall.[12] In all of the paintings of the men and in *Tapuya Dance*, the light falls from the left. Similarly, in all of the paintings of women, except *African Woman with Child* (1641; cat. no. 21), the light falls from the right.[13] The still lifes show a similar pattern, and this, together with their low viewpoint, implies that they were placed high on the wall above the ethnographic portraits:[14] the four still lifes with the light falling from the right were probably placed over the women, with the rest showing light from the left placed over the images of the men, *Tapuya Dance*, and *Johan Maurits with Brazilians*.

The twelve still lifes (e.g., cat. nos. 24–27) display fruits, vegetables, flowers, and nuts carefully arranged along a simple gray ledge. Unlike the dark or neutral backgrounds favored by contemporary still-life painters in the Netherlands, here the background is a cloudy, gray-blue tropical sky. The still lifes have a trompe l'oeil function, appearing to open, like windows, onto the Brazilian sky. While they form a series, the paintings do not create a continuous image. Indeed, they appear to represent the sky at different times of day and under different weather conditions. The depiction of fruits and vegetables common in Europe alongside tropical fruits suggests that "exoticism" was not the most important criterion for the works' subject matter. For example, *Still Life with Vegetables* (ca. 1642–44) includes Old World cucumbers, radishes, and cabbage, all brought to Brazil by European colonists. Similarly, in *Still Life with Tropical Fruits* (ca. 1641; cat. no. 24), cashew fruits, pineapple, and passion fruit are mixed with oranges and other fruits introduced into Brazil. These still lifes celebrate the fecundity of the land and a successful harvest of local produce.[15] Rather than inciting the Dutch to colonize Brazil, they demonstrate that the promised colonization had already taken place.[16]

As Johan Maurits described them in 1679, Eckhout's eight ethnographic portraits depict the "*wilde natien*" (literally, "savage peoples") under his command while he was governor in Brazil.[17] Although the majority of these peoples are indigenous to Brazil, the inclusion of Africans makes it clear that the count did not limit his empire to Brazil alone. Between 1637 and 1641, while he was governor in Brazil, WIC ships under his command captured several forts and key sites for the gold and slave trades along the west coast of Africa. There is, however, no evidence that Eckhout ever traveled to Africa. It is much more likely that these figures

are, like most ethnographic portraits, based on a mixture of fact and fantasy.

The four images of Amerindians (cat. nos. 16–19) display a Tapuya (Tarairiu) man and woman and a "Brazilian" (Tupinambá) pair. "Tapuya" was a pejorative Tupinambá term adopted by Europeans, now thought to mean "enemies"[18] or "tribes of the interior."[19] Europeans believed that all Tapuyas were savages and cannibals, although the Tarairiu, a Tapuya tribe, were allies of the Dutch in Brazil.[20] "Brazilian" was the term the Dutch generally used for the Tupinambás who lived in the *aldeias* (villages) under European supervision. These "Brazilians" also worked on the colony's plantations and fought with the Dutch against the Portuguese.[21] It is a term that speaks to their assimilation and to their position as the most widely recognized Amerindians.

Historian Ernst van den Boogaart has convincingly argued that Eckhout's images of "Brazilians" and Tapuyas were conceived of in opposition to each other. According to this interpretive model, expanded upon by others such as the anthropologist Peter Mason, Eckhout's series "illustrates Dutch rule" over the native Amerindian population and functions as a justification for the "civilizing" presence of the Europeans, who "improved" the Amerindians by introducing European dress, weapons, and customs into their populations.[22] Evidence of the primitive status of the Tapuya couple, according to this interpretation, are the body parts she carries, his "deforming" facial decorations, their nude but unheroic bodies, and their wild surroundings. This is contrasted with the images of the Tupis, who are clothed, more attractive, and are pictured within peaceful, cultivated landscapes.[23] It is indeed difficult to reconcile these images of "semi-civilized" Tupinambá Indians with written accounts from the sixteenth century, which describe the Tupinambás as a barbaric people with a fondness for eating human flesh.[24] In this manner, the "Brazilians" are a colonial suc-

cess story, their place as wild cannibals having been taken over by the Tapuyas.

This hierarchy of savage and civilized extends also to the "nearly civilized" mixed-race couple, *Mulatto Man* (ca. 1641; cat. no. 22) and *Mameluca* (1641; cat. no. 23), who are placed at the top of this chain of being. Scholars argue that Eckhout's peoples of mixed race are more attractive and refined than his Amerindians and Africans. They are "decently dressed," look more "European," and carry and wear objects (fine jewelry, a gun, and a rapier) that signify a superior degree of civility.[25] While none of these scholars suggests that Eckhout's series endorses miscegenation, they propose that the higher status of the man and woman of mixed race in relation to the rest of the figures is based on the fact that their fathers would have been European. In Brazil, mestizo women like the *mameluca* created a class from which European soldiers and colonists could select "acceptable" wives and concubines, while mulatto men were slaves, interpreters, and soldiers in the colonial armies. Accordingly, Eckhout portrayed the man as a soldier and suggested that the woman is sexually available by depicting her as a "dusky Brazilian flora."[26] Her low-cut white dress and the basket of flowers she carries connect her to the figure of Flora, the Roman goddess of "flowers, gardens, spring, and love," a favorite guise in which to depict courtesans, especially in Italian Renaissance painting.[27]

In contrast to the Amerindians and the mixed-race couple, the Africans (cat. nos. 20–21) are an awkward fit into van den Boogaart's hierarchy. This interpretive framework allows for only three levels of civility for the four pairs of figures in Eckhout's cycle, with the black Africans and the Tupis, both considered "recruits to civility," ending up on "more or less the same level."[28] Van den Boogaart's interpretation focuses on the Amerindians in Brazil, so it is not surprising that he does not give a full analysis of the Africans. Nonetheless, Africans did not have a sta-

tus and function comparable to that of Amerindians in Dutch Brazil. During this period, the Africans encountered by the Dutch in Brazil and Western Africa were not only slaves but also royalty, official ambassadors, and traders in gold, ivory, and human beings. The African man in Eckhout's portrait holds an Akan sword, signaling his connection with Guinea (now Ghana), where WIC ships under Johan Maurits's command captured Elmina in 1637.[29] Such a sword would have been the possession of a ruler or a man of high status, although in Eckhout's portrait it is tucked, rather oddly, into the loincloth of a half-naked man.[30] The African woman's basket and hat connect her to Angola, where in 1641 the WIC captured Luanda, the most important site on Africa's west coast for the traffic in slaves.[31] While the brevity of her clothing suggests that she is enslaved, her jewels and elaborate hat point to a higher status. Although some scholars have suggested that the child with the woman is mulatto because of his light skin color, contemporary Dutch writers believed that black children were born the same color as "Brazilians" and became darker due to the burning rays of the sun.[32]

While the African has exposed breasts and a child, like the Tupinambá woman, her costly ornaments set the women apart. Furthermore, the African is aligned more closely to the *mameluca* by the emphasis on her sexuality: the child points a phallic ear of corn toward her vagina,[33] and she smokes a pipe, here tucked into the sash at her waist, a habit conventionally associated with prostitutes in contemporary Dutch painting.[34] She is a black Venus to the *mameluca*'s "dusky flora." Similarly, the African man's sword and spears are much finer than the weapons held by the Tupinambá man. This suggests that the hierarchy should be revised to include a new level for the Africans in between the "Brazilians" and the racially mixed couple.

As depicted in his portrait, surrounded by his "Brazilian allies," the count presided over the palace hall and ruled the "nations" depicted in the ethnographic cycle. In all four of the paintings of men, the subjects carry weapons, supporting the governor and his colony with their strength, ability to hunt, and military prowess. Similarly, all four women carry baskets and make an offering to Johan Maurits. The African woman offers fruit and the pleasures of her beautiful, fecund body. The *mameluca* carries flowers and flirtatiously lifts her skirt. The "Brazilian" woman offers her labor. Last but not least is the Tapuya woman, who, with a deceptively innocent expression, brings the severed hand and foot of her most recent human victim to the governor and his colonial order. An appropriate gift from an ethnic group said to be cannibals!

In Vrijburg, Eckhout's cycle created the image of a stable and prosperous empire under Johan Maurits. But the promise of this cycle of images faded with the count's departure from Brazil in 1644 and dissipated entirely when the Dutch formally signed over their colony to the Portuguese in 1654.

Frans Post

Frans Post was born in 1612 in Haarlem, the Netherlands, the second son of Jan Janszoon Post of Leiden, a celebrated glass painter who died in 1614.[35] During the seventeenth century, Haarlem was a flourishing artistic center and home to a number of landscape specialists, such as Esaias van de Velde, Pieter de Molyn, and Jan van Goyen, all important figures in the development of the naturalistic Dutch landscape. Nothing is known of Post's training, but it is likely that he was taught by a local master. His Brazilian works strongly resemble the landscapes by his contemporaries in Haarlem in composition, style, and technique. Especially close are the works by his brother Pieter and those by Cornelius Vroom. Post's Brazilian motifs are nonetheless new; as Wolfgang Stechow states, "the old bottle was filled with new wine."[36]

Engraving by Frans Post showing a sugar mill, from Caspar Barlaeus's *Rerum per ocenntium in Brasilia* (1647). Bodel Nijenhuis Collection, Leiden University Library, Netherlands

Post's Brazilian Landscapes

While Eckhout's paintings offer close-up representations of the peoples and produce of Dutch Brazil, Post pulled back for a more expansive view, turning his eyes to the land itself. The paintings and numerous drawings he made while he was in Brazil also served as the basis for the landscapes he painted in the Netherlands, and for the engravings he designed for Barlaeus's *Rerum per ocenntium in Brasilia.*[37] Clear differences have been noted between these bodies of work. Made for Johan Maurits, Post's landscapes painted in Brazil offer panoramic vistas, often with Dutch forts in the distance, representing the land conquered by the Dutch and their means of keeping it. His engravings for Barlaeus's history celebrate particular historical events and illustrate more generalized views of the provinces under Dutch control. Finally, the paintings of the Brazilian landscape he made after his return to Europe are quite distinct from those he made in Brazil, emphasizing "exoticism" over topography.

Seven of the landscapes Post painted while in Brazil have survived (see cat. no. 28). These works, all oil on canvas and measuring around 60 by 90 centimeters, share a number of characteristics. They depict specific locations in Dutch Brazil, identifiable because of the representation of recognizable topography and buildings. Most include views of water. A selection of Brazilian vegetation is shown, and occasionally birds and other small animals are featured in the foreground. Figures are few and almost seem lost in the landscape. The skies are a curious gray, seemingly heavy with rain, an aspect that is emphasized by the fact that they take up at least half of each canvas. All of the works are quite subdued in palette, especially when compared to the artist's post-Brazilian production, and this lends them a somber, almost reverential quality characteristic of Dutch tonal landscapes of the 1620s to the 1640s.

It has been suggested that Post was charged with the documentation of Dutch forts and other structures in Brazil.[38] Forts are indeed featured in the background of five out of the seven extant paintings from Brazil. Nonetheless, the paintings present idealized images of everyday life in the conquered Brazilian provinces under Johan Maurits's governorship, with a particular emphasis on the peaceful landscape of the countryside. In this way, they are like the prints and paintings of the native landscape made by Post's contemporaries in the Netherlands, especially those working in the city of Haarlem.[39] An early example is Claes Visscher's print series *Pleasant Places* (1611). In Post's "pleasant places," the Dutch landscape depicted by Visscher has been exchanged for that of Brazil: palms and papayas replace oak trees, plantations and forts replace Dutch farmhouses, Amerindians and enslaved Africans replace Dutch rural laborers, and Frederiksstad, Recife, and Mauritsstad replace Haarlem.

As in the Dutch paintings and prints, the land in Post's paintings is prosperous, and all of its inhabitants are happy, even the slaves. This same observation can be made regarding the pictorial vignettes Post designed for Marcgrave's 1643 map of Brazil. The largest of these small scenes

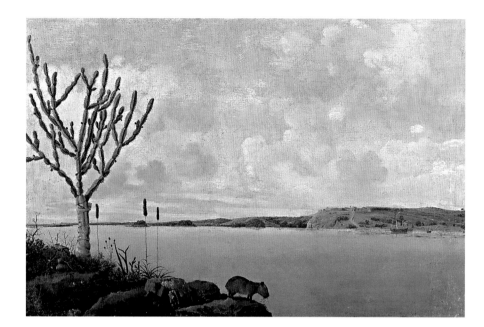

TOP: **FRANS POST** *The Rio San Francisco and Fort Maurits in Brazil*, 1638. Oil on canvas, 62 x 95 cm. Musée du Louvre, Paris. BOTTOM: Engraving by Frans Post showing Rio São Francisco with Fort Maurits, from Caspar Barlaeus's *Rerum per ocenntium in Brasilia* (1647). Bodel Nijenhuis Collection, Leiden University Library, Netherlands

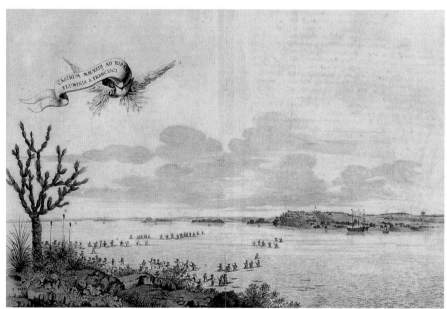

represents a sugar mill. (Given that sugar was the basis of the colonial economy, it is not surprising that sugar mills turn up in many of Post's landscapes.) In this vignette, slaves at work in the mill proceed at a leisurely pace, and other slaves can be seen drinking, dancing, and making music in the upper-left corner of the image. Post's works are often celebrated for their documentary value, and yet even those made in Brazil are highly selective in what they offer the viewer. The sugar mills are productive and the life of the slaves is presented as carefree and untroubled; as Elmer Kolfin notes, there are no overseers with whips and none of the slaves is

chained.[40] Yet Brazil was notorious for the high rate of slave mortality due to the harsh conditions in the fields and sugar mills. This more sinister aspect has no place in Post's view of Dutch Brazil.

While many of the engravings Post made for Barlaeus's history illustrate victorious battles and other important events, the paintings made in Brazil offer seemingly timeless views of everyday life in the colony. For example, *The Rio São Francisco and Fort Maurits in Brazil* (1638) includes a capybara (called a "water pig" by the Dutch in the seventeenth century), which grazes on the river bank next to a cactus tree and Brazilian vines with fruits. At first glance,

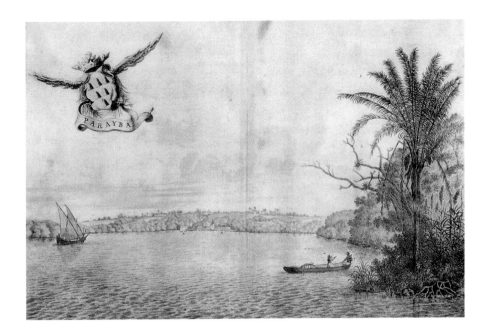

this appears simply to be a rather charming and idyllic painting, and it is only upon looking more closely that one sees Fort Nassau on the hill of the opposite shore. Post's image takes possession of this seemingly empty river landscape, so recently wrested from the Portuguese. In the Barlaeus version of this image, however, the capybara has disappeared, the Brazilian fruits are unrecognizable, and the river is full of Portuguese, who are chased by the Dutch. Post's peaceful view of Brazilian nature now illustrates the aftermath of a battle that took place in 1637, with the Portuguese under Admiral Bagnuoli struggling to escape their Dutch pursuers.[41]

Unique among Post's paintings made in Brazil for its rich depiction of tropical wildlife is the newly discovered *View of the Town and Homestead of Frederick in Paraíba, Brazil* (1638; cat. no. 28), a lovely view of the town from across the river.[42] The right foreground is peppered with eight aquatic birds, most of which are copies of drawings made by Marcgrave in Brazil. The engraved version of this painting replaces the birds with a black man and woman—most likely slaves—smoking pipes and enjoying a boat ride. Given changes like this, it is an oversimplification to characterize Post's engravings for Barlaeus's history as "documentary" and the paintings

made in Brazil as more "decorative."[43] By including specific kinds of flora and fauna in his paintings made in Brazil, Post most likely intended his images to be true to the particular landscapes he depicted.

Like his engravings, Post's paintings after 1644 show a markedly different view of Brazil than his images made in the colony. The further he was from Brazil in both time and space, the more imaginary and paradisiacal his paintings became. In these images, which form the largest part of his oeuvre, Post used brighter colors and more exotic details in the form of South American plants and animals. Sloths lie on the ground next to lizards. Snakes swallow armadillos and rabbits. Post was not interested in placing these animals in their correct habitats, as he had with the capybara in *The Rio São Francisco and Fort Maurits in Brazil*. As Joaquim de Sousa-Leão has noted, "to avoid repetition Post scrambled his subjects like a jigsaw puzzle."[44] Nonetheless, certain scenes are repeated such as sugar mills and views of Olinda with church ruins. In Post's later images, the skies are a clearer, brighter blue, there is a greater profusion of exotic plants and animals, and there is less concern with topographical accuracy. These paintings recall Flemish landscapes of the sixteenth century, especially those depicting an earthly paradise.[45]

In the Netherlands, Post's European images of Brazil hung on the walls of wealthy burghers and were in the collections of the elite, including Prince Frederick Henry. Although the Dutch returned the Brazilian colony to the Portuguese in 1654, Post continued to paint these representations until at least 1669. There was clearly still a demand for such images, which may have been seen as representations of the lost paradise of the Dutch in Brazil to some, but more likely spoke to a general interest in the exotic and unfamiliar.

The History of Eckhout's and Post's Paintings from Dutch Brazil

Once in Europe, the paintings and drawings by Eckhout and Post no longer served solely to enhance and represent Dutch rule in Brazil. Rather, they became images of the "exotic," prized for their rarity and eventually acquired by the highest-ranking members of Europe's aristocracy. In 1652, Johan Maurits made his first gift of Brazilian images to his patron, Frederick William, elector of Brandenburg, receiving in turn land and other favors.[46] This gift may have secured for the count his elevation to imperial prince, which probably occurred under Frederick William's sponsorship.[47] In addition to a series of sixteen now lost paintings by Eckhout, this gift included ivory furniture carved with Brazilian motifs and more than seven hundred drawings and oil studies on paper by Eckhout, Marcgrave, and possibly Post that are now in the collection of the Jagiellon University Library in Kraków.[48]

In 1654, the same year that the Dutch officially handed over their colony in Brazil to the Portuguese, Johan Maurits sent twenty-six paintings to his cousin King Frederick of Denmark.[49] This gift included all of Eckhout's paintings in the Vrijburg cycle, in addition to a life-size portrait of Johan Maurits also by Eckhout and three paintings of Africans: a man in Portuguese clothing and his two servants. (These last three images are often attributed to Eckhout, although it is not certain that he painted them.) When the paintings arrived in Copenhagen, *Johan Maurits with Brazilians* was separated from the rest of the Vrijburg cycle. The life-size portrait was also lost. The rest of the images are in the collection of the National Museum of Denmark in Copenhagen, where they were sent when the Royal Danish Kunstkammer was dismantled. It is known that Johan Maurits was made a member of the "order of the elephant" by King Frederick III, but it is unclear if the conferring of this title was related to this gift. Johan Maurits was rather attached to these works and later regretted having given them away, writing a letter in 1679 in which he asked if he could have the paintings in the ethnographic series back if they were not appreciated.[50] Unfortunately for him they were appreciated, and he had to make do with copies made in Copenhagen, which have since disappeared.

The gift by Johan Maurits that often garners the most attention is, however, the large collection of paintings and other works that he assembled in 1679 and sent to Louis XIV.[51] This gift included twenty-seven paintings by Post, eighteen of which were described as "small landscapes" and may have been painted in Brazil.[52] (The remainder were newly made representations of Brazil, part of Post's Haarlem production.) Only four of these images are still in France, all in the collection of the Musée du Louvre in Paris. Despite the magnitude and magnificence of this gift, Johan Maurits received nothing in return, no land, official titles, or political favors. Documents from this period inform us that the gift was appreciated, but it is easy to imagine that Johan Maurits, who died shortly thereafter, was disappointed that nothing more tangible was forthcoming. It is often said that he expected money in return, but it is nonetheless unlikely that he anticipated such a mercantile response to his present; at this level of aristocratic gift-giving, political and social favors were more likely to have formed payment than

hard currency. In 1679, the Dutch had only recently ended their war with the French, which had lasted from 1672 to 1678, and it is possible that this gift should also be interpreted in this context.

In postcolonial Brazil, the paintings by Eckhout and Post have played a different role. Here, they have been embraced as artifacts from the past—nostalgic reminders of this important moment in Brazilian history and prized as the first paintings of Brazil. Already in the nineteenth century, half-size copies were made of six of Eckhout's paintings in Copenhagen for the Brazil's Emperor Dom Pedro II.[53] However, it was the twentieth century that saw the greatest revival of interest in these works of art. Admirers of Eckhout's paintings have been frustrated by their out-of-the-way locations in Copenhagen and Kraków and by the fact that he made far fewer images than Post, none of which are available to private collectors.[54] As such, paintings by Post have been widely sought—by Brazilians in particular—and museums in Europe, North America, and Brazil all have works by him in their permanent collections. In viewing the paintings by Eckhout and Post, we can experience the wonders of Brazil, "this beautiful country," as experienced by the Dutch in the seventeenth century.[55]

Notes

This essay is based on my doctoral dissertation, which focuses on the works of art made by Albert Eckhout in Dutch Brazil (Northwestern University, anticipated 2001). My research has been supported by the Kress Foundation, the Fulbright Foundation, the Friends of the Mauritshuis, and Northwestern University. I would like to thank Larry Silver, Claudia Swan, Eric Jan Sluijter, Elmer Kolfin, and Robert Launay for their criticism and comments on earlier versions of this work.

1. See the important book by J. A. G. Mello, *Tempo dos flamengos. Influência da ocupacão holandesa na vida e na cultura do norte do Brasil* (2nd ed.; Recife: Governa de Pernambuca, 1978). Indispensible for the history of this period is C. R. Boxer's *The Dutch in Brazil, 1624–1654* (2nd ed.; Hamden, Conn.: Archon Books, 1973).

2. As things turned out, he was the first and last governor of the colony.

3. Elected from the ruling house of Orange-Nassau, stadholders governed the Netherlands from the sixteenth to eighteenth centuries.

4. See R. Joppien, "The Dutch Vision of Brazil: Johan Maurits and His Artists," in Ernst van den Boogaart, ed., *Johan Maurits van Nassau-Siegen 1604–1679: A Humanist Prince in Europe and Brazil* (The Hague: Johan Maurits van Nassau Stichting, 1979).

5. The original letter is in the Koninklijk Huisarchief (Royal Dutch Archives, hereafter KHA), The Hague; reproduced and transcribed in Erik Larsen, *Frans Post, interprète du Brésil* (Amsterdam: Colibris Editora, 1962), p. 255. In this letter, Johan Maurits claimed that he had six artists with him in Brazil; but since this letter accompanied a gift, the number was possibly an exaggeration in order to make his gift seem more impressive.

6. Lawrence Otto Goedde, "Convention, Realism, and the Interpretation of Dutch and Flemish Tempest Painting," *Simiolis* 2/3 (1986), p. 146. Although speaking here of tempest paintings, this observation is applicable to much seventeenth-century Dutch art. See also Goedde's essay "Naturalism as Convention: Subject, Style, and Artistic Self-Consciousness in Dutch Landscape," in Wayne Franits, ed., *Looking at Seventeenth-Century Dutch Art: Realism Reconsidered* (Cambridge: Cambridge University Press, 1997), pp. 129–43.

7. I have chosen this spelling based on the way that Eckhout signed his paintings in Brazil; this is one of a number of variants for the spelling of Eeckholt.

8. In addition to my own research, these biographical details are drawn from Thomas Thomsen's *Albert Eckhout, ein niederländischer Maler und sein Gönner Johan Maurits der Brasilianer. Ein Kulturbild aus dem 17. Jahrhundert* (Copenhagen: Levin og Manksgaard, 1938) and H. E. van Gelder's "Twee Braziliaanse schildpadden door Albert Eckhout," *Oud Holland* 75 (1960), pp. 5–30.

9. In this essay, I have chosen to use the term "ethnographic portrait" to describe a hybrid image that displays a synthesis of ethnographic modes of image-making and the formal qualities generally associated with portraiture. In the same way that portraits

reproduce features specific to a given individual, an ethnographic portrait emphasizes those aspects of a person that are not his alone but are characteristic (or thought to be characteristic) of a larger—often ethnic or national—group. Thus particular emphasis is placed on aspects such as costumes, weapons, hairstyles, skin coloring, and (in the eighteenth century and later) "racial" differences. Indeed, it can be said that a hallmark of the ethnographic portrait is the "realistic rendering of authentic exotic artifacts, whose authenticity is then (unjustifiably) assumed to extend to the representation as a whole." See Peter Mason, *Infelicities: Representations of the Exotic* (Baltimore: Johns Hopkins University Press, 1998), p. 46.

10. J. J. Terwen, "The Buildings of Johan Maurits van Nassau," in van den Boogaart, *Johan Maurits van Nassau-Siegen*, p. 96.

11. The figures in these paintings were described in this way by contemporaries, including Zacharias Wagener, a German administrator and WIC employee in Dutch Brazil, whose *Thierbuch* (ca. 1641) included copies of paintings by Eckhout with commentary. "Mulatto" is used to describe a man or a woman with one white European and one black African parent. "*Mameluca*" refers to a woman with one white European and one Tupinambá parent. In Dutch Brazil, it was assumed that the father (never the mother) was European. Of the *mameluca*, Wagener states, "Illicit relations between Brazilian [ie., Tupinambá] women as much with Portuguese as with Dutch leads to the birth of many of these [children] of prostitutes, among whom it is not uncommon to find attractive and delicate men and women." Of the mulatto man, Wagener states, "The people produced by the relations between black women and Portuguese are called 'Mulaten.'" See the facsimile edition of the *Thierbuch*, in Cristina Ferrão and José Paulo Monteiro Soares, eds., *Dutch Brazil, Vol. II: The "Thierbuch" and "Autobiography" of Zacharias Wagener*, trans. David H. Treece (Rio de Janeiro: Editora Index, 1997), pp. 180–81.

12. I would like to thank Ernst van den Boogaart for sharing his thoughts on the arrangement with me.

13. It is unclear why both paintings of Africans show the light coming from the left. They may predate the rest of the portraits and could have been originally intended to hang next to each other.

14. This may be the reason they lack a date and signature. See Alan Chong and Wouter Kloek, *Still-Life Paintings from the Netherlands 1500–1720* (Zwolle: Waanders Publishers, 1999), p. 192.

15. Ibid.

16. Diego Vega suggests that the still lifes "incite us to colonize Brazil." See his article, "Tropical Flavours: Still Lifes by Albert Eckhout," *FMR* 104 (June 2000), p. 126.

17. Johan Maurits, letter to Resident Le Maire in Copenhagen, July 26, 1679 (KHA, The Hague, A4, 1477). "Nations" is a term used by Europeans during this period to identify different ethnic groups or what Margaret Hodgen calls "cultural wholes." In this instance, Johan Maurits is obviously referring to non-European peoples. See Hodgen, *Anthropology in the Sixteenth and Seventeenth Centuries* (Philadelphia: University of Pennsylvania Press, 1964).

18. Karl Friedrich Philipp von Martius, *Beiträge zur Ethnographie und Sprachenkunde Amerika's, zumal Brasiliens*, 2 vols. (Leipzig: F. Fleischer, 1867); quoted in Robert Lowrie, "The Tarairiu," in Julian H. Steward, ed., *Handbook of South American Indians: The Marginal Tribes*, vol. I (Washington, D.C.: United States Government Publishing Office, 1946), p. 553. Lowrie calls "Tapuya" a pejorative and nonspecific "blanket term" applied to many different Indian groups by hostile Tupinambás and European outsiders, recommending that it be eliminated from scientific usage ("Tapuya," in *The Marginal Tribes*, p. 556). See also Peter Mason, "Portrayal and Betrayal: The Colonial Gaze in Seventeenth Century Brazil," *Culture and History* 6 (1989), pp. 43–44.

19. John Hemming, *Red Gold: The Conquest of the Brazilian Indians* (London: Papermac, 1978), p. 297.

20. See Ernst van den Boogaart's important study, "Infernal Allies: The Dutch West India Company and the Tarairiu, 1631–1654," in van den Boogaart, ed., *Johan Maurits van Nassau-Siegen 1604–1679: A Humanist Prince in Europe and Brazil*, pp. 519–38.

21. Of course, the Portuguese also had their own Tupinambá allies.

22. Van den Boogart's argument (first made in "Infernal Allies") is more fully developed in his essay "The Slow Progress of Colonial Civility: Indians in the Pictorial Record of Dutch Brazil, 1637–1644," in *La Imagen del Indio en la Europa Moderna* (Seville: Consejo Superior de Investigaciones Científicas, 1990), p. 395. As Mason has noted, to be "civilized" means to be "docile and amenable to European domination." See his "Portrayal and Betrayal," p. 45; the arguments made in this article are reproduced in his later works, including (with Florike Egmond) *The Mammoth and the Mouse: Microhistory and Morphology* (Baltimore: Johns Hopkins University Press, 1997) and *Infelicities* (see note 9).

23. Van den Boogaart, "The Slow Progress of Colonial Civility," pp. 13–14; Mason, "Portrayal and Betrayal," pp. 48–49.

24 . The most important accounts of Brazil from the sixteenth century include *Hans Staden's Wahrhaftig Historia … in Neuen Welt* (1557), Jean de Léry's *Histoire d'un voyage fait en la terre du Brésil* (1578), and André Thevet's *Les Singularitez de la France antarctique* (1558). Staden's is the most sensationalistic of these works.

25. Van den Boogaart states, "They are decently dressed albeit barefoot" ("The Slow Progress of Colonial Civility," p. 402). See also B.-M. Baumunk, "Von Brasilischen fremden Völkern. Die Eingeborenen-Darstellungen Albert Eckhouts," in Karl-Heinz Kohl, ed., *Mythen der neuen Welt. Zur Entdeckungsgeschichte Lateinamerikas* (Berlin: Frölich & Kaufmann, 1982), p. 192. Mason argues that the image of the *mameluca* conveys a "more Europeanised sensuality" ("Portrayal and Betrayal," p. 55).

26. P. J. P Whitehead and M. Boeseman, *A Portrait of Dutch 17th Century Brazil: Animals, Plants and People by the Artists of Johan Maurits of Nassau* (Amsterdam: North-Holland Publishing Company, 1989), p. 73.

27. Jane D. Reid, *The Oxford Guide to Classical Mythology in the Arts, 1300–1990s*, vol. 1 (New York: Oxford University Press, 1993), p. 434. See also Julius S. Held's classic study, "Flora, Goddess and Courtesan," in *Essays in Honor of Erwin Panofsky* (New York: New York University Press, 1961), p. 208.

28. Van den Boogaart, "Infernal Allies," p. 538, and "The Slow Progress of Colonial Civility," p. 402.

29. Doran H. Ross, "The Iconography of Asante Sword Ornaments," *African Arts* 9, no. 1 (1977), p. 16.

30. See Whitehead and Bosesman, *A Portrait of Dutch 17th Century Brazil*, p. 74. The African man's limited dress in this image would have been highly unusual for a man of noble status in Ghana but quite usual for a slave. Eckhout also made oil sketches of Africans in Brazil (now in the collection of the Jagiellon University Library, Kraków). Their dress is much more elaborate and formal than that represented here, indicating that they were most likely ambassadors from the Congo who visited the colony circa 1643.

31. Her basket is Bakongo, and her elaborate hat was probably also made in the same region. Since 1980, scholars have unquestionably repeated Bente Dam-Mikkelsen and Torben Lundbæk's assertion that the hat she wears is "of an oriental type which Dutch merchants had brought from Asia to their allies in the Sohio kingdom at the mouth of the Congo" (*Ethnographic Objects in the Royal Danish Kunstkammer, 1650–1800* [Copenhagen: Nationalmuseet, 1980], p. 42), a statement based on evidence of Dutch trade in peacock feathers from the East Indies with Sonho (also Sohio). (I would like to thank Torben Lundbæk for clarifying this point for me.) However, it now seems far more probable that the hat is of African manufacture, given its pattern and the mode of its construction, with the peacock feathers added to address the cosmopolitan tastes of the ruling elite in the Congo region. Thomsen states that the hat is of a type worn by Africans from the Christian area of the Congo (*Albert Eckhout*, p. 173).

32. As Pieter de Marees wrote of Africans in Ghana in 1602, "when the young children are first born they are not completely black, but reddish, like the Brazilians." See his account of the Gold Coast of Guinea, *Beschryvinghe ende historische verhael van het Gout Koninckrijk van Gunea*, ed. S. P. L'Honoré Naber (The Hague: Nijhoff, 1912). This is a reprint of the 1602 original.

33. Mason, "Portrayal and Betrayal," pp. 54–55.

34. I would like to thank Eric Jan Sluijter for bringing this to my attention. In a similar vein, Mason argues that the tobacco pipe is an allusion to sexual activity ("Portrayal and Betrayal," p. 55).

35. See Joaquim de Sousa-Leão's *Frans Post 1612–1680* (Amsterdam: A. L. Gendt & Co., 1973) and Larsen's *Frans Post* for biographical information on Post. Other good sources include Joppien's "The Dutch Vision of Brazil" and Whitehead and Boeseman's *A Portrait of Dutch 17th Century Brazil*.

36. Wolfgang Stechow, *Dutch Landscape Painting of the Seventeenth Century* (2nd ed.; London: Phaidon, 1968), p. 169. Stechow first called attention to the "kinship" between Post and Vroom.

37. Thirty-two of Post's drawings (most dated 1645) for the Barlaeus engravings are now in the collection of the British Museum, London.

38. Whitehead and Boeseman, *A Portrait of Dutch 17th Century Brazil*, p. 179.

39. See the special edition of the *Nederlands Kunsthistorisch Jaarboek* on landscape, *Nature and Landscape in Netherlandish Art*, ed. Reindert Falkenburg et al. (Zwolle: Waanders, 1998). In particular, see Huigen Leeflang, "Dutch Landscape: The Urban View; Haarlem and Its Environs in Literature and Art" (pp. 53–115), and Catherine Levesque, "Landscape, Politics, and the Prosperous Peace" (pp. 223–57).

40. See Kolfin's study of the representation of slaves (primarily in Suriname), *Van de Slavenzweep en de Muze, twee eeuwen verbeelding van slavernij in Suriname* (Leiden: Koninklijk instituut voor taal-, land- en volkenkunde, 1997), p. 30.

41. Caspar Barlaeus, *Nederlandsch Brazilie onder het bewind van Johan Maurits Grave van Nassau*, ed. and trans. S. P. L'Honore (The Hague: Nijhoff, 1923), pp. 51–56. (This is a translation into Dutch of the Latin original, *Rerum per octennium in Brasilia* [Amsterdam, 1647].) Barlaeus includes the transcription of a letter from Johan Maurits to Prince Frederick Henry describing the flight of the Portuguese over the river.

42. Discovered in 1995, the painting is now in the collection of Patricia Phelps de Cisneros, Caracas.

43. Beatriz and Pedro Corrêa do Lago, "Frans Post's Brazilian Paintings," in Paulo Herkenhoff, ed., *Brazil and the Dutch, 1630–1654* (Rio de Janerio: Editores Letda, 1999), p. 248.

44. Sousa-Leão, *Frans Post*, p. 28.

45. Stechow, *Dutch Landscape Painting of the Seventeenth Century*, p. 169. See also Thomas Kellein and Urs-Beat Frei, *Frans Post, 1612–1680* (Basel: Kunsthalle Basel, 1990), and Peter Sutton, "Introduction," in *Masters of Seventeenth-Century Dutch Landscape Painting*, exh. cat. (Boston: Museum of Fine Arts, 1987), p. 48.

46. This gift is discussed by Joppien, among others; see his "Dutch Vision of Brazil." Important documents related to this gift are reproduced by Larsen in *Frans Post*, pp. 252–53.

47. Joppien, "Dutch Vision of Brazil," p. 323.

48. Eckhout's lost cycle, painted in Brazil or The Hague between 1640 and 1650, included seven life-size oil paintings of Amerindians, depicting the peoples of the different provinces *"nach dem Leben,"* surrounded by the appropriate plants and animals. These images were accompanied by nine smaller paintings for under windows, depicting rarities found "nowhere else in the world," possibly natural-history representations. (See the September 7, 1652, inventory of this gift, reproduced as document 50 in Larsen, *Frans Post*, p. 253.) The surviving natural-history and ethnographic drawings and oil studies made in Brazil by Eckhout and Marcgrave can be found in the four volumes of the *Theatri rerum naturalium Brasiliae*, in *Handbooks I* and *II*, and in the *Miscellanea Cleyeri*. These seven volumes contain the Brazilian drawings presented by Johan Maurits to Friedrick William. The drawings were gathered into these volumes by the elector's physician Christian Mentzel, and later they

became part of the *Libri picturati* collection of natural-history images in the former Preussicher Staatsbibliothek in Berlin. During World War II, the Brazilian volumes were transferred to Silesia and then to a monastery in Grüssau (now Krzeszów) for safe-keeping. From there, they eventually made their way to Kraków, where there are now in the collection to the Jagiellon University Library. The Brazilian volumes have been reproduced in a facsimile edition under the title *Brasil-Holandês/Dutch-Brasil*, eds. Cristina Ferrão and José Paulo Monteiro Soares, 5 vols. (Rio de Janeiro: Editora Index, 1995). Unfortunately, the reproductions in this work are inconsistent in quality. See P. J. P. Whitehead, "The Clusius and Other Natural History Pictures in the Jagiellon Library, Kracòw," *Archives of Natural History* 16, no. 1 (1989), pp. 15–32, for a brief overview of the complicated history of the *Libri picturati*. Among the Brazilian images in Kraków are also a number of unidentified oil studies of birds. Based on a study of their style and technique, these images cannot be attributed to Eckhout or Marcgrave. They appear to be copies of Marcgrave's watercolors from the *Handbooks*, like the birds in Post's *View of the Town and Homestead of Frederick in Paraiba, Brazil*, and furthermore closely resemble the birds in Post's paintings in style. This suggests that Post may be the author of these studies.

49. See Thomsen's *Albert Eckhout* for excerpts from important documents related to this gift.

50. Johan Maurits, letter to Resident Le Maire in Copenhagen, July 26, 1679 (KHA, The Hague, A4, 1477).

51. See the discussion of this gift in Joppien, "The Dutch in Brazil," and Sousa-Leão, *Frans Post*.

52. Corrêa do Lago, "Frans Post's Brazilian Paintings," p. 239.

53. Whitehead and Boeseman, *A Portrait of Dutch 17th Century Brazil*, p. 168.

54. The oil study of two fighting tortoises attributed to Eckhout in the collection of the Mauritshuis, The Hague, is probably not by him.

55. Johan Maurits, letter to Louis XIV, February 8, 1679 (Archive of Johan Maurits, KHA, The Hague). The letter is reproduced in Larsen's *Frans Post*, p. 255. In letters to officials in the Netherlands, Johan Maurits frequently described Brazil as an earthly paradise.

Indigenous Cultures

The selection of objects from Brazil's indigenous cultures represents only a fraction
of the visual riches of native peoples from many parts of the country, whose civiliza-
tions have comprised, both past and present, an integral part of Brazilian society. The
oldest piece in this group—the sixteenth- or seventeenth-century feathered cape
(cat. no. 1) of the Tupinambá people, a branch of the Tupi found throughout coastal
areas of Brazil at the time of the first European contacts—is of major historical
importance as it is one of only seven such objects remaining in European museums.
During the colonial period, these cloaks, which ceremonially transformed wearers into
bird-men, were collected as objects of curiosity and wonderment by Europeans. We
know from early descriptions that they were used by shamans or males of the highest
standing in rites of passage from boyhood to manhood. This aspect of performance
and ceremony is inherent in virtually all of the objects on display in this section.

The flute-mask (cat. no. 4) of the Wayana people (Carib-speaking groups from
the extreme north of Brazil) was also designed for use in male initiation ceremonies.
In this case, the sound of the instrument, played by the wearer of the mask, combined
with its visual impact to call forth its potency. Also from Wayana territory is the feath-
ered back plate (cat. no. 6) made from the plumes of six types of birds. It is worn in
conjunction with the ritual initiation mask (cat. no. 7) created from feathers and vege-
tal materials. Both of these pieces possess cosmological symbolism. The mask, for
example, takes the form of a supernatural being, Olokóimë, who lives in deep bodies
of water, emerging from the depths when hungry. When this creature, represented by
the mask, appears at crucial moments in initiation rites, his presence transforms the
space and the participants, allowing them to enter another realm. The ritual arrows of
the Wayana are both utilitarian and spiritualized weapons that represent the symbolic
links between humans and their prey; the examples shown here (cat. no. 14) are
specifically for hunting monkeys.

The big-face mask (cat. no. 9) is worn in ceremonies held in anticipation of war-
fare by the Tapirapé people, who inhabit the northeast regions of the inland state of
Mato Grosso. This mask, representing male power in warfare, is thought to ritually
possess the soul of an enemy warrior named Kayapó. Tapirapé men and boys also
fashion small wax dolls (e.g., cat. no. 12) that embody the supernatural spiritual force
called *topu*; these personifications of storms, capable of launching lightning bolts at
humans, travel on small canoes. All of the ritual objects created by this and other
groups are intimately connected to their creation mythology and cosmological leg-
ends. Their spiritualized quality removes them from the conventional, aestheticized
qualities that Westerners refer to as art. —Edward J. Sullivan

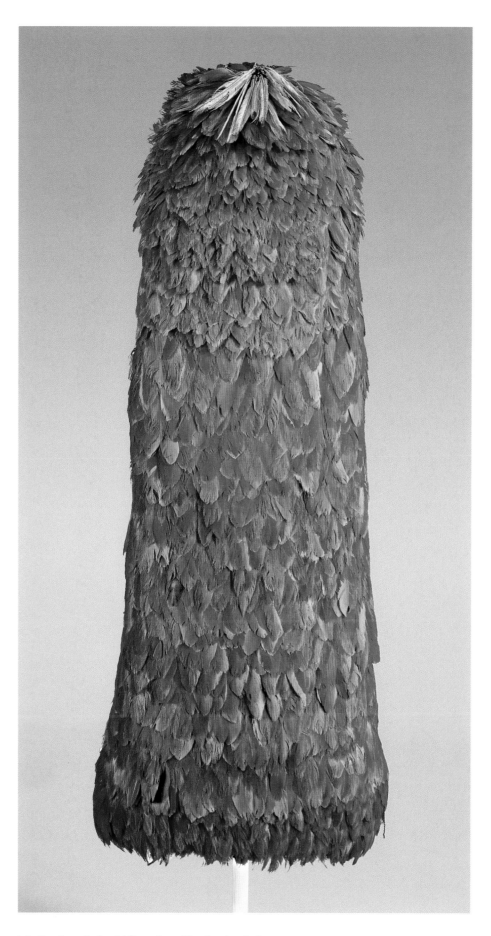

1. Feathered cape, Tupinambá, Pernambuco, 16th–17th century. Feathers, 127 x 54 x 25 cm.
National Museum of Denmark, Copenhagen

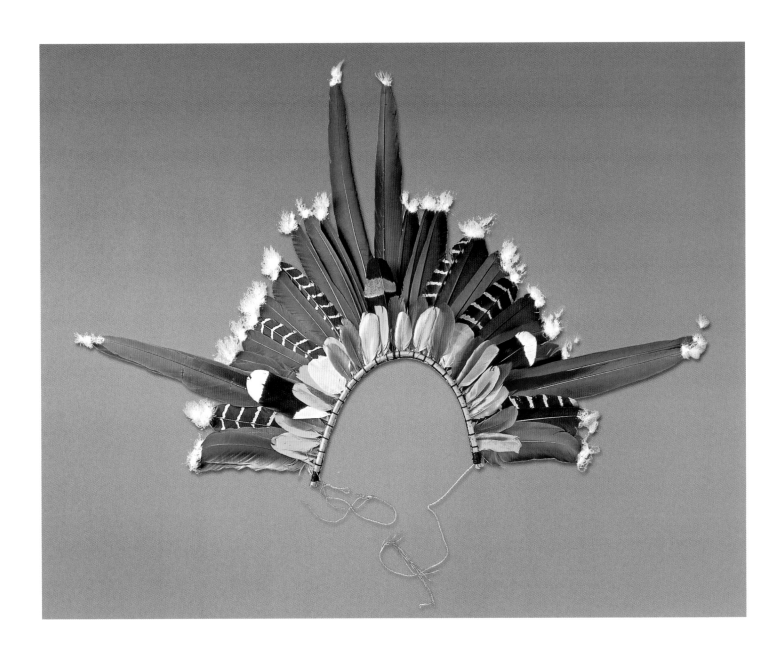

2. Crown, Bororo, Mato Grosso, n.d. Tucum fibers and feathers, 24.5 x 15 cm. Museu de Arqueologia e Etnologia, Universidade de São Paulo

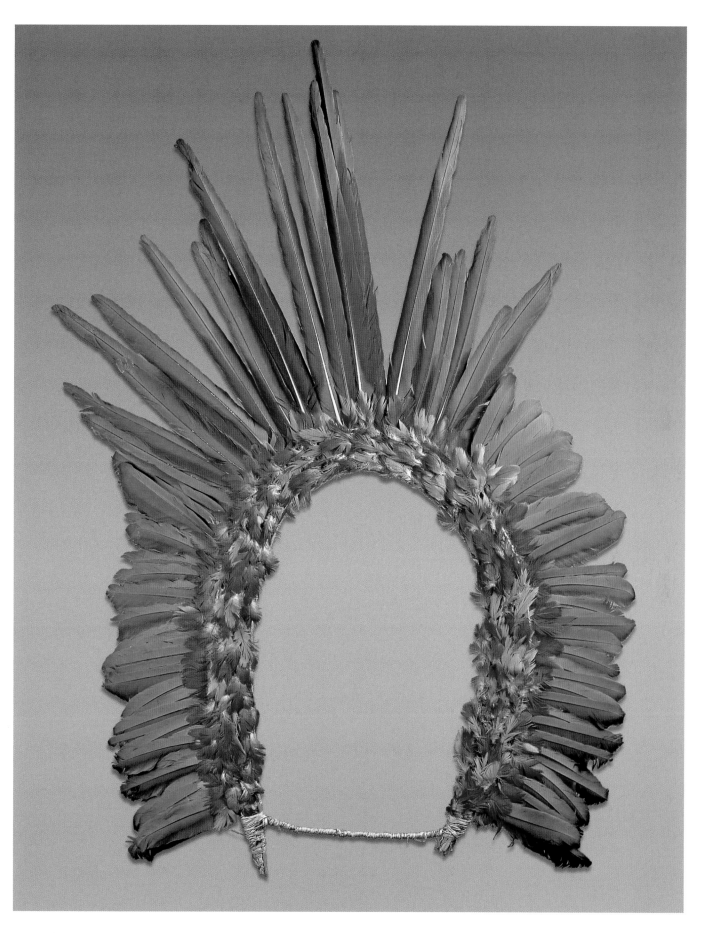

3. Feather diadem, Assurini, Pará, n.d. Wood, tar, cipó, envira, and feathers, 115 x 80 x 8 cm. Museu de Arqueologia e Etnologia, Universidade de São Paulo

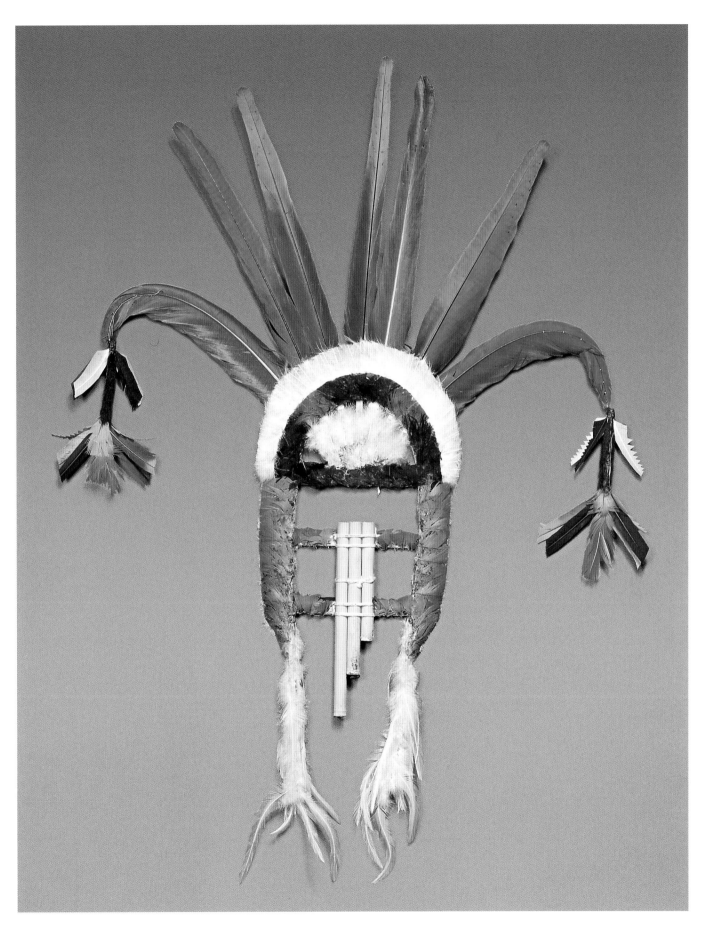

4. Flute-mask, Tateo Wayana, Pará, 20th century. Feathers and cane, 80 x 62 cm. Museu Paraense Emílio Goeldi–Conselho Nacional de Desenvolvimento Científico e Tecnológico/Ministério da Ciência e Tecnologia, Belém, collected by Lucia Van Velthen, 1995

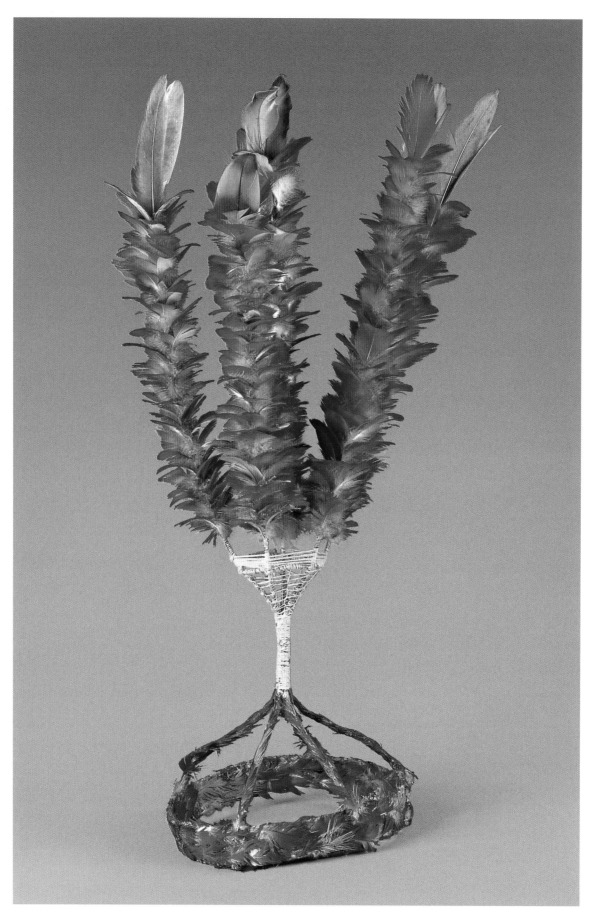

5. Head ornament, Waipi, Amapá, n.d. Feathers, cotton thread, and wood, 62 x 42 x 32 cm. Museu de Arqueologia e Etnologia, Universidade de São Paulo

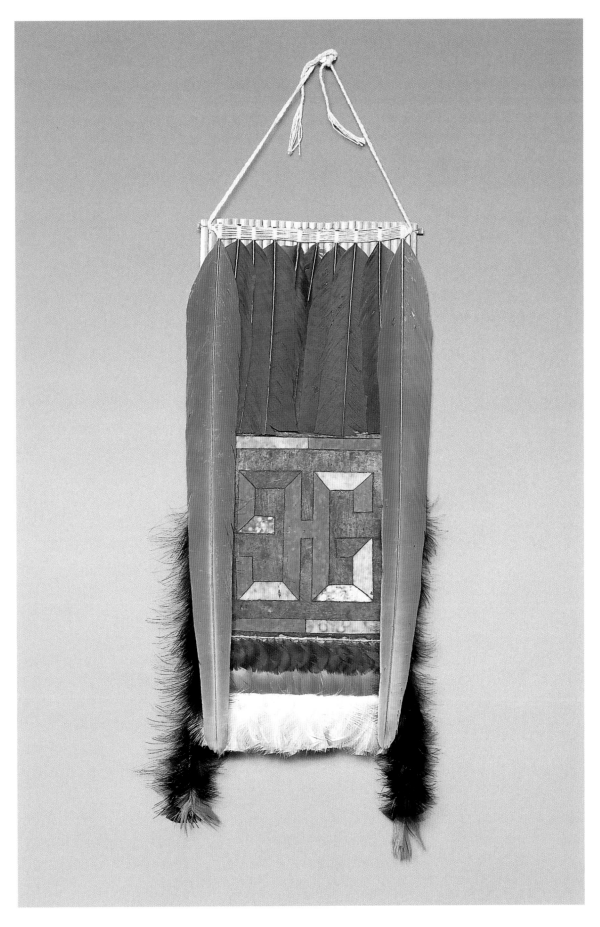

6. Feathered back plate, Yeye Wayana, Pará, 20th century. Feathers, cane, and cotton thread, 48 x 22 cm.
Museu Paraense Emílio Goeldi, Belém

FACING PAGE: 7. Ritual initiation mask, Anakari Wayana, Pará, 20th century. Feathers, sapajou hair, beetle wing, and natural fibers, 234 x 188 x 20 cm. Museu Paraense Emílio Goeldi–Conselho Nacional de Desenvolvimento Científico e Tecnológico/Ministério da Ciência e Tecnologia, Belém, collected by Lucia Van Velthen, 1989

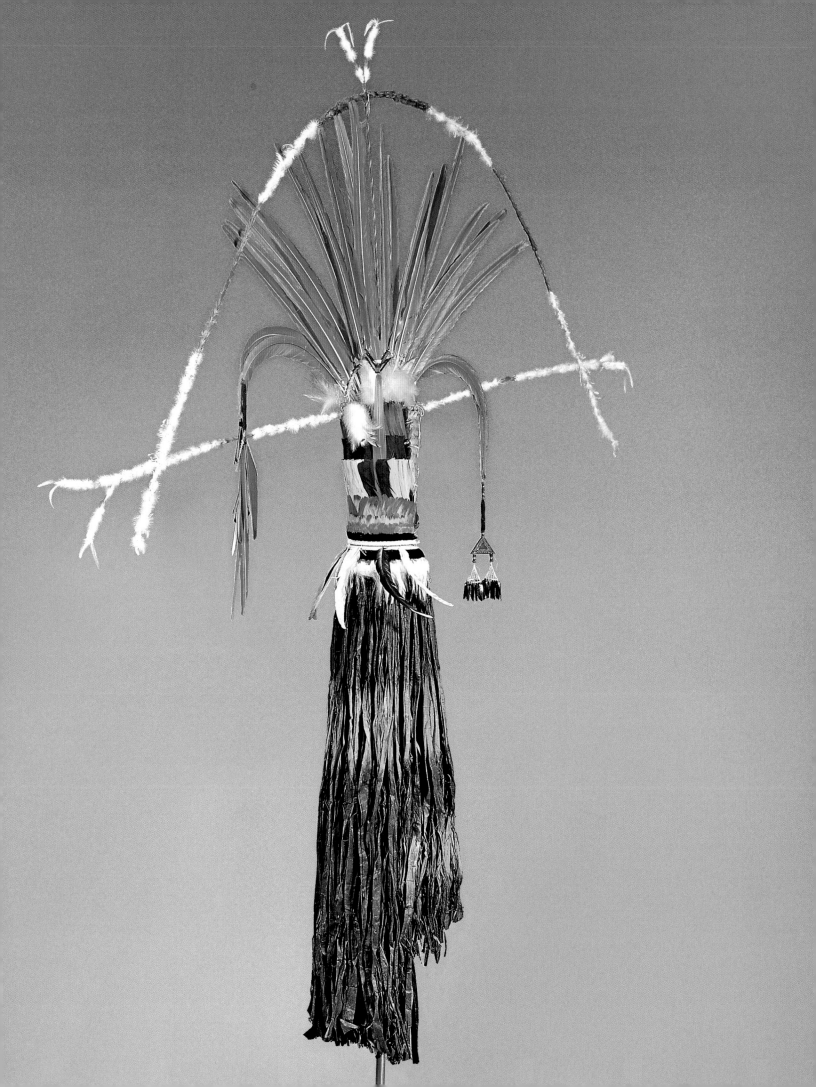

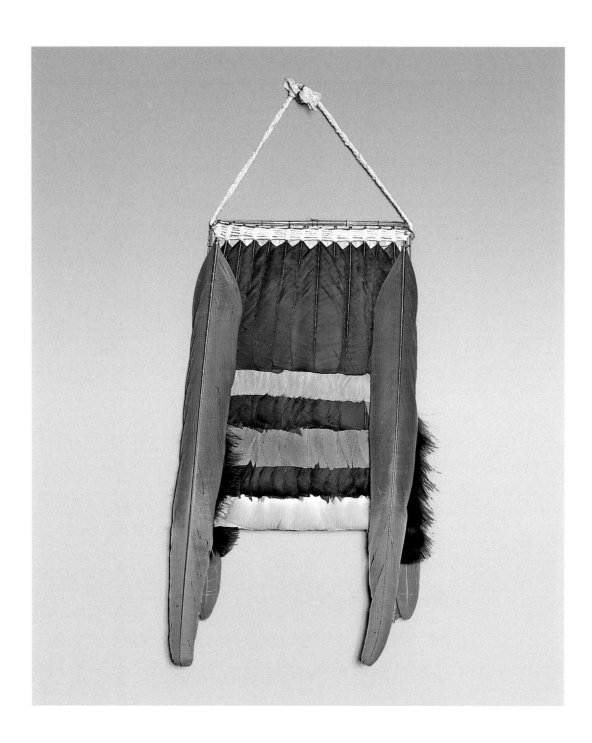

8. Feathered back plate, Arigó Wayana, Pará, 20th century. Feathers, cotton thread, and natural pigments, 35 x 17 cm.
Museu Paraense Emílio Goeldi–Ministério da Ciência e Tecnologia, Belém, collected by Lucia Van Velthen, 1989

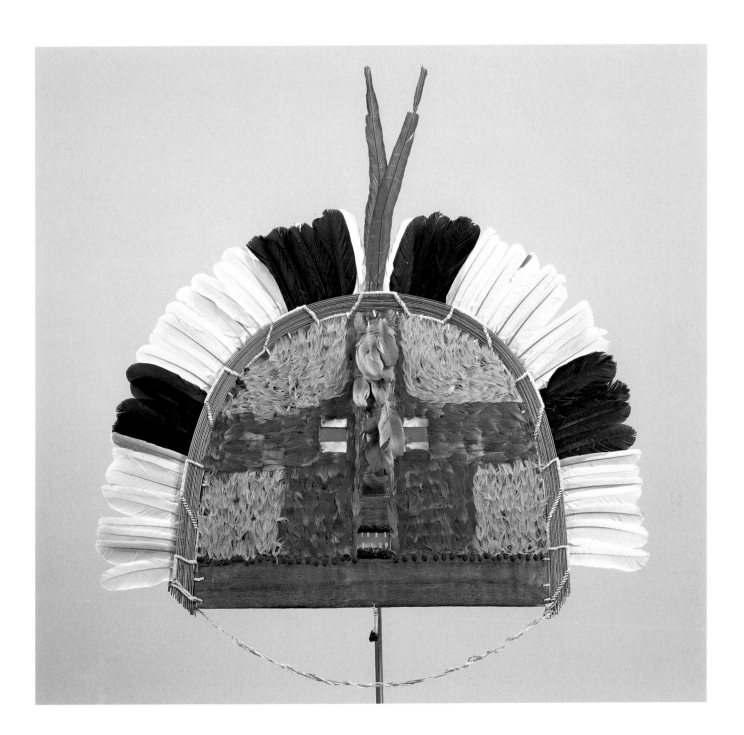

9. Big-face mask, Tapirapé, Mato Grosso, n.d. Feathers and wood, 65 x 70 x 5 cm. Museu do Índio, Rio de Janeiro

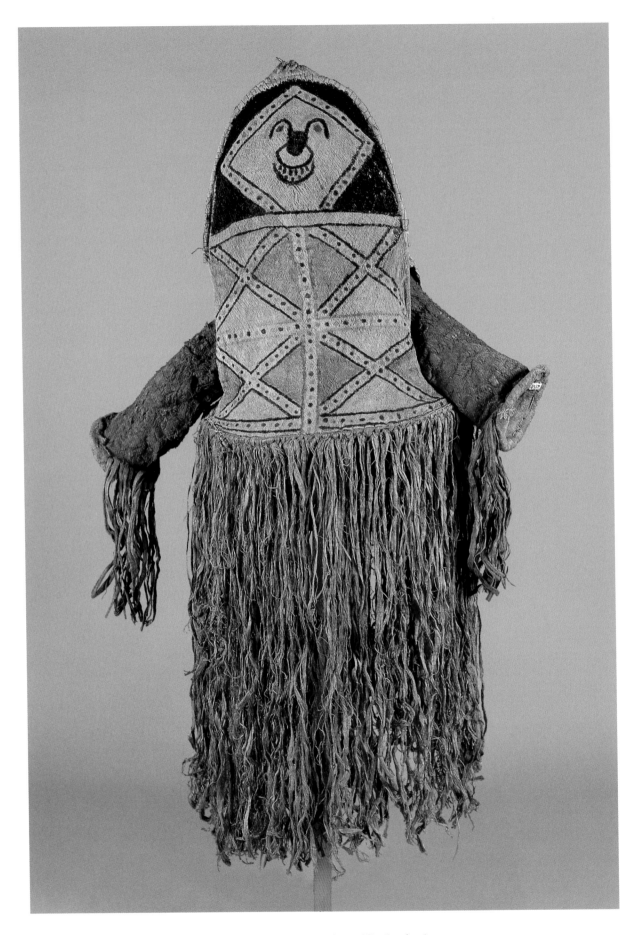

10. Anthropomorphic mask, Wanano, Amazonas, n.d. Bark cloth, natural pigments, and natural fiber threads, 146 x 75 x 30 cm.
Museu Nacional, Universidade Federal do Rio de Janeiro

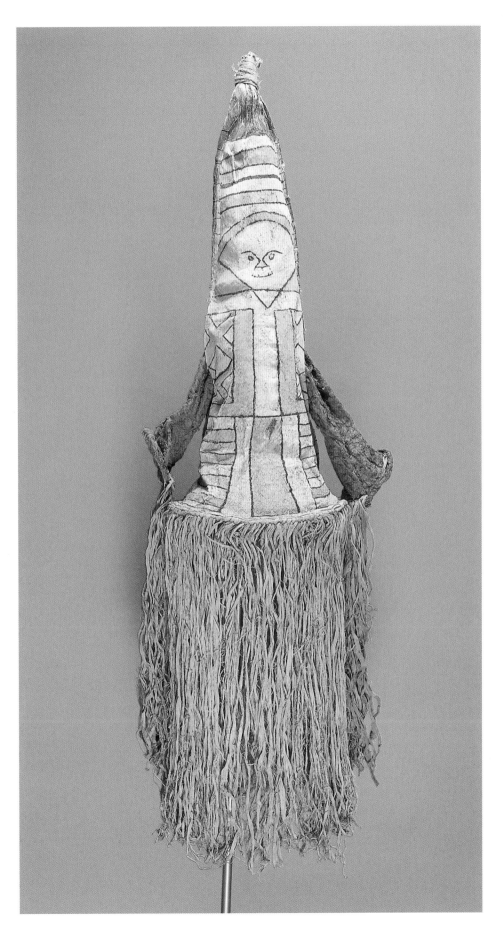

11. Ritual mask, Kobewa, Amazonas, n.d. Mamatá sap and natural pigments, 170 x 75 cm. Museu Paraense Emílio Goeldi–Ministério da Ciência e Tecnologia, Belém, collected by Theodor Koch-Grunberg, 1905

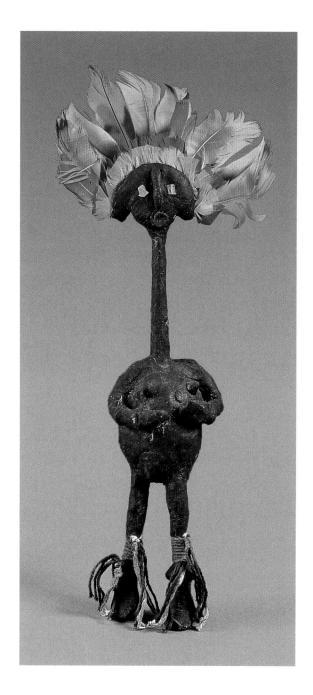

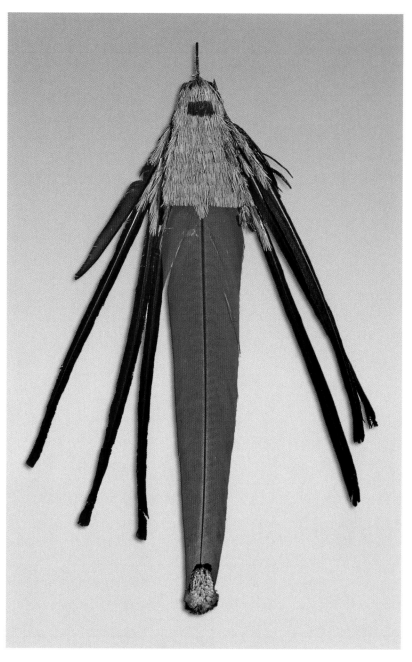

LEFT: **12.** Wax doll (god of lightning), Tapirapé, Mato Grosso, n.d. Wax, feathers, and cotton fibers, 34 x 15 x 7 cm. Museu de Arqueologia e Etnologia, Universidade de São Paulo. RIGHT: **13.** Feather labial ornament, Urubu Kaapor, Maranhão, n.d. Feathers, 24.5 x 15 cm. Museu de Arqueologia e Etnologia, Universidade de São Paulo

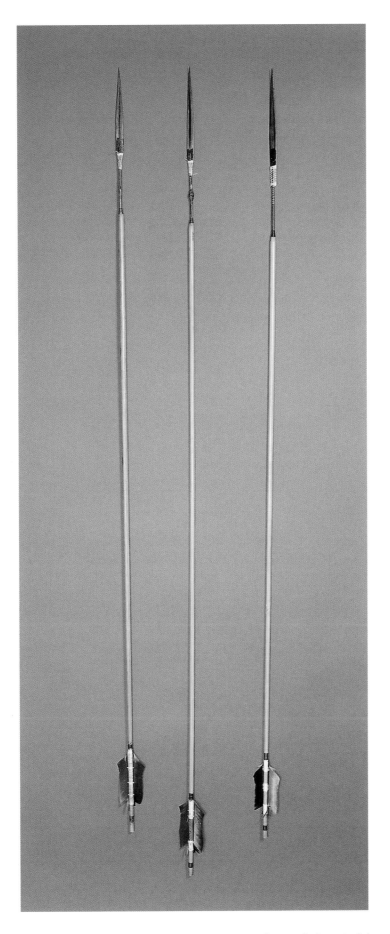

14. Monkey hunting arrows, Araíba Wayana, Pará, 20th century. Bamboo, cane, feathers, natural pigments, and cotton fibers, 179 x 8 cm each. Museu Paraense Emílio Goeldi–Conselho Nacional de Desenvolvimento Científico e Tecnológico/Ministério da Ciência e Tecnologia, Belém, collected by Lucia Van Velthen, 1989

Albert Eckhout and Frans Post

The first artistic and scientific studies of Brazil by Europeans were undertaken in the little-known period from 1630 to 1654 during which the Dutch, under the aegis of the Dutch West India Company, colonized part of the northeastern coast of Brazil. Johan Maurits van Nassau-Siegen, the German count who was the only governor-general of the Dutch colony, gathered talented artists and scientists at his Brazilian court, including the Dutch painters Albert Eckhout and Frans Post, who together produced some of the most important resources documenting European colonization of the New World during the seventeenth century.

Eckhout's surviving works from Brazil include one painting of dancing Tapuya Indians, eight ethnographic portraits, and twelve still lifes, and except for eight of the still lifes all are shown here. It is likely that these works, along with a now-lost life-size image of Johan Maurits with "Brazilian" (Tupinambá) Indians, formed a cycle of works intended to decorate the main hall of the Vrijburg Palace, the count's official residence in Dutch Brazil. The eight life-size ethnographic portraits, most of which were completed in 1641, represent two pairs of Amerindians (one Tapuya, or Tarairiu, the other Tupinambá, or "Brazilian"), a pair of black Africans, and a pair of mixed racial background. These images depict the different races under Johan Maurits's rule, representing a hierarchy of "civility" (from a seventeenth-century Dutch perspective), with the Tapuya Indians at the bottom and the mulatto man and woman at the top. The still lifes depict a mix of tropical fruits and vegetables common in Europe, suggesting that so-called exoticism was not the most important criterion for the subject matter of this cycle. Rather, these works were intended to celebrate the fecundity of the land and a successful harvest of local produce, including the vegetables introduced into Brazil by the Dutch.

In his landscapes, Post offered panoramic vistas representing the land conquered by the Dutch and sometimes, with a Dutch fort in the distance (e.g., cat. no. 31), their means of keeping it. Some works depict specific locations, identifiable because of the representation of recognizable topography and buildings, and occasionally feature a selection of Brazilian vegetation and birds and other small animals in the foreground. Post continued to paint images of Brazil after he returned to Europe in 1644. The further he was from Brazil in both time and space, the more imaginary his paintings became and the more he used bright colors and exotic elements. Post continued to paint these representations until 1669, suggesting that there was still a demand for such images. Perhaps these Brazilian scenes represented the lost paradise of the Dutch in Brazil, but it is more likely that they spoke to a general interest in the exotic and unfamiliar at the time. —Rebecca Parker Brienen

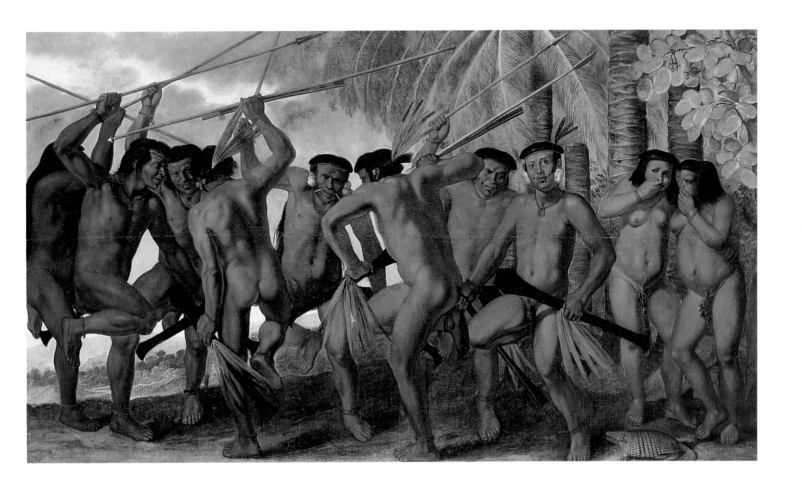

15. **ALBERT ECKHOUT** *Tapuya Dance*, ca. 1641. Oil on canvas, 168 x 294 cm. National Museum of Denmark, Copenhagen

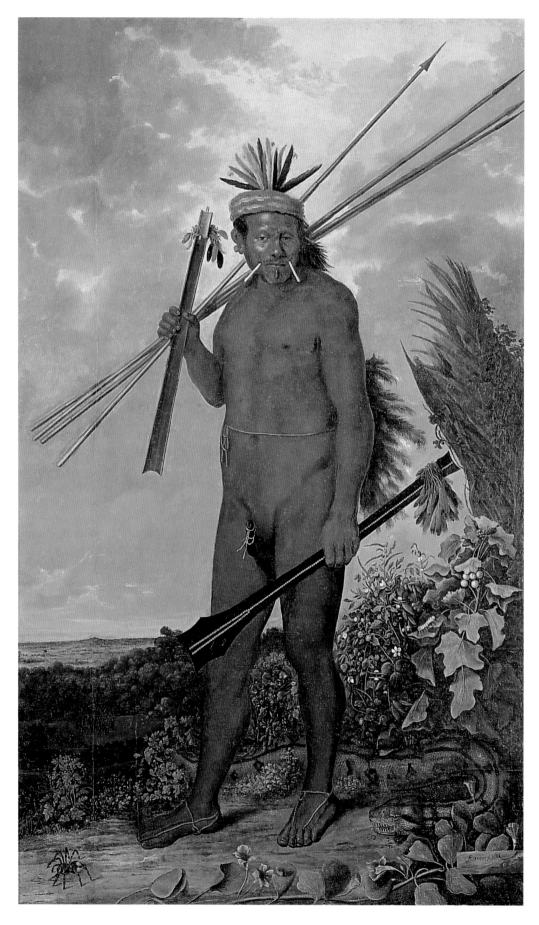

16. **ALBERT ECKHOUT** *Tapuya Man*, 1641. Oil on canvas, 266 x 159 cm. National Museum of Denmark, Copenhagen

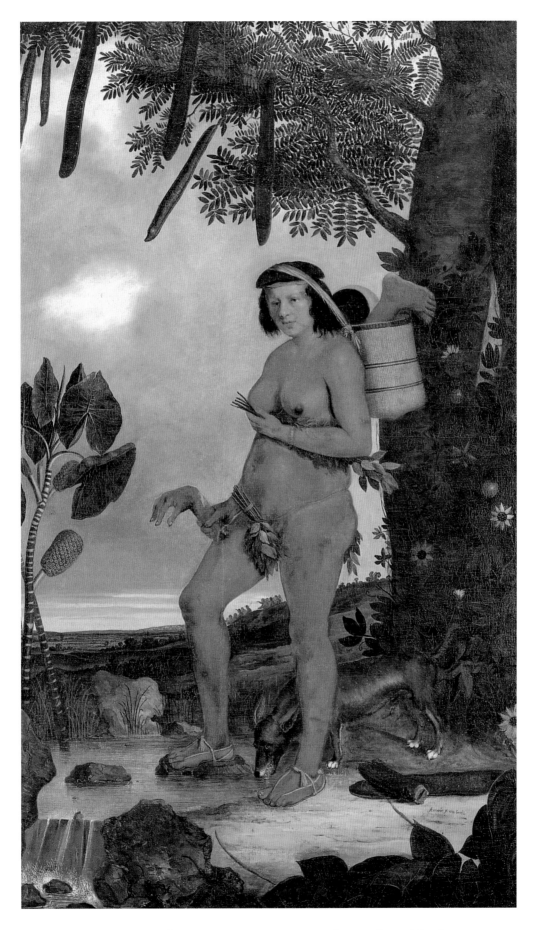

17. **ALBERT ECKHOUT** *Tapuya Woman*, 1641. Oil on canvas, 264 x 159 cm. National Museum of Denmark, Copenhagen

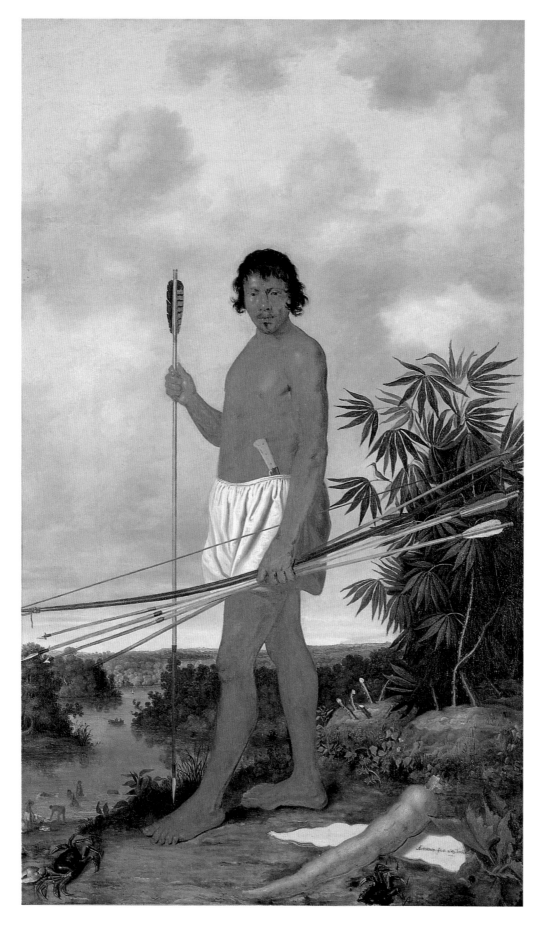

18. ALBERT ECKHOUT *Tupinambá Man*, 1641. Oil on canvas, 267 x 159 cm. National Museum of Denmark, Copenhagen

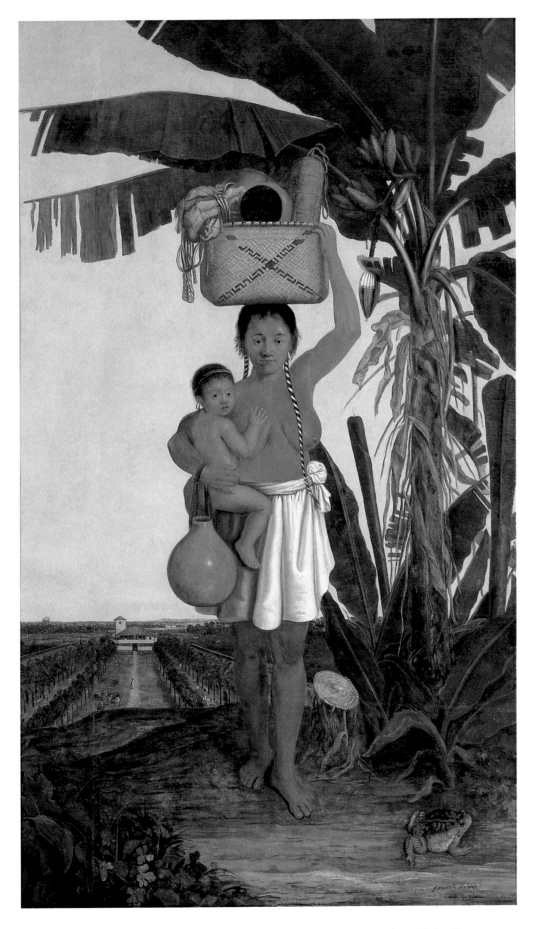

19. ALBERT ECKHOUT *Tupinambá Woman*, 1641. Oil on canvas, 265 x 157 cm. National Museum of Denmark, Copenhagen

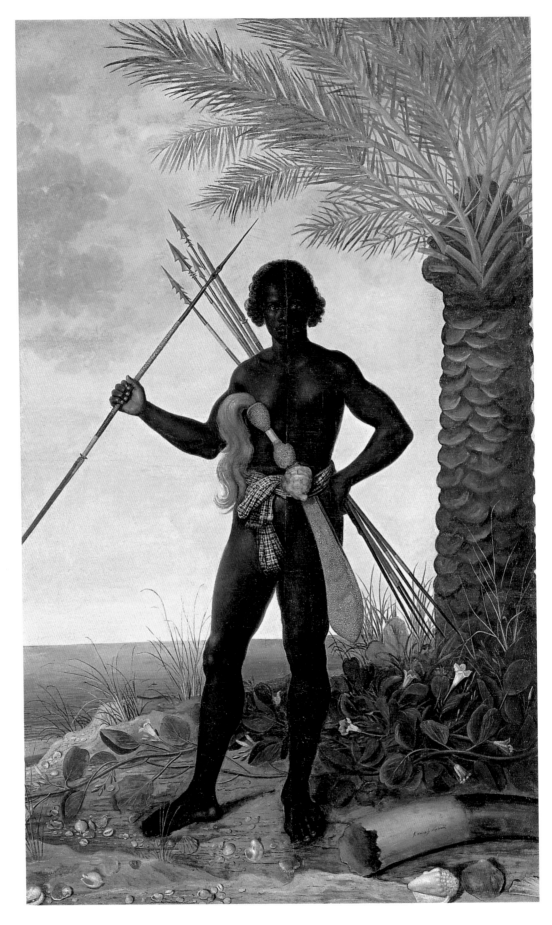

20. ALBERT ECKHOUT *African Man*, 1641. Oil on canvas, 264 x 162 cm. National Museum of Denmark, Copenhagen

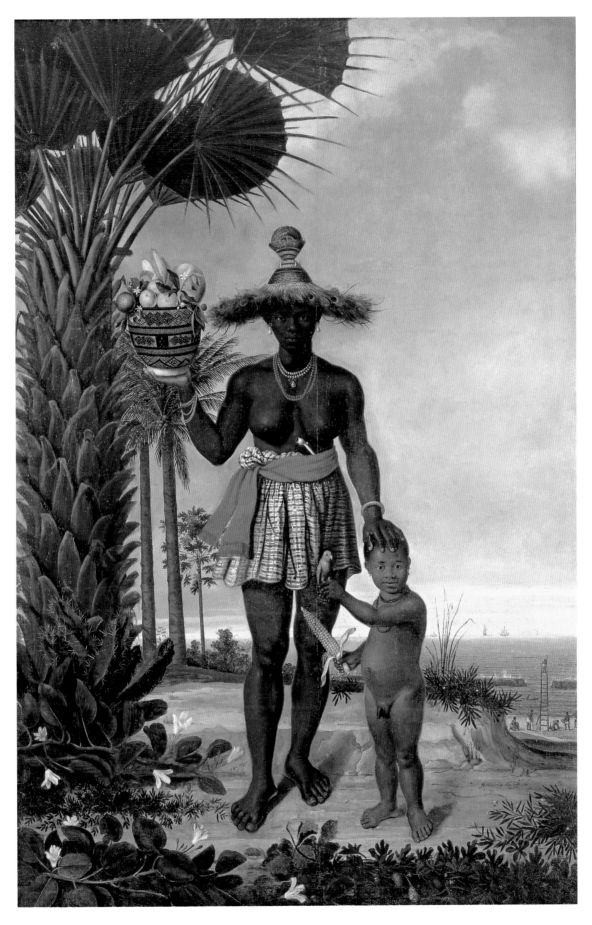

21. ALBERT ECKHOUT *African Woman with Child*, 1641. Oil on canvas, 267 x 178 cm.
National Museum of Denmark, Copenhagen

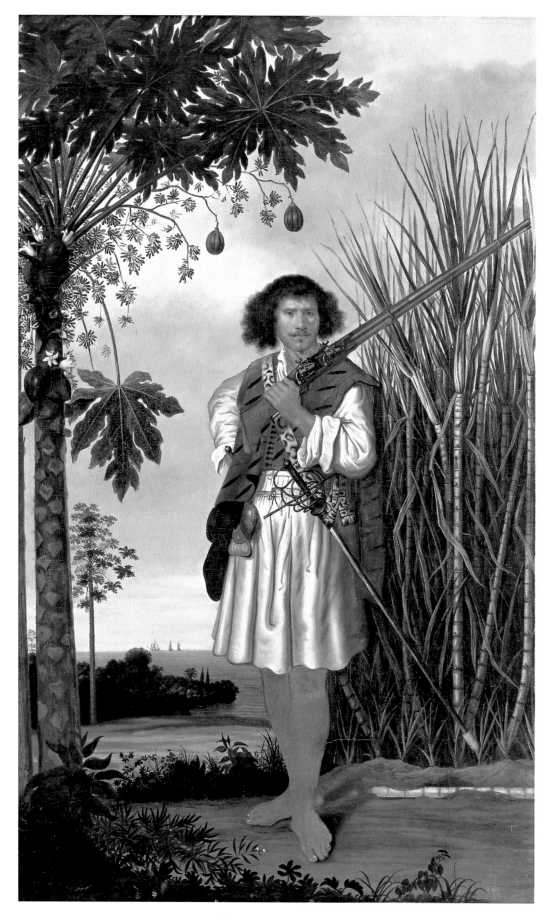

22. ALBERT ECKHOUT *Mulatto Man*, ca. 1641. Oil on canvas, 265 x 163 cm. National Museum of Denmark, Copenhagen

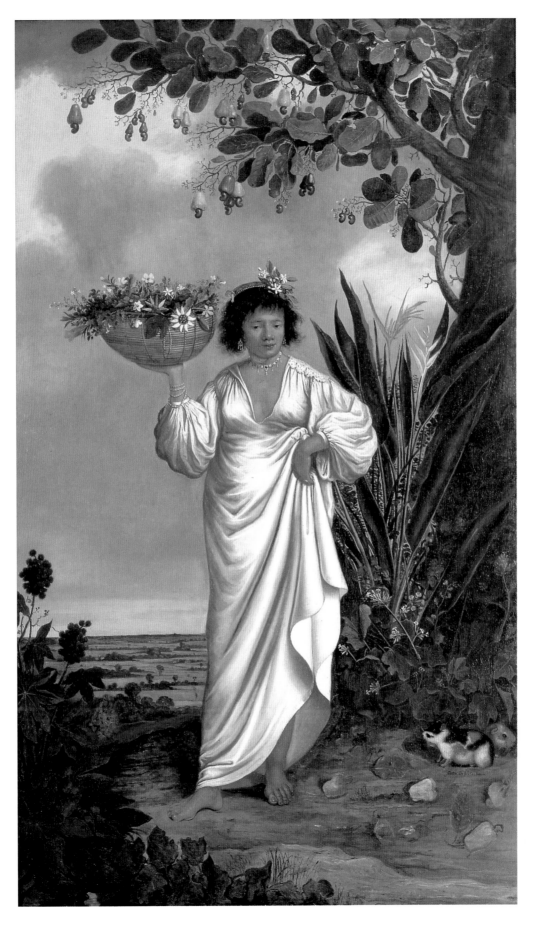

23. ALBERT ECKHOUT *Mameluca*, 1641. Oil on canvas, 267 x 160 cm. National Museum of Denmark, Copenhagen

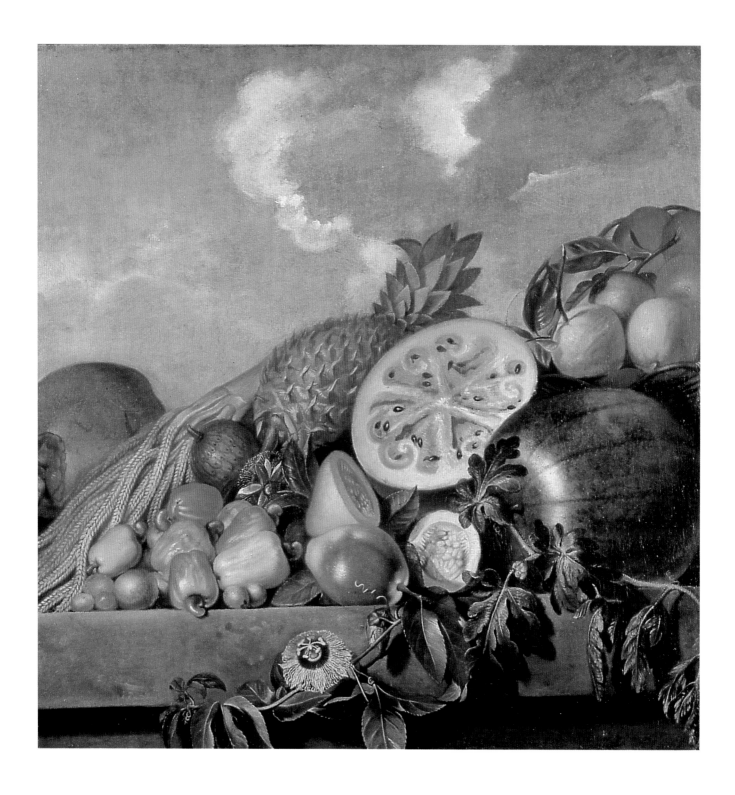

24. ALBERT ECKHOUT *Still Life with Tropical Fruits*, ca. 1641. Oil on canvas, 93 x 90 cm.
National Museum of Denmark, Copenhagen

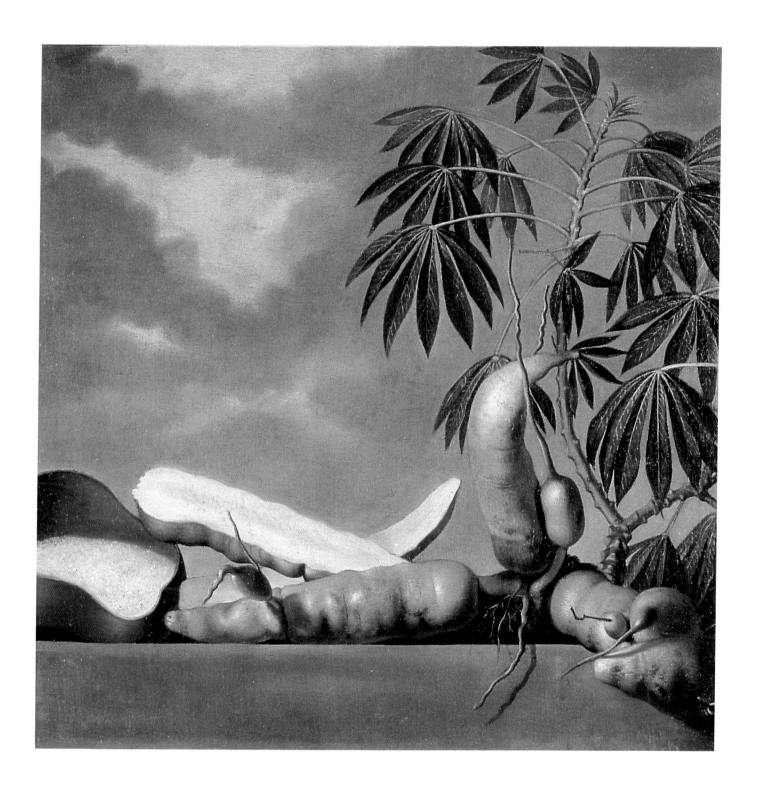

25. ALBERT ECKHOUT *Still Life with Manioc*, ca. 1641. Oil on canvas, 93 x 90 cm. National Museum of Denmark, Copenhagen

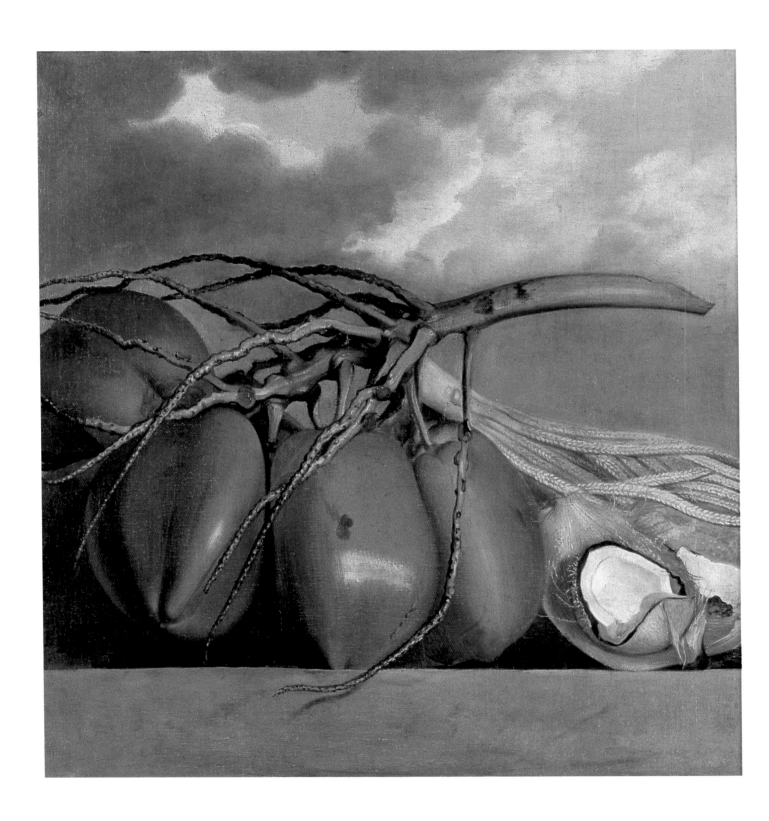

26. ALBERT ECKHOUT *Still Life with Coconuts*, 1641. Oil on canvas, 96 x 90 cm.
National Museum of Denmark, Copenhagen

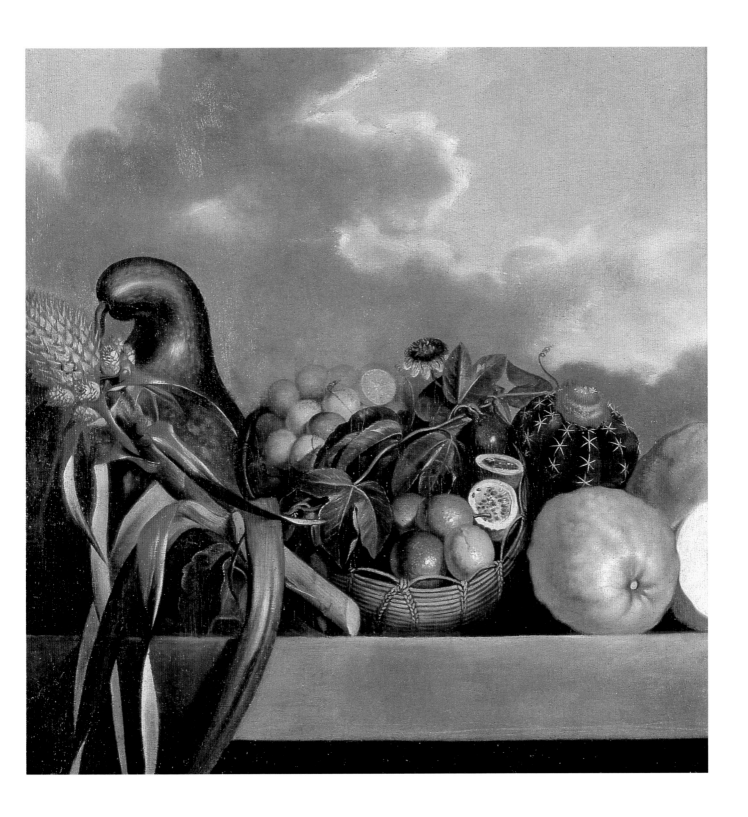

27. ALBERT ECKHOUT *Still Life with Gourds, Fruit, and Cactus,* ca. 1641. Oil on canvas, 98 x 90 cm.
National Museum of Denmark, Copenhagen

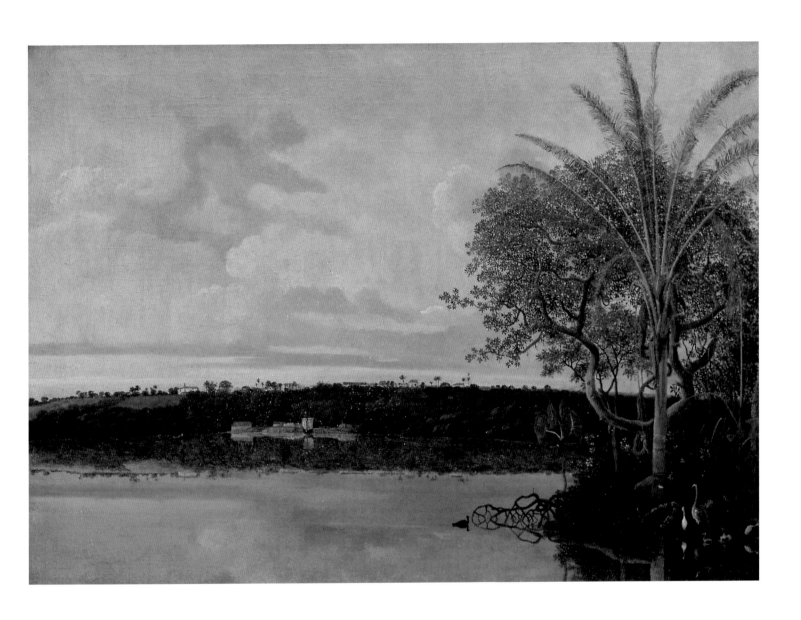

28. FRANS POST *View of the Town and Homestead of Frederick in Paraíba, Brazil*, 1638. Oil on canvas, 61.6 x 85.1 cm.

Collection of Patricia Phelps de Cisneros, Caracas

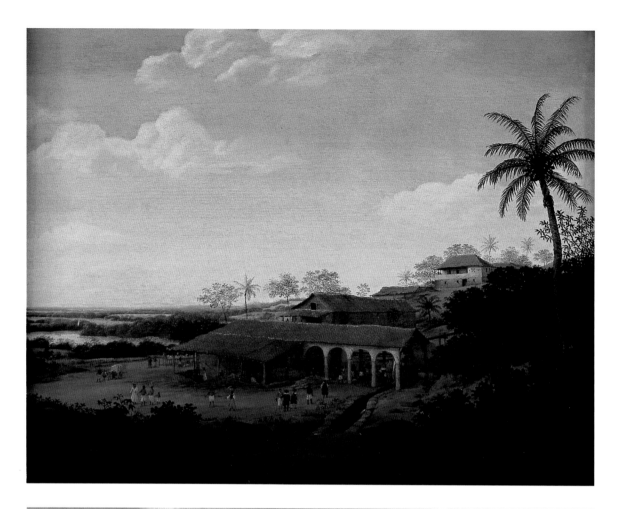

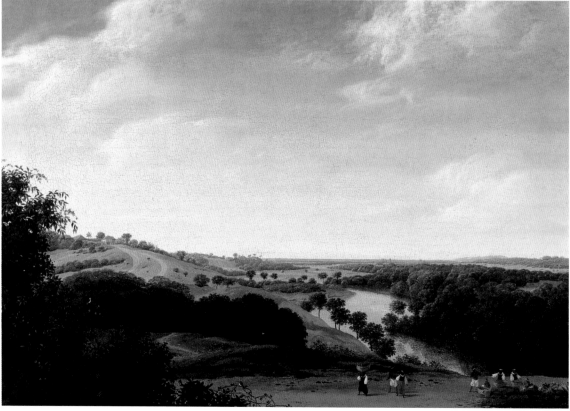

TOP: **29. FRANS POST** *Sugar Plantation*, 1661. Oil on wood, 43 x 48 cm. Collection of Beatriz and Mário Pimenta Camargo, São Paulo. BOTTOM: **30. FRANS POST** *Brazilian Landscape*, 17th century. Oil on canvas, 63 x 93.5 cm. Fundação Maria Luisa e Oscar Americano, São Paulo

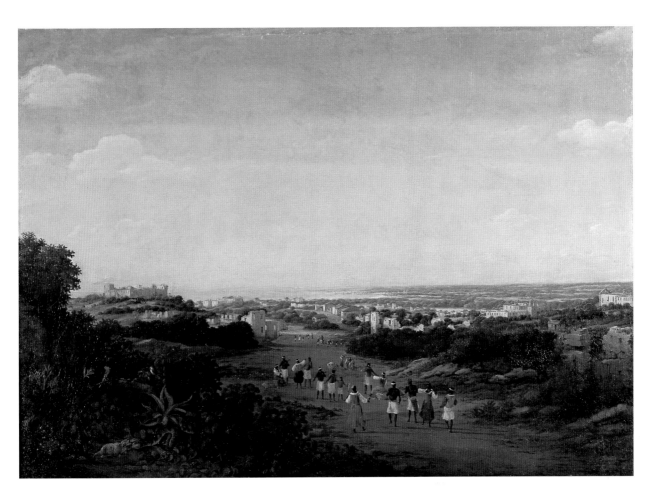

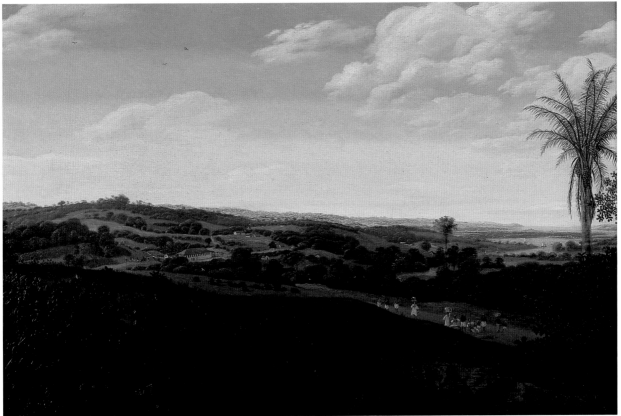

TOP: 31. FRANS POST *View of Olinda*, 17th century. Oil on canvas, 79 x 111.5 cm. Museu Nacional de Belas Artes Collection, Rio de Janeiro. BOTTOM: 32. FRANS POST *Brazilian Landscape with Procession*, ca. 1644–59. Oil on wood, 47 x 67 cm. Collection of Beatriz and Mário Pimenta Camargo, São Paulo

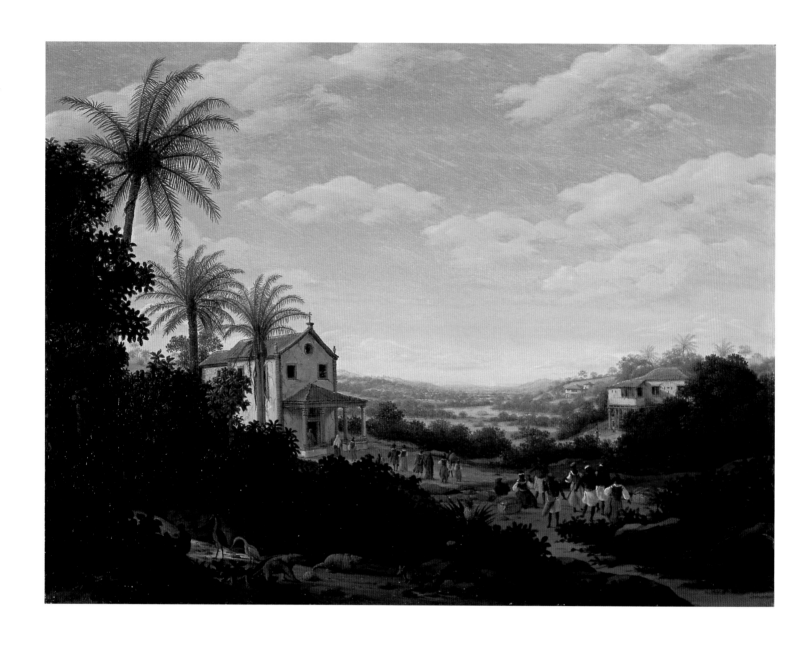

33. FRANS POST *Brazilian Landscape with Dancing Natives and a Chapel*, 17th century. Oil on wood, 43.2 x 57.8 cm.
Collection of Patricia Phelps de Cisneros, Caracas

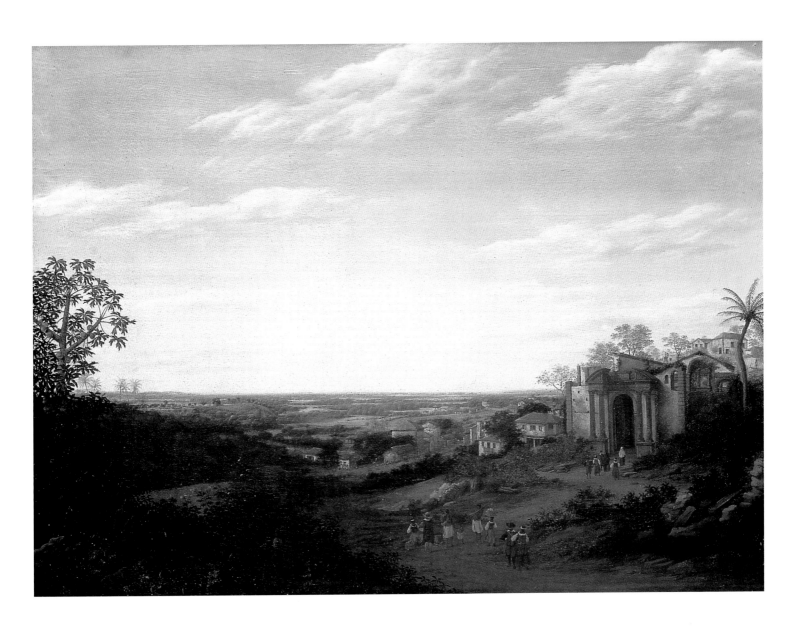

34. FRANS POST *Ruins of the See of Olinda*, ca. 1660s. Oil on canvas, 86 x 114 cm. Instituto Histórico e Geográfico Brasileiro
Collection, Rio de Janeiro

Baroque

Brazil

The Baroque Culture of Brazil

Affonso Ávila

The Baroque was in its own time what might be called an art of consumption. The late seventeenth and eighteenth centuries in Europe were marked by the historical and cultural contingencies of the confrontation between the Reformation and Counter-Reformation. The cultural context and lines of aesthetic construction during this period were derived from the genius of Michelangelo, who according to Nikolaus Pevsner was the "father of the Baroque." Here, "consumption" might be understood as a cultural concept involving the circularity of representative forms and functions drawn from the mindset, religious life, and even the socioeconomic structures that existed both on a collective and individual level. For this essay, which is aimed at providing information to a diverse and inquisitive audience, it seems important to remember the origin of the word "Baroque." In art history, the term either arose from the designation for an arcane form of scholarly reasoning or was suggested by a similarly named, irregularly shaped pearl that was brought to Europe by Portuguese and Spanish explorers.

The semantic analogy, in either case, created a negative impression of the period in terms of Classical or Renaissance rules and standards of beauty that were in favor at the time, and which had governed the imagination, tastes, and formal aspects until that point. From the perspective of a civilization seized by this brilliant new style, it should be pointed out that amid the Baroque revolution of creative originality, the Spaniard Baltasar Gracián was already codifying in his *The Wit and Art of Genius* not only the formal principles of the Baroque in the visual arts and literature but also the conflicted attitude that had created it from the paradoxes of a consciousness steeped in religion, the coercions of an absolutist sense of power, and, by contrast, humanity's irrepressible sensuality and the artist's own identity during this turbulent period in history.

It is true that the semantic and reductive aspect of the term later became fixed within the cultural vocabulary, and that even the poet and great ecumenical thinker Goethe repudiated it in 1786: a date contemporaneous with the surviving branch of Latin American Baroque and with the greatest of its works, such as the two Franciscan chapels in Ouro Prêto and São João del-Rei, and the Brazilian, tropical representations of the Stations of the Cross and the Prophets at Congonhas by O Aleijadinho (Antônio Francisco Lisboa). In *The Italian Journey*, the author of *Faust* called the phenomenon "Baroque excrescence," only making an exception for the works of "father" Michelangelo. The reaction of this reformist luminary is not surprising, given that in Latin America, even in Brazil, the Baroque would experience more than a century of "obscurantist terror" at the hands of the critics.

However, the surfaces and dimensions of the Baroque in its Latin American and Brazilian, and more specifically, Baroque-Rococo manifestations from the region of Minas Gerais, continue to provide a captivating cultural or consumer asset in general terms of research and tourism, as well as in terms of its metabolizing function as a spiritual or intellectual distinguishing element for national and/or continental identity. Although *Brazil: Body and Soul*, as exhibition and publication, has provided an opportunity for stylistic and creative focus, there is hardly enough space to specifically touch on, analyze, and qualify all the major examples of architecture, sculpture, woodwork, painting, and so on. Nevertheless, consideration of the individual works in isolation or as a whole should enable us to grasp the visual-architectonic representation of the High Baroque during its culmination in this hemisphere. One or more of the remarkable examples, both in terms of form and grace of conception, could or should figure in our citations; however, one cannot hierarchically dissociate or isolate, in the specter of a given cultural process, fractions of signification and creation as opposing or irreconcilable niches within civilization's framework of epochal changes and transformations or of more permanently synchronic perspectives.

When, as a youth, dissatisfied with empty truths and rebelling against nebulous questions, I directed myself toward the open field of study that was the Baroque. This implied using the peaceful and accommodating approach of the researcher, who, especially in the spheres of Brazilian academia and preservation, almost instinctively maintains a scrutinizing gaze only when faced with an artistic monument's interior and surroundings, its environment. I may have rebelled against this confining academic approach more as a result of my own multicultural background than because of mere intellectual censure. That approach, perhaps as a result of critical or historical shortcomings, ignored the broader horizons of cultural phenomenology. Within the privileged scenario of Baroque monumentalism, where was I to place humanity and society's active and participatory organism of rituals, dramas, and leisure activities, as well as privations. Should not "environment" also involve spirit, intellect, and lifestyle? I conducted factual research in a localized manner, focusing on churches and convents, and concluded—with the support of those rare studies that fortuitously provided traces of the literary Baroque, the musical Baroque, and the Baroque of theater and ritual—that the Baroque, either at its European source or in its Latin American or Brazilian tropicalization, was a culture of original and intrinsic breadth.

The main lines of this process of circularity, and the consummate victory of a culture that came to breathe and typically express itself as the Baroque, in all its peculiar significations and characteristics, were founded on three bases: catechism, education, and spiritual or temporal power. The religious and secular organizations undertook this task with noteworthy

confessional and institutional applications, which, in Latin America and Brazil, depended on the material and political consolidation of the Iberian conquest and establishment of the new, tropical territories. The three modes of "sowing" (a choice word used by Father Antônio Vieira, an extremely Baroque writer) established the Tridentine spirit and way of life in Brazil, a colony that was, in principle, seen as inhospitable, but considered by many travelers and scholars of the time as a "vision of Paradise," in the words of historian Sergio Buarque de Hollanda. It was a time in history when, as a result of navigational adventures and the expansion of the traditional map of the world with new spaces, extraordinary value was placed on utopian projects and prospects. This utopianism was in response to both a late-medieval sense of anxiety and to the idealistic and recuperative image of an Eden whose loss provoked, for the primeval biblical understanding, an entire civilizing plan that had become stigmatized by misfortune and turbulence. For a humanity situated between and confounded by paradoxes and paroxysms, the Baroque completely embodied, breathed, and expressed, through its ideological and cultural channels, the duality of apprehension and hope that was essentially a fusion of devotional spirituality (Paradise) and irrepressible terrestrialization of the senses (the forbidden union of Adam and Eve).

Keeping in mind an image of Brazil during the seventeenth and eighteenth centuries, or even during the sixteenth century, the century of discovery, it can be said that the sentiment that drove the first anonymous bricklayer to build the first church drove others to build the convents, monasteries, colleges, and churches—which had internal facilities for theological training, spiritual devotion, and meditation and external missions for liturgy, preaching, and catechism—along the eastern swath and adjacent areas of Brazil, disseminating a form of coastal Baroque from the north to south. This form of the Baroque spread faith, knowledge, and standards for ethical behavior and recreation. Along with this first modality of explicit cultural insemination of the Baroque along the coasts, a second modality was expanding in a more basic and dispersed fashion into the hinterlands and frontiers. This second modality added to the construction of forts and other demarcations of conquest the activity of missionaries and the building of rural and rustic chapels, all in a mimetic form that was not moderated by the stoicism of the courageous fathers and friars—many of whom were schoolmasters or self-taught artisans—in the face of the determined Jesuit militia and the material detachment of the Franciscans.

The third modality, which was reasserted by faith in a surprising residual advance of the Baroque, occurred on a culturally more elevated and cohesive level among the insulated, mountainous gold and diamond mines of Minas Gerais. Seventeenth-century applications were made—motivated by the need for urban and social establishments in a territory closed off to standard confessional orders—in a pact between political and religious authorities. It is true, however, that elements of the coastal Baroque of the ports and eastern centers of population, as well as those of a quantifiably and qualifiably more urban Baroque, could be found here given the greater potential for investment among the mining centers. In addition, there was a constructive and ideological or social segmentation of a more elitist nature, together with more populist institutional and devotional elements, with less power to initiate and undertake works in architecture or the visual arts. Given the absence of standard religious orders—which were impeded from having any activity in the mining territory by decree of the royal authorities, who were fearful of contraband organized under the

LEFT: Pilgrimage with processional image of Christ at the late-18th-century sanctuary of Bom Jesus do Livramento in Liberdade, Minas Gerais. RIGHT: Title page for *Áureo Trono Episcopal* (Lisbon, 1748), which describes festivities marking the establishment of the bishop primate for Minas Gerais

AUREO THRONO
EPISCOPAL,
COLLOCADO NAS MINAS DO OURO,
O U
Noticia breve da Creação do novo Bispado Marianense, da sua felicissima posse, e impossa entrada do seu meriissimo, primeiro Bispo, e da jornada, que fez do Maranhão,
O EXCELLENTISSIMO, E REVERENDISSIMO
SENHOR
D. Fr. MANOEL
DA CRUZ,
Com a Collecção de algumas obras Academicas, e outras, que se fizerão na dita função,
AUTHOR ANONYMO,
Dedicado ao
ILLUSTRISSIMO PATRIARCA
S. BERNARDO,
E dado à luz por
FRANCISCO RIBEIRO
DA SILVA,
Clerigo Presbytero, e Conego da nova Sé Marianense.

LISBOA,
Na Officina de MIGUEL MANESCAL DA COSTA, preffor do Santo Officio. Anno 1749.
Com todas as licenças necessarias.

protection of canonic right—religious structure and practice in Minas Gerais was in the control of lay-religious associations, which were secular and not entirely confessional in nature, comprising community parish churches, as well as brotherhood and Third Order chapels. Within the area dominated by coastal Baroque, the catalyst for expansion used official means of closing off areas for dominion, inevitably under armed expulsion, as was the case with the Jesuits, who during the mid-eighteenth century became absolute masters of the vast Mission Territory in southern Brazil.

There was reason for the politically adopted vigilance of mining regions since these were economic and social areas containing a repository of wealth that was exposed to the risk of contraband and external strategies, which in fact often included the complicity of international religious orders. Once the circumscribed limitations were put in place in Minas Gerais, as well as in other regions in Brazil and Latin America, the structure of ethical and spiritual organization and the definition of lifestyle and forms of collective social leadership—or even the organic nature of culture within this Atlantic, trop-

ical environment with its own artistic and intellectual idioms—did not generally differ very much in its own nature and adaptive responses to our way of living, feeling, and expressing ourselves. Eighteenth-century urban life was marked by the peculiar feature of industries of mineral extraction and commercial transport, whereas seventeenth-century ports and cities were characterized by the dominant agrarian economy. This influenced the tone, aspect, and rhythm of affiliation with both original and assimilated forms of the Baroque. As was natural, the church presided with its dogmas, values, and rituals over individual and community life. Its liturgical calendar and schedule of seasonal and sporadic festivities governed events of not only a devotional or congregational nature but also of a permanent or ephemeral nature within the cultural and artistic circle—all stamped with the persuasive and ludic processes of the residual Baroque.

Simple parish churches, convents, and the more exalted churches of both wealthy and humble orders played an important role during the seventeenth and eighteenth centuries in the rise of coastal and mountain urban areas by serving as

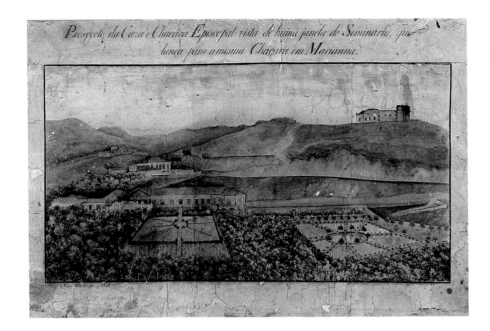

View of the Episcopal Palace, Mariana, Minas Gerais, with
Farm and Gardens (1809), a watercolor by José Joaquim
Viégas de Menezes

factors for demographic concentration and establishment, as well as for the founding of population centers in agrarian areas. The fundamental activity of these religious agents, along with the influence of organized bureaucracy and trade, was undoubtedly that of attracting, congregating, and stimulating new forms of social and community life. The work to which I have devoted myself for the past years, *Festa barroca: Um indicador de mentalidade* (The Baroque festival: An intellectual and spiritual indicator), has given me the opportunity to focus on events or paradigms in colonial Brazil and, by extension, in the Iberian peninsula and the rest of Latin America as prime channels for the enunciation and communication of culture, exemplified in the festivities held in the cities of Porto, Mexico City, Bahia, Pernambuco, Rio de Janeiro, and, on a more programmatic and collective level, in the region of Minas Gerais. These events in general displayed the underlying playful nature of the Baroque spirit by stimulating the ruling class and workers and servants, in addition to church and civil authorities, to employ every innate talent for a moment of mere enjoyment or of pious exaltation. In the exceptional case of the *Capitania de ouro e dos diamantes* (Captaincy of gold and diamonds), liturgi-

cal, civic-religious, and other circumstantial events enabled groups of people involved either in a dominant, intermediary, or servile position in the social pact of mineral exploitation the opportunity to suspend the "order of things" and enjoy a social and spiritual respite from the harsh project of the arduous and impious drudgery of economic ambition and exploration.

In the chronicle of colonial Brazilian history, reference should be made to several major social festivities imbued with the Baroque legacy. In 1748, signaling the establishment of the bishop primate for the region of Minas Gerais, a procession arrived in the city of Mariana, with its princely retinue—musicians, chaplains, masters of ceremony, poets, and church orators—from the distant bishopric of São Luís do Maranhão. The journey, lasting a year and two months, through inhospitable wilderness established the first cult festival in the regional history of Minas Gerais. This festival not only featured ceremonies of a liturgical or ritual nature, but also courtly and street pageantry that combined music, dance, theater, and poetry and included the participation of blacks and indigenous peoples. With regard to the use of poetry in popular gatherings and events in Minas Gerais, the region had its creative

LEFT: Print showing funeral obelisk for João V (1750–51) at the cathedral of Nossa Senhora do Pilar, São João del-Rei, Minas Gerais. RIGHT: Title page for *Triunfo Eucaristico* (Lisbon, 1734), which describes the Triumph of the Eucharist celebration in Ouro Prêto in 1733

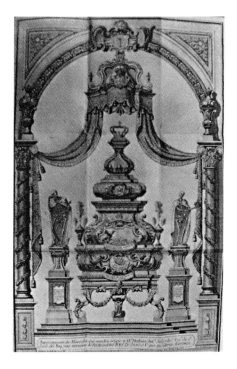

culmination in celebrations three years later commemorating the death of João V in what is now the cathedral of Nossa Senhora do Pilar in São João del-Rei. These events featured the personal appearance of a noteworthy but nearly unknown Luso-Brazilian poet, Mathias Antônio Salgado. To this day, no festival of a religious and popular nature has compared with the renowned celebration of the Triumph of the Eucharist, which is a triumph of faith and society, and which initially evidenced a desire for or even a premonition of the solidifying sense of nationhood. Without any status or class distinctions, the celebration marked the inauguration of a new parish church (also an invocation of the Virgin of Pilar) in Ouro Prêto in 1733 and provided a democratic meeting point for whites, blacks, and mestizos in an effusive display of joy and playful exuberance that can only be compared with the monumental, cyclical parade of Carnival in Rio de Janeiro. If wealth clashed with poverty, Baroque cultural circularity was able to reconcile them, as it is still able to in its residual form, by means of a two-hundred-year-old complex of hemispheric identity and of Brazilian identity in all of its inexhaustible outpourings. Religious pilgrim-

ages, rural and urban commemorations of atonement, and mass cultural expressions still exist with the characteristic flourishes and motifs of the Baroque.

The Four Cornerstones

Having concluded my general introduction to Brazilian Baroque culture, I will now focus, in my own personal way, on the connecting links between Brazilian Baroque and its stylistic sources in Europe and its tropical variants throughout Latin America. I will review the categories that are called—on the basis of analyses by pioneering scholars in the field and, somewhat immodestly, my own particular observations over a long career of study—the four cornerstones upon which the formal and ideological system for the identification and autonomous definition of the Baroque phenomenon is based.[1]

The first cornerstone is *persuasive intention and impact*. It resulted from the Counter-Reformist doctrine decreed by the Council of Trent (1545–63). Along with the historical sponsorship, opportunism, and absolutist sanction defined by the political philosophy of state power as conceived of by Machiavelli, the commercial and bellicose enveloping of the voyages of

discovery and conquest, and the confessional enveloping of the Jesuits and other orders, this doctrine led to an extraordinary configuration of internal European resistance and, later, to the sedimentary activity of geographic expansion.

The second cornerstone is *primacy of the visual*. Assuming, by extension of the art of persuasion, an art of service, it was only natural that the Baroque sought, as an instrument for immediate communication—to communicate the message of the Counter-Reformation and Absolutism—the primacy of the visual, not only within the realm of artistic creation but also in more peripheral areas relating to lifestyle. This involved a programmatic tendency toward the use of optic suggestion, the captivation of the gaze, in the ritual and ornamentation of the church, in the valorization of color, light, and landscape in visual and architectural space, in theater scenery, as in the works of Spanish playwright Pedro Calderón de la Barca, or even in the ephemeral or contextual choreography within the quotidian or exceptional structure of the social praxis.

The third cornerstone is *geometry of the curve*, or *curving of forms*. In the search for the primacy of the visual, and through an accentuation of the persuasive intention, either by the creator of the work of art or the person receiving the message, the Baroque imposes this third structural element in its visual or written discourse. It has paradigms such as Francesco Borromini in architecture and Antônio Vieira in the bombardment of the literary phrase. This cornerstone also involves the *illusion of masses in motion*—also found in the Borrominian architectonic grammar but a late arrival in the region of Minas Gerais—exemplified by the synesthetic dynamism of Bernini's sculpture, the diagonal perspective of O Aleijadinho's figures in Congonhas, and the invention of illusionist painting in the great ceiling panels by Fra Andrea Pozzo in Rome. By way of addendum, within the framework of the shifting ellipsis of volume and light, in praise of the timeless aspect of the Baroque, and the battle for the sublime in which it was engaged, in the conception of primary Baroque and tropicalized New World Baroque more than a century separates the visually marvelous depictions of Saint Theresa of Avila by Bernini and the prophet Daniel by O Aleijadinho.

The fourth cornerstone is *rebellion through play*. In addition to the three structural segments or layers of the Baroque already noted, there exists an either implicit or explicit prevalence of ludic elements, which are manifested in an instinctual substratum or in the psychology of play, as conceived of by anthropologist and historian Johan Huizinga in his classic book *Homo Ludens*. Ludic influence touched on all aspects of social life during the seventeenth and eighteenth centuries, spreading from Europe to Ibero-America in the form of religious ritual, public diversions, and the production and consumption of artistic and literary creations. This was a rebellion through play, both on the part of artists and Baroque society as a whole, in which, in one case or another, a subjective will to freedom and flight was displayed and directed against the ethical stifling of Counter-Reformist forces—the result of historical pressures—and Absolutism. In 1971, I therefore posited the ideological or philosophical concept of the ludic pact as one of the characteristics that defined the Baroque historical and cultural phenomenon.

The Process of Cultural Circularity

By charting, classifying, analyzing, and thereby circumscribing or expanding on the specific signs of the period or those that were spread by the historical and cultural movements and strategies of seminal or disseminated Baroque, it is possible to arrive at a vector of greater scientific coherence, which, not merely based on opinion, will explain the Baroque phenomenon for our enlightenment and knowledge.

Without a critical structure, as opposed to the previous amateur whims of academic and extracurricular contradiction, this vector, which is in a preliminary phase of methodological systemization, would be little more than an academic caprice in a field that is always open to suggestion within a wide range of reception and judgment. Marked by curved movement, in the style of Borromini and the Spanish poet Luis de Góngora y Argote, or, if one prefers, draped in folds of innate Deleuzian verbal charm, the legacy of a more frigid sensibility of a Gothic-Frankish vein, the Baroque is only sensual in theory. I have pointed out semiotic and intersemiotic channels, frequencies, and pitches, which may be characterized as relating to cultural circularity. This pertains to the identification and deciphering of mobile processes by means of transmigration, distribution, reception, assimilation, canonization, and the transformational reduction of models, paradigms, and persistent elements of a formative, ideological, and behavioral nature within a geographical framework as manifested in lifestyle and artistic, literary, and ludic ritual representations. All of this is characterized by cultural curves, whose circularity can be described as high, medium, or low.

Within the original framework of the Baroque—Europe—the interrelationship of stylistic tendencies, paradigms, and hegemonic structures emerged with a significant geographic rhythm that was able to transform a language and mindset already exposed to Mannerist transition and the ideological impulse of the Counter-Reformation: a process of cultural circularity that may only be historically comparable to the dogmatic but seductive expansion of the first wave of Christianity. Fostered by a sort of *crise de conscience* resulting from the irrevocable subjectivist idealism of the Renaissance and the new cosmic consciousness of the scientific revolution, the Catholic and fideist machine in Rome articulated a reaction, with its

own implicit propagandist contours, that fatally provoked a striking cultural response given the spiritual and political power that the church still wielded within its traditional domain. The decrees emanating from Trent sought to impose a strategy for extreme political control based on programs reaffirming the church's dogmas and influence—programs in which the arts, offering such enchantments as new magnificent spaces, architectonic volumes, and allegorical images of saintliness, played a decisive role and function.

While this tactic had an immediate effect within the realm of the Catholic church, it also cut open breaches in the Lutheran ranks, with the successive establishment of Counter-Reformist enclaves, principally in Central Europe: Bavaria, Bohemia, Prague, and other centers and regions, where sumptuous new monasteries and churches were constructed, enriched by the unique creative idioms offered in the arts. These artistic solutions were imbued with "nationalistic fantasies," in Heinrich Wölfflin's words, and after later reaching the Iberian peninsula, underwent their own social and architectural transmigrations, through the tropical extremities of the European continent, and eventually in forms and influences that were appropriate to the new tropical domains under conquest in the Americas. This nostalgic sense of triumph was politically correct in terms of the circumstances experienced in Rome at the time. It was not tied to a persuasive formal victory, marked by the impact of monumental works, but flowed into and inflated, through ritual and cultural representation, the entire lifestyle of those people who were loyal to the Catholic church or, more emphatically, were conveniently co-opted.

Amid this assault, which was also manifested economically by the fervor of initial strides toward the Industrial Revolution, the church used the Tridentine decrees to terrestrialize the

religious spirit. Approximations were made not between God and humans, as in medieval or Gothic triumphalism—symbolized in cathedral arches—but between God and his entourage of saints and angels, brought into an everyday, colloquial context and transformed into, for example, the characters and walk-ons in the sacramental play *El gran teatro del mundo* by Calderón, which was staged as a biblical *memento homo* with ornamental scenery comprising imagery and temples. Or they were placed in installations and performances, in the Horatian carpe diem of the "spectacle that transcends the art of the ephemeral" (Wölfflin) of courtly or popular ludic dynamics—such as the noble theater of Molière at Versailles or the rural festive backdrop of Góngora's *Soledades*—or in the staged corrals and arenas of itinerant pieces by Calderón, Lope de Vega, and Francisco de Rojas Zorrilla. For all of these, the power of the new, the feeling of unfamiliarity and the captivation of the senses, which broke with the authority of Classical stability or Mannerist appeasement, went beyond the incantatory and persuasive intention of the Counter-Reformist program and invaded the homogenizing terrain of the Reformation's nonaesthetic rationalism. With a mystical inspiration that was more Lutheran than Catholic, Johann Sebastian Bach, a prototypical Baroque musician as well as an organist for Protestant chapels, left us works of intense evangelical emotion, as in the *Saint John Passion* and *Saint Matthew Passion*.

Some lower- or minor-grade curves of this cultural circularity, such as those of a popular rural or urban dynamic, to which might be added Góngora's series of sung *letrillas* (short verses) or the multiple architectonic elements employed in devotional processions, or those of a middle grade, such as courtly rituals and ceremonies, can be said, as with Bach, to register within the European frequency of high circularity. This classifying distance, which expresses,

defines, and disseminates the superior paradigms of Baroque creativity and invention in terms of stylistic identity, extrapolates the original Tridentine design for the Baroque and posits it within a circle of greater diametric proportions, within a semantic, intersemiotic, and ecumenically influenced sphere. Forms expand and interpenetrate in linguistic versions, "nationalistic fantasies," and agglutinations of a visual-architectonic nature or in literature, ideas, imagery, receptive taste, approximations, and similarities, which are linked to a pathos of Baroque intercourse. As incidental examples within a typological and geographic repertory that has not yet been duly analyzed, one which synchronically incorporates a variety of legacies, there are, in the realm of architecture, not only the sophisticated example of Versailles, where Louis XIV capriciously injected a shot of adrenaline into the flaccid, ethnically insensitive veins of the Cartesian and utterly un-Baroque ancestral French temperament, but, more important, the shift toward conceptual exuberance or transnationalization of the Italians Nasoni and Bibiana, the German-Italian Ludovice, or the Hungarian-born Mardel, within the sphere of Iberian architectonic grammar.

The Survival of the Baroque
While in decline in Europe, but still carrying as its baggage a circular nexus of flourishes, a sort of Baedeker, the Baroque undertook its most important enterprise, its leap across the Atlantic, an encounter between the Europeanized and sacralized West—despite the ideological-religious and political-economic antimonies already emphasized—and the new, rudimentary, and purportedly primitive West, the *American* West, punctuated by sediments of pre-Columbian civilizations unimagined by the so-called discoverers. The transport of the Baroque to this immense continent between two oceans, which would be baptized Ibero-America or Latin America,

despite or, perhaps, because of the armed assault of the conquest, gave the style an afterlife, which—given the initial preparation, in terms of spirit and taste, by the Mannerist elements that had anchored in Latin America after the first century of occupation—adapted an artistic inclination and sensibility to the new context and reality. The rise, development, and maturation of the Baroque within its main area of origin, a rather tropicalized region comprising Mediterranean Italy, Spain, and Portugal, gave its lifestyle and creativity a sense of immediate perspective, affirmation, assimilation, and abundance within the new equatorial context.

Expanding on the American horizon for a period of two centuries, including its late germination in the eighteenth century, and followed by the ways of seeing, feeling, and formulating of its partner, the Rococo, the cultural phenomenon referred to as High Baroque can be limited to and defined by its links. This can be done not only in terms of co-opting original paradigms but also in terms of the way this Baroque became enriched by the peculiar, autochthonous accretions imposed on it in the New World by even more tropical and impetuous use of imagination and inventiveness than was seen at its European source.

The process of cultural circularity applied to the American context of the Baroque rests on three primary lines: expansion, establishment of style, and, at its height, as stated by José Lezama Lima[2] and reiterated by many other scholars in their own way: Equatorial Baroque. This phenomenon of Equatorial Baroque, which was appropriated and endowed with different formal and semantic properties is, in terms of historic or synchronic vectors, a response by the colonized to the colonizers. Lezama Lima also, perhaps unwittingly, supported the philosophical or anthropological theory of anthropophagy put forth by the Brazilian Modernist Oswald de Andrade: the devouring, swallowing, and digesting of imported cultural elements.

Latin-American Baroque—consisting of Central-Continental Baroque, primarily in New Spain (Mexico); Andean Baroque, in areas along the Pacific, most notably Ecuador and Peru; and Southern-Atlantic Baroque, in the Brazilian coastal areas and interior, with its main fulcrum for two hundred years located along the Bahia-Minas Gerais axis—can be compared to the three structural "panels," or elements, of a retable. This retable has niches that are at times expressionistic, supporting elements rooted in Europe, and at times impressionistic and that combine with the insertion of autochthonous, tropical elements in a final expression of emancipating forms and signs that bestow new vitality and beauty. The determining factor for this montage within one composite unit of differences, culminating in the summation of a new process of being, feeling, and formulating, was undoubtedly an accomplishment of the ideal of the Counter-Reformation, in its alliance with power, which at that point took the form of the absolutist Luso-Spanish Empire, in which the Jesuits and other orders, all within their regulated spheres of influence and activity, undertook, against the natural indigenous resistance of a primitive or symbolic and exotic order, their mission to implant both in the mind and in artistic representation content that could not be questioned.

First Panel: At first, nostalgia among members of the Iberian court, especially in Mexico, led to a pursuit of spectacular solutions, transplanting—as an initial, mimetic step in the circularity of culture—rituals, guiding principles, hierarchic postures, and decisions in taste, translated as metaphor, as solemn and imbued with power as possible, in place of the original monarchical structure. The viceroy managed to rival in social and spiritual exaltation the pomp and circumstance of the royal house of Spain. This prime moment

of cultural reflectivity, as celebrated by Octavio Paz, under the mimicking splendor of the autonomous court in Mexico was characterized by the refinement of churches and monasteries and the revival of intellectual life through establishment of a national university and printing press, dominated by such luminaries as Sor Juana Inés de la Cruz and Carlos de Siguenza y Góngora, nephew of the poet of *Soledades*. Festivities accompanied the resplendent activities of the court, and at least two events merit particular mention due to their exceptional nature: the inauguration of the Conceptionist Convent, and the poetry competition sponsored by the University of Mexico in honor of the Immaculate Conception, both of which date from the late seventeenth century and were presided over by Cruz and Siguenza.

The pomp of Spanish Mexico, in Baroque content and context, accompanied the refined lifestyle of the time and extended to the viceroyalty of Peru. Indigenous populations were not entirely marginalized as they had already been co-opted by the church. The festival of Corpus Christi, celebrated in Cuzco during the same period, documented in the form of two immense Baroque paintings, the inherent ludic exuberance that infused Ibero-American religious life. On the basis of descriptions and the pictorial narrative that have survived to this day, the celebration in Cuzco emulated, from half a century earlier, the greatest spectacle of this type, a monumental Baroque performance of the ephemeral, the Triumph of the Eucharist, in Ouro Prêto in 1733 for the inauguration of the new parish church of Nossa Senhora do Pilar.[3]

Second Panel: Within the realm of Ibero-American visual arts and architecture, the record must be set straight concerning the supposed lack of exchange and underlying connections between the creative works in Hispanic America and those in Luso America. As the importance of monastic and secular organizations has already been made clear, it is appropriate to emphasize, as supported by Leopoldo Castedo, Graziano Gasparini, Ramón Gutiérrez, and other scholars, the concept of cultural circularity, either in isolated or far-reaching instances, as seen in models such as heavily ornamented facades or retables, which display simultaneous evidence of contributions from the remote Plateresque style, the use of Churrigueresque motifs, or more contemporary Spanish influences alongside elements of indigenous pre-Columbian imagery, as in the noteworthy example of the Iglesia de la Compañía in Arequipa, Peru, or the church in Tepotzlán, Mexico, or the church of San Lorenzo in Potosí, Bolivia.

This Baroque-American miscegenation, as it were, is not restricted to designs in the Spanish idiom of the Central Andes. Examples of equal semiotic exuberance exist in Brazil, such as the Franciscan complex in Salvador, Bahia, which Riccardo Averini selected as the central icon for his now classic theory of "Baroque tropicality"; his doing so is not surprising as that tropical architectural complex marked the decisive point for the insertion of African elements and sensibility. (Given the implicit syncretic implications, it is possible to speak of the existence of a Black Baroque in Bahia—an idea that is not uniquely my own—in contrast to a White Baroque in Minas Gerais, which was also tempered by a strong mulatto presence.) Also, it is during this tropical and turbulent period of expression in seventeenth-century Bahia that the concept of "tropical Brazilian divergence" is put forth by major authors writing within the Portuguese Baroque literary tradition: the Luso-Bahian sermonizer Father Antônio Vieira and poet Gregório de Matos.

Third Panel (the crowning point of our American Baroque retable): The period of circularity ended with the importation and diffusion of models and finished

Festival of Saint Anthony with performance of Afro-Brazilian dance *congado* in front of early-18th-century church in Itaverava, Minas Gerais

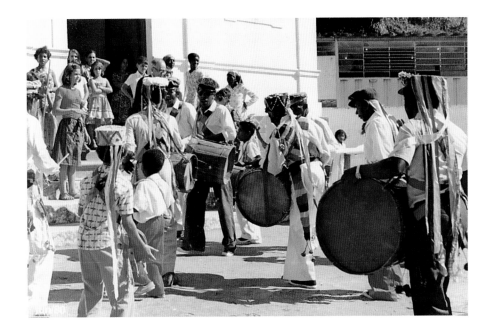

works of painting and sculpture, which originated from Iberian and even Roman artists and ateliers—as demonstrated in the research now being undertaken by Luis de Moura Sobral, Victor Serrão, Myriam Andrade Ribeiro de Oliveira, and Lygia Costa in the current study of Luso-Brazilian Baroque—in exchange for sugar and, later, gold. The discovery of gold and diamonds in a mountainous region with a Mediterranean climate in colonial Brazil resulted in an extraordinary migratory influx and settlement of people, including artists trained in regional schools with their own original styles. The gold rush in Minas Gerais fostered the growth of Baroque and Baroque-Rococo culture in their Atlantic leap of survival into the Americas. This resulted in a creative crystallization of a legacy of Western art through its various periods and centuries, which, according to Germain Bazin, culminated in the work of O Aleijadinho—in the Franciscan churches of Ouro Prêto and São João del-Rei, the sculptures of the Prophets and the Stations of the Cross in Congonhas, and an imposing griffe of retables and imagery—as well as in the works of many other great artists, such as the painter Manoel da Costa Ataíde, the sculptor Francisco Vieira Servas, and the architect Lima Cerqueira.

Minas Gerais was the first region in the Americas to undergo extensive and well-thought-out urban planning: a network of major and smaller urban areas provided with centers for culture, learning, and recreation; theater, music, literature, artisan-training workshops under the patronage of Third Order brotherhoods; roadside pilgrimage sites with hundreds of extraordinary religious constructions; and even a political project for a possible independent nation, within the mature socioideological context of Baroque humanism: the so-called *Inconfidência*. All of this amounts to an extremely propitious locus for a case study of the final stages of Baroque cultural circularity, which should provide encouraging perspectives for new specialists. Latin-tropical identity—with contradictory tendencies at once idealistic and dramatic but lured by the same dream—has been focused on the current and residual question of the Neo-Baroque, whether posited by Severo Sarduy or Carmen Bustillo, as part of the essential synchronic mindset of our times, whether it be psycho-Baroque or anthropo-Baroque. Analyzed in particular in Hispano-American poetry and prose, this tendency can also be found in the wealth of Baroque sediment in Minas Gerais or in the influences extending to

the written works of Guimarães Rosa (for example, *Grande sertão: Veredas*) and the architectural works of Oscar Niemeyer (in Pampúlha and Brasília). We should also not forget the links to extraordinarily resonant works within the Neo-Baroque idiom that are being produced in Brazil today (for example, *Galáxias* by Haroldo de Campos), the anthropological phenomenon of social carnivalization (in Bahia, with its erotic and Gregorian roots), and the visual proliferation in urban areas of organized and creative chaos (in the Favela da Rocinha in Rio de Janeiro).

My purpose in this essay has been to provide a synthesis of the historical and ongoing process of franchising of the Baroque, of the High Baroque, which was able to contaminate its contiguities with expression and meaning. This cannot be understood through the mere random caprices of semiotic theory, but rather through a more scientific reading, through the research and interpretation of the *curves* in forms and signs on an intersemiotic and interdisciplinary level. It can only be achieved by a compatible study of cultural circularity.

Translated from the Portuguese by
Regina Alfarano and David Auerbach.

Notes

1. See my initial studies in Affonso Ávila, *Resíduos seiscentistas em Minas*, with the critical edition of *Triunfo Eucarístico* (Lisbon, 1734) and *Áureo Trono Episcopal* (Lisbon, 1749), 2 vols. (Belo Horizonte: Universidade Federal de Minas Gerais, 1967).

2. The Cuban José Lezama Lima is the author of the novel *Paraíso* and theoretical essays in *La Expresión americana*, which have been authoritatively annotated by the Brazilian Irlemar Chiampi.

3. See Ávila, *Resíduos seiscentistas em Minas*.

Brazilian Baroque Art

Cristina Ávila

Although the development of the arts in Brazil has been studied by many scholars, including Rodrigo Mello Franco de Andrade, Affonso Ávila, Germain Bazin, John Bury, and Robert Smith there is still a lack of specialized research in a number of areas, ranging from formal aspects to an overall vision of the subject. No real synthesis of the various elements comprising colonial art in Brazil is available. My goal in this essay on sculpture and ceiling painting is to cover some of the basic typologies that have already been identified, in order to further an understanding of the evolution of a period in art that has been widely discussed but whose unique aspects have received little attention. I will consider examples from the seventeenth, eighteenth, and early nineteenth centuries.

With regard to the study of colonial sculpture it is important to understand that it includes two fundamental areas that my essay focuses on: carved wood work, a term used to designate the wood sculpture that adorns altars and other ornamental relief work covering the walls of religious buildings; and statuary, a generic term used in the discussion of religious sculptures made from wood or terracotta. Another category, monumental sculpture in stone, began to achieve decisive importance after the mid-eighteenth century, with the use of soapstone in decorative relief work and in massive statuary, such as that created by O Aleijadinho (Antônio Francisco Lisboa) at Congonhas do Campo, Minas Gerais.

Brazilian Baroque art also includes significant examples in a variety of religious decorative arts (silverwork, lamps, alms dishes, pitchers, basin sets, etc.), furniture, and devotional paintings, or ex-votos, depicting a particular miracle performed by a saint. Such items were often given to churches in compliance with a vow. Finally, in what might be considered a fourth sculptural category, there are the

smaller pieces that are found in oratory chapels throughout Brazil, as well as in urban residences or ranch houses. These objects display traditional European craftsmanship and Afro-Brazilian influences, demonstrating the strength of the transplanted Catholic faith in the Brazilian colony.

Typologies of Sculpture

The characteristic carved-wood retables of the seventeenth century displayed archaic features echoing the Portuguese Romanesque period or adapting Renaissance models. In Brazil these formal principles were transmuted into four tendencies: Mannerist, Portuguese National style, João V style, and Rococo.

Mannerist retables use straight columns with floral decoration on the lower third portion of the column shaft, bordering painted panels or niches with images; they are crowned with capriciously carved pediments, generally containing a panel in the center.

Portuguese National style retables use Romanesque facades, influenced by the Manueline style. It is characterized by the presence of twisted columns, also called torso or Solomonic columns. It is important to remember that the term "Solomonic" was first applied to Bernini's columns at the Vatican, which were traditionally thought to be based on those in Solomon's temple. These columns are crowned by concentric archivolts. There is also a profusion of ornamentation with a preference for phytomorphic elements (such as grapes, acanthus leaves, and trellised vines) and zoomorphic elements (such as birds, generally phoenixes or pelicans). Main altars employ a pyramidal construction called the dais, which is located on the rostrum. These retables have a progressive sense of formal freedom.

In the eighteenth century, with the reign of João V from 1706 to 1750, retable typology begins to evolve. The inspiration for retables in the João V, or Joanine, style and its affiliated Brito style came from

Portugal, with the arrival of two allegorical coaches in 1718 given by Pope Clement VI; their excess in conchoid decoration was later imitated in the design of religious missions. Also used as sources by woodworkers were Portuguese books such as *Perspectiva pictorum et architectorum* (1693–1700) by the Jesuit Andrea Pozzo, who executed the trompe l'oeil ceiling paintings and retables at the churches of Sant'Ignazio and Il Gesù in Rome. His vigorous retable designs feature curved, sectioned pediments adorned with seated angels on both sides; valances in the center; friezes with chain floral motifs flanking the dais; and Solomonic columns. The characteristics of the Joanine retable include crowning with an arch; seated angels on the frontispiece sections; small baldachins; and valances with false tasseled curtains supported by small putti. Angelic figures also serve as visual support elements at the base of the corbeled columns, in the manner of small atlantes. There are also corbeled pilasters and Solomonic columns similar to those of Bernini.

An extension of Joanine style, the so-called Brito style first emerged in 1726 in the Capela da Venerável Ordem Terceira da Penitência in Rio de Janeiro, which was worked on by Manuel de Brito and Francisco Xavier de Brito. Some authors have speculated that these artists shared the same atelier, although it is doubtful they were related. Among their innovations was the use of oval and circular medallions. This style was consolidated in Francisco Xavier de Brito's work in Minas Gerais, especially the completion of the main altar (1746–51) at the parish church of Nossa Senhora do Pilar; in Ouro Prêto, which reveals a greater tendency toward the use of sculpture and ornamentation.

Rococo retables have a heightened sense of architectonic dignity. There is a structural simplification and a reevaluation of the main altar, with the presence of plain arches and crowning, in many cases embellished with great sculptural

compositions, and the predominance of straight columns. Rococo ornamentation is concentrated in the use of sinuous conchoids, bows, flowers, foliage, and so on. Compositions tend to be asymmetrical.

In contrast with carved woodwork—and in our context, retables in particular—the study of Brazilian statuary is still at a preliminary stage. Nevertheless, various typologies can be clearly traced over the centuries. Sixteenth-century statuary is characterized by a rough appearance and little suggestion of movement. Bodies are disproportionately and stiffly rendered, along a geometrically vertical axis. Any sense of movement is concentrated in the knees and arms, while the head is held rigidly and the face tends to have a grave expression completely devoid of drama. Hair is depicted by using parallel or undulating furrows. Drapery follows the structure of the piece, and employs the same verticality. Polychrome work shows little variety and tends toward dark browns, greens, reds, and blues. Pedestals are rather simple.

In seventeenth-century statuary this sense of immobility, rigidity, and geometric structuring continues in simple, static compositions. Massive figures are frontally posed. Drapery is still rendered vertically with straight pleating and angular finishes. The head, out of proportion with the rest of the body, is rigid, and the round face has a sweet, discreet expression. Hair is stylized, ornamental, and uncovered, eyes are painted, feet are shod, pedestals are semicircular. Dark tones continue to characterize polychrome work, which has no gilding and scant use of floral patterns. More bodily movement—a key element in Baroque style—is visible in statuary made toward the end of the century. Clothing is rendered with more stylized draping, and facial expressions are more suggestive of emotion. In the case of depictions of the Virgin, clouds and static cherubs have begun to appear. While still simple in

nature, pedestals are sometimes embellished with rectangular forms.

At the beginning of the eighteenth century, sculpted images are geometrically composed along an axis symmetrically dividing the composition's masses. Faces and clothing have dramatic expression. Clothing now clings to reveal the contours of the body, and there is a timid sense of movement. Cloaks have begun to be pleated to suggest bodily forms. With regard to pictorial decoration, *pastiglio*, gilding, and floral patterns are used. Glass is now inset for eyes. Toward the middle of the century, the qualities of Baroque style are manifested in all their splendor. Works are endowed with a sense of movement that disrupts the rigidity of symmetrically divided masses. This is emphasized by the use of fluttering forms in the drapery, resulting in the so-called wind effect. The body now twists back on itself, and a diagonal relationship is established between its elements. The entire composition is enriched by the suggestion of artificial breeze, for example in the highly refined plaiting of hair, which is sometimes held together with ribbons. Pedestal bases are decorated with volutes, cherubs, conchoids, and so on. Polychrome work is enriched through the use of a variety of tones, heavy gilding, *pastiglio*, and sgrafitto.

After 1760 the rendering of sculpted images was influenced by Rococo stylistics, with the appearance and formal application of lightness, ascending movement, spirituality, and asymmetry. The bodily axis now extends from the nose toward the left foot, diagonalizing the draping of clothing, especially in the case of cloaks. In depictions of the Virgin, cherubs are scattered chaotically, accentuating asymmetry. In Minas Gerais the polychromy on the tropical fruit *rosinhas de Malabar*, which appears as a decorative element, reveals simple, highly refined work. Paint is applied in fine, uniform layers, and discreetly balanced with the gilded work.

During the nineteenth century, with the advent of Neoclassicism, sculpted images have softer features, false torsion, and rigid poses. After 1850 the use of purpurin overtakes that of gold, and countless gesso statues are imported from Europe. These are quickly substituted for the statuary of the Brazilian Baroque period.

Chronological Analysis of Sculpture
The study of seventeenth-century sculpture, as well as the other arts during this period, is directly linked to a consideration of the religious orders established during the mid-sixteenth century and which played an essential role in the cultural and artistic development of colonial Brazil during the next 150 years.

Among the Jesuit works are some of the oldest preserved retables in Brazil, which generally fall into the Mannerist style. The earliest are apparently those in the chapel of the Colégio da Nossa Senhora da Graça in Olinda, which represent rather simple structures wrought in stone. Considerably more elaborate are the retables in the complex of the old chapel of the Colégio do Rio de Janeiro (demolished in the twentieth century), which are currently preserved at the church of Nossa Senhora do Bom Successo in Rio de Janeiro. These retables are so well executed that their originality transcends the poor quality of the local materials employed.

In addition to the works executed for these colleges, there are retables in the chapels of missionary outposts. These adhere to European Mannerist models but include elements taken from local flora and incorporated in the ornamentation: pineapple, guava, lilies, cashews. Such is the case with the retables at the chapel of São Lourenço dos Índios in Niterói, Rio de Janeiro. In the rural areas of the state of São Paulo there are a number of retables that diverge from Portuguese models by applying new proportions to Mannerist principles of facade treatment. This can be seen at the chapel of Nossa Senhora da Conceição in Santana do Paraíba.

As for statuary, there was a considerable import trade in Portuguese sculpture, as well as in all types of decorative furnishing and liturgical vestments. Nevertheless, the presence of stylistically archaic, locally executed images can be clearly seen. Among the oldest works produced in Brazil are those found at the chapel of São Lourenço in Niterói, as well as the images of Saint Ignatius and Saint Francis Xavier at the chapel of Nossa Senhora da Assunção de Anchieta in Espíritu Santo. The last two were executed in the style of the period.

Compositions in terra-cotta became notably more expressive during the seventeenth century. The region of São Paulo produced a particularly significant quantity of such objects, called *imagens de bandeirantes* because of the sculpting technique used by the *bandeirantes*, the explorers and prospectors, of the period. Aside from São Paulo, important production centers for terra-cotta statuary are found in the present states of Bahia and Rio de Janeiro and to a lesser degree in Pernambuco and Espíritu Santo.

One of the artists working in terra-cotta in Bahia was Frei Agostinho da Piedade. Of Portuguese origin, he was an apprentice at the monastery of São Bento in Salvador. His work as a sculptor was accidentally discovered by Clemente da Silva-Nigra, thanks to a signature on the back of a statue at Nossa Senhora do Monteserrate (now in the collection of the Museu de Arte Sacra in Bahia). The uncommon practice of signing pieces, in the case of Frei Agostinho da Piedade, led to the discovery of an image of Saint Anne, dated 1642, and a Christ Child, in Olinda, among other works. Frei Agostinho da Piedade's style is marked by a pronounced archaism, with geometric structural compositions along the lines of the Renaissance pyramid, saintly poses, and placid facial expressions. His works demonstrate considerable

nobility and sobriety, in contrast to the ecstatic excesses of the Baroque.

The monastery of São Bento in Rio de Janeiro was home to another monk who worked in terra-cotta, Frei Agostinho de Jesus, who was Brazilian by birth but ordained in Portugal. His pieces display fewer obvious archaisms than the sculpture of Frei Agostinho da Piedade. According to Myriam Ribeiro de Oliveira, "his works show a greater sense of movement, with more natural and graceful expressions, and even a touch of roguishness in their physiognomy, which may be a result of the artist's tropical origins."[1]

A third Benedictine sculptor, Frei Domingo da Conceição da Silva, worked in wood carving and statuary. He has been credited with all of the carved woodwork of the original main altar, transept, and the first dais of the nave, along with several statues, at the monastery of São Bento in Rio de Janeiro. As de Oliveira writes, "the talent evident in the carving of elaborate acanthus foliage is also found in the sculpting of putti figures, which are comparable to small Hercules, given the strong expressiveness emanating from them."[2]

Noteworthy among the works by Franciscans is the "gold chapel" at the convent of São Francisco de Assis da Penitência in Recife, renowned for the sumptuousness of its gilded woodwork. This carved woodwork extends to the walls and ceilings, which are covered in revetment, and comprises one of the examples of the so-called gold-lined churches, a style that would flourish at the beginning of the eighteenth century. This chapel's interior decoration is similar to the Portuguese National style.

Indeed, during the first decades of the eighteenth century, the carved woodwork of the northeastern region of Brazil continued to adhere to the Portuguese National style in the design of retables. The convent of São Francisco in Salvador is an important example of the use of the gold-lined church as a model. Here, carved woodwork entirely covers the walls of the building. Of the church's retables, only those located in the transept follow Portuguese models, given the presence of new elements that are characteristic of the Joanine style.

In the Northeast, the Franciscan workshops most frequently disseminated the Joanine style. Few examples remain due to renovations, when Rococo and Neoclassical works were substituted for them. Undoubtedly the best group of retables to survive are those at the convent of Santo Antônio in João Pessoa, Paraíba.

Joanine retables are characterized by the inclusion of statuary within the matrix of the carved woodwork, especially at pediment crowns or in the position of atlantes. Individually or in groups, these statues, which are sometimes of considerable size and rhetorical function, are subordinated within the general lines of the retables, where an Italian sense of grandiloquence predominates. Of the retables that most closely approximate Joanine prototypes, those in Bahia, the altarpieces at Cruzeiro da Sé, and the main altar of the Ordem Terceira do Carmo, Cachoeira, in the vicinity of Bahia, can be cited.

Rococo retables were infrequently used in Bahia, with only a few extant hybrid examples, where rocaille is insinuated into the Joanine carving. This is seen at the church of Nossa Senhora da Conceição da Praia in Salvador, Bahia. In Pernambuco a few fine Rococo examples are preserved, such as the main altar (1771) of the church of Misericórdia in Olinda, and the altarpiece of the church of Crucifixo de Sé, in the same city.

With regard to statuary, two artists seem to have dominated the scene in eighteenth-century Bahia: Francisco das Chagas, known as Cabra, and Manuel Inácio da Costa. Little seems to be known about Cabra, who was presumably born at the beginning of the eighteenth century. He was hired in 1758 by the Third Carmelite Order of Salvador to create the three statues *Christ Crucified*, *Christ Seated*

on the *Cold Stone*, and *Christ Bearing the Cross*, but none of these works can be clearly identified, and they probably disappeared toward the middle of 1788. Among the noteworthy statues attributed to das Chagas is *The Dead Christ*, which powerfully conveys a sense of anguish. Similarly, *The Flagellated Christ* by da Costa is a strong figure set in a straight, upright position, whose facial muscles are dilated in an expression that suggests the acceptance of suffering.

During the late-eighteenth and early-nineteenth centuries, there was a school of Bahian sculptors whose salient characteristics were refinement in gesture and posture, drapery displaying a skilled sense of movement, and sumptuous polychromy. Their work greatly influenced other artistic centers in Brazil.

Despite its less comprehensive nature, given that it was only created for local use, eighteenth-century Pernambucan statuary also had its own unique characteristics. It displayed extraordinary technical precision, which, in serial production, overtook that of Bahia. This technical quality is primarily seen in the polychromy, which, in most cases, required gilding of the entire piece prior to the application of colors. Delicate sgrafitto work reveals the gold through geometric or floral motifs in a variety of ornamental patterns. Physical expressions stand out and are individualized. Local types, with their almond-shaped eyes and dark skin, are often modeled.

The wood carving of Minas Gerais, and other sculpture from the area, has been the most carefully studied in Brazil, possibly because of the large number of intact examples, but certainly because of O Aleijadinho's work. Throughout this vast territory, wood carving can be found from three periods: Portuguese National, Joanine, and Rococo. Noteworthy examples from the first period are undoubtedly the altarpieces along the side aisles of the parish church of Nossa Senhora da

Conceição, and the retable in the small chapel of Nossa Senhora do Óin Sabará.

Around 1730 a new element began to be employed: the canopy, or *baldacchino*. This is not the Joanine canopy, strictly speaking, but a diminutive version that is generally flanked by stylized angels. This small canopy is a substitution for the archivolts that had traditionally crowned retables. The retable torso columns are subdivided by a new means of support: the corbeled pilaster. In Ouro Prêto the nave retables at the parish churches of Nossa Senhora do Pilar and Nossa Senhora da Conceição display fine examples of these new elements that are characteristic of the early Joanine style.

As I have noted, the introduction of a fully developed Joanine style in Minas Gerais can be credited to Francisco Xavier de Brito, who had worked on the Igreja da Penitência in Rio de Janeiro. Some of his sculptures can also be seen at the parish churches of Catas Altas and Nossa Senhora do Pilar in Ouro Prêto.

In Minas Gerais strong regional characteristics are evident in the design of retables, such as the use of straight columns instead of Solomonic columns and the noticeable absence of statuary crowning the supports. Two great sculptors of the Rococo period stand out in the region of Minas Gerais: O Aleijadinho, and Francisco Vieira Servas. Other artists who have been the subject of less careful study, such as José Coelho Noronha and Jerônimo Félix Teixeira, were also working in the area, on the lateral altarpieces at Bom Jesus do Matozinhos in Congonhas. Servas's most important pieces are distinguished by the presence of gilding in a valanced crossbow motif. Confirmed examples of his work are the main retable (1770–75) at Nossa Senhora do Rosário in Mariana and the main altar and one of the lateral altarpieces (1778) at Nossa Senhora do Carmo in Sabará. Work in the same style at the parish church of Itaverava might have also been made by Servas.

A specific characteristic of the Rococo retable in the style of O Aleijadinho, in contrast to the work of Servas, is the substitution of the crossbow motif with an imposing grouping of sculptures, centered around a triangular shape formed by the Holy Trinity. Among O Aleijadinho's freestanding sculptures of this type are the images of Saint John of the Cross and Saint Simon Stock, on the side altarpieces at the church of Nossa Senhora do Carmo in Sabará. The physiognomies of the young Saint Simon and the considerably older Saint John are extremely realistic, as if they were created from living models.

In the works of O Aleijadinho at Congonhas do Campo executed between 1796 and 1805, the progression from initial realism to stylization, in the reduction of details and the more vigorously rendered drapery, which now forms accentuated angles, can be seen. In 1800, after completing the sculptures comprising the Stations of the Cross, O Aleijadinho began work on the Old Testament prophets. These twelve monumental sculptures are perfectly integrated as architectonic supports.

Ceiling Painting

Here, the typologies are more limited than with sculpture. The earliest period of colonial painting produced panels, or coffers, decorated with grotesque or crudely rendered scenes in a Mannerist style. The panels employ reticulated compositions, with pronounced crossbeam molding setting off individual panels. The most commonly used form of ornamentation incorporates a stock variety of grotesquerie, often including a representation of a member of a religious order at the center of the medallion. The use of chinoiserie—a technique that was expanding in Europe—on a wide variety of objects, from tiles to furniture, did not arrive in Brazil as the result of the handiwork of Asian artists, as some literature would have it, but through treatments created by Portuguese artists. At the end of this phase the Italian model of

architectonic perspectival illusionist painting began to spread throughout Brazil, influenced by Fra Andrea Pozzo's work at Sant'Ignazio in Rome. From the main entablature an illusionist effect is created that is capable of transporting the observer directly to the heavens, by seeming to break through the very limits of the interior space. Later on some Brazilian artists create simpler architectonic treatments, reducing arches and entablatures to hollowed-out supports through which it seems possible to observe the sky. This can be seen in Minas Gerais in work by the painter Manoel da Costa Ataíde. His central painting for the ceiling of the church of São Francisco de Ouro Prêto is adorned by rocaille, which works with the composition to create a canopy effect.

The most significant panels of the early period are those in the sacristy of the cathedral of Bahia, which are attributed to Friar Domingos Rodrigues, a native of Portugal, who lived from 1657 to 1706. Examples of Brazilian fauna can be detected among the complex designs, an indication that the painter was sensitive to the environment in which he worked. The central figures are copied from period engravings.

The sanctuary of the church of Nossa Senhora do Rosário in Embu, São Paulo, built toward the end of the seventeenth century, has a painted ceiling that is decorated with grotesquerie. This work is attributed to Father Belchior de Pontes, according to his biographer, Father Manoel Fonseca. Among the ceiling's unique elements are the pineapple motifs that appear along the crossbeam moldings, which add a Brazilian touch to the work.

The painting at the chapel of São Francisco da Penitência in Recife, a gold chapel, was executed between 1699 and 1702. Here the ceiling and lateral wall panels are of significant quality but uncertain origin.

The church of São Francisco in Bahia contains a painted ceiling with geometric

motifs, which was executed between 1733 and 1737. The ceiling is noteworthy because of its harmonious relationship to the church's carved woodwork.

Also during the same period, in 1737, Caetano da Costa Coelho was contracted to paint the nave ceiling at the church of Ordem Terceira da Penitência in Rio de Janeiro, initiating the period of trompe l'oeil, or architectonic perspective, painting in Brazil. José Joaquim da Rocha was the most outstanding painter of this genre. He was responsible for an expressive trend in Bahia that produced an entire school of painting. His most well-known works are the ceiling paintings at the churches of Nossa Senhora da Conceição da Praia and Nossa Senhora dos Aflitos.

The work of Friar Ricardo do Pilar, who died in 1700, stands out in Rio de Janeiro. He was born in Europe but came to Brazil to work on the monastery of São Bento. He also produced the fourteen paintings on wood on the main altar of the church of São Bento. According to Clemente da Silva-Nigra, Friar Ricardo do Pilar used as models five engravings executed in 1579 on the instructions of the Benedictine Order of Spain, which deal with the life and miracles of Saint Benedict; he also used the 366 engravings of the Augsburg Kalendarium, dated 1677.

A parenthetical note may be of interest at this point concerning the use of visual quotations from print sources in colonial painting in Brazil. Evidence of this practice is found throughout the country, as Hannah Levy observed during the 1940s in her contributions to publications of the Serviço do Patrimônio Histórico e Artístico Nacional.3 The painter Jesuíno de Montes Carmelo, for example, worked in this way, as can be seen in the sanctuary ceiling at the church of Nossa Senhora do Carmo in Itu.

In Minas Gerais illusionistic or trompe l'oeil painting reaches its finest expression in the achievements of two artists: Guarda-Mor José Soares de Araújo, who produced the greatest body of paintings in Diamantina, and Ataíde, from Mariana, whose works are quite diverse and distributed among a variety of cities. Soares de Araújo's work is characterized by treatments of an architectonic nature, which are symmetrically structured along horizontal and vertical axes, somewhat like those of José Joaquim da Rocha in Bahia. This is clearly seen in the nave ceiling at the church of Nossa Senhora do Carmo in Diamantina.

Ataíde's work firmly established new Rococo tendencies, not only in Minas Gerais but throughout Brazil. He achieved this within a framework of greater creative freedom—characterized by buoyant use of color and dynamic compositions—that implemented the hallmark diaphanous illusionism of Rococo with a degree of sophistication never before seen in Brazil. His masterwork is undoubtedly the extraordinary ceiling of the church of São Francisco de Ouro Prêto, where audacity and pictorial elegance are fused with the strength and purity of O Aleijadinho's architectonic and ornamental plan, enveloping the central allegory of the Virgin in a kinetic network of columns, angels, and rocaille forms.

Ataíde's other ceilings and canvases along the same compositional lines, although somewhat diluted in structure, are equally expressive and beautiful, such as the main altars of the parish church of Santo Antônio in Itaverava, the church of Nossa Senhora do Rosário dos Prêtos in Mariana, and the parish church of Santo Antônio in Santa Bárbara.

Other artists who were working in Minas Gerais include João Baptista de Figueiredo, who collaborated in the painting and gilding of the main altar of the church of São Francisco de Assis in Ouro Prêto, between 1773 and 1775; João Nepomuceno Correia e Castro, who worked at the sanctuary of Bom Jesus de Matozinhos in Congonhas; Joaquim Gonçalves da Rocha, who painted the nave

ceiling panel at this sanctuary, representing the feast of Saint Elias; and Manuel Rebelo e Souza, who painted the nave ceiling at the church of Santa Efigênia do Alto da Cruz in Ouro Prêto.

Translated from the Portuguese by Regina Alfarano and David Auerbach.

Notes

1. Myriam Ribeiro de Oliveira, "Escultura colonial brasileira: Um estduo preliminar," in *Barroco* 13 (Belo Horizonte, 1984–85), p. 11.
2. Ibid., p. 12.
3. See Hannah Levy, "A pintura colonial no Rio de Janeiro," *Revista do serviço do patrimônio histórico artístico nacional*, no. 6 (Rio de Janeiro) (1942), pp. 7–79, and "Modelos Europeus na Pintura Colonial," *Revista do serviço do patrimônio histórico artístico nacional*, no. 8 (Rio de Janeiro) (1944), pp. 7–66.

Brazilian Baroque Architecture

Augusto C. da Silva Telles

The architecture created in Brazil during the sixteenth century and first half of the seventeenth century was fundamentally a transposition of what was being done in Portugal at the same time, with only a few adaptations and simplifications resulting from the prevailing economic, technological, and political conditions. It was a period that was no longer tied to the Renaissance yet was still not Baroque; rather, it constituted a transitional, Mannerist phase. Nevertheless, given Portugal's impoverishment at this time, and subsequently Brazil's, Luso-Brazilian Mannerist architecture, although solid, bore an appearance of deprivation, and has been referred to as stylistically simple, or, as George Kubler has put it, "plain architecture."[1] This period was one of great upheaval. Portugal was subjugated to the Burgundians of Spain from 1580 to 1640, and parts of northeastern Brazil were under Dutch occupation during 1624–25 and 1630–54. An example of this

transitional phase, still from the sixteenth century, is the church of Nossa Senhora da Graça de Olinda, which is annexed to the old college of the Jesuits. Designed by the friar and architect Francisco Dias, it follows the plan of the church of São Roque in Lisbon, with a single nave and side chapels; the main altar at the end of the nave also has two side chapels. Despite its rugged and spare appearance, Graça de Olinda is an elegant work. Contemporary structures include the church of the old Carmelite convent of Olinda, which followed the same scheme, and the parish church of Olinda, presently the cathedral, which was designed with its own anachronistic, old-fashioned elements: three naves with side chapels.

In the second half of the seventeenth century, after the Dutch were expelled during the so-called Pernambuco Restoration, more imposing churches and buildings were erected, and along with them appeared structures, ornamentation, and

interior spaces bearing Baroque characteristics: chiaroscuro, impressions of movement, volumetric compositions. During this period churches continued to be designed with side chapels and the facade divided by pilasters and entablatures, in some instances with volutes on the top, as in the colleges of Salvador and Belém. The church of the college of Salvador was begun in 1657 and followed the same architectural scheme. Its nave is lined with white marble, in contrast to the main and lateral chapels, which are dominated by retables and the use of gilded and polychrome woodwork, as is the nave's carved, reticulated vault, in the center of which sits a spectacular high-relief sculpture bearing the emblem of the Society of Jesus. The church of São Francisco Xavier of the old college of Santo Alexandre in Belém do Pará follows the same architectural layout as Salvador. The simple nave is embellished by two monumental, structurally dynamic Baroque pulpits—with canopies, cherubs, and volutes—attributed to José Xavier Traier. The facade is adorned by bold, crudely crafted voluting toward the top of the building and is flanked by bell towers.

Initially used only in chapel retables, carved woodwork was subsequently used to cover walls and ceilings. In churches erected at the end of the seventeenth and first half of the eighteenth centuries, gilded and polychrome carving extended to walls, columns, and the entire interior space. Robert C. Smith refers to these as the "wholly golden churches."[2] This also occurred in churches that had been built in part during previous phases, as with the church of São Bento in Rio de Janeiro, which dates from the beginning of the seventeenth century, or with São Francisco de Salvador, which, despite being a work of the eighteenth century, followed an earlier design. The church of São Bento in Rio de Janeiro was begun in 1641 on the basis of a plan dating from 1617 by Brazil's principal engineer, Francisco Frias da Mesquita. When it was enlarged in 1670 by Father

Bernardo de São Bento, ample side chapels were inserted with intercommunicating passageways that formed lateral naves. At the end of the century Father Domingos da Conceição began overlaying the main altar, chancel arch, and nave with reticulated panels of carved archivolts, lintel columns, and cherubs straddling acanthus leaves. Before he died, he left models or rough drafts of the engraving work, which was continued by the masters who followed him, so that all of the revetment exhibits a unique sense of unity that defines the character of the church's Baroque space, contrasting with the expanses of masonry and Galilee stonework of the lateral chapels, galleries, sacristy, and monastery cloister. The main altar was restructured at the end of the century (1787–94) by Inacio Ferreira Pinto, who, despite denouncing Neoclassicism, preserved the original images carved by Father Domingo, as well as the paintings along the nave walls and the vault by Ricardo de Pilar. In Salvador the church of São Francisco de Assis, located at the end of a church courtyard, across from the church of the Jesuits, continued the style of the latter, even though it was built at the beginning of the eighteenth century (1708–30), thereby distinguishing itself from the other Brazilian Franciscan churches. Its interior—main altar, side chapels, nave, and vault—form an entirely gilded and exuberant whole, with a veritable forest of acanthus leaves, canopies, and cherubs in various positions, which is described by Germain Bazin as an "astonishing phantasmagoria of form," competing with the Franciscan church in Porto, Portugal.[3] In contrast to all this Baroque decoration, the sides of the main altar are fitted with borders of seventeenth-century tilework, which is repeated again in the sacristy, the chapter room, the vestibule, and throughout the cloister.

During the second half of the seventeenth century and into the eighteenth, the Franciscans created their own architectural style for their convents and churches,

which is referred to by Bazin as "The Franciscan School of the Northeast."[4] It is characterized by the use of cloisters (as in the convent of Salvador), surrounded by verandas with Tuscan columns that directly support the roof eaves and with ground floors marked by arcaded galleries. The churches occupy one of the wings and comprise a portico, vestibule, single nave, and wide main altar. The naves are simple, adorned only by tiled wainscoting, and one of the sides is divided by a wide arch that leads to the chapel of the Franciscan Third Order. In the churches of Igarassu, Penedo, and João Pessoa, the vaulted ceilings are embellished by perspective painting. Carved decoration is limited to the main altar and the altars lining it. The facades are designed following two models: the convents of Ipojuca in Pernambuco and Cairu in Bahia. The former, which dates from 1660, has a square facade with lateral pilasters, three arches at the base, and three windows at the choir level. The top is decorated with a triangular fronton of archaic design. At the convent of Cairu, dating from 1654, the facade design, which has no similar previous counterpart in Brazil or among the many examples in Europe, is Baroque in style with graduated steps, five arches at its base, three windows at the choir level, and an acroterium with a niche at the top. The sides of the steps are lined by vibrant volutes and pinnacles. The churches of Olinda and Igarassu are modeled on a conjunction of two different designs. The central part of the edifice is similar to Ipojuca but with a surrounding wall in the base, a wall that supports volutes placed against it. At the top is a central acroterium flanked by volutes. The convent at João Pessoa in Paraíba, built in the second half of the eighteenth century, adopted the Cairu plan, substituting the Baroque volutes and decorative elements of the windows and capitals for the delicate and elegant Rococo volutes and decorations of the period. In this convent the churchyard's side walls are distinctive in the way that

they converge toward the temple and are set with tiles the entire length and decorated with niches depicting the Stations of the Cross in tile panels. The churchyard entrance is adorned with a monumental stone cross.

The chapels of the Franciscan Third Order, adjacent to the convent churches, differ radically from them. The walls and ceiling of the late-seventeenth-century chapel in Recife, referred to as the Golden Chapel, are entirely covered with woodwork, painted panels, and tiled, reticulated borders. The altar retables, with twisted columns and concentric arches, are inserted in niches along the walls. As a whole, this harmonious, homogeneous, and dynamically Baroque space makes a strong impact. The Franciscan Third Order church of Terceiros de São Francisco da Penitência in Rio de Janeiro was constructed at the beginning of the eighteenth century. It has a single nave and main altar bordered by galleries, a sacristy, and chapels, including an early chapel that opens off an arch leading to the convent church. The nave and main altar are embellished with exuberant gilded woodwork executed between the years 1726 and 1739 by Manuel de Brito and Francisco Xavier de Brito, exhibiting exceptional unity of composition. It represents a transmigration of art from Lisbon, where Manuel de Brito had previously worked at the church of São Miguel da Alfama in Lisbon, to Rio de Janeiro and from Rio de Janeiro to Minas Gerais, to which Xavier de Brito subsequently traveled and where he produced, among other works, the main altar for the church of Nossa Senhora do Pilar in Ouro Prêto. The vibrant decoration of the Rio de Janeiro church's woodwork is organized according to alternating rhythms, with canopies, corbels, and sculpted faces on the altars, chancel arch, and walls. In period documents Xavier de Brito was referred to as a master sculptor. The upper entablature breaks with the linear structure of the nave, creating a dynamic sense of Baroque

movement. The trompe l'oeil paintings by Caetano da Costa Coelho covering the barrel-vaulted ceilings were the earliest examples in Brazil of their kind. Similar styles of decoration can be found in the church of Conceição dos Militares in Recife and in the church of the Carmelites in Cachoeira, Bahia.

The church of Conceição dos Militares displays rather crude but vibrant woodwork, concentrated within the main altar and along the back wall of the nave, with other sections remaining unfinished. However, a vigorous, sophisticated entablature with projections and recesses winds around the entire nave and is topped by a continuous false balcony with balusters and cherubs that appear to support the ceiling, which is horizontal and adorned with imposing carved woodwork and robust rocaille inset with painted panels; it is a work without precedent in either Brazil or Portugal. The Carmelite church of Cachoeira also has carved facing and undulating entablatures of the nave and main altar. These churches represent a new tendency that began in the early 1800s: salon churches, whose broad naves are lined by altars along the lateral walls, and side aisles or galleries extend from the entrance to the apse, where the sacristy was located. The inner space of these structures, with their strong Baroque spatial treatments, is defined by carved woodwork extending either partially or entirely throughout the interior. A similar situation occurs with the church of Nossa Senhora do Carmo do Recife, where the main and side altars of the nave are embellished with gilded and polychrome retables, which as a whole turns the space into a sort of museum of period woodwork, from high Baroque through Rococo.

At the end of the seventeenth century profound socioeconomic changes occurred in Brazil. Up until this point only the coastal swath was populated by Luso-Brazilians, and sugarcane was the engine for the economy and civilization. However, as a result of forays into the continent's interior on the part of the so-called *bandeiras*, or expeditions, gold was discovered, and then diamonds. European civilization therefore began to extend into the interior, with the establishment of hamlets and villages at the sites where gold and precious stones were being quarried. The creation of the *capitania* (an early administrative district) of Minas Gerais allowed for the organization of the population that was establishing itself in these extensive regions. At the same time there was a decline in the sugar trade provoked by competition in the Caribbean basin, which led to a period of stagnation in the region of Bahia. The Northeast would have also suffered such a decline if it were not for the creation by Portugal's Marquês de Pombal of the Pernambuco and Paraíba Trading Company. In 1765 the seat of government was transferred from Salvador to Rio de Janeiro, which had been designated as the obligatory transit point for the mineral wealth that was bound for Portugal. The initial influences of the Borromini School arrived in Brazil during the first decades of the eighteenth century: buildings designed on a plan of elongated polygonals or ovals; an emphasis on the vertical, marked by monumental pilasters extending the height of the structures; subdivision of facades; bordering retables; and the accentuation of dihedral angles on the exterior and interior. This style of architecture began to take hold in Rio de Janeiro with the church of Nossa Senhora da Glória do Outeiro (1714–39), in Recife with the church of São Pedro dos Clérigos (1729–59), in Salvador with the church of Nossa Senhora da Conceição da Praia (1736–65), and in Ouro Prêto with the church of Nossa Senhora do Pilar (1730–46).

Nossa Senhora da Glória do Outeiro, a design attributed to the military engineer José Cardoso Ramalho, is composed of two joined prisms, with elongated octagonal bases, and a squared-base bell tower in the front. On the exterior the dihedral angles of the prisms are

emphasized by double-height pilasters with robust pinnacles, while the bell tower is subdivided by an intermediary entablature that ends at the bell gables. The interior, despite the modernity of this plan, seems archaic with its lime-washed walls and vaulted ceilings divided by pilasters, entablatures, and stone arches. São Pedro dos Clérigos—a design of the architect and master-stonecutter Manuel Ferreira Jácome—includes the octagon that defines the nave in the exterior rectangular plan. Its front exterior is divided by monumental pilasters; in the center, the portal includes a window on the level of the choir, all with Baroque decoration, while in the sides, the gaps are more enhanced and localized at an intermediate level. The interior's pilasters mark off the angles, separating altars and sanctuary, and rich gilded woodwork predominates. The curved ceiling is adorned with perspective painting. Nossa Senhora da Conceição da Praia, constructed of marble blocks imported from Portugal, has foreshortened bell towers flanking its central structure that are demarcated by monumental pilasters, while the sides of the building are divided by two floors with an intermediate entablature. The interior contains a rectangular floor with beveled angles accentuated by pilasters of light-colored marble separating the chapel niches and the sanctuary, all of which are adorned by gilded woodwork. The vaulted ceiling displays an exceptional painting by José Joaquim da Rocha. In Ouro Prêto, the church of Nossa Senhora do Pilar represents a singular case—the sole example of a unique Luso-Brazilian architecture—with the decagonal nave defined by a carved wood enclosure with gilded Corinthian pillars that visually support the upper entablature and vaulted ceiling with coffers and paintings, all contained within the mud-wall rectangular-shaped edifice. The pillars are interspersed with gilded and polychrome retables and balconies in the upper galleries. This work was completed in 1736, but the church was inaugurated in 1734, with the staging of

the "Eucharistic Triumph," an unusual Baroque performance that included a procession transporting the Eucharist from the church of Rosario. The main altar includes an innovative retable with voluminous sculptures, characteristic of the second phase of Minas Gerais Baroque, which is the work of Xavier de Brito.

During the middle and latter part of the eighteenth century, architectural innovations occurred primarily in a few areas: the Northeast, Rio de Janeiro, and Minas Gerais. In the Northeast, with São Pedro dos Clérigos as the only example of the Borromini School, these innovations focused on developments in church facades, similar to what was taking place at the time in Portugal in the regions of Porto and Braga. Entablatures were enlivened and elevated. Medallion windows located on the pediments were brought down to the main part of the facade, toward the center of the structure, above the choir windows. The upper contours of the facade were undulated and curved outward into asymmetric voluting. The facade tended to display a unifying composition, a Baroque characteristic, once the lower portion had been recessed into the pediment, thus acting as a binding element for the entire facade. The intention of this composition is similar to that found in Portugal in the work of Nicolau Nasoni and André Soares but with one fundamental exception. In Portugal entablatures tended to be eliminated or were enveloped by the upper ornamentation of the pediment, but in Brazil entablatures were enlivened and raised, thus continuing to provide a strong structural element by tying together the external angles of the facade while at the same time being supported by them. This structural solution is found in the churches of São Bento de Olinda (1760–63) and Nossa Senhora dos Prazeres de Guarapes (1755–82) in Jaboatão, the chapel of Nossa Senhora da Conceição da Jaqueira (1766) in Recife, and the churches of Nossa Senhora do Carmo (1767), Terceiros do Carmo (1797),

Rosário dos Homens Prêtos (1777), São José do Ribarmar (1788), and Matriz de Santo Antônio (1791).

This same structural solution can be found in the Franciscan convent churches in Recife, as well as at Marechal Deodoro in Alagoas, aside from the more recent churches at Goiana in Pernambuco, and somewhat further off, in the parish church of Icó in Ceará. The facades of São Bento de Olinda, Nossa Senhora dos Prazeres de Guarapes, and the chapel of Nossa Senhora da Conceição da Jaqueira are similar: the raising of the entablature and the upper contours composed of sequential curves reveal a timid example of Rococo; and the medallion window at the top of the facade, below the entablature, is surrounded by decorative elements in the style of a Maltese cross. Of all of the churches of Pernambuco, Nossa Senhora do Carmo exhibits the most robust entablature, structured with a unique sense of movement, with the use of curves and angles, and crowned with sequential voluting that rises toward the center, surrounding a niche bearing the image of the patron saint. (We have already discussed its Baroque interior.) The retable in the main altar of the church of São Bento de Olinda deserves mention: it contains strong, Baroque carved woodwork, a prime example of Brazilian craftsmanship, with a deep central niche, where repeating shell-like elements soar in sequential waves, flanked by bold, vertical columns sprouting vegetation. Above, a conchoidal curve seems to spring up toward the vault. As a whole Rococo aspects are combined with elements that hint at Neoclassicism, but the entire structure seems touched by an exceptional sense of dynamism. The analogies with the altarpiece at the convent church of Tibães in Portugal are clearly evident, although this one displays its own distinctive character.

In Rio de Janeiro the church of São Pedro dos Clérigos, which was contemporaneous with Glória do Outeiro, was demolished in 1943. Conceived in the form of a rotunda, its center plan was based on an oval flanked by two concave chapels, a lanterned dome, and cylindrical bell towers. Its exterior was cylindrical in form and subdivided at the top by an intermediate entablature. A certain relationship can be established between the churches of São Pedro dos Clérigos de Mariana and Rosário de Ouro Prêto. Three churches in Rio de Janeiro from the middle of the eighteenth century were designed along polygonal or oval plans, although their interiors did not display these same kinds of alterations, since their interior decoration of woodwork and stucco is, for the most part, representative of the nineteenth century. The church of Lapa dos Mercadores (1747–90) has an oval nave, with later interior decoration, but above the chancel arch is an exceptional Baroque votive shield. Nossa Senhora Mãe dos Homens (1752–90) has an octagonal nave. And Nossa Senhora da Conceição e Boa Morte (facade, 1758), a design of José Fernandes Pinto Alpoim, has a nave with side chapels and a transept illuminated by a clerestory at the top, onto which two chapels open; in addition, the main altar, with a retable executed by Valentim da Fonseca e Silva, known as Mestre Valentim, is an important late-Baroque work.

The majority of the churches built during this time, pertaining to brotherhoods or third orders, followed the previously described style: main altar and nave with altars set against the lateral walls. Among these, the churches of São Francisco de Paula, São José, Santíssimo Sacramento da Antiga Sé, and Cruz dos Militares, among others, already exhibit a nineteenth-century style of decoration. The church of Ordem Terceira do Carmo stands out in this group. In its interior, the side altars and main altar—a work by Luiz da Fonseca Rosa and Mestre Valentim, who was his disciple—have their dais flanked by Berninian columns and are crowned by canopies, but the carved facing that completely covers the walls and vault dates from the nineteenth century. The

facade, entirely of stonework, is static, with pilasters that extend to the upper entablature, whose only undulating elements are the Rococo curvature of the window adornments and the robust pediment, which is framed by curves and countercurves at its highest point (in the style of Nossa Senhora das Mercês in Lisbon). The limestone door frame is a beautiful Rococo composition with a medallion of the Virgin in the center, which was brought from Lisbon and set in 1761. Four chapels from the second half of the eighteenth century constitute prime examples of carved Rococo interiors: the novitiate's chapel at Ordem Terceira do Carmo and chapel of Our Lady of Victories at São Francisco de Paula, both with carved work by Mestre Valentim, the chapel of the Most Holy Sacrament at São Bento, and the abbot's chapel within the monastery at São Bento. In the refined gilded woodwork, elements of rocaille can be found in the retables, which are also developed along with walls where they form molding that frames paintings and windows. Above the doorway to the novitiate's chapel is a false choir inset with its own organ. In the central retable niche of the chapel of the Most Holy Sacrament, the tabernacle is designed in the form of a flame, with volutes and curves rising skyward toward a crowning canopy. The abbot's chapel displays abstract decorative elements; reliquaries are scattered across the retable and side walls, and the undulating elements and rocaille cannot be contained by the chapel's structure or angles.

Mestre Valentim also designed the Passeio Público (Public garden) for Viceroy Luiz de Vasconcelos, which extended from the embankment at the Boqueirão Lagoon. The entry gate is flanked by curving pilasters, which defined two possible routes. The first, along the garden itself, passed between two elongated stone pyramids and ended at the Fonte dos Amores (Lovers' fountain), where two bronze alligators are displayed in a pool with a Baroque carved stone backdrop; further on

one arrives at a terrace that formerly looked out on the bay. The second, in the direction of the Rua das Belas Noites (today Rua das Marrecas), led to the Marrecas fountain—another work by Valentim—where a concave semicircular wall formed the backdrop for two pools surmounted by bronze statues of Narcissus and Echo (which today stand in the Botanic Garden). This fountain was demolished at the end of the nineteenth century, and the garden was redesigned by the botanist Auguste François Marie Glaziou. The two routes formed a characteristic expression of the Baroque period: the dynamic sense of proceeding through differentiated spaces. Also under the aegis of the viceroy, Valentim drafted a plan for the Largo do Carmo fountain (now the Praça XV de Novembro), a small stone edifice whose sinuous walls form convex angles. Cascades gushed forth from conchoidal shapes on three of the sides. At the top a sinuously curving entablature is crowned by a balustraded platband. At the center sits a stone pyramid with a bronze armillary sphere at its apex. The entire structure is made of gneiss from the Rio de Janeiro region with limestone decorative elements conceived in the Baroque-Rococo spirit. It is the only example of its kind in Brazil.

As already noted, Luso-Brazilian civilization had its beginnings in Minas Gerais at the end of the seventeenth and beginning of the eighteenth centuries. Within a short period the sudden wealth created by the discovery of gold deposits attracted a huge influx of people to this region from various places on the Brazilian coast and from Europe. At the time, the establishment of convents and monasteries was strictly prohibited, which meant that parish churches and brotherhood or third order churches were the only religious institutions allowed. Therefore, buildings constructed during the first half of the eighteenth century simultaneously followed two different architectural styles. The parish church of Sabará adopted the

use of three naves, the church of Mariana (subsequently the cathedral), has three naves, a transept, and a deep sanctuary; the parish churches of Antônio Dias and Cachoeira do Campo in Ouro Prêto, of São João del-Rei, Tiradentes, and Catas Altas, among others, adopted the plan of a single nave with side aisles or compartments. However, in Minas Gerais, quite apart from what occurred in the rest of the country, aisles running along the side of the naves were eliminated by the middle of the century, with bell towers being the only lateral elements in such churches. This occurred, for example, in the churches of Santa Efigênia and São Francisco de Paula in Ouro Prêto, in the parish church and church of Bom Jesus de Matozinhos in Congonhas, and in the parish church of Ouro Branco. This design was customary in Portugal, where the use of side aisles was a rarity. In all such churches the interior space was chiefly defined by the altar retables and carved woodwork revetment.

From the first decades of the century the parish churches of Sabará and Cachoeira do Campo, as well as the chapel of Nossa Senhora do Ó in Sabará, have sixteenth-century-style woodwork—archivolts and twisted columns—presenting Baroque spaces that are sober and static. The parish churches of Nossa Senhora do Pilar in São João del-Rei (1736–40) and Santo Antônio in Tiradentes (1738–40), which differ drastically from each other, present the first examples of high Baroque retables and carved woodwork in Minas Gerais. They preceded the arrival of Francisco Xavier de Brito in 1746. The carved woodwork at the parish church of Tiradentes is quintessentially Baroque. The main altar dais is flanked by straight scaled columns and torch-bearing cherubs supported along a curved balcony; above, dynamic volutes and a voluminous canopy are supported and surrounded by the figures of angels; on the pedestals, atlantes are set in kinetic poses. The retable is entirely gilded, and the main altar is covered by a bordered vault with a web of chestnut-colored voluting. The choir, above the nave entrance, is an extraordinary work: two rows of tapered-base pillars (in the style of the library at the university in Coimbra) support the floor, above which sprout garlands of foliage. The whole gives the impression of a theater loge. The main altar of the parish church of São João del-Rei, whose architect remains unknown, contains innovative carved woodwork, related in style to examples in Lisbon and Evora. Around the main altar, Berninian columns are crowned by sculptures of angels and finally by the figures of the Holy Father and the dove of the Holy Spirit framed by voluting and canopies, which extend toward the church vault. A direct influence for this type of woodwork can be found in the work of José Coelho Noronha at the parish church of Caeté (1752). The parish church of Nossa Senhora do Pilar in Ouro Prêto, with its polygonal nave enveloped by carved woodwork, as we have already mentioned, is a unique example in Brazil. Its main altar, the work of Xavier de Brito, represented the arrival in Minas Gerais of the type of woodwork found in the church of Penitência in Rio de Janeiro, and it is reflected in countless works, such as the church of Santa Efigênia in Ouro Prêto and the parish church of Catas Altas, where elements of the Rococo anticipated O Aleijadinho's style. Aside from Nossa Senhora do Pilar, two churches in Minas Gerais that predate 1762 followed plans adapted from Borromini: the church of Nossa Senhora do Rosário in Ouro Prêto and São Pedro dos Clérigos in Mariana. They were built practically at the same time, both designed by the stonecutter and architect José Pereira dos Santos. Their almost identical floor plans are composed of two intertwined ovals. Nossa Senhora do Rosário, which was completed at the end of the century, has a convex facade and cylindrical towers. São Pedro dos Clérigos was not finished until the beginning of the twentieth century. Central European Baroque and the churches of Glória do Outeiro and São Pedro dos

Clérigos in Rio de Janeiro have been convincingly cited as possible influences.

Some exceptional examples of Baroque style can be found in the civic architecture of Minas Gerais. The chapter house in Mariana and the former mint (Casa dos Contos) in Ouro Prêto stand out for their structural refinement and for their architectural and decorative details: the rounding off of angles and the undulating border of the balcony windows at the mint, as well as the elegant inscribed shield of the chapter house, with its asymmetrical volutes extending toward the central image of the Virgin. The town hall in Mariana is a unique specimen in Brazil due to the utter nobility and refinement of its proportions. The design for this building is the work of José Pereira dos Santos. The facade is marked by a double stairway that leads first to a main entrance with an elegant shield that attaches to a roof tower. A comparison may be made with the town hall in Vila Real de Trás-os-Montes, Portugal.

Minas Gerais is rich in public fountains. Almost all of them follow a similar design: a wall decorated with capricious curvatures and decorative stone insets—shields, volutes, conchoidal shapes, anthropomorphic figures—on brilliant whitewashed masonry. Among those worthy of particular mention are fountains at the Casa dos Contos, Largo de Marília, also in Ouro Prêto, and São José in Tiradentes. The latter, located at the center of a broad public space, is fronted by benches and pools for various uses.

The Franciscan churches of Ouro Prêto and São João del-Rei and the Carmelite church in Ouro Prêto, which date from the second half of the eighteenth century, adopted exceptional architectural plans that are nevertheless of Borrominian derivation. Their floor plans and the structures themselves are characterized by a meshing of curves and straight lines, with the creation of points and edges that produce tension. At the same time, these were the result of the regional architectural plan, which had eliminated the nave side aisles, leaving the bell towers protruding in their flanks. Another element characterizing these plans are the portals set at the center of the facades, incorporating the central medallion window above. The doors are set into wall surfaces with Rococo, but strong and dynamic, treatments. The character of these churches is due in part to O Aleijadinho (this name by which Antônio Francisco Lisboa is generally known translates as "The Little Cripple"). He intervened in the construction of the church of Nossa Senhora do Carmo in Ouro Prêto in 1770, altering the initial 1766 plan of his father, Manuel Francisco Lisboa. The towers, with curved surfaces flanked by pilasters, were stepped back from the facade, which presents an undulating form, an entablature that curves toward the center and a lowered and capriciously contoured medallion window, which is set between the choir windows, with asymmetric curves, and relates visually with the door-frame decoration. The church doorway is both elegant and dynamic with lateral pilasters flanking its frame and conchoidal shapes forming frontons soaring above; in the center there is a large escutcheon with the Carmelite emblem and the crown of the Virgin. These latter elements are linked to the medallion window, so that the entire facade functions as an integral whole. The rear wall of the nave is chamfered at each side of the transept, and the side walls have been thickened at the center in order to contain the pulpit access steps.

The church of São Francisco de Assis in Ouro Prêto, begun in 1766 on O Aleijadinho's plan, is one of the most significant Baroque monuments in Brazil and the world. In 1774 the architect proposed modifications to the facade, separating the choir windows and closing off the side doors leading into the nave. This structure represents the work of one architect, and its composition echoes this sense of integral harmony. The angles of the

nave are curved and convex, and the pulpits have been inserted into the chancel arch intrados. The main altar is covered by a cloister vault, which is linked to the top of the retable. The soapstone pulpits containing bas-reliefs and the gilded and polychrome retable are also the works of O Aleijadinho. This retable represents the crowning achievement of carved work in Minas Gerais—from the parish church of Nossa Senhora do Pilar in Ouro Prêto to the church at Catas Altas to those in Nova Lima (initially from the Jaguara hacienda). It is a work with Rococo characteristics but displays great strength and dynamism. Columns with twisted lower sections and crosshatching flank the dais, which is crowned by a group of sculptures of the Holy Father, Christ, the Holy Spirit, and the Virgin, set between Baroque volutes, which ascend toward the vault above. These are bordered by bas-relief sculptures of Franciscan saints, which mark the vault cornice. The retable, cloister vault, pulpits, and chancel arch all join together in one unified composition.

On the church's exterior, the cylindrical towers are linked to the facade by concave surfaces. The facade center is flanked by Ionic columns, and its Baroque frontispiece dominates the entire composition. Pilasters with conchoidal elements border the church door frame, and seated angels extend from the entablature. In the center, above the door lintel, a medallion of the Virgin is inserted between groups of angels. A Franciscan escutcheon crowns the entire composition, linking it to the choir windows and the covered medallion window, where a bas-relief representing the stigmatization of Saint Francis is set. The columns bordering the facade support entablature projections that thrust out above and below and support an acroterium with a stone cross surrounded by flames. Contemporaneous with the alterations to the facade of this church in 1774 is the plan presented by O Aleijadinho for the Franciscan church of São João del-Rei. According to the draft for the design,

which is part of the collection of the Museu da Inconfidência, the door frame had not been completely resolved. The facade's upper part between the bell towers is composed of Rococo volutes that recall those employed at the Carmelite church of Sabará. The Franciscan church of São João del-Rei was built by Francisco de Lima Cerqueira, and the final plan was greatly modified, mainly with regard to the decorative elements of the gable and the bell towers. The side walls of the nave undulate with curves and countercurves, and the main altar retable, which was influenced by the one at Ouro Prêto, appears heavy and lifeless.

The Holy Mount, the concept of a local pilgrimage site substituting for the holy sites of Palestine, was a recurrent theme in Europe's sacred architecture since the fifteenth and sixteenth centuries. The sanctuary of Bom Jesus de Matozinhos in Congonhas do Campo was initiated in 1757 by Feliciano Mendes, a Portuguese prospector, after he was cured of a serious illness. In order to build Bom Jesus de Matozinhos he begged for alms along the entry routes to Minas Gerais. When he died in 1765, the main altar had already been finished. Completion of the rest of the structure followed, in a plan similar to that of Santa Efigênia in Ouro Prêto. The interior contains three Rococo altars. The main altar has a capriciously curved canopy that is supported by voluted columns, which frame the Lord crucifix. The surrounding church courtyard was constructed between 1777 and 1790, the work of Tomás de Maia Brito. From 1796 to 1799 O Aleijadinho sculpted images in wood for the seven stations of the Passion. The figures of Christ, the Apostles of the Last Supper and Gethsemane, and the other principal figures of the stations are the artist's own rendering; subsidiary figures were completed by his assistants. These sculptures were exhibited in the five chapels devoted to the stations. Only the first chapel, pertaining to the Last Supper, was finished during

O Aleijadinho's lifetime; the rest were constructed during the course of the nineteenth century. The painters Manuel da Costa Ataíde and Nepomuceno Correia e Castro began polychrome treatment on the images in the chapels pertaining to the Last Supper, the Agony in the Garden, and the imprisonment by Caiaphas. The rest of the figures were polychromed as the chapels were completed during the nineteenth century. From 1800 to 1803 O Aleijadinho produced soapstone sculptures of the twelve Old Testament prophets and installed them along the parapets of the church courtyard, which must have been specifically designed under his direction. The two sets of stairs leading to the courtyard, each with two flights and landings, are symmetrically centered in the front of the church. The walls forming the parapets extend along elongated curves at opposing angles or in rectilinear sequences-a feature only found in the work of O Aleijadinho. The statues of the prophets are set symmetrically along these parapets, in accordance with their historical importance, and contain emblematic expressions and gesticulations. This site in Congonhas was directly inspired by Portuguese sanctuaries, such as Bom Jesus in Matozinhos, near Porto, as well those in Braga and Lamego. However, the courtyard in Congonhas is distinguished because the statues have the same importance as the architectural composition. In Portugal such images tend to be merely decorative elements along the staircases that dominate the sites. In Congonhas, however, O Aleijadinho was both architect and sculptor.

Translated from the Portuguese by David Auerbach.

Notes

1. See George Kubler, *Portuguese Plain Architecture— Between Spices and Diamonds. 1521–1706* (Middletown: Wesleyan University Press, 1972).

2. See Robert C. Smith, "The Seventeenth and Eighteenth-Century Architecture of Brazil," in *Proceedings of the International Colloquium on Luso-Brazilian Studies. Washington, 1950* (Nashville: Vanderbilt University Press, 1953), or in H. V. Livermore, ed., *Portugal and Brazil—An Introduction* (Oxford; Clarendon Press, 1963).

3. See Germain Bazin, *L'Architecture religieuse baroque au Brésil*, 2 vols. (Paris/São Paulo: Librairie Plon/Museu de Arte de São Paulo, 1956–58).

4. Ibid.

The Main Altar of São Bento de Olinda

Augusto C. da Silva Telles

The large retable of the main altar of São Bento de Olinda is a Baroque-Rococo masterpiece without antecedent in Pernambuco or all of Brazil, although it does present some indications of the coming Neoclassicism (see cat. nos. 35.1–.6). Carved entirely in wood and gilded in gold, it is structured with four cylindrical columns decorated with foliage; the two outer columns are positioned more prominently forward. All of the columns have Ionic capitals topped by entablature segments. The deep central niche extends up to the crown, with succeeding shell-shaped curves climbing upward, as if the waves could reach to a throne at the top for the Consecrated Host. On each side of the altar table, the columns lean on dynamic, voluted supports. At the top of the retable, resting on the central columns, a Baroque composition of volutes form an arch, projecting toward the main altar ceiling. The ensemble is sided by robust volutes that rest on the

external columns. The main altar's access door and the tribune spans are embellished by carved and gilded balconies and canopies that echo the retable design. In addition, the choir balcony at the center has a central arch that frames a sculpture of Christ on the cross by Friar Domingos da Conceição.

Germain Bazin and Robert C. Smith both have posited that the São Bento retable is the work of a master from the Minho or Braga region of Portugal because of its similarities with the carvings at the São Martinho de Tibães Benedictine monastery in Portugal and those at the Santa Maria de Pombeiro and São Miguel de Refoio de Basto monasteries. The shell-like shapes, beads, and acanthus foliage of those carvings display a muscular vigor (*vigueur musclé*) as defined by Bazin, who compares them to the undulating movements of ocean waves. The architectural designs of André Soares or one of his students, Friar José de Santo Antônio

Vilaça, might well have reached Olinda, because the abbot Friar Miguel Arcanjo da Anunciação traveled to Tibães, the headquarters of the Portuguese Benedictine Congregation, for triennial legislative, or general chapter, meetings.[1]

The retable at Olinda was the swan song of Baroque-Rococo carving in northeastern Brazil, and it was never again matched. The Santa Teresa de Olinda convent main altar, which was inspired by it, and the São Pedro dos Clérigos church in Recife, which copied it, do not succeed in creating the exuberance of the retable of Olinda. The following remarks will serve to put the importance of the São Bento masterpiece into a wider context of both Benedictine history and the development of Brazilian ecclesiastical architecture.

Saint Benedict and the Benedictines

Saint Benedict of Nursia (ca. 480–547) was born to a wealthy family in Nursia, Italy. He left as a young man to live as a hermit in a grotto in Subiaco, forty miles outside of Rome. Over the next few years his reputation as a holy man grew, and he attracted a following. He then moved to Montecassino, where he built a much larger monastery, which in 529 became an abbey. At Montecassino he wrote his Benedictine rule defining the guidelines of a monk's life: devotion to God, retreat from the world, community life, poverty, chastity, obedience to the abbot, and permanent residence at one monastery. The motto was *ora et labora*: pray and work. The Benedictine rule is the foundation of Western monasticism.

The monasteries were located on the outskirts of cities and towns, and the monks dedicated their time to agricultural labor, maintenance of the monastery, and scholarly work. The physical nucleus of the monastery was the cloister, around which the various rooms were centered. The church occupied one of the wings and comprised the sacrarium, or the main altar, where services took place, and the nave, which held the choirs and stalls for the monks and friars. The other wings facing the cloister housed the sacristy, the chapter room, the workroom, the dormitories, the refectory, the kitchen, the infirmary, the inn, the vestibule, the barn, and other rooms. Individual cells later replaced group dormitories. Another late addition to monastery design was the library, which became a vital center for both the monastery and for medieval culture in general. The library is where manuscripts and religious art from ancient times to the present were held and where calligraphers and illuminators prepared their copies of ancient texts and new documents.

Montecassino became the center from which Saint Benedict's influence spread, and Benedictine abbeys were founded all over Europe. During the first few centuries after the death of Saint Benedict, the abbeys were independent from each other, with no bond other than the Benedictine rule itself and obedience to the pope. In the twelfth and thirteenth centuries the monasteries of each ecclesiastical province were united into a congregation, and a system of governance was established for the abbeys in each congregation.

Brazilian Monasteries

The Portuguese Benedictine Congregation was founded in 1566 through a papal bull, and the first members came to Brazil in 1581 to live under the leadership of Friar Antônio Ventura de Laterão. They arrived in Salvador, where they were greeted by the governor and the bishop, and settled at the little church of São Sebastião, near the city entrance. Shortly thereafter, they built their own abbey. The church and monastery were plundered and heavily damaged by the Dutch in the early seventeenth century. By the late seventeenth century, construction began on a new church, designed by Macário de São João, a Spanish friar who was probably the architect of Santa Teresa church and convent (now the Museu de Arte Sacra).

The new Benedictine church, a cruciform plan, follows the design of Il Gesù in Rome (1568–84), the mother church of the Jesuit order, with a dome over the transept—a disseminated design found throughout Europe, including Spain, but which did not reach Portugal until the late seventeenth century. Construction was often interrupted, and the main altar was not completed until the early nineteenth century. In the early twentieth century the dome was finally built, in addition to the two towers flanking the facade. The monastery was also extended at this time, and the retable that had been temporarily erected in the nave was taken down and placed at the Monte Serrate monastery church, where it remains today.

Church authorities and the residents of various cities and towns desired the presence of the Benedictines, and therefore monks were sent from the Salvador monastery to Rio de Janeiro in 1586, to Olinda in 1590, and to Paraíba (later renamed João Pessoa) and São Paulo in 1598, at each of these locations building monasteries. The monasteries along the coast faced serious difficulties from the Dutch invasions and occupations of Salvador from 1624 to 1625 and of other areas of the Northeast from 1630 to 1654.

In Rio de Janeiro the Benedictines were initially located at Nossa Senhora do Ó chapel, later occupied by the Carmelites. They settled permanently on the top of what is now São Bento hill, near the chapel Nossa Senhora da Conceição. In 1641 construction of a monastery and church commenced, designed by Francisco Frias da Mesquita and revised by Friar Bernardo de São Bento. Decorative carvings were added by Friar Domingos da Conceição at the end of the century.

In Olinda the Benedictines first resided at São João Batista chapel but soon moved to Nossa Senhora do Monte, donated by the diocese. They were unhappy with the location, however, and acquired a spacious, elevated area along the seaside, where they started building a church and monastery. When Olinda was occupied by the Dutch, the monks had to leave, and the monastery was plundered and burned. After the invaders were expelled, the Benedictines started rebuilding the monastery.

Friar Mauro Teixeira arrived in São Paulo in 1598, and built a chapel dedicated to Saint Benedict on the north side of the village. Years later, upon the arrival of other monks, a monastery was organized by the chapel, which grew to become an abbey. The explorer Fernão Dias Paes was its great benefactor, donating funds to build the church and extend the monastery; he is buried under the main altar.

The Benedictine monastery in Paraíba was greatly damaged during the Dutch occupation. A new church was started in 1721 and completed by mid-century. By the late nineteenth century, however, the monastery was unoccupied and fell into disrepair.

Many of the large monasteries received donations that allowed them to establish smaller, dependent monasteries. The Benedictines of Salvador created the Nossa Senhora da Graça monastery in the mid-seventeenth century, when Catarina Paraguaçu donated a chapel on property belonging to Diogo Álvares, who was known as O Caramuru. Both the monastery and the church were extended in the eighteenth century, but the cloister and the bell tower were left untouched. Nossa Senhora de Monte Serrate monastery, on the Itapagipe peninsula, was probably first a small church that belonged to the Garcia d'Avilas before it was donated to the Salvador Benedictines. The church, reputedly designed by Baccio da Filicaia, holds a main altar, with a dome and a porch over columns at the front of the nave. The chapel has a retable from the Salvador monastery and a terra-cotta image of Saint Peter repenting, by the outstanding seventeenth-century clay sculptor Friar Agostinho da Piedade.

The Olinda monastery oversaw the exquisite Nossa Senhora dos Prazeres church; its main altar was a votive chapel built by Field Master Francisco Barreto de Menezes to honor the Virgin Mary after his victories in the battles of Guararapes, when the Dutch were finally expelled. The chapel and the property on which it is located, where the battles took place, were donated to the Benedictines. The church nave and main altar are overlaid with patterned, two-shaded blue tiles, dating from 1680 to 1690. According to the art historian Santos Simões, this is "the largest and most important blue tile repository in the Luso-Brazilian collection." The facade was built in two stages: it was begun in the mid-eighteenth century and then completed in 1782 by Francisco Nunes Soares, who also worked on the facade of the church at the Olinda monastery.

São Bento de Olinda Monastery

After the Pernambuco Restoration—when the Dutch were driven out of Brazil in 1654—and the monks returned to Olinda, construction of the São Bento monastery and church was immediately resumed. The work was carried on for many years, with stops and starts, because of financial difficulties. By the mid-eighteenth century the most definitive elements were complete: the church bell tower and facade, reputedly designed by Master Francisco Nunes Soares, who also completed the Prazeres de Guararapes church facade.

These two facades feature innovations similar to the trends in Portugal at the time, in the regions of Porto and Braga, seen in the works of Nicolau Nasoni and André Soares: the entablature is raised and curved; the medallion window on the pediment is moved down to the main part of the facade, in the center above the choir windows; and the upper contours of the pediment undulates and curves outward, following Rococo taste. Both churches' facades, as well as that of Conceição da Jaqueira chapel in Recife, feature a medallion window that is surrounded by decorative elements in the style of a Maltese cross.

Friar Miguel Arcanjo da Anunciação served as abbot of São Bento from 1786 to 1789, during which time the main altar was extended into the sacristy space, and a new sacristy was built. The monastery covers an entire block around the cloister, to which it is connected via an arcade; the monks' cells are on the second floor, with windows overlooking the cloister. The monastery is similar to the Benedictine monastery in Rio de Janeiro. The church, which occupies one of the wings, has a portico under the choir, a single nave, altars on lateral walls, and a deep main altar, behind which lies the sacristy.

During these three years, the sacristy was equipped with a chest of drawers, cabinets, painted panels, and ceiling paintings. Smith attributes the great chest of drawers and the cabinets to the carving master José Gomes de Figueiredo, who produced similar works for the São Pedro dos Clérigos church sacristy in Recife.[2] At the center of the chest of drawers is a prominent panel depicting Our Lady of Sorrows, by the Pernambuco painter José Eloy. Smaller panels of scenes from Saint Benedict's life, displayed throughout the sacristy, are the work of the Pernambuco painter Francisco Bezerra. The panels have carved and gilded Rococo frames with marblelike blue pieces. The flat ceiling holds three large panels by the same painter, who also painted and gilded the frames.

The carvings are similar to those of the retable of Nossa Senhora do Pilar chapel, carved by Mestre Simão, and to carvings dating from the same period at São Francisco, at the small Paudalho monastery in Pernambuco, and at the Crucifixo da Sé chapel in Olinda. The São Bento sacristy carvings, though, are livelier and more robust. The carvings at São Bento's large main altar, created in the preceding three-year period, from 1783 to 1786, although also Rococo, are completely different in terms of structure and sculptural form. Bazin describes the sac-

risty carvings embellished with cut and applied beads as "rocaille découpé en applique" and the bulging Rococo at the high altar as "rocaille boursouflé."[3]

Benedictine Monasteries in the Nineteenth and Twentieth Centuries

The Brazilian monasteries were controlled by the Portuguese until 1827, when a papal bull of Leo XII created an independent Brazilian Benedictine Congregation, in consequence of the country's separation from the Portuguese kingdom. In 1855 the Brazilian imperial government forbade the acceptance of novices to the monasteries, and the monasteries slowly grew short of members. In 1868 the Brazilian Benedictine Congregation comprised only forty-one monks and, by the close of the century, only nineteen divided among seven abbeys; only one monk resided in Rio de Janeiro. The monastery in Rio de Janeiro was used as army troop quarters from 1824 to 1831 and again in 1859, and the interior of the monastery and its art collection were greatly damaged. A similar situation occurred at the monastery in Salvador. A law school was opened at the Olinda monastery in 1824 and remained in existence until mid-century, when it was transferred to Recife. Olinda and São Paulo housed the first two law schools in Brazil.

At the end of the period of the Brazilian Empire, in 1889, the Brazilian Congregation signed an agreement with the Belgian Congregation at Beuron to revitalize the Brazilian monasteries. Monks from Beuron arrived in Brazil to live at the monasteries in Olinda, Rio de Janeiro, Salvador, and São Paulo and helped establish the foundation of boys' schools.

Translated from the Portuguese by Regina Alfarano.

Notes

1. See Robert C. Smith, *Frei José de Santo Antônio Ferreira Vilaça—escultor beneditino do século XVIII*, 2 vols. (Lisbon: Fundação Calouste Gulbenkian, 1972); Smith, *Igrejas, casas e móveis: Aspectos da arte colonial brasileira* (Recife: Universidade Federal de Pernambuco, 1979); Smith, "A verdadeira história do retábulo de Nossa Senhora do Rosário da igreja de São Domingos de Viana do Castelo," in *Revista e Boletim da Academia Nacional de Belas Artes. 23* (Lisbon) (1967); and Germain Bazin, *L'Architecture religieuse baroque au Brésil*, 2 vols. (Paris/São Paulo: Librairie Plon/Museu de Arte de São Paulo, 1956–58).

2. See Robert C. Smith, "José Gomes Figueiredo and His Eighteenth-Century Pernambucan Sacristy Furniture," in *The Connoisseur* (London) (April 1972).

3. See Bazin, *L'Architecture religieuse baroque au Brésil.*

Main Altar, São Bento de Olinda

Olinda, in the northeastern state of Pernambuco, is an important site in the history of Brazilian art and society. A vital city during the Dutch presence in the region from 1630 to 1654—along with the Dutch capital, Mauritsstad (now Recife)—Olinda also became a center of the sugar economy that bourgeoned during the seventeenth and eighteenth centuries. It is the site of some of the most impressive colonial buildings in the region, among them the Benedictine monastery of São Bento, including its church, known as São Bento de Olinda.

The church has a highly ornate facade (1760–63) in the Rococo style, which apparently was designed by architect Francisco Nunes Soares. The main altar, created between 1783 and 1786 during a period when extensive renovations were made to the church and the monastic complex to which it belongs, is a masterpiece of Brazilian Baroque art. Made of carved and gilded cedar, the altar is in the ornate, even florid style that defines the late, or Rococo, phase of the Baroque. (However, there are certain elements that foreshadow the Neoclassical style that developed in the following century.) Measuring 13.6 meters in height, 7.9 meters in width, and 4.5 meters in depth, the altar is structured around four Ionic columns, which have exuberant foliage covering their cylindrical shafts. In the center, the deep niche extends to the crown, with successive shell-shaped elements climbing to the top to a throne for the Consecrated Host.

Several prominent art historians have studied this main altar, including Germain Bazin and Robert C. Smith, who both suggested that its stylistic precedents may be found in retables in churches around the city of Braga in the Minho region of northern Portugal. Carvings of the altars of churches in this area could have reached Olinda through São Bento's abbot, Frei Miguel Arcango da Anunciação, who traveled to the town of Tibães, the headquarters of the Portuguese Benedictine order, to attend general chapter meetings. Although there are other large altars in Northeast Brazil that were inspired by that of São Bento, such as the altars of Santa Teresa in Olinda and São Pedro dos Clérigos in Recife, none of them approximates the dramatic grandeur of this masterpiece. —Edward J. Sullivan

FACING PAGE: 35.1. Facade and bell tower, São Bento de Olinda

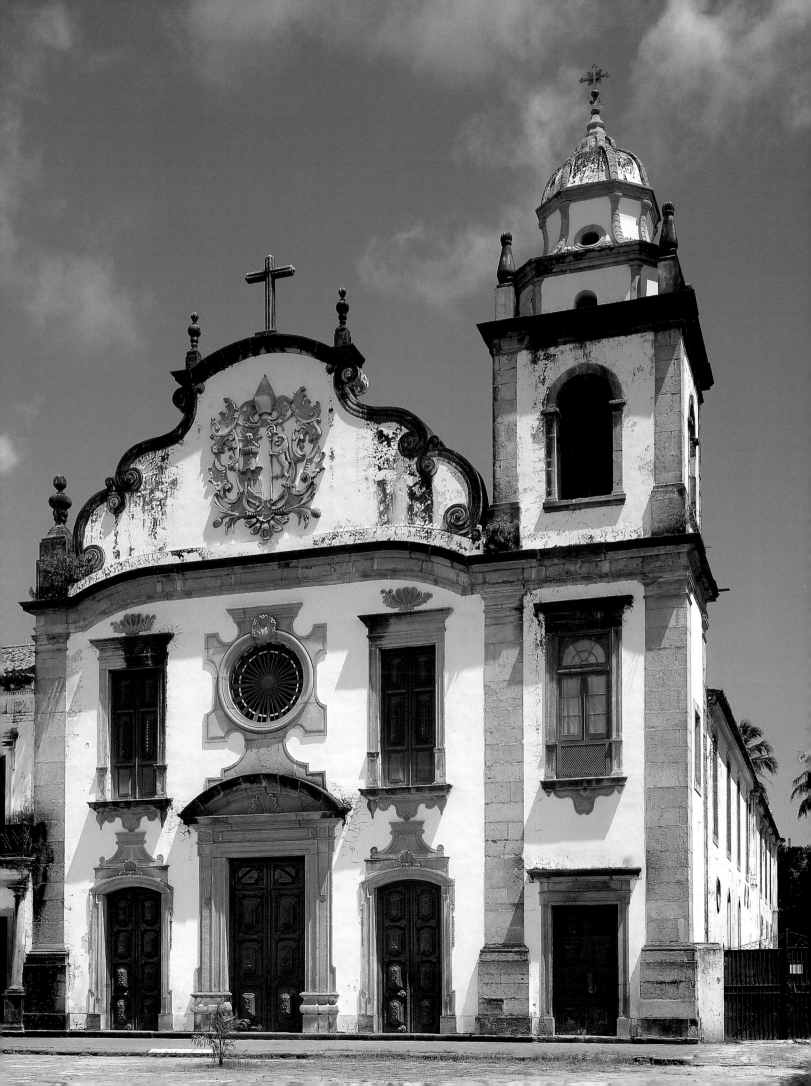

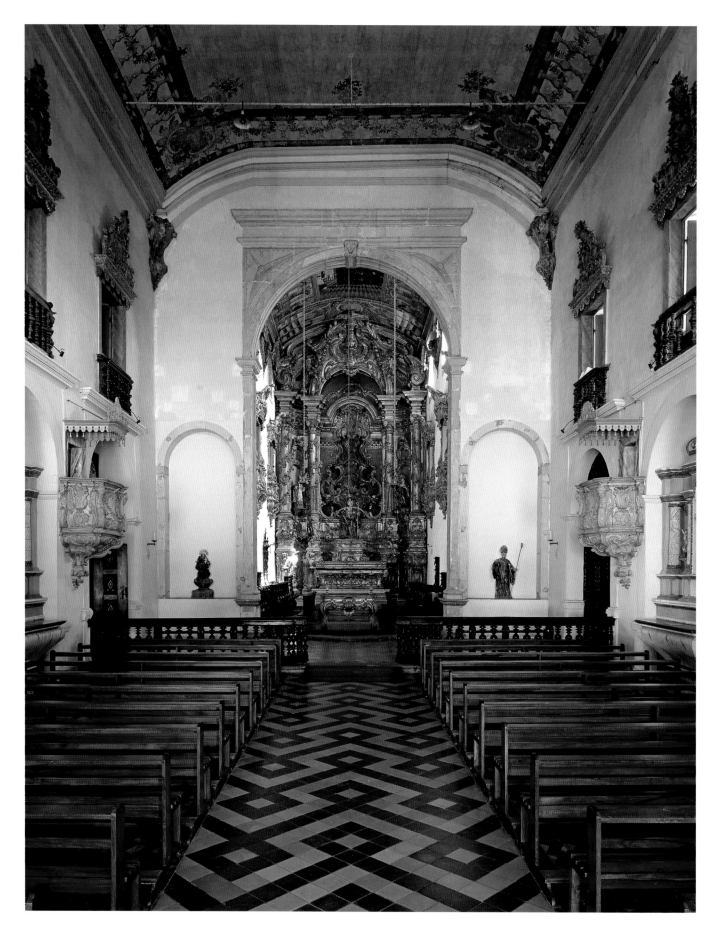

35.2. Interior, São Bento de Olinda, looking toward main altar

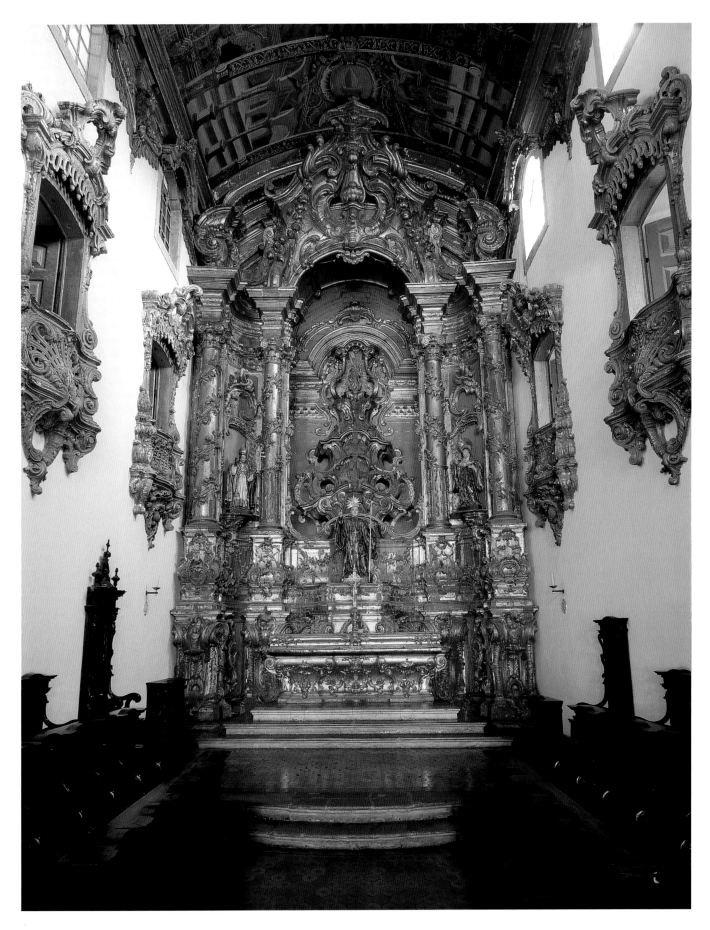

35.3. Main altar, São Bento de Olinda

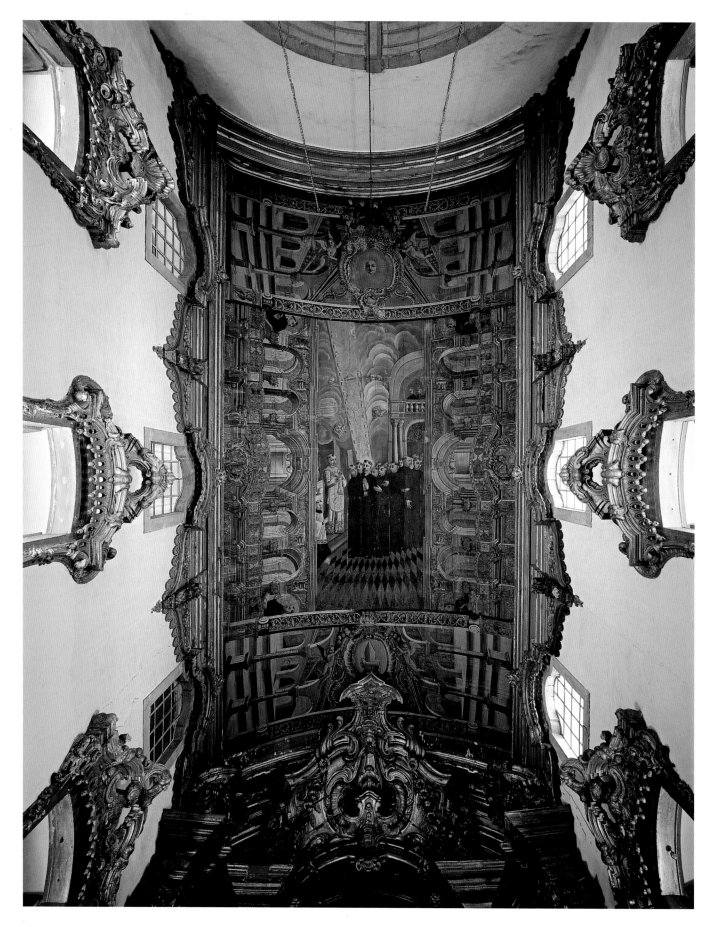

ABOVE AND FACING PAGE: **35.4.** Painted ceiling, São Bento de Olinda

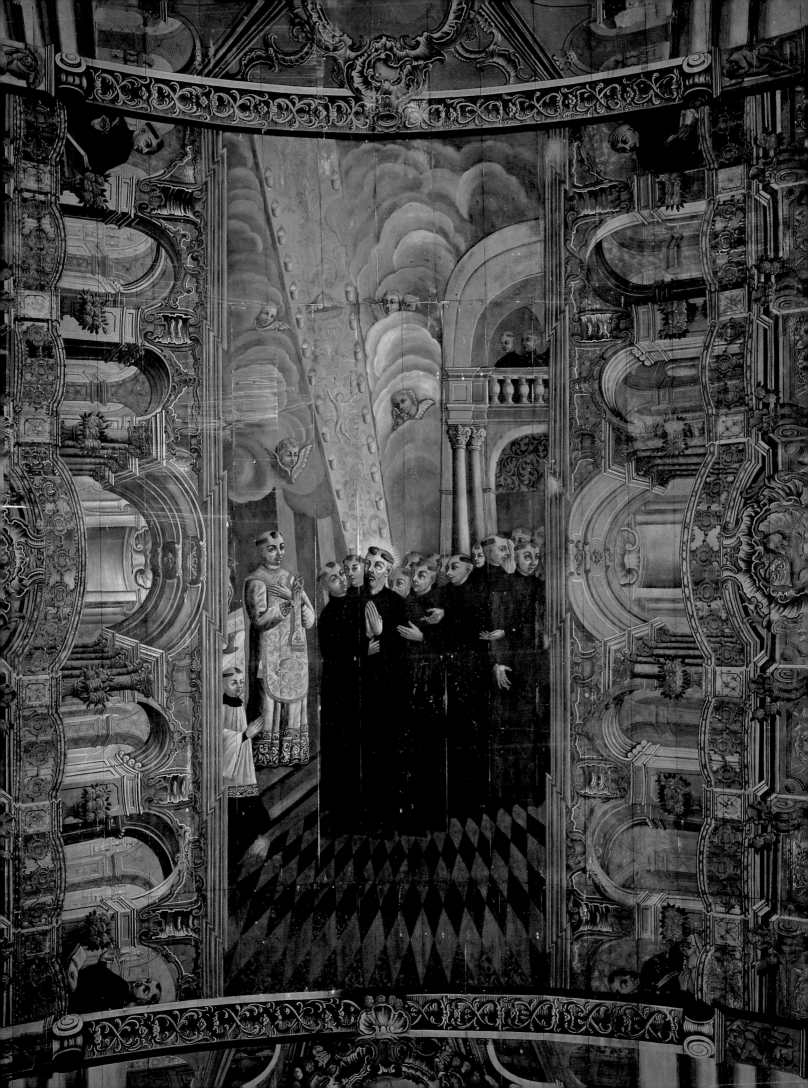

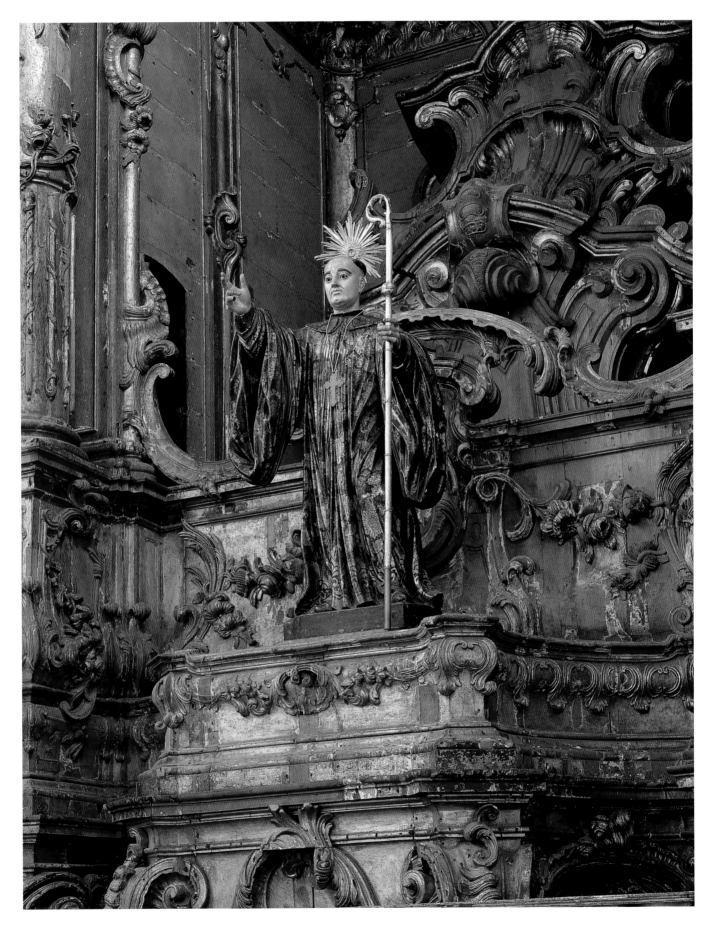

35.5. Main altar (detail), São Bento de Olinda

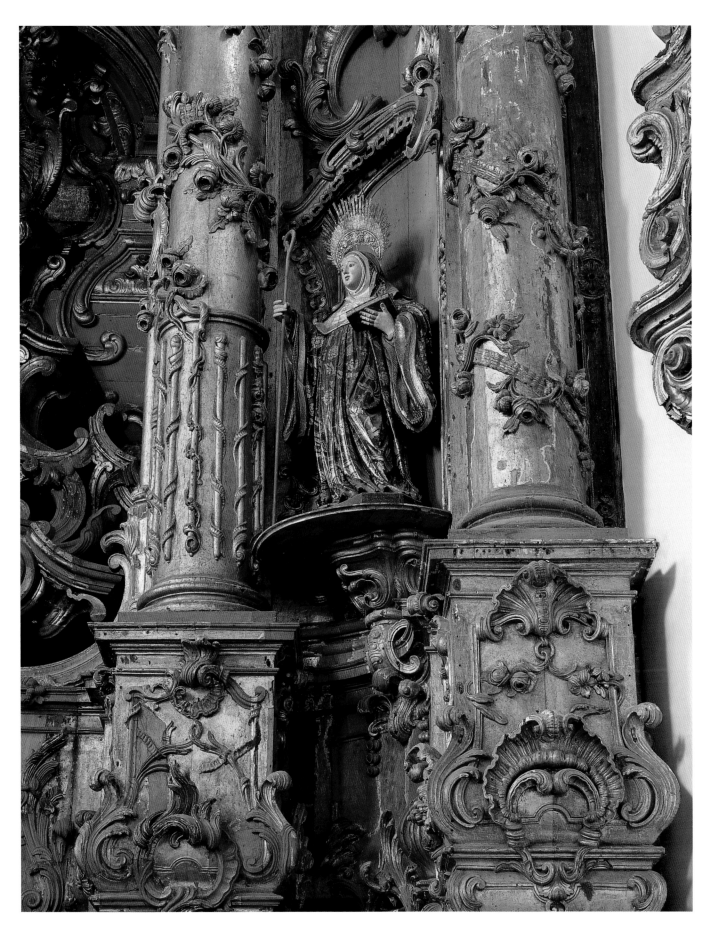

35.6. Main altar (detail), São Bento de Olinda

Baroque Sculpture

Today, the term "Baroque" has connotations of overabundance and an excess of decoration, yet we use it here merely as a convenient label to characterize a long and complex historical period in Brazil that stretches from the seventeenth century to, in some regions such as Minas Gerais, the early decades of the nineteenth century. Whereas painting was the art form held in the highest regard in most countries during the Baroque period, sculpture held pride of place in Brazil. Most Brazilian Baroque sculpture is made of wood, with very little in stone or metal. The sculptures are usually painted in lifelike tones and, to heighten the realism, provided with hair and sometimes glass eyes. Their immediacy and dramatic quality underline the fervor of devotion and the strength of the faith of those who commissioned and prayed to them.

Brazilian Baroque sculpture evolved from the hieratic stiffness of seventeenth-century terra-cotta pieces by such artists as Frei Agostinho da Piedade to the Rococo interest in detail and ornamentation of later eighteenth-century works. Specific stylistic characteristics were determined by several factors, one of which was geography. The ecclesiastical orders also determined iconographical content.

The sculptures are grouped both thematically and chronologically. There is a preponderance of imagery dedicated to the life of the Virgin Mary, who has always enjoyed great veneration in Brazil. Depictions of the life of Christ as well as of male and female saints are also present in this section. One of the most compelling subcategories of saints is that of the so-called "black saints," such as Saint Efigénia and Saint Elesbão, who were venerated especially in the churches and confraternities established for slaves and former slaves.

One of the salient characteristics of Brazilian Baroque art in general is its appeal to the senses and intense emotionalism. Much of this art is intended to be experienced in a public setting, whether in a church or chapel or during the many religious processions that mark the calendar year. Processional sculpture includes scenes of the life as well as the Passion and Death of Christ. The hands, feet, head, and bust of these figures are carved in detail, while the rest of the body is left unfinished, as it was (and still is) the custom to dress these figures.

Two of the most outstanding artists in the history of Brazilian Baroque sculpture were of African descent: Mestre Valentim (Valentim da Fonseca e Silva), a sculptor, architect, and landscapist active in the region of Rio de Janeiro, and O Aleijadinho (Antônio Francisco Lisboa), a sculptor and architect active in Minas Gerais. —E. J. S.

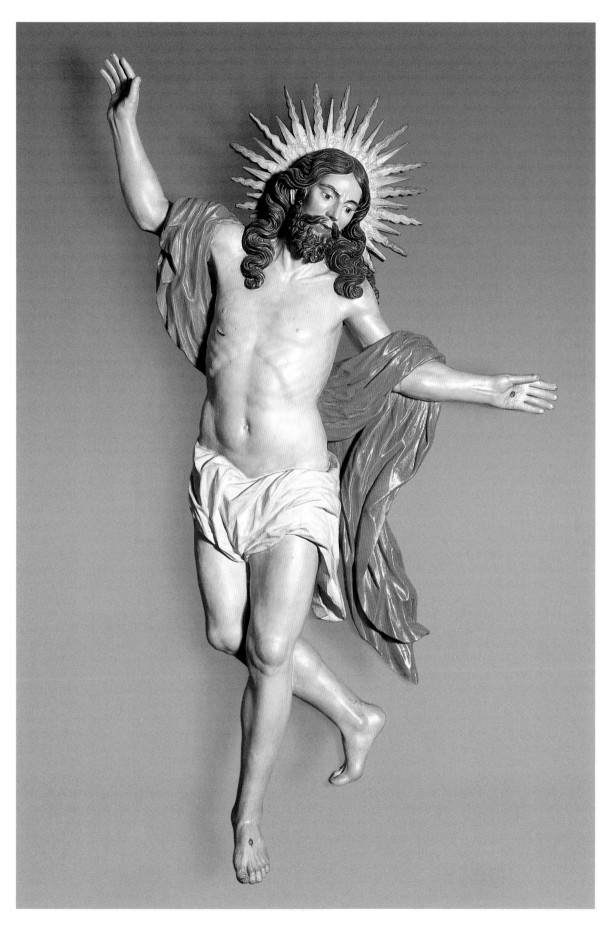

36. FREI DOMINGOS DA CONCEIÇÃO E SILVA *Resurrected Christ*, 17th–18th century. Polychromed wood,
255 x 150 x 35 cm. Private collection

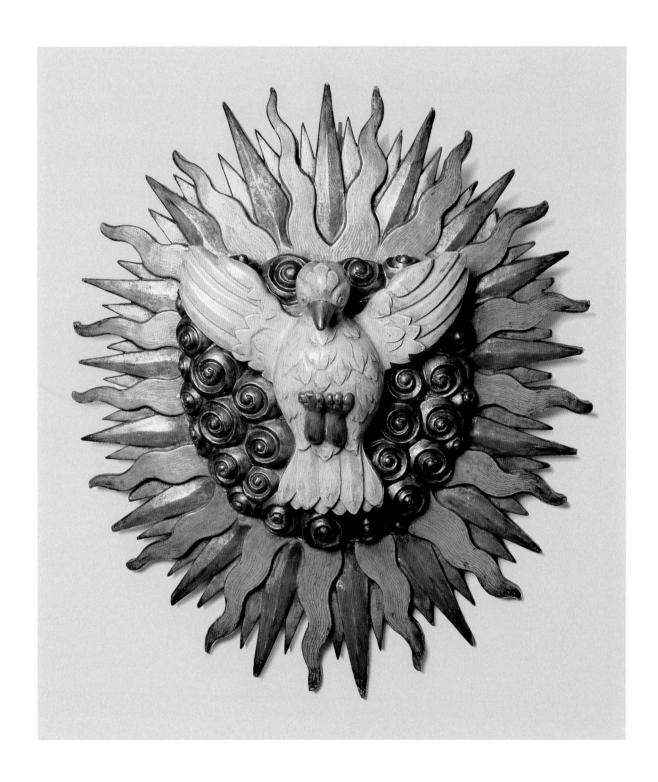

37. ANONYMOUS *Holy Spirit*, 17th century. Polychromed wood, 73.5 x 67 x 21 cm. Museu de Arte Sacra de São Paulo

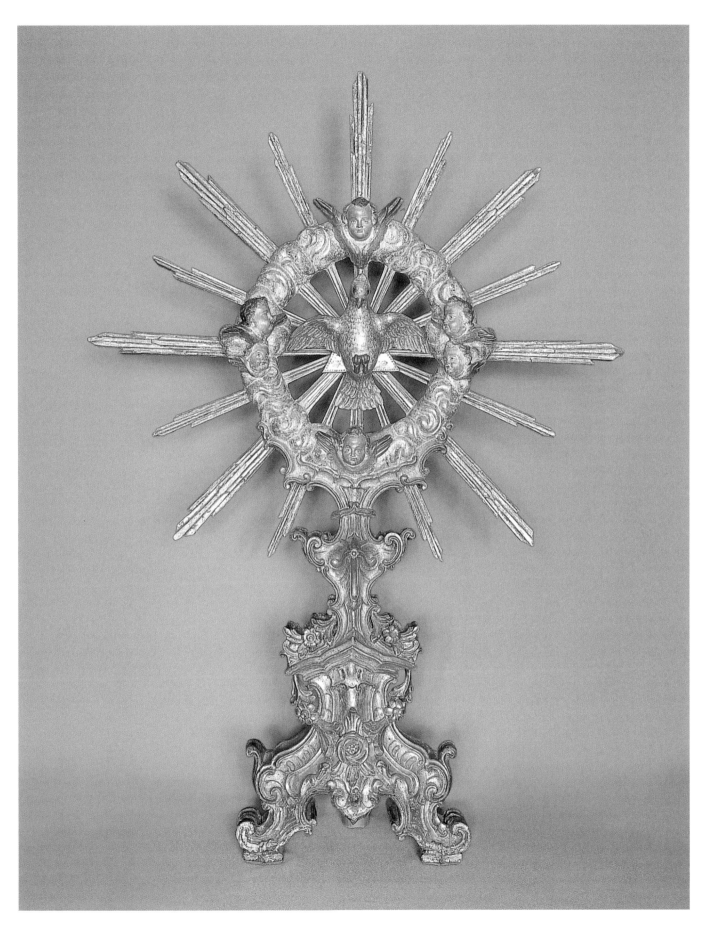

38. ANONYMOUS *Holy Spirit*, 18th century. Polychromed wood, 110 x 80 x 25 cm. Private collection

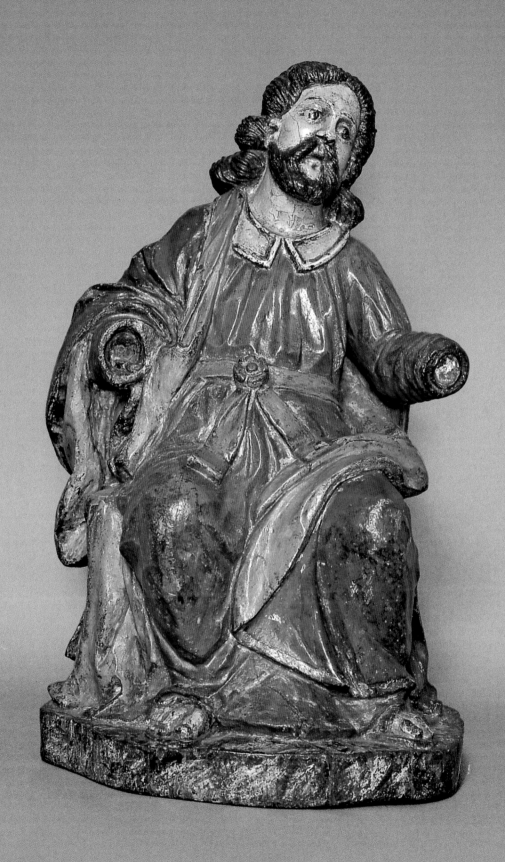

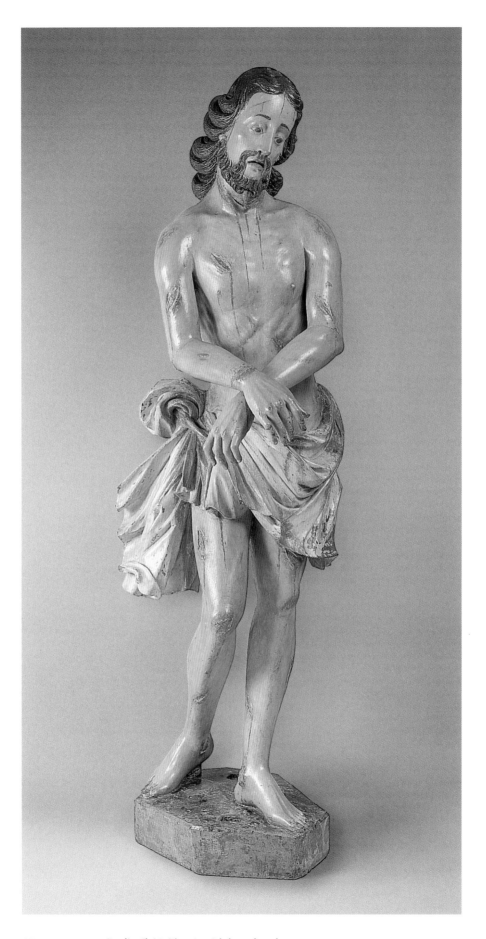

40. ANONYMOUS *Standing Christ*, 18th century. Polychromed wood, 172 x 73 x 52 cm.

Collection of Marcelo de Medeiros, São Paulo

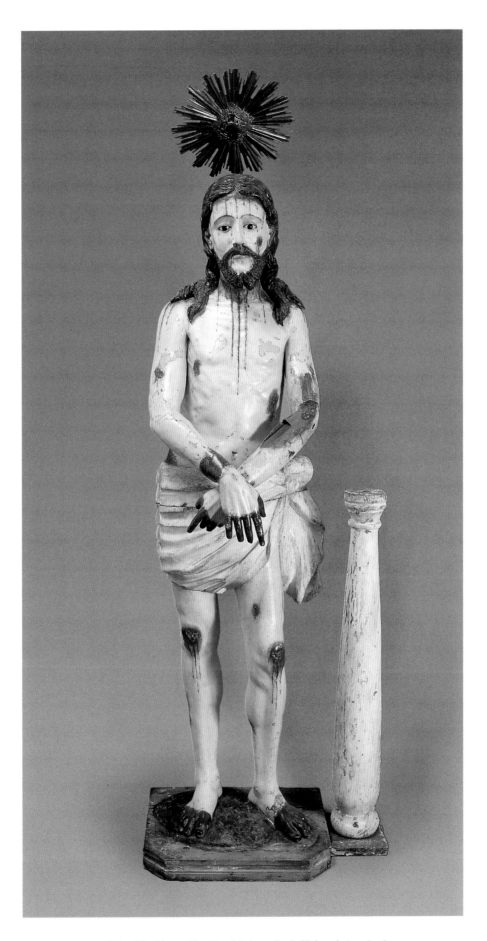

41. ANONYMOUS *Christ of the Column*, 18th century. Polychromed and gilded wood, 162 x 46 x 48 cm.
Private collection

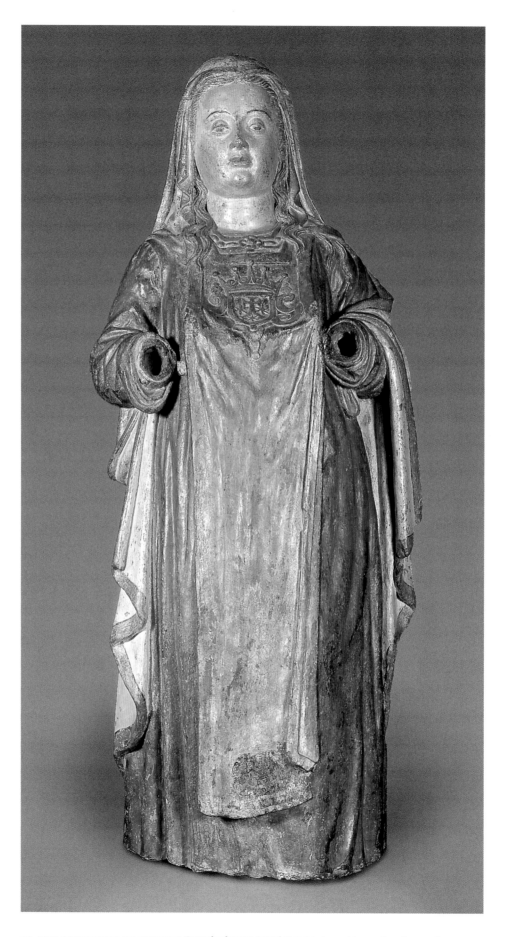

42. FREI AGOSTINHO DA PIEDADE *Our Lady of Mount Carmel*, 1640. Polychromed terra-cotta, 106 x 50 x 36 cm.
Private collection

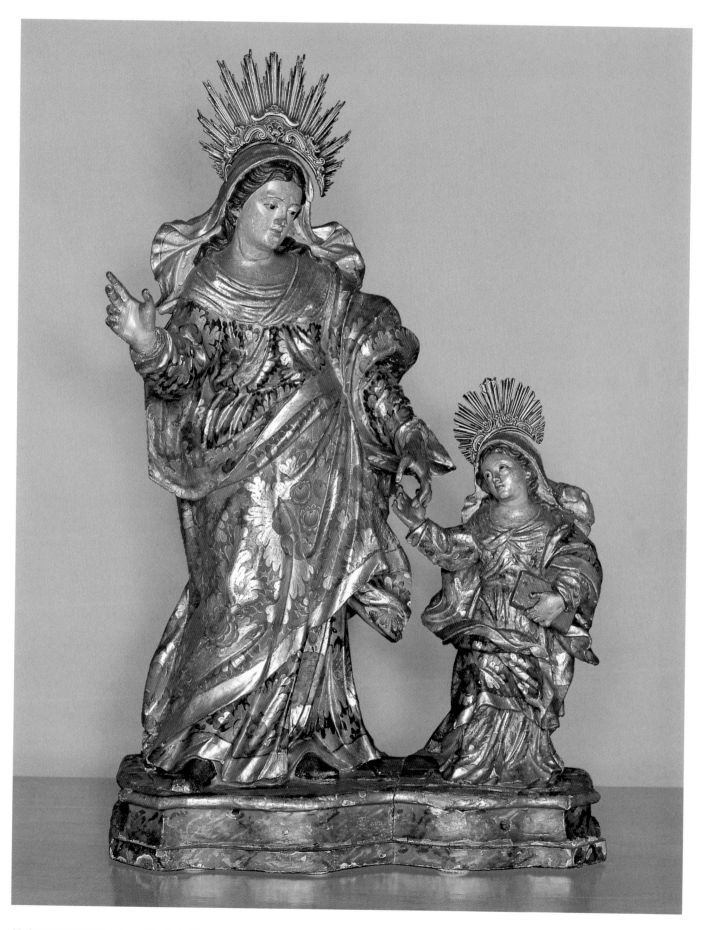

43. ANONYMOUS *Saint Ann and the Virgin*, 18th century. Polychromed and gilded wood, 107 x 66 x 34 cm. Private collection

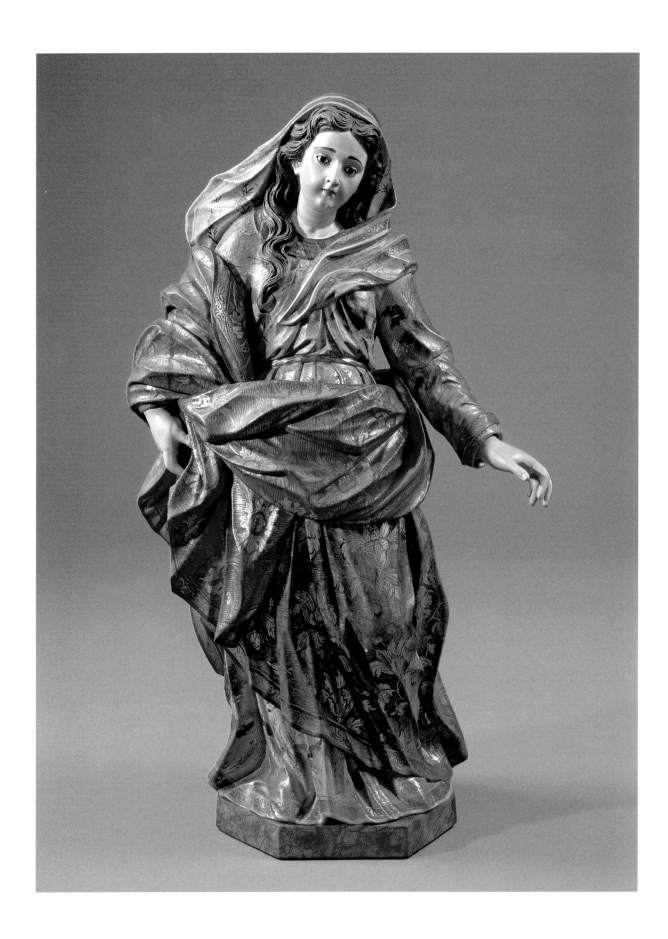

44. ANONYMOUS *The Virgin Mary*, 18th century. Polychromed and gilded wood, 76 x 39 x 26 cm. Igreja Nossa Senhora do
Carmo de Olinda–5a Superintendencia Regional/Instituto do Patrimônio Histórico e Artistico/Ministério de Cultura, Pernambuco

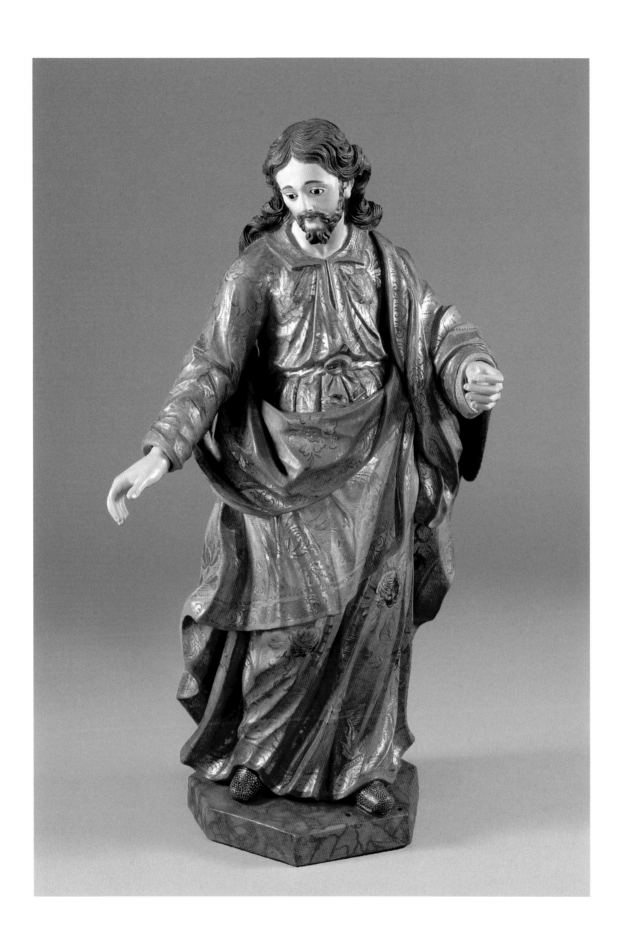

45. ANONYMOUS *Saint Joseph*, 18th century. Polychromed and gilded wood, 74 x 43 x 35 cm. Igreja Nossa Senhora do Carmo de Olinda–5a Superintendencia Regional/Instituto do Patrimônio Histórico e Artistico/Ministério de Cultura, Pernambuco

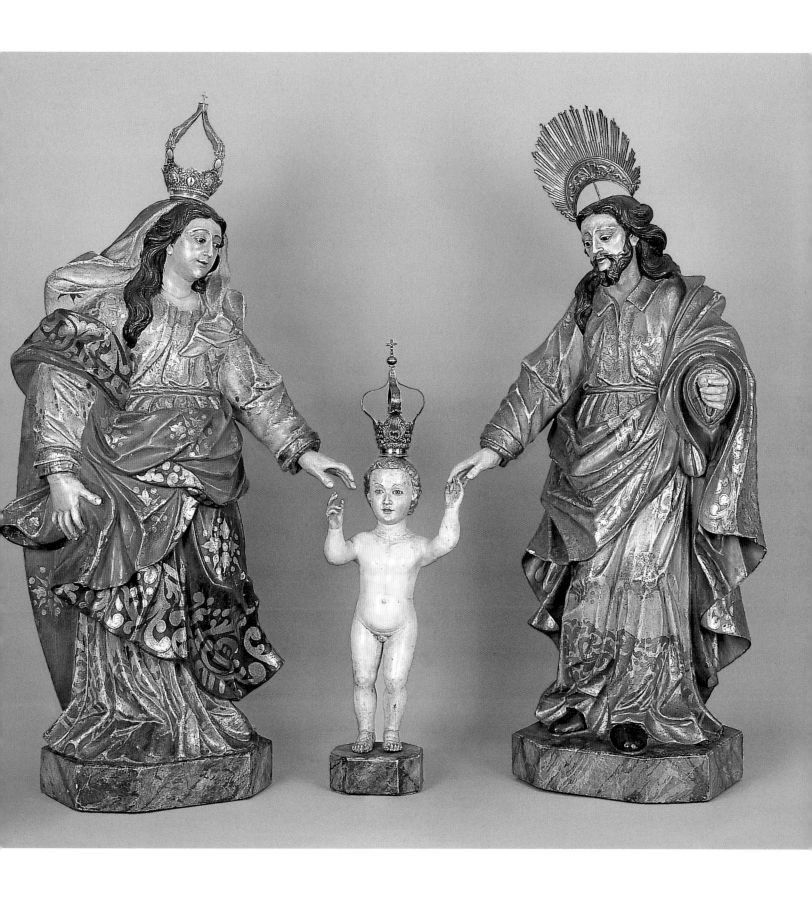

46. ANONYMOUS *The Holy Family*, 18th century. Polychromed wood, *Virgin Mary*: 74 x 44 x 23 cm; *Jesus*: 42 x 18 x 10.5 cm;
Saint Joseph: 74 x 40 x 24 cm. Private collection

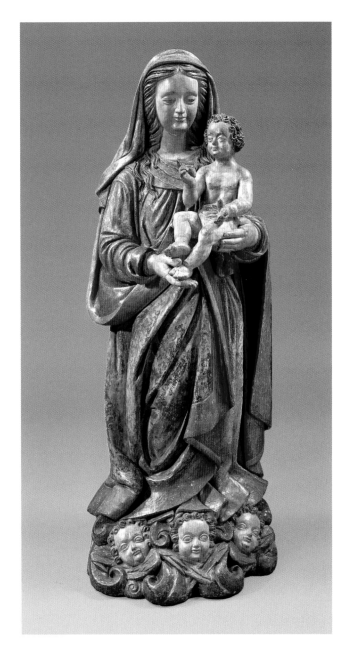

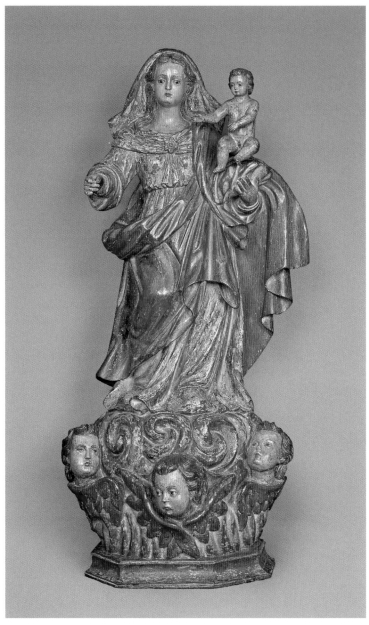

LEFT: **47. FREI AGOSTINHO DE JESUS** *Our Lady of Pleasures*, 17th century. Polychromed terra-cotta, 104 x 41 x 40 cm.
Private collection. RIGHT: **48. MESTRE OLIVEIRA** *Our Lady of the Rosary*, 18th century. Polychromed wood, 73 x 35 x 28 cm.
Collection of Mr. and Mrs. José M. Carvalho, Rio de Janeiro

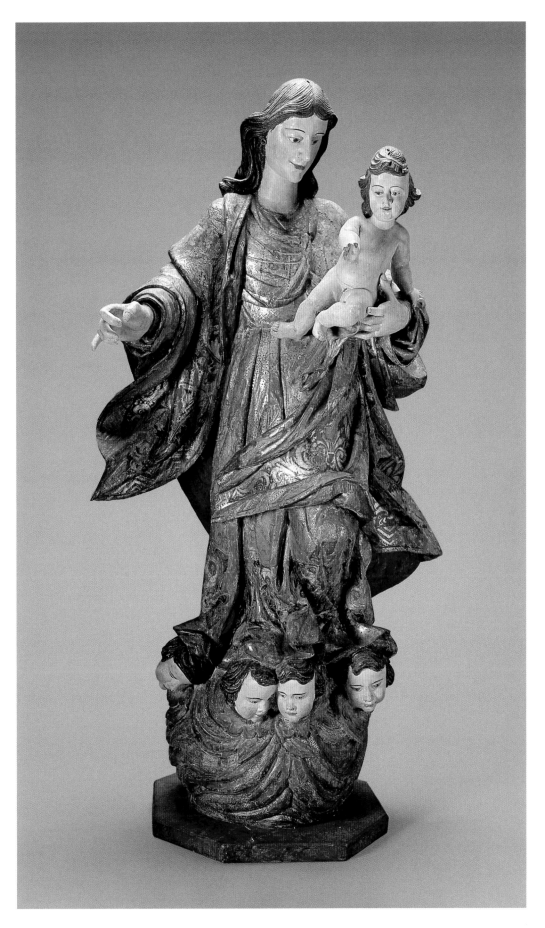

49. FRANCISCO DE VIEIRA SERVAS *Our Lady of the Rosary*, 18th century. Polychromed wood, 110 x 40 x 40 cm.
Private collection

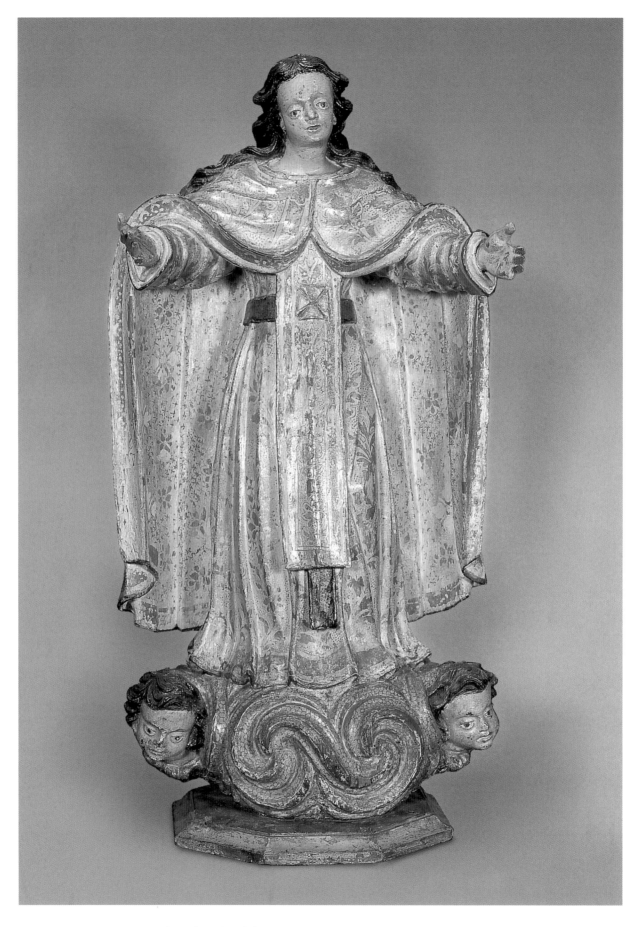

50. MESTRE PIRANGA *Our Lady of Mercy (Carmelite Order)*, 18th century. Polychromed and gilded wood, 69.5 x 34 x 28 cm.
Collection of Renato Whitaker, São Paulo

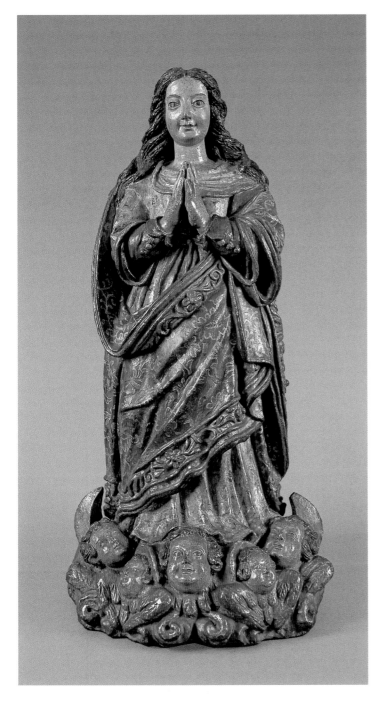

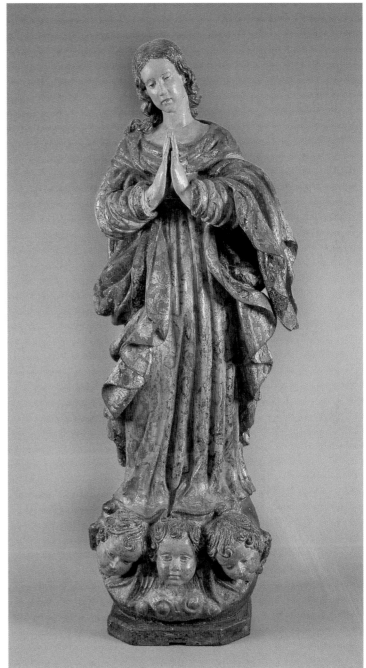

LEFT: 51. ANONYMOUS *Immaculate Conception*, 16th century. Polychromed wood, 68 x 35 x 27 cm. Collection of Ladi Biezus, São Paulo. RIGHT: 52. ANONYMOUS *Immaculate Conception*, 18th century. Polychromed wood, 90 x 36 x 33 cm. Collection of Ladi Biezus, São Paulo

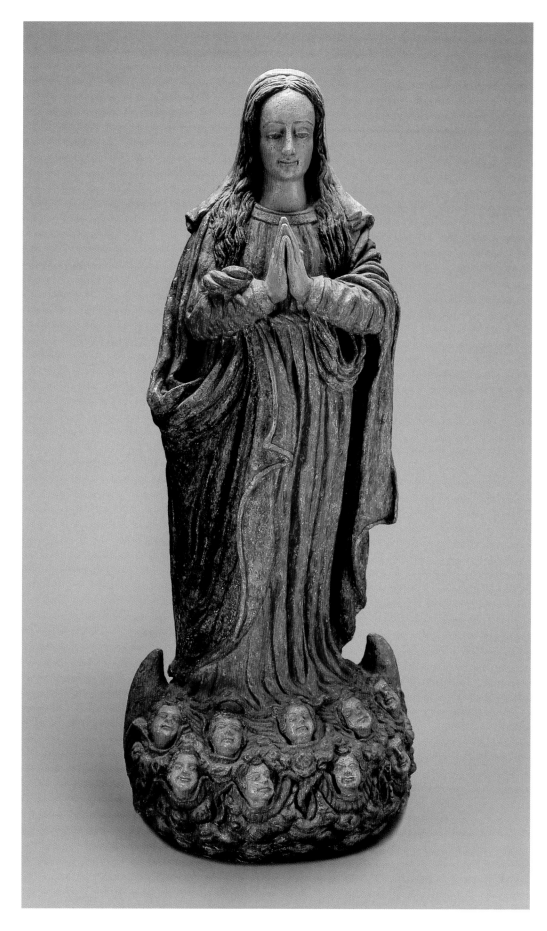

53. ANONYMOUS *Immaculate Conception*, 16th century. Polychromed terra-cotta, 97 x 44 x 34 cm. Private collection

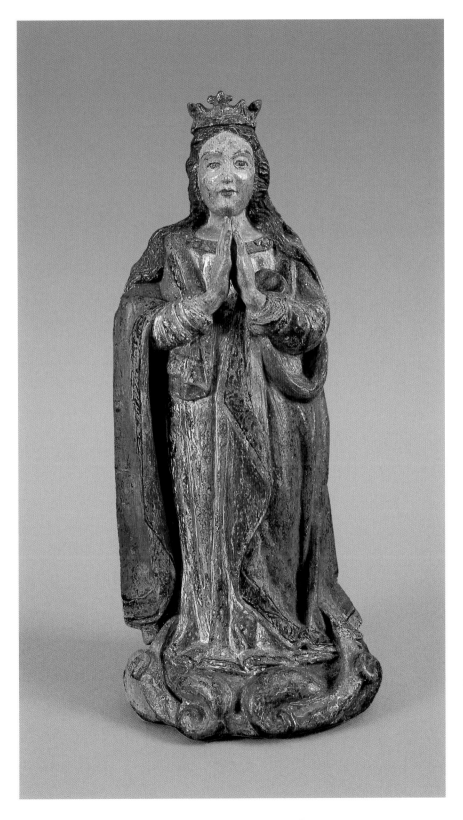

54. ANONYMOUS *Immaculate Conception*, late 16th century. Polychromed terra-cotta, 47 x 22 x 20 cm.
Collection of Ladi Biezus, São Paulo

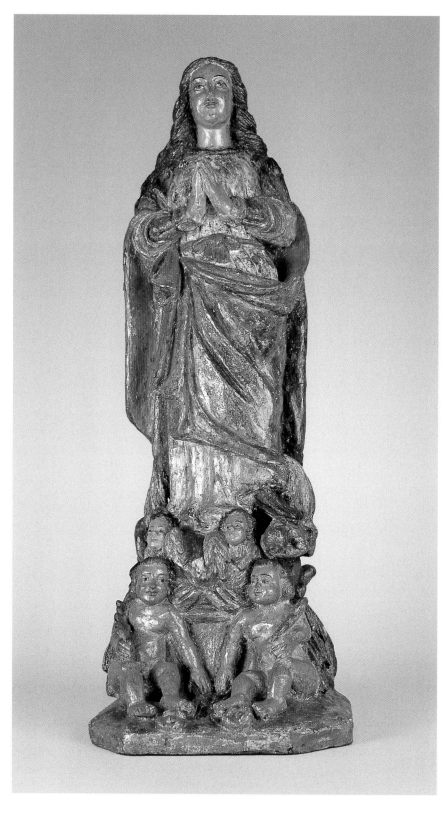

55. ANONYMOUS *Immaculate Conception*, 17th century. Polychromed wood, 57 x 22 x 22 cm.
Collection of Ladi Biezus, São Paulo

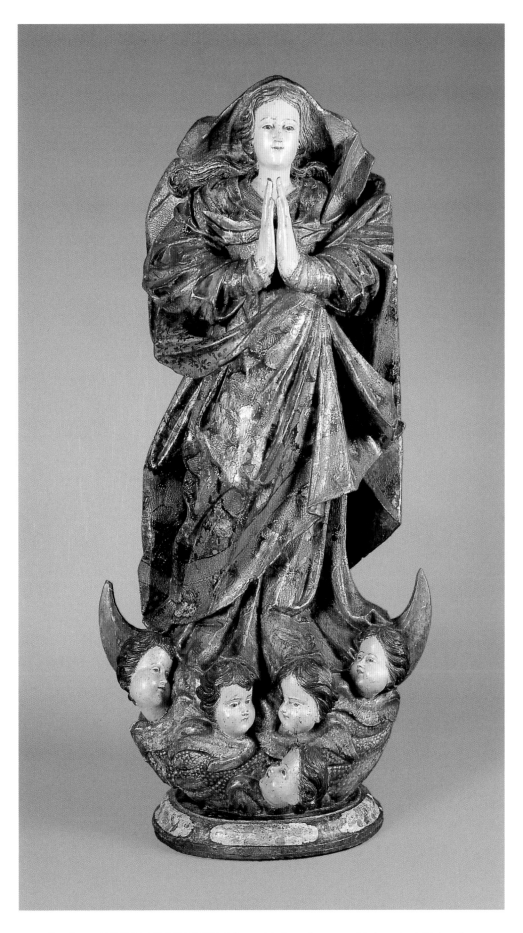

56. Attributed to FRANCISCO XAVIER DE BRITO *Immaculate Conception*, 1740–50. Polychromed and gilded wood,
102 x 48 x 33 cm. Instituto do Patrimônio Histórico e Artístico/Ministério de Cultura, Museu da Inconfidência, Ouro Prêto

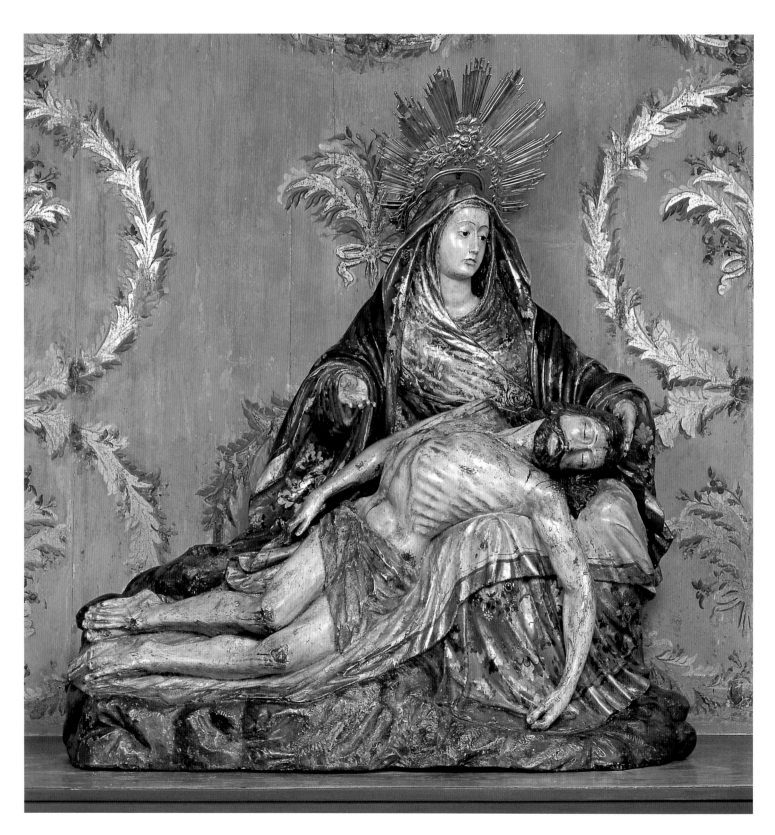

57. ANONYMOUS *Pietà*, 18th century. Polychromed and gilded wood, 90 x 97 x 43 cm.

Collection of Marilisa Rodrigues Rathsam

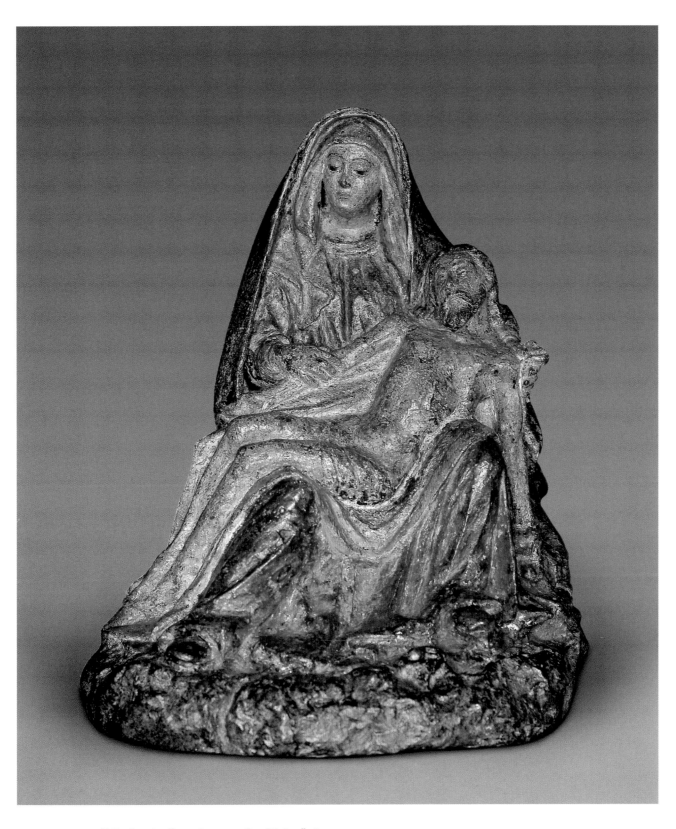

58. ANONYMOUS *Pietà*, 17th century. Terra-cotta, 33 x 31 x 28 cm. Private collection

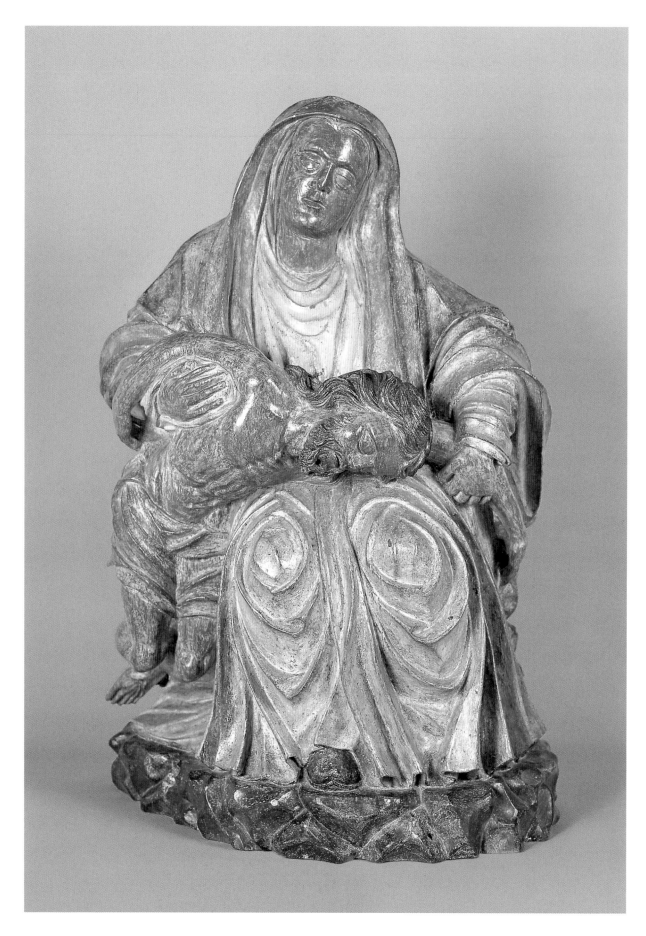

59. MESTRE PIRANGA *Pietà*, 18th century. Polychromed wood, 83.5 x 54.6 x 36.5 cm. Collection of Renato Whitaker, São Paulo

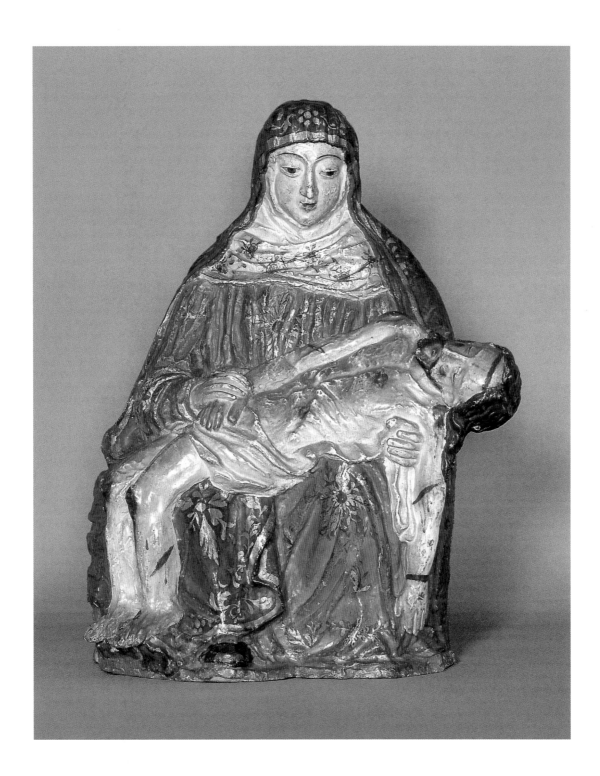

60. ANONYMOUS *Pietà*, 18th century. Polychromed terra-cotta, 46 x 38 x 22 cm. Private collection

FACING PAGE: **61. ANONYMOUS** *Our Lady of Sorrows*, 18th century. Polychromed wood, h. 180 cm.
Arquidiocese São Salvador da Bahia (Catedral Basílica, Salvador)

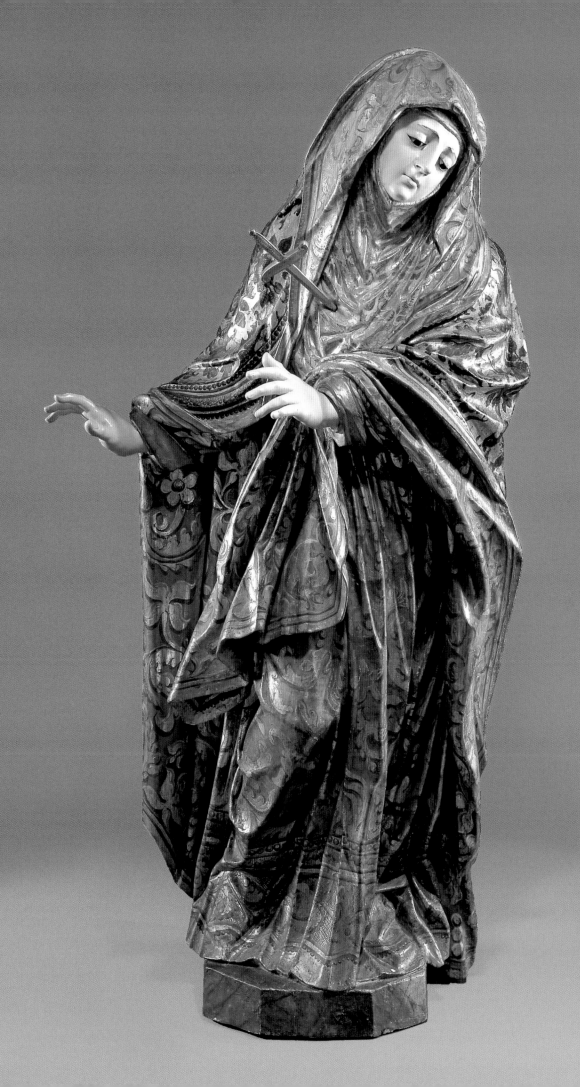

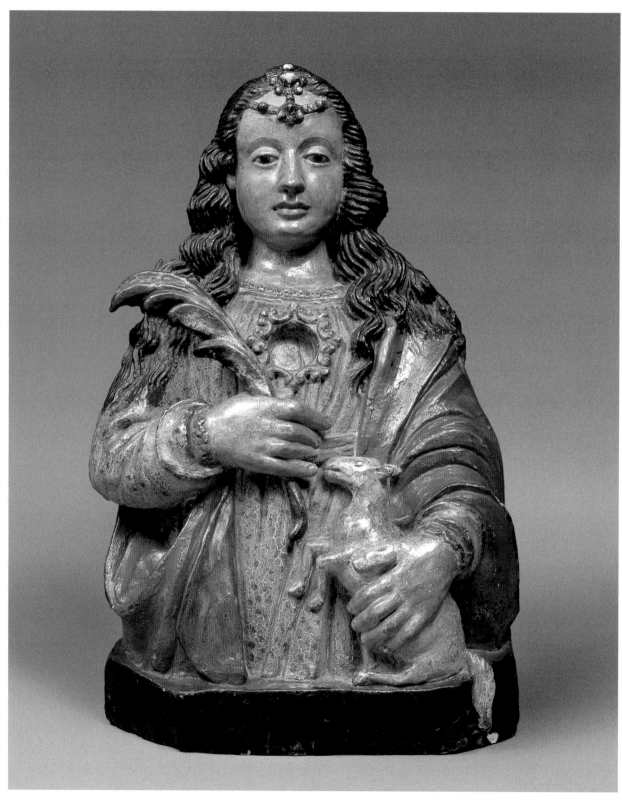

62. MESTRE DE ANGRA *Reliquary Bust of Saint Engracia*, 17th century. Polychromed terra-cotta, 53 x 36 x 28 cm.
Collection of Ladi Biezus, São Paulo

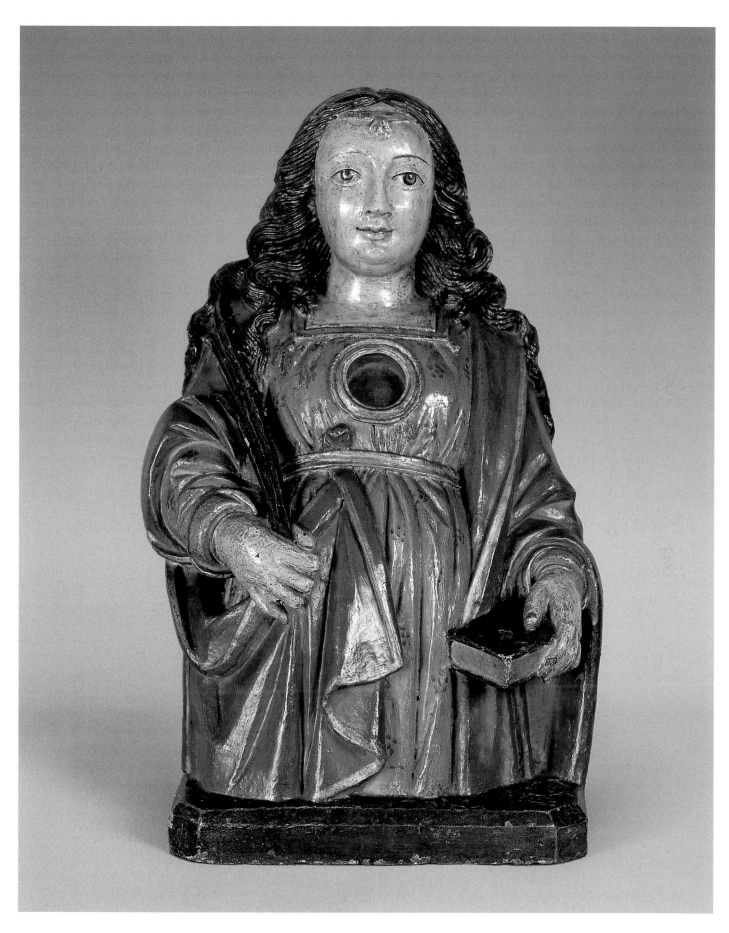

63. ANONYMOUS *Reliquary Bust of Saint Ursula*, 17th century. Polychromed terra-cotta, 65 x 45 x 30 cm.
Collection of Orandi Momesso, São Paulo

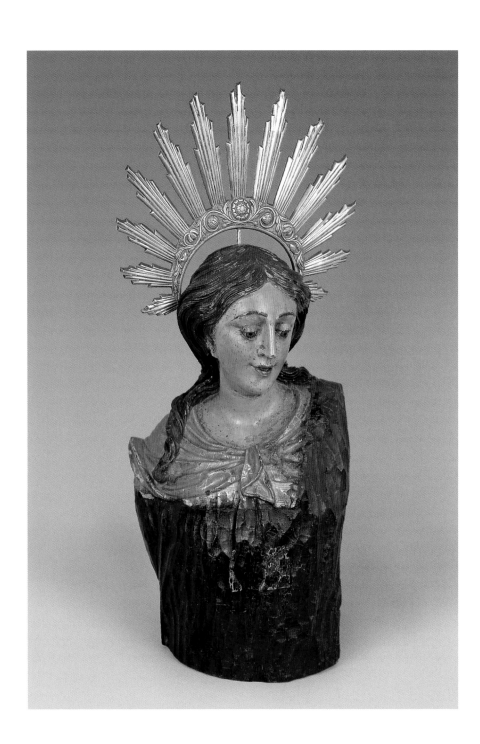

ABOVE: **64. ANONYMOUS** *Bust of a Saint*, 18th century. Polychromed wood, 51 x 30 x 25 cm. Private collection.

FACING PAGE: **65.** Attributed to **FRANCISCO XAVIER DE BRITO** *Mary Magdalene*, 18th century. Polychromed wood, 61 x 44 x 34 cm. Museu de Arte Sacra de São Paulo

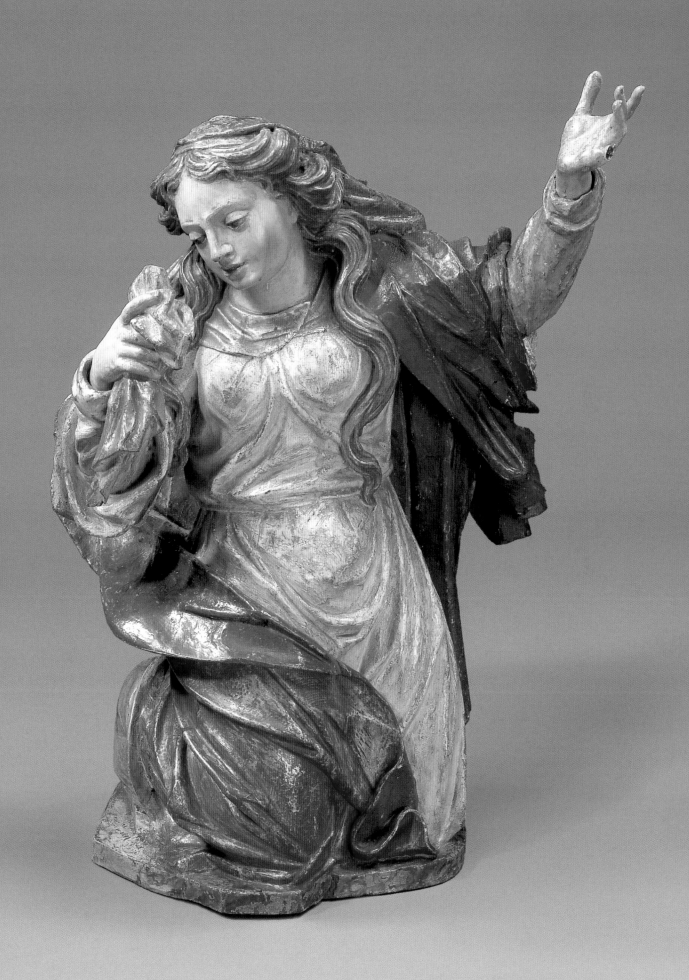

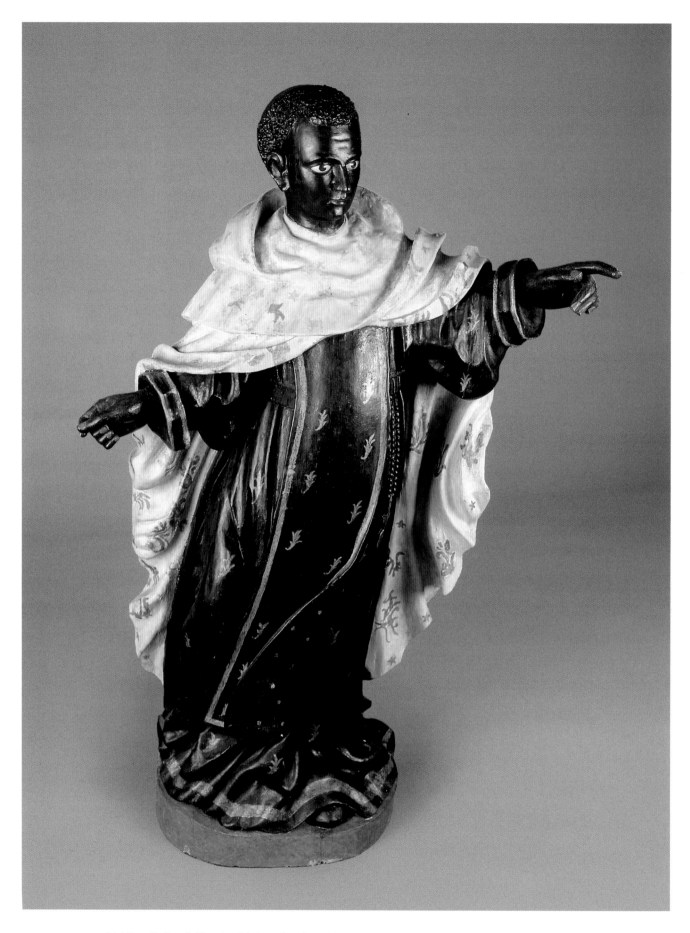

66. **ANONYMOUS** *Saint Moses the Hermit*, 18th century. Polychromed wood, 139 x 86 x 40 cm.
Confraria/Igreja de Nossa Senhora do Rosario dos Homens Pretos de Olinda

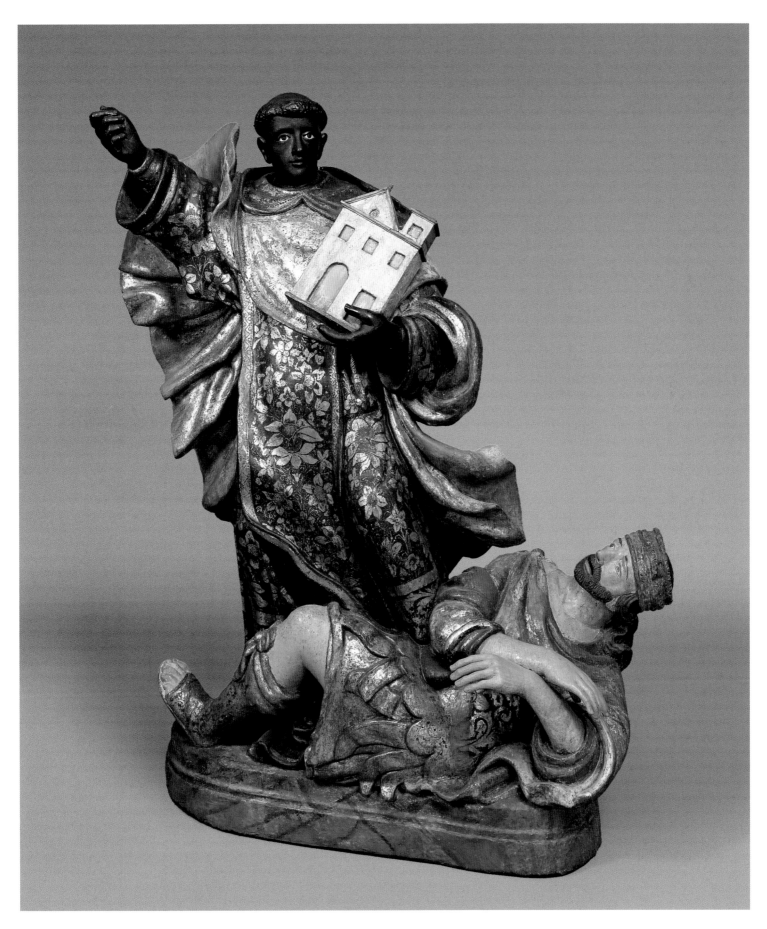

67. ANONYMOUS *Saint Elesbão*, 18th century. Polychromed and gilded wood, 120 x 105 x 50 cm. 5a Superintendência
Regional/Instituto do Patrimônio Histórico e Artistico/Ministério de Cultura, Pernambuco

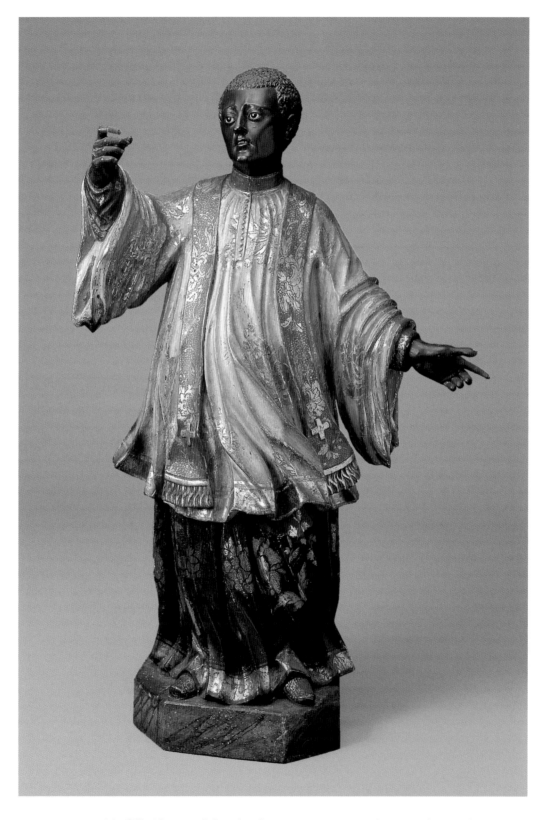

68. ANONYMOUS *Saint Phillip*, 18th century. Polychromed wood, 97 x 70 x 50 cm. 5a Superintendência Regional/Instituto do Patrimônio Histórico e Artistico/Ministério de Cultura, Pernambuco

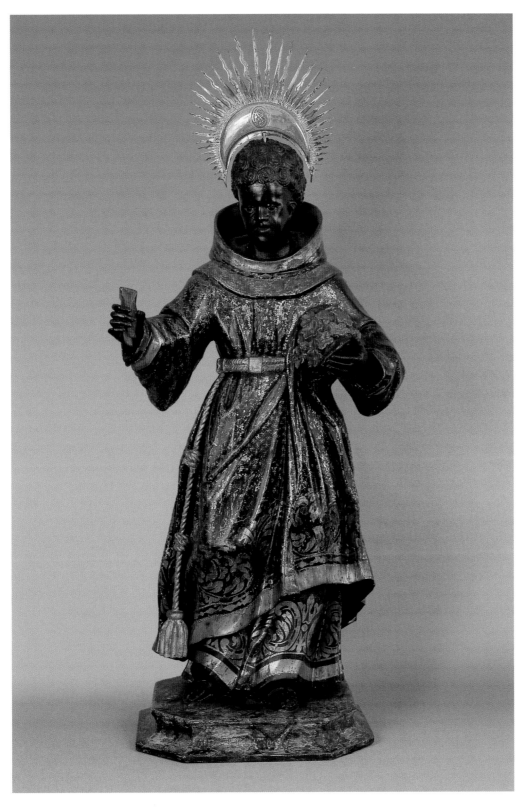

69. ANONYMOUS *Saint Benedito*, 18th century. Polychromed and gilded wood, 80 x 45 x 37 cm. Private collection

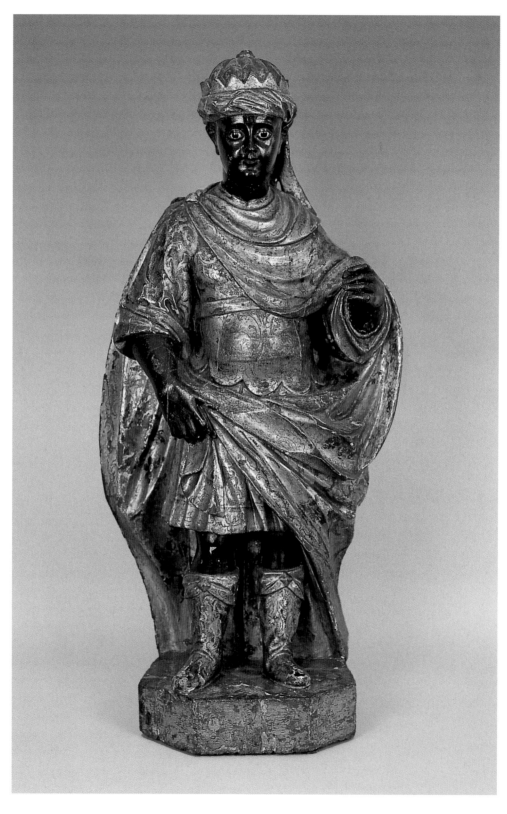

70. MESTRE SABARÁ *Balthazar*, 18th century. Polychromed wood, 72 x 33 x 21 cm. Private collection

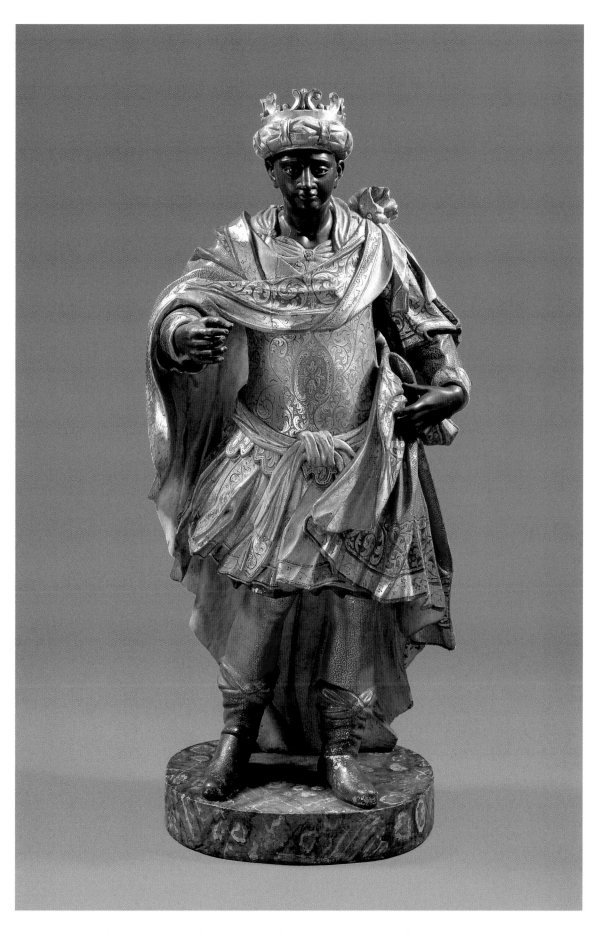

71. ANONYMOUS *Balthazar*, 18th century. Polychromed and gilded wood. 101 x 52 x 42 cm. 5a Superintendência

Regional/Instituto do Patrimônio Histórico e Artistico/Ministério de Cultura, Pernambuco

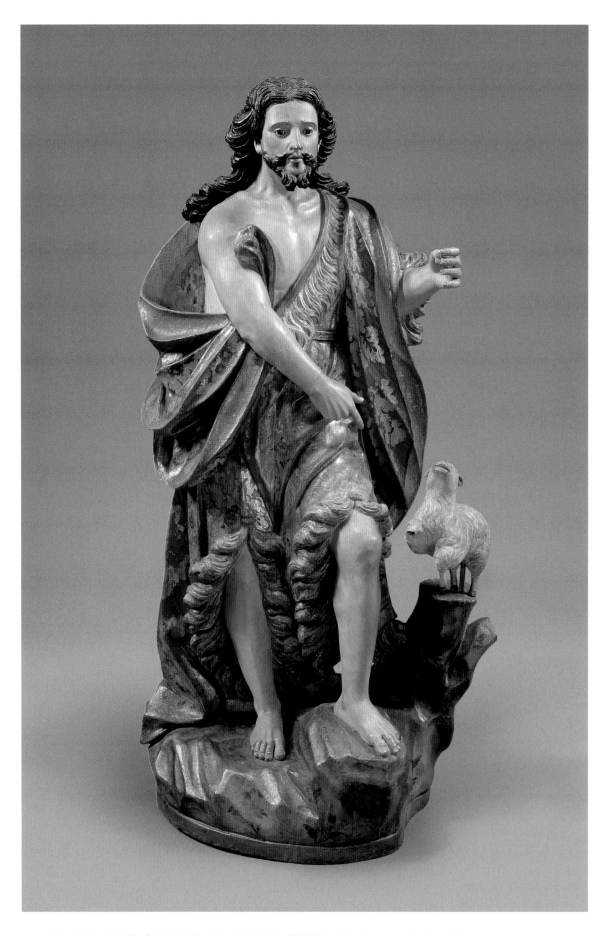

72. ANONYMOUS *Saint John the Baptist*, 18th century. Polychromed and gilded wood, 101 x 70 x 40 cm. Igreja Nossa Senhora
do Carmo de Olinda–5a Superintendência Regional/Instituto do Patrimônio Histórico e Artistico/Ministério de Cultura, Pernambuco

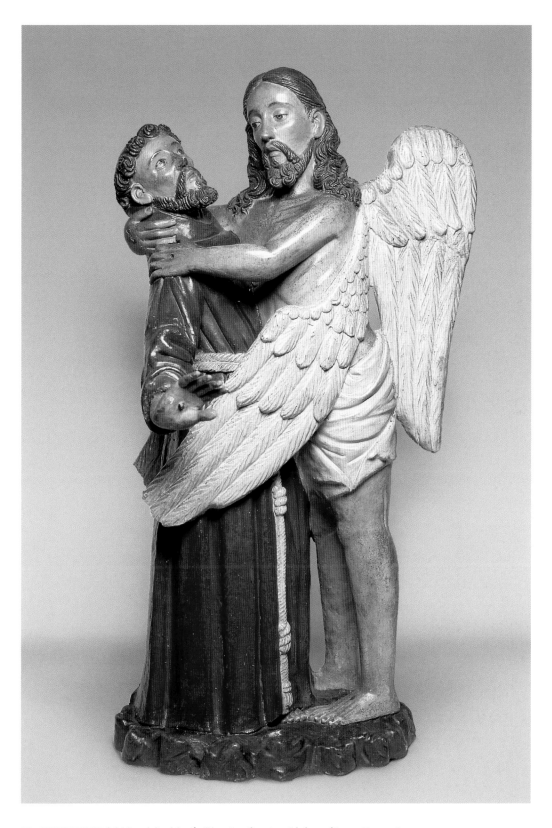

73. ANONYMOUS *Saint Francis Receiving the Stigmata*, 17th century. Polychromed terra-cotta, 105 x 65 x 47 cm.
Museu de Arte Sacra de São Paulo

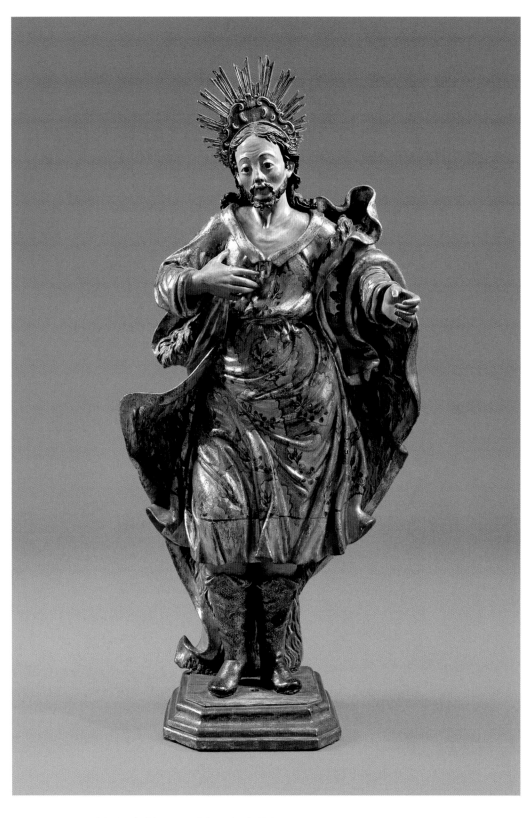

74. ANONYMOUS *Saint Joseph*, 18th century. Polychromed and gilded terra-cotta, 94 x 49 x 36 cm.
Collection of Beatriz and Mário Pimenta Camargo, São Paulo

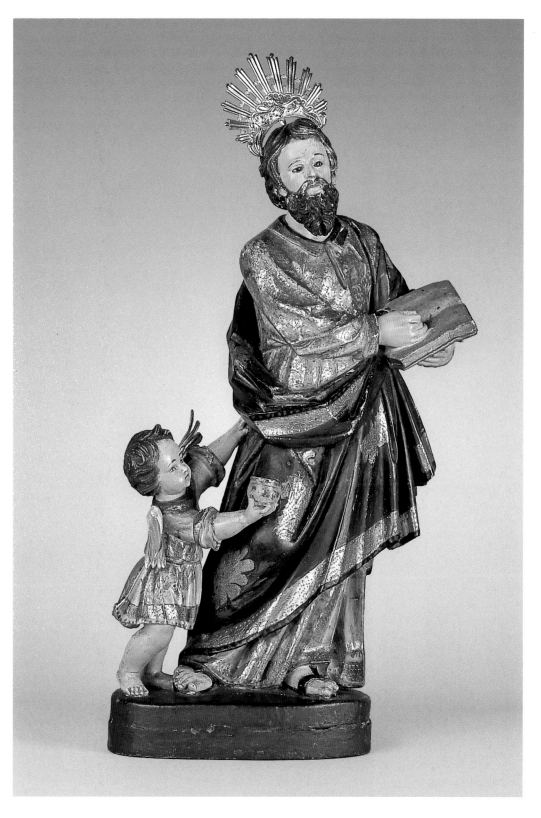

75. ANONYMOUS *Saint Matthew*, 18th century. Polychromed wood and silver, 52 x 32 x 13 cm.
Collection of Ario Dergint, Curitiba

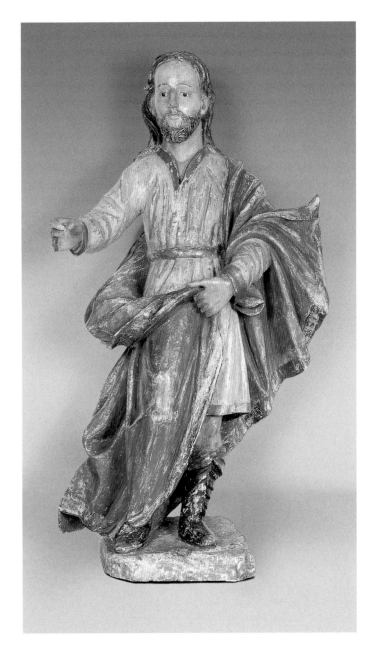 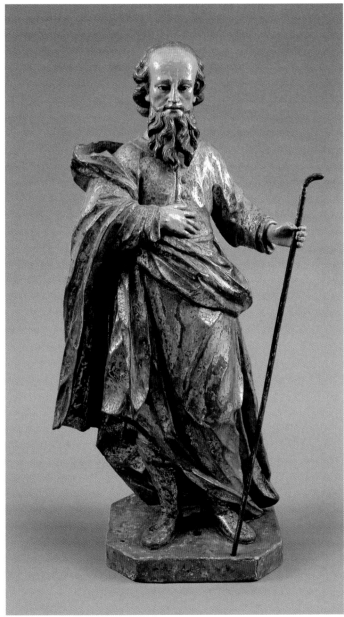

LEFT: **76. ANONYMOUS** *Saint Joseph*, 18th century. Polychromed wood, 107 x 62 x 37 cm. Private collection.

RIGHT: **77. FRANCISCO XAVIER DE BRITO** *Saint Joachim*, 18th century. Polychromed wood, 86 x 45 x 33 cm.

Collection of João Mauricio de Araújo Pinho, Rio de Janeiro

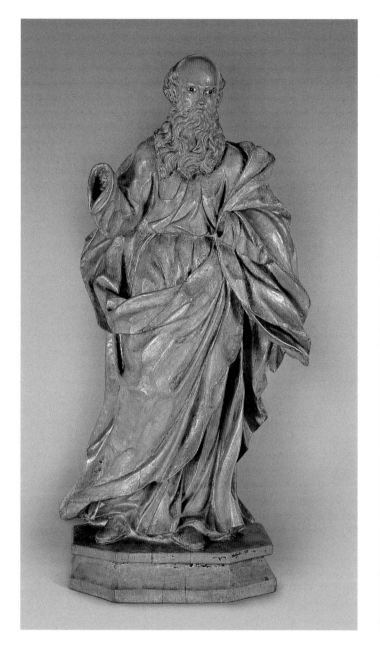

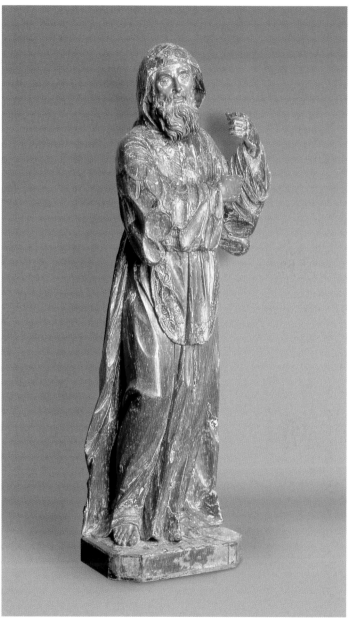

LEFT: **78. FRANCISCO XAVIER DE BRITO** *Saint Paul*, 18th century. Wood and glass, 94 x 40 x 23 cm. Private collection.

RIGHT: **79. FRANCISCO XAVIER DE BRITO** *Saint Francis*, 18th century. Polychromed wood, 158 x 60 x 70 cm.

Private collection

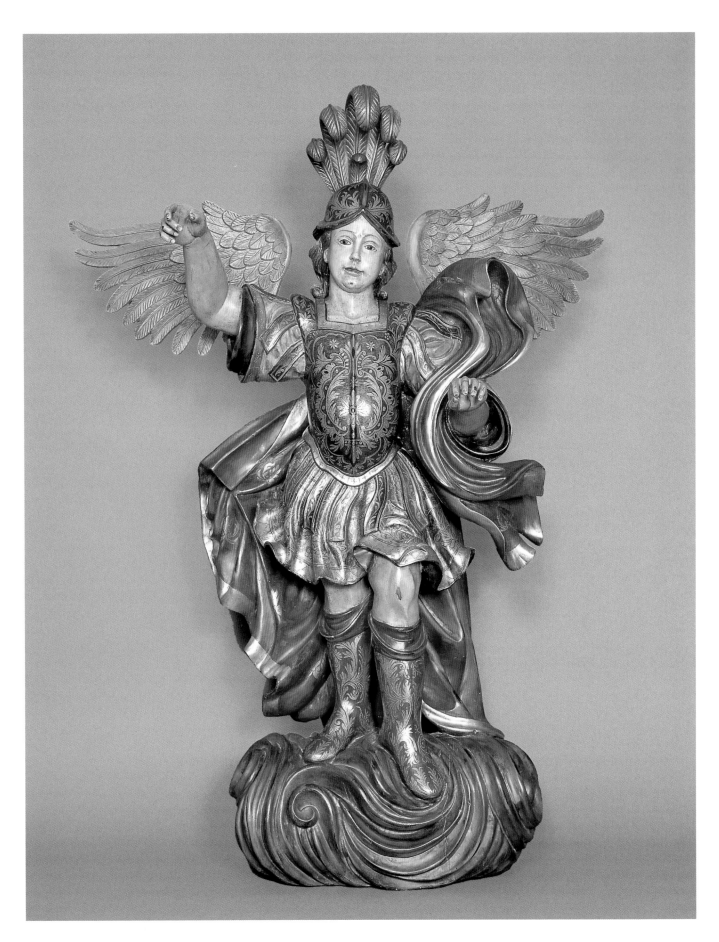

80. ANONYMOUS *Saint Michael Archangel*, 18th century. Polychromed wood, 132 x 84 cm. Private collection

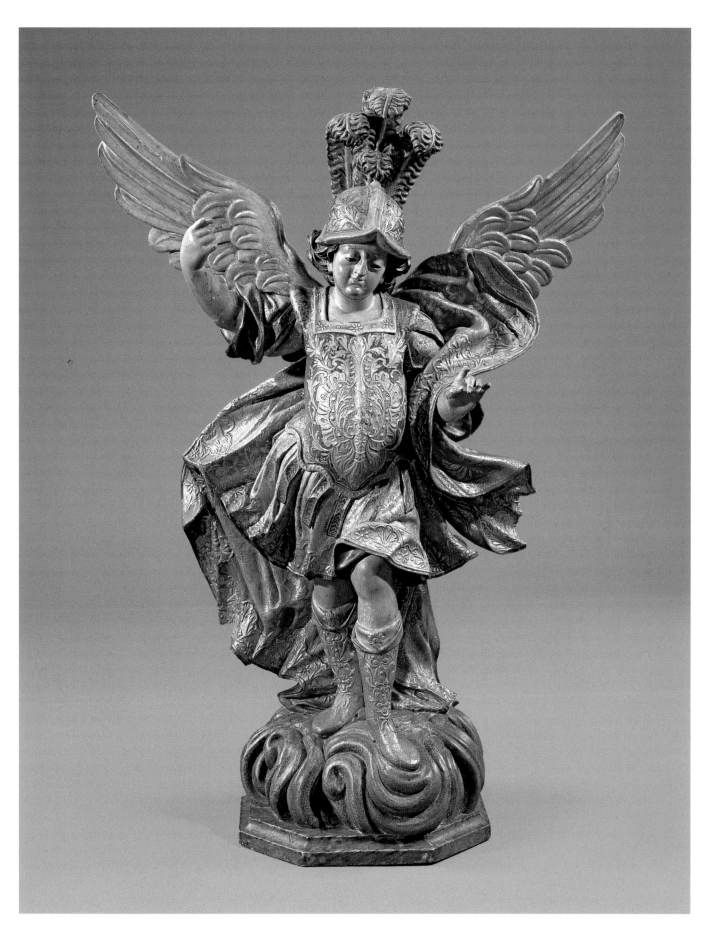

81. ANONYMOUS *Saint Michael Archangel*, 18th century. Polychromed and gilded wood, 104 x 80 x 29 cm.
Collection of Beatriz and Mário Pimenta Camargo, São Paulo

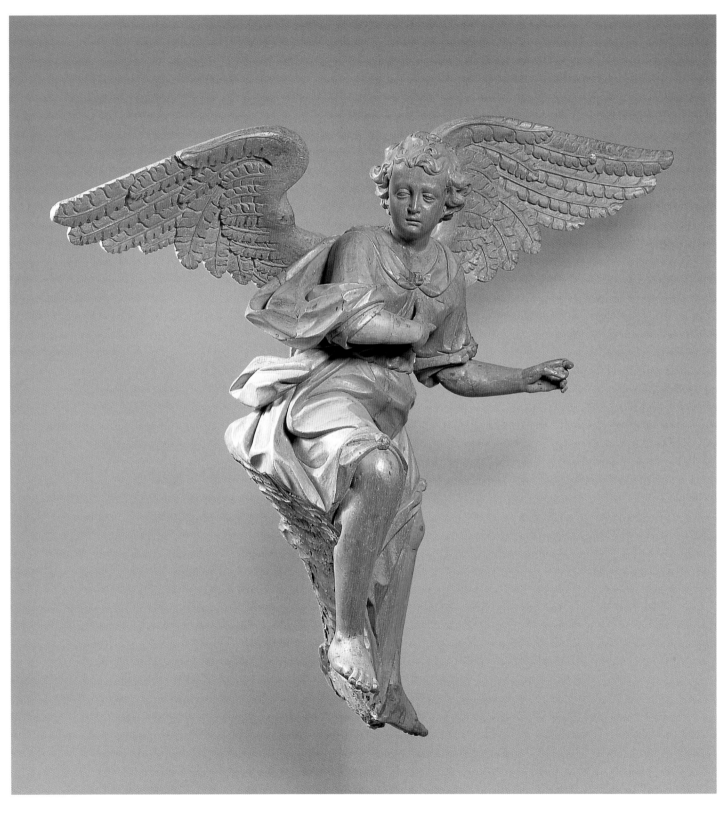

82.1. ANONYMOUS *Angel*, 18th century. Wood, 130 x 140 x 70 cm. Collection of Beatriz and Mário Pimenta Camargo, São Paulo

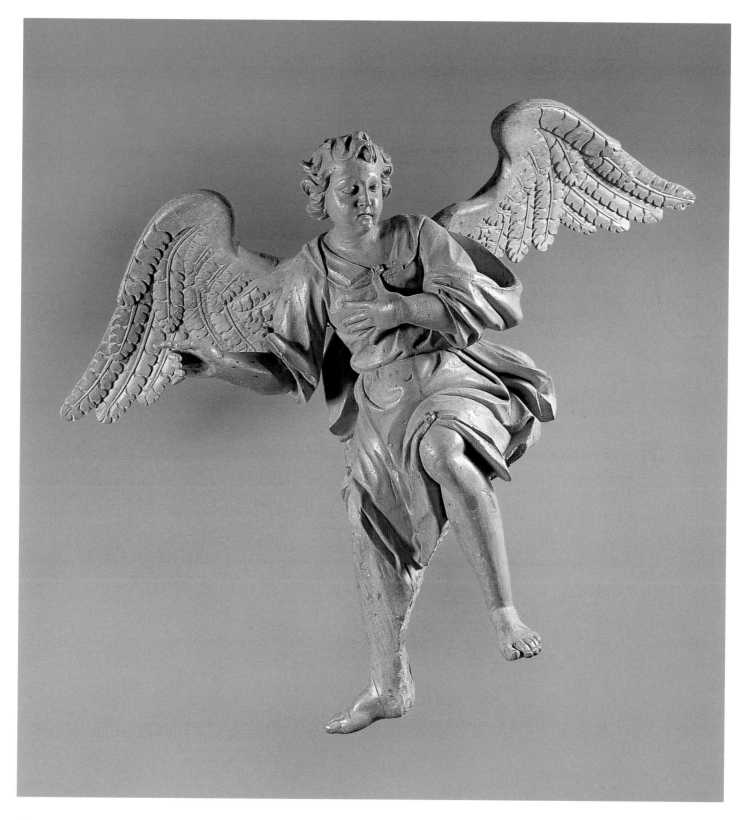

82.2. ANONYMOUS *Angel*, 18th century. Wood, 130 x 140 x 70 cm. Collection of Beatriz and Mário Pimenta Camargo, São Paulo

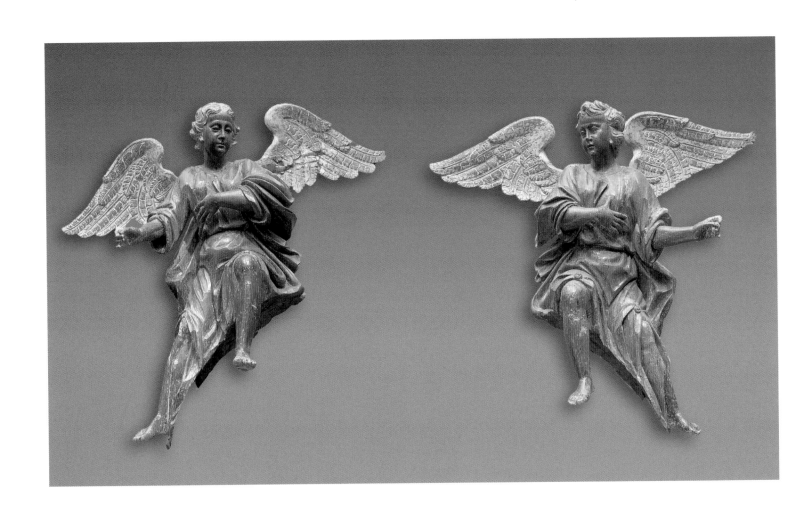

83. **MESTRE VALENTIM** *Angels,* late 18th century. Wood, LEFT: 132 x 70 x 56 cm; RIGHT: 122 x 144 x 46 cm. Private collection

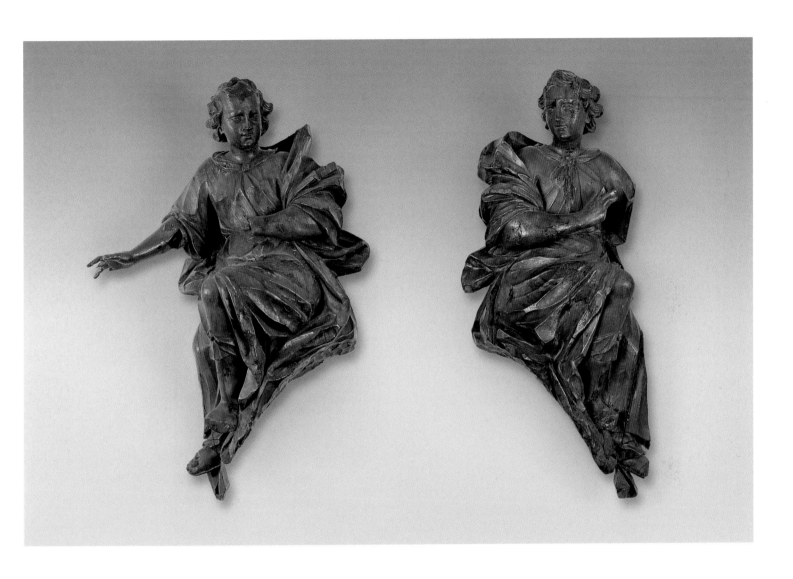

84. Attributed to **MESTRE VALENTIM** *Figures of Virtue*, 18th century. Cedar, LEFT: 113 X 77 X 34 cm; RIGHT: 120 X 60 X 35 cm.
Museus Castro Maya–Instituto do Patrimônio Histórico e Artistico/Ministério de Cultura, Rio de Janeiro

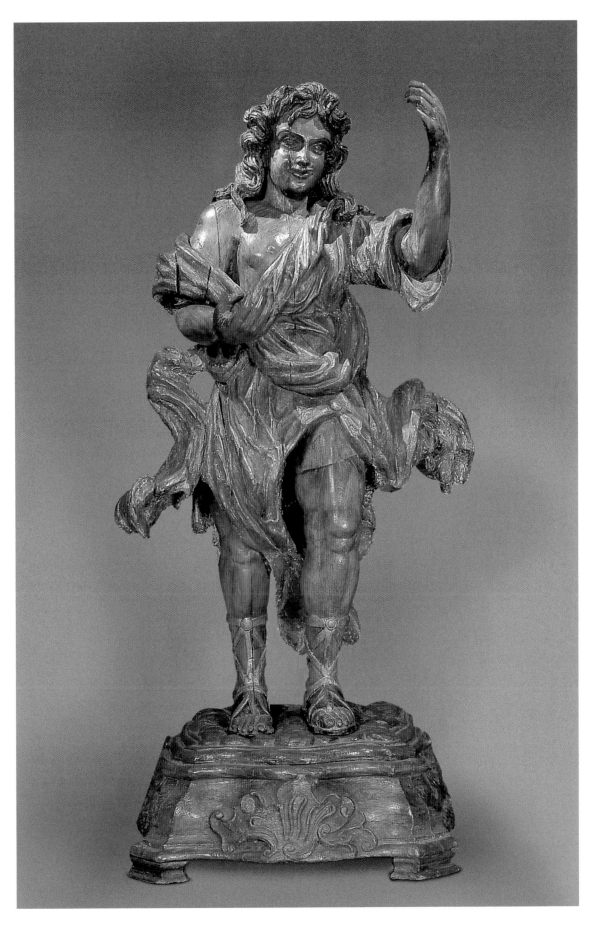

85. MESTRE VALENTIM *Torchère Angel*, 18th century. Polychromed wood, 150 x 68 x 50 cm. Private collection

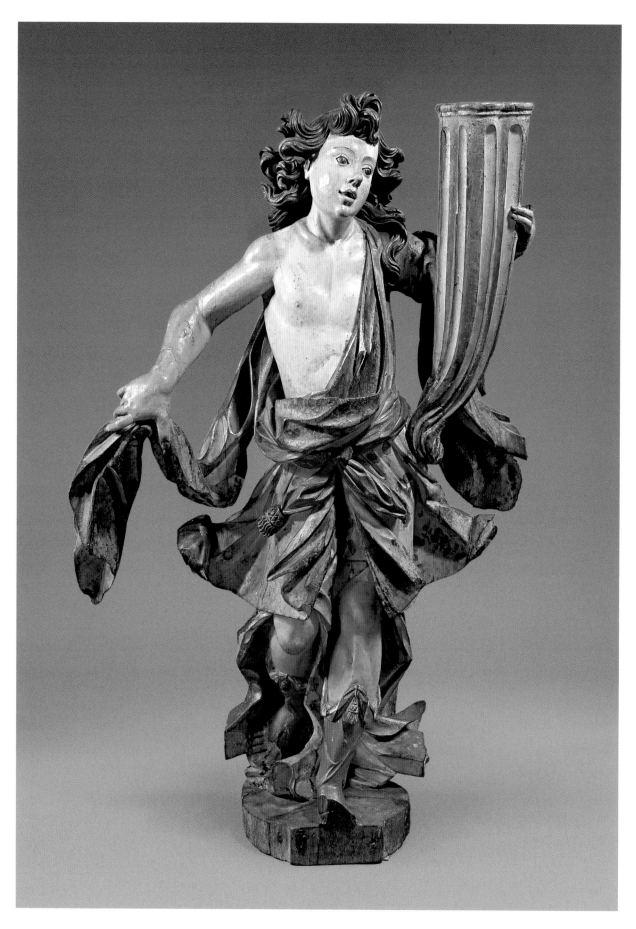

86.1. Attributed to **FRANCISCO VIERA SERVAS** *Torchère Angel*, 18th century. Polychromed wood, 150.5 x 95.3 x 40.4 cm.

Museu da Inconfidência–Instituto do Patrimônio Histórico e Artístico/Ministério de Cultura, Ouro Prêto

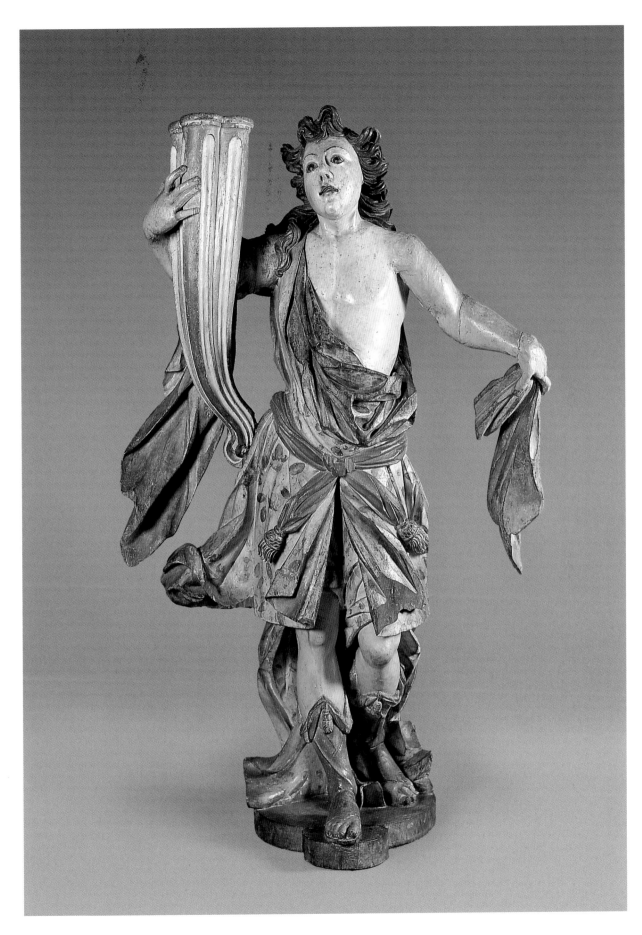

86.2. Attributed to **FRANCISCO VIERA SERVAS** *Torchère Angel*, 18th century. Polychromed wood, 149 x 100 x 37 cm.
Museu da Inconfidência–Instituto do Patrimônio Histórico e Artistico/Ministério de Cultura, Ouro Prêto

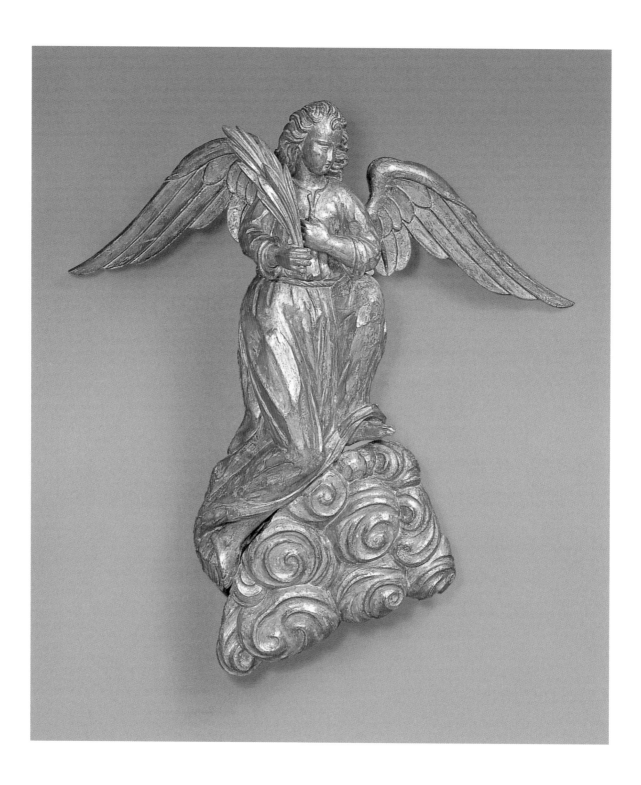

87.1. ANONYMOUS *Angel*, 18th century. Gilded wood, 120 x 140 x 60 cm. Private collection

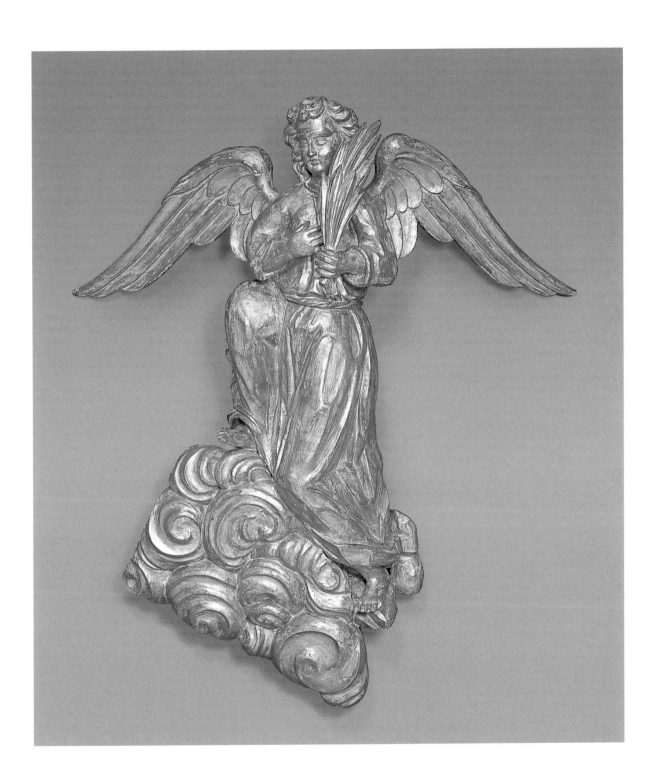

87.2. ANONYMOUS *Angel*, 18th century. Gilded wood, 120 x 140 x 60 cm. Private collection

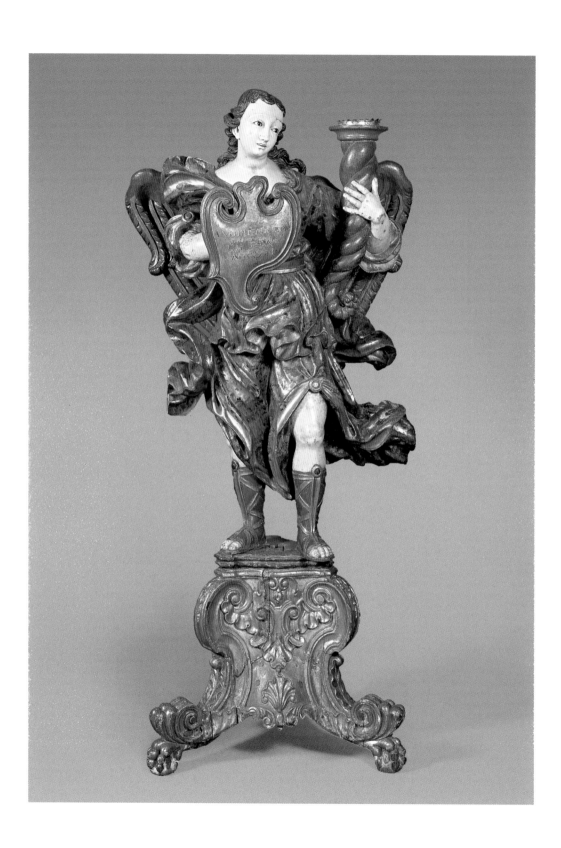

88.1. ANONYMOUS *Torchère Angel*, 18th century. Polychromed wood, 195 x 90 x 80 cm.
Arquidiocese São Salvador da Bahia (Catedral Basílica, Salvador)

221

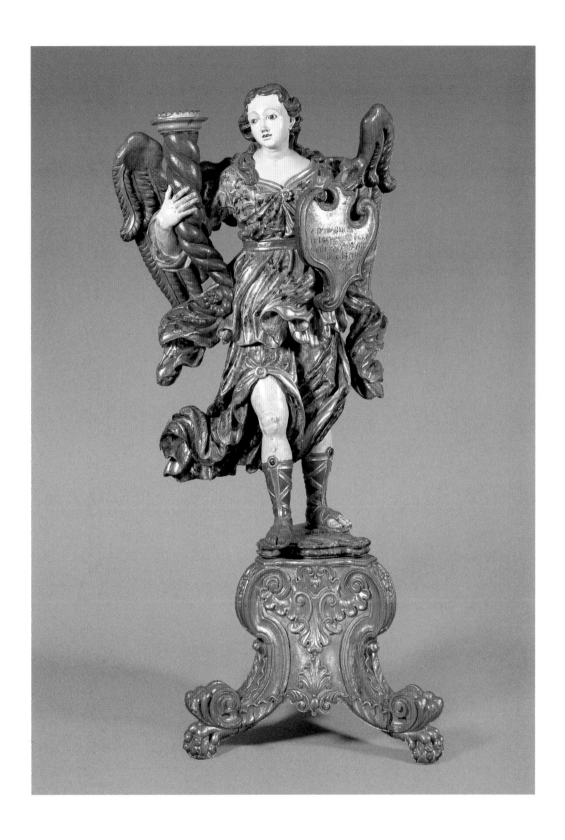

88.2. ANONYMOUS *Torchère Angel*, 18th century. Polychromed wood, 195 x 100 x 90 cm.
Arquidiocese São Salvador da Bahia (Catedral Basílica, Salvador)

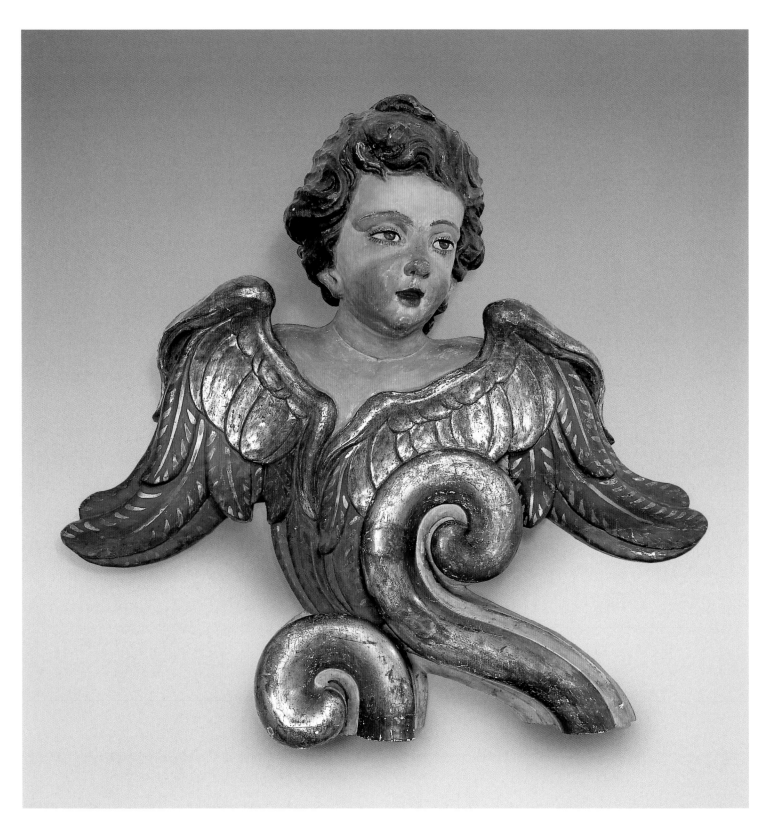

89. MESTRE VALENTIM *Bust of an Angel*, 18th century. Polychromed and gilded wood, 140 x 145 x 35 cm. Private collection

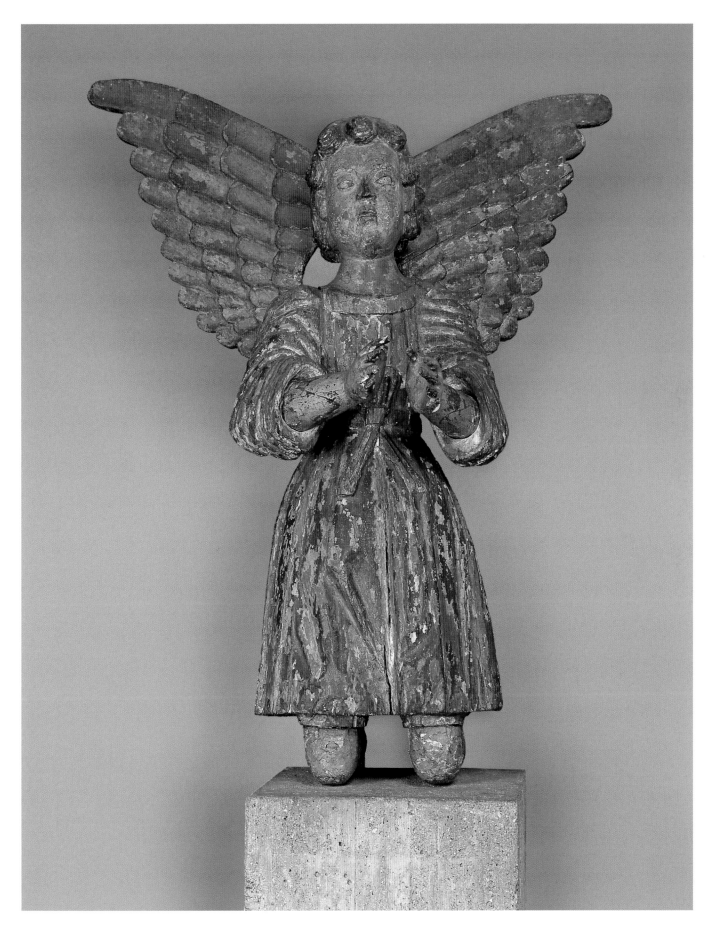

90. ANONYMOUS *Angel*, 18th century. Polychromed wood, 93 x 71 x 55 cm. Private collection

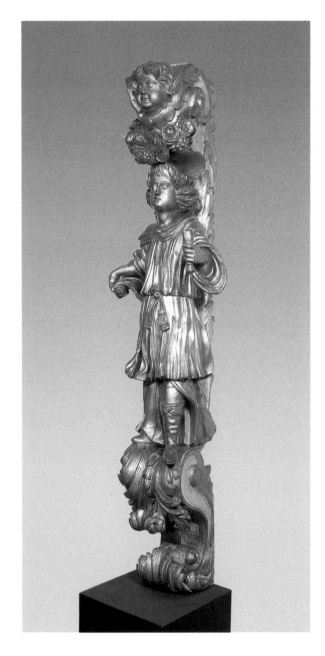

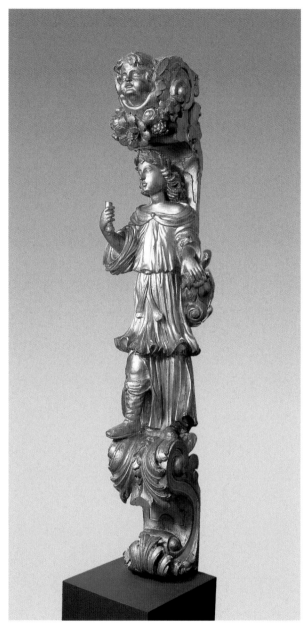

91. ANONYMOUS *Caryatids*, 18th century. Gilded wood, 205 x 56 x 44 cm each. Museu de Arte Sacra de São Paulo

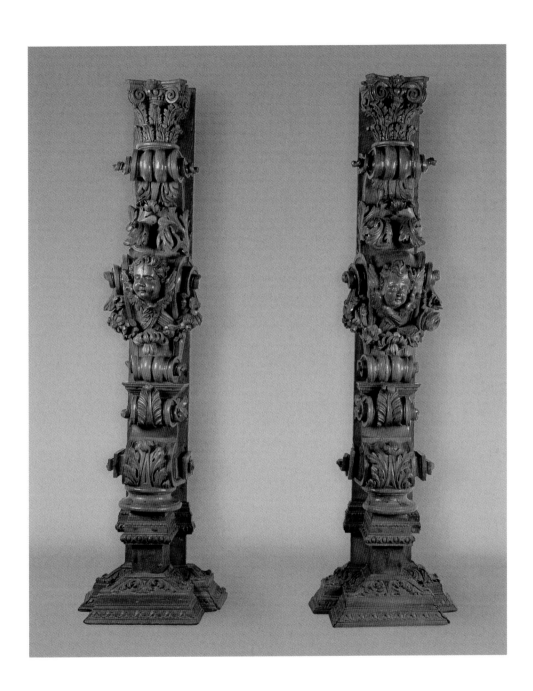

92. ANONYMOUS *Columns*, 18th century. Wood, 210 x 65 x 42 cm each. Collection of
Beatriz and Mário Pimenta Camargo, São Paulo

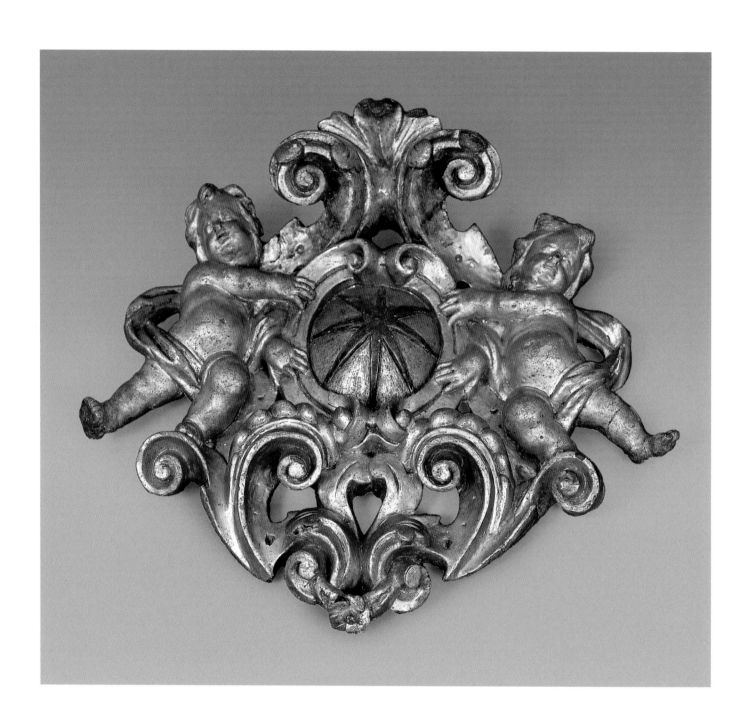

93. ANONYMOUS *Decorative Element with Two Angels*, 18th century. Gilded wood, 50 x 56 x 22 cm. Private collection

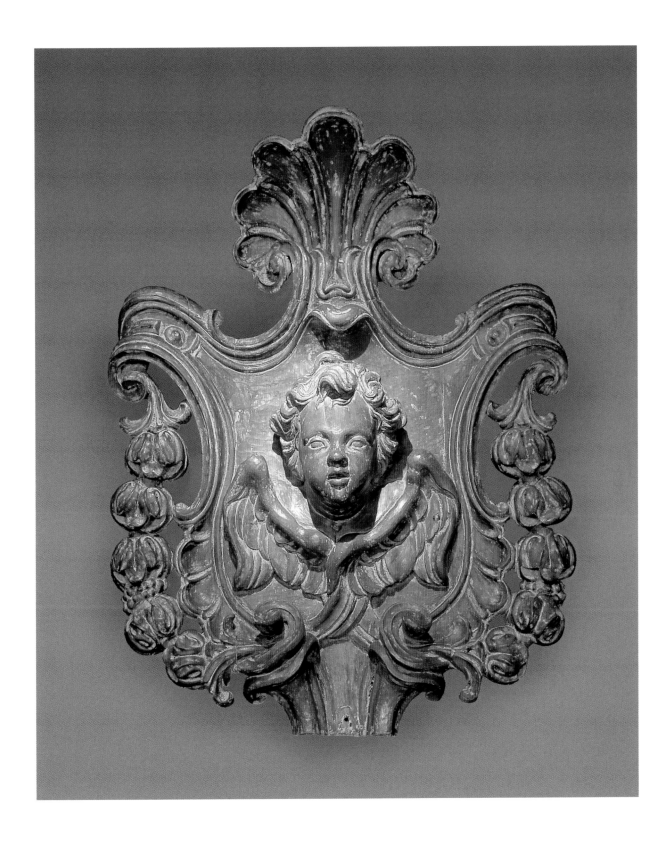

94. **MESTRE VALENTIM** *Decorative Element with Angel*, 18th century. Wood, 110 x 79 x 20 cm. Private collection

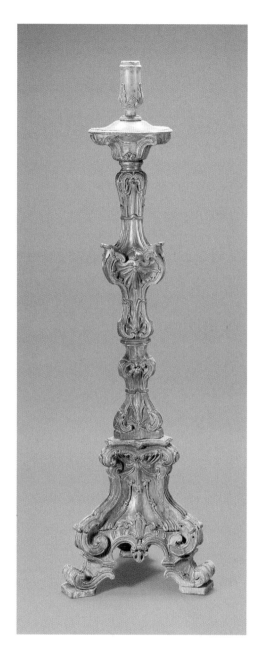
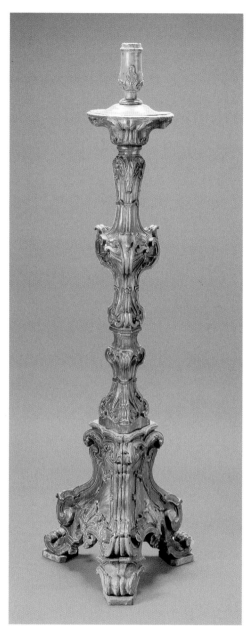

95.1 MESTRE VALENTIM *Torchères*, 18th century. Wood, 172 x 50 x 30 cm each. Private collection

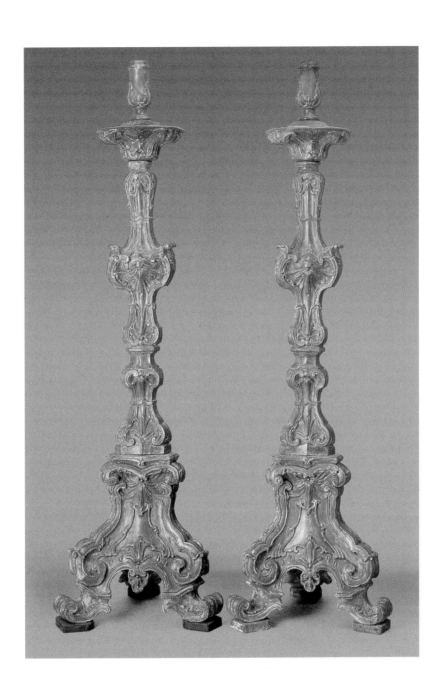

95.2 MESTRE VALENTIM *Torchères*, 18th century. Wood, 172 x 50 x 30 cm each. Private collection

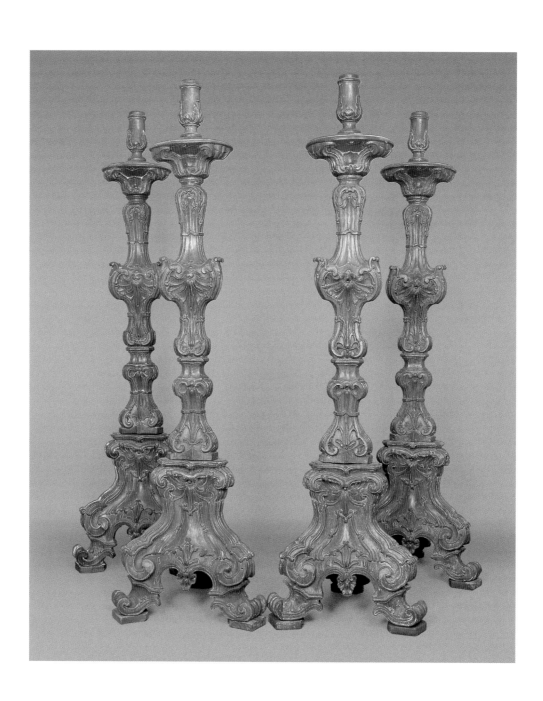

96. MESTRE VALENTIM *Torchères*, 18th century. Gilded wood, 172 x 49 x 53 cm each. Private collection

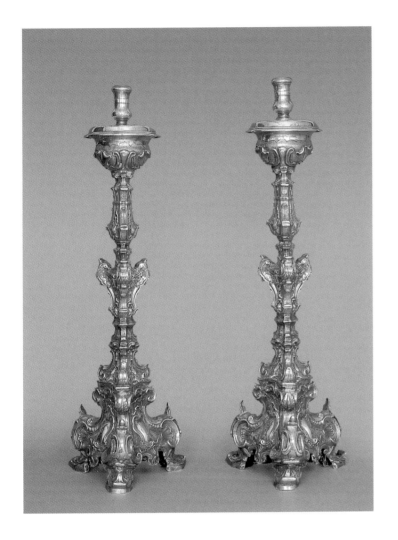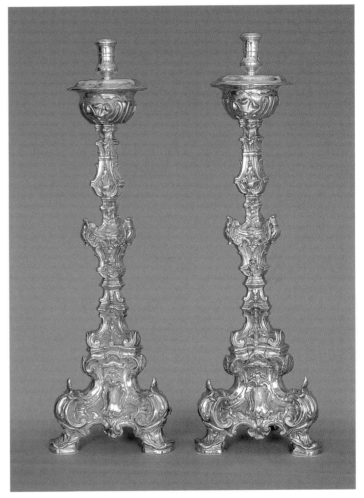

LEFT: **97. ANONYMOUS** *Torchères*, 18th century. Silver, 70 x 23 x 23 cm each. Private collection.
RIGHT: **98. ANONYMOUS** *Torchères*, 18th century. Silver, h. 66 cm each. Private collection

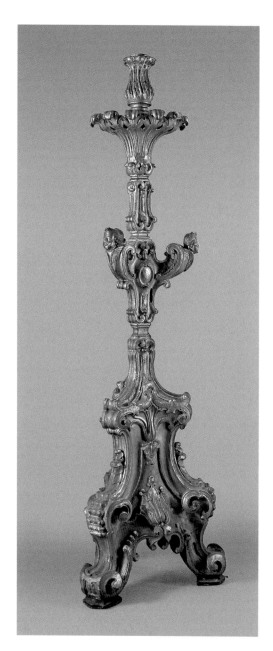
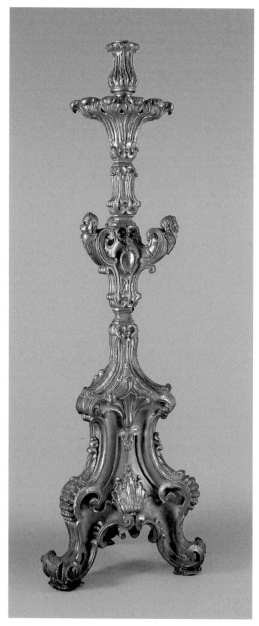

99. MESTRE VALENTIM *Torchères*, 18th century. Gilded wood, 193 x 67 x 64 cm each.
Irmandade da Santa Cruz dos Militares, Rio de Janeiro

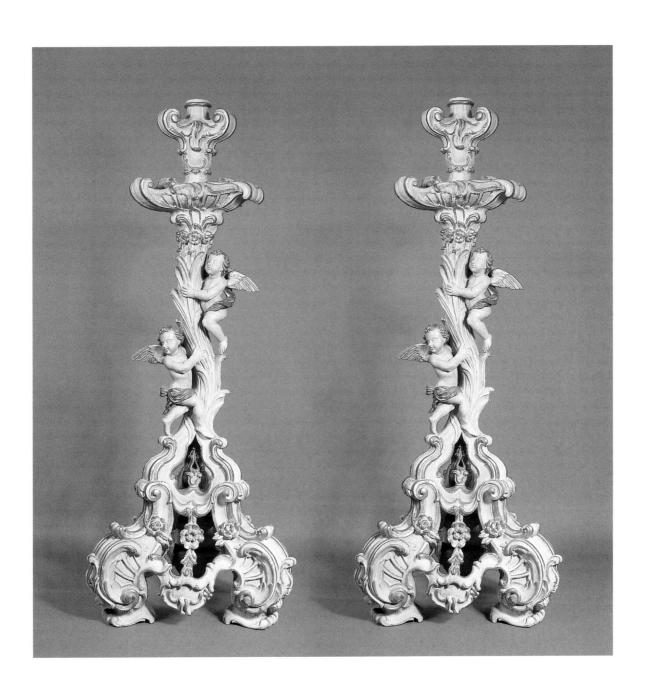

100. ANTONIO RODRIGUES MENDES *Torchères with Angels*, 1774. Polychromed and gilded wood, 184 x 87 x 87 cm each.
Santa Casa da Misericórdia da Bahia

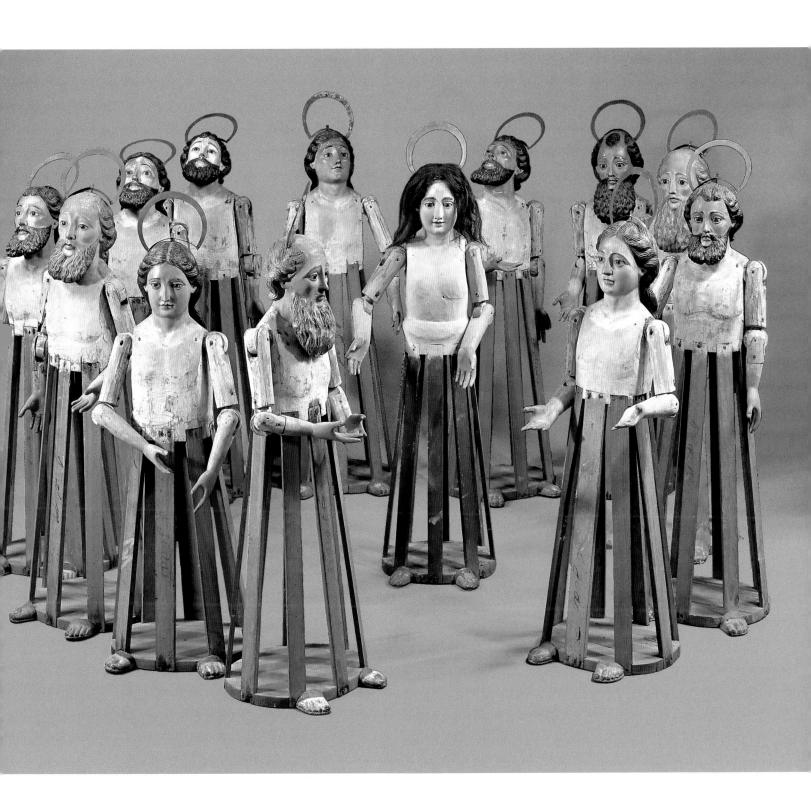

101. ANONYMOUS *Pentecostal Figures*, 18th century. Polychromed wood, 81.5–88.5 cm high. Fundação Pierre Chalita, Alagoas

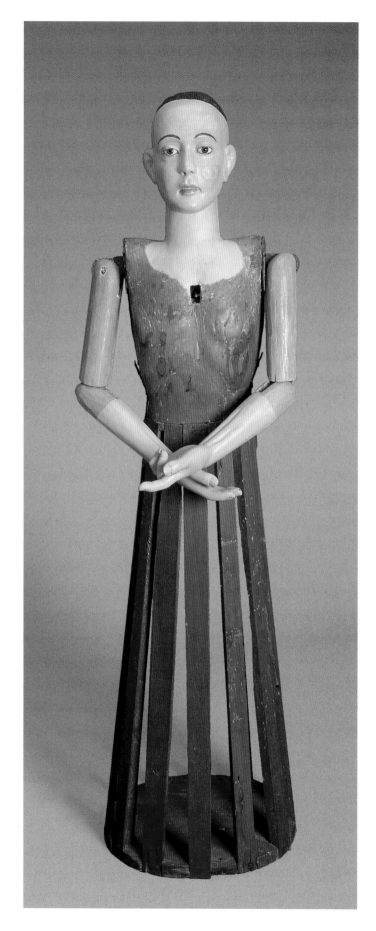

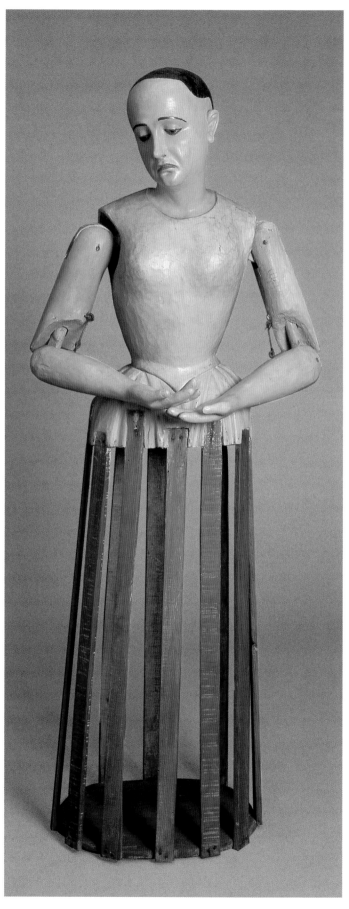

LEFT: **102. ANONYMOUS** *Female Saint*, 18th–19th century. Polychromed wood, 149 x 46 x 35 cm. Confraria/Igreja de Nossa Senhora do Rosario dos Homens Pretos de Olinda. RIGHT: **103. ANONYMOUS** *Mary Magdalene*, 18th–19th century. Polychromed wood, 133 x 42.5 x 29 cm. Confraria/Igreja de Nossa Senhora do Rosario dos Homens Pretos de Olinda

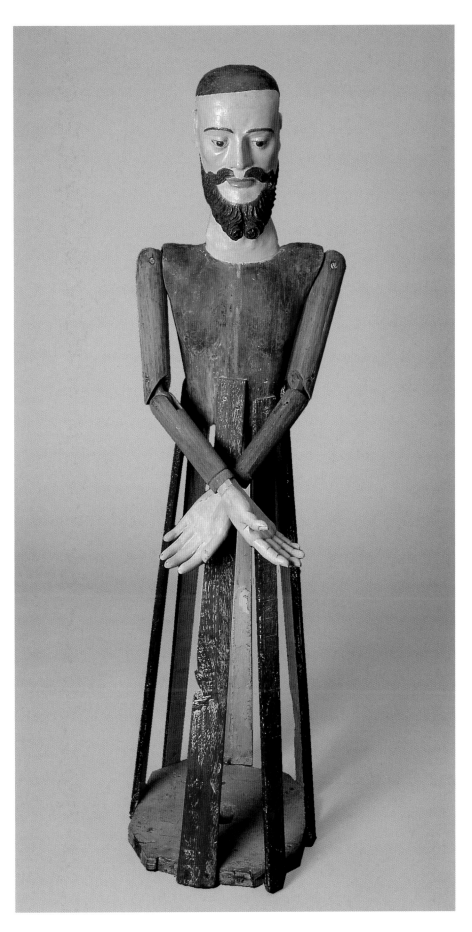

104. ANONYMOUS *Christ of the Cana Verde*, 18th–19th century. Polychromed wood, 145 x 42 x 37.5 cm.
Confraria/Igreja de Nossa Senhora do Rosario dos Homens Pretos de Olinda

O Aleijadinho

Antônio Francisco Lisboa, known as O Aleijadinho (The Little Cripple), is the most famous artist of the Brazilian Baroque. He was born in 1738 in the town of Bom Sucesso in Minas Gerais to a Portuguese architect and an Afro-Brazilian slave. Minas Gerais was the richest area of the country in the eighteenth century, due to the gold, diamonds, and other precious stones discovered there. Towns in the region, both large and small, constructed impressive churches, monasteries, convents, and other ecclesiastical buildings. Some of the most characteristic Baroque buildings, with their dramatic, even theatrical interior and exterior decorations, are found in places such as Ouro Prêto, Mariana, Sabará, São João del Rei, and Diamantina. Many of these buildings bear the mark of the artistic genius of O Aleijadinho.

O Aleijadinho was an architect as well as a sculptor. His highly expressive, often idiosyncratic style of sculpture became a hallmark of the Rococo phase of the Brazilian Baroque. There is uncertainty about O Aleijadinho's training. He was undoubtedly the beneficiary of his father's profession and may also have studied with local sculptors Rodrigo Melo Franco de Andrade and Francisco Xavier Brito. The first documented reference to the career of O Aleijadinho is from 1766, when he was commissioned to design one of his most significant projects: the church of São Francisco de Assis in Ouro Prêto, including the facade and sculptures in the interior. Other early commissions include work for the church of the Ordem Terceira do Carmo de Sabará as well as the sculptures on the facade of the church of the Ordem Terceira de São Francisco in Ouro Prêto.

During the 1770s, O Aleijadinho began to suffer from a debilitating disease, perhaps leprosy or syphilis. The condition crippled his hands to the extent that his sculpting tools had to be strapped to his forearms by his assistants in order for him to work. Nonetheless, he continued to produce extraordinary examples of religious art. His masterpiece is located at the pilgrimage site of Bom Jesus de Matozinhos in the town of Congonhas do Campo, seventy kilometers from Ouro Prêto, where he executed between 1796 and 1799 (in collaboration with a number of assistants) life-size, cedar-wood scenes of the Passion and Death of Christ for the chapels that line the road to the main church. Between 1800 and 1803, he executed twelve soapstone sculptures of Old Testament prophets for the outside staircase of the church. These impressive works are among the most significant sculptures of the Western Baroque-Rococo tradition. O Aleijadinho died in 1814. —E. J. S.

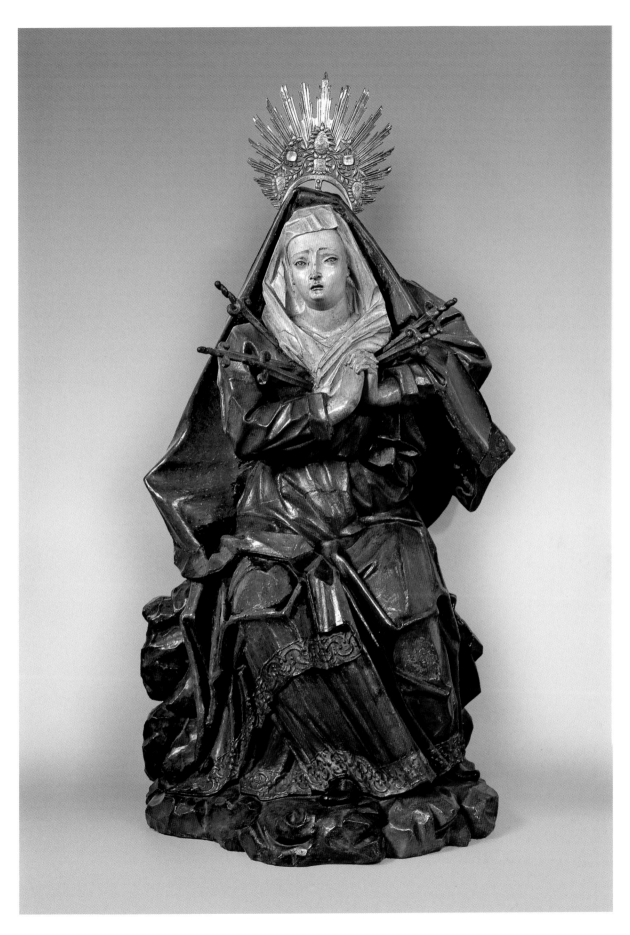

105. O ALEIJADINHO (Antônio Francisco Lisboa) *Our Lady of Sorrows*, 18th century. Polychromed wood,
83 x 48 x 34 cm. Museu de Arte Sacra de São Paulo

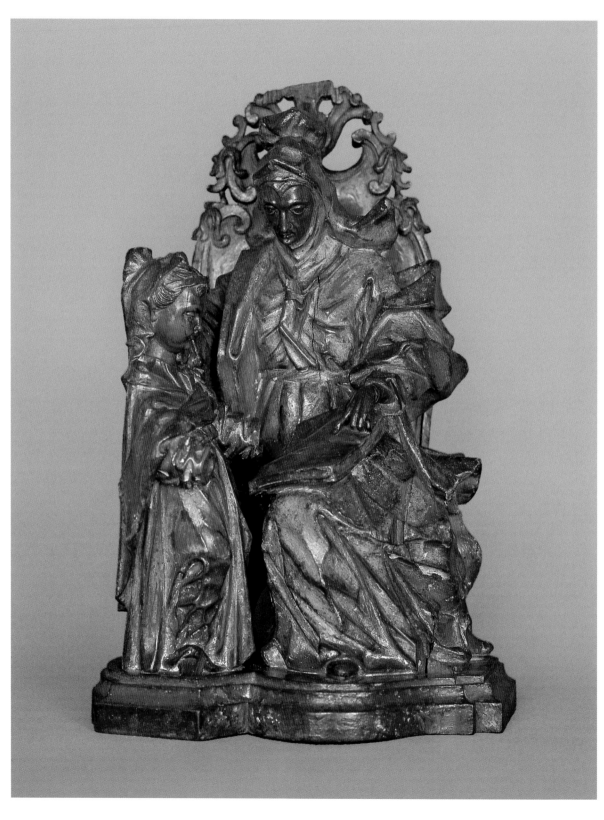

106. O ALEIJADINHO (Antônio Francisco Lisboa) *Saint Anne Teaching the Virgin*, 18th century.
Wood with resin, 32 x 21 x 17 cm. Collection of Renato Whitaker, São Paulo

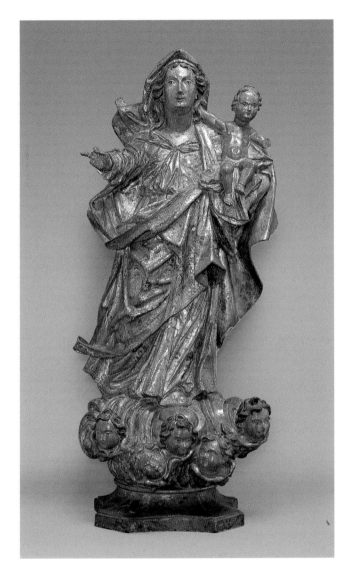

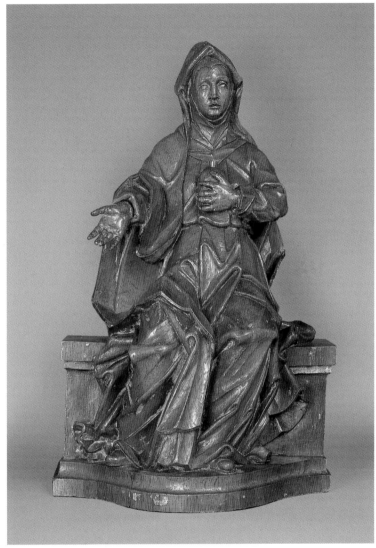

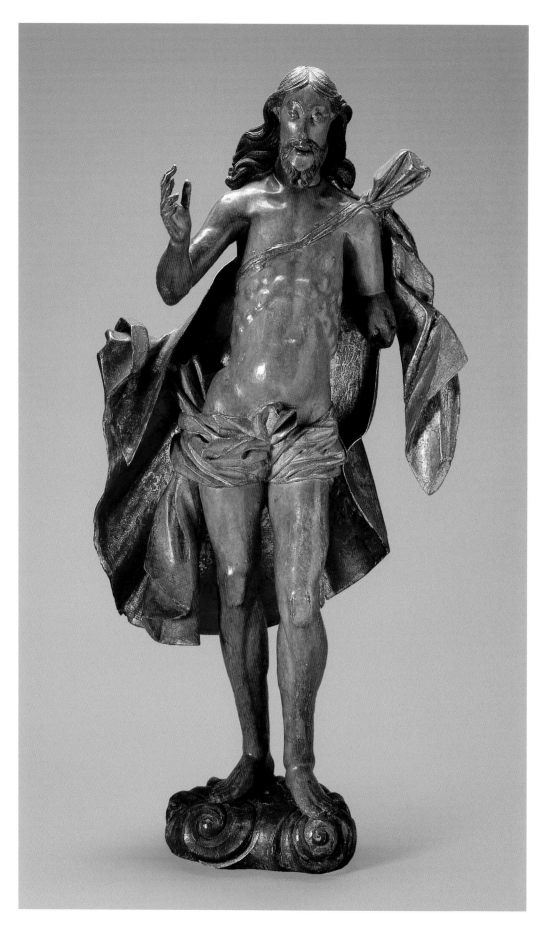

109. O ALEIJADINHO (Antônio Francisco Lisboa) *Resurrected Christ*, 18th century. Polychromed wood,
110 x 58 x 27 cm. Collection of Antonio Maluf, São Paulo

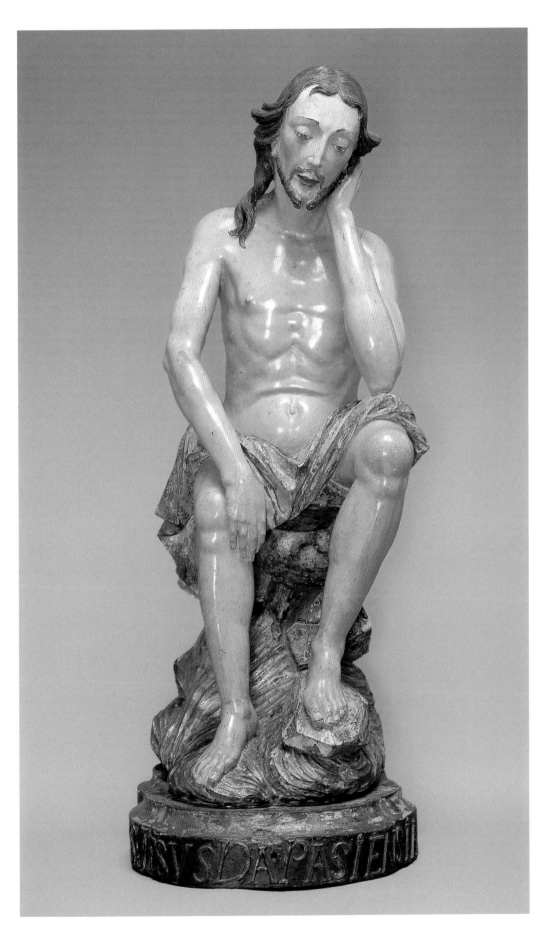

110. Attributed to **O ALEIJADINHO** (Antônio Francisco Lisboa) *Our Lord of Patience*, 18th century.
Polychromed wood, 79.5 x 31 x 34.5 cm. Collection of Renato Whitaker, São Paulo

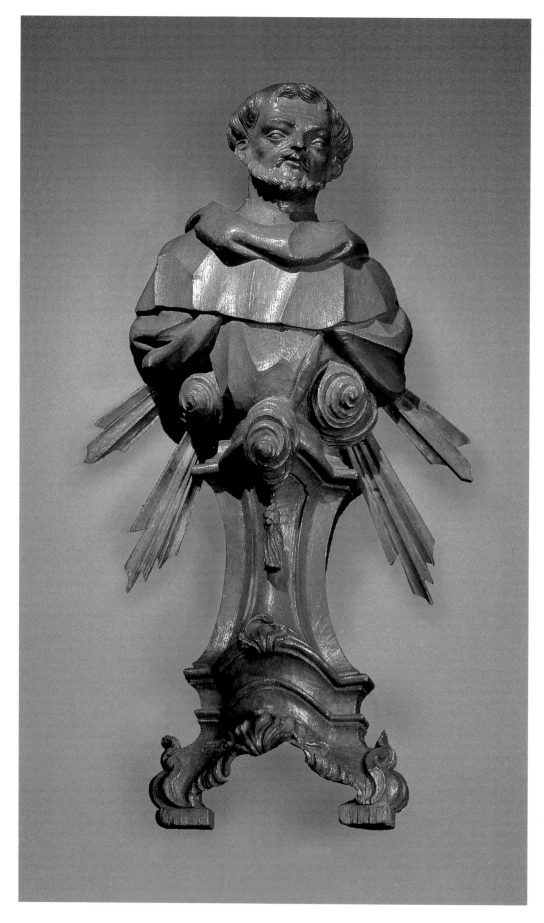

111. O ALEIJADINHO (António Francisco Lisboa) *Bust of a Saint,* ca. 1775–1785. Cedar, 69 x 41 x 16 cm. Private collection

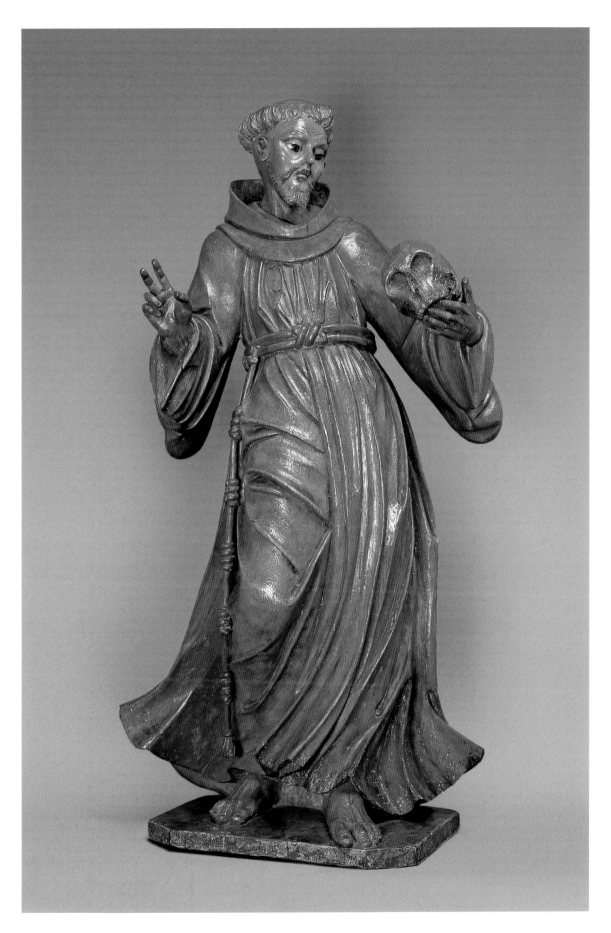

112. Attributed to O ALEIJADINHO (Antônio Francisco Lisboa) *Saint Francis of Assisi*, 18th century.
Wood with resin, 81 x 17 x 34.3 cm. Collection of Renato Whitaker, São Paulo

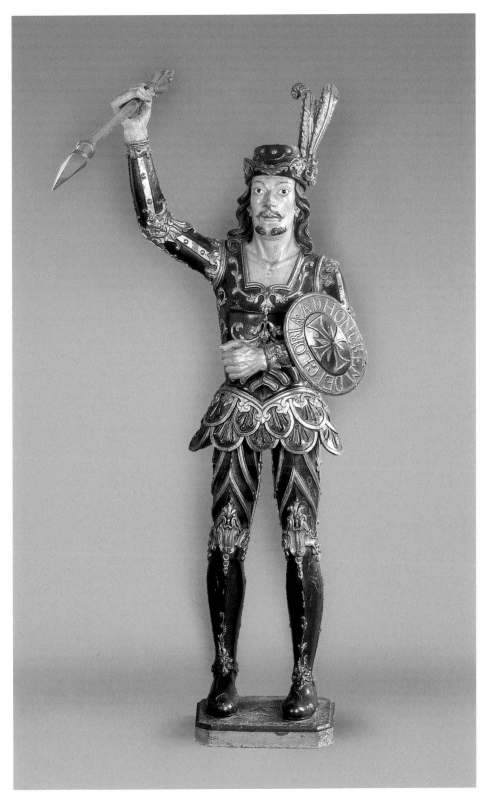

113. Attributed to O ALEIJADINHO (Antônio Francisco Lisboa) *Saint George*, 18th century. Polychromed and gilded wood, 203 x 90 x 56 cm. Museu da Inconfidência–Ministério de Cultura/Instituto do Patrimônio Histórico, Ouro Prêto

248

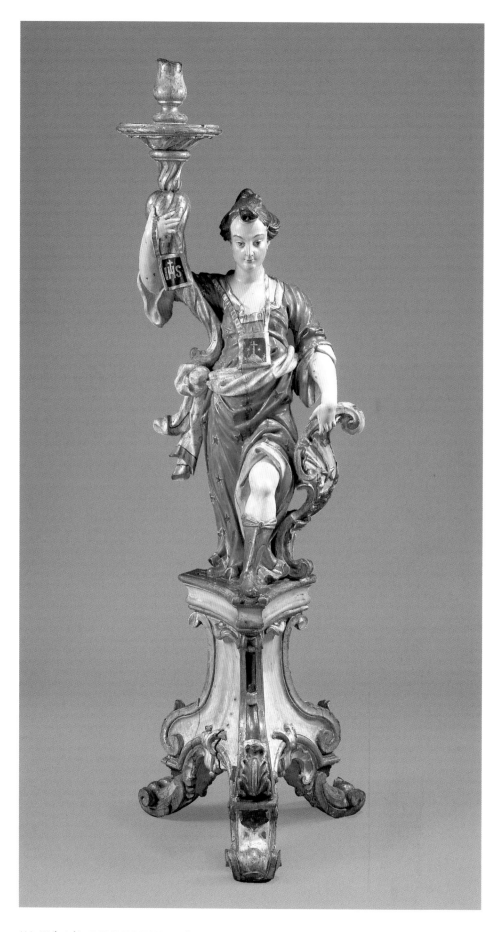

114. Attributed to O ALEIJADINHO (Antônio Francisco Lisboa) *Torchère Angel*, 18th century. Polychromed and gilded wood, 173 x 55 x 51 cm. Museu da Inconfidência–Ministério de Cultura/Instituto do Patrimônio Histórico, Ouro Prêto

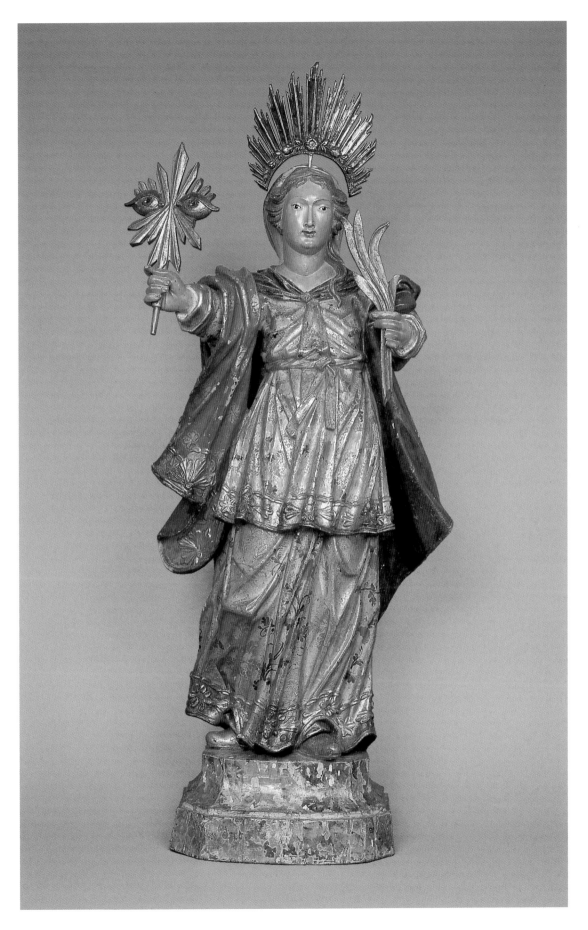

115. Attributed to O ALEIJADINHO (Antônio Francisco Lisboa) *Saint Lucy*, 18th century.
Polychromed wood, 52 x 25 x 17 cm. Collection of Renato Whitaker, São Paulo

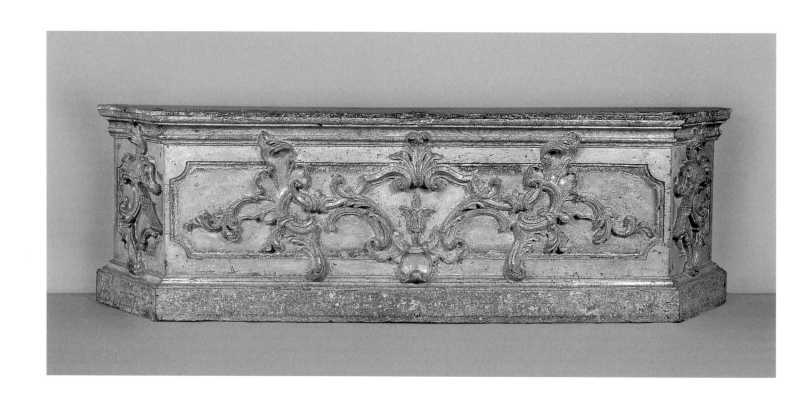

116. O ALEIJADINHO (Antônio Francisco Lisboa) *Architectural Fragment*, 18th–19th century.
Polychromed wood, 65 x 225 x 40 cm. Collection of Ladi Biezus, São Paulo

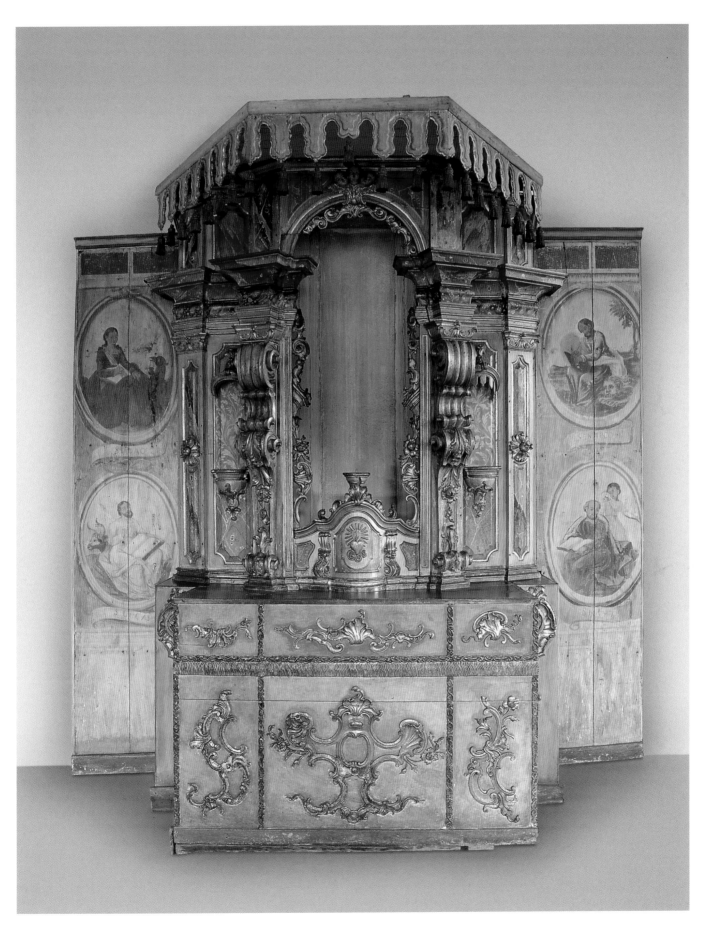

117. Attributed to **O ALEIJADINHO (Antônio Francisco Lisboa)** *Retable*, 18th century. Polychromed and gilded wood, 325.3 x 334.2 x 109.8 cm. Museu da Inconfidência–Ministério de Cultura/Instituto do Patrimônio Histórico, Ouro Prêto

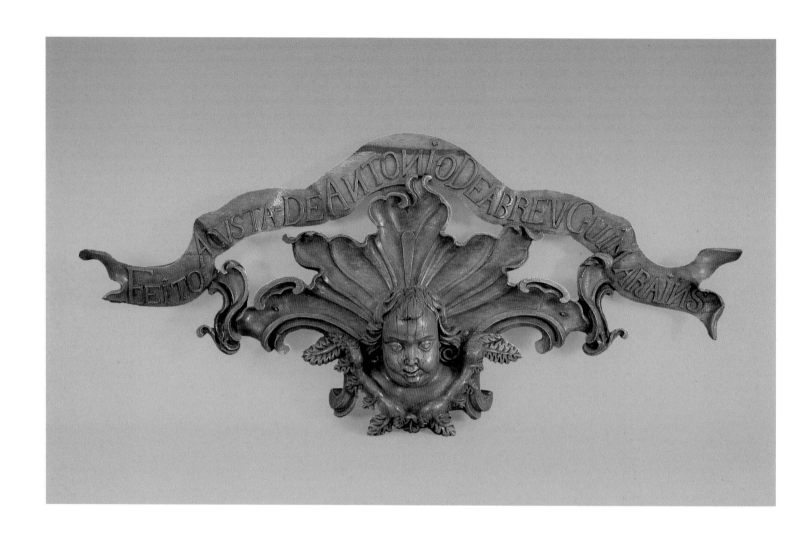

118. O ALEIJADINHO (Antônio Francisco Lisboa) *Decorative Element*, 18th century. Wood, 78 x 170 x 28 cm.

Collection of Beatriz and Mário Pimenta Camargo, São Paulo

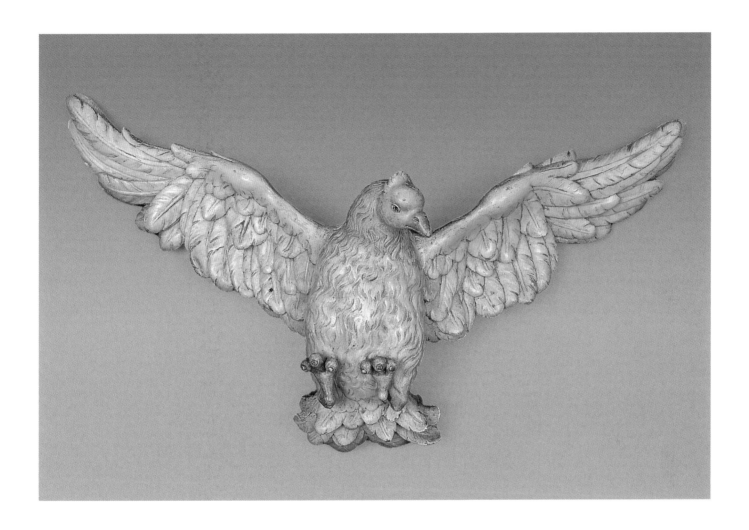

119. O ALEIJADINHO (Antônio Francisco Lisboa) *Holy Spirit*, 18th–19th century. Polychromed wood, 38 x 60 x 20 cm.
Collection of Sandra Penna, Belo Horizonte

Baroque Painting

The best-known examples of Brazilian Baroque painting are perhaps those done within architectural settings, including the many ceiling paintings on wood panels found in churches throughout the country. Among the most striking examples of these are in the Northeast and in Minas Gerais, such as the florid Rococo fantasies created by Manuel da Costa Ataíde on the ceiling of the church of São Francisco in Ouro Prêto in 1803–04.

Brazil: Body and Soul includes a small but extremely important selection of eighteenth-century works on panel. Among the most unusual are two paintings from a four-part series painted for the church of São Cosme e São Damião in the town of Igarassu, Pernambuco (now in the convent of Santo Antônio in the same town). By an anonymous painter working in 1729, they are highly evocative images: *The Arrival of the Portuguese and Their Triumph over the Igarassu Indians in 1532* and *The Miracle that Spared the Town of Igarassu from the Plague* (cat. nos. 121–22). These paintings display strong narrative qualities that engage the viewer, who becomes a participant in the proto-cinematic running narrative.

This section also includes two panels (cat. nos. 125–26) from Recife that depict the miracles of the life of Saint Benedito, one of Brazil's many black saints. One panel depicts the saint praying in the company of other monks, while the other is a tender image of the Virgin and Child appearing to the saint. There are also panels depicting scenes from the martyrdom of Saint Quiteria and the life of Saint Francis.

Secular painting in the Brazilian Baroque is relatively rare. While some portraits survive, there are few depictions of everyday life or historical scenes. Two paintings on canvas dated circa 1789 offer extraordinarily important information about many aspects of quotidian life in late-eighteenth-century Rio de Janeiro, including dress, means of transportation, and construction practices: *Fire at the Retreat of Nossa Senhora do Parto* and *Reconstruction of the Retreat of Nossa Senhora do Parto* (cat. nos. 133–34) by João Francisco Muzzi. The retreat was an asylum or reformatory for women who were confined there at the wishes of their husbands or fathers. It burned in late August 1789 and was quickly reconstructed according to plans devised by the sculptor and architect Mestre Valentim. In *Reconstruction*, we see a portrait of the Afro-Brazilian architect showing his plans to the Viceroy Dom Luis de Vasconcelos. The exhibition also includes the four-part *Allegory of the Four Continents* (cat. nos. 135.1–.4) by the eighteenth-century Afro-Brazilian master José Theóphilo de Jesus. —E. J. S.

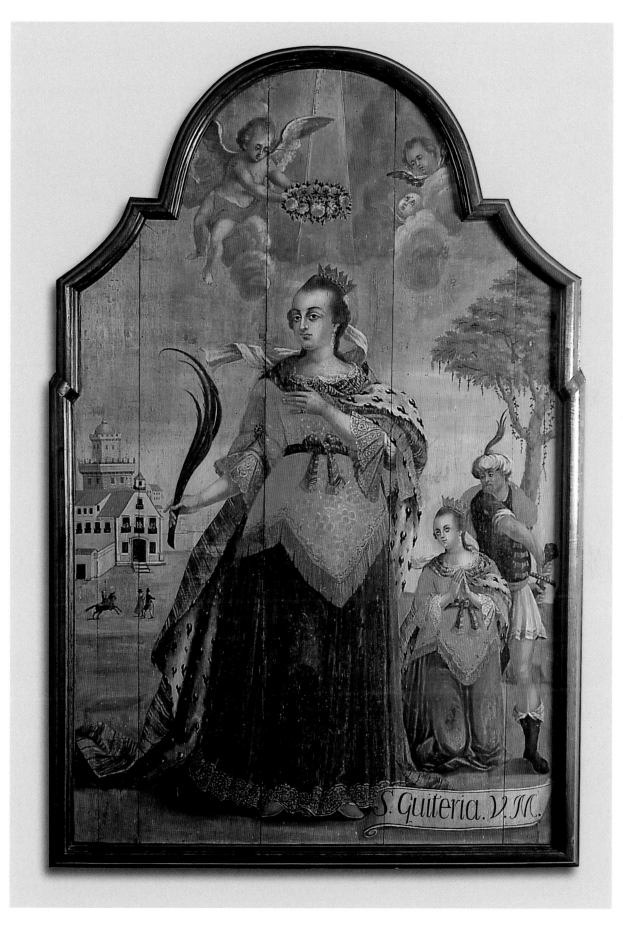

120. ANONYMOUS *Virgin Martyr Saint Quiteria*, 18th century. Tempera on wood, 248 x 166 cm. Arquidiocese de Olinda e Recife, Convento de Santo Antônio, Pinacoteca de Igarassu

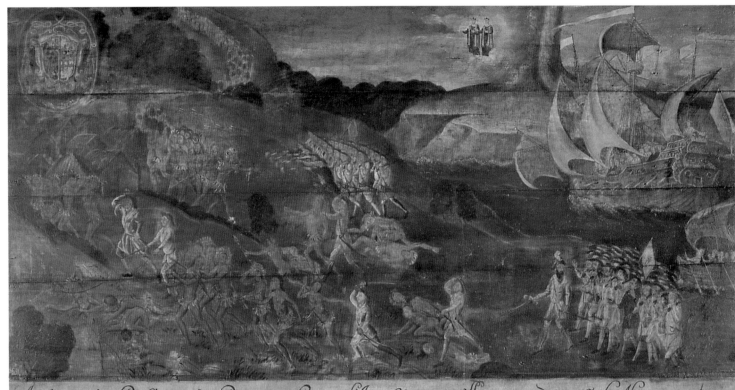

Apr.ª terra q̃ em Pern.ᶜ tiverão os Portugueses foy esta d'Igaraßú [nome, q̃ lhe trouce a admiração dos Naturaes vendo a grandeza das noßas embarcaçoens, Sendo o mesmo na sua lingoa Igaraßú q̃ Não gr.ᵉ] chegando á ella no anno d'1530. em 27 d'7ᵇʳᵒ dia d'SS. Cosme e Damião. Cõ cujo patrocinio vencerão no mesmo dia tão gr.ᵈᵉ multidão d'Indios, cõ expulsarão fora attribuindo aos Sᵗᵒˢ a vitoria. V.ᵉ Fr. Raf. de IHS. in Cast. lus. 1. l. n. 15. Em mayor triunfo do esquecim.ᵗᵒ se f̃es este dep.ᵗᵉ das esmollas q̃ d'eo p.ª esta Igr.ª o Ill.ᵐᵒ S.ᵒʳ D. Joseph Fialho d'esel. mem. no año de 1729, e q̃ f̃es a festa aos S.ᵗᵒˢ á sua custa.

121. ANONYMOUS *The Arrival of the Portuguese and Their Triumph over the Igarassu Indians in 1532*, 1729. Tempera on wood, 174 x 273 cm. Arquidiocese de Olinda e Recife, Convento de Santo Antônio, Pinacoteca de Igarassu

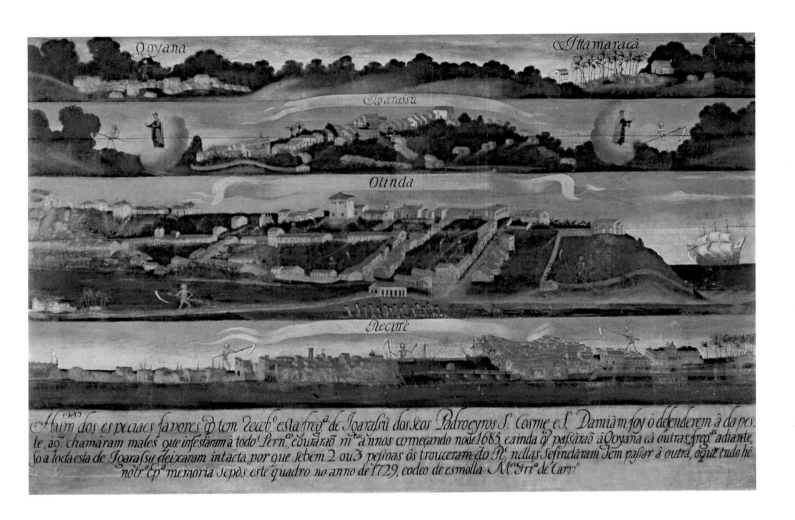

122. ANONYMOUS *The Miracle that Spared the Town of Igarassu from the Plague*, 1729. Tempera on wood,

148 x 242 cm. Arquidiocese de Olinda e Recife, Convento de Santo Antônio, Pinacoteca de Igarassu

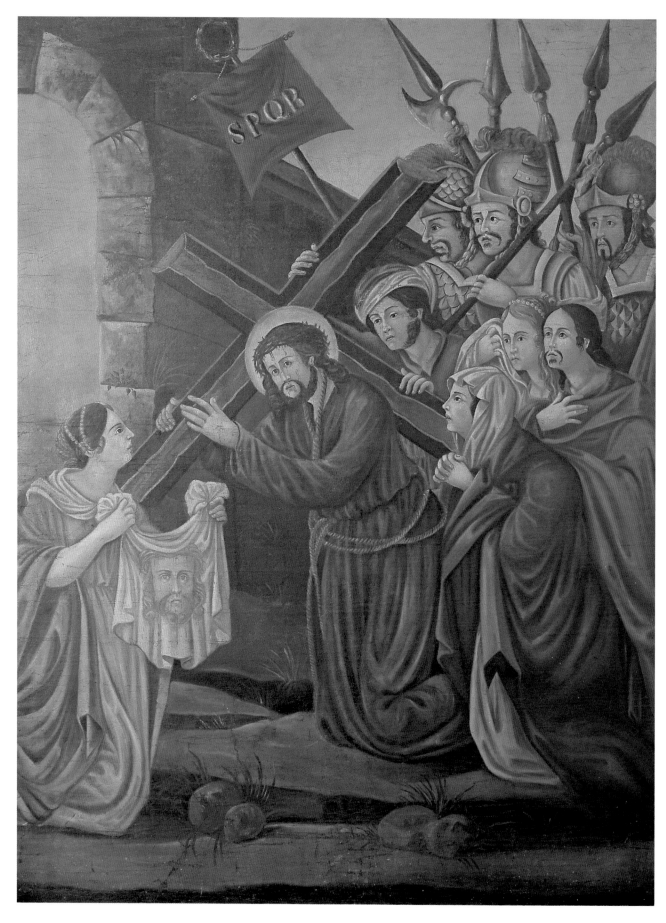

123. ANONYMOUS *Scene of the Passion of Christ*, 18th century. Oil on canvas, 203 x 152 cm. Private collection

CHRONICA 2.P.F. 435.

124. ANONYMOUS *Chronicle of Patriarch Saint Francis*, 18th century. Oil on wood, 166 x 218 cm. Arquidiocese de Olinda e Recife,
Convento de Santo Antônio, Pinacoteca de Igarassu

125. **ANONYMOUS** *Apparition of the Virgin to Saint Benedito*, 18th century. Polychromed wood, 142 x 210 cm.

5a Superintendencia Regional/Instituto do Patrimônio Histórico e Artistico/Ministério de Cultura, Pernambuco

126. ANONYMOUS *Saint Benedito and Other Monks*, 18th century. Polychromed wood, 142 x 211 cm. 5a Superintendencia
Regional/Instituto do Patrimônio Histórico e Artistico/Ministério de Cultura, Pernambuco

262

127. JOSÉ JOAQUIM DA ROCHA *Angel with Torch, Rope, Sword, and Purse with Thirty Coins*, 1786. Oil on canvas, 105 x 95 cm. Museu de Arte da Bahia, Salvador

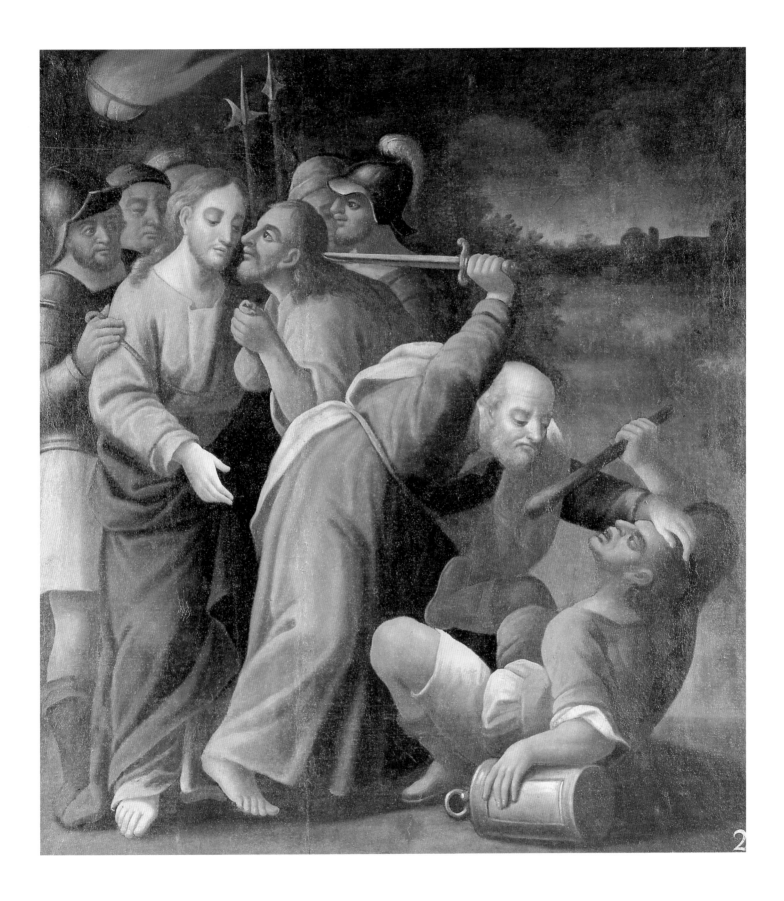

128. JOSÉ JOAQUIM DA ROCHA *The Kiss of Judas, and Peter Cutting the Ear of Maichus*, 1786. Oil on canvas, 105 x 95 cm.

Museu de Arte da Bahia, Salvador

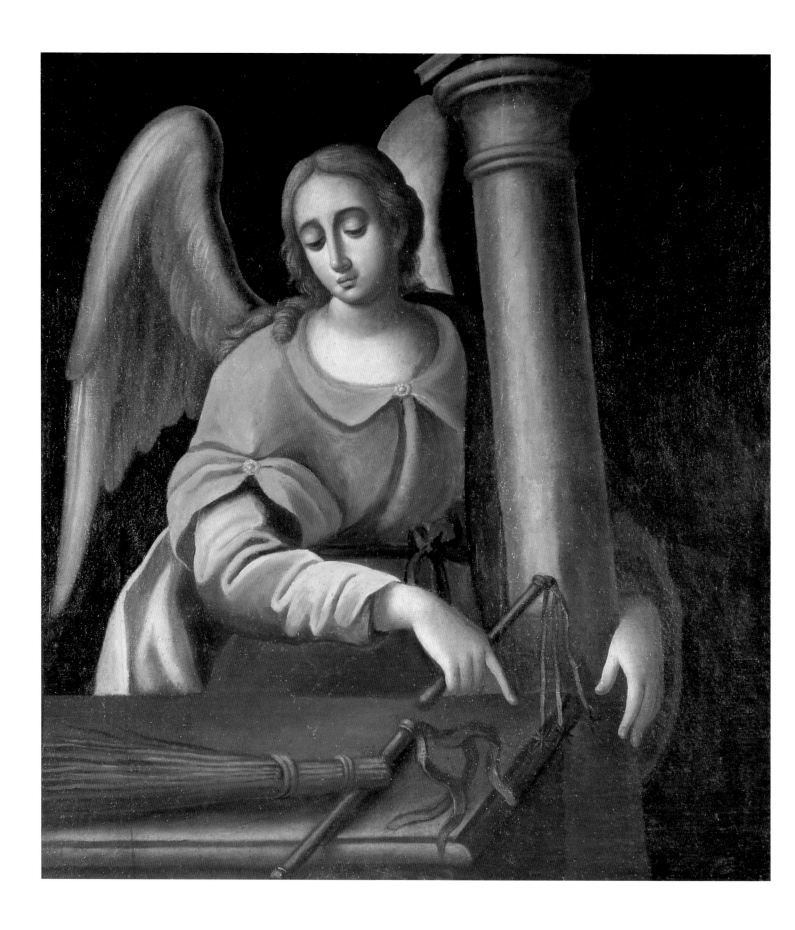

129. JOSÉ JOAQUIM DA ROCHA *Angel with Column and Scourge*, 1786. Oil on canvas, 105 x 95 cm.
Museu de Arte da Bahia, Salvador

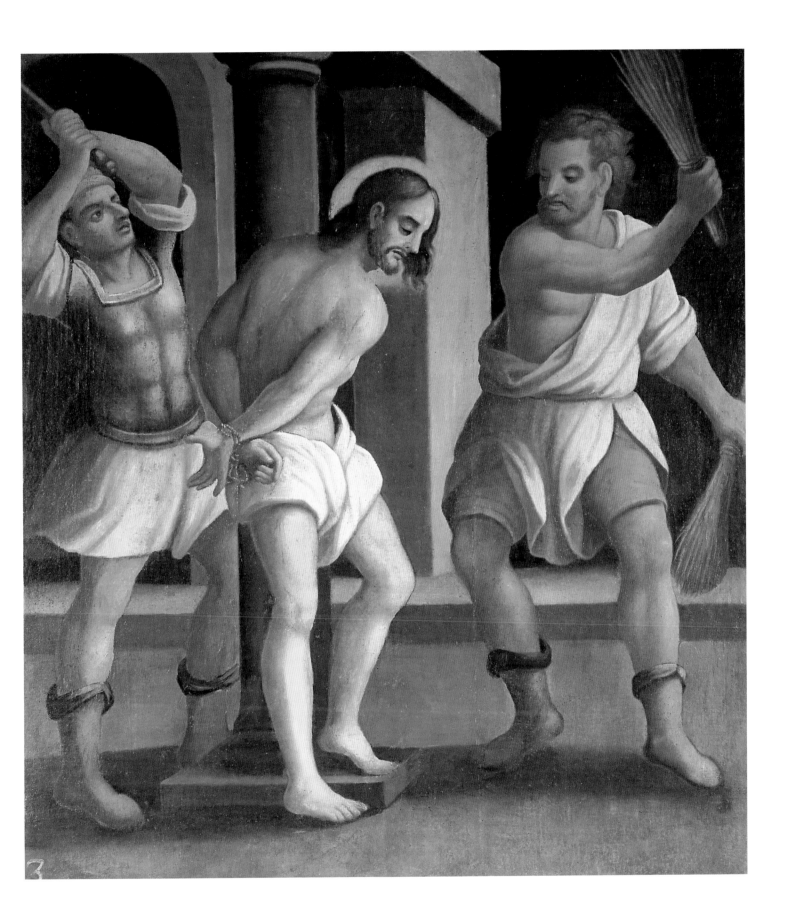

130. JOSÉ JOAQUIM DA ROCHA *The Flagellation*, 1786. Oil on canvas, 105 x 95 cm. Museu de Arte da Bahia, Salvador

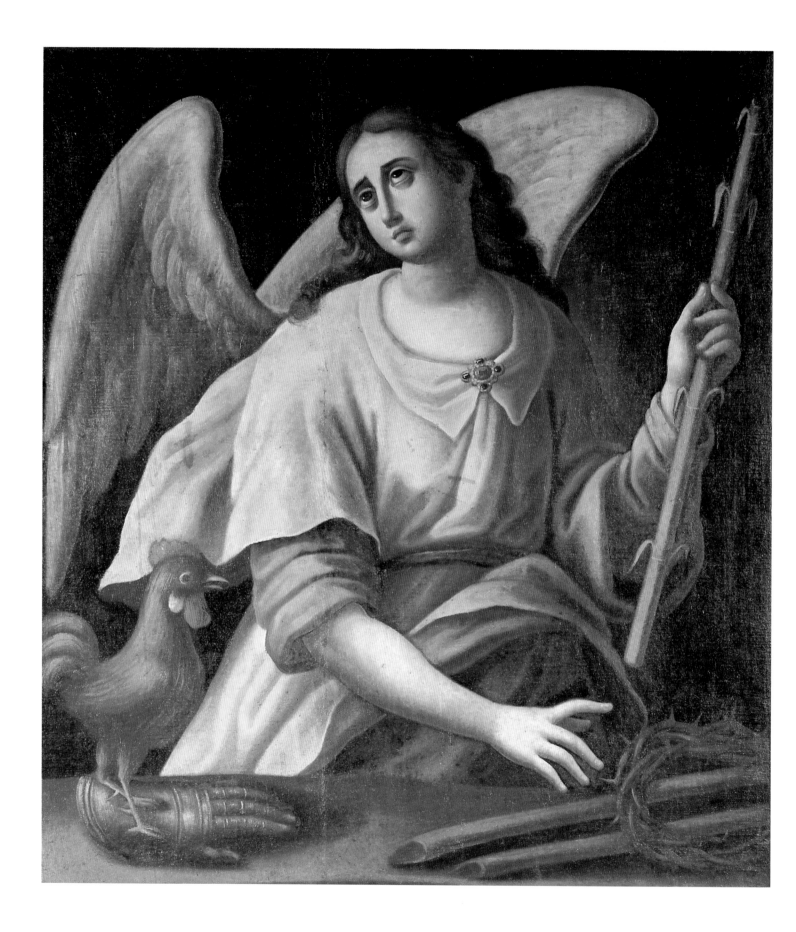

131. JOSÉ JOAQUIM DA ROCHA *Angel with Crown of Thorns, Cane, Rooster, and Soldier's Glove*, 1786. Oil on canvas,
105 x 95 cm. Museu de Arte da Bahia, Salvador

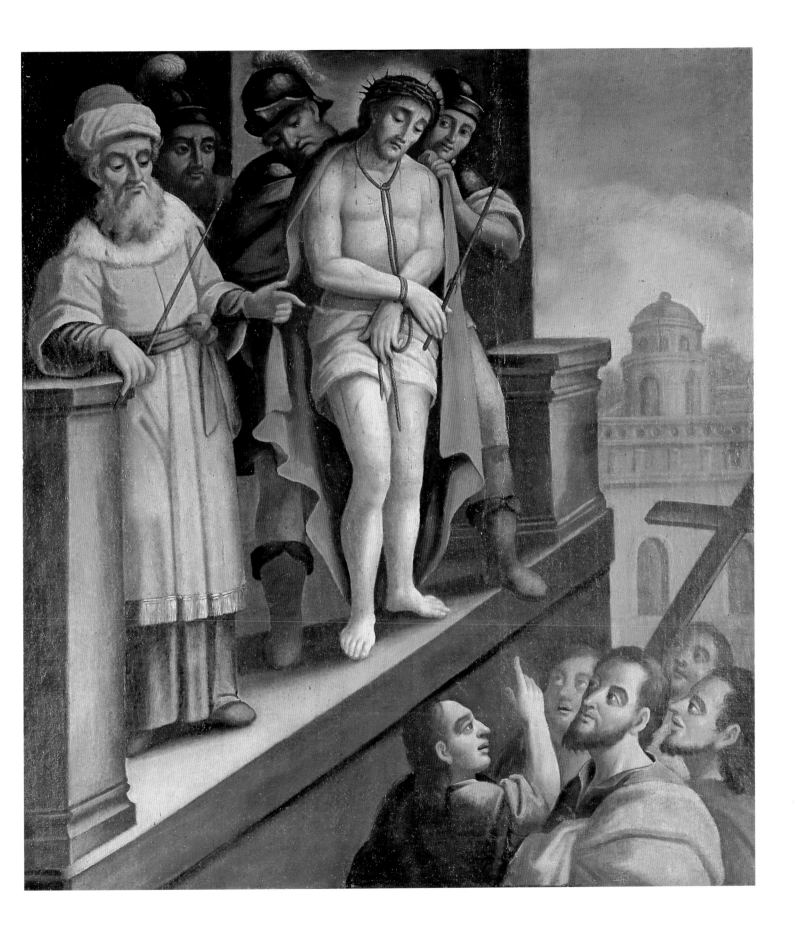

132. **JOSÉ JOAQUIM DA ROCHA** *Ecce Homo*, 1786. Oil on canvas, 105 x 95 cm. Museu de Arte da Bahia, Salvador

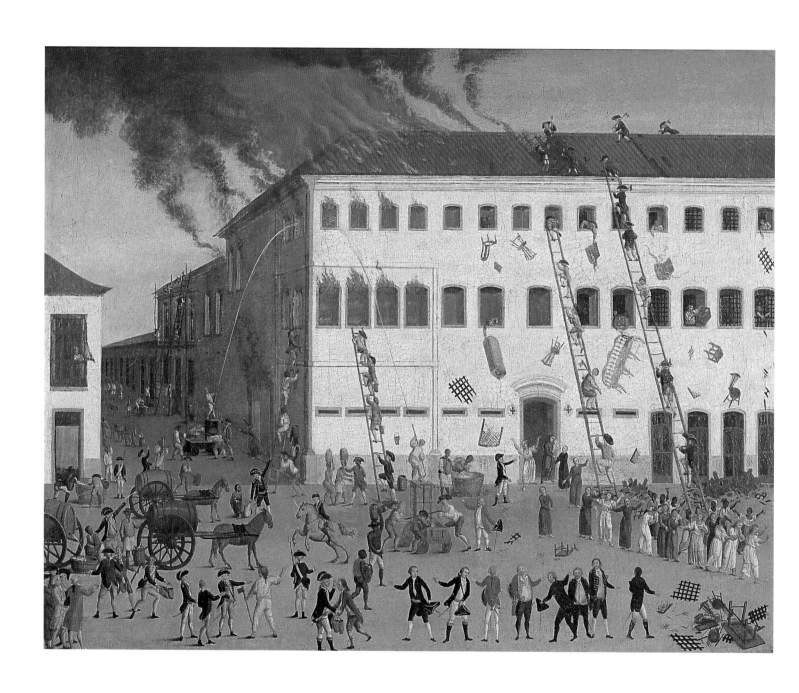

133. JOÃO FRANCISCO MUZZI *Fire at the Retreat of Nossa Senhora do Parto*, ca. 1789. Oil on canvas, 113 x 138 cm.

5a Superintendencia Regional/Instituto do Patrimônio Histórico e Artistico/Ministério de Cultura, Pernambuco

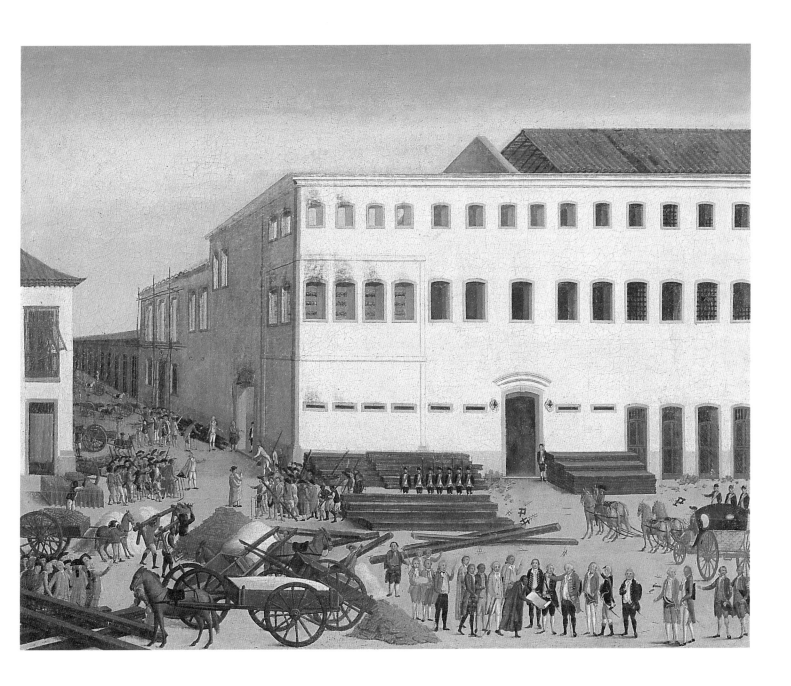

134. JOÃO FRANCISCO MUZZI *Reconstruction of the Retreat of Nossa Senhora do Parto*, ca. 1789. Oil on canvas, 113 x 138 cm.

5a Superintendencia Regional/Instituto do Patrimônio Histórico e Artistico/Ministério de Cultura, Pernambuco

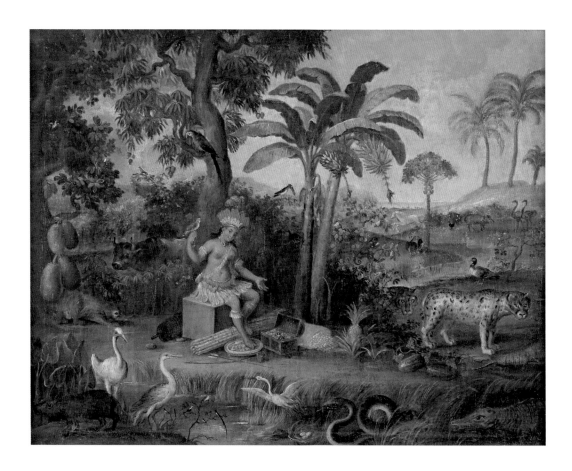

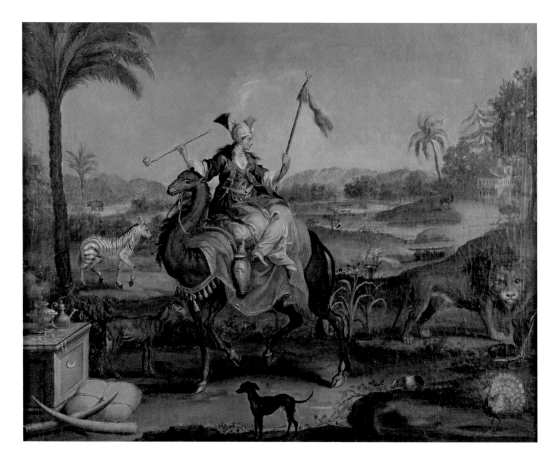

TOP: **135.1. JOSÉ THEOPHILO DE JESUS** *Allegory of the Four Continents: America*, 18th century. Oil on canvas, 65 x 82 cm
Museu de Arte da Bahia, Salvador. BOTTOM: **135.2. JOSÉ THEOPHILO DE JESUS** *Allegory of the Four Continents: Asia*,
18th century. Oil on canvas, 65 x 82 cm. Museu de Arte da Bahia, Salvador

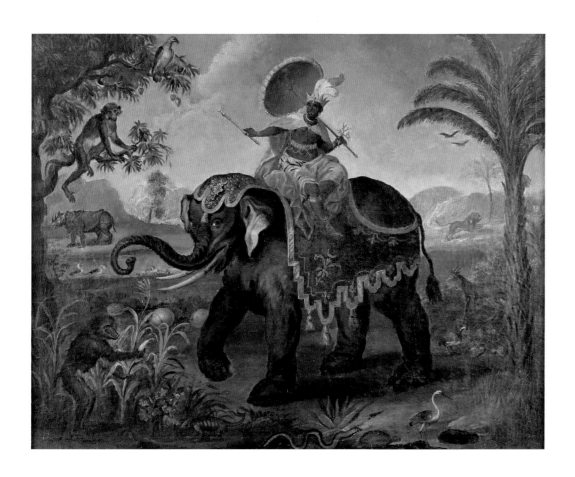

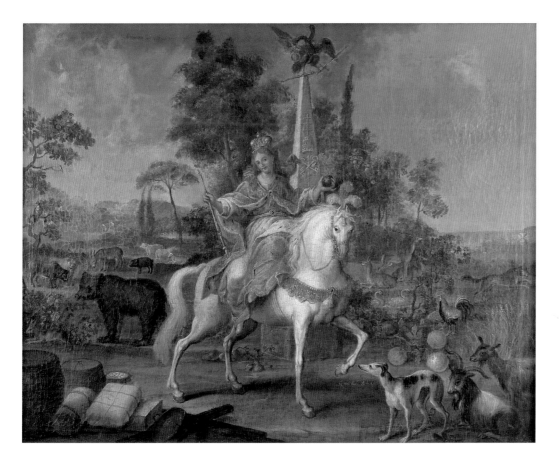

TOP: **.135.3. JOSÉ THEOPHILO DE JESUS** *Allegory of the Four Continents: Africa*, 18th century. Oil on canvas, 65 x 82 cm
Museu de Arte da Bahia, Salvador. BOTTOM: **135.4. JOSÉ THEOPHILO DE JESUS** *Allegory of the Four Continents: Europe*,
18th century. Oil on canvas, 65 x 82 cm. Museu de Arte da Bahia, Salvador

Jewelry

In the collection of the Museu Paulista da Universidade de São Paulo, there is an exquisite oval-shaped painting of a Bahiana, a regal Afro-Brazilian woman from Bahia, dating from the mid-nineteenth century (cat. no. 136). She may be a slave in a wealthy household or the free daughter of slaves. She is seated, wearing an off-the-shoulder black dress and white gloves and her hair is swept up. Her body is silhouetted against a gold background like a Madonna or a saint. What captivates the viewer most is the elegant jewelry this Bahiana wears. Around her neck and shoulders are strand after strand of necklace, each composed of intricately ornate gold beads. She has gold bracelets on her wrists, and on her head are three rows of gold ornament, holding her hair in place.

From Brazil's early history up to 1850, slaves were brought to the country from parts of Africa where metal-working traditions were deeply entrenched in the local cultures. The people of the Fanti-Ashanti, Baule, and Yoruba groups brought with them detailed knowledge of the making of jewelry and other body adornments. This skill would be especially important to those who were brought to Minas Gerais, Brazil's greatest mining region. Gold from Minas Gerais was fashioned into objects that employed decorative patterns and casting techniques similar to those of West Africa.

The examples of gold jewelry once belonging to slaves or former slaves include intricately filigreed necklace beads and a very distinctive type of bracelet called a "cup," as it resembles an elongated drinking vessel. Not only is this jewelry testimony to the strength of African conventions of decoration in the New World, but it may also be conceived as a form of resistance to European cultural hegemony in Brazil. Among the most compelling examples of so-called "slave jewelry" are the *balan-gandás*: accumulations of amulets made of disparate elements (gold, silver, stone, coral, bone, and so on), gathered together and worn on chains around the neck or on belts around the waist. They are powerful receptacles of spiritual force and are meant to assure good fortune and protection from injurious spirits. Thus they are not inert talismans but articles of adornment that play an active, physical, performative role when worn by their owner. —E. J. S.

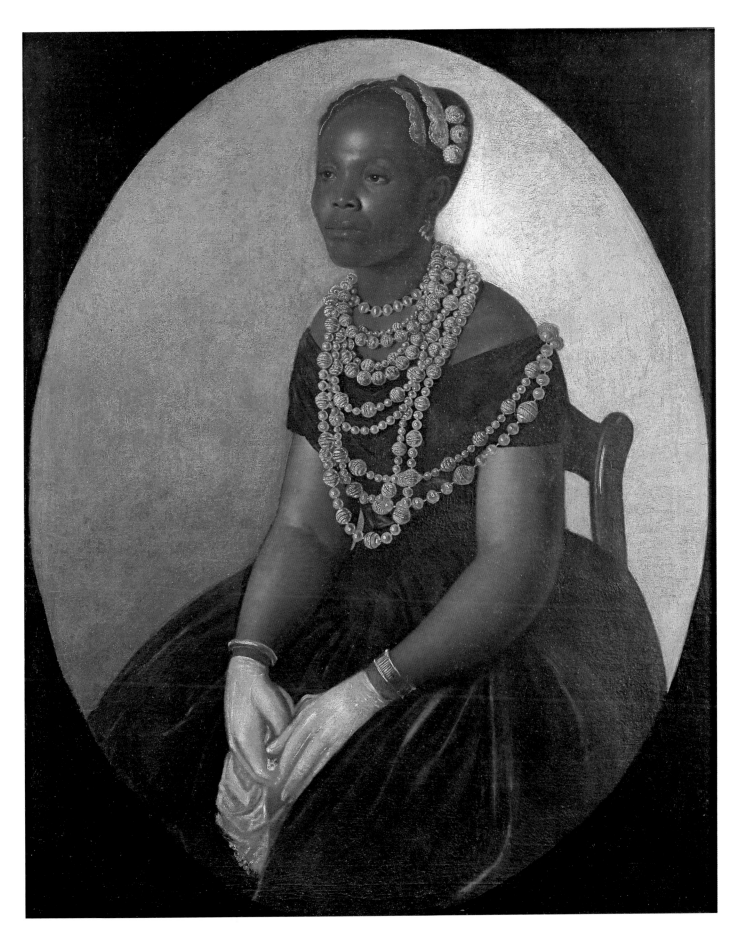

136. ANONYMOUS *Woman from Bahia*, mid-19th century. Oil on canvas, 95.5 x 76.5 cm.

Museu Paulista da Universidade de São Paulo

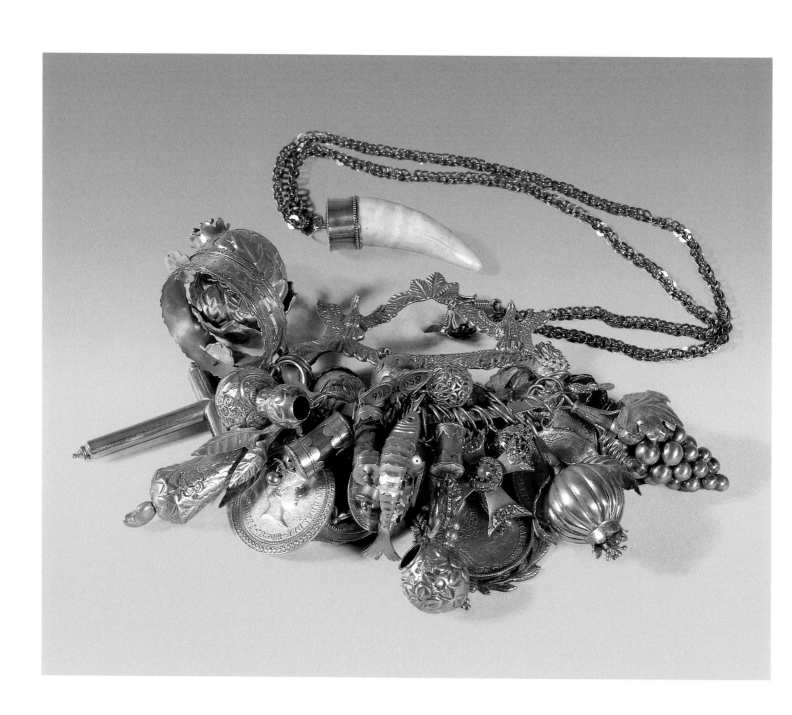

137. Amulets, 19th century. Gold and other materials, 41.7 x 7 cm. Fundação Museu Carlos Costa Pinto, Salvador

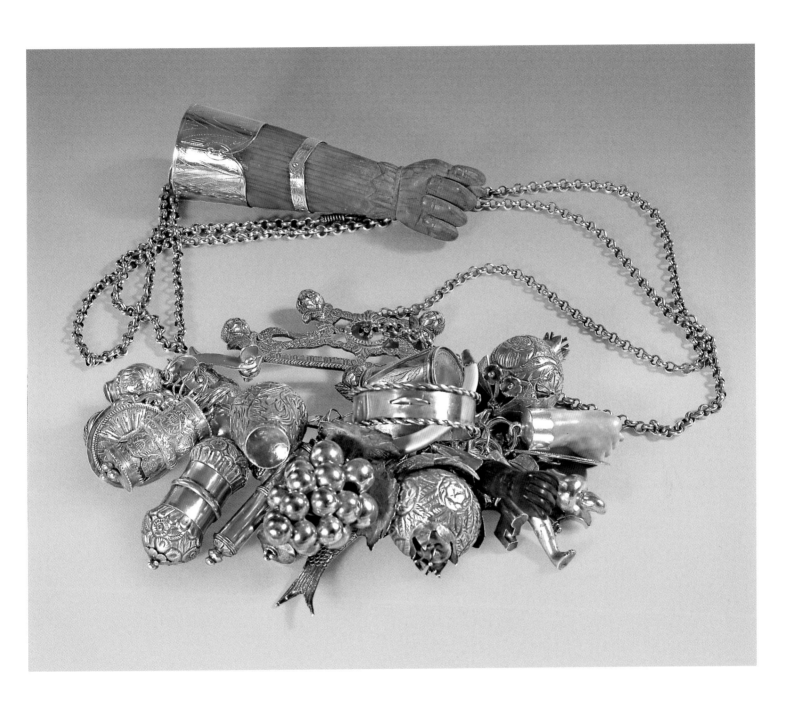

138. Amulets, 19th century. Silver and other materials, 9.8 x 15.5 cm. Fundação Museu Carlos Costa Pinto, Salvador

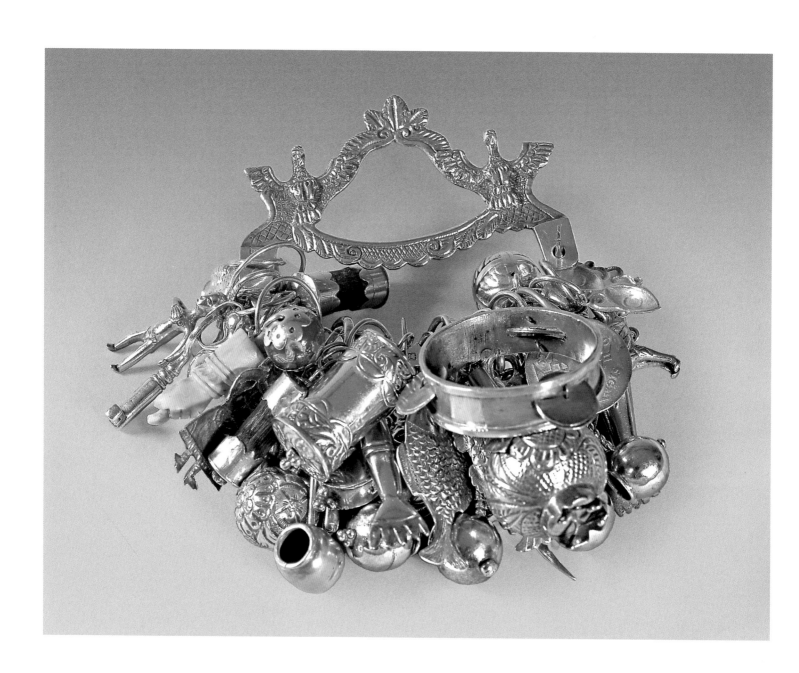

139. Amulets, 19th century. Silver and other materials, 7 x 8 cm. Fundação Museu Carlos Costa Pinto, Salvador

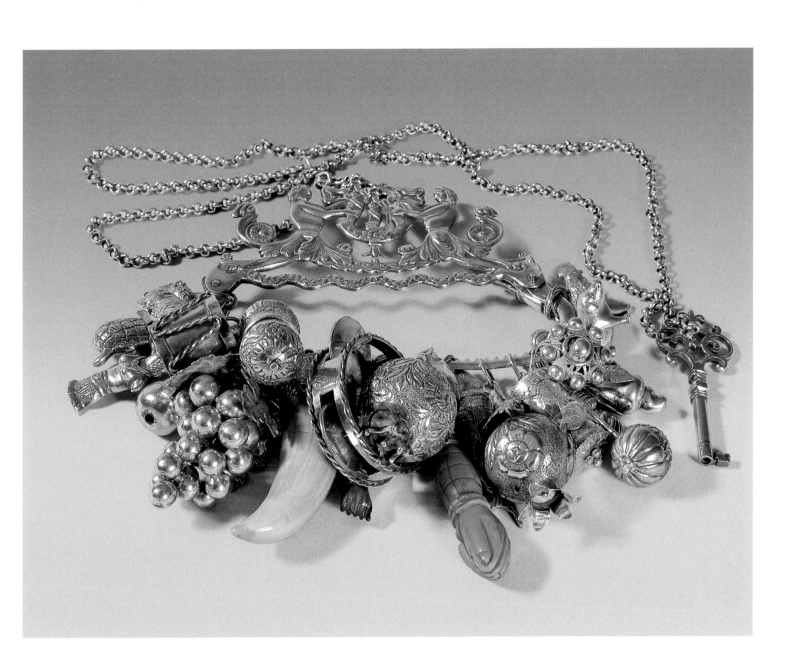

140. Amulets, 18th century. Silver and other materials, 14.3 x 18.6 cm. Fundação Museu Carlos Costa Pinto, Salvador

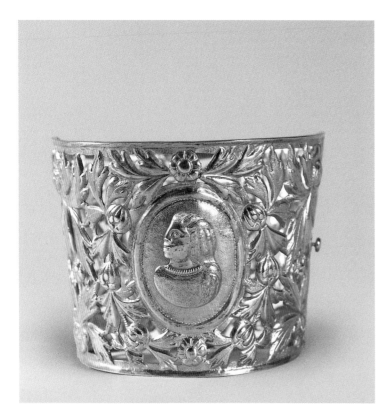

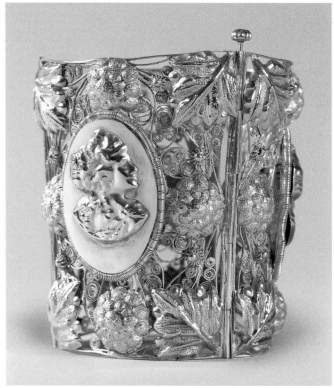

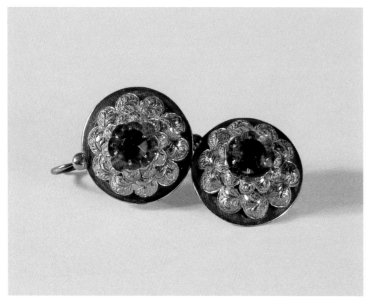

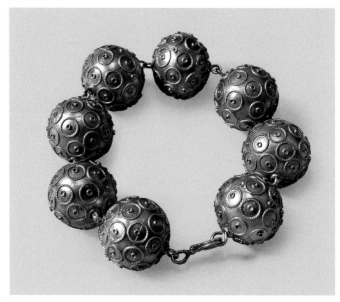

CLOCKWISE FROM TOP LEFT: 141. Bracelet, 19th century. Gold, 7 x 9.2 cm. Fundação Museu Carlos Costa Pinto, Salvador.
142. Bracelet, 18th century. Gold, 11.2 x 9.5 cm. Fundação Museu Carlos Costa Pinto, Salvador. 143. Bracelet, 18th century.
Gold, 22.5 x 2.3 cm. Fundação Museu Carlos Costa Pinto, Salvador. 144. Earrings, 19th century. Engraved gold and green stone,
3 x 2.2 cm. Fundação Museu Carlos Costa Pinto, Salvador

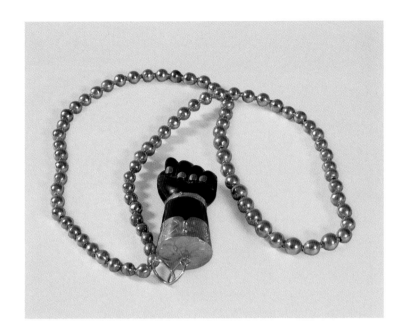

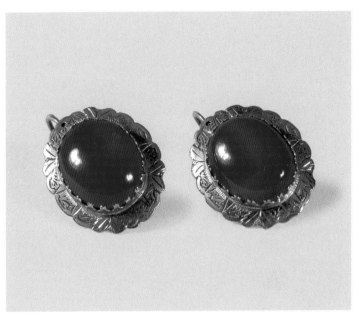

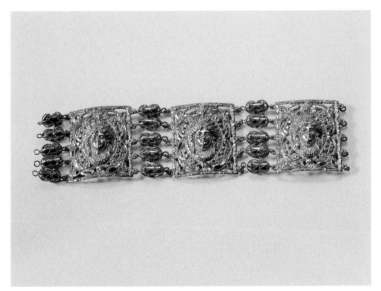

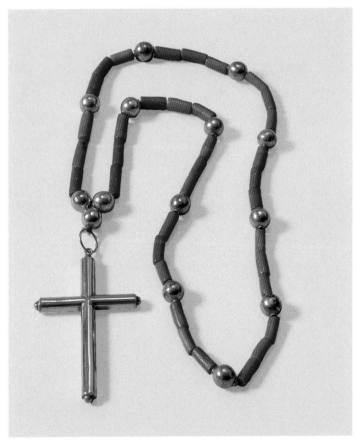

CLOCKWISE FROM TOP LEFT: 145. Necklace with amulet, 19th century. Gold and pitch coal, 53 x 3.7 cm. Fundação Museu Carlos Costa Pinto, Salvador. 146. Earrings, 19th century. Gold and amber, 3.3 x 2 cm each. Fundação Museu Carlos Costa Pinto, Salvador. 147. Necklace with cross, 19th century. Gold and coral, 45.5 x 5.4 cm. Fundação Museu Carlos Costa Pinto, Salvador. 148. Bracelet, 19th century. Gold, 6 x 24.3 cm. Fundação Museu Carlos Costa Pinto, Salvador

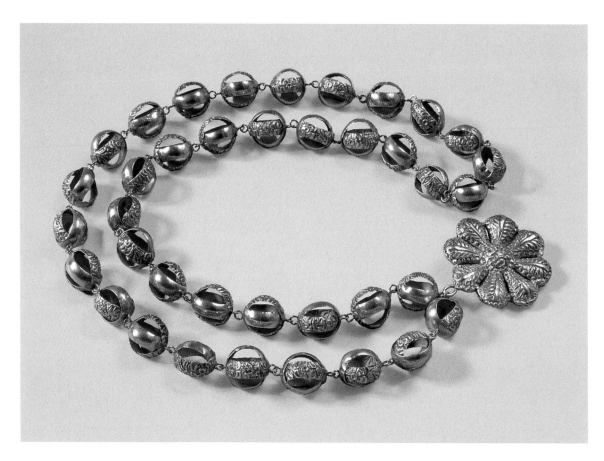

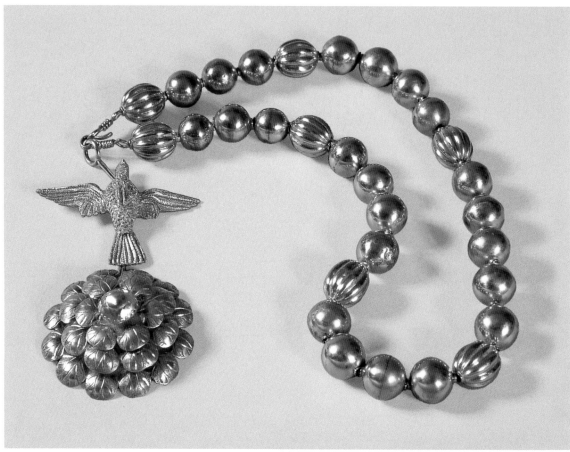

TOP: **149.** Necklace, 19th century. Gold, 64 x 6.5 cm. Fundação Museu Carlos Costa Pinto, Salvador. BOTTOM: **150.** Necklace with pidgeon and rosette, 19th century. Gold, 42.2 x 7.1 cm. Fundação Museu Carlos Costa Pinto, Salvador

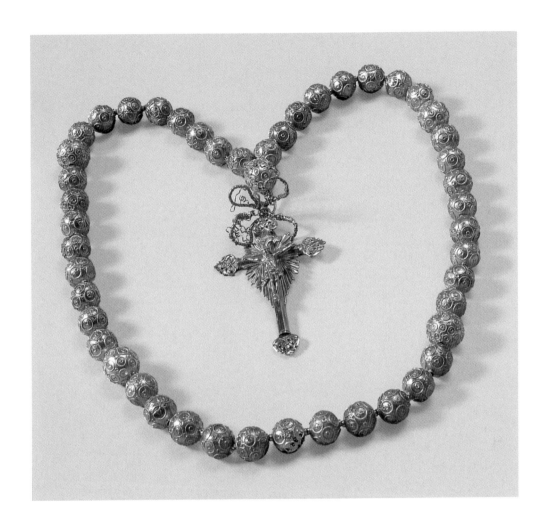

151. Necklace with cross, 19th century. Gold, 53 x 6.2 cm. Fundação Museu Carlos Costa Pinto, Salvador

Oratories

Oratories, or *oratórios*, which have been made in Brazil since the eighteenth century, allow us a glimpse into a private, intimate side of Brazilian spirituality. While they are not unique to Brazil (examples are also found in Portugal and Spain, as well as in other nations of Latin America), they have been used there for a particularly wide range of purposes, and there are a surprisingly diverse range of categories and sizes of these private altars. The smallest are the traveling oratories, or *oratórios de viajem*. Like most oratories, they are usually made of wood although some, designed to hang around the neck on a chain, have been made of precious materials such as gold. Traveling oratories are often extremely simple, with doors that can be closed during transport or when the oratory is not in use, and a single image of the Virgin or a saint inside. Domestic oratories, which are common in Brazil, are placed in the corner of a room and contain an image of either a saint to whom the owner has a particular devotion or an advocation of the Virgin, such as the Immaculate Conception or the Virgin and Child. There are also larger oratories for use in chapels or other intimate rooms of convents and monasteries. These tend to be more elaborate and reflect the stylistic characteristics of the painting, sculpture, and architecture of the region where they were manufactured. Those made in Minas Gerais, for example, are often painted in pastel colors, while those from the northeastern states such as Pernambuco are usually painted in stronger tones and adorned with more florid details. The most European-looking examples are often from Rio de Janeiro. Most oratories are by anonymous artists, although such great Brazilian Baroque masters as O Aleijadinho, Francisco Viera Servas, and Manuel da Costa Ataíde are all recorded as having participated in the creation of oratories.

Among the most fascinating oratories are the Afro-Brazilian examples. These are often small, with simple wood carving used to create the structure and the images within. The Afro-Brazilian oratories sometimes reflect the syncretic qualities of the popular faith of slaves and persons of African descent. Images of popular Afro-Brazilian saints such as Saints Efigénia, Cosmos, and Damian are often included, as are other elements extraneous to traditional Christian symbolism, such as jewelry, paper flowers, and coins. —E. J. S.

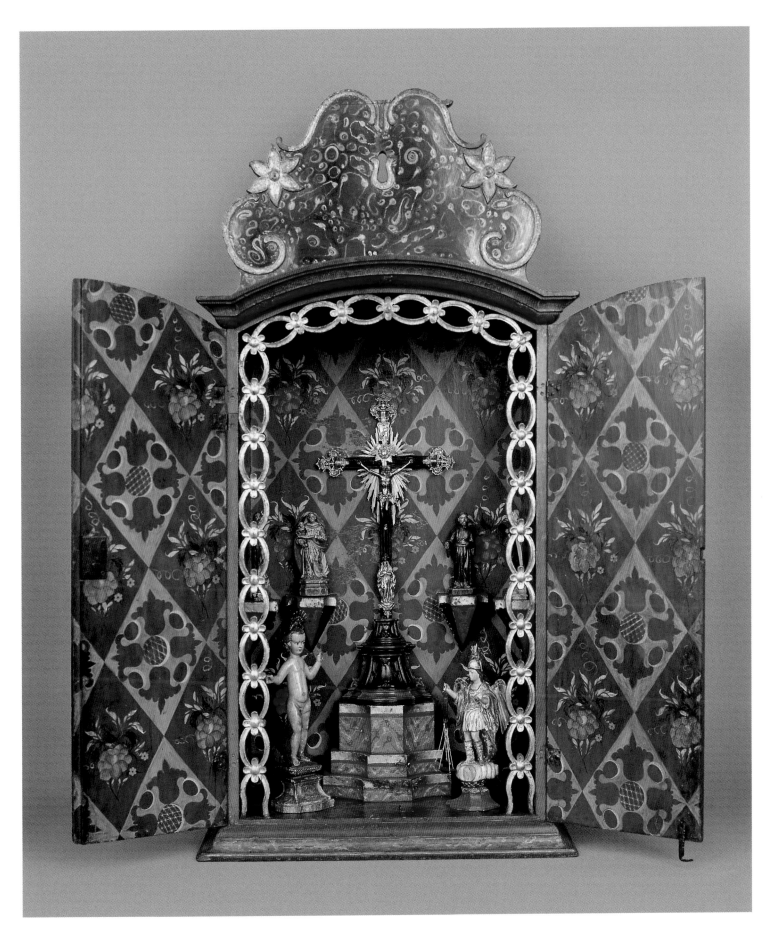

152. ANONYMOUS *Oratory*, 19th century. Polychromed and gilded wood, 137 x 119 x 35 cm. Museu do Oratório, Ouro Prêto

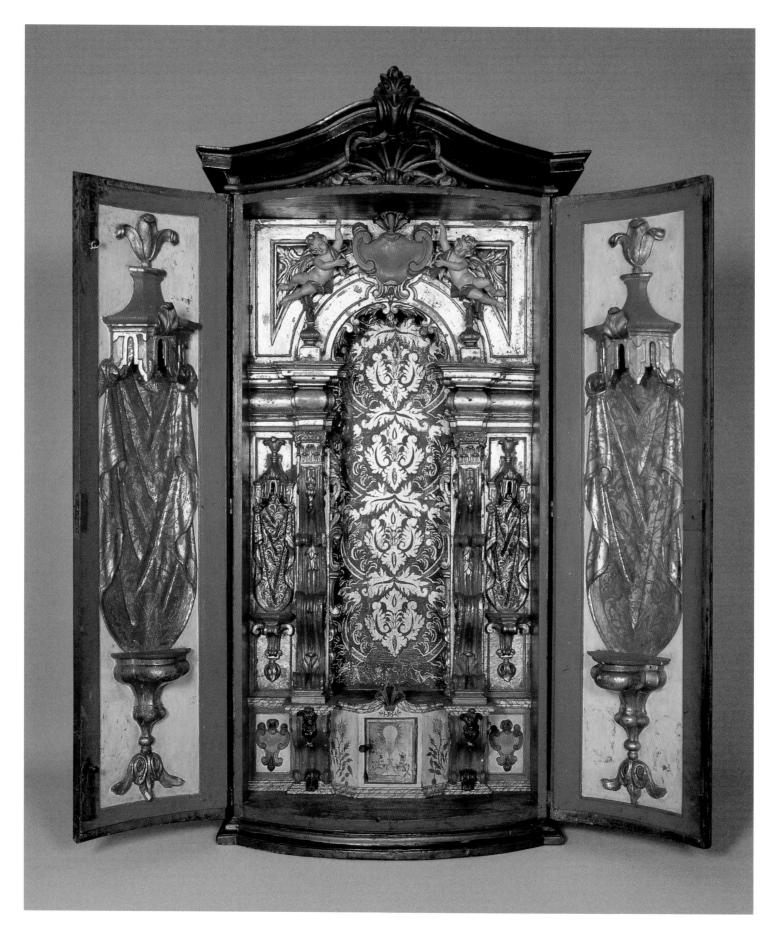

153. ANONYMOUS *Oratory*, 18th century. Polychromed and gilded wood, 160 x 77 x 45 cm. Museu Mineiro–Superintendência de Museus/Secretaria de Estado da Cultura, Minas Gerais

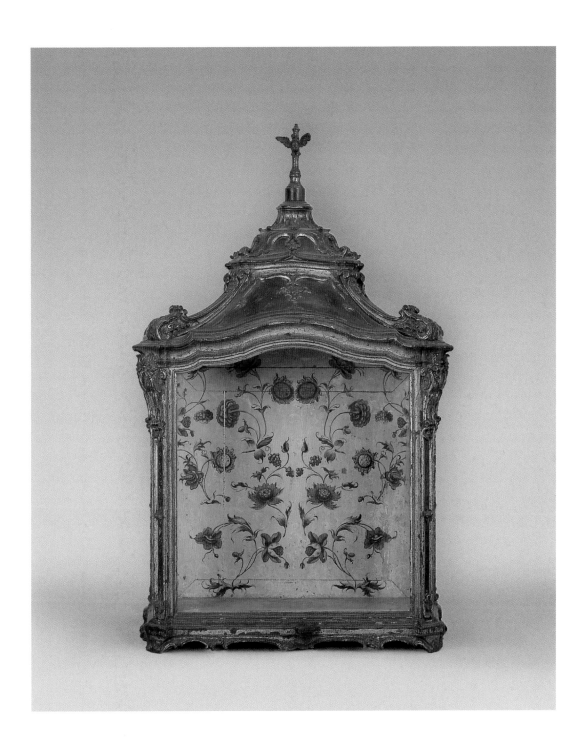

154. ANONYMOUS *Oratory*, 18th century. Polychromed wood, 76 x 51 x 24 cm. Private collection

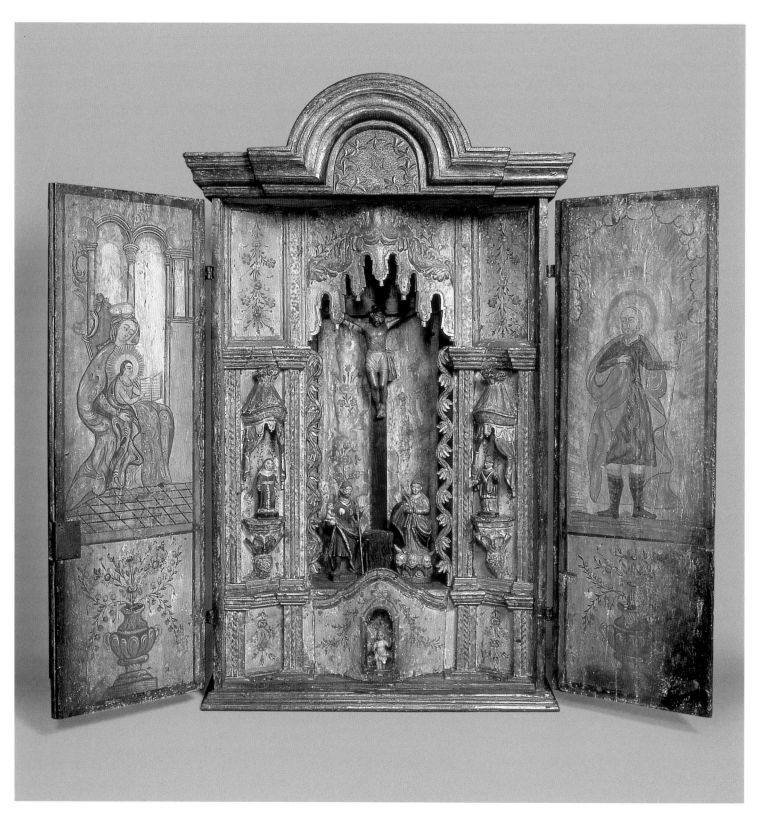

155. ANONYMOUS *Oratory*, 18th century. Polychromed wood, 120 x 77 x 36 cm. Collection of Ladi Biezus, São Paulo

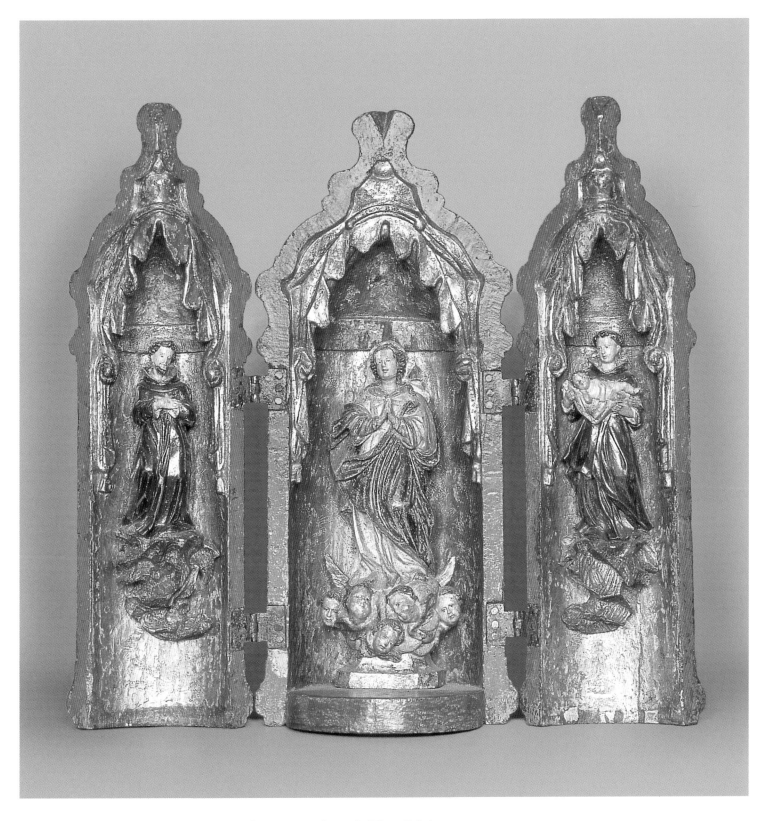

156. **ANONYMOUS** *Oratory*, 18th century. Polychromed wood, 38 x 18 x 18 cm. Collection of Ladi Biezus, São Paulo

FACING PAGE: **157. ANONYMOUS** *Afro-Brazilian Oratory*, 19th century. Polychromed wood, 93.5 x 61.5 x 26 cm.
Museu do Oratório, Ouro Prêto

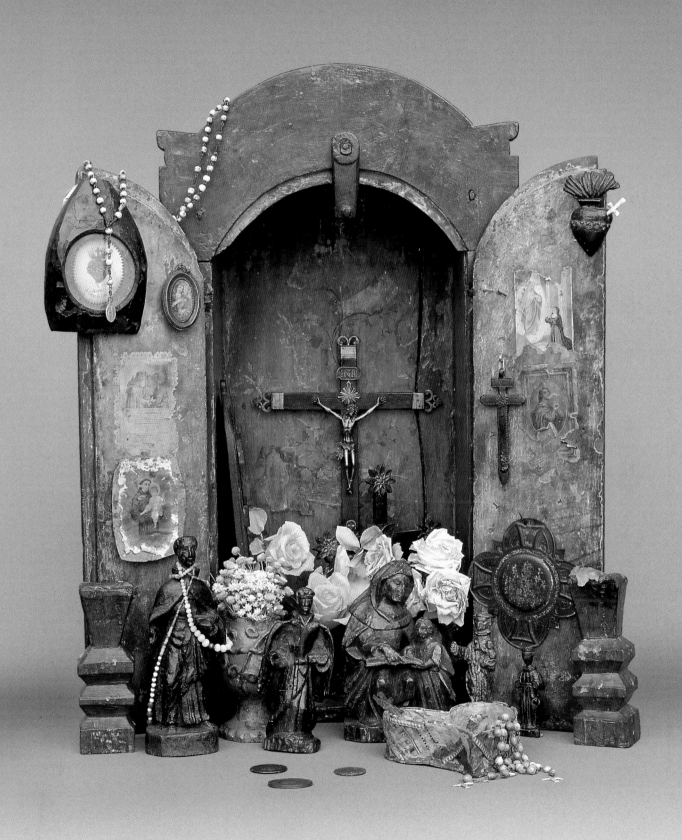

Baroque Silver

The sumptuousness and drama of Brazilian church interiors from the late sixteenth century on derive in large part from the quantity of objects with which they are adorned. These include not only paintings and sculpture but also gold and silver religious pieces. Ceremonial crosses, reliquaries, processional lamps, chandeliers, incense boats (*navetas*) in the shape of ships or, in many cases, birds (one of the most characteristic forms of Brazilian Baroque silver), ciboria, chalices, pattens, and vessels for holy oils are just some of the types of silver articles of ecclesiastical use that survive from the Baroque period.

Although there are few instances of secular silver from the sixteenth and seventeenth centuries, many examples from the eighteenth century survive. Some of these items were created for a specifically Brazilian context, such as the bowls known as *farinheiras*, made to hold manioc flour, an important ingredient in the Brazilian diet. Many eighteenth-century silver pieces display typical Rococo elements, including an emphasis on the accumulation of delicate decorative forms.

The earliest silversmiths arrived in Brazil from Portugal in the 1560s. They relied on imported silver (usually from Peru), which was traded in exchange for slaves. By the seventeenth century and throughout the eighteenth, the centers of silver production were in Salvador da Bahia and Olinda. Later, Rio de Janeiro assumed an important role in silver manufacturing. Many silver objects were imported into Brazil from Portugal, and it is sometimes difficult to ascertain the origins of a given piece. Some of the products of Brazilian ateliers bear motifs of local vegetation.

In the eighteenth century, members of the Jesuit order instructed the indigenous residents of the missions in southern Brazil and Paraguay in the art of silver-making, and the results were often striking. The government in Lisbon attempted to control silver production in order to assure a market for imports from Portugal, but this effort was less than successful. A decree issued in 1766 (enforced until 1815) officially halted the production of silver and gold objects in Brazil, yet this was often ignored. In the postcolonial period, silver continued to be a significant art form, and the tradition was reinvigorated by the arrival of skilled craftsmen from Europe in the nineteenth century. —E. J. S.

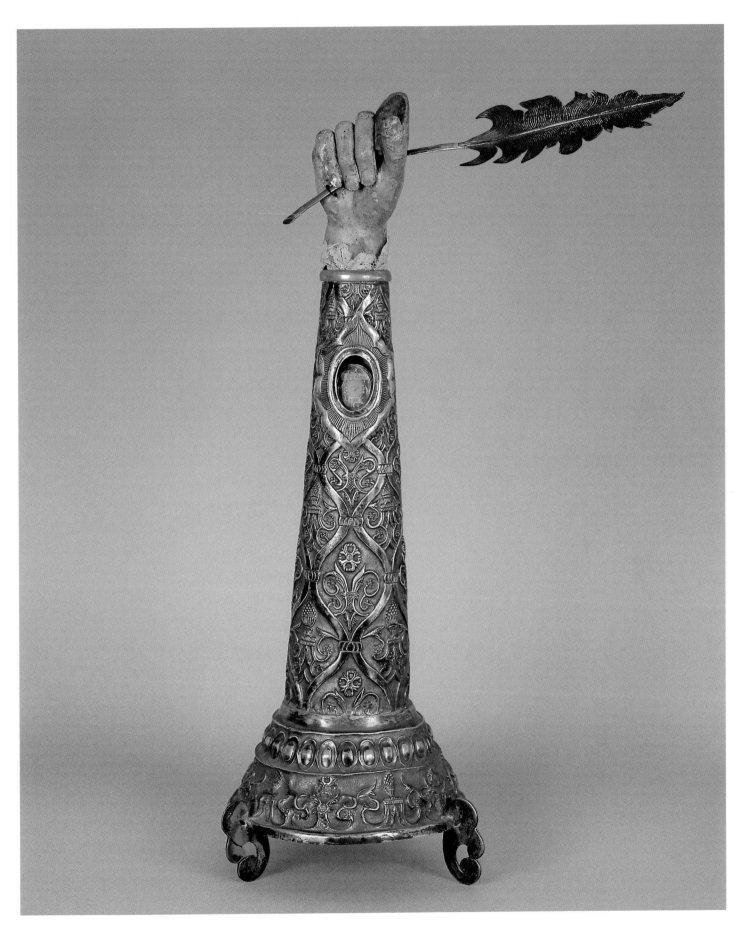

158. Arm reliquary, 18th century. Silver, 51 x 19 x 19 cm. Private collection

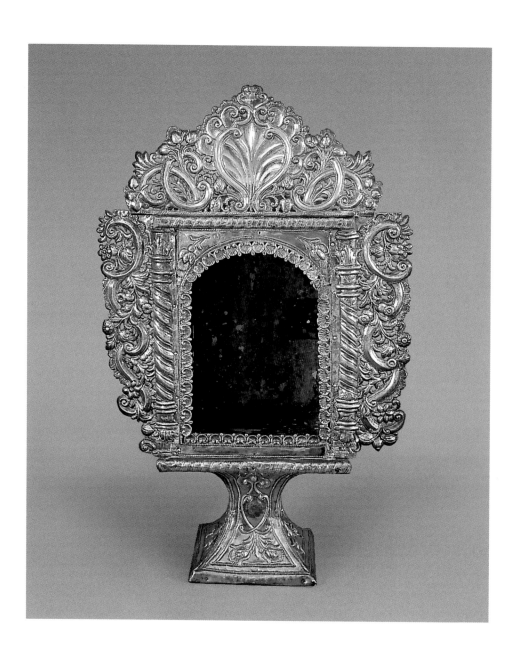

159. Tabernacle, 18th century. Silver, 70 x 42 x 25 cm. Collection of Beatriz and Mário Pimenta Camargo, São Paulo

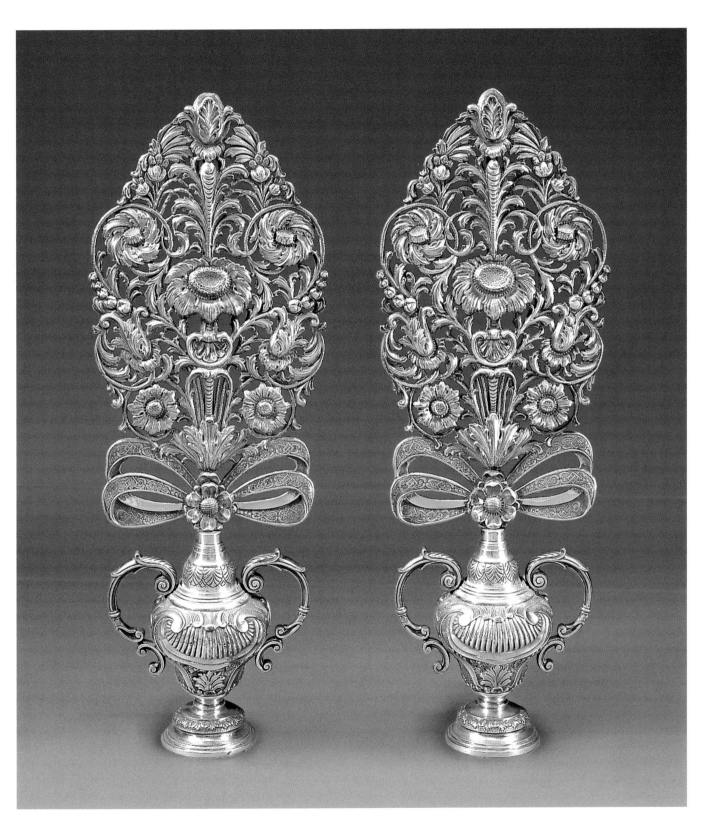

160. Altar palm leaves, 18th century. Silver, 82 x 28 x 18 cm each. Collection of Beatriz and Mário Pimenta Camargo, São Paulo

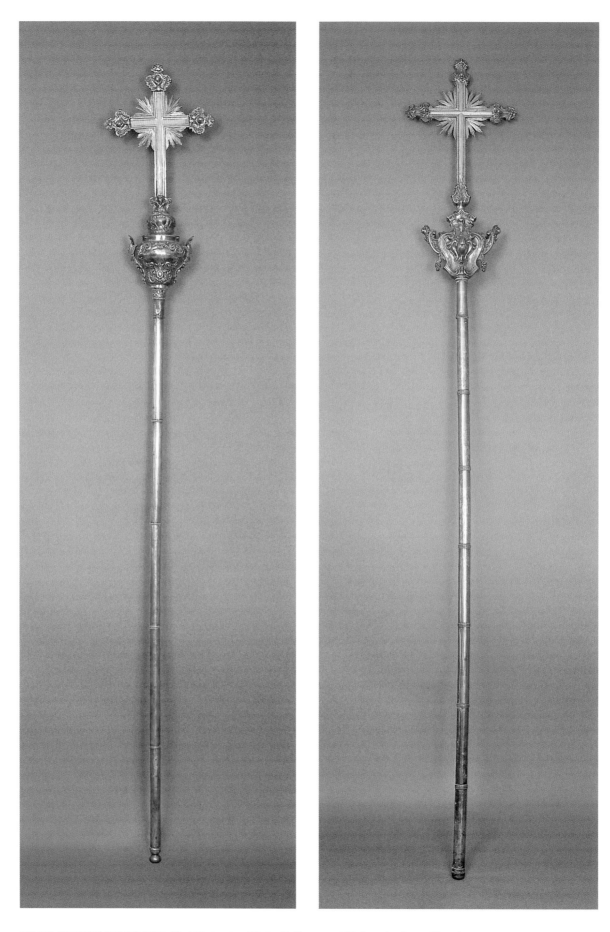

LEFT: **161.** Processional cross, 18th century. Silver, 158 x 31 x 15 cm. Private collection. RIGHT: **162.** Processional cross, 18th century. Silver, 190 x 34 x 9 cm. Private collection

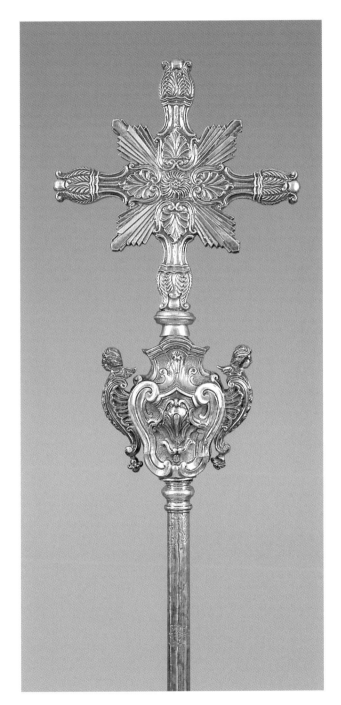

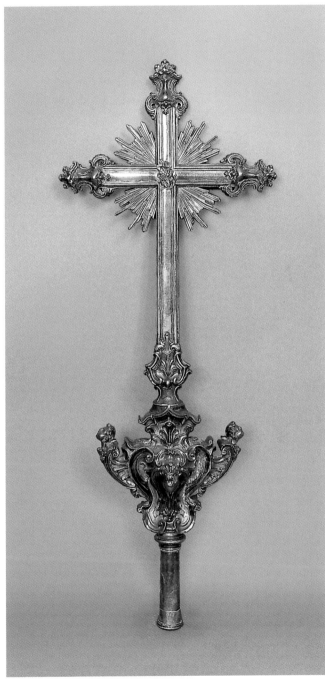

LEFT: **163.** Processional cross, 18th century. Silver, 195 x 34 x 11 cm. Collection of Beatriz and Mário Pimenta Camargo, São Paulo.

RIGHT: **164.** Processional cross, 18th century. Silver, 158 x 31 x 15 cm. Private collection

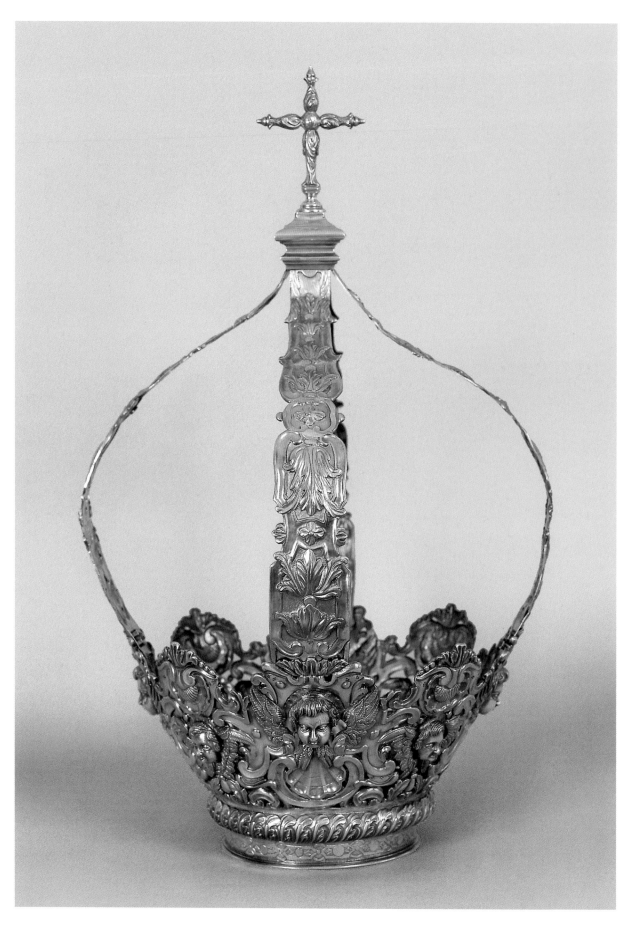

165. Crown, 18th century. Silver, 57 x 34 x 34 cm. Private collection

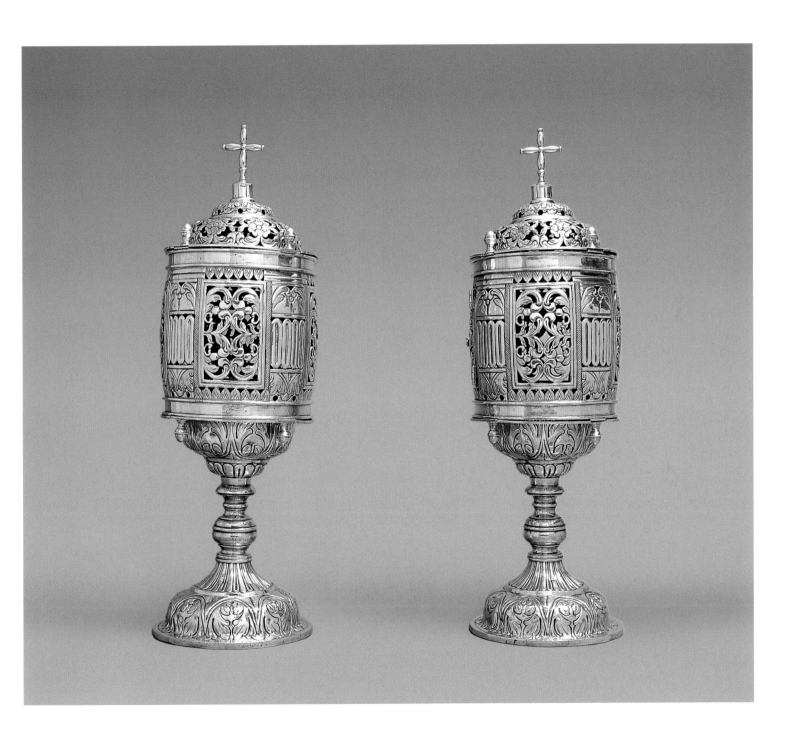

166. Lanterns, 18th century. Silver, 71 x 22 cm each. Collection of Sandra Penna, Belo Horizonte

298

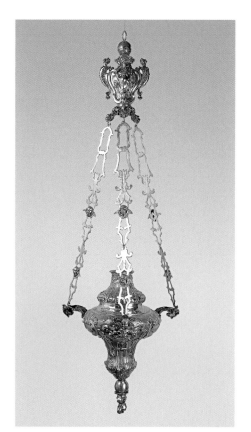
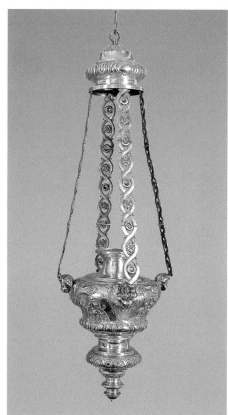
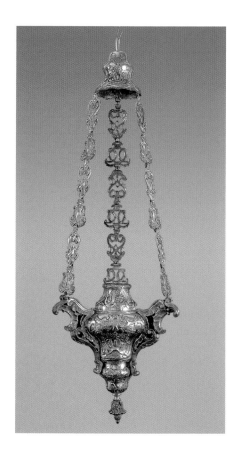

LEFT TO RIGHT: **167.** Hanging lantern, 18th century. Silver, h. 72 cm. Private collection. **168.** Hanging lantern, 18th century.
Silver, h. 91 cm. Private collection. **169.** Hanging lantern, 18th century. Silver, h. 130 cm. Private collection

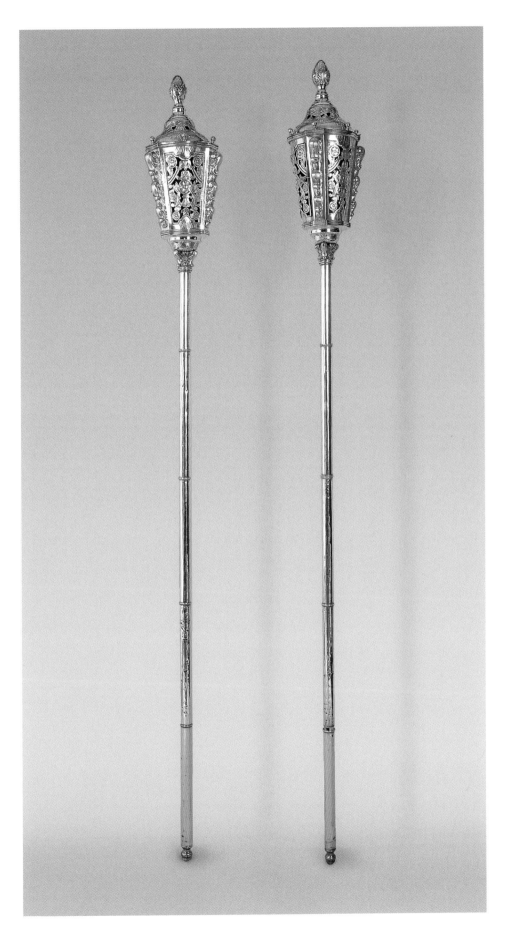

170. Processional lanterns, 18th century. Silver, 71 x 20 cm each. Private collection

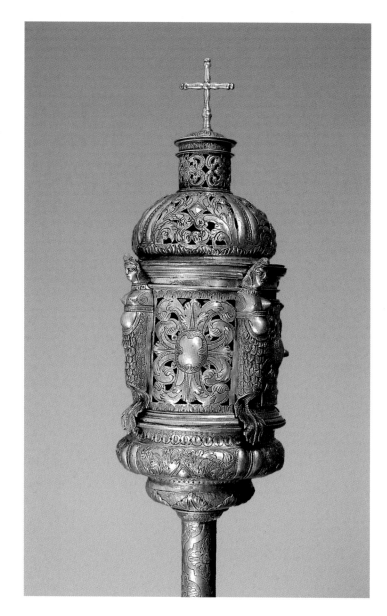

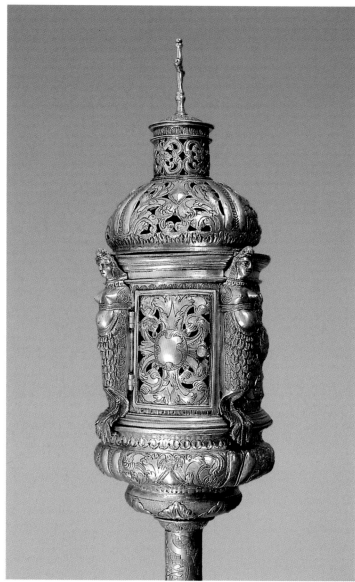

171. Processional lanterns, 17th century. Silver, 230 x 23 x 23 cm each. Private collection

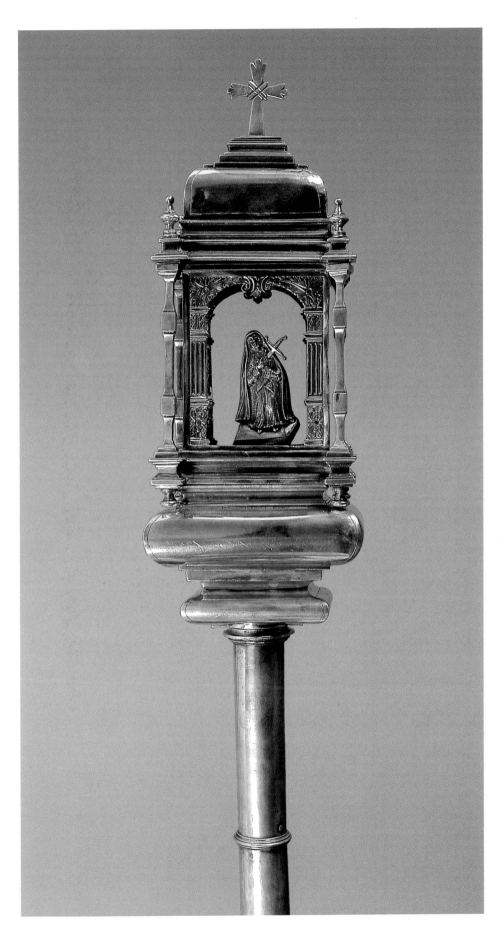

172. Processional lantern with oratory niche, 17th century. Silver, 273 x 13 x 11 cm. Private collection

CLOCKWISE FROM TOP LEFT: **173.** Vessel for holy oils, 1683. Silver, h. 37 cm; diam. 21 cm. Collection of Beatriz and Mário Pimenta Camargo, São Paulo. **174.** Vessel for holy oils, 1683. Silver, h. 37 cm; diam. 21 cm. Collection of Beatriz and Mário Pimenta Camargo, São Paulo. **175.** Vessel for holy oils, 1683. Silver, h. 37 cm, diam. 21 cm. Collection Beatriz and Mário Pimenta Camargo, São Paulo. **176.** Vessel for holy oils, 1683. Silver, h. 62 cm; diam. 34 cm. Collection of Beatriz and Mário Pimenta Camargo, São Paulo

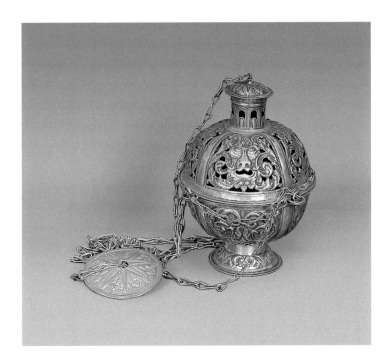

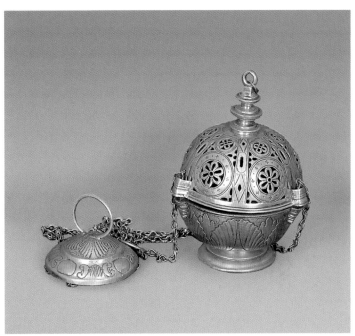

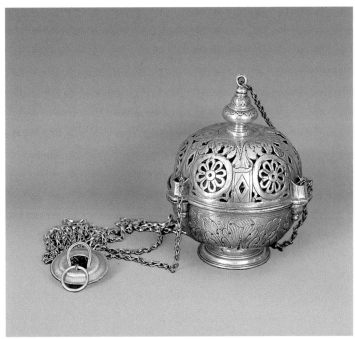

CLOCKWISE FROM TOP LEFT: **177.** Incense burner, 18th century. Silver, 19 x 16 x 16 cm. Private collection.
178. Incense burner, 17th century. Silver, 18 x 15 x 12 cm. Private collection. **179.** Incense burner, 17th century.
Silver 25 x 12 x 13 cm. Private collection

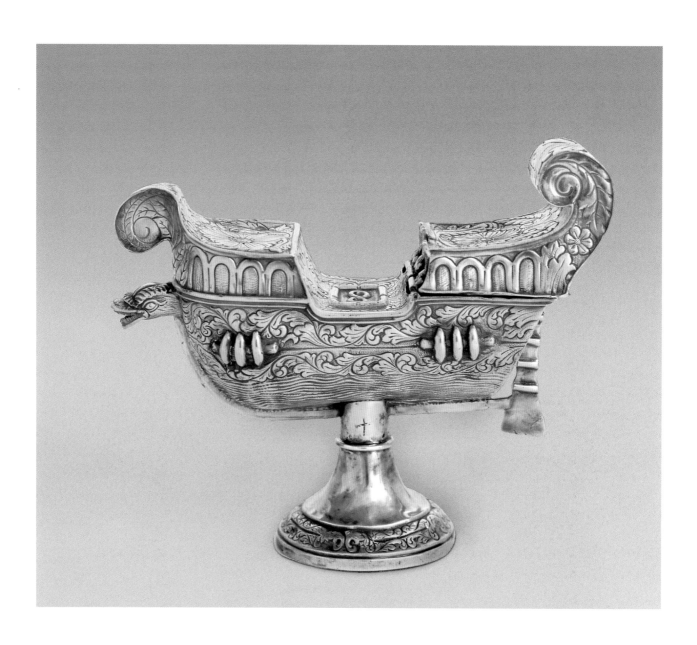

180. Incense vessel, 17th century. Silver, 18 x 23 x 8.5 cm. Private collection

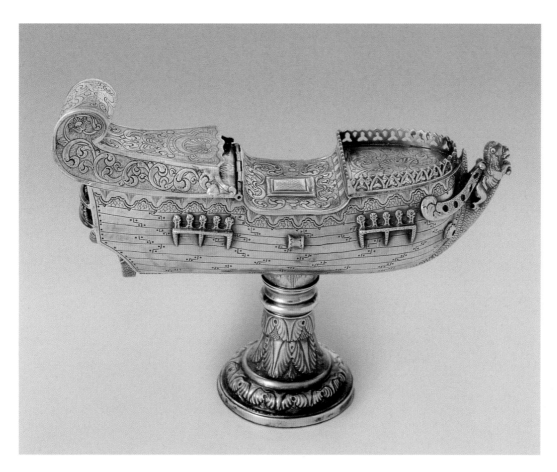

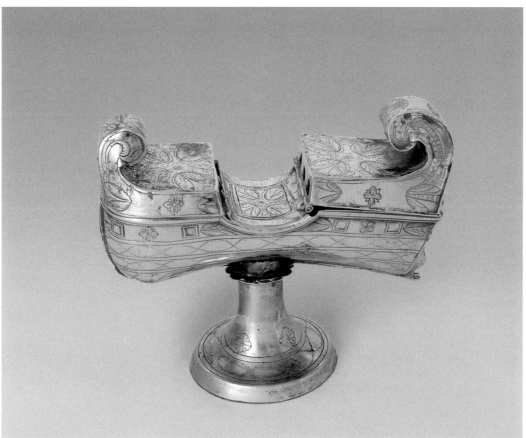

TOP: 181. Incense vessel, 17th century. Silver, 17.5 x 25 x 8 cm. Private collection. BOTTOM: 182. Incense vessel, 17th century. Silver, 15 x 18 x 5 cm. Private collection

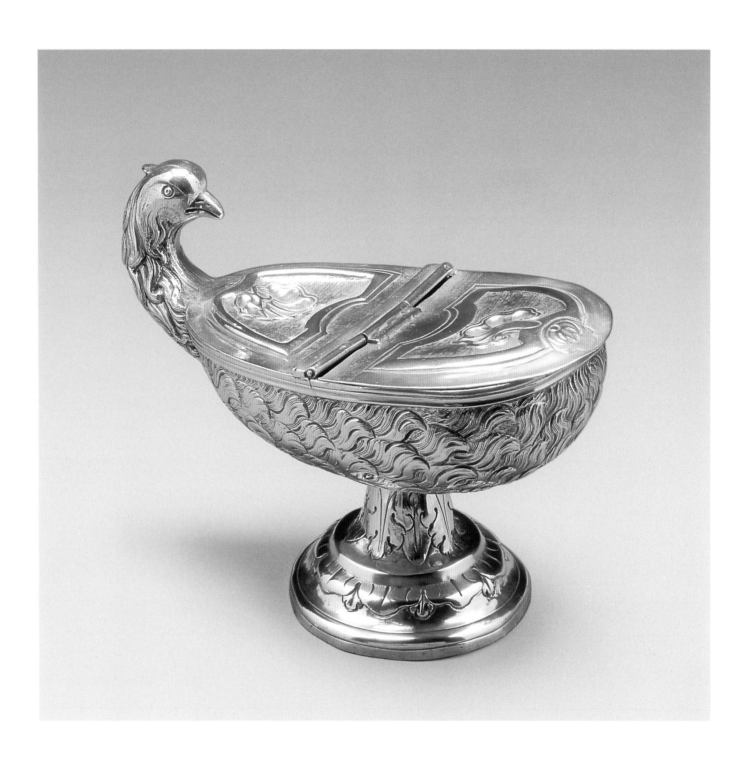

183. Incense vessel, 18th century. Silver, 15 x 21 x 11 cm. Private collection

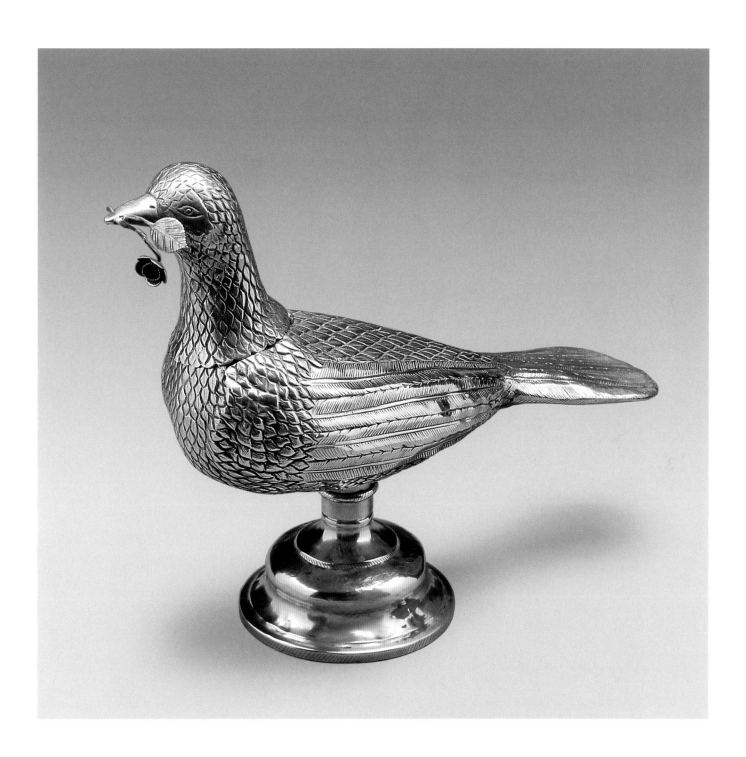

184. Incense vessel, 18th century. Silver, 22 x 17 x 10 cm. Private collection

TOP: **185.** Alms dish, 18th century. Silver, h. 15 cm; diam. 30 cm. Private collection. BOTTOM: **186.** Foot basin, 18th century.
Silver, h. 51 cm; diam. 18 cm. Private collection

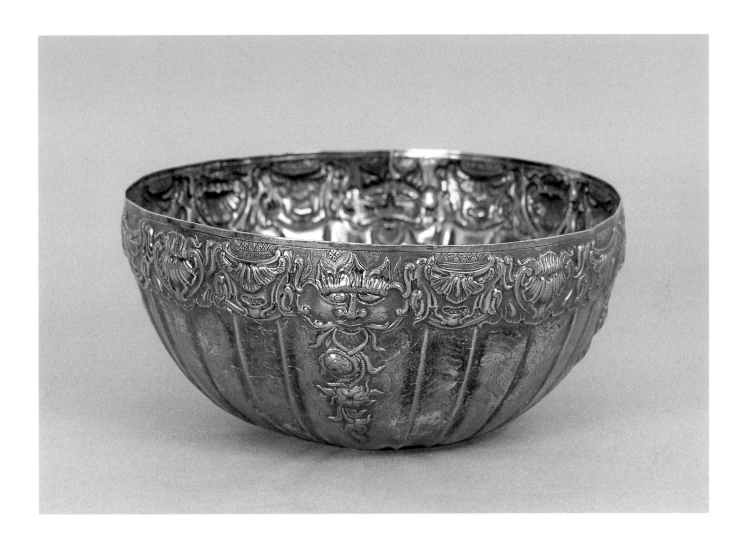

187. Vessel for manioc flour, 18th century. Silver, h. 19 cm; diam. 18 cm. Private collection

Afro-Brazi

an Culture

Exhibiting Afro-Brazilian Art

Emanoel Araújo

The subject of blacks and the arts in Brazil is not one I could say I have devoted any systematic research to in the academic sense. However, my service as director of the Museu de Arte da Bahia and, currently, as director of the Pinacoteca do Estado de São Paulo, as well as my own art work, have led me to consider what has seemed a curiosity in the world of art: the ethnic origin of Brazilian art, specifically works by black artists. Over the past fifteen years, a series of projects have brought to the public eye the results of such considerations, culminating in 2000 in the exhibition *Negro em corpo e alma*, as part of the monumental *Mostra do redescobrimento* marking the five-hundredth anniversary of the Portuguese discovery of Brazil.

The exhibition entitled *A mão afro-brasileira—Significado da contribuição artística e histórica*, organized by the Museu de Arte Moderno in São Paulo in 1988, and the publication of the catalogue by the same name,[1] commemorating the one hundredth anniversary of the abolition of slavery in Brazil, were the initial points of departure for uncovering the significance of the contribution of black artists, as well as what this participation meant in terms of our own identity. It became necessary to reveal who blacks were and who blacks are and, for a people emerging from the terrible stigma of slavery, why this affirmation had such great relevance. Extensive research work swept through archives, libraries, and publications in search of a people hidden by the dust of poorly recounted histories or by the standard "whitening" factor endemic to those who ascend socially in Brazil. Thanks to the collaboration of university researchers, such as Aracy Amaral, Anna Maria Beluzzo, and Carlos Eugênio Marcondes Moura, the materials that were collected could be systematized and the research could be broadened to include not just the visual arts but also music, literature, and finally the study of Brazil's habits and customs.

This proposal to recover, at least partially, the role of the black and the mestizo in the development of Brazilian arts and culture was encompassing and enticing and stands as the most systematic and profound work on this subject to date. The iconographic materials, historical documents, occasional references, few citations, and short essays were scattered through other historical works or in studies conducted in the social sciences, where the vast majority of the bibliography pertaining to blacks in Brazil is concentrated but is almost entirely limited to the study of slavery or to the black contribution to religious syncretism, language, and customs. Aside from this there were a few references to the black influence in music or, mostly in thematic terms, in literature. However, in the field of visual arts, and to any profound extent in music and literature, only fragments could be found.

Nevertheless, by sifting through the vast general bibliography pertaining to blacks in Brazil, by forging paths on the basis of historical documents or from the testimonies of foreign travelers who were in Brazil during the time of slavery, and by collecting indications found in the few existing articles and essays, we came to agree with Marianno Carneiro da Cunha, who believes that blacks had a definitive role in shaping Brazilian art. Cunha finds their presence "in the carving and gilded work of Baroque churches beginning in the second half of the sixteenth century" and concludes that "the infiltration of the slave in Brazilian art coincides with the real development of the arts in Brazil."[2] Based on these statements, we decided to systematically seek out indications of the cultural and artistic contributions made by blacks and their descendants since the arrival of the first slave shipments to Portuguese America.

Historical documents from the eighteenth century provided significant clues where to look. And so we searched eighteenth-century narratives of the great feasts and celebrations, such as *Triunfo Eucharistico*, describing the Triumph of the Eucharist celebration in Ouro Prêto, Minas Gerais, the *Relação das faustissimas festas*, recounting festivities that took place at the church of Santo Amaro da Purificação in Bahia, or descriptions of Brazilian commemorations of the marriage of Princess Dona Maria with the Infante Dom Pedro, which occurred in Portugal in 1764. Of particular interest were the Santo Amaro da Purificação festivities, for which the local guild of goldsmiths was responsible for a presentation of the kings of the Congo, creating figures whose apparel and extremely rich ornamentations have been described in great detail.[3] For the Bahian guild to present such a show of wealth for an African devotional celebration makes it probable that its members were, in fact, black. It is also probable that this profession was by and large practiced by blacks in Minas Gerais and Rio de Janeiro, despite the 1621 prohibition by the Portuguese Crown against blacks, Indians, mestizos, and even freed slaves working with silver. Not coincidentally, the Crown finally decided to disband all of the goldsmith guilds in Bahia and Rio de Janeiro in 1766. Despite these measures, the prohibitions only caused the profession to be practiced underground. An English traveler at the beginning of the nineteenth century thus found hidden at the Forte do Barbalho, in Salvador, countless craftsmen who were devoted to the production of holy artworks and adornments, all at the service of the fort commander.

The structure of the guild in the creation of artworks in Brazil during this time only served to evade the restrictions imposed on the development of the arts by colonial rule, and, in fact, it fostered the development of a tradition of black art during the formative period of Brazilian culture. Similar dynamics are found in the field of music, as evidenced by the research of Francisco Kurt Lange on the guilds of Minas Gerais,[4] in the cities flourishing from the gold prospecting of the period. In the eighteenth century,

musicians of the Nossa Senhora do Rosário brotherhood, who were for the most part blacks, were also called upon to play at the highly aristocratic church of Nossa Senhora do Pilar de Vila Rica, since no one else of such skill could be found among the other orders. Later on, in a similar vein, Tollenare observes that at the beginning of the nineteenth century the local aristocracy in Bahia and Pernambuco would dance the *lundu* in their elegant salons. This dance originated at the *senzala* (slave house). These were the beginnings of the miscegenation that would so profoundly characterize Brazilian culture and society.

However, such scant material would be insufficient to definitively substantiate Cunha's conclusions concerning the black presence in Brazilian art. In the past, there have been very few scholars genuinely preoccupied by this question or few who dealt with it in any systematic or profound way. Manoel Querino, an Afro-Brazilian writer, researcher, and journalist from Bahia, in some ways pioneered this field, although he limited himself to research on Bahia, preoccupied with establishing the ethnicity of the artists he studied. Despite the fact that many critics have contested his work due to its imprecision and historically uncorroborated data and allegations, it did actually preserve important names and references, which would have been lost were it not for his initiative. Prior to him, perhaps only Manoel de Araújo Porto Alegre,[5] in his work on the Rio de Janeiro school of painting, and Francisco Bretãs, in a monograph on O Aleijadinho[6] (Antônio Francisco Lisboa), may be considered to have made any major contribution in this area.

Later on, despite the important research of figures such as Hannah Levy,[7] Judite Martins,[8] Joaquim Cardoso, Luis Jardim, Rodrigo de Mello Franco, Dom Clemente Marianno da Silva-Nigra,[9] which was brought together in publications such as the *Revista do patrimônio histórico e artístico nacional*, scholarly works on art and history,

so much in vogue during the 1940s and 1950s, seem to have fallen into limbo. Worthy of mention among contemporary research is the contribution made by Cunha on a subject that has also been studied by Pierre Verger: the artistic continuity and exchange between Africa and Brazil.[10] If Africans brought to Brazil as slaves soon underwent a process of becoming Brazilian, their masters and Brazilian society as a whole also underwent a process of Africanization due to contact with the slaves. This circular influence would continue into the final period of slavery and would persist after abolition. The most recent studies on the period of slavery estimate that nearly thirty thousand blacks returned to Africa at the end of the nineteenth century. Many of these had been freed, but were deported either for being unproductive or as punishment for mutinous acts. Returning to Africa, these former slaves—bringing back the knowledge and creative skills they had developed in Brazil—excelled as architects, builders, sculptors, painters, and performers. This was the first cultural contingent lost by Brazil, which nevertheless retransplanted significant aspects of Brazil's incipient culture in Nigeria and Dahomey. The first Brazilian community to be reconstructed outside its national boundaries was in fact black, and its contribution was fundamentally cultural in nature.

Another extremely important contribution by a contemporary author, because of its perceptual acuity and its constant preoccupation with demystifying Brazilian art and the role that African heritage played in its development, is the work of Clarival do Prado Valladares.[11] We are particularly indebted to his detailed analysis of the Coleção Preserverança in Alagoas and to the materials at the Instituto Histórico in Alagoas and its counterpart in Bahia, which bring together sacred objects seized by the police in their extensive and thorough efforts to repress *candomblé*, Afro-Brazilian religion, in northeastern Brazil and Bahia. Among these are works carved

from wood based on prototypes from areas in Africa that had supplied slaves for Brazil, works which are still found today among the objects of religious groups on the African continent. Due to the profanation of sacred spaces, the seizure of appurtenances, religious objects, and sacred sculptures, little remains of the autonomous artistic works of these Afro-Brazilians. Prohibited from the moment of their arrival from free artistic expression in their own sacred objects and sculptures, as Valladares observes, Africans in Brazil channeled much of their creativity into officially sanctioned religious works, where its presence can be clearly seen. As in the case of the smith guilds and musicians, underground work was once again responsible for preserving artistic objects of a genuinely African nature among the slaves of Brazil. Only the violence and enforced repression by the authorities could put a stop to this artistic production.

Nevertheless, it should be pointed out that Valladares's extraordinary work would not have been possible without the previous contribution of Nina Rodrigues. In an article published 1904,[12] this pioneer in anthropological research on blacks in Brazil was the first to treat the work created by the descendants of African slaves *as art*. Despite the racist bias of the evolutionary concepts guiding her analysis, Rodrigues recognized the artistic value of the liturgical objects produced by Afro-Brazilian cults. While commenting on the strange proportions in Vitorino dos Anjos's carved woodwork on the main altar of the parish church of Campinas, she was obliged to recognize, perhaps contrary to her own convictions, that this black artist's work was oriented by some other, non-European aesthetic sense of reason, despite the fact that the artwork was executed within the most rigorous European canons.

Finally, we should take into account the reflections of the great Mário de Andrade, which are among the essential sources for the recognition of the black

contribution to the development of the arts in Brazil. It is our understanding that he was the first to draft a true apology on the role of mixed-race peoples in the arts, while at the same time taking into account the ambiguities and perhaps even the stigma suffered by the mestizo artist. He sensitively analyzed the work of mixed races in Brazil, observing:

> The most important proof that there was a collective racial impulse in Brazil can be found in the situation of the mulatto. Colonial Brazil, due solely to its economic circumstances, and with the most minimal political intervention on the part of Portugal, would take two centuries before it began to enrich itself with any artistic creations. . . . Caldos Barbosa and Mestre Valentim are mulattos. Leandro Joaquim, who was from the same period and one of the greatest painters in Rio de Janeiro, was also mestizo. Father José Mauricio Nunes Garcia (1767–1830), also mulatto, was the most noteworthy of our colonial musicians. It is curious to observe that all of these mixed-race people appear to have excelled in the visual arts and in music. This demonstrates that there is a strong black element in these fields.[13]

The *A mão afro-brasileira* exhibition brought together a wide range of documents and iconography and allowed us to more thoroughly analyze data and corroborate what was merely stated in passing or barely insinuated with regard to black, brown, and mixed-race artists. We can finally know exactly who they were. Some of these artists, such as O Aleijadinho, Mestre Valentim, and Francisco das Chagas, referred to as Chagas or O Cabra, were well known, while others only came to light after a long period of research. Among these we should mention the great painter from the Rio de Janeiro school, Manoel da Cunha, son of a slave, and born a slave

himself in Rio de Janeiro in 1737. After he bought his freedom from his masters, he produced the painting on the retables at the church of the Ordem Terceira de São Francisco de Paulá, as well as many other portraits of the trustees of the Santa Casa de Misericordia in Rio de Janeiro. We can also cite Leandro Joaquim, whose magnificent works can be seen at the Museu Nacional de Belas Artes and the Museu Histórico in Rio de Janeiro. We should also mention Father Jesuino do Monte Carmelo. The principal artist during the colonial period in São Paulo, a mulatto painter, musician, and architect, Monte Carmelo was commissioned to paint the ceilings at the Carmelite churches in Iru and São Paulo, which are so movingly described by Andrade.[14]

Also worthy of note are José Theophilo de Jesus, a mixed-race freed slave, according to his birth certificate, who went to study in Portugal at the expense of Mestre José Joaquim da Rocha. Along with many other of Rocha's disciples such as Verissimo de Freitas, Franco Velasco, and the Afro-Brazilian sculptor Domingo Pereira Baião, Jesus was part of a contingent known as the black artists of Bahia. Similarly, we have been able to confirm the presence of black painters in the Rio de Janeiro school and in the Bahia school, as well as among the Rococo painters in Minas Gerais. Given the prior lack of documentation, it was not previously possible to corroborate the presence of black artists in São Paulo. However, evidence emerged through Andrade's accounts attesting that both Patrocinio da Silva Manso, a resident of Minas Gerais, and his disciple Monte Carmelo, were mulatto.[15] Finally, Eugênio Leal's work concerning Alagoas, points to evidence of black artists in the Northeast, as well as many other painters in Pernambuco.

The research that resulted from tracing the existence of blacks and mixed-race peoples in the arts in Brazil has corroborated a significant presence in nearly all the country's regions. In attempting to establish the historic and artistic contribution of these people, *A mão afro-brasileira* reviewed Afro-Brazilian artists beginning in the eighteenth century, mainly from 1700 through 1815 (the time of O Aleijadinho and Mestre Valentim's deaths), although some of the artists working during this period survived into the middle part of the nineteenth century. The project then went on to consider the nineteenth century proper, with artists from the Escola Imperial de Belas Artes, ending in the twentieth century with the so-called academics. Finally, we arrived at contemporary art, covering a wide range of trends, as well as the popular arts. In this regard, our project represents the broadest study possible of Afro-Brazilian visual arts, including forays into both highbrow and popular music, literature, jewelry, and finally, the sacred cuisine of the Afro-Brazilian cults. Even in its incompletion, *A mão afro-brasileira* had the merits of serving as a bibliography and provided a near exhaustive list of the most important blacks in the world of the arts.

The wide scope of this first project ended up forming something of a huge matrix, from which subsequent projects were later developed as the various facets of this world began to fall into place. Once these projects began to produce a visible inflection at the staid Pinacoteca do Estado, the museum was obliged to alter its outlook. Subsequent exhibitions were labeled by one critic "the saga of Afro-signs at the Pinacoteca."[16] This expression was coined after submitting the proposal for a second large project, which we developed between late 1992 and early 1993 and which opened in November during Mês da Consciencia Negra (Black awareness month). It involved the presentation of a group of exhibitions under the title *Vozes da diaspora*.

This ambitious project included five different exhibitions, each exploring in its own distinct way the great reserve of Afro-Brazilian cultural heritage that we had been able to trace and organize with some

sense of clarity. The first exhibition, *Os pintores do século XIX*, brought together some of the most important figures of the nineteenth century.[17] The second, having a contemporary focus, was devoted to and entitled *Altares emblemáticas de Rubem Valentim*.[18] The third, *Brasil Africa Brasil. Pierre Verger 90 anos*, organized as an homage to Verger on his ninetieth birthday, showed the exodus from both sides of the Atlantic through his extraordinary photographs.[19] The fourth exhibition, *Arte ritual do candomblé*, centered around an installation by Regina Vater. The fifth and final exhibition, *O Inconsciente Revelado*, was organized around the works of an extraordinary popular artist, Agnaldo Manoel dos Santos,[20] whose works explores the continuity of African ancestry in the art of its Afro-Brazilian descendants.

The meshing of such different perspectives in order to appreciate the black presence in Brazilian arts may require explanation. What became extremely evident from the *A mão afro-brasileira* project was the distance separating the Baroque (and Rococo) period of art in Brazil—a period extending from the eighteenth century to the beginning of the nineteenth century—from what was subsequently produced, as if by some fundamental rupture. The Baroque period was essentially marked by the collective nature of its artwork, which was organized around the religious societies and brotherhoods. It was also distinguished by the considerable presence of black or mulatto craftsmen, artisans, and artists, a phenomenon owing to the aristocratic pretensions of a slave-owning society, in which manual work was looked upon as a sign of social inferiority. This point is of such significance that Francisco Lange, a scholar of colonial erudite music in Minas Gerais, affirms that the collective nature of artistic production was, in general, the reason for a predominance of blacks in the arts. In fact, according to Lange, "brotherhoods comprised of people of color were a great hotbed for artistic stimulus to the

degree that these people soon began to establish an influence due to the resolute and courageous nature of their lives. This was achieved without the discredit of the white population, from whom they gained a level of admiration, mainly in the fields of erudite music, sculpture, architecture and painting."[21]

There was nothing to hinder freed blacks, mulattos, or even slaves from working as assistants or apprentices, and they were able to do so practically without competition in the arts. This situation rapidly began to disintegrate after the beginning of the nineteenth century, with the arrival of João VI and the end of the colonial period in Brazil. From an artistic and socio-historical viewpoint, one of the first consequences of the establishment of the royal family in Rio de Janeiro was the arrival of the Franciscans in 1812. Since artists formed a considerable part of this group, the Academia de Belas Artes was established at the seat of the viceroyalty in 1816. Once it was organized as a school, the Academia initiated an essentially different kind of instruction from the earlier model of collective apprenticeships in which apprentices could, in time, go on to become assistant artisans and eventually master artisans, according to each one's technical and creative development. With the establishment of a standardized form of artistic instruction, the Academia also created selective criteria for access to this instruction, which would be restricted to a qualified elite. Previously, instruction had been reserved for the apprentices and was open to and dominated by black and mestizo artists. In the Academia, however, criteria began to be defined in which individuality, authorship, and singular talent became the new basis for recognizing value in a work of art, thereby replacing the former collective structure of the guild.

The Academia did not initially exclude black or mestizo artists. In fact, during its early years these artists were the natural stock of talent it had to rely upon. Among the noteworthy artists educated

there during this period were the sculptor Charles Pinheiro, a mulatto, and a constellation of black artists including Estevão Silva, Antonio Rafael Pinto Bandeira, Antonio Firmino Monetiro, and Artur da Costa and his brother, João Timotheo da Costa. Along with Emmanuel Zamor, a Salvadoran painter raised by adoptive French parents in Paris, these artists made up the *Os pintores negros do século XIX* section of the Pinacoteca's *Vozes da diáspora* exhibition.

What distinguishes these painters of the early Academic period, aside from small differences in their careers, is the utter failure of their work to escape the sense of tragedy that enveloped their lives. When artwork ceased to be collective in nature, the individual artist was obliged to live from his or her own artistic production. Despite each of these artists' momentary success, the slave-owning society of the nineteenth century would not or could not recognize the real value of their work. Under the weight of inescapable preconceptions and discrimination, their careers suffered enormously. Given their overall conditions of impoverishment, and the rise after the end of the Empire of a general indifference to the arts, black artists in Brazil almost disappeared from the official art world during this period. The twentieth century begins with the sole figures of José Benedito Tobias and Benedito José de Andrade, between the 1920s and 1940s. Noteworthy in the subsequent Modernist period are Otávio Araújo, whose training in the 1950s is the result of an "artistic family of São Paulo," in the words of Mário de Andrade, and, in Bahia, the looming figure of Rubem Valentim. After the disappearance of significant black artists from official art in Brazil between the end of the nineteenth century and the beginning of the twentieth century, the majority of Afro-Brazilian artists began to focus their activities in the field of popular art.

Given the context of *Vozes da diáspora*, it is understandable that the other exhibitions centered around established contemporary artists such as Valentim, popular artists such as Agnaldo Manuel dos Santos, or the extraordinary and passionate photographer, ethnologist, and historian Pierre Verger, whose own circumstances led him to become an initiate and devotee of Afro-Brazilian cults. Verger's work, perhaps more than anyone else's, contributed to unveiling the dual nature of the exchanges between Africa and Brazil as connecting links between peoples with the same history on two different sides of the Atlantic. It was therefore appropriate that Verger's photographs establish a dialogue with *Temple of Oxalá*, the installation of contemporary artist Regina Vater, an homage to the primordial formal origins of the god Fun Fun, creator of the world and of humankind.

After the large and multifaceted *Vozes da diáspora*, another exhibition in 1993 in Frankfurt, *Arte e religiosidade afro-brasileira*, along with the publication of a book by the same name,[22] explored the continuities, reinventions, adaptations, and retranslations that occurred between Africa and Brazil, with religion and art as the focus: *candomblé* and Catholicism, fine art and popular art. From either point, how do we arrive at interpretation of such intermingled histories? With regard to African sculpture, George Nelson Preston states:

> Whoever is familiar with African art understands that it is essentially based on a reductionist aesthetic, in which shapes, lines and masses become abstracted and reduced, in order to produce forms that are simpler than those that we observe in reality. On an intellectual level, African sculpture was created to be viewed as an invocation of certain ideals, and not as an imitation of reality. This explains why the use of striking structural or anatomical details or the reduction of everything to essential forms are dominant elements in African art.[23]

Such principles enable us to understand the erudite expression of contemporary artists like Rubem Valentim and Ronaldo Rego, as well as the popular expression of Agnaldo Manoel dos Santos and Mestre Biquiba Guarany. Likewise, they shed light on the structural meaning of devotional works like the ex-votos of northeastern Brazil, the saints carved from pine burl by slaves in eighteenth century Vale do Paraíba, or the cult sculptures and objects produced by Mestre Didi in Bahia. The intransigence of the African aesthetic can be observed with uninterrupted continuity in similar artistic examples, whether in expressions of popular, erudite, sacred, or profane art. If Agnaldo's work repeats the Afro-Catholic convergences of ex-voto sculptures—the shape of the nose, bas-relief of eyes, and ideographic fixing of details—the works of Mestre Didi are linked to African religion by the cult practices of *candomblé* and the persistence of iconography for strictly liturgical purposes. Mestre Didi's visual expression also makes use of certain Afro-Brazilian symbolic forms—the *ibiri*, or sacred club, of Omolu, the *opaxorô* of Oxalá, the pestle of Xangô—reworked in a wide range of materials such as plastic, shells, straw, wood, and terra-cotta, whose graphic elements translate the myths of the pantheon of African *orixás*, or illustrious ancestors. It is important as well to mention Mestre Didi's own religious authority in the cult of African ancestral worship. His ritual links formed the basis for his works in sculpture, allowing him to use diverse voices to express himself in his art: as a writer who narrates stories and myths of origin, as a priest, as a visual artist. This sense of *ancestry* creates a dialogue between transfigured reality and Mestre Didi's own origins.

The work of Rego is revelatory in this same regard. From the sacred silence of Jacarepaguá, Rio de Janeiro, his place of residence and a magical center for religious practice, Rego's sculptures of forged steel or boxes of painted wood attempt a profound understanding of the links between nature and religion, the creative enigma of signs and symbols. Translating the symbiosis between the Afro-Brazilian religions *candomblé* and *umbanda*, Rego's work reveals the image of religious transformation practiced in the great urban centers of Brazil. The richness of these images can be seen in the graphic use of *candomblé* ideograms and in the construction of his oracle boxes.

In 1994, another large exhibition was organized. Initially in São Paulo and then, at the request of the ministry of culture, travelling to Brasília in November 1995, *Os herdeiros da noite—Fragmentos do imaginário negro*[24] served to commemorate the death, three hundred years earlier, of Zurchi dos Palmares, one of the most important Quilombola slave-group leaders. With this project we attempted to provide a survey of the African diaspora in the New World not only by approaching the various trends in Afro-Brazilian art but also by establishing a direct dialogue with African matrixes, as well as with other African-American artists in the United States and the Caribbean basin. The exhibition sought to arrive at an aesthetic formed from conventions other than those of the Western artistic tradition. Indeed, we sought an aesthetic organized from the viewpoint of ancestry, that link in the collective unconscious through which the black artist is able to transform him or herself into the great receiver and executor of traditions stemming, through the diaspora, from Paleo-African art. This exhibition was founded primarily on "theories of nonconstruction, reduction, frontality, and repetition of primary forms" codified by Preston:

tension between virtual and real axes;
tension between virtual and real symmetry;
rhythmic cadences, accumulations in a primary geometric form or confirmation of volume, plane, negative spatial area, in closed or open forms;

regularity of generic rhythm interrupted by adherent motifs, arranged fortuitously, formal surprises or inversions similar to a fugue of basic framing units;

nonconformity between painted areas and plane surfaces;

visual games in which reduced forms become ambivalent and can be read as the alternative representation of something, synonymous or antithetical;

pars pro toto motif employed in an obvious way so as to represent something in its totality;

mixed technique combinations which to a Westerner appear as textures, modeling, colors, objects or ideas correlated in an irrational form[25]

Such parameters opened our exhibition to synthesizing the aesthetic production of artists both popular and erudite, known and anonymous, and revealing a sense of continuity in African art that extends beyond the boundaries of that region. Preston's theory of Paleo-African art provides a challenge to conventional Eurocentric art history and lends new definition to the cross-cultural comparison of visual works from the Caribbean and Africa, as well to the parallels between this art and the art of Brazil. A common aura touches them all.

The purpose of *Os herdeiros do norte* was not to explain or disclose a pure and untouched black culture. We first wanted to construct a point of reference for accessing the stock of images that show clear influences of African origin, whether in popular or erudite music, painting, and sculpture, even among the most contemporary of representations. We therefore attempted to find the connecting links between such apparently diverse conventions as Paleo-African art and more recent popular or intuitive art—links, for example, between the instruments used for the *orixá* cults; the *balangadâs*, or women's jewelry, made by anonymous silversmiths in nineteenth century Bahia; the *cazumba*

masks from Bumba-meu-boi, Maranhão; and the masks used by the horsemen of Pirenópolis. Such links also could be seen to extend to the ex-votos, or *milagres* (miracles), as affirmed by Luis Saia: "Although from a cultural point of view the *milagre* might be included as part of the Catholic tradition, in no way can it be classified as religious art, much less Catholic art. Studies conducted in this regard allow us to conclude that from a functional point of view this is magical sculpture, and an authentically mestizo art phenomenon that originally derives from African technical traditions."[26]

The same argument allows us to understand the importance of the small images of saints carved from pine burl, which we can at least say represent some form of syncretism in art or in religion, given that they seamlessly fuse extraneous elements that coexist sui generis from distinct conventions of logic. It is not only their characteristics as magical objects, as actual amulets, that reveal their African meaning. Their form and representational techniques originate from the metonymy of *pars pro toto*, the application of schematic and geometric reductionism, or the emphasis on certain relevant structural details. Thus, Francisco de Castro Ramos Neto, correctly observes that these figures pertain to

an art rooted in the concrete reality of the visible world (as opposed to an imagined reality). Nevertheless, it does not represent this world on the basis of visual impression, but on the basis of conceptualization. This aspect was decisive for Picasso, in that he came to formulate his work on the conceptualism of African art, thereby revealing what he rightly understood was the major failure in Western art. . . . If anything survives from the art of the Africans in their Brazilian descendents, and as I understand it does, it was transformed into another artistic language with its own specific attributes,

the tributary of a new form of faith. The expressive force remains the same, as is attested by the excellent work that survives from anonymous artists, who were imbued with true poetic intuition in this new homeland, without any models or teachers.[27]

This is precisely the case with artists such as Rubem Valentim and Agnaldo Manuel dos Santos. Valentim's works represent a specific type of ancestral processing that is characteristic of artists who maintain a profound bond, either consciously or unconsciously, with their origins. The artist defined his work in painting and sculpture as a search for *"riscadura brasileira,"* or "Brazilian graphics," based on ritual ideograms, an art deeply anchored in national, Afro-Brazilian roots, but articulated in an internationally intelligible syntax. Thus, Valentim's works, which are clearly associated with the Constructivist tendency in Brazilian art, employ geometric abstraction as a system of expression. This abstraction, however, is based on transmuted archetypal signs drawn from Afro-Bahian culture, in particular the tools, altar structures, and god symbols of the *orixá* cults: the bow of Oxossi, the double-headed hatchet of Xangô, the round fans of Xum, the emblem of Ossaim, the iron tools of Exu. These symbols, formed anonymously as products of the silent figurative work of the collective unconscious, originally had a geometric form. But transposed into works of fine art, as Olivio Tavares de Araújo notes,[28] "they have been adapted, reorganized, interconnected, constructing a new discourse whose vocabulary is derived from another, previously existing one." A miscegenated representation of African inheritance, Valentim's abstract geometric language recreates symbols that are found already in the day-to-day life of the sacred *candomblé* communities of Bahia.

Agnaldo's orientation is somewhat different from Valentim's. Along with Mestre Biquiba Guarany, Agnaldo is one of the most important exponents of black popular art. Agnaldo learned his profession from Mestre Guarany—the creator of the admirable *carrancas* (mastheads) that adorned the boats of the São Francisco river for so many years—and from Mário Cravo Júnior, who discovered an artist hidden in his timid and delicate assistant.[29] However, the power of ancestry in Agnaldo's art is owed first and foremost to the artist's own talent and immense creativity. He might have had some contact with African art but not to the point where it would have influenced him in any significant way. He simply never studied it. Nevertheless, he appropriated, or created in his own way, a characteristically African form of representation, to the degree that his sculptures seem to be close approximations of similar examples found on that continent. In the simplification of eye or mouth, the formation of the nose, and the scarifications, as well as in certain symbolic representations that involve myths of the Yoruba gods, Agnaldo's sculptures follow the most traditional conventions of Paleo-African art, employed "not in an intentional, but an organic form," which makes Agnaldo "the most Brazilian of the genuinely Afro-Brazilian artists."[30] Rooted in ancestry, his work reflects an integration of the conventions of African art.

Through artistic processes such as Valentim's and Agnaldo's, the immaterial and transitive symbols of culture are often made to *resignify* or to signify differently. In 1997, another exhibition, *Arte e religiosidade no Brasil—Heranças africanas,*[31] once again gave us the opportunity to reflect upon the artistic melding of the sacred and the profane. As an experiment, we were able to reexamine the works of Valentim, Mestre Didi, and Agnaldo, as well as the pine burl saint carvings and wooden ex-votos from the Northeast, the sculptures of Ronaldo Rego, the artifacts of the *candomblé peji* sanctuaries, liturgical objects, arms and instruments of the *orixás* made by the ironsmiths of Bahia, the black Catholic saints, the Yoruba divinities, and some of the

works by our finest photographers. This heterogeneous group seemed to sing entirely in unison, revealing a single and powerful heritage.

It was after this long course of events that we came to organize the exhibit *Negro de corpo e alma*,[32] within the framework of the monumental *Mostra do redescobrimento*. The project had been evolving since 1995, again with the collaboration of university researchers and faculty from the department of anthropology at the Universidade de São Paulo such as Maria Lúcia Montes and Luciana Bittencourt, and subsequently with the participation of researchers such as Carlos Eugênio Marcondes de Moura, who had worked with us on previous projects. The objective of this project was to plunge into the depths of the question of black identity and the discussion of race relations in Brazil. In this way, we sought to define the framework that has determined the social relationships between blacks and whites over the course of history. *Negro de corpo e alma*, whose title translates as "black in body and soul," functioned as a metaphor for considering one of the most difficult themes in Brazilian culture, involving passions, hatreds, realities, and fantasies, all infused with the overwhelming element of power, as well as fervently defended political positions. Without proposing to raise any ideological banner, considering the emotions it would have inevitably stirred up, the exhibit sought to systematically reflect upon the way in which black people have been absorbed into Brazilian society over the course of five centuries of living together with whites. A relational framework was established in order to get to the very core of our national identity.

Therefore, what we attempted to consider in this exhibit was the way in which the representation of white and black cohabitation was formulated. This allowed us to extract an outline for identifying exactly what it meant to be black in body and soul. Our proposal was to work with the forms of representation of blacks in

Brazil. With this exhibition, we primarily sought to deconstruct the images that—first in the eyes of foreigners, then within our own society—acted to create powerful stereotypes that have formed the basis for preconceived discourse that to this day characterizes the identification of blacks in our country. The exhibition grew out of observations of these images in various visual mediums—sculpture, painting, prints, design, and photography—as well as a wide range of literary and documentary forms, which over the course of five centuries have shaped the modes of representation for race relations in Brazil.

This exhibition developed along three thematic approaches: "seeing the body," "seeing oneself," and "feeling one's soul." The first approach explored the construction of black identity through the eyes of foreigners, who perceived blacks as body-objects, slaves onto whom the European imagination could project its own fantasies of sensuality and horror, repeating with the African the same vision it had of the indigenous groups in the New World: that of being situated between the Paradise and the Inferno of the tropics. The second thematic approach sought to uncover the internalization of this perception by blacks themselves in their search for identity; this negative image of inferiority eventually became incorporated as an instrument of resistance against the white oppressor. Finally, with the last approach, the exhibition explored the presence of cultural legacy and African ancestry in the works of black artists, which was timid and inarticulate within the framework of the Academia but later courageously applied and visibly reflected in the works of those who were able to rediscover their own souls through their artwork. In the long run, the enigma of national identity remains. This enigma is divided between the preconceptions of the eye as it considers the body, which translates into the conditions of social exclusion under which blacks continue to live in Brazil, and the fascination with the

incorporations of the soul, which little by little has impregnated Brazilian culture, transforming traditions and customs of African origin into symbols of national identity: the popular dish *feijoada*, the samba, Carnival. It is our hope that our reflections on art may have helped to provide some answers to the painful but essential questions of this subject.

After the long search for the place and significance of the black contribution to the arts in Brazil, we must state that *Negro de corpo e alma* also had to be an expression of profound sentiment and an affirmation of commitment. The exhibition was conceived primarily as a love song to black peoples: blacks from Africa, blacks from the Caribbean and North America, blacks from Central and South America, blacks from Europe and Oceania. But above all, we sang to the black people of Brazil, to whom we dedicated this moment when we celebrated the five-hundredth anniversary of our culture. *Negro de corpo e alma* commemorated black people who worked in all artistic mediums and forms of representation and how they incorporated all of them while still bearing the stigmas created by a threatened hegemony.

No people has been treated with such great hostility on the basis of such banal and horrible preconceptions. No people has suffered so much rejection in the history of world civilizations. No people has ever been so objectified, hated and disdained, as if without soul and feelings. History has also shown that no other people has been so simultaneously a symbol of good and bad as blacks have been. No other people has been able to unite the forces of nature in such a glorious liturgy of warrior gods and goddesses, of pure love, kindness, and joy. This people, enslaved and taken to the New World, perplexed in the face of such a hostile world, lacerated body and soul, resisted such hostility. It created great art that changed the aesthetic established by old dogmas, inaugurating new conventions in Western art. It created a great society in the four corners of the world, united by a common and profound sense of diaspora—a society that, like a trickle of water, slowly and silently infiltrated the cultures of other lands, expanding language and music, as well as the sense of joy and torment, passion and longing.

Blacks absorbed and were absorbed by the world's appalling treatment, and no other group has fought so fiercely for human dignity, here, there, anywhere. This people accepted syncretism as a form of permanence, as resistance to a culture of resignation and erudition. It was Baroque, Neoclassical, and Modern. It was apprentice, disciple, and master. Master of life learned and savored every day, every hour, every minute. It represented and was represented as one of the Four Continents, affirming its presence in a world of other conquerors. It completely submitted to the representation as Black Mother, like a pelican who feeds her own meat to her offspring and the offspring of others with a sense of religious abnegation. It accepted the burden of incarnating Evil, represented as the people of the children of Cain, who carry with them all of the world's guilt as a gesture of humility before an imposed God, who impassively looks on at the sins of humanity. It was also contrite in its representation among the black brotherhoods of Nossa Senhora do Rosario, in its Christian devotion to all of the black saints, brothers by blood and in suffering, Saint Efigénia and her father, Saint Elesbão, as well as Saint Benedito and Saint Antônio do Cartagero.

As a warrior, this people bravely resisted at Palmares under the rule of Zumbi, who is now a national hero. It boldly fought at Guarapes, during the expulsion of the Dutch. There, another hero, Henrique Dias, received the Order of Christ from Pedro II, as payment for Portugal's debt to him and in recognition for his selfless devotion to the Crown. Even if mistreatment resurfaced in the Malês uprising, it helped build for Brazil its much dreamed of independence at the

battles of Bahia, although the Indian is eulogized as the symbol of national identity. In the war with Paraguay, it once again served as a courageous force to fan the flames of national pride.

This people sought out its own space to represent its body and its soul, heedless of whether this body and this soul would incorporate other colors, or, if they would be of one sole color, black, red, white, mulatto, or *cafuzo,* African or American. It accepted all emotional hardships but incorporated into its emotions the force of seduction and sensuality, demolishing the boundaries between races to create, through miscegenation, one single race. Its body and soul were incorporated into Brazilian society through its ability to feel the soul and affirm the splendor of the body in its many languages of representation. Body and soul submitted to the scrutiny of a perverse view of scientific evolution or exalted in the sensibility of Brazilian arts and literature, in the hands of Lasar Segall and Aldo Bonadei, in the words of Jorge de Lima, Oswaldo de Camargo, and Elisa Lucinda. This people invented great joy in music and dance—the *maracarus, afoxes,* samba, and Carnival, as well as in the sacred liturgy of the communal *terreiro* spaces—a black-white joy that carries with it all the suffering of a world incapable of understanding difference while having created difference between white and black, yellow, and red. One day, this world will have to recognize that black is not only a color but a value. Here is where the great conquest of the black body and soul resides: in the value of color.

Translated from the Portuguese by David Auerbach.

Notes

1. Emanoel Araújo et al., *A mão afro-brasileira—Significado da contribuição artística e histórica* (São Paulo: Tenenge, 1988).
2. Marianno Carneiro da Cunha, "Arte afro-brasileira," in Walter Zanini, ed., *Historia geral da arte do Brasil* (São Paulo: Instituto Morella Salles, 1983).
3. Francisco Calmon, *Relação das faustissimas festas* (Rio de Janeiro: Funarte/Instituto Nacional do Folclore, 1992).
4. Francisco Kurt Lange, "A organização musical durante o período colonial brasileiro Separata," in *Actas do V Colóquio internacional de estímulos lusa-brasileiros,* vol. 4 (Coimbra: Universidade de Coimbra, 1966).
5. Manuel de Araújo Porto Alegre, "Memória sobre a antiga escola fluminense de pintura" (1841), *Revista do Instituo Histórico e Geográfico Brasileiro* (1984).
6. Francisco Bretas's monograph is reprinted in Rodrigo José Ferreira Bretas and Myriam Ribeiro de Oliveira, *Passos da Paixão* (Rio de Janeiro: Ed. Alumbramento, 1984).
7. Hannah Levy, "A pintura colonial do Rio de Janeiro," *Revista do SPHAN* 6 (1942), pp. 7–78.
8. Judite Martins, bibliographical references to Antônio Francisco Lisboa, *Revista de SPHAN* 3 (1939), pp. 179–205.
9. Dom Clemente Marianno da Silva-Nigra, "Artistas colônias mineiros," *Revista de história* 2, no. 6 (1951), pp. 411–19.
10. Pierre Verger, "Influências África-Brasil e Brasil-África," in *Brasil África Brasil. Pierre Verger 90 anos* (São Paulo: Ed. Pinacoteca do Estado, 1992).
11. Clarival do Prado Valladares, "A iconografia africana no Brasil," *Revista brasileira de cultura* 1, no. 1 (Sept. 1969): pp. 37–48.
12. Nina Rodriguez, "As belas artes dos colonos pretos do Brasil," *Kosmos* (1904).
13. Mário de Andrade, "O Aleijadinho," in *Plásticas aspectos das artes plásneas no Brasil* (São Paulo: Livr. Marons Fontes Ed., 1965).
14. Mário de Andrade, *Padre Jesuino do Monte Carmelo* (São Paulo: Livr. Marons Fontes Ed., 1963).
15. Ibid.
16. "A saga dos afro-signos na Pinacoteca," *Jornal das exposições,* no. 4 (November 1992).
17. Emanoel Araújo, "Vozes da diáspora," in *Pintores negros do século XIX* (São Paulo: Ed. Pinacoteca do Estado, 1993).
18. Olivio Tavares de Araújo, "Penetrar no amor e na magia," in *Altares emblemáticos de Rubem Valenum* (São Paulo: Ed. Pinacoteca do Estado, 1993).
19. Verger, "Influências África-Brasil e Brasil-África."
20. Clarival do Prado Valladares, "Agnaldo Manoel dos Santos: Origem e revelação de um escultor primitivo," *Revista Afro-Asta* 14 (Dec. 1993: pp. 22–39.
21. Lange, "Organização musical."
22. Emanoel Araújo et al., *Arte e religiosidade afro-brasileira* (Frankfurt: Câmara Brasileira do Livro, 1993).
23. George Nelson Preston and Emanoel Araújo, *Afrominimalismo brasileiro* (São Paulo: MASP, 1987).
24. Emanoel Araújo et al., *Os herdeiros da noite—Fragmentos do imaginário negro* (São Paulo: Ed. Pinacoteca do Estado, 1994).
25. Preston, *Afrominimalismo brasileiro.*

26. Luis Saia, *Escultura popular brasileira* (São Paulo: Gaveta, 1994).

27. Francisco de Castro Ramos Neto, "Nó-de-pinho, imaginária estólica afro-brasileira em São Paulo," in Araújo et al., *Os herdeiros da noite—Fragmentos do imaginário negro.*

28. Olivio Tavares de Araújo, "A vertente erudita," in Araújo et al., *Os herdeiros da noite—Fragmentos do imaginário negro.*

29. Valladares, "Agnaldo Manoel dos Santos."

30. Neto, "Nó-de-pinho, imaginária estólica afro-brasileira em São Paulo."

31. Emanoel Araújo et al., *Arte e religiosidade no Brasil—Heranças africanas* (São Paulo: Pinacoteca do Estado, 1997).

32. Emanoel Araújo et al., *Negro de corpo e alma. Mostra do redescobrimento* (São Paulo: Associação Brasil 500 Anos Artes Visuais/Fundação Bienal de São Paulo, 2000).

Afro-Brazilian Tradition and Contemporaneity

Juana Elbein dos Santos

A discussion of Afro-Brazilian art implies epistemologically fanning the embers of tradition, especially the *religar*, or spiritual link, the vision of the world from which this art emerged and of which it indissolubly forms a part. Afro-Brazilian culture re-creates African culture in Brazil as a transatlantic continuity. It has a particular religious symbolizing historicity that permeates and mobilizes the sociocultural condition of the country's population of African descent, which is currently estimated to number around 68.7 million. By including the statistics for "blacks" and "*pardos*" (the mixed-race classification still used by official Brazilian institutions), Brazil has one of the largest black populations of any nation, ahead of Zaire (45.3 million), South Africa (35.1 million), and the United States (34 million). The vigorous participation of Afro-Brazilians within the sociocultural fabric of Brazilian life incontrovertibly demonstrates the recontextualization of ancient African culture, bringing a uniqueness to Brazil's complex makeup as an Amerindian-Afro-European nation.

The Afro-Brazilian aesthetic process emerges from the context, thought, and emotional experience of a worldview based on African matrixes. By reflecting upon this worldview, in a process I heuristically characterize as "symbolizing historicity," it is brought into being. I intend to open up a centripetal meditation, emphasizing the incredible capacity of people of African descent to create their own tactics for continuously expanding values of identity, dialectically re-creating themselves within Brazil's sociocultural diversity. Since the seventeenth century—particularly in the state of Bahia—Afro-Brazilian aesthetic production has been emerging and recomposing itself in a condition of continuity and discontinuity in terms of the resonance of its initial reutterances of the distant past. Certain fundamental aspects generate and

foster the expansion and re-creation of this African legacy, and examining them allows for a better understanding of how and why original models and values managed to renew themselves.

Although the colossal pressures of exclusion and disparagement stemming from the ideologies and policies of the Eurocentric elite cannot be minimized, it is important to recognize that the process of Afro-Brazilian continuity depended upon internal as well as external, imposed factors. Along with insurgencies and revolts, the African ethos in Brazil extended its own accommodations and variables, through its own dynamic, by means of the tactical force of existential affirmation, interjecting and digesting contextual elements according to specific modes and values. Alongside their aesthetic activities visible in the official culture, Afro-Brazilians created an immense body of sacralized works—concentrated and known only within local communities—in community and family altars whose emblems were used in celebrations, ceremonies, and rites. Some of these still undated wooden and metal sculptures and emblems seem to have originated in West Africa. They were later copied and re-created by priests who were specially trained for such work. Only by the early twentieth century did these objects begin to be described and photographed by researchers and writers and become known outside the communities.[1]

It is important to point out some constituent elements that have enabled a sense of continuity, some of the core, disseminating institutions of a mythico-religious nature and their representations and manifestations: the *terreiro*—a ritual community space and sometimes an institution—and its specific poles of affirmation and radiation; the unique religious aspects that transmit a given vision of the world and foster a sense of communality and existential affirmation; the basic principles that govern the spiritual link between human beings, the universe, and nature; the initiating transmission and the *ashe* (or *axé*), the power of realization, and its transmittal through the dynamic of interpersonal relationships; and the aesthetic expressions that emerge and are at the service of symbolic utterance and comprise a specific language whose vocabulary and manifest and latent semantics render the Afro-Brazilian weltanschauung visible.

Despite the social and legal relationships imposed by slavery, which continued to influence all social relationships even after its abolition, Africans and their descendants in Brazil were able to transplant within their dialectical coexistence a unique civilizing system that is epitomized by highly organized associations. Brazilian culture was profoundly influenced by the institutionalized groupings or spaces known by the generic term "*terreiros*." In these community spaces, the customs, hierarchy, literature, art, mythology, behavior, values, and actions of various African kingdoms and regions were re-created, albeit dynamically.

In Brazil all of the ethnic groups from the Yoruba region are known as Nagô, a Yoruba designation that was originally unknown in Brazil. For a variety of reasons the culture that is generically known as the Nagô or the compound name Jeje-Nagô expanded and influenced the various cultural manifestations of the country's African descendants.[2] As in West Africa, religion permeated all activities, regulating and influencing everyday life, engendering a profound sense of community, and preserving and reconstructing even the smallest aspects of the community's cultural legacy. Particularly in Bahia the material and spiritual spaces of "mother Africa" were restructured in well-organized social units: *terreiros* (in Portuguese) or *ègbés* (in Nagô). In these units the cults of the sacred beings, the tradition of the *orixás*, or illustrious ancestors, and the *eguns*, or spirits of the dead, continues and is renewed. Traditional religion, the driving force of institutional continuity, was the reason for the establishment of communities.

Terreiro communities and *ègbés* were, and continue to be, organizing centers for cultural formation, elaboration, and dissemination, radiating nuclei for a complex symbolic system that establishes its own modes of communication.

This communication system forms the basis for a language made up of a network of signs—gestures, sounds, exclamations, rhythms, colors, forms—whose symbolic exchanges and interrelationships are transferred across all spaces and activities of the community. The social group is thus able to express its will in one direction or another. The language's symbolic efficiency results from a process capable of incorporating and promoting exchanges among its members by creating a plural and consensual set of expressions. Symbolic discourse in *terreiro* communities is affirmed primarily by liturgical practice, in various public and private ceremonies and rituals. Dance, rhythm, color, form, object, bead, gesture, leaf, hairstyle, sound, text, and emblem become expressions of the sacred. They are instruments of a communication system whose signifying forms help manifest and transmit the complex symbolic texture of community identity.

From the patrimony of their language Afro-Brazilians have created one of their most persistent and self-defining instruments, which is reworked into rhythm, music, literature, and visual expressions. Symbolic discourse passes through generations, simultaneously determining, transmitting, and transcending its time of origin, transforming existence into a multiple, "neo-African" symbolic universe, dialectically re-created in the *terreiro* communities of Bahia and throughout the Afro-Brazilian world. Generational transcendence and continual expansion are fundamental to understanding the capacity for dynamic recontextualization inherent among Afro-Brazilians. One of the defining aspects of this universe, which permeates all symbolic space, is its system of initiation. Knowledge is

acquired, fixed, developed, and disseminated to the degree it is lived through experience. In this regard community life in the *terreiro* is essential; it is the foundation for cohesion and dissemination. The transmission of knowledge is achieved, not through reading or logical reasoning on either a conscious or intellectual level, but through community experience, in gestures handed down from generation to generation.

The dissemination of the symbolic universe requires a means of communication that must constantly remake itself through dynamic interaction. Such communication both supports and contributes to the relationship formed between members of the *ègbé* and the sacred and mythic beings such as the *orixás*. This communication is charged with powers of mobilization and realization that extend to all of the dimensions of human custom. The *ègbé* members receive, fix, and develop this mythic, symbolic, and sacralized power, which enables them to become one and identify with the signs and elements of the system that they also help to set in motion. This power of realization, which is charged with a mythic structuring energy, ensures the existence of the community itself by processing alliances among past, present, and future, thereby creating an initiating lineage.

Ashe is the fundamental communication-enabling principle of the *ègbé*. As an inductor of action, *ashe* is acquired, received, and enriched by mystic, interpersonal, and ritual experience, reaching into the most profound depths of body and mind through symbolic elements such as blood, fruit, and herbal offerings and through gestures and words. Symbols transcend reality. The shells, palm ribs, beads, and rhythms chosen and accepted by group consensus to represent a need, a lack, or an underlying meaning are projected outside of and transcend time. Employed through generations, they become powerful signs of communication, or unifying referents. This symbolic

presentification is empowered by existence in all its infinite contexts. The finitude of the *ègbé* participant is transcended by his or her capacity to receive and diffuse, beyond the confines of his or her own life, the infinite and transcendent existence of the absolute signs of *ashe*. The network of signs, consubstantiated in symbolic relationships, has the power to bring abstract-conceptual, aesthetic, and emotional language into the present from its mythic origins, restoring and renewing life. Its manifestations have the ability to faithfully follow African traditions in conveying the mythic and sacred beings and entities that regulate cosmic, social, and individual phenomena. The act of naming brings existence; uttering and understanding the enunciated word confers existence upon the named.

Symbolic or symbolizing language not only reflects upon the social mode of the *ègbé* but also provides factual information that has meaning when approached through its manifest and latent relationships. The manifest relationships of the language provide us with its ethos, the aesthetic configuration of its signifying discourse, its style or way of life. These relationships provide the material that both hides and reveals the emotionally re-creative ontopoetics—the *eidos*, or latent aspect—that bear the underlying power of the *ashe*, the power of mythic energy, the power to structure and realize. The latent discourse of symbolizing language transmits lived experience, emotional memory, affectivity, and the most profound manifestations of existential needs and fantasies. Through the *eidos* mythic powers are radiated, made present, and symbolized by the manifest aesthetic configurations of the ethos. These initiating principles imprint a sense of meaning, force, direction, and presence upon language. The symbolizing language of the *terreiro* community is an aesthetic construct that arises from within. It is fundamentally a discourse on the experience of the sacred, containing all of the past and present

beings and events—the inexpressible assemblage of evocative and restorative theophanies of the initial principles—which are continually relived and re-created. In this context, although I am not examining the constellation of sacred entities and their representations, it is important to point out *exu*, a dynamic element that sets everything into motion, since it is found in all of the *orixás* and ancestral male and female pantheons.

The sacred archive is inherited by each generation; it lives in the initiates of the Afro-Brazilian symbolic universe. An essential characteristic of this universe is that for each spiritual or abstract element there corresponds a material or corporeal representation or location. This derives from the fact that African descendants conceived of existence as taking place on two planes: the concrete physical world, the *àiyé*, which includes humanity and all natural inhabitants of this world, the *araye*; and the metaphysical beyond, the *òrun*, an abstract conception of immensity, infinity, and distance. The unlimited vastness of the *òrun* is populated by supernatural beings or entities, the *ara-òrun*. The *òrun* is conceived of as being parallel to and coexisting with the real world. Everything—every individual, tree, animal, city, etc.—in the *àiyé* has a spiritual and abstract double in the *òrun*; conversely, everything that exists in the *òrun* has its own material representation in the *àiyé*.

Mythic energy, the power of the *ashe*, is contained and transmitted through material elements and representations. Every initiate, entity, object, or element of nature is a depository and a vehicle for a specific aspect of *ashe* manifesting itself in visible form through the intermediary of three basic "blood" signs, or colors: white, red, and black. These colors indicate a belonging to three regulating principles of existence and their power of renewal. The combination of these "blood" signs allows for a determined realization. All existence, in order to be realized, must receive and contain aspects of white, red, and black in

equal proportions and particular equations, thereby conferring meaning upon the units comprising the system. Through a particular combination these colors individualize and allow for a given meaning. Each combination comprises a unique result, a microcosm that allows for the inference, once contextualized, of the macrocosms of the symbolic universe. Objects, emblems, clothing, body painting, and sculptures all contribute to the expression of universal, cosmic, and theological understanding. As the French linguist Maurice Houis states, "Prior to becoming forms of art, they are forms that have the function of signifying the multiple relationships the individual has with his or her technical and ethical medium."[3] They not only evoke mythic qualities and matrixes but also reinstill the entire worldview from which they emerged, with all of its varied sociopolitical and cultural relationships.

The three element-signs representing the domains of white, red, and black direct the three principles or forces that make up the universe and everything that exists in it: *iwà*, the principle of existence; *ashe*, the principle of realization; and *aba*, the principle of induction, which allows things to be precisely oriented toward their objective. *Iwà* pertains to the domain of the white and is the power that makes existence in general possible. *Ashe*, energizing existence in general and enabling existence to occur, pertains to the combination of the three colors but is especially represented by the color red. *Aba*, conferring purpose and providing direction, becomes present through the color black.

The complexity of these symbolic relationships can be seen in the mythic king Shango (or Xangô), the *orixá* representing purpose, the power of realization, and dynasty. Shango is linked to the symbol of fire, the domain of red. His family constellation is composed of his mother, Yemanjá, the *orixá* symbolizing water, and his father, Oshala, the *orixá* symbolizing air. Shango's immediate ancestor is

Oranyian, the hero who founded the Nagô nation and established its royal dynastic lineage. Fire thus appears as a dynamic element, the result of an interaction between the elements of water and air. In this context red symbolizes the power of realization: the red blood of *ashe*, circulating and giving life. Shango represents the uninterrupted current of life, which is expressed by the function of *aláàfin*, "epitome of the absolute power of royalty," according to P. Morton Williams.[4] Even though Shango symbolizes inheritance, the collective image of ancestry, and therefore incorporates a part of the color white, the image of the tree and wood, he is fundamentally associated with the power of realization expressed by the color red, by fire and thunder. Reminiscent in his mythic origin to the ancestral *egun* (one myth states that the *egun* stole his clothes), Shango's symbolic function is to ensure life within the physical world, the *àiyé*. It is significant that Shango leaves the heads of his priests when they are about to die; he does not remain among the dead. His essential incompatibility with death is illustrated in the research of Lydia Cabrera, who once asked her informants, "Why is Shango afraid of the dead?" They unanimously replied that it was not a question of fear: "Shango is not afraid of the *Iku* [Death]," they responded. "He does not flee the dead. Shango does not like the cold 'skeleton' since he is alive and he is warm."[5]

The profound significance of the colors that conduct the principles of existence can be seen in the fact that they are constantly used to mark "belonging" and render visible the language of the cultural pact and its aesthetic manifestations. The language that arises from these traditional matrixes is a symbolizing process that radiates a rich mythic-liturgical legacy in an exuberant aesthetic-identifying manifestation, crossing over the territorial spaces of the community and overflowing in a multiplicity of colors, forms, and rhythms in the streets, public squares, museums, and galleries.

The *oshe* Shango and other ritual aspects inspired the initial, nearly geometric compositions of the artist Rubem Valentim, who also employed the basic "blood" colors of white, red, and black. These compositions were later re-created in magnificent minimalist constructions.

The *shashara*, the ritual brush of the *orixá* Obaluàiyé, used in a variety of combinations—inspired by the prescribed emblematic forms and colors of the mythic constellation of the *orixás* Nana and Oshumare—appears in the original sculptures of my husband, the priest-artist Deoscóredes Maximiliano dos Santos, known as Mestre Didi. His works transmit a sense of both tradition and renewal. During his entire life he has made and sacralized ritual objects; his aesthetic production inspired by traditional matrixes has led to new symbolizing interpretations. Starting with the *shashara* each sculpture represents a variation, a fugue, a melodic improvisation, an ode dedicated to the perpetuation of traditional form. Each creation offers innovative insight into tradition.

Mestre Didi also creates contemporary forms that do not have a strictly religious function. In a symbolizing process, he makes use of traditional materials and techniques to create contemporary art, thereby transmitting the cosmic understanding he has inherited. His works are authentic in an emotional, ethical, and visual sense and exhibit a formal coherence, at once traditional and new.

In the dialogue between past and present, where reactualized reality does not limit a discussion of the real to the here and now, an ethos emerges that transcends the boundaries of variables between *terreiro* communities. Despite the manifest differences that distinguish each *terreiro*—handclaps, chants, rites, histories, antiquity—and the lack of a centralized sociopolitical power among their myriad groupings and hierarchic structures, their ethos, African in origin, extends throughout Brazil. By expressing collective experiences, liturgical practices, and the memories of ancestry and its representations, the ethos of the *terreiro* communities allowed them to forge their own unique historicity. The trajectory of this historicity profoundly marks the complex, delicate, and difficult coexistence of a specific sociocultural plurality whose distinct but interinfluencing institutions are part of the diverse makeup of Brazil. Despite the fact that this trajectory arises principally from the worldview of the ancient Nagô culture, it provides a point of reference for the entire Afro-Brazilian population.

Beginning in the sixteenth century, various cultures of African origin were introduced to Brazil by the Europeans. After four centuries, evidence of their presence and participation, along with those of other cultural legacies, remains irrefutable. A sense of continuity was established from these cultures' initial principles, and, despite leaps, lacunae, and reinterpreted borrowings, a specific Afro-Brazilian historicity came into being. This historicity presupposes a central constituent subjectivity, which is capable of re-creating its past by creating its present and of establishing relationships between the mundane circumstances and aesthetic institutions (religion, liturgy, art, literature) of *terreiro* communities and the original, mythic circumstances that accompany and underlie them. Afro-Brazilian culture does not simply and literally repeat a preexisting African reality from more or less forgotten or petrified records; instead, it fundamentally appropriates, digests, and recontextualizes them. This constructed recovery from the inscriptions of the past or pasts, through constant symbolizing activity, has produced not just a new history but a new sense of history.[6]

One task of scholarship is to understand this symbolizing historicity as a conducting axis that renders visible, for example, the hero Shango and his attributes, not only as *aláàfin* (king) of the Oyo Empire of the sixteenth century, but also as a dynamic principle capable of renewing

and transforming the dynamic sociocultural cohesion among Afro-Brazilian communities. The legacy of Western scholarship hegemonically reduces and obscures the complex space that is Afro-Brazilian culture by universalizing differences or encasing diversity in uniformity. A proper scholarship seeks to establish the multiple links of the African worldview, which is punctuated by the elements and pulses of nature invested with spirituality and force.

Arranged in pantheons, as elements and patrons of nature, the various spiritual entities have their own respective symbols, emblems, temples, and hierarchies. For example, the *orixás* and the initiating lineages that are re-created in the communities come from a wide range of geographical regions and the most diverse moments and contexts in African history. Every being, pantheon, object, item of clothing, emblem, sculpture, and particle of the material or abstract universe (the *àiyé* or the *òrun*) makes "belonging" present through symbolic utterance. Language quivers with the multiplicity of pertinent forms, spaces, colors, and materials, exposing the content of the initial cultural pact. Recontextualized in new spaces, in a transatlantic saga, this pact assembles a manifold scaffolding for its historicity. Defying the repressive forces of European domination, it reconstitutes itself from generation to generation, affirming the continuity of its existence.

On the national level the question of diversity has been and continues to be divisive, complex, and difficult vis-à-vis a political establishment inflected by the persistence of Eurocentrism and social inequality. Nevertheless, there is a paradoxical reality in the inextinguishable and rich imagination of the Afro-Brazilian people. For example, the *oriki*, the salutation, one gives in homage to the *orixá* Shango is "*kao kabiesilé*," which literally means "we are seeing our heroic leader" but can be freely translated as "Shango is here with us." *Orikis* are part of the oral literature; agglutinated and metaphorical forms or phrases that take the shape of exclamations or poems, they are attributive names that reflect back on history, personal qualities, actions, lineages, cities, or related facts. The Shango *oriki* establishes a profound identification with the patriarch-founder, the sociopolitical structuring force of the community and restorer of a singular ethos in the multiple diversities of Brazilian society.

The everyday life of the *terreiro* community, with all of the internal contradictions present in any extended family, is a paradigmatic space for the construction and reconstruction of equilibrium. The experience of the initiate, which develops into the maturity of wisdom, codifies the ethics of relationships and their contextualizations and contacts with diversity. The need to put forth and make viable a new ethics of human diversity, of coexistence, in absolute terms with regard to the Other—to achieve consciously profound forms of solidarity applicable to the diverse forms of aesthetic expression—has been reiterated time and again. To live in multiplicity and not perish is the challenge of the Afro-Brazilian tradition's ability to continually re-create past-present-future in defiance of the increasing uniformity of globalization and cyberspace. And yet, to live in multiplicity may also mean attempting to be part of the movement of the world, learning to relate with what we are and what we are not. To not stamp out differences is a path for creativity, whereby human diversity can be transferred in accordance with the given contexts. To paraphrase the writer Márcio Tavares d'Amaral, to live with democratic integrity means tension, struggle, attrition, creativity, the ethics of the agitation of difference, to joyously learn from diversity.[7]

Rites, ceremonies, costumes, colors, emblems, literature, and cuisine are joined with the radiating, unending flow of the sacred and profane through music, dance, theater, visual arts, styles, and values. My own contribution to such manifestations

includes *Ajaká*, a choreographic work with dialogue and songs, which I cowrote with Deoscóredes Maximiliano dos Santos and Orlando Senna and concerns the mythic saga of the adolescent Ajaká, grandson of the supreme being Oduduwá, who after various initiation rites became the restorer of life. Dos Santos has also created the opera *A Fuga Do Tio Ajai*, which is about the flight of slaves and was performed in theaters and in the streets and public squares.

My objective has been not to propose definitions or examine and reflect upon aesthetic canons but to note the aesthetic process that emerges from the context, thought, and emotional experience of a worldview based on African matrixes. *Agbon* is the Yoruba word for wisdom. This single concept symbolizes the good, beautiful, and useful. The beautiful (aesthetic manifestations, works of art) has certain connotations of style and value, which communicate the knowledge of the symbolic utterance and its language. While not minimizing the dramatic circumstances of exclusion and disparagement experienced by the peoples of African descent from postcolonial times to the present, I have directed our focus away from assessments that are historically negative toward one that emphasizes the participation of Afro-Brazilians and their cultural production.

Many of my observations emerge not from research, reading, and studies alone but also from my own committed, long-suffering, and at times brutal experience of humanity. Suppression, concealment, and conformity, however, have not and will not extinguish the creativity of the extremely rich imagination of Afro-Brazilians. Inspired by myths, trees, rivers, lakes, sacred stones, and the paintings of novices, this creativity adorns the *pejis*, the altars dedicated to *orixás*. It is transmuted in dance, music, and emblems. And it is represented in the works of Emanoel Araújo, Agnaldo Manoel dos Santos, Mestre Didi, Helio Oliveira, Ronaldo Rego, Arthur Bispo do Rosario, Rubem Valentim, and Niobe Xandó, as well as of so many others whose art is unexhibited and unpublished. Such creativity exists in the very core emotions of the collective conscious and unconscious, in the symbolizing current of the extended community, in the poetic essence of the people. In the words of Deoscóredes Maximiliano dos Santos, an *alapini*, a supreme priest of the ancestor cult, "We are the ones who construct our own history, who transmit it to our children, who then transmit it to their children, and then to their children's children. As long as one of my people remains alive, the brilliant fire shall be inextinguishable."[8] For those of us who have been the witnesses and privileged participants of a given era and whose participation has granted a new level of civic and existential responsibility, to discuss the ethos and eidos of Afro-Brazilian communality means believing in the utopia of a viable humanity.

Translated from the Portuguese by David Auerbach.

Notes

1. The first time some of these objects received public appraisal was in Nina Rodrigues, "Colonos pretos do Brasil— A escultura," in *Revista brasileira* (Bahia, 1896), subsequently published in *O animismo fetichista dos negros bahianos* (Reis e Comp., 1900; Rio de Janeiro: Civilização Brasileira, S.A., 1935).
2. Concerning the complexity of Nagô culture, see Juana Elbein dos Santos, *Os Nagô e a morte*, 10th ed. (Petróplois: Vozes, 2000).
3. Maurice Houis, "Letterature de style oral" entry, in *La Grande Encyclopédie Larrousse*, vol. 2 (1972).
4. P. Morton Williams, "Yoruba Responses to the Fear of Death," *Áafrican*, no. 3 (1960).
5. Lybia Cabrera, *El monte*, 1st ed. (Havana, 1954)
6. The concepts mentioned in this paragraph emerged from exchanges and discussions that occurred during an interdisciplinary seminar that brought together anthropologists, psychologists, psychoanalysts, and community leaders. Discussions were published in Juana Elbein dos Santos, ed., *Diversidade humana dasafio planetário* (SECNEB, Communitates Mundi, 1998), p. 83 et seq.
7. See Márcio Tavares de Amaral, "Espaço e ação: A crise da identidade e a comoção das diferenças," in dos Santos, *Diversidade humana desafio planetário*, pp. 143–48.
8. Interview with Deoscóredes Maximiliano dos Santos, in documentary film *Egungun*, produced on the island of Itaparica, Bahia, by SECNEB in 1981.

African Cosmologies in Brazilian Culture and Society

Maria Lúcia Montes

A culture impregnates a people's experience of life with meaning. Consequently, no culture is destroyed except by the literal, physical, destruction of its people. The black imagination that traveled the slave route between Africa and the Americas gathered fragments of cultures that were shattered but had not entirely succumbed under the weight of slavery. Significantly, religion constitutes the principal domain where reinvention and continuity are evident on both sides of the Atlantic. By providing an understanding of the vicissitudes of existence, by organizing emotions, African religions sustain themselves in Brazilian culture through cosmologies where the sacred permeates the totality of the experience of the world. Cosmologies are analogous to Nature and permeate the social life of every human being. They are religions that condense cultures, where art and the sacred become inseparable.

The aesthetic experience of cosmologies in Brazil participates in a system of references in which each object has a function and an objective with regard to the sacred. The beauty of a sculpture is not discernible from the god whose force it carries; the elaboration of the mask is not understood without the rite of which it is a part; the banner has no meaning if removed from the ceremony of which it is an emblem. These aesthetic objects do not exist independently from what they represent: it is not what the eye sees, but what the mind recognizes as symbolically significant and what the hand labors to recreate. The sacred is the source of an entire production of art that has remained clandestine, and the origin of an aesthetic that is not recognized by official history but which nevertheless presents unique Afro-Brazilian characteristics. This vision of the sacred has enabled the black imagination in Brazil to speak the language of art. Anchoring this vision, the African cosmologies have impregnated every aspect of the experience of life and culture

of Brazil as it emerged from colonialism and, given the involuntary assimilation of the indigenous and African cultures it has sought to destroy, inevitably became mestizo.

Certain questions indicate the complexity of the processes by which African cosmologies were assimilated into Brazilian culture. What is the place of the female in these cosmologies? What meaning do these cosmologies confer to festivals. And to what extent do festivals provide meaning regarding the insertion of African men and women in Brazilian society? These are certainly challenging questions, due less to the breadth of the themes than to an academic tradition and a political attitude that has forged almost unshakable positions, which have only recently been questioned. Gilberto Freyre's idea of a racial democracy founded upon miscegenation has been rendered suspect by a new understanding of the long history of sexual violence against the female slave and the lasting social inequality resulting from slave relations.[1] Likewise, festivals, when not viewed outright as mystifying, have, until recently, been considered of minor importance to the understanding of Brazil's difficult cultural identity. Traditional studies of the festivals tended to promote an alienated vision of cultural identity by shifting the focus away from the essential issue: the inequality of the insertion of the African man and woman within the Brazilian class structure.

However, issues that have been discarded by more recent thinking are not necessarily less important to consider.[2] Quite to the contrary. Freyre's reflections on the role of the black woman in the private space of the home—culturally assimilated, an example of successful social integration—suggest a reading of the master-slave interaction in a different light, as a two-way street. Freyre's work also suggests, as do other later studies,[3] that if Brazil Americanized its slaves, they also, without intent or deliberation, Africanized

the country of their masters. All of the following have been transformed into symbols of national identity: ritualistic recipes for making devotional food for the gods were transformed into typical dishes in Bahia;[4] the obscene *umbigada*, a dance in which one dancer bumps stomachs with the dancer who replaces him, as the drums beat at the *senzala*, or slave house, was incorporated by the maxixe, a dance that would later excite and scandalize the court ballrooms of the late-nineteenth century;[5] and the festivals at the Tia Ciata *terreiro*, or place for the performance of Afro-Brazilian cults, gave rise to the informal groups of carnival revelers known as *ranchos* and *blocos* and ultimately to the samba schools.[6] On the religious plane, the dialogue of different cultures did not happen without risks, but produced obvious continuities and unsuspected associations.[7] In order to reexamine these issues, it is necessary to work with the fine fabric of meanings—each employing their own symbolic references—that humans weave into the realm of culture, and to attempt to understand the codes that sustained the relations between blacks and whites and masters and slaves in Brazil. In searching for female models that emerge from African cosmologies in the New World and in analyzing their relation to the meaning of Brazil's festivals, one may find some of the founding models of Brazilian society and culture.

Cosmologies

The Africans who were dragged to Brazil by the barbarisms of slavery, starting in the seventeenth century,[8] initially came from the west coast of Central Africa. They were Congolese, Angolan, Cabinda, Benguela, Mozambican, Guinanan, Bantu, and Sudanese. Theirs were not just vilified bodies that rotted at the bottom of slave ships but souls that were shattered and would have to overcome their predicament in order to extract some meaning from their having been reduced to objects and merchandise. The beginning of the forma-

tion of an African identity in the Americas was possible by the proximity of languages and the substratum of beliefs that revolved around more or less similar world views.[9] These world views, or cosmologies, can be defined within the vast spectrum that Robert Farris Thompson has called the "Kongo cosmology."[10] This term designates a broad cultural universe that extends far beyond the borders of the old Congo, itself merely a product of nineteenth-century European colonialism.

Macrocosm and microcosm mirror one another in this cosmology, and the world is represented by signs that indicate the four stages of the sun. From sunrise to sundown, passing by its zenith, the sun traces the trajectory of the cosmos and the development of human life. This movement can be represented as a vast mountain, which is reflected on another mountain, *mpemba* in the world of water, *kalunga* in the kingdom of the dead. The sun rises and sets, as the living and the dead exchange day and night. Thus, in the eternal cycle of life, death is only a passage that takes the living to the world of *mpemba*, beyond the river-sea, to meet his or her ancestors. The midpoint of the trajectory of life, the highest point in a person's maturity, the summit of the cosmic mountain, corresponds to the lowest point in the kingdom of the dead. This symmetry enables a person to obtain maximum strength from one's ancestors at a critical moment of one's life.[11]

Not by chance, rituals of initiation take place at the center of a crossroad, on the *ponto riscado*, at a cross drawn at the entrance of the *terreiro* to assist in the invoking of the spirits, which represents the intersection of the two halves of the cosmos. Along with the *ponto cantado*, a singing to invoke the spirits, the *ponto riscado* can be found, to this day, in the rituals of *macumba* and *umbanda* in Brazil.[12] Equally significant, the Africans who were brought over as slaves considered that crossing the ocean, the *kalunga grande*, conferred upon them all the status of

malungos, those who came over on the same boat and together crossed the boundary of death.[13] Here, on the coast opposite Africa, they were already in the kingdom of death. For Brazilian slaves, life in Africa could only be lived vicariously through the collective strength of the rites surrounding the sacred beat of the drums, which invoked the power of the ancestors to assist those who had survived.

The religions based on the cult of the ancestors gradually merged with other cosmologies brought to the Americas by slavery and concentrated essentially around the Yoruba culture that comprised a vast portion of Nigeria and the Nagô, or Yoruba, peoples in Benin. Due to political conflicts that led to their defeat by the Dahomey, the Yoruba swelled the numbers of Africans arriving in Brazil.[14] As had happened before with the Bantu, distinct but related cosmologies—those of the Nagô, the Gêge (the Fon), and even the Islamic Hausa—blended and were intertwined in the religion of the *orixás*, or illustrious ancestors.[15] These cosmologies were perceived as incarnations and manifestations of *axé* (also spelled *ashe*), the vital force inhabiting all the cosmos, heaven, earth, and nature with its elements and its living things, including human beings.[16] Morally neutral, *axé* gives life or takes it away, brings about cure or plague, justice or its refusal, abundance or scarcity.[17] The cosmos is presented as divided into distinct areas corresponding to the different elements of nature: water, air, earth, fire. Within each area there are equivalencies, homologies, which permit the creation of a common sense of belonging. Therefore, a rigorous system of classification unites the cosmos and human life, space and time,[18] the days of the week and the holy places, animals and plants, and what becomes food and what is destined for ritualistic use, along with the beat of the drums and the dance steps, the colors and the materials from which objects are made, and the ritualistic gowns and ornaments used by the faithful.[19]

Senhoras do cosmo

Within the cosmologies forcibly brought from Africa, there is much space for distinctions between genders and, as a result, it is possible to construct female images that function as true archetypes and assist in the integral deciphering of human types, from physical appearance to the most intimate personality traits. *Orikis*, or oral phrases, teach Brazilians to salute the great *iyabás*, also known as *senhoras do cosmo* (ladies of the cosmos) or *donas do mundo* (mistresses of the world), to indicate the signs that delineate territories, and to show the boundaries of the sacred, as shown by the following examples:

> Nanã: No chicken is plucked while alive. Still water that kills without warning.

> Iemanjá: Mother who has humid breasts. The woman's flute who, upon awakening, plays in the king's court. Oxum does not allow bad things to affect me. She dances in the depths of wealth. Oiá is the only one who can grab the buffalo's horns. With her thumb she crushes the innards of liars.[20]

Each *iyabá* is characterized by attributes that reveal a unique form of power: the razor's edge, the control over death, fertility, abundance, or the wild and free force. The faces of the African goddesses are highly enigmatic and implicitly confront Brazilians with the issue of their own identity.

Who are the *senhoras do cosmo* in the Afro-Brazilian religions? Seen from the outside, their universe can be the object of a systematic study that might describe, more or less precisely, certain female stereotypes represented by the *iyabás*. Seen from the inside, however, comprehension of this universe requires a learning process that can only be obtained through direct experience, occurring little by little over time. One identifies Nanã by the manner

in which the curved body dances while holding an *ibiri*, or staff, and by the sweeping motion of arms that appears to be cleaning the *terreiro* of mud. The beautiful Oxum is dressed in golden yellow and holds a mirror in her hands, reflecting her vanity. She dances with gracious movements, and murmurs softly, like the babble of running waters. The nervous beat of the drums calls Oiá to dance; in quick and precise movements her hands carry the *eruexin*, a fan made from a horse's tail, sending away the *eguns*, or spirits of the dead. The vertiginous spinning at the eye of the storm is brought on by *Dona do vento, rainha dos raios*.

The myths, retold by rites as much by the scholarly gathering of fragments of information,[21] permit a gradual understanding of the power of the *iyabás* and their intricate relationships with other *orixás*, some of whom are friends or relatives, others enemies. Within these relationships, a hierarchy of rights and responsibilities must be understood and maintained, along with rules shaping each respective cult. In a learning process premised on integral experience, sensibility, and reason, body and soul are engaged in understanding the cosmologies expressed through sensory forms, where sounds, colors, and movements are made meaningful by the presence of the sacred. What do the stories and images of *iyabás* mean? What do they tell us about the place of African men and women in the formation of Brazil's culture and identity?

The Female Model and the Place of the Afro-Brazilian

In reviewing the 500 years of Brazilian history, one must examine the legacy of colonialism from different points of view. One approach is to focus on its phallic aspect, which can be interpreted as having repressed the female image and transformed the words *Pátria amada Mãe gentil* (Beloved country sweet Mother) from the Brazilian national anthem into empty rhetoric. If Brazilians were prevented from

incorporating the female image and giving it value, this helps to account for the secondary position women occupy in Brazilian society to this day.[22] With regard to Brazil's African heritage, such a thesis should be evaluated against the backdrop of the cosmology of the *iyabás.*

For its part, Brazilian literature discourages an understanding of domination as a one-way street. In the seventeenth century, Gregório de Matos described the affection of the slave owners toward blacks, mestizos, and mulattoes as one of the "evils that afflict Bahia," but he was also the first to praise the love of a black woman.[23] Three hundred years later, Mário de Andrade, who was, himself, referred to as a mulatto as if to do so were an insult, wrote some of his most outstanding verses in a poem about a mulatto woman sleeping in a hammock.[24] During the nineteenth century, the *lundus,* a popular type of song and dance of African origin,[25] composed by blacks and whites alike, insinuated with little subtlety both the charm of the black woman desired by the white man and the tempting but prohibited relationship between the slave or free mulatto and the *iaiazinha* (white girl). This was also the theme of a well-known song by the mulatto Paula Brito, a friend of Machado de Assis and the first Brazilian publisher, whose bookstore was the habitual gathering place for some of most important names in politics and culture during the reign of Pedro II.[26]

At work here are elements much more complex than the sexual game alone—or not, depending on how one chooses to interpret events that occur at such psychic depth. Take, for instance, the figure of the white poet Jorge de Lima, the author not only of *Nega Fulô* but of verses providing some of the most pointed perceptions of the female universe under slavery. In *História,* for example, Lima maps the trajectory of an *ancila negra,* or black slave woman, between Africa and Brazil. Raped by the ship's captain, crew, and foreman, she avenges herself by bewitching her white master. Subsequently victimized by the anger of the master's wife, she reaffirms her intent for vengeance by seeking the help of *exu,* the force that sets all things in motion. The poet's perception of the psychic complexity of the relationships between white men and the black women who serve them goes even further, as when he describes the *ancila negra:*

> there is still much to repress,
> Celidônia, oh beautiful Yoruba girl
> who rocked my hammock,
> accompanied me to school,
> told me animal stories
> when I was small,
> really very small
>
> There is much to repress and forget:
> the day in which you drowned,
> without telling me you were
> going to die,
> black woman who in death escaped,
> teller of stories from your kingdom,
> black angel forever exiled
> Celidônia, Celidônia, Celidônia!
>
> never more the signs of return.
> Forever: everything remained as
> a ringing bell
> And I remain small,
> bewitched and sleeping,
> really sleeping a lot [27]

Representations of Afro-Brazilian culture within slavery speak of both the body and the soul. Under the yoke of slavery, black and white bodies alike become a language and a weapon of repression by the differences that are inscribed upon them. The body represents attraction and repulsion and is an instrument of seduction and terror due to the very attraction it inspires. In this universe, where the sacred is expressed and understood as a total sensory experience, body and soul are inseparable. And yet, it is the soul, at least for the slave, that remembers the sorcery of Africa, the power of *axé* capable of making the body vibrate with life or languish,

capable of making the master tremble with desire and terror, awed by the power of life and death he has over the slave who, conversely, also dominates him. The power of this remembrance profoundly affects the master's body as well and, in turn, disrupts his own soul. It makes him mock those who seduce him and whom he fears, a mockery which, in a double movement, is reciprocated by the slave whose life or death the master holds in his hands. Is this not what the *lundus* say, as also shown in the late-nineteenth-century poetry of Luís Gama?[28]

Identity and Power

Seduction, terror, and laughter are crucial elements in the construction of identity of both blacks and whites, masters and slaves. Such relationships, asymmetrical and conflicted, are filled with a permissive complicity, where it is not a question of this *or* that but this *and* that. Therefore, the violence and cruelty marking the formation of Brazil's society and culture might be due, not so much to the incapacity of the colonizer to incorporate the value of the female, but to the seduction and terror of incorporating a racialized, "othered" female. Here, the subjugation of the indigenous and African peoples was quite distant from the Christian norms of civilization and colonization. Here, the Manichean distinctions between good and evil were lost, causing the need to reiterate the constancy of cruelty and violence in spasms and as a reaction. Darcy Ribeiro is therefore right when he states that it is not only our hand that holds the whip but also our back on which it cracks.[29]

The structural ambivalence present in the relationship between sexes, intertwined with the logic of domination based upon racial difference, thoroughly permeates the social incorporation of female images of the religion of the *orixás*. Within their myriad nuances, each image reflects specific realms of power. However, as with the representational logic of the male *orixás*, the female *orixás* go from good to

evil with no sense of discontinuity. Such terms merely reflect the use one makes of the power of *axé* with regard to the collective or individual good. The significance of these female images must be understood at a deeper level than is offered by a sociological treatment of the slave woman's condition, given that these images are not structured around an idea of gender equality presupposed to be natural or necessary by contemporary society.

The incorporation of these images, and the sociocultural and racialized models of the relationships between genders they support, certainly leads to the conclusion that the formation of Brazil's identity was difficult, eccentric, and outside the realm of what is considered normal. Such a formation might even be called perverse, as it was founded on structurally asymmetrical relationships that lead to a disallowance or, at least, to an ambivalence toward what was incorporated. For this very reason, it provides for a more ambiguous and deeper experience of identity, one that is both beyond and beneath power. It is beyond power for those who reincorporate the African legacy and are no longer afraid of the kingdom of death, having already conquered it, such as the old black women of the Irmandade de Nossa Senhora da Boa Morte (Sisterhood of Our Lord of the Good Death),[30] and those who have embraced death, as did the slaves consumed by *banzo*, a deathly homesickness for Africa that wastes the body and will, portrayed so well by Lima in *Benedito Calunga*.[31] It is beneath power, outside of reach, for those who retreat and enclose themselves in perfect humility, as do the *pretos velhos*, or old blacks, of the *umbanda* cults.

As a result of being both beyond and beneath power, domination must be thought to occur symbolically. Although we are far from the racial democracy professed by conservative ideology, we are closer to understanding how, in the realm of the home, long considered a woman's place just as it was for the black female

slave, the intimate relationships between people tend toward ambivalence and often corrode the models of domination of the slave society. The female images of the great *senhoras do cosmo* are incorporated in this other, symbolic sphere of power and are expressions of cosmologies inscribed in a constitutive manner in the formation of Brazilian society and culture.

Catholic Devotion, Black Imagination, and the Baroque Festival

If slavery subjugates the body, it does not necessarily rob the slave of his or her soul. Forcibly integrated into a society where the master destroys all signs of belonging by confiscating all connections of blood, language, or nation, the black slave patiently recreates them within the new culture, which he or she assimilates at the cost of subverting it from the inside, attaching new meanings, new habits, and inventing new traditions. The slave, forced to adopt the beliefs of the master, ends up transforming them, by incorporating ideas from a different system of beliefs into his or her forms of devotion. Beyond the work in the fields is the festival, and the black sisterhood cosmologies allow for the interpretation of Catholic devotion by other beliefs, reestablishing ties with Africa by invoking the help of Saint Benedict or the Lady of the Rosary. In this way, the battle of Lepanto and the wars of the African kings are fused with the European mythologies of Charlemagne, the battles between Christians and Moors, and the desire for another sort of justice where expressions of good and evil are often intertwined.

During the festive processions, while praising God and the saints or powerful lords, the Benedictine brotherhood and the professional guilds create a new place for the black in slave society: "On the afternoon of the sixteenth the Kingdom of Congo set forth, comprised of more than eighty masks with farcical attire and richly adorned with gold. Among them were the King and the Queen, [for whom] special places had been set on a platform of three steps, covered in precious cloths, with two chairs made with green gauze and gold flowers and fringes. . . . After they had both taken their respective seats, they were entertained by the Sobas and the masks of their guard, and later went to dance the *talheiras* and *quicumbis*, to the sound of instruments particular to them and their rites."[32] This is a description of an eighteenth-century black festival within the Faustian festivals of Santo Amaro da Purificação, Bahia, on the occasion of the marriage of Maria, princess of Brazil, and the prince of Portugal. The *congada* or *moçambique* dances, which reenact royal processions, date far back and are still performed by blacks in Catholic festivals. Such dances are witness to a dialogue established between near and distant shores and, through history, have gradually formed the fabric of Brazil's mestizo culture. The baroque elements of this festival necessitate that we consider how, beyond the private realm of the home, the African cosmologies in Brazil are also perpetuated and reinvented in the public space.

More than an art style, the Baroque in Brazil constitutes a fact of civilization, indicating a particular sensibility and a world vision that, in the long duration of history, forms the ethos of a culture.[33] The continuous existence of a real culture of festivals, Baroque in its model, deeply impregnates the Brazilian imagination. As the venue for "the solemn moment in the existence of a people, where a moral, religious, and poetic ideal acquires a visible form," the festival is the "transition from common life to art" and becomes a privileged level of thinking.[34] The significance of the Baroque legacy contained in festivals exists in the contemporary world as a live form of culture and not merely as a surviving artifact. It makes its appearance, far from the erudite canons of culture or the art exhibited in museums, in what is referred to as popular culture:

the primary place where the presence of the black man and woman and the legacy of the African cosmologies is inscribed in the formation of Brazilian identity.

If the festival is where disparate cosmologies converge, interact, and merge in Brazilian culture, religion provides the legitimacy of the festive expression and reintroduces cosmologies to their native idiom. In the service of God, the Baroque festival reveals the modus operandi of a particular imagination. It employs canonical, symbolic characters from the Christian hagiology or classical mythology, which are reutilized for moralizing purposes. The occasion for the festival might be the day, the life, or the martyrdom of a saint, or even a triumphant procession of a prince or a church dignitary. The festival is by nature a material and symbolic bricolage,[35] which attempts to construct an intelligible order of the world based on its sensory expression. At the same time, it is a "total social fact,"[36] an event that permeates all the dimensions of social life and reflects the moral and social order by showing the place each person occupies in the procession, all the while displaying the social organization, the hierarchy of wealth, prestige and power that sustain it.[37] The festival is like a text to be interpreted, written in a unique language of sensory forms from which art is made. When we decipher the writing the festival inscribes in space and time, we are able to read, through it, what society says about itself.[38]

Cosmologies in Confrontation

When reading documents about colonial festivals in Brazil, one's attention is drawn to the almost ethnographic and detailed descriptions of the material, visual, and auditory elements through which the festival structures its narrative: scenic architecture, colors, attire, masks, adornments, dance, musical instruments, the rhythms each group uses to mark its choreography.[39] These reveal that the narrative seeks to impart its truth by involving all our senses, simultaneously directing our

attention to a current event and to structures of an imagination that has evolved over its long history. The Baroque festival is formed around an archaic cosmology that anchors the order of social life and nature on the supernatural. Thanks to the diversity that characterizes its production, from its remote medieval Christian origins through the Renaissance, the Baroque festival has incorporated and reinterpreted powerful pagan elements, which are transcultural in value. These elements can themselves be reinterpreted to express other symbolic content, through which different cultures attempt to provide meaning to good and evil, abundance and scarcity, the fertility of the land and of women, as well as the misery of hunger and inexorability of death; in short, the experience of living and dying, along with the happiness and anguish that are part of it. The Baroque festival reveals itself as a place of confluence and negotiation between distinct cosmologies.

This process could not happen without ambiguities or ambivalence. In the festival processions, allegories often portray dragons, devils, giants, and dwarves, representing marginal or anomalous characters—transcultural symbols associated with evil. However, they also depict current evils such as idolatry, be it pagan, Moorish, or Afro-Native-Brazilian. Opposing these figures are Christ and the saints, as well as the portentous cherubs or the ambiguous archangels and virtues, who can be easily assimilated as the winged guardians of other gods or as protective spirits of nature; one example is the famous seventeenth-century angel-musketeer of the Andes so often depicted in Peruvian colonial art.[40] In this way, fragments of other world visions, through which myriad cultures appear, might recognize themselves and, incorporating these elements, transcend the Christian vision, which serves as pretext, thus transforming the festival and conferring upon it new meanings and uses. Moreover, these symbols and their meanings can only be

deciphered through the sensory forms, visual and auditory, in which they are represented, as they are literally translated into corporal languages and musical structures, which shape them as subjective experience. This is the ambiguous place where, in Brazil, Christian faith is layered onto African cosmologies already in a process of transformation.

Baroque Festival, Popular Culture

A double characteristic ensures the confluence of Christian faith and African cosmologies. On one hand, the archaic character of a world vision that legitimizes the ancien régime is inseparable on the political plane from an order—simultaneously natural, supernatural, and social—where the African cosmologies can easily be mirrored. On the other hand, the spectacular nature of the Baroque culture that produces the staging of festivals, and proclaims the truths of the spirit by convincing the senses, provides a homology to the African cosmologies of the inseparability of body and soul. This convergence of assimilation and re-creation results in unique Afro-Brazilian cosmologies that to this day permeate Brazil's popular culture.

Within the symbolic universe and the visual and auditory forms of the popular festivals in Brazil, we can still find the small viola and the various drums—*caixas*, *tamboretas*, *pandeiros*, and *tamborís*—that were present in dances from the Renaissance on and which the Catholic Church would only later officially ban from liturgical festivities. In Brazil, however, they stubbornly remained part of the devotional festivals of Congo or the Folias do Divino and the Folia dos Santos Reis. The decorated canes of used for the *moçambique* are musical instruments, symbolically similar to the bells attached to the worn-out clothes used by the *caboclos de lança*, or spear-carrying mestizos, in the *maracatu* dance of rural Pernambuco. The *moçambique* dancers also fasten bells to their legs, transforming them into additional musical instruments played by the moving

body. In the *maracatus* and *congadas*, the crowning of the black Magi in the festival of Epiphany is fused with the staging of original African processions, with their kings, courts, and banners. In the samba schools, these characters are represented by the *mestre-sala* (master of the hall) and the *porta-bandeira* (standard bearer).

The African masks re-created, with magnified proportions, in the *cabeções* (big heads) of the Recife or São Paulo carnivals often represent terrifying characters, such as Death or devils, which were also found in nineteenth-century processions or as part of the iconography of Carnival at the turn of the twentieth century. The body language of the *guerreiros de lança* (warriors with spears) from the rural Maracatu is found in the black *danzantes* (dancers) in a Venezuelan celebration of Corpus Christi.[41] This same body language is also replicated in the *terreiro* of *candomblé*, an Afro-Brazilian religion, thereby underscoring the shared significance of the gesture of humility before Christ and the attitude of the initiated who salute the *orixá* or an older person from their particular *casa de santo* (house of the saint). It is difficult to determine the origin of this body language. Which came first, Christian devotion or the ancestral memory of rites from distant lands that have been lost forever? Which was the first experience, Catholic or African, to acquire a new meaning and influence the other?

Such examples can be multiplied indefinitely, attesting to the similarities and continuities between forms of popular culture and a distant Baroque ancestry. The connection between popular manifestations and an erudite or high culture, long viewed as exclusively associated with the Baroque, is thereby reestablished and enforced in the festival, often in uncanny ways. The festival provides a material, visual, and auditory social field through which symbolic meanings are expressed and, consequently, represented aesthetically. The festival reveals its true significance as a transition between daily

existence and art, therefore becoming a sign of a particular sensibility. In a society such as Brazil's, organized around the spectacle of power, with everything geared toward celebration, the Baroque festival can reveal the place of the black man and woman in society by providing them a place in the public arena. Here, even slaves—despite the day-to-day violence to which they were subjected—were guaranteed their place. At least in the eyes of God everyone is perceived as equal. For this reason, despite their ambiguity, the festival has always provided a sense of belonging and inclusion. The great processions that celebrate the triumph of Corpus Christi by exhibiting heresies conquered by the Christian faith, including the cosmologies of the black slaves, which are presented allegorically by dances with drums, have paradoxically guaranteed that these cosmologies continue to be exhibited, albeit in Catholic processions.[42]

African Cosmologies, National Culture

The permanence of the Baroque spirit in the festival, restricted in our time to popular forms, may shed light on some of the characteristics of our society and culture. As an archaic form of culture, the festival teaches social hierarchy and placement, but it also provides a radical model of equality regarding the kingdom of God. It establishes an ethics of reciprocity, imposing solidarity among equals and obligations of reciprocity, even if asymmetrical, among unequals. Roberto DaMatta designates the festival's tripartite system of reference—the home, the street, and the other world—in order to explain the ambiguous limitations separating private and public spheres and the dilemma of a society unable to decide once and for all between the ethics of individual interests and the ethics of reciprocity among people, between equality and hierarchy.[43] Not knowing what one wants because—following Plato, like the philosopher and the child, one always wants both—is an indeci-

siveness typical of the Baroque. Or, to paraphrase Eugenio d'Ors, the Baroque spirit is naturally attracted to the forms that fly but is unable to give up the forms have weight.[44] The Baroque is caught between the vertigo of transcendence and the convincing of the senses, between the infinity of the cosmos and the glory of the ephemeral, between eternity and the splendorous transience of life.

The Baroque festival provides the best guarantee for the perpetuation of the cosmologies of blacks slaves, for whom life was already the experience of death. Daily life became the attempt to extract some meaning from existence, provided by the joy of the drums that enabled slaves—surrendering in trance to the dance—to reconnect with their ancestors and the *orixá*. The rhythms, sounds, tastes, gestures, and postures were carefully categorized in the nineteenth century by the painter Johann Moritz Rugendas and reappeared in the works of his contemporaries, Nicolas Antoine Taunay and Jean-Baptiste Debret. Yesterday's exuberant attire or the humble manner of performing daily work—like today's splendor of a dance of the *orixás* in a festival in the *terreiro* or of the *passista* (dancers) of a samba school—revealed a permanence expressed by the body. The body is the last stronghold of cultural resistance and persistence. It allows us to understand that permanence is also the effort of the soul to preserve a world vision that, in a two-way flux, runs between Africa and Brazil and signifies integration and exchange more than untouched identity.

Conclusion

By collecting the fragments of African cosmologies that impregnate the Brazilian imagination, we attempt to reflect upon the things that surround us but which we do not see, as well as those things that we see and negate: the absorption, deep and complete, of African cultures by slave society. This absorption is so ancient that we are no longer conscious of it. These cul-

tures have proven their capacity to persist and have made us forget that their native soil is elsewhere. Art provides a means through which we can remember and recognize this fact. Although used in the context of Catholic worship, as an expression in recognition of a miracle, a cross that an anonymous believer ornamented with an *ibejis* and a votive offering is a quasi-magical object, a fetish filled with power. The nineteenth-century images of saints that slaves from Vale do Paraíba in São Paulo sculpted from *nó-de-pinho*, a hardwood of particular strength, provide another such example; it is said that the protection they offered was proportional to the difficulty of their sculpting. In both cases, these fetish-sculptures show the same reduction of lines and volume. These figures' synthetic characteristics recall sculptures, Bembe or Bambara in origin, of the sacred Twins or a ritual mask.[45] Though the motif is Catholic in function, the aesthetic behind these beautiful objects of devotion is undoubtedly African.

The hand that creates—by sculpting wood, painting a canvas, knitting cloth—establishes a dialogue between the material and mind of the creator. In some instances, the material dictates the form, forcing the creator to extract a predetermined figure; in others, the motif subverts the material, dictating aerial symbols and oneiric images. Hand, motif, and material, nonetheless, are brought together by technique, a social product that results from accumulated knowledge and the manual skill attained through the work routine. A system of meanings is thereby created, and art becomes a code of communication that condenses the memory of a group and unfolds as a daily plot in the creator's life. The black imagination in Brazilian art is expressed in the popular universe as though it were the native language. Few descendants of slaves, however, are recognized as artists. The majority are referred to as craftsmen or artisans, terms associated with craft, a so-called lesser art. Their products are recognized not as culture but as folklore. Consequently, the importance of the African heritage is best understood within the tradition of popular art. It is manifested in a minimalist aesthetic that, reducing the representation of the motif to its synthetic suggestion, may be rediscovered by contemporary artists tracing their own courses, thereby returning to the canonical forms of archaic African sculpture. The reinvention of the splendor of the churches of Minas Gerais or Pernambuco can be found in the rich ornaments of simple altars, the ritual objects of Afro-Brazilian cults, or in the explosion of colors of the costumes and the *carros alegóricos* (allegorical floats) of a samba school. This should cause no surprise. Black, mulatto, and mestizo artisans were able during the eighteenth century to hear the echoes of the 1600s and to re-create the Baroque with the inevitable originality of the copy. The exchange between old and new, tradition and invention, that continues to occur on both sides of the Atlantic, uniting them, is filled with echoes of African roots, the diaspora, and the aesthetics of resistance. For this very reason, it has universal meaning.

Translated from the Portuguese by Michael Reade.

Notes

1. Gilberto Freyre, *Casa grande e senzala* (Brasília: Ed. UnB, 1963).

2. Claude Lévi-Strauss, *O pensamento selvagem* (São Paulo: Cia. Ed. Nacional, 1976).

3. Pierre Verger, "Influências África-Brasil e Brasil-África," in E. Araújo, ed., *Brasil Africa Brasil. Pierre Verger 90 anos* (São Paulo: Pinacoteca do Estado, 1992).

4. Manuel Querino, *A arte culinária na Bahia* (Salvador: Livraria Progresso Ed., 1954), and Roger Bastide, "A cozinha dos deuses. Candomblé e alimentação," *Cultura e alimentação*, no. 1 (January 1950).

5. Haroldo Costa, "O negro na MPB," *Revista do patrimônio histórico nacional* 25 (1997).

6. Roberto Moura, *Tia Ciata e a pequena África no Rio de Janeiro* (Rio de Janeiro: Funarte, 1983), and M. L Montes, "O erudito e o que é popular: estética negra de um espetáculo de massa," *Revista USP* 36 (January–March 1996).

7. Pierre Verger, *Notas sobre o culto aos Orixás e Voduns na Bahia de Todos os Santos, Brasil, e na antiga Costa dos Escravos, Africa* (São Paulo: EDUSP, 1998), and Emanoel Araújo and M. L. Montes, eds., *Negro de corpo e Alma* (São Paulo: Associação Brasil 500 Anos/Fundação Bienal, 2000).

8. Pierre Verger, *Fluxo e refluxo do tráfico de escravos entre o Golfo de Benin e a Bahia de Todos os santos. Séc. XVI a XX* (Salvador: Corrupio, 1987).

9. Robert W. Slenes, "Malungo, n'goma vem!" *Revista USP* (December–February 1999).

10. Robert Farris Thompson, *Flash of the Spirit: African and Afro-American Art and Philosophy* (New York: Random House, 1983).

11. Thompson, *Flash of the Spirit*, and Placide Tempels, *Bantu philosophy* (Paris: Présence Africaine, 1969).

12. Lísias Nogueira Negrão, *Entre a cruz e a encruzilhada* (São Paulo: EDUSP, 1996).

13. Slenes, "Malungo, n'goma vem!" and Carlos Eugênio Marcondes de Moura, *A travessia da Calunga Grande* (São Paulo: EDUSP/FAPESP, 2000).

14. Alberto Costa e Silva, "O Brasil, a África e o Atlântico no século XIX," *Studia* 52 (1994).

15. Baba Ifa Karade, *The Handbook of Yoruba Religious Concepts* (York Beach, Maine: Samuel Weiser, 1994), and Natalia Bolívar Aróstegui, *Los orishas em Cuba* (Havana: Ediciones Unión, 1990).

16. Carlos Eugênio Marcondes de Moura, ed., *Olóòrìsà. Escritos sobre a religião dos orixás* (São Paulo: Ed. Ágora Ltda., 1981), Moura, ed., *Bandeira de Alairá. Outros escritos sobre a religião dos orixás* (São Paulo: Nobel, 1982), and Moura, *Leopardo dos olhos de fogo* (São Paulo: Ateliê Editorial, 1998).

17. Monique Augras, *O duplo e a metamorfose: A identidade mítica em comunidades nagô* (Petrópolis: Vozes, 1983).

18. Juana Elbein Santos, *Os nàgò e a morte. Pàde, Asèsè e o culto Egun na Bahia.* (Petrópolis: Vozes, 1977).

19. Claude Lépine, "Contribuição ao estudo do sistema de classificação dos tipos psicológicos no candomblé ketu de Salvador," doctoral thesis, Dep. Ciências Sociais/FFLCH/ USP, São Paulo, 1978.

20. Verger, *Notas sobre o culto aos Orixás e Voduns na Bahia de Todos os Santos, Brasil, e na antiga Costa dos Escravos, Africa.*

21. Pierre Verger, *Lendas africanas dos orixás* (Salvador: Corrupio, 1985), and Reginaldo Prandi, *Mitologia dos Orixás* (São Paulo: Companhia das Letras, 2000).

22. Roberto Gambini and Lucy Dias, *Outros 500* (São Paulo: Ed. SENAC, 2000).

23. Gregório de Matos, *Poemas Escolhidos* (São Paulo: Ed. Cultrix, 1976).

24. Mário Andrade, *Paulicéia Desvairada* (São Paulo: s/e, 1922).

25. Rossini Tavares Lima, *Da conceituação do lundu* (São Paulo: s/e, 1953).

26. Araújo and Montes, *Negro de corpo e Alma.*

27. Jorge de Lima, *Poesia completa* (Rio de Janeiro: Ed. Nova Aguilar, 1997).

28. Luís Gama, *Primeiras trovas burlescas de Getulino* (São Paulo: Typographia Dous de Dezembro, 1859).

29. Darcy Ribiero, *O povo brasileiro* (São Paulo: Companhia das Letras, 1995).

30. Adenor Gondim, "As Senhoras da Boa Morte," in E. Araújo, ed., *Arte e religiosidade no Brasi—Heranças africanas* (São Paulo: Pinacoteca do Estado, 1997).

31. Lima, *Poesia completa.*

32. Francisco Calmon, *Relação das Faustíssimas Festas* (1762), facsimile reprint (Rio de Janeiro: Funarte/INL, 1982).

33. Arnold Hauser, *História social da arte e da cultura* (Lisbon: Jornal do Foro, 1954).

34. Jacob Burckhardt, *Civilisation de la Renaissance en Italie* (Paris: Plon, 1958).

35. Lévi-Strauss, *O pensamento selvagem.*

36. Marcel Mauss, *Sociologia e antropologia* (São Paulo: EDUSP, 1974).

37. Robert Darnton, *O grande massacre de gatos* (São Paulo: Brasiliense, 1989).

38. Clifford Geertz, *The Interpretation of Cultures* (New York: Basic Books, 1973).

39. Simão Ferreira Machado, "Triunfo Eucharistico" (1734), in Affonso Avila, ed., *Resíduos seiscentistas em Minas. Textos do século de ouro e as projeções do mundo barroco* (Belo Horizonte: Centro de Estudos Mineiros, 1967), and M. L. Montes, "Entre a vida comum e a arte: a festa barroca," in E. Araújo, ed., *O universo mágico do Barroco brasileiro* (São Paulo: CIESP/SESI, 1998).

40. J. Mesa and Teresa Gisbert, "Ángeles y Arcángeles," in *El retorno de los ángeles* (La Paz/Paris: Union Latine, 1997), and Dominique Fernandez, "Donceles y soldados," in *El retorno de los ángeles.*

41. Fundação Bigott, "Corpus Christi," *Revista Bigott* 15 (1989).

42. René Ribiero, *Cultos afro-brasileiros do Recife* (Recife: Instituto Joaquim Nabuco de Pesquisas Sociais, 1952).

43. Roberto DaMatta, *A casa e a rua* (Rio de Janeiro: Ed. Guanabara, 1987).

44. Eugenio d'Ors, *O barroco* (Lisbon: Vega, s/e).

45. George Nelson Preston and Emanoel Araújo, *Afro-minimalismo brasileiro* (São Paulo: Best Ed./MASP, 1987).

Afro-Brazilian Art

The role played by Africa in the formation of the Brazilian collective consciousness cannot be overstated. From the earliest contacts between the New and the Old Worlds, cultural patterns have developed in Brazil that parallel those of many of the African civilizations from which slaves were taken. Food, language, visual art, music, and dance are all elements of Brazilian culture that have been permeated and enriched by contributions from Africa.

Some of the greatest masters of the Baroque period, such as O Aleijadinho (Antônio Francisco Lisboa) and Mestre Valentim, were of African descent, and many examples of Baroque sculpture bear witness to the impact of Africa. These include images of the Virgin and angels with dark skin and African features, and representations of the many "black saints," such as Saint Elesbão and Saint Efigénia. Gold and silver jewelry from Bahia also testifies to the significance of African inspiration in the ornamental arts.

The African influence is also of considerable importance in regard to contemporary art. Brazilian art historian Marta Heloísa Leuba Salum has stated that "Afro-Brazilian art is a contemporary phenomenon . . . encompassing any expression in the visual arts that recaptures, on one hand, traditional African aesthetics and religiosity and, on the other, the sociocultural contexts of blacks in Brazil." The art of Mestre Didi is a key link in understanding the phenomenon of Afro-Brazilian art. His ritual scepters and other pieces, fashioned from palm ribs, leather, shells, and other materials connect the manifestations of the Yoruba spirits with allusions to ancient myths of creation. They possess an inherent power, both spiritual and visual, and serve as icons expressing the potency of contemporary artistic and religious experience.

Works by Agnaldo Manoel dos Santos, GTO (Geraldo Teles de Oliveira), and Maurino Araújo share a common style and spirit. The totemic sculptures of dos Santos and Araújo reflect an ongoing dialogue with traditional forms of African wood carving. In the highly complex sculptures of GTO, human figures appear to crawl over one another, creating dynamic patterns suggesting organic growth. Rubem Valentim created two- and three-dimensional totemic figures that appropriate the Constructivist vocabulary of the Concrete movement. His relief sculptures entitled *Temples of Oxalá* (1977, cat. nos. 214.1–.3) refer to an important *orixá* (god/spirit) of the Nagô-Yoruba religion. Ronaldo Rego, a priest in the Umbanda religion (which combines elements of Bantu and Christian worship), creates works that suggest sacred rituals. His *Oratory* (1990s, cat. no. 213), for example, recalls an intimate home altar, while at the same time providing a site for the reaffirmation of the power of faith. In his choice of colors, Rego makes reference to specific *orixás*, such as Xangô, whose personality is identified with red. —Edward J. Sullivan

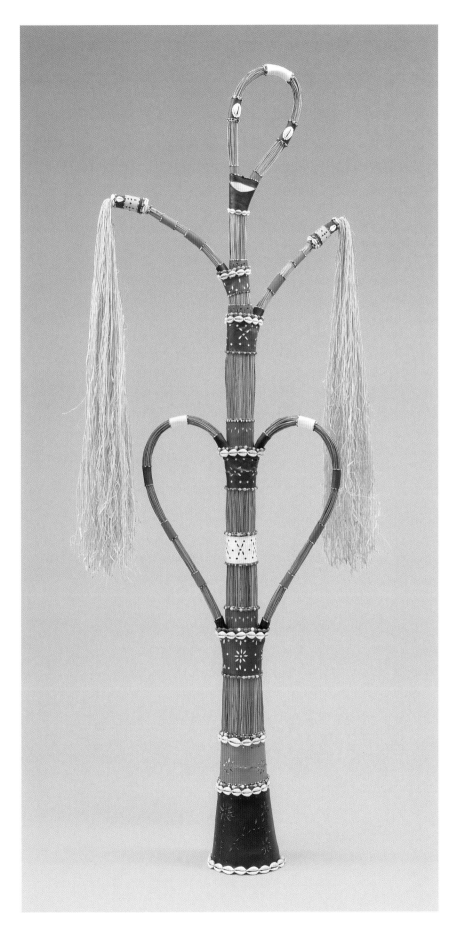

188. MESTRE DIDI *Iwin Igi (Ancestral Spirit of the Tree)*, 1999. Bundled palm ribs, leather, beads, and cowrie shells, 190 x 60 cm. Collection of the artist

348

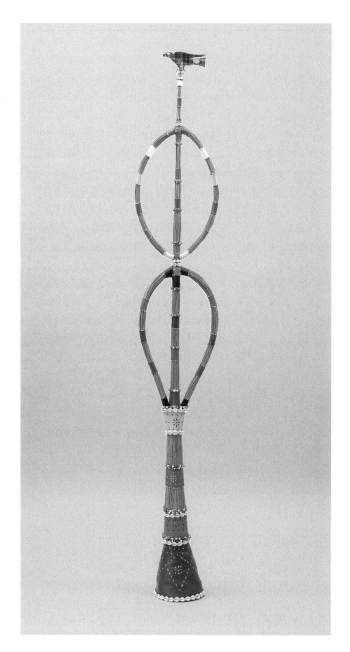

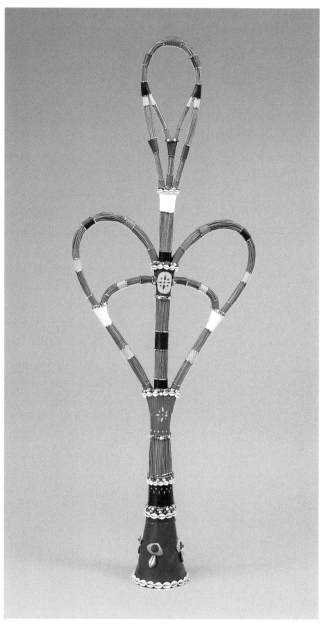

LEFT: **189. MESTRE DIDI** *Òpò Orun Oun Aiye (Pillar Uniting this World and the Other)*, 1999. Bundled palm ribs, leather, beads, and cowrie shells, 210 x 35 cm. Collection of the artist. RIGHT: **190. MESTRE DIDI** *Oná Ibametá Awo (The Three Paths of the Mysterious Cross-Roads)*, n.d. Bundled palm ribs, leather, beads, and cowrie shells, 142 x 55 cm. Collection of the artist

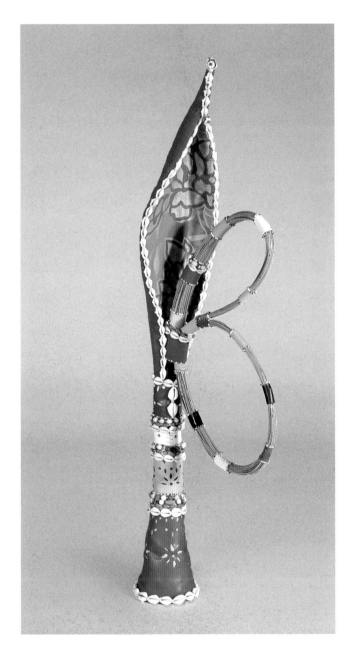

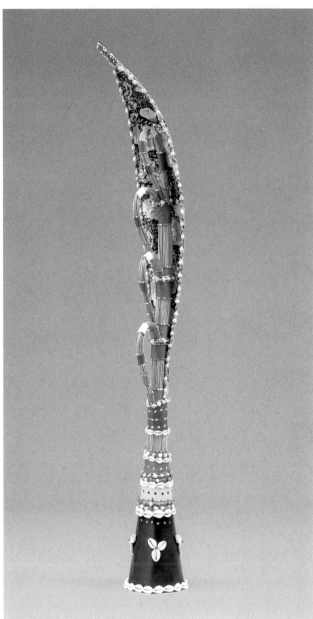

LEFT: **191. MESTRE DIDI** *Ope Awo II (Mysterious Palm)*, n.d. Bundled palm ribs, leather, beads, and cowrie shells,
68 x 34 x 12 cm. Collection of the artist. RIGHT: **192. MESTRE DIDI** *Asé Nàná Ninu Ibô (Power of the Forest in the Earth)*, 1999.
Bundled palm ribs, leather, beads, and cowrie shells, 107 x 20 cm. Collection of the artist

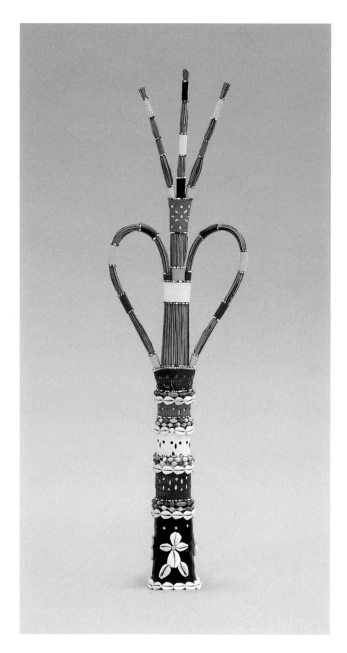

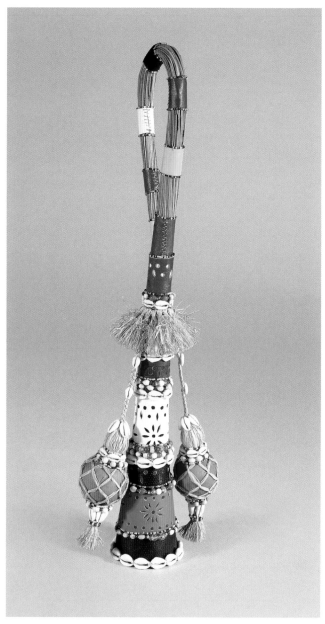

LEFT: **193. MESTRE DIDI** *Oná mètá (The Three Paths)*, n.d. Bundled palm ribs, leather, beads, and cowrie shells, 130 x 40 x 16 cm. Collection of the artist. RIGHT: **194. MESTRE DIDI** *Opá Ibiri ati ado Meji (Nanã's Scepter)*, n.d. Bundled palm ribs, leather, beads, and cowrie shells, 69 x 12 x 24 cm. Collection of the artist

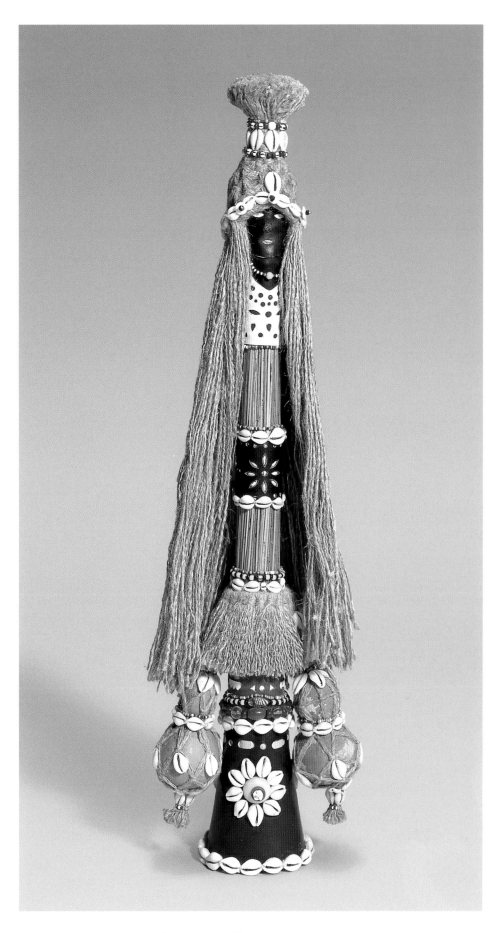

195. MESTRE DIDI *Òbá Obadena (King of the Sentinels)*, n.d. Bundled palm ribs, leather, beads, and cowrie shells, 68 x 24 x 24 cm. Collection of the artist

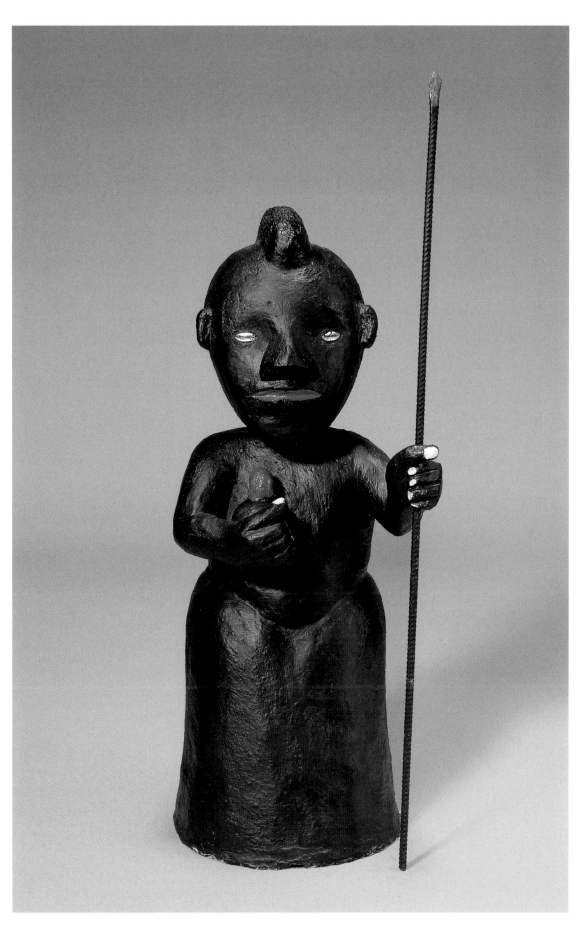

196. MESTRE DIDI *Ésù Amuniwá (Orixá Eshu with his Cabalash of the Expansion)*, n.d. Mixed media, 67 x 20 x 18 cm.
Collection of the artist

354

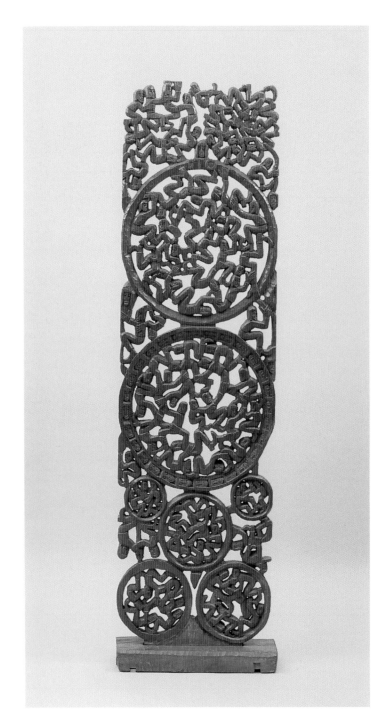

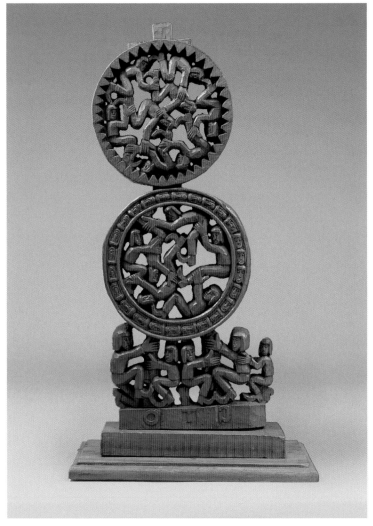

LEFT: **197. GTO (Geraldo Teles de Oliveira)** *Column*, n.d. Wood, 224 x 65 x 22 cm. Pé de Boi Galeria de Arte Popular, Rio de Janeiro. RIGHT: **198. GTO (Geraldo Teles de Oliveira)** *Column*, n.d. Wood, 118 x 64 x 30 cm. Atração Escritório de Arte, São Paulo

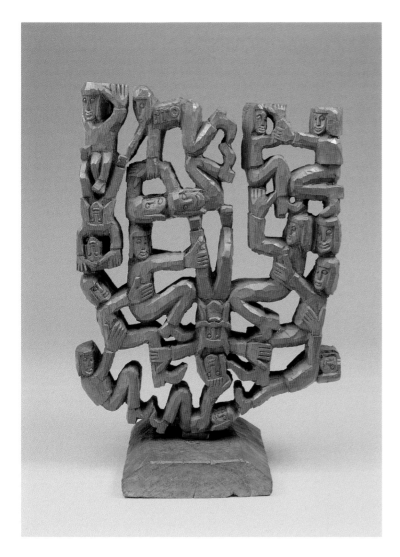

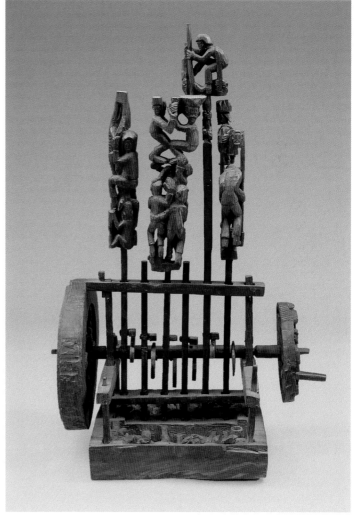

LEFT: **199. GTO (Geraldo Teles de Oliveira)** *Untitled*, n.d. Wood, 70 x 48 x 26 cm. Atração Escritório de Arte, São Paulo. RIGHT: **200. GTO (Geraldo Teles de Oliveira)** *Untitled*, n.d. Wood, 94 x 62 x 37 cm. Collection of Paulo Vasconcellos, São Paulo

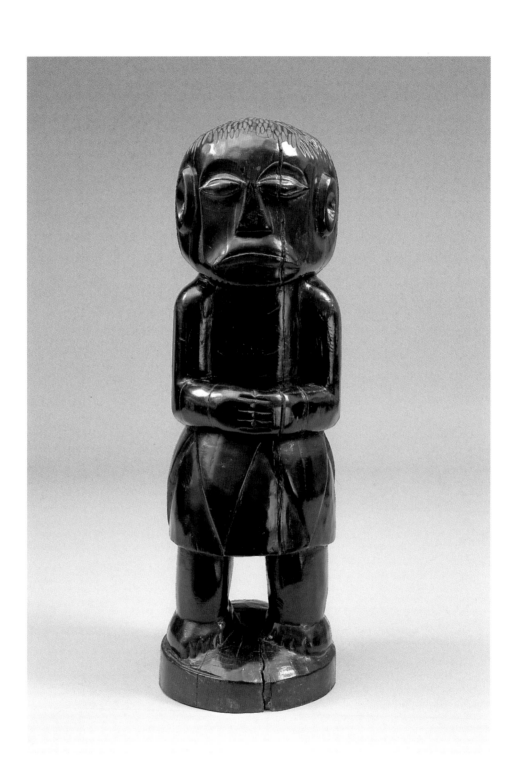

201. AGNALDO MANOEL DOS SANTOS *Untitled*, n.d. Wood, 65 x 20 x 24 cm. Collection of Ladi Biezus, São Paulo

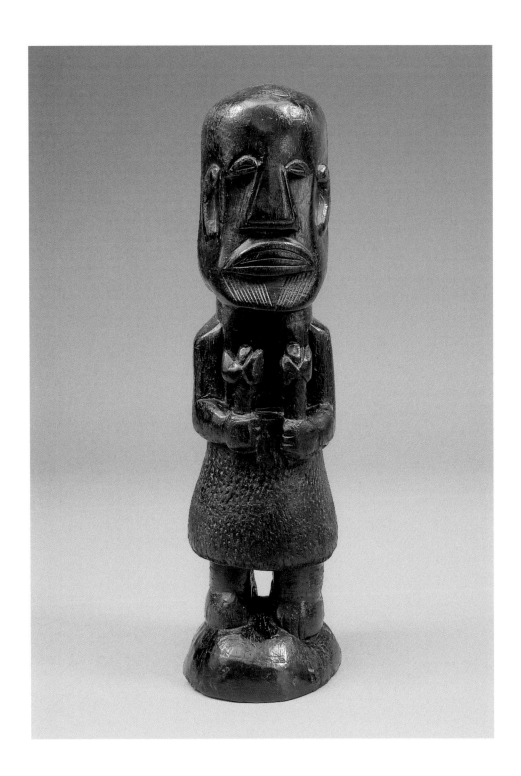

202. AGNALDO MANOEL DOS SANTOS *Xangô*, n.d. Wood, 60 x 16 x 16 cm. Private collection

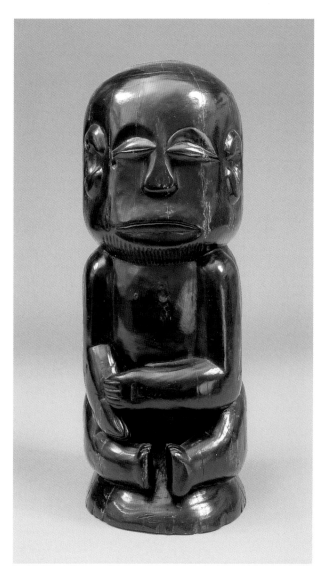

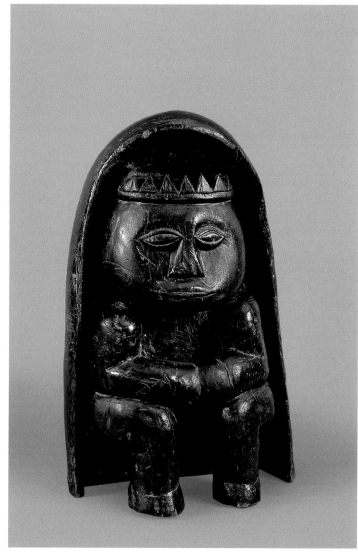

LEFT: 203. AGNALDO MANOEL DOS SANTOS *Figure*, 1950s. Wood, 60 x 23 x 31 cm. Atração Escritório de Arte, São Paulo. RIGHT: 204. AGNALDO MANOEL DOS SANTOS *Seated King*, n.d. Wood, 52 x 29 x 23 cm. Collection of Ladi Biezus, São Paulo

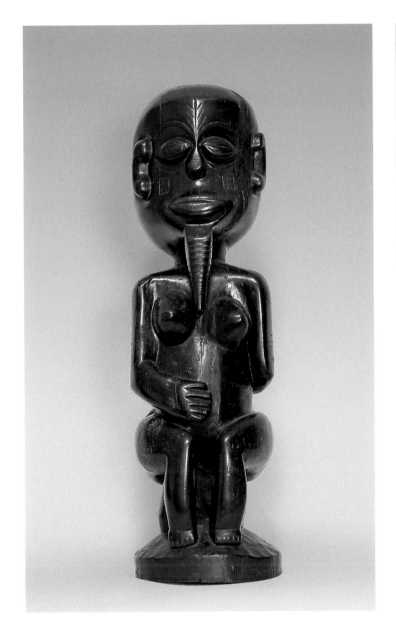

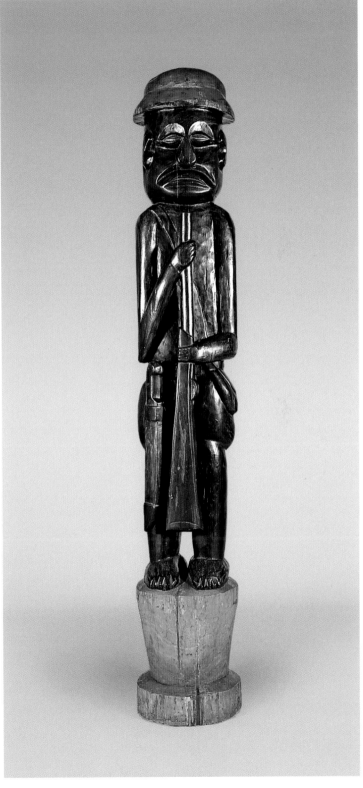

LEFT: **205. AGNALDO MANOEL DOS SANTOS** *Seated Figure*, 1950s. Wood, 68 x 21 x 24 cm. Atração Escritório de Arte,
São Paulo. RIGHT: **206. AGNALDO MANOEL DOS SANTOS** *Oxossi the Hunter*, n.d. Wood, 196 x 33 x 35 cm. Fundação
Cultural do Estado da Bahia, Museu de Arte Moderna da Bahia, Salvador

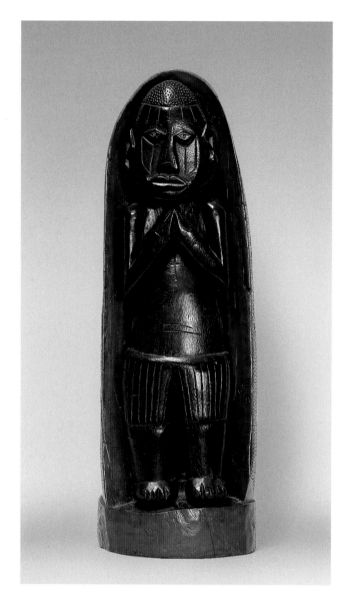

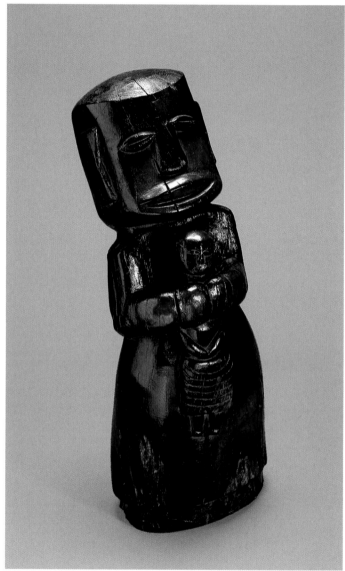

LEFT: **207. AGNALDO MANOEL DOS SANTOS** *Saint*, 1950s. Wood, 72 x 24 x 22 cm. Atração Escritório de Arte, São Paulo. RIGHT: **208. AGNALDO MANOEL DOS SANTOS** *Figure with Child*, n.d. Wood, 58.5 x 22 x 15.5 cm. Collection of Ladi Biezus, São Paulo

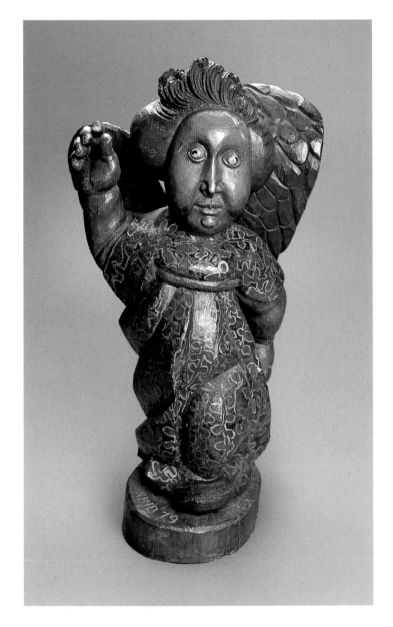

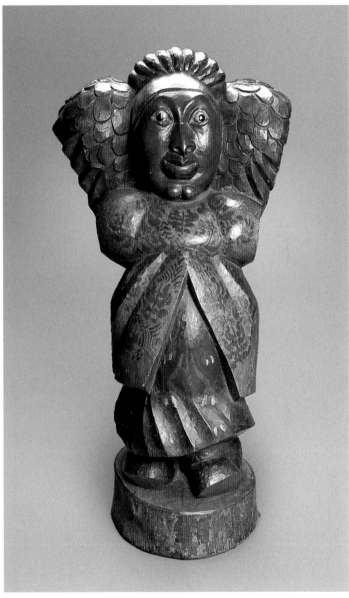

LEFT: **209. MAURINO ARAÚJO** *Angel*, n.d. Polychromed wood, 63.5 x 34 x 29 cm. Collection of Diógenes Paixão.

RIGHT: **210. MAURINO ARAÚJO** *Angel*, n.d. Polychromed wood, 63.5 x 34 x 29 cm. Collection of Diógenes Paixão

211. RONALDO REGO *Little House of Eres*, 1992. Polychromed wood, 90 x 60 x 14 cm. Collection of the artist

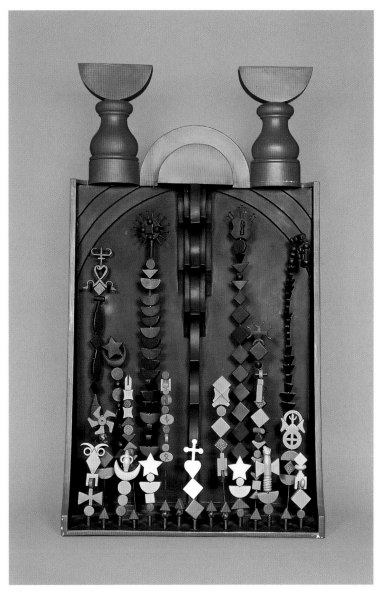

LEFT: **212. RONALDO REGO** *For Your Upturned World*, 1991. Polychromed wood, 100 x 43 cm. Collection of the artist.
RIGHT: **213. RONALDO REGO** *Oratory*, 1990s. Polychromed wood, 128 x 72 x 29 cm. Pinacoteca do Estado de São Paulo

FACING PAGE: 214.1. RUBEM VALENTIM *Temple of Oxalá*, 1977. Acrylic on wood, 128 x 76 x 76 cm.
Fundação Cultural do Estado da Bahia, Museu de Arte Moderna da Bahia, Salvador

214.2. **RUBEM VALENTIM** *Temple of Oxalá*, 1977. Acrylic on wood, 155 x 70 x 70 cm. Fundação Cultural do Estado da Bahia, Museu de Arte Moderna da Bahia, Salvador

214.3. RUBEM VALENTIM *Temple of Oxalá*, 1977. Acrylic on wood, 220 x 78 x 78 cm. Fundação Cultural do Estado da Bahia, Museu de Arte Moderna da Bahia, Salvador

368

LEFT: 215. RUBEM VALENTIM *Relief Emblem no. 6*, 1968. Acrylic on wood, 150 x 100 cm. Private collection.
RIGHT: 216. RUBEM VALENTIM *Relief Emblem no. 2*, 1977. Acrylic on wood, 150 x 100 cm. Private collection

217. RUBEM VALENTIM *Relief Emblem no. 8*, 1977. Acrylic on wood, 150 x 100 cm. Private collection

Modern Br

azil

Literary and Artistic Culture in Modern Brazil

Haroldo de Campos

One cannot speak of modern Brazilian culture without making certain critical remissions to its past or, better said, to the dialogical relationship between its past as culture and its present as creation. To do so, one must look at this diachrony in a synchronic manner, in order to make evident the disruptive elements within the dominant tradition. As the linguist Edward Stankiewicz notes:

> The problem of synchrony in poetic language is different from the one in everyday language. Poetic traditions are immersed in diachrony. Synchrony comes in only in our attitude toward diachrony, in our acceptance or rejection of the poetic traditions which have been transmitted to us. . . . I think that the attitude we take toward particular traditions leads us to continuous innovations.[1]

Convergently, the critic Roman Jakobson

conceived the possibility of a suprastructural "historical poetics," which, in turn, prompted Gérard Genette to propose a "structural history of literature."[2] Within such formulations one must also consider Walter Benjamin's warning: "All images of the past that do not allow themselves to be recognized as significant by the present that sought them are irrecoverable, and risk disappearing."[3]

Such preliminary considerations can be applied to both the literary and the artistic domain. For this reason, the *Brazil: Body and Soul* project can be programmatically defined by its effort to focus on two distinct periods of artistic production: the Baroque and the twentieth century. Taking as a guiding principle the "Baroque prevalence in Brazilian art," as stated by the art historian Leopoldo Castedo, the exhibition and its accompanying publication propose to articulate the cultural links that can be identified by comparing both periods. Castedo, who opposes traditional criticism

and historiography, proposes that certain "coincidences in temperament and style," characteristic of the Baroque, contributed to "Brazil's cultural independence occurring before its political independence."[4]

In a similar though more radical vein, I have elsewhere advocated the thesis that Brazilian literature has never had an origin that could be pinpointed and chronologically determined. I say more radical because such a claim strips all substantialist residue and challenges the very notion of identity. Such a view thwarts the attempts to establish the beginning of a gradual evolutionary and formative process, whose maturity might coincide with the political emancipation of Brazil in 1822 and with the emergence of Romantic nationalism.[5] In my thesis, the transformative, transtemporal process is more relevant to Brazilian culture than its formative process. The latter conforms to the essentialist metaphor of origin and identity (national spirit) and is heavily impregnated with organic-ontological concepts. The transformative process, on the other hand, corresponds to a modal emphasis, in which attention is given to the movement of "difference" against a universal backdrop.

Regarding the issue of origin, I have argued that Brazilian literature never had an infancy. There was never an embryonic phase in the biological sense, of a maturity progressively attained and preceded by a sort of tentative and rudimentary kindergarten. "Infant" comes from the Latin *fari*, meaning he or she who does not speak and, consequently, lacks discursive fluency. During the Portuguese-Brazilian colonial period, literature was never aphasic, that is, without voice; rather, it was born adult, immediately speaking the most elaborate code of the era: the universal stylistic repertoire of the Baroque. Within this context, forged in the setting of the tropical-American New World, an exuberantly creative poet such as Gregório de Mattos Guerra (1636–1695) was able to establish his unique mark. More produc-

tive than "origin" with its genetic-evolutionary imprint, is the operational concept of *Ursprung* elaborated by Walter Benjamin. *Entstehung* (genesis), viewed as a point of origin, culminates in the *Parousia* (presence) of a conclusive identity. *Ursprung* derives from the etymological notion of a "jump" and is associated with *Verwandlung* (transformation). It is the vertigo of this process that produces "difference."[6] The eruption of Brazilian Baroque within the context of the ecumenical art of the seventeenth and eighteenth centuries can be aptly described as a jump and was nothing short of vertiginous. The prevalence of the Baroque noted by Castedo might also be likened to the Benjaminian notion of *Fortleben* ("afterlife") through which this style can be dispersed in multiple avatars, posterior to its historical moment.[7]

The development of an awareness of a Baroque "afterlife" can be traced in the critical trajectory of the literary historian António Candido. In his fundamental book *Formação da literatura brasileira: Momentos decisivos* (1959), Candido initially opted for the historiographic criterion of formation, critically reinterpreting and updating the ideal of Brazil's Romantic period.[8] He did so in accordance with the concept of histories of national literatures, characteristic of nineteenth-century European criticism, and guided by the ideological criterion of political autonomy. In "Literatura de dois gumes" (1966), however, Candido hints at a shift away from his formative historiographic position, which had disregarded the Baroque as an anomalous outbreak, and instead began to move toward what I call an oxymoronic position—fully realized in "Dialética da malandragem" (1970)—where the prevalent critical objective was to capture a "feeling of opposites" by identifying in a given cultural or literary tendency the play of opposite components. Such a perspective appeared to be more inclined toward transformation than formation. The Baroque, previously scrapped or reduced to the condition of a mere literary and

cultural manifestation without any formative-systematic relevance, here becomes a pole in a dynamic game of opposites. This constituted a way of seeing that Candido himself avows to be more dialectic. The Baroque style therefore typified a "crucial language," which by its "sense of extremes and opposites" was adaptable to the New World and its "unknown or uncommon reality." The redeemed Baroque had the ability, as Candido now recognizes, to generate "tenacious means of expressions that, in spite of the passage of literary styles, remained as something congenial to the country."[9]

Synchronic incisions into diachronic culture enable us to trace the unique traits that allow us to refer to the stylistic "after-life" of the Baroque. First, a bit of history. Three seventeenth-century writers from Bahia deserve special attention: the poets Gregório de Mattos Guerra and Manuel Botelho de Oliveira (1636–1711); and the Jesuit mestizo prosaist Antônio Vieira (1608–1697). During a time in which Portugal prohibited the printing press in Brazil, the writings of Mattos acted as a newspaper of the colony, to the point that his verses are an invaluable source of historical research.[10] Mattos was perfectly versed in all poetic genres, from the lyric to the religious. He was also an exceptional satirist, evidenced both in his scathing criticism of social behavior and in his erotic-eschatological works. Linguistic fusion is another distinctive trait of Mattos's poetry. He employed a hybrid Portuguese that was sprinkled with Spanish, indigenous languages, and African words, not to mention the playful use of prankish or even crude popular expressions. The contemporary Portuguese critic Alfredo Margarido has referred to it as a "transethnic language."

Oliveira was less important than Mattos but was equally representative. Oliveira was the first Brazilian author to have a book published during his lifetime: *Música do parnaso* (Lisbon, 1705). He was a multilingual poet (Portuguese, Spanish, Italian, and Latin) who anticipated the polyphonic vocation of Brazilian culture. The critic-historian Luciana Stegagno Picchio describes his outstanding short poem "A ilha da maré" as the moment when the "sensory exasperation of the Baroque becomes focused . . . on the pleasures of the palate" and, consequently, on the fauna and flora of the tropics, which are referred to by their strange and melodic indigenous names: *cajus, pitangas, pitombas*.[11] With regard to the eloquent prose of Vieira, both Brazil and Portugal lay claim to his Baroque splendor. He was born in Lisbon in 1697 but was active both in the colony and in Europe. It was in Brazil that Vieira wrote some of his most beautiful sermons and became a champion, in the manner of Las Casas, of the indigenous people's cause.[12]

Brazilian Arcadianism of the 1700s, represented, above all, by the so-called Plêiade Mineira, was not just a Neoclassical expression of a frontal opposition to the Baroque in the Illuminist fashion of Luís António Verney, the author of *Verdadeiro método de estudar* (1746) and a critic of Luís de Camões (1524?–1580), Vieira, and the Baroque metaphor as a whole. The Arcadianist works issuing from Vila Rico (now Ouro Prêto) are impregnated with Baroque mannerisms and stylization, especially in the cases of Cláudio Manoel da Costa and Alvarenga Peixoto. For this reason, Sérgio Buarque de Holanda states that Arcadianism in Brazil was "an isolated incidence that had neither immediate repercussions, nor thwarted the blossoming of the tendencies connected with the late Baroque."[13]

Between the Plêiade Mineira and Romanticism, one finds the extreme example of a so-called unclassifiable writer who was rejected by the historiographic canon: Odorico Mendes (1799–1864), the remarkable humanist from Maranhão. Similar to George Chapman in English and Johann Heinrich Voss in German, Mendes was the creative translator into

Portuguese of Greek and Latin epics such as the *Iliad*, *Odyssey*, and *Aeneid*. Mendes's daring syntactical-lexical flights and refined phraseology led Sílvio Romero in *História da literatura brasileira* (1888) to attack Mendes's work as being "monstrous" and "contorted." This stigmatizing verdict, often repeated, is currently being supplanted by modern studies in translation, which finally recognize Mendes as the patriarch of "transcreative translation."[14]

Candido has advanced the idea that Brazilian Romanticism established an integrated literature with a harmonious and transparent language, where the emotional fervor characteristic of the movement was moderated by a Neoclassical Arcadianism. This view can only be sustained by ignoring the disruptive elements that act as foreign bodies and, from the edges, attack and disrupt the linear-teleological course of traditional historiography. Candido's thesis makes it imperative that all discordant voices "outside the habitual discourse of time," to use Romero's phrase, be systematically minimized or canceled. Of course, this is not tenable.

The most clamorous example of disruption of teleological order occurs with Joaquim de Sousa Andrade (1832–1902), known as Sousândrade. Chronologically, he has been considered a second-generation Romantic and today is widely held to be the most original and innovative poet of that period. His long poem *Guesa* (1868–88), in which Romantic travels in a Byronic vein are presented in a descriptive-narrative style, is filled with Baroque imagery and syntax, along with neological polyglot inventions. In contrast, his deft use of satire, reminiscent of Mattos's bold language, is present in two outstanding sections of *Guesa*. One, "Tatuturema" (*Canto II*, 1858–68), stages an orgiastic dance in Amazonia, revealing an upside-down nativism—decadent "savages" corrupted by the white conqueror and tamed by religious instruction—through a hybrid language that com-

bines Portuguese, Tupi, and Latin. In the other section, "Inferno de Wall Street" (*Canto X*, 1877–88), we find the native Central and South American pilgrim (symbolized by Guesa, a ritualistic victim in the mythology of the Muiscas of Colombia) being confronted by the chaotic universe of the New York Stock Exchange, presided over by the Mammon god. In the end, Guesa is sacrificed to the speculators and magnates, the real power behind the Gilded Age of North America. Employing a multilingual style of composition, the poem constitutes an early diatribe against the ascending exploitation of American-style capitalism. It anticipates both the financial hell of Ezra Pound's *Cantos* and—given the trans-American amplitude of Guesa's pilgrimage and the utopian celebration of an Inca-inspired socialism—Pablo Neruda's *Canto general*.[15]

Satire, exponentially expanded by the Baroque, is echoed in other singular works of Brazilian literature. *Cartas chilenas*, attributed to the Arcadianist Tomás Antônio Gonzada (1744–1814), is one such example. Another is the eschatological *Exilir do pagé* by Bernardo Guimarães (1825–1884), which is a shameless parody of the heroic language that sought to idealize the native Brazilian, the best example of which might be the poem "I-Juca-Pirama" by the prototypical Romantic, Gonçalves Dias (1823–1864). Still another example of satire's corrosive and demystifying power can be found in "Bodarrada" by the Afro-Brazilian abolitionist poet Luís Gama (1830–1882). When Candido, in "Dialética da malandragem," traces this satiric vein, he does so by abandoning his former teleological orientation and adapting a nonlinear and fragmentary manner, describing popular sources such as "Pedro Malazarte," the "cursing muse" of Mattos, or the "*malandro*" (tricksterlike) novel of Manuel António de Almeida, *Memórias de um sargento de milícias* (1854–55), a unique and innovative version of the Baroque picaresque, which later reappeared in the experimental novels of Oswald de Andrade

(*Memórias sentimentais de João Miramar*, 1924; *Serafim ponde grande*, 1934) and Mário de Andrade (*Macunaíma*, 1928).

To further expand our transtemporal inquiry, we include the last period of Joaquim Maria Machado de Assis (1839–1908), which has been considered abortive by Romero.[16] These works, distinguished by a crystalline style and an aesthetics of sparseness, bestow on Machado the status of Brazil's Borges of the 1800s. Due to his innovative contributions to the techniques of fiction, these works can be advantageously reread in the light of the Manipean satire and against the backdrop of Mikhail Bakhtin's theories of carnivalization and dialogism. These innovations present certain similarities to Almeida's novel, but the good-natured, realistic, and popular satire of *Memórias de um sargento de milícias* is contradicted by Machado's acid, disenchanted, and ambiguous metaphysical irony.[17] We should also mention Cruz e Sousa (1861–1898), the "*cisne negro*" (black swan) who led our Symbolism: the Brazilian branch of the artistic movement that initiated the rehabilitation of Luis de Góngora y Argote in Europe. Cruz e Sousa, in a sonnet committed to the antislavery cause, makes use of the syntagma "red, colossal, thunderous, Gongorical" to express his indignation against the callous advocates and beneficiaries of slavery and to harass them.[18] (Brazil was the last country on the American continent to abolish slavery; it lasted until 1888, coexisting with the Empire of Pedro II until the eve of the Republic.)

With regard to prose, a Baroque style laced with scientific jargon can be glimpsed in the winding language of Euclides da Cunha's documentary epic *Os sertões* (1902). (The same can be said, going back for a moment to poetry, of "Eu" (1912) by the unique Augusto dos Anjos, with its bizarre phonic explosions and frequent anatomical-pathological themes.) Raul Pompéa, Cunha's contemporary, employed in *O Ateneu* (1888) an obsessively verbal aesthetics that at times borders on the grotesque. Mário de Andrade recognized it as the "last and final expression of the Baroque in Brazil," comparing its effects to the golden churches of Santo Antônio in Rio de Janeiro and São Francisco in Salvador.[19]

The dispersed stylistic features of the Baroque are spontaneously projected on the present production of Brazilian literature. Likewise, the curves of the buildings of the architect Oscar Niemeyer appear to replicate the captivating curves of the Baroque in Minais Gerais and the art of O Aleijadinho; Jean-Paul Sartre was correct in detecting this convergence. [20] Like Lezama Lima, the Cuban who saw the miscegenation of the tropical-American Baroque as an art of counterconquest, Oswald de Andrade defined it as a utopian style capable of saving Europe from its "Ptolomeic egocentrism." Oswald's Anthropophagy, making use of the vocabulary of cannibalism, was a movement that sought to devour European values and critically masticate them from a Brazilian perspective. In a certain way it was the Modernist parallel, in the 1920s, to Baroque's earlier hybridism. Anthropophagy was put forward by Oswald's *Manifesto antropofágo* (1928) and Mário de Andrade's panfolkloric rhapsody *Macunaíma* (1928). Oswald's anthropophagic way of thinking can be thought of as an anticipatory, though crude, form of deconstructionism. Augusto de Campos refers to the seventeenth-century poet Mattos as our "first anthropophagous."[21]

Guimarães Rosa's neo-glossal novel *Grande sertão: Veredas* (1956), with its multilingual impregnation and universal themes camouflaged by a regional sensibility, is already a Neo-Baroque manifestation in all its vitality. Another example is *Paradiso* (1966) by the Cuban Lezama Lima. Prior to that, the Baroque tendency had made its mark in Brazil, though in a less accomplished way, in Jorge de Lima's *Invenção de Orfeu* (1952), a verbose, lengthy and rhetorical poetry explicitly influenced

by Camões and Mendes. Affonso Ávila's poems in *Cantaria barroca* (1975) are also, by definition, Baroque. João Cabral de Melo Neto, with his geometrical compositions and especially in his serial and combinatorial poems of engineering ingeniousness, can also be viewed as Neo-Baroque; we must not forget that Johann Sebastian Bach, mathematician of fugues, was a late-Baroque musician. The coexistence of proliferation and simplicity—consider the orthogonality of the urban colonial facades—is not rare in Brazil's Baroque universe. For this reason, Brazilian Concretist poetry was criticized both for its semantic-structural likeness to the Baroque as well as for its departure from the antiseptic purity and ideological absenteeism of the Concrete poetry and plastic conceptions of the Swiss Eugen Gomringer and Max Bill.[22]

The Cubist-inspired work of the painter Tarsila do Amaral, in her *Pau-Brasil* and *Antropofagia* phases, was a predecessor of a Constructivist movement in Brazilian art. While structurally sophisticated and influenced by Fernand Léger, Tarsila's work was invigorated and Brazilianized by her choice of themes and, above all, by its use of a rural sense of coloring, which she incorporated with deliberate formal simplicity. Another predecessor was Vicente do Rêgo Monteiro, who in the 1920s employed a quasi-monochromic ocher, frequent indigenous themes, and a geometric style that was between Art Deco and Cubism. finally there is Alfredo Volpi, highly praised for his paintings of orthogonal facades and little flags and masts. This master of compositional simplicity and subtlety of tempera colors coexisted during the 1950s with the young Constructivists/Concretists from São Paulo. That decade witnessed the blossoming of a Concretist vanguard not only in São Paulo—the Brazilian capital of industrialization and the setting for the Modernist revolution of the exhibition *Semana de arte moderna* in 1922—but also in Rio de Janeiro, where the dissident Neo-Concretists arose after 1958. Though it by

no means implies specific affinities with the government's developmentalist program, these artists had as their epistemological metaphor the city of Brasília, President Juscelino Kubitschek's new capital. It is well known that the favorite art form of the Brazilian president, since the time he governed Minas Gerais, was not poetry or even pictorial art but architecture. And his favorite artist, beginning with the chapel of Pampulha in Belo Horizonte, was the Marxist Niemeyer—a fact that attests to the open-mindedness and democratic tolerance of Kubitschek.

Brazil's colonial past, with virtually a single-crop agricultural economy based on slave labor until the end of the Empire, gave way in the 1950s to a predominantly industrial economy. Since the 1980s, Brazil has been the world's eighth largest economy. In spite of such changes, archaic structures persist in Brazilian society. Fundamental social and economic problems have obstructed the advancement of a real democracy based on the attainment of true citizenship. Many issues remain unresolved, such as agrarian reform, which might alter the hegemony of vast landed estates, or a just redistribution of wealth, which is concentrated in the hands of a small minority. It is unnecessary to underline the fact that since the dark years of the military dictatorship, starting in 1964, these inequalities have only increased, even though that dictatorship per se ended in the mid-1980s.

As my theme is culture, it is fitting that I turn to a proposition of Friedrich Engels, Karl Marx's collaborator, who speaks of the "predetermined domination of the division of labor." Each period, "presupposes a specific intellectual heritage (*Gedankenmaterial*), which is transmitted by its predecessors and becomes its starting point." This explains why "it can happen that economically backward countries," in this specific domain, "can become those who play first violin." It is true that Engels refers to classical

German philosophy in the context of an economically backward and politically reactionary Germany as compared to the English industrial revolution and the French political revolution. However, it is clear that his proposition/paradigm can be applied, by analogy, to other singular spheres of intellectual activity, such as the literature and arts of so-called peripheral countries like Brazil.[23]

With regard to culture, one can not speak of "underdevelopment," an expression, as Octavio Paz ironically warns, that is derived from United Nations economic jargon.[24] Machado de Assis, for example, were it not for the limited exposure of Brazilian literature and the isolation of the Portuguese language, would have been considered, already in his time, among the great writers of world literature.[25] Many of his most distinguished international readers acknowledge as much, including the Cuban Cabrera Infante, the Peruvian Vagas Llosa, the Mexican Carlos Fuentes, and the North Americans John Barth, John Updike, and Susan Sontag.

Modern and contemporary Brazilian culture has achieved universal recognition, whether in its literary,[26] artistic, or architectural expressions, as well as with such films of Baroque sensibility as *Deus e o Diabo na Terra do Sol* (1964) by Glauber Rocha and *Os sermões de Vieira* (1990) by Júlio Bressane, to use only two examples. Likewise in music, consider the minimalist bossa nova and the exuberant and sophisticated works of the Tropicália. Brazilian culture has been able to overcome its infrastructural constraints while, when circumstances have so dictated, remaining critical and combative regarding the injustices of its context.

Translated from the Portuguese by Michael Reade.

Notes

1. Edward Stankiewicz, comment to "Part Nine: Retrospects and Prospects," in Thomas A. Sebeok, ed. *Style in Language*, (Cambridge, Mass.: MIT Press, 1960). See also Haroldo de Campos, "Por uma poética sincrônica," in de Campos, *A arte no Horizonte do Provável* (São Paulo: Perspectiva, 1949).

2. Roman Jakobson, "Concluding Statement: Linguistics and Poetics," in Sebeok, *Style in Language*; and Gérard Genette, "Structuralisme et critique litttéraire," in *Figures* (Paris: Seuil, 1966).

3. Walter Benjamin, "Über den Begriff der Geschichte," Theses V, VI, and XIV and Apendix A, in *Gesammelte Schriften*, vols. 1 and 3 (Frankfurt: Suhrkamp Verlag, 1978).

4. Leopoldo Castedo, *A constante barroca na arte brasileira* (São Paulo: MEC/Conselho Federal de Cultura, 1980); and Castedo, "El barroco y su decoración—De Roma al mestizaje americano y a la identidad brasileña," *Barroco*, no. 17 (Itatiaia: Belo Horizonte, 1993–96).

5. See Haroldo de Campos, "Da razão antropofágica: Diálogo e diferença na cultura brasileira" (1980), in de Campos, *Metalinguagem e outras metas* (São Paulo: Perspectiva, 1992); and Campos, *O seqüestro do barroco na formaçãoda literatura brasileira: O caso Gregório de Mattos* (São Paulo: Fundação Casa de Jorge Amado, 1989).

6. See Haroldo de Campos, *O seqüestro do barroco na formaçãoda literatura brasileira*; and Jacques Derrida, *La Grammatologie* (Paris: Les Éditions de Minuit, 1967).

7. For concept of *Fortleben*, see Walter Benjamin, "Die Aufgabe des Übersetzers," *Gesammelte Schriffen*, vol. 4 , bk. 1.

8. António Candido, *Formação da literatura brasileira: Momentos decisivos* (São Paulo: Editora Martins, 1959). See also Hans Robert Jauss, "Literaturgeschichte als Provokation der Literaturwissenchaft" and "Geschichte der Kunst und Historie," in Jauss, *Literaturgeschichte als Provokation* (Frankfurt: Suhrkamp Verlag, 1970); and Roberto Ventura, "Uma história épica," in *Estilo tropical: História cultural e polêmicas literárias no Brasil* (São Paulo: Companhia das Letras, 1991).

9. António Candido, "Dialética da malandragem," *IEB/USP*, no. 8 (1970); and Candido, "Literatura de dois gumes"(1966), in Candido, *A educação pela noite e outros ensaios* (São Paulo: Editora Ática , 1987). See also Haroldo de Campos, "A poesia concreta e a realidade nacional," in *Tendência* no. 4 (Itatiaia: Belo Horizonte, 1962) for the characterization of the Baroque as a "formal constant of Brazilian sensibility."

10. See Segismundo Spina, *Gregório de Mattos* (São Paulo: Editora Assunção Ltda., 1946); Stuart B. Schwartz, *Burocracia e Sociedade no Brasil Colonial* (São Paulo: Perspectiva, 1979).

11. Luciana Stegagno Picchio, *La Letteratura Brasiliana* (Milan: Sansoni, 1972). In a similar manner, a listing of typical names and flowers in the Taino language appears in the Canary Islands writer Silvestre de Balboa's *El espejo de paciencia* (1608), a Baroque epic claimed, for its pioneering place in Cuban literature, by Romanticism and the contemporary era.

12. Vieira is described as the "*grande figura luso-brasileira*" in *Dicionário cronológico dos autores portugueses*, vol. I (Instituto Português do Libro/Publicações, Europa-América, 1985).

13. Sérgio Buarque de Holanda, *Capítulos da Literatura Colonial Brasileira* (São Paulo: Editora Brasiliense, 1991).

14. Haroldo de Campos, "Da tradução como criação e como critica" (1962), in de Campos, *Metalinguagem e outras metas* (São Paulo: Perspectiva, 1992).

15. See Augusto de Campos and Haroldo de Campos, *Re-visão de Sousândrade* (São Paulo: Edições Invenção, 1964) second ed.: Nova Fronteira, 1982); and Haroldo de Campos, "La peregrinación transamerica de Sousándrade," *Cuadernos americanos (nuevo época)* 6, no. 78 (UNAM, 1999).

16. See Sílvio Romero, *Machado de Assis: Estudo comparativo de literatura brasileira* (Rio de Janeiro: Laemmert & Co. Editores, 1897).

17. See J. G. Merquior, "Gênero e Estilo das Memórias Póstumas de Braz Cubas," *Colóquio/letras*, no. 8 (Lisbon: Gulbenkian, 1972); Enylton de Sá Rego, *O calundu e a panacéia: Machado de Assis, a sátira menipéia e a tradição luciânica* (Rio de Janeiro: Forense Universitária Editora, 1989); Picchio, *La letteratura brasiliana*, which mentions that Almeida's "'stylistic line' has in Machado his nodal point." In Spanish-speaking America, the Mexican Fernández de Lizardi (*El periquillo sarniento*, 1816) was the first to return to the picaresque style; because of this, Emir Rodriguez Monegal (*The Borzoi Anthology of Latin American Literature*, vol. 1, New York: Knopf, 1977) associates him with Almeida.

18. Luciana Stegagno Picchio refutes the opinion of Astrojildo Pereira, who believes that Symbolism, being a reactionary movement, "was agreeable to the objectives of the counter-revolution" and refers to the "sonnets, poems and abolitionist prose" of the Afro-Brazilian poet Cruz e Sousa as examples. In a similar vein, see Alfredo Bosi, *História concisa da literatura brasileira*, 32nd ed. (São Paulo: Cultrix, 1994). Curiously, Ferreira Gular, in "Vanguarda e modernidade" (*Tempo brasileiro*, no. 26–27, 1971), takes Pereira's restricted position further by stating that the Brazilian Symbolism of Cruz e Sousa, as a whole, was an alienated movement with not connection to our reality.

19. Mário de Andrade, "O Ateneu" (1941), in de Andrade, *Aspectos da literatura brasileira* (São Paulo: Martins Editora, n.d.).

20. See Affonso Ávila, *O poeta e a consciência crítica*, second ed. (São Paulo: Summus Editorial, 1978). From the architectural point of view, the O Aleijadinho-Niemeyer parallel had already been established by Lúcio Costa in "Carta-depoimento"(1948) and "Depoimento de um arquiteto carioca" (1951), in Costa, *Sobre arquitetura*, vol. 1 (Pôrto Alegre, Brazil: Faculdade de Arquitetura do Rio Grande do Sul, 1962).

21. See José Lezama Lima, *La expresíon americana* (Santiago de Chile: Editorial Universitaria, 1969); Oswald de Andrade, *A marcha das utopias* (1953); Haroldo de Campos, *Morfologia do Macunaíma* (São Paulo: Perspectiva, 1972); and Augusto de Campos, "Arte final para gregório" (1974), in Augusto de Campos, *O anticrítico* (São Paolo: Companhia das Letras, 1986).

22. See Theon Spanudis, "Gomringer e os poetas concretos de São Paulo," *Suplemento dominical, Jornal do Brasil* (Rio de Janeiro, Sept. 15, 1957); Haroldo de Campos, "Construtivismo no Brasil: Concretismo e neoconcretismo," in Lisbeth Rebollo Gonçalves, ed., *Tendências construtivistas* (São Paulo: Acervo do MAC/USP, Centro Cultural Banco do Brasil, 1996). Lúcio Costa, "Oportunidade perdida" (1953), in *Aspectos da literatura brasileira*, refutes Max Bill's criticism regarding the "Baroque excesses" ("capricious and gratuitous curves") of Oscar Niemeyer, attributing it to Bill's "purist functionalism."

23. Freidrich Engels to Conrad Schimidt (1890), in Karl Marx and Engels, *Sur la litterature et l'art* (Paris: Éditions Sociales, 1962).

24. Octavio Paz, "Invención, subdesarrollo, modernidad," in Paz, *Corriente alterna* (Mexico: Siglo XXI, 1972).

25. See António Candido, "Esquema de Machado de Assis," in Candido, *Vários escritos* (São Paulo: Livraria Duas Cidades, 1970).

26. Mario Benedetti states "Hoy en dia, el escritor latinoamericano está en un pie de igualdad con los creadores de otras tierras y otras lenguas." ["Today, the Latin-American writer is on equal footing with the creators of other lands and other languages."] Mario Benedetti, "Temas y Problemas," in *America Latina en su literatura*, C. Fernández Moreno, ed. (Paris: Siglo XXI/UNESCO, 1972).

Places of Modernism in Brazil

Icleia Maria Borsa Cattani

For Modernist artists in São Paulo during the 1920s, Brazil was an undefined place, both as a physical site and as a homeland and residence for Modernist artists. The nation was undergoing a slow process of industrialization, torn between a scarcely known, often disdained past and a present profoundly marked by the patrimonialism and self-importance of a provincial elite resistant to any change in social structures. The growing desire among artists to affirm something new, to assert their cultural and artistic identities as Brazilians, was discussed alongside values and practices imported from "Mother Europe." How could the desire to be culturally and artistically modern be realized, and how could a new place be created from such contradictory and uncertain conditions?

Paradoxically, the intention of inaugurating a new moment in art for this country of the future, as Brazil was generally considered, was not accompanied by any desire to make a tabula rasa of the past, as was the case with the avant-garde in Europe. On the contrary, modern radicalism was ignored in favor of the humanist tradition in vogue in Brazil at the time, a tradition from which the first organized Modernist movement never managed to sever ties.[1] Writers such as Mário de Andrade and Oswald de Andrade emphasized the antagonism between the new socioeconomic reality of the metropolis—although this reality was modest compared with the metropolises of the developed world—and the provincial and conservative reality of cultural and artistic life.

In any analysis concerning Modernist painting in Brazil, which mainly developed in the city of São Paulo in the period between 1917 and 1929, two interrelated processes should be taken into account: first, the desire among artists to move forward, in view of the art produced in Europe, and disavow the Brazilian academic tradition; second, the association of these artists not with the more avant-

garde European movements but with those that responded to the economic and political crises occurring on the old continent by connecting themselves with a return to order. This resulted in a neutralization of previous ruptures and a reinsertion of "tradition" and the "eternal values" of art into contemporary artistic production.[2] Such were the underlying concepts for the "avant-garde" in São Paulo during the 1920s, when industrialization was being implemented through the periodic slash-and-burn measures that were characteristic of the country's subordination within the international capitalistic system. As an inevitable result of the process of rapid importing and implementation of alien systems, the ideology of change preexisted the actual production of works of an innovative nature.[3]

The Birth of Brazilian Modernism
From the early 1910s and up until the 1920s, poets and writers such as Mário de Andrade and Oswald de Andrade began to write about the need to modernize Brazilian culture, establishing a concept of Modernism as an entity that preexisted outside of Brazil. It was to be the task of top intellectuals to claim and incorporate Modernism as part of a new phase of Brazilian culture. Nevertheless, given the provincialism of the cultural environment, results were slow to appear.

Exhibitions within the framework of Modernist idioms caused negligible repercussions. In 1917, however, an exhibition by Anita Malfatti came as something of a revelation to some young artists and intellectuals. Malfatti had returned to São Paulo after studying in Germany and the United States, and the paintings she showed were clearly Expressionist in nature. The esteemed critic and writer Monteiro Lobato wrote a virulent article attacking this exhibition, causing those who yearned for new forms of expression to rally around the painter. As a result, this event was considered the "fuse of Modernism."[4]

Modernism began to become more concrete during the 1920s, and was officially born in São Paulo in February 1922 at the *Semana de arte moderna* (Week of modern art), an exhibition that brought together a group of writers and artists who were preoccupied with bringing the country into the present culturally and artistically. The *Semana de arte moderna* remains something of an inaugural event on a symbolic level, comparable to the Armory Show that had taken place in the United States nine years earlier, despite differences in the type of works presented at the two exhibitions.[5] The main objective of the Brazilian artists was to announce the arrival of Modernism rather than actually or fully applying it to their art. Modernism had already existed in Europe, and it was up to the Brazilians to bring their country up to date, once again importing the product of an external sociocultural process. The works that were exhibited are characterized by merely a few Modern fragments and a general sense of eclecticism, be it from one artist to another or even in the works of the same artist. This eclecticism indicates not only a desire to experiment in the different styles considered to be Modern by the Brazilians of the time but also a more didactic impulse to show the public the possible broader spectrum that existed in Modernism.

Nevertheless—and in this regard the *Semana de arte moderna* confirmed a tendency toward figuration and representation relating to nineteenth-century Brazilian art—the artists proceeded with a very specific reading of the diverse currents of Modernism, selecting from Fauvism, Expressionism, and even nineteenth-century Symbolism, as well as a so-called post-Cubism. The exhibition can be considered a milestone more in terms of the scandal it provoked and the programmatic impulse it exposed than by the actual qualities of the works presented. The real quest for Modernism in art began after the *Semana de arte moderna*.

In 1923 Victor Brecheret, Emiliano Di Cavalcanti, Anita Malfatti, Oswald de

Andrade, Vicente do Rêgo Monteiro, and Tarsila do Amaral all were in Paris. Malfatti's creative trajectory had ended in 1917, after Monteiro Lobato's criticism, but the other artists began to develop their own styles, which mixed Expressionist and Post-Cubist elements with formal, chromatic and thematic elements directed toward a synthesis of Modernism with the "Brazilian" spirit.

Tarsila is one of the most representative artists in terms of how Modernism began to assert itself in Brazilian visual arts. She was studying in Paris when the *Semana de arte moderna* occurred in February 1922. When she returned to Brazil a few months later, she became a convert to Modernism through the influence of a few artists and writers. In 1923 she returned to Paris to study Modern art, undergoing what she referred to in an interview at the end of the year as "military service in Cubism."[6] This expression reveals the regulating and disciplining extreme with which she envisioned her apprenticeship in Modernism. Albert Gleizes and André Lhote, her teachers during that year, were artists who promoted a dogmatic vision of Cubism based on rules and edicts and inevitably linked to French tradition. The position of Fernand Léger, under whom she also studied, was somewhat different. He developed a less dogmatic law of generalized contrasts, which Tarsila applied in her *Pau-Brasil* series of paintings. But even Léger went through a period of rigorous systematization that was contrary to the avant-garde's freedom of experimentation.

The other Brazilian artists in Paris at the time adopted their own formal systems, which included elements alluding to these same models. Léger's influence is evident in the monumental and hieratic nature of the figures in Rêgo Monteiro's *Pietà* (1924), in which we can also perceive elements of Expressionism—mostly from the work of the sculptor Ernest Barlach—as well as of non-European formal systems. Di Cavalcanti borrowed even further from Expressionism, most notably from Otto

Dix and Georg Grosz. His career as a caricaturist is exemplified by the Expressionist drawings he completed in 1923. Later works continue to show Expressionist characteristics, along with Post-Cubist traces and clear allusions to African sculpture. Brecheret, who had been in Paris since 1921, was developing an intensely Expressionist style of sculpture, apparent not only in the strange positions and features of his figures—as in *Head of Christ* (1920–21), exhibited during the *Semana de arte moderna*—but also in the dramatic play of light and shadow on the volumes.

During these apprenticeships in Modernism, and simultaneous definitions of individual styles, it can be clearly seen that artists were appropriating from the various styles considered to be Modern at the time. In some works they established a harmonious commingling of formal systems that were originally incompatible.

Rediscovering Brazil

The appropriations made by Modernist artists sometimes appeared in the form of playful experimentalism. They initiated games with the formal systems that had served as their models. It is here that the conundrum of "Modernist" painting can be discerned, namely in the dichotomy between place and contexts. The "play on appropriation" essentially refers to the systematic appropriation of various semiotic traces from Modernist European painting, along with their playful manipulation in contexts that differ from the original source. The "play on accumulation" is characterized, on the other hand, by recourse to works marginalized by the official Brazilian culture: indigenous art, primitive art, popular art, and art of African origin, as well as the specific subversions of Baroque art from Minas Gerais, in particular, trompe l'oeil, in which the absence of perspectival depth causes figures, clouds, and other elements to seem to accumulate on a single plane, thereby creating superimpositions.[7] There was a clear desire to create a style of painting employing

indigenous cultural and ethnic sources that had specific formal and thematic characteristics, but at the same time, a Modern and erudite style.

Thus, subsequent to or simultaneous with (depending on the artist) the period of apprenticeship to Modernism, there was a preoccupation with the search for signs that might connote "Brazil," the place, in the works of each artist. Through her own career Tarsila once again translated in an extremely evident way this desire to create individual formal systems that were both Modern and self-identifying, thus creating a sense of equality of difference.

In 1924, Tarsila made two trips to "rediscover" Brazil: the first to Carnival in Rio de Janeiro; the second to Semana Santa, or Holy Week, in Minas Gerais. These trips gave birth to a singular style, one marked not only by Léger's law of generalized contrasts—softness juxtaposed with rigidity, flatness with volume, etc.— but also by a palette that was unique and unusual for European Modernism and inspired by Brazilian popular culture. Tarsila's color choices—such as pinks, ceruleans, sulfurous greens—were ones that, according to her, she had learned were in "poor taste." Inspired by Modernism's sense of freedom, she used this palette in her paintings during this period.[8] The canvases from 1924 to 1927 comprise what is generally called her *Pau-Brasil* period. In 1924 Oswald de Andrade published his *Pau-Brasil* manifesto based on these paintings, proposing a program for integrating Modernism and primitivism, economic and social modernization (through industrialization), and cultural identity. In Tarsila's *Pau-Brasil* paintings such as *São Paulo* (135831) and *E.F.C.B.* (both 1924, cat. nos. 227 and 228) we can see an amalgamation of mechanical elements (bridges, towers, numbers, train cars, traffic signs, all rendered with flat, geometric borders or forms, using pure colors such as red and bright blue) with elements that identify the Brazil of popular, small-town culture (simple houses and churches, coconut palms and other tropical plants also rendered using Tarsila's unique palette with plant life painted in volumetric and rounded-off forms). The images are characterized by an accumulation of elements. While these formal machinations follow Léger's, the juxtaposition of divergent elements creates spaces of uncertainty, as if they were torn between formal systems and distinct, irreconcilable realities.[9]

During this same period other Modernists were forging similar paths. Di Cavalcanti would establish his poetic vision based on the popular typology of Brazilian society, notably from Rio de Janeiro and Afro-Brazilian culture. Thus, his paintings such as *Samba* (1925, cat. no. 238) and *Five Girls from Guaratinguetá* (1930, cat. no. 236) outline thematic and chromatic differences in relation to European models, especially by employing a warm palette with a predominance of earth tones, which render his style personal and immediately identifiable. Rêgo Monteiro, who was already conducting research on indigenous cultures, developed a system of monumental and volumetric forms employed in nearly monochromatic paintings. The sources of his poetic vision are linked to the Marajoara culture in Amazonia, with its anthropomorphic earthenware funerary urns, and the bas-reliefs of European antiquity. From these origins he created images of archetypal depth, marked by symmetry and immobility, as well as by intensely expressive, stylized faces. Even when dealing with Christian themes, as in the *Pietà* of 1924, Monteiro's paintings have an archaic substratum that distinguish them from European works of the period.

Parallel Idioms

Lasar Segall, who settled in Brazil in 1923, became closely associated with the Modernist movement during the following years. His own style, which was marked by Expressionism, sometimes showed the thematic insertion of ele-

ments from tropical nature or ethnic types that existed in Brazil, as seen in his *Black Mother* (1929) and *The Banana Grove* (1927, cat. no. 226). His formal system underwent new experimentations similar to those of Di Cavalcanti and Tarsila. We can see the effect of accumulation, also present in Tarsila's works of this period, in Segall's painting *Brazilian Landscape* (1925). The two-dimensional relationship between figure and background present in his works such as *Boy with Lizard* (1925) is rather unique since it evokes representations in Brazilian popular art. Of the Modernist painters practicing in Brazil, Segall was the one to most closely approach the ideal of Mário de Andrade's "Brazilian painting," which posited that Expressionism was the international style most suited to the Brazilian sensibility because it was representative of the country's own cultural identity.[10]

Artists in Rio de Janeiro are also worth mentioning. Ismael Nery created paintings and drawings whose salient oneiric quality is similar to that of Marc Chagall's work, which he came to know during a trip to Paris in 1927. Over time, and in view of his personal life, typified by illness and an obsession with death, Nery took to depicting distorted bodies that were cut open, quartered, and with exposed viscera. As with Frida Kahlo in Mexico, the Surrealist aesthetic was a revelation for this artist, and it enabled him to express a strongly autobiographical universe. Cícero Dias was also drawn to Surrealism but as a pretext for another form. His works—creating a playful, often sensual universe in which strange scenes at times veer toward the nonsensical—have a sense of lightness and mirth and a poetic understanding of the world that distinguish them from other Surrealist art.

Myths

Beginning in 1928, Tarsila entered a new period in her painting career that was marked by monumentalization and the reduction of elements, as well as by the use of volume to bring uniformity and

equivalence between depictions of humans and plants. Her canvas *Abaporu* (1928), whose title uses the Tupi-Guarani word for cannibalism, moved Oswald de Andrade to publish the *Manifesto antropófago* (Cannibalist manifesto), announcing a movement that promoted the abandonment of Western rationalism in favor of a "liberating primitivism," proposing the symbolic devouring of the "other" and the absorption of its essential qualities in order to produce something new and unique.

Tarsila's *Anthropophagy* (1929, cat. no. 234) reproduces the central figures of her paintings *Black Woman* (1923, cat. no. 218) and *Abaporu*. *Anthropophagy* not only transfers these works onto the same canvas—where both assume tremendous similarity, as if two sides of the same body—it also transfers them from 1923 to 1929. In the mythic totemization of *Anthropophagy*—taboo transformed into totem, according to Oswald—vegetation also becomes totemic. To a certain extent vegetation becomes assimilated into the human body and metamorphosed by it.

Anthropophagy refers back to the myth of a young country with a voracious desire to conquer backwardness, capable of incorporating numerous models in its art in order to create something new. Tarsila's painting renders this myth visually in its corporeal transformations, substitutions, metamorphoses, and distortions. It also provides fertile ground—the circular division of space, the expansive use of color—for the circularity of the mythic odyssey, wherein the hero always returns to his origins, for atemporality, the "timeless forever now," and for formal modalities: intensity of colors and their harmonious application, reversible paths, monumentality, hieratism, frontal figuration.[11] Many of these characteristics are also present in various paintings by Di Cavalcanti and Rêgo Monteiro from previous years, which provide a configuration of similar formal questions and exchanges. In paintings by Tarsila such as *The Egg* (1928, cat. no. 233),

Forest (1929), and *Setting Sun* (1929, cat. no. 232) accumulated space is now preceded by an illusion of depth, while still evading the laws of classical space. The relationship between forms is no longer established according to the modalities of superimposition and juxtaposition but is articulated by means of the structuring of figure and background. The horizon cuts the canvas in half, which allows for the opposition of two areas of color nearly equivalent in size. The number of colors diminishes, while their intensity increases.

Tarsila's mythic spaces are, to an extent, open to the infinite. They are spaces in which signs become significant due to their limited number, their position on the canvas, and their corporeality. Her paintings are bound by a poetic vision of the circular, of the oval, which refers to the myth of heroic return, though somewhat modified. The *Antropofagia* movement may very well have provided the setting for Tarsila's Ithaca: from *Black Woman* to *Anthropophagy*, from point of departure to point of arrival, arriving the same, yet changed. The figures in *Black Woman* and *Abaporu* have been adapted, seeking a union in which they might lose their own features in order to assimilate with the "other" and the surrounding vegetation.

A contiguity with Surrealism during this period of Tarsila's work is evident, through the openness of possibilities and the projection of the unconscious into her art, not to mention the corporeal transmutations, substitutions, and metamorphoses and the splicing and collage of elements, which typify the processes of the unconscious and dreams and were familiar to artists of the time through the writings of Sigmund Freud. When Oswald proposed "cannibalism" as a guiding theoretical principle for his specific vision of Brazilian culture, there was a double taboo that was being transformed into a totem, since the "other" was double in nature: first, the European culture imposed by colonization, which was the fixed model; second, the indigenous, popular Brazilian cultures,

as distant from the white elite of European origin, or more so, as from the original conquistadors. The devouring was a double act, marked by the admiration and rage of the European and the consequent superiority and guilt of the Brazilian in relation to other Brazilians. The totem would be created from the white, modern, cultivated Brazilian: the Modernist, qualitatively equal to his or her European counterpart but distinct due to this double heritage.

Affirming a Brazilian Modernism

In the 1930s the artistic scene in Brazil suffered a brutal transformation. The 1929 stock-market crash in New York had a destabilizing effect on the agrarian aristocracy to which Tarsila and several other Modernists belonged. Leftist and rightist political movements that had existed during the 1920s tightened their positions. The first half of the 1930s was marked by attempted revolutions and coups from both sides. Most artists sympathized with the Left, and, especially during the decade's first five years, their works reflected adherence to leftist ideals. During this period of participatory zeal and belief in the role of art as a consciousness-raising tool, there was a tendency toward more classical figuration, with only a few Modernist traces. For the artists of this second phase of Brazilian Modernism, the formal, thematic, and ideological bond with European movements calling for a return to order was more direct and unanimous. The initial dichotomies between traditional ideas and those of the avant-garde—not only general theoretical ideas but also those that were the basis for individual formal systems—dissolved in favor of a conservative Modernism profoundly linked to the concepts of realistic figuration and the Western humanist tradition operative since the Renaissance.

The first phase of Modernism, with its dichotomies and fragilities, had been rich in possibilities. Some of these had become manifest, while others remained latent. With the establishment of the

Estado Novo government (1937–45), a political program exalting nationalism was ushered in. In order to "faithfully" depict Brazil during this period, Gustavo Capanema, the minister of education, promoted Modern artists. The 1930s marked a new period for Modernism in the visual arts, which would extend until the end of the 1940s. Once again there was a programmatic tendency. However, instead of responding to the needs of a small group of artists and intellectuals, this period was concerned with the concept of a more integrated society and with the Brazilian government's conciliatory policy seeking to unite archaism and Modernism. In art this took the form of defining "national values," primarily through the exaltation of themes relating to work and the worker, as can be seen, for example, in paintings by Cândido Portinari such as *Mestizo* (1934, cat. no. 239) and *Coffee* (1935, cat. no. 240). Portinari was considered the Modern painter par excellence of the Estado Novo, during which President Getúlio Vargas temporarily brought harmony to Brazil's diverse social and economic interests under the guise of a more important interest: the nation-state. Referred to as the Father of the Poor for the social measures he introduced, Vargas had first assumed power in 1930 after deposing President Washington Luís Pereira de Sousa.

Portinari's works of the 1930s show predilections for classical and monumental figures in the style of Pablo Picasso and for the muralism of the Mexicans Diego Rivera and David Siqueiros, who were already known in Brazil. *Coffee* represents a visual exaltation of Brazilian labor and the economy. The work, which received an award from the Carnegie Institute in Pittsburgh, brought the painter fame and justified the formal system he had been working with. The award demonstrated the degree to which such themes and formal treatment were being accepted. Teeming with characters going about their individual tasks, the painting is organized along two diagonal axes that converge in

the foreground, where the harvesting and sacking of coffee are depicted. The focal point is at the juncture of these axes, where some workers are shown. Painted in the style of Rivera, the figures are rendered in monumental and totemic dimensions. A male figure stands out in the right foreground. He is the ideal prototype of the worker, with developed muscles, arms as thick as columns, and powerful hands grasping heavy buckets without showing any signs of exhaustion. This heroic worker contrasts with the static and hieratic myths rendered during the first phase of Modernism. Instead of providing an element that might lead to a new identity, he already symbolizes a modern Brazil, a producer of wealth, in which rural and urban, old agrarian oligarchies and the new industrial bourgeoisie coexist.

Somewhat removed from Modernist considerations, a group of artists arose whose major preoccupation was with technique. Some of them had received academic training in Brazil or abroad, while others were self-taught. Their most important models came from the Novecento and Valori Plastici movements in Italy. Once again, other realist tendencies that marked the international scene during the 1930s and 1940s at times reflected completely conservative political positions.

A New Place/New Places

During the 1930s and 1940s, amid the different styles of figuration that were being employed, some artists developed works that displayed distinct visions and defined a new place, a new Brazil.

Among the Brazilian artists of the first four decades of the twentieth century, Oswaldo Goeldi was the one who most closely adhered to an Expressionist ethos. Most of his works were prints and drawings, and their blackness transforms the most appeasing subject matter into images of intense expressiveness. His modern and tragic vision stands in contrast to the traditional figuration of other artists, and his rigorous ethics caused him

to criticize the compromises some of them made with regard to the government and the ruling classes. In his work he created a place for visual reflection that was rarely achieved by other Brazilians.

Alberto da Veiga Guignard created a new place, a "non-place,"[12] a world in which all that is solid seems perfectly at home in midair, as if floating weightlessly, without any density. He was one of the few artists of the 1930s and 1940s to achieve the objectives of the Antropofagia movement, to "devour" other cultures and produce something new and uniquely "Brazilian." He appropriated the formal elements of Raoul Dufy and Henri Matisse, as well as some of the naive qualities of Henri Rousseau. The vertical and flat spatial treatments and accumulative effects of Tarsila's *Pau-Brasil* paintings are also sometimes evident. Some of Guignard's works, in which dispersed figures are subjected to vertical treatments, create a sense of emptiness that recalls Chinese painting; others, those in which the figures seem to float unfettered in space, evoke the works of Cícero Dias. An internalized, lyrical, "popular" world, linked to the Baroque legacy of Minas Gerais, is represented within a modern space. The accumulations of Modernist painting are connected with an ethereal world, lacking depth and density. What does this world mean? We might imagine a penitent recluse from our mechanical age.[13] We might also imagine a new world, one founded not on alienation but on utopia. A world characterized not by apprehension and adversity but by constructive audacity. A world of infinite spaces bridged together by a sense of refuge. A world full of possibilities, where the eye is drawn to find new paths beyond the void. In contrast, Alfredo Volpi created a flat world, where the facades of row houses form great swaths across the canvas. Later, Volpi would veer toward extreme formal stylization, bordering on abstraction, in paintings such as *Black and White Flags* (1959, cat. no. 252). The route toward abstraction was one that other artists began to take at the end of the 1940s, but nonfigurative production would only really appear in the 1950s.

During the first four decades of the twentieth century, Modernism concerned itself in part with an uncertain visual and social place, as well as with dichotomous or ambiguous images. Many of the possibilities that had been opened up by the first Modernist generations never came to concrete fruition or at least were not identified or recognized as such. Nevertheless, this period of Modern art established an enduring mythic place to which artists are continually drawn back; commemorations are made again and again. In particular, the "cannibalism" proposed by *Antropofagia* has endured in our present age as myth and as artistic and cultural metaphor. At the same time, such new places have forged an identity and the affirmation that another kind of art is possible.

Translated from the Portuguese by David Auerbach.

Notes

1. See Annateresa Fabris, *Figuras de lo moderno (posible)* in Brasil 1920–1950 de la Antropofagia a Brasilia (Valencia: IVAN Centre Julio González, 2000).
2. See Jean and Ali Laude, "Retour et/ou rappel à l'ordre?," in *Le retour à l'ordre* (Saint-Étienne: CIEREC, Université de Saint-Étienne, 1975).
3. See Icleia Cattani, *Lieux et milieux de la peinture "Moderniste" au Brésil 1917–1929*, doctoral thesis (Paris: Université de Paris, I. P. Sorbonne, 1980).
4. See Aracy Amaral, *Artes Plásticas na Semana de 22* (São Paulo: Perspectiva, 1972).
5. Ibid.
6. Quoted in Aracy Amaral, *Tarsila, sua obra e seu tempo* (São Paulo: Tenenge, 1986).
7. See Cattani, *Lieux et milieux de la peinture "Moderniste."*
8. See Amaral, *Tarsila.*
9. See Icleia Cattani, "Les lieux incertains," in vol. 3 of Eliane Chiron, ed., *L'Incertain X—l'Oeuvre en proceè* (Paris: CERAP, Editions de la Sorbonne, 1998).
10. See Fabris, *Figuras de lo moderno.*
11. See Cattani, *Lieux et milieux de la peinture "Moderniste."*
12. See Rodrigo Naves, *A forma dificil* (São Paulo: Ática, 1996).
13. Ibid.

From Concretist Paradox to Experimental Exercise of Freedom

Maria Alice Milliet

The 1959 group exhibition of Brazilian artists in Munich—*Ausstellung Brasilianischer Kunst* at the Haus der Kunst—did little to further the understanding of the rise of rationalist poetics in Brazil. Next to the metaphorical and narrative painting of the Modernist movement led by Cândido Portinari, at that time, the most renowned Brazilian artist, the geometrical work of Alfredo Volpi, Milton Dacosta, Ivan Serpa, Franz Weissmann, and Lygia Clark was indeed surprising. When not outright negative, European critics were reticent, given the distinct tendencies shown at the exhibition. They did not contain their disappointment at being presented with a nondenotative language. "Where are the Brazilians?" they asked.[1] Visitors who came seeking a vague exoticism usually evoked by this distant South American country certainly felt a similar frustration. After all, what had happened to the exuberant warm colors and sensual forms so often associated with Brazil?

Emiliano Di Cavalcanti's paintings are always helpful when one is attempting to identify the Brazilian character. The European public found in his work the expected *Brazilianness* and allowed itself to be seduced by the ecstatically languid mulatto women depicted, who appear to be eternally available in their aloofness. The reaffirmation of the warm tropical imaginary was satisfying to most. It was therefore hard to understand the renewed undertaking of the Constructivist project in such an apparently inadequate context, especially without having first exhausted the romantic vision, which always seeks the picturesque, folkloric, and exotic in the European periphery. In a culture like that of Brazil, which has favored the representation of local scenery and types for a long time, the eruption of a Constructivist language could only have been the result of recent events in the country's history. It was necessary to recognize that Brazil was advancing, as Mário Pedrosa insisted.

As proof of the modernization under way, he cited the "ultramodern, ultranew city that was in the process of being built," that is, Brasília.[2]

And then, without any warning, in an article written for *Die Presse* in Vienna, the art critic Jorge Lampe expressed his interest in investigating what he termed the "Concretist paradox."[3] His hypothesis was that the adoption of a geometric and controlled language might signify a reaction to adverse circumstances. Perhaps, he wrote, it was the defense of "a people who live in a subtropical environment where nature threatens to absorb the intentness of the inhabitants."[4] In this case, the geometrical exercise would serve to exorcise chaos. The assumption here is that the tropical chaos contaminated and weakened one's will. In exploring the issue, Lampe concluded that such a paradoxical artistic expression was the result not of a "calculated formalism" but of a "profound will," evident in the work of Weissmann, Clark, and, above all, Volpi. This *profound will* would explain the "cohesion and parallelism with Modern Brazilian architecture." Pedrosa found this interpretation to be a "luminous intuition."[5] Accustomed to the misunderstanding of critics, the extent of Lampe's insight did not escape him: "Going beyond cosmopolitan fad or sensibility . . . the Viennese critic Jorge Lampe hit the mark regarding what is most enigmatic, most original, and perhaps most vernacular in the country's cultural production. Shouldn't one ask oneself: though still embryonic and precarious, but already existing, might this paradox, this profound will, not signal a Modern and native Brazilian art, one with an authentically regional dialect, filled with strong and tasteful accents, but part of the great abstract and universal language? As is already the case of our architecture?"[6] Time would confirm the importance of those beginnings founded upon Constructivist rigor. Its development, however, reached far beyond the limits of Modern art. The shift from Constructivist

art to the experimental exercise of freedom is more than a path. It is a jump.[7]

In Brazil, the Constructivist vanguard emerged under protest. Many intellectuals were engaged in preserving Modern Brazilian art from what, in their perception, consisted of the loss of its character and virtue. As a result, they resisted this self-referential art. Most of them were accustomed to solutions long established by Modernism and could not envision how such a cold aesthetic, which refused any depiction of the visible and was rigid in its geometric formalism, could be integrated into Brazilian culture. The loss of the figure, that is, the negation of representation was, for those who defended artists' ideological engagement, perceived as a symptom of alienation from Brazilian reality. In fact, for a long time the influence of Zhdanovism on Socialist Realism obliterated the possibilities opened by Constructivism, which during its historical moment had been able to shape new and revolutionary ideas.

From the 1930s until the mid-1940s there was little renewal in the language of visual arts. The great experimentalist impulse of the 1920s was replaced by a sense of complacency, in large part due to the emphasis on a thematic approach that resulted from artists' growing ideological engagement. This only began to change when a new generation became interested in exploring formal issues, the syntax of composition, and the relationship between art, science, and technology. "What is the reason for this in a country such as ours, inclined to accommodation and to the lack of rigor in all things, to a lazy Romanticism, and to nonchalance, a country that prefers vagaries of half-answers and the repetitions of instinct to the clear distinctions of intelligence?"[8] Pedrosa asked the question that he knew was in the air, and one that served as a pretext to indicate the precursors of the Constructivist project, here associated with the origins of Modern Brazilian architecture. Viewed in this manner, the

Constructivist aesthetic in Brazil extends back to the 1930s, when Oscar Niemeyer, Lúcio Costa, and Affonso Reidy, among others, adopted the functional rationalism of Le Corbusier as their bible. For those young architects, the "exercise of dry austerity from the Functional convent" constituted the necessary asceticism to abolish decorativist architecture.9 They broke with the taste for ornamentation characteristic of the colonial Baroque and still in vogue during the eclectic style that predominated in urban buildings until the early decades of the twentieth century.

The discipline of the "convent where Niemeyer was educated," as Pedrosa phrased it, is similar to that of Tarsila do Amaral's "military service in Cubism," as she referred to her Parisian education with Albert Gleizes and Fernand Léger. Though she did not allow their analytic radicalism to impact her work—for the contact with the French masters happened during the *retour à l'ordre*—Tarsila absorbed from their Cubist lesson the two-dimensional vision, geometric forms, and flat and contracting colors visible in the naive Constructivism of her landscapes during her *Pau-Brasil* (brazilwood) phase. She had already, in the painting *Black Woman* (cat. no. 218) from 1923, dared to contrast the geometrical background with the topological treatment of the figure. This type of distortion would be reused in her *Antropofagia* phase. In her best works, Tarsila brings together memories of a mythical and popular universe with cosmopolitan information, announcing a "possible modernity" for Brazilian art. However, no one went a step further. Di Cavalcanti and Portinari never reached the point of deconstructing the pictorial space. Instead, they absorbed the post-Cubist leftovers that had little to do with Cubism's original revolutionary Analytic and Synthetic phases.

"From the rigors of functional dogmatism arose a true Brazilian school of architecture, with access to the whole world, and bearer of two distinct qualities: the 'international style' and regional Brazilian

characteristics, both profoundly meaningful and influential," Pedrosa wrote.10 A phenomenon of such cultural repercussions did not go unnoticed in the artistic milieu, but favorable conditions for a discussion regarding the fundamental issues of Modern art only occurred after the end of World War II. It's true that, during the long period when representational art was dominant, there was always a latent desire to break with traditional practices. We can see this through decorative arts that followed the first Modernist architecture (of Gregori Warchavchik and Flávio de Carvalho), embracing geometric formalism and simplicity in carpets, stained glass, flooring, panels, and furniture designed by Lasar Segall, Regina Gomide, and John Graz, which were in perfect harmony with Art Deco aesthetics. However, the geometric conception accepted in architecture and decorative arts was not embraced in painting and sculpture until an intense need for change contaminated the whole field of cultural activity.

The Constructivist impulse in Brazil gained importance when viewed in the context of the reestablishment of international exchange, the redemocratization of the country, the development of national industry, and an accelerated urbanization. What attracted the new generation of Brazilian artists was the idea of integrating art into the industrial society. Outside Brazil, the world had different concerns. While Europe suffered the aftereffects of World War II and produced an art of conciliation that diluted what remained of the artistic and revolutionary vanguards, Abstract Expressionism triumphed in New York and extended its influence worldwide in the wake of the new hegemony of the United States. On the other hand, the abstraction of the School of Paris and the gestural expressionism promoted by American politics had in common a valorization of subjective and intuitive expression, which even allowed for lyrical and romantic overtones. The Brazilian Constructivist project, free from the disil-

lusionment of war and optimistic about technological progress, sought to transpose the rationality of industrial production to the realm of art.

Institutionally, one cannot separate the renewal in the visual arts from the action of private patrons. Until the late 1940s, culture had been mostly sponsored by the government. At that time, Brazilian entrepreneurs, stimulated by economic success, started to invest in art. Three important museums were founded almost simultaneously: the Museu de Arte de São Paulo (1947), guided by Assis Chateaubriand, who owned a media conglomerate that included newspapers, radio stations, and, eventually, television channels; the Museu de Arte Moderna de São Paulo (1948), whose patron was Francisco Matarazzo Sobrinho, a metallurgist; and the Museu de Arte Moderna do Rio de Janeiro (1949), presided over by Niomar Moniz Sodré. Together, these institutions infused new vitality into the Rio–São Paulo circuit and irreversibly accelerated Brazilian cultural life. All three immediately promoted international exhibitions, courses, and conferences that stimulated the development of a Constructivist consciousness. A memorable sequence of lectures was presented in 1948 at the Museu de Arte de São Paulo by the Argentine art critic Jorge Romero Brest, and in 1950, the museum's program included an exhibition of the work of Max Bill, including his architecture, painting, and sculpture; the show proved important in fostering an understanding of Concrete art. These contributions were decisive in promoting the Constructivist tradition and the commitment for a universalist cultural strategy. As a result, Modernist figuration, which up until then had remained intact, was challenged in its position as the guardian of what it held as its highest praise: the national aspect of art.

Internationalism was the order of the day. It is worth mentioning that museums were expected to follow the model of New York's Museum of Modern Art. Nelson

Rockefeller came to Brazil on numerous occasions to urge the private sector in this direction, and left behind a small collection of works to be donated to the future Museu de Arte Moderna de São Paulo. In March 1949, the museum was inaugurated with the exhibition *Do figurativismo ao abstracionismo*, organized by the French critic Léon Degand, a supporter of the nonfigurative art, who had been invited by Matarazzo to be the museum's director. In 1951, the museum dared to promote the first São Paulo *Bienal*. The event had enormous repercussions within the country, especially in its early incarnations. Brazilian artists were now regularly exposed to the best Modern art and to the most up-to-date contemporary works. All of this information had a great impact on local art, stimulating the renewal of plastic language. In the first *Bienal*, the Swiss delegation, composed of Sophie Taeuber-Arp, Max Bill, Paul Lohse, and others, made a strong impression on young Brazilian artists. The international prize for sculpture went to Bill, whose ideas would serve as the basis for the Concretist movement in the Rio–São Paulo axis. Among the Americans, Jackson Pollock and Mark Tobey presented vigorous Abstract Expressionist works, which, however, failed to have the same impact as Concrete art.

The Concrete movement began to take shape around 1951 in São Paulo and Rio de Janeiro. The commitment of young artists to ideals that were based on Neo-Plasticism, Constructivism, the Bauhaus, and the reinstatement of universalizing principles proposed by Max Bill, director of Hochschule für Gestaltung in Ulm, at the time corresponded to a desire to go beyond the ideological limitations of Modernism in favor of an effective participation of art in the construction of a technological society. Intrinsic to Concretism was an aesthetic rationality incompatible with, as Waldemar Cordeiro wrote, the "position of the romantics who want to transform art into a mystery and a miracle" and opposed to "the intellectualism of

ideologues who wish to attribute to art tasks it can not accomplish, because they are contrary to its nature."[11] The Concretist movement sought to integrate art into industrial production and mass communication. The artist/designer had the responsibility of contributing to the socialization of good form.

For Pedrosa, the intended rationality of the movement lent it a premonitory character: "Might this not signal a spiritual, and even ethical, reawakening in Brazil?"[12] This question suggests that the larger Constructivist program not only aimed at reformulating the language of plastic art, but went beyond that in seeking a moral reform. By refusing a sentimental vision of culture, the theoreticians of the Concretist movement proposed replacing improvisation with planning, subjective processes with objectivity, craft with technique, in a clear adhesion to development guided by industrialization. Generalized planning, from an urban vision to the material necessities of daily life, sought to integrate art with private and public spaces. This insertion ends up being political because it adds a social dimension to artistic work. In a country where the rural and paternalistic tradition was barely beginning to decline, to view the harmony of society within the context of a modernizing rationality was mostly an exercise in idealism. This utopian activity was confined to the theoretical horizon of the reformist proposals that guided the actions of the cultural vanguard represented by Concretism and Neo-Concretism.

The São Paulo group remained faithful to the Concretist orthodoxy. It condemned the emergence of emotional, oneiric, or libidinal content in art. This position was clearly set forth in the *Manifesto ruptura* (1952), signed by Cordeiro, Lothar Charoux, Geraldo de Barros, Kazmer Féjer, Leopoldo Haar, Anatol Wladyslaw, and Luis Sacilotto. The São Paulo artists formed a cohesive entity, while the Rio de Janeiro group was more individualistic and less homogeneous. The interaction among Concretist artists in Rio de Janeiro was due to friendship, intellectual stimulation, and apprenticeship, not to a programmatic objectivity. An eclectic group of students, including Clark, Lygia Pape, Weissmann, Abraham Palatnik, and Hélio Oiticica, was formed around Serpa. "One thing unites them, and which they do not compromise . . . the creative freedom."[13]

The integration of the arts was part of the ideology of Constructivism. The brothers Haroldo and Augusto de Campos and Décio Pignatari founded the magazine *Noigrandes* in 1952 and participated in the first *Exposição de arte concreta* in 1956–57 along with artists from Rio de Janeiro and São Paulo. The intention of "conceiving a poem that is mathematically planned in its entirety will, in the artistic process, tilt the balance toward the Constructivist rationality . . . while allowing as much as possible for the unique nature of each art form, it will lead to the disappearance of the difference in attitude, so clearly understood by Mário Pedrosa, between the Concretist poet and painter."[14] "The Concrete poem," replied Ferreira Gullar, "must be meaningful as a quotidian and intuitive experience, so as not to become a mere representation of compiled scientific laws in the field of language."[15]

After the group exhibition, the split within the Concretist movement was made public in the press. It was a moment of intense critical debate in both cities. The divergence between the Concretists from Rio de Janeiro and those from São Paulo revolved around the latter group's dogmatism, which the Rio de Janeiro artists felt threatened to paralyze the movement. The Neo-Concretist manifesto of the Rio artists appeared in the catalogue for the first *Exposição neoconcreta* (1959), which included works by Amílcar de Castro, Gullar, Weissmann, Clark, Pape, Reinaldo Jardim, and Théon Spanudis. The manifesto called for "taking a stance with regard to 'geometric' nonfigurative art and especially Concrete art taken to a dangerous rationalist excess."[16]

The accentuated formal concern, inspired by mathematical thinking and the application of the theories of Gestalt psychology, led Concrete art to the limited exploration of the "geometric possibilities of the eye."[17] In practice, Concretism focused its energies on the battle to reformulate the language of visual arts, with incursions of moderate repercussion in graphic arts and design. It had neither the stamina nor the critical objectivity to evaluate its effective participation in a wider range of production. Later on, the Neo-Concrete dissidents denounced the stagnation of Concrete art due to its formalism, and positioned themselves against the reduction of art to pure visuality. They sought to expand the potential of the artwork beyond the perceptible optic game. By critically reworking the means of expression, from questioning the support to the complete breakdown of traditional categories of art, Neo-Concrete artists called upon the observer to go beyond contemplation, that encouraged the inquiries of Clark, Pape, and Oiticica toward environmental space. The intention of collectivizing artistic creation—already implied in Clark's *Bichos* (Machine-animals, e.g., cat. nos. 263–65) series—aimed to create, outside of the art system, a space where life joined art.

While experimentation constituted the field within which Neo-Concrete art operated, Concretist rationalism led to an epistemological approach in the production of art that was void of any phenomenological significance. It was against this ideal, and works of art that demonstrated the laws of physics or mathematical statements, that Neo-Concretism reacted. Without denying its origin, it launched formal and expressive experiments from a solid Constructivist base. Against mechanistic reduction, it offered the *being in the world* (Maurice Merleau-Ponty) and went even further by attempting to promote a synthesis between logos and poetry. Neo-Concretist knowledge is not limited to Concretist epistemology, that is, to a system of cause and effect applied to art. Rather, it uses poetics as a way of overcoming this reductionism. It reaffirms artwork's capacity for transcending its materiality by creating new meanings and continuously renewing itself in a flux that integrates artist, artwork, and the public.

For Oiticica, the end of painting coincides with the conquering of real space. According to him, *Metaschemes* were still part of a well-studied "lesson in nonacademic formation." But they are not only this. They also contain indications of his later incursions beyond two-dimensionality, the spatial development of which—in *bilaterais* (bilaterals) and *relevos espaciais* (spatial reliefs)—is the result of this preamble. The concern was no longer to break with representation and content but to explore the issues inherent to the structuring of the plane. In his studies on paper or canvas, Oiticica focused on the disorganization of the Cartesian matrix adopted by Piet Mondrian. In the initial works of the *Metaschemes* series the irregular organization still retains vestiges of orthogonality: the densely occupied surface cracks, and the rectangles dance upon the support, like city squares misaligned after an earthquake. From then on, instead of leading to a shuffling of forms, the dispersion prevails until the space is almost completely emptied. The emptiness grows as the loss of stability evolves from simple oscillation to a centrifugal movement that projects the fragments outward. This dispersion operated on the plane anticipated the shift from structure and color to the open space, attuned to propositions set forth by Clark, who urged leaving the wall to gain the world.

Clark had been working with planes on *superfícies moduladas* (modulated surfaces), using an approach that was comparatively more radical than Oiticica's at the time. The guiding principle that directs the modulation of the plane is no longer the structuring of a single space, but the discovery of what Clark called the *linha orgânica* (organic line): a virtual line

between two planes, as seen at the junction between canvas and frame. Though still two-dimensional, her works have nothing in common with conventional painting or even with Concrete art. The artist's interest was no longer pictorial. She used a compressor to cover the squares with industrial paint. Just black and white. The whole emerges by the contiguity of the parts. In juxtaposed painted wooden boards, a line/groove is accentuated when adjacent squares are of the same color and disappear when they are of contrasting colors; thus, the fascinating virtuality of line.

From clusters of squares and surfaces dynamically cut by diagonals, Clark arrived at two paradigmatic works in the evolution of her work. One is entirely white with a streaked surface. On its colorless surface there is only a hint of action, somewhat like the reverse of a painting. The other, a black disk with a small part of its border invaded by white, shows the outside contaminating the inside. In either case, the issue is spatial. Euclidean space has been replaced by topology. The outcome of these works would be the *Casulos* (cocoons), resulting from the swelling and rupture of the plane, and the *Bichos*, sheets of metal joined by hinges.

Along with Oiticica and Clark, Pape explored spatial relations, but her starting point was the plane worked horizontally. While carving the block for a woodcut, she followed the grain and carved deeper and deeper, until she cut through it. When printed, white lines and grooves appeared on the black surface like frayed fabric: the *Tecelares* (weavings). "The day I made an entirely white woodcut, I stopped. I had reached light," she recalled.[18] The disruption of the plane is a breach of commitment with traditional categories of art. In *Book of Creation* (1959–60), Pape invented a code, a game, a language. She narrates without words, and is helped by whoever handles the geometric forms she proposes. From there she went on to the scenic space of dance and cinema. The trio—Clark,

Oiticica, Pape—promoted the Neo-Concrete subversion: artists' emancipation from any ties to institutional art.

The understanding of the transition from Concrete to Neo-Concrete is crucial because it underlines the critical advance within the Constructivist project in Brazil, without which that project would have been limited to a simple adaptation of principles and practices from a European context. The impasse reached by the Constructivist program is part of the dissolution of the developmental dream. The basic equation on which utopian reform was based—rationality, production, and progress—was overcome, at the turn of the 1960s, by political and economic adversities that made its unfeasibility clear. Brazil revealed its internal contradictions during a sequence of events that marked the transition from democratic regime to military dictatorship. The crisis, caused by the rising inflation associated with the historic exclusion of large segments of society, culminated in a challenge to the capitalistic solution—a challenge immediately quelled by armed intervention. In this troubled context, it was impossible to continue believing in a functional aesthetization of society. Born as a criticism of the Constructivist program, Neo-Concretism—by questioning the formalist idealism and the intended integral participation of art in society—anticipated the general disillusionment that followed the suppression of liberties. When the Neo-Concrete group began to disperse, some of its members, especially Clark and Oiticica, were ready to embark on experimentation unfettered by dogma. Their course toward antiart led them to undertake, in unique ways, the most incisive questioning of the statuses of art and artist, opening the dematerialization of the artwork and the dissolution of artists' individuality in favor of a collective creativity.

Among those who explored geometrical forms without ever intending to make Concrete art, Alfredo Volpi was considered a master by the Concretists. He was a self-

taught painter with an aversion to theory, but that did not discourage the Concretists from viewing in his abstract-geometrical paintings an adhesion to the principles of the movement. Paradoxically, the critics of the time by hailing the popular roots and pictorial quality of his work rescued the *Brasilianness* that had been initially negated by the rejection of representationalism. Nonetheless, it is certain that Constructivist essentialism influenced the work of this artist. Volpi had matured as an artist through his sustained pictorial treatment of the modest landscape of São Paulo and by his contact with the frescoes of Giotto, which he visited quite often during a lengthy sojourn in Italy. Back in Brazil, he worked on the planimetric series *Facades* in 1953. The geometric organization of these works derives from the frontal planes of row houses, accentuated by the dynamic interplay of alternating colors. The tendency toward formal simplicity and the absence of depth had begun to appear during the late 1940s and progressed until it reached a complete detachment from the subject. Icons extracted from folk art, such as little flags and poles, became the syntax of Volpi's formal compositions. Masterly use of tempera allowed him to achieve a unique chromatic vibration. Although praised by critics, he distanced himself from intellectual speculations, choosing to guide his singular work by formalizations always associated with popular elements, a sensible use of color, and an infallible Constructivist intuition.

The originality of Sérgio Camargo's work should suffice to show the extent to which multiple and varied sources inspired the formation of the Constructive repertoire in Brazil. Camargo's references go from the Classical tradition of the relief—from the Parthenon to the doors of the Baptistery in Florence—to works of Lucio Fontana, Constantin Brancusi, and Jean Arp, not to the mathematical ideas of Max Bill. However, when Camargo's work was shown in a London gallery during the 1960s, next to works of Oiticica and Clark,

the art critic Guy Brett identified a common sensibility, which he attributed to the same cultural background: "a strong sense of the body and physical movement."[19] The artist himself lent a carnal connotation to his relationship with the matter, referring to it as an "intimate commerce with whose breath I have mixed my own." Moved by the "always real and present affective memory," Camargo sought the "retrieval of initial balances, imperious directions, light densities, preferences, occasional comfort of believable volumes, bodies bathed by light, spontaneous versatile rhythms, active shadows, stiff presence, lyric surfaces, skin cadences. . . ." What he called the "*praxis* of adventure" gave birth to the unity of thought implicit in his work. Instead of providing theoretical justification, Camargo spoke of the "softening of the matter by a diffused concept" and the almost spontaneous process by which "the matter matures and is decanted, then produces and reproduces multiple precious things, futile and fundamental."[20]

Camargo's work is not easily defined. To interpret it as a manifestation of rationalist formalism is to ignore its complexity. The internal logic of his sculptures is not limited to cold rationality. Rather, it can be viewed as a systemic body of work open to the imponderable: what nourishes and makes his art alive is at the same time a source of concern and disorder. His works are organic because each consists of a combination of truncated elements displayed on a plane leaning against a wall or resting on the floor. Light makes the white surfaces pulsate. At every moment, visual and tactile perceptions are confused: in his reliefs, the oscillation of light and darkness on the surfaces is reminiscent of textured skin, raw surfaces bleached by the sun, which are nothing more than the memory of archaic sensations.

In the end, individualities have been more prominent than movements or groups. The works of certain artists have survived: Volpi, Oiticica, Clark, Weissmann,

Camargo. The fading of the Constructivist project brings to a close the second and last cycle of Modern art in Brazil, and opens for contemporary art as, Pedrosa announced, the postmodern began. After the utopian aspirations there came a direct, perceptive, and engaged experimentation, one that does not condition and is not conditioned by reality. Something of a "return to the world," as Oiticica would say. Bearing his motto—"we live off adversity!"—which might well summarize this new and radical "realism."[21]

Translated from the Portuguese by Michael Reade.

Notes

1. Mário Pedrosa, "Crítica da crítica," in Aracy Amaral, ed., *Mundo, homem, arte em crise* (São Paulo: Perspectiva, 1986), p. 30; originally published in *Jornal do Brasil* (Rio de Janeiro), July 1, 1959.

2. Ibid., p. 30.

3. Mário Pedrosa, "O paradoxo concretista," in Amaral, *Mundo, homem, arte em crise*, p. 25; originally published in *Jornal do Brasil* (Rio de Janeiro), June 24, 1959.

4. Mário Pedrosa, "Paradoxo da arte moderna brasileira," in Otília Arantes, ed., *Acadêmicos e modernos*, vol. 3 (São Paulo: Edusp, 1998), p. 317; originally published in *Jornal do Brasil* (Rio de Janeiro), December 30, 1959.

5. Ibid., p. 318.

6. Ibid., p. 319.

7. Mário Pedrosa, "Por dentro e por fora das Bienais", in Amaral, *Mundo, homem, arte em crise*, p. 308.

8. Mário Pedrosa, "Crítica da crítica," p. 24.

9. Ibid., p. 27.

10. Ibid., p. 27.

11. Waldemar Cordeiro, "O objeto," in Aracy Amaral, ed., *Projeto construtivo brasileiro na arte 1950–1962* (Rio de Janeiro/São Paulo: MEC/Funarte/ MAM-RJ/Pinacoteca de SP, 1977), p. 74; originally published in *Arquitetura e decoração* (São Paulo) (December 1956).

12. Pedrosa, "Crítica da crítica," p. 26.

13. Mário Pedrosa, "Grupo Frente," in F. Cocchiaralli and A. B. Geiger, eds., *Abstraciosnismo geométrico e informal: vanguarda brasileira nos anos 50* (Rio de Janeiro: Funarte/Instituto Nacional de Artes Plásticas, 1987), p. 231; originally published in the Grupo Frente exh. cat. (Rio de Janeiro: Museu de Arte Moderna) (July 1955).

14. Haroldo de Campos, "Da fenomenologia da concepção à matemática da composição," in Cocchiaralli and Geiger, *Abstracionismo geométrico e informal*, p. 227; originally published in *Jornal do Brasil* (Rio de Janeiro), June 23, 1957.

15. Ferreira Gullar, Oliveira Bastos, and Reinaldo Jardim "Poesia concreta: experiência intuitiva," in ibid., p. 229, originally published in *Jornal do Brasil* (Rio de Janeiro), June 23, 1957.

16. Ferreira Gullar, "Manifesto neoconcreto," in ibid., p. 234; originally published in *Jornal do Brasil* (Rio de Janeiro), March 22, 1959 .

17. Waldemar Cordeiro, "O objeto," p. 75.

18. Interview with Lygia Pape, in Cocchiaralli and Geiger, op. cit., p. 160.

19. Guy Brett, in *Leticia, Carvão, Ludolf, Schaeefer, Toral, Camargo*, exh. cat. (São Paulo: Galeria de Arte das Folhas, 1958).

20. Sérgio Camargo, in ibid.

21. Hélio Oiticica, "Esquema geral da nova-objetividade," in *Aspiro ao grande labirinto* (Rio de Janeiro: Rocco, 1986), pp. 95 and 98.

Apollo in the Tropics: Constructivist Art in Brazil

Agnaldo Farias

With its Bauhaus-inspired Futura-style logo stamped in extra-bold lower case, the *Manifesto ruptura*, published in 1952, served as a point of departure for Concretism, the Brazilian version of geometric abstraction. There could be no doubts concerning the rational source of artistic expression that the text was defending. Seven artists signed the text—Waldemar Cordeiro, Lothar Charoux, Geraldo de Barros, Leopoldo Haar, Anatol Wladyslaw, Kazmer Féjer, and Luis Sacilotto—though it was evident that Cordeiro was its sole author. That each of the signers had converged upon São Paulo, though only two were born in Brazil, says a great deal about Constructivist art, which emerged in the country's only industrial complex, a tropical magnet attracting tides of immigrants in search of work.

Abstraction had actually made its entrance onto the Brazilian scene some years prior to the publication of "Ruptura." Among its major manifestations were the highly acclaimed Alexander Calder exhibition in Rio de Janeiro in 1948; *Do figurativismo ao abstracionismo*, which opened in 1949 in São Paulo, at the inaugural exhibition for the country's first museum of modern art; and a Max Bill exhibition, organized by the Museu de Arte de São Paulo (MASP) in 1950. Curated by the French critic and director of the Museu de Arte Moderno (MAM), Léon Degand, *Do figurativismo ao abstracionismo* only included three "local" artists: the aforementioned Cordeiro, the Romanian artist Samson Flexor, also residing in São Paulo, and the Brazilian Cícero Dias, who was living in Paris. Degand also brought together artists from the Cercle et Carré, Nouveaux Réalistes, and Abstraction-Création groups, in addition to such relevant names as Calder, Vasily Kandinsky, Francis Picabia, and Robert Delaunay. What was initially intended to be an impartial exhibition on the current artistic trends of the period became a platform for launching

Abstractionism in Brazil's timid cultural environment of the time. Considering the power exercised by the two major figures in Brazilian Modernism, Emiliano Di Cavalcanti and Cândido Portinari, acerbic critics of Abstractionism in all its forms,[1] whose own works were an articulation of the ultimate weaknesses of Modernism's first wave, these three exhibitions had a revolutionary impact upon a retrogressive cultural scene.

While Calder was perceived as a pioneer, Max Bill had a much more enduring influence, stimulating investigations within the *Ruptura* group and leading them to adopt the term Concretism for themselves. With regard to this term, Bill's use of it apparently went beyond the intentions of its actual author, Theo van Doesburg, who had coined it to explain a break with the artistic conventions that had been in use since the Renaissance—perspective, figure/ground relationship, illusionistic use of color, and pictorial space as metaphorical space subservient to external signification. For Bill, Concretism designated an objective art framed by mathematical concepts, an idea expanded with the creation, in 1951, of the Hochschule für Gestaltung Ulm, of which Bill was the first director. With colleagues such as Tomás Maldonado and Max Bense, artists attracted to the Hochschule für Gestaltung Ulm included Alexandre Wilner, Almir Mavignier, and Mary Vieira.[2]

It should be stated that the institutional clout of the MAM in São Paulo was crucial in legitimizing abstraction in Brazil. It was hardly a surprise when the São Paulo *Bienal*, established as a force in its own right by the MAM in 1951, awarded its first grand prize to Bill. Within the context of the museum's collections, Bill's sculpture *Tripartite Unity*, inspired by the Möbius strip, was symbolic of a new artistic order for younger artists interested in making an impact on the aesthetic course of a nation that was finally replacing an agrarian/coffee-exporting system of production with industrial development.

Concretism

With its concise and intentional iconoclasm, Cordeiro's *Manifesto ruptura* attacked three fronts of artistic production as representing the "old guard": naturalism, the negation of naturalism by "madmen," "primitives," "expressionists," and "surrealists"; and "nonfigurative hedonism." While dismissing figuration—which in Brazil had still not managed to embrace Cubism, nor begun to perceive art as a cognitive process irreducible to any other—Cordeiro was also dissatisfied with abstraction's tachism, a progressive distancing from the visible. In a newspaper article, he accused the painter Cícero Dias of creating abstract works while keeping within representational parameters.[3] Against style, the *Ruptura* group viewed art as a "cognitive medium that could be conceptually deduced," and adhered to Konrad Fiedler's "pure visibility" as a theoretical foundation.[4] They set a course for artistic expression to be paved by reason, objectivity, and universalism and replaced the word *create*, a traditional aesthetic term with strong romantic connotations, with the word *invent*, which had obvious associations with the fields of science and technology and linked the group to other theoretical areas they would eventually incorporate: Wiener's cybernetics, Charles Sanders Peirce's semiology, and, above all, Gestalt theory.[5]

According to the directives adopted by these artists, art should separate itself from individual expression, from gesture and its correlatives, in order to produce works embedded in the rationality of form. These could include visual games, capable of breaking with the existing visual syntagmas; ambiguities constructed from line and plane; subtle variations of forms presented in series; non-autonomous use of color. Such works would avoid any considerations of a psychological nature and would be subordinate to and make use of the structural rhythm of the canvas. All of these aspects were part of the understanding that the

new artistic principles would be governed by "all experiences that foster a renewal of the essential values of the visual arts (space-time, movement and material)."[6]

Luís Sacilotto's *Concretion 5521* (1955, cat. no. 253), like other works by Cordeiro, Charoux, and Nogueira Lima, illustrates the aforementioned points. The painting's three square shapes—white, gray, and black—are arranged side-by-side on a canvas, forcing the viewer to continually oscillate between constructing and deconstructing the Gestalt rectangular shape they form together. This planar oscillation is accentuated by two joining and interpenetrating axes of parallel straight lines. The eye, attracted to the strong contrast of the black line cutting across the white plane, glides easily across the canvas until the same line, which crosses over into the gray plane, is transformed into white, creating a new contrast. The clear and simple use of geometry works off the tension between planes and lines in a way that is similar to figure/ground relationships, or to the alterations of chiaroscuro and positive/negative space. In contrast to the content of representational works, paintings such as this offer perceptual games and force the eye into incessant movement, thereby allowing it to discover new spatio-temporal relationships. Cordeiro's rigorous refinement and dissemination of these ideas led to the wide-spread promulgation of Concretism, attracting young artists and finding many practitioners in literature, especially poetry.[7]

The reader may find it curious that mid-century Brazil would appropriate a form of ultra-rationalism practiced by the European avant-garde of the 1920s. Brazilian naturalism had long equated artistic expression with the realistic portrayal of the people and the tropical landscape, but it was Concretism that would be adopted almost as a new national art by the late 1950s. Though the Concretists exhibited a fetishism of technology similar to European constructivism, they also tended to deconstruct the stereotype asso-

ciating tropical peoples with emotion, if not indolence, which was prevalent as the country took its first decisive steps toward industrialization. In this regard, the construction of the new national capital city of Brasília according to the directives of the "Charter of Athens" was a landmark for the collective will to defeat backwardness through rationalism. Brazil, in the distinctive words of Mário Pedrosa, had been condemned to modernity.[8]

With the pervasiveness of rationalism an inevitable backlash occurred, and with it, an internal crisis in Concretism. It came from artists working in Rio de Janeiro. These artists' very specific reading of the concepts behind Concretism was evident at the Exposição Nacional de Arte Concreta, which opened in December 1956 at the MAM in São Paulo and in January 1957 at the MAM in Rio de Janeiro. For Waldemar Cordeiro, the works exhibited by these artists showed a high degree of "anti-northernism." "We even find brown in these paintings," he commented, showing his disdain for the color he felt was too closely associated with the landscape.[9]

Neo-Concretism

Although a great deal has been written on the subject, the schism between the Concretists and the Neo-Concretists deserves attention in order to clarify the contrast between the scientific rationalism of the São Paulo practitioners and the intuitive and humanist approach more apparent in Rio de Janeiro.[10] It must be remembered that São Paulo was Brazil's great industrial complex and therefore held a key position with regard to Brazilian development, offering artists the possibility of real participation in the productive process. In this context, the country finally seemed able to support the existence of the artist-designer, a personality that had been forged in the inner recesses of the Bauhaus. Initially, Rio de Janeiro seemed to keep pace with such developments. The creation there, in 1963, of the Escola Superior de Design Industrial, the first of

its kind in the country, fostered a sense of freedom, or at least showed that local artists could develop more experimental lines of investigation, and was in keeping with Rio de Janeiro's position as the cultural center of Brazil.

All the same, the eventual differences in artistic vision between Concretism and Neo-Concretism, between São Paolo and Rio de Janeiro, must be seen more as the result of differences between members of the two groups than between the political or economic profiles of the two cities. In 1959, the schism within Concretism was translated into the drafting of the *Manifesto neoconcreto* by the poet Ferreira Gullar. This act would result in the forging of a group of artists including Lygia Clark, Lygia Pape, Hélio Oiticica, Willys de Castro, Amílcar de Castro, Franz Weissmann, Aluísio Carvão, and Hercules Barsotti. According to the first lines of Gullar's manifesto, Neo-Concrete expression meant "taking a position with regard to non-figurative 'geometric' art [...] and, in particular, with regard to Concrete art executed on a dangerous foundation of rationalist exacerbation." The manifesto continued by negating the validity of scientific positivism transferred to art, criticizing the supposed objectivity of the Gestalt. Instead, it invoked the philosophical systems of Merleau-Ponty, Langer, and Cassirer as a means of repositing the problem of expression. The text concludes by affirming "the independence of artistic creation in the face of objective cognition (science) and practical cognition (ethical, political, industrial, etc.)."[11] It should be pointed out that although Gullar was an active member and spokesperson for the group, his text was compromised by his own preoccupations, which were not necessarily shared by the other artists. It was immediately clear that his censuring tone failed to adequately emphasize the real importance that the Neo-Concretists continued to confer on both science and mathematics.[12]

Neo-Concretism's great contribution, to paraphrase the critic Ronaldo Brito, was its role in critiquing and exposing the limitations of the Constructivist project as a cultural strategy for Brazil. The creative preoccupation of the Neo-Concretists, in works by Clark, Oiticica, and Pape in particular, was contrasted by "attempts to convert the work [of art] into a system of complex relationships, with the casual observer transformed into a participant."[13] So persistent was the attempt by these artists to erase the boundary between art and life that endeavors were also made to eliminate the separation between artwork and spectator, as well as the canonical categories of painting and sculpture. In their place arose hybrid, unclassifiable works, which led to Gullar's publication, in 1960, of "Theory of the Non-Object," an essay important for its anticipation of questions that would surround international artistic production for two decades to come.[14]

Two series of works by Clark, *Modulated Spaces* (1955/1956) and *Units/Unities* (1958), serve to underscore the ways in which the artist invaded the territory of Concretism's optical investigations in order to question the limitations of pictorial space. Here the artist's considerations reach the absolute limit of the problem of framing. Once figuration has been abandoned, we are left with the pictorial plane constrained by the presence of the frame, which separates it from the world. To liberate this plane would mean liberating the painting itself, extending it into life, which Clark achieves by gradually incorporating the frame, initially bringing fragments of it toward the interior of the painting until it finally becomes the painting surface or pictorial plane itself. Similarly, Clark's *Bichos* (Machine-animals, e.g., cat. nos. 263–65) series was created with a dual intention of demolishing the rectangular plane, which she believed had been entirely exhausted,[15] and making the spectator an active "subject" of the work— that is, removing her from a passive stance so that she can manipulate a "living organism." With these works, the artist achieves

a kind of hybrid object, allowing the spectator to be simultaneously taken in by both sight and touch and involving him or her in a spatio-temporal experience. The *Grubs* series is an evolution on the *Bichos*, with Clark adapting the Möbius strip and exchanging the limited mobility of her previous works for more malleable materials clinging to stones, architectonic structures, or tree trunks.

By the time she produced the *Relational Objects* of 1966–68, Clark had entered the sensorial phase of her career. Made up of masks, gloves, and goggles, these works address what she termed the "nostalgia for the body." Once established in Paris, Clark continued to create experiences in which the spectator became objectively and physically aware of herself, "[reencountering] his/her own body by means of tactile sensations produced by objects."[16] Working with young people in an experimental group at the Sorbonne, Clark began to intensify her objective of distinguishing individual identity—she referred to her audience as "patients"—by mediating in a given work the spectator's contact with herself. Her fertile career culminated with her leaving clinical experience as a backdrop for her art, an art that was no longer executed in works but in rituals.

The surprising parallels between the works of Clark and Hélio Oiticica provide ample testimony for the complexity of the Neo-Concretists' response to the Constructivist Project. During the first stage of his career, Oiticica also discussed the possibility of liberating painting—and in his particular case, color—from the obligation of being fixed to a wall. After completing the *Metaschemes*, he went on to the *Spatial Reliefs* and from there to the *Meteors* and the *Parangolés*. Produced between 1957 and 1958, *Metaschemes* is, according to the artist, an obsessive dissection of pictorial space, a response to European tachism, whose mawkishness he saw as seeping into Brazil. Starting from a geometric scheme formed by planes containing colors or lines, the artist opened up irregular spaces through the insertion of varied movements and rhythms. The organizational logic evident in the composition, along with the constant use of exact parallelograms, is offset by a sense of controlled disorganization, a remarkable combination of adroitness and blunder, resulting from a subtle variation of the formats or positions of these parallelograms within the blank space of the paper.

Sharing Clark's certainty about the death of painting,[17] Oiticica approached the treatment of ambient space in *Reliefs*. He further developed the trajectory in *Great Nucleus* (1960), where geometry persists in the arrangement of rectangular plaques, but "affectivity" is achieved through the warm homogenous yellow tones in which they are painted. Surrounding the body of the spectator who passes between them, the suspended plaques play on the permutations of transparency and opacity, in which color is fused with form. With *Meteors* (1963/1967), Oiticica became interested in having the spectator submerged in a relationship with color that was more than retinal, allowing him to experience the piece not merely through sight, but also touch. He achieved this effect through what he called "trans-objects"—receptacles created in a variety of materials with which spectators could manipulate color, experience its texture when applied to wood or, when contained in a glass wall, perceive its variations on wire mesh. In this way, spectators would eventually come to the understanding that color, like any substance among the world's infinite materials, might be transmuted into solids, liquids, or gas; into substances that could be rough or smooth, harsh or soft, opaque, brilliant, or transparent.

Between *Meteors* and *Penetrable*, ambient works which surround the spectator's entire body, Oiticica created the *Parangolés* (1964, cat. nos. 280–84). Initially envisioned as tents and banners, these works evolved into hoods made from a vast range of fabrics—massive, flexible, with open or closed

seams, painted or appliquéd—which were to be worn by spectators. The intention was to give color a kind of structure in space, a radicalization of the experiments begun with the body-enveloping installation of the *Reliefs*. These works were in keeping with one of the fundamentals of the Neo-Concrete artistic vision. According to the artist: "With the first banner, which functions through *the act of being carried* (by the spectator), or through *dancing*, the relationship between the dance and the structural development of these works becomes visible, as a 'manifestation of color in ambient space.' The entire structural unity of these works is based on the notion of 'structure/action,' here within a fundamental context.[...] The work requires direct bodily participation. Aside from covering the body, it invites one to move, *to dance*, in the final analysis."[18]

Parangolés would gain notoriety at the *Opinion 65* exhibition, held by the MAM in Rio de Janeiro. During these years the public had become accustomed to expecting virtually anything created in the name of art. They did not, however, expect to find themselves dressed up as *mangueiras*, the outstanding "passista" dancers of the samba schools to which the artist actually belonged. The audience for *Parangolés* strutted around the exhibition space to Oiticica's loud and syncopated musical accompaniment. Amidst the sweat and joy of the festivities, enchanting all those who wanted to join in, the Constructivist "dream" was transformed. Apollo had finally given in to the "sweet cadences of the samba."

Translated from the Portuguese by David Auerbach.

Notes

1. After the initial phase of Brazilian Modernism—which was launched in São Paulo with the famous *Semana de 22* and Oswald de Andrade's and Tarsila do Amaral's *Antropofagia*—the movement entered the 1930s with a strong ideological desire to discredit aesthetic experimentation. See especially João Luis Lafetá, *1930: A Crítica e o Modernismo* (São Paulo: Duas Cidades, 1974). Figurative painting would reign supreme over Brazil's artistic scene until it became contested by abstraction. But when it came, the attack was swift and sure. The ideologue Di Cavalcanti writes of the 1950s: "Today in Brazil there are two paths [...] One is the straight path of formalist painting [...] abstract decorativism or trifling primitivism. The other leads to painting in the service of life [...] participating in the daily forging of our future as a free nation [...] it is the realist technique that is most closely linked with this state of mind." Quoted in Aracy Amaral, *Arte para quê—A preocupação social na arte brasileira 1930–1970* (São Paulo: Nobel, 1984).
2. Haroldo de Campos compiled a small but elucidating selection of texts by Max Bense, which attest to the familiarity the Ulm professors had with Brazilian art. Max Bense, *Pequena Estética* (São Paulo: Perspectiva, 1971).
3. Waldemar Cordeiro, "Ruptura" in Aracy Amaral, ed., *Waldemar Cordeiro: Uma aventura da razão*, exh. cat. (São Paulo: Museu de Arte Contemporânea da Universidade de São Paulo, 1986), p. 62.
4. Ibid., p. 63.
5. With regard to Gestalt theory, Cordeiro was already applying it to his studies at the Academy of Fine Arts in Rome. See Cordeiro, "Teoria e Prática do Concretismo Carioca," in *Waldemar Cordeiro*, p. 72. Cordeiro began to include other theoretical references after becoming closely linked with the poets Haroldo and Augusto de Campos and Decio Pignatari, who were translators and commentators of the seminal works by Peirce, McLuhan and Wiener.
6. See Aracy Amaral, ed., *Arte Construtiva no Brasil: Coleção Adolpho Leirner* (São Paulo: Cia. Melhoramentos, DBA, 1998), p. 94.
7. Published in 1956, just prior to the "Exposição Nacional de Arte Concreta" at the MAM in São Paulo, the text "Plano Piloto para Poesia Concreta," signed by Décio Pignatari, Haroldo and Augusto de Campos, provides insight into this relationship. See *Teoria da Poesia Concreta: Textos Críticos e Manifestos 1950–1960* (São Paulo: Duas Cidades, 1975).
8. Mário Pedrosa, "Introdução à Arquitetura Brasileira" in *Dos Murais de Portinari aos Espaços de Brasília*, Aracy Amaral, ed. (São Paulo: Perspectiva, 1981), pp. 321–27.
9. See *Waldemar Cordeiro*, p. 73.
10. The best overview on the subject, the exhibition *Projeto Construtivo Brasileiro na Arte (1950–1962)*, organized by Aracy Amaral at the Pinacoteca do Estado de São Paulo and Museu de Arte Moderna do Rio de Janeiro in 1977, was sharply criticized by two writers in São Paulo. See in particular the article by Décio Pignatari, "A vingança de Aracy Pape" in *Arte Hoje*, 2 (Rio de Janeiro: Rio Gráfica, 1977), pp. 12–13.

11. Ferreira Gullar, "Manifesto Neoconcreto," in Aracy Amaral, ed., *Projeto Construtivo Brasileiro na Art (1950–1962)*, exh. cat. (São Paulo: Pinacoteca do Estado de São Paulo, 1977), pp. 80–84.

12. In a subsequent statement, Lygia Pape abandoned the northern orientation of Merleau-Ponty's phenomenology for a Neo-Concrete creative stance. See Lygia Pape, "O que eu não sei" in *Ítem*, 1 (Rio de Janeiro: Coimbra/Mourão/Basbaum, 1995), pp. 17–19.

13. Ronaldo Brito, *Neoconcretismo—Vértice e Ruptura do Projeto Construtivo Brasileiro*, second edition (São Paulo: Cosac & Naify, 1999), p. 70.

14. Ferreira Gullar, "Teoria do Não-Objeto," in *Projeto Construtivo Brasileiro na Arte*, pp. 85–94.

15. Lygia Clark, "Livro-Obra" in Manuel J. Borja-Villel, ed., *Lygia Clark*, exh. cat. (Barcelona: Fundació Antoni Tàpies, 1997), p. 117.

16. Clark, "El Cuerpo es la Casa: Sexualidad, Invasión del 'Território' Individual" in *Lygia Clark*, p. 247.

17. Hélio Oiticica, "Aspiro ao Grande Labirinto" in Guy Brett, Catherine David, Chris Dercon, Luciano Figueiredo, and Lygia Pape, eds., *Hélio Oiticica*, exh. cat. (Paris: Galerie Nationale du Jeu de Paume, 1992), p. 42.

18. Hélio Oiticica, "Anotações sobre o Parangolé" in *Hélio Oiticica*, p. 93.

Modernism

In February 1922, an event took place at the Teatro Municipal in São Paulo that altered the course of Brazilian art history: a four-day arts festival known as the *Semana de arte moderna*. This event was analogous in its impact to New York's *Armory Show* of 1913. In both cases, the public had the opportunity to see new approaches to visual expression, including works that shocked conservative visitors. Much of what constituted Brazilian Modernism had its roots in such international phenomena as Expressionism, Futurism, and Cubism. However, artists such as Tarsila do Amaral, Victor Brecheret, Emiliano Di Cavalcanti, Anita Malfatti, Vicente do Rêgo Monteiro, and Lasar Segall searched for ways to create a unique "Brazilianness" in their art.

At the time of the *Semana de arte moderna*, Tarsila, the best-known Brazilian artist of the 1920s, was in Paris, where she spent a good part of the decade studying with friends and mentors such as Constantin Brancusi, Fernand Léger, and André Lhote. The period from around 1923 to 1930, the most productive span in her long career, may be divided into two phases: the *Pau-Brasil* period of 1924–27 and the *Antropofagia* period of 1928–29. In the first of these, named for brazilwood, the country's original export product, Tarsila created icons of Brazilian nationalism such as *Black Woman* (1923, cat. no. 218) and images of rural life such as *Shantytown Hill* (1924, cat. no. 229). During the second, named after the 1928 *Manifesto antropófago* (Cannibalist manifesto) by Oswald de Andrade, she produced work with Surrealist overtones, as in *The Egg* (1928, cat. no. 233).

Tarsila's art of the 1930s, like much Brazilian painting of the time, evidenced an interest in social realism. The most significant artist of this phase of Brazilian Modernism was Cândido Portinari, who impressed both Brazilian and North American audiences with his images of rural workers. His most famous of these, *Coffee* (1935, cat. no. 240), depicts the arduous life of agricultural workers in the interior of Brazil.

Alberto da Veiga Guignard represents a younger generation of artists associated with Modernism. He is probably best remembered for his dreamy landscapes of the Baroque cities and town of Minas Gerais, in which brightly colored buildings are set against hazy mountain landscapes. While Guignard's paintings are not directly connected to Surrealism (which had many proponents in Latin America in the 1930s and 1940s), they nonetheless have an oneiric quality that removes them from the realm of the everyday.

The sculpture of Maria Martins is much more explicitly Surrealist in its attempts to concretize inner emotions, fears, and dreams. The biomorphic quality of her bronze pieces is related to the imagery of artists like Jean Arp, Joan Miró, and Yves Tanguy. Martins was an intimate friend of Marcel Duchamp, and their relationship shaped the direction of both artists' work. —Edward J. Sullivan

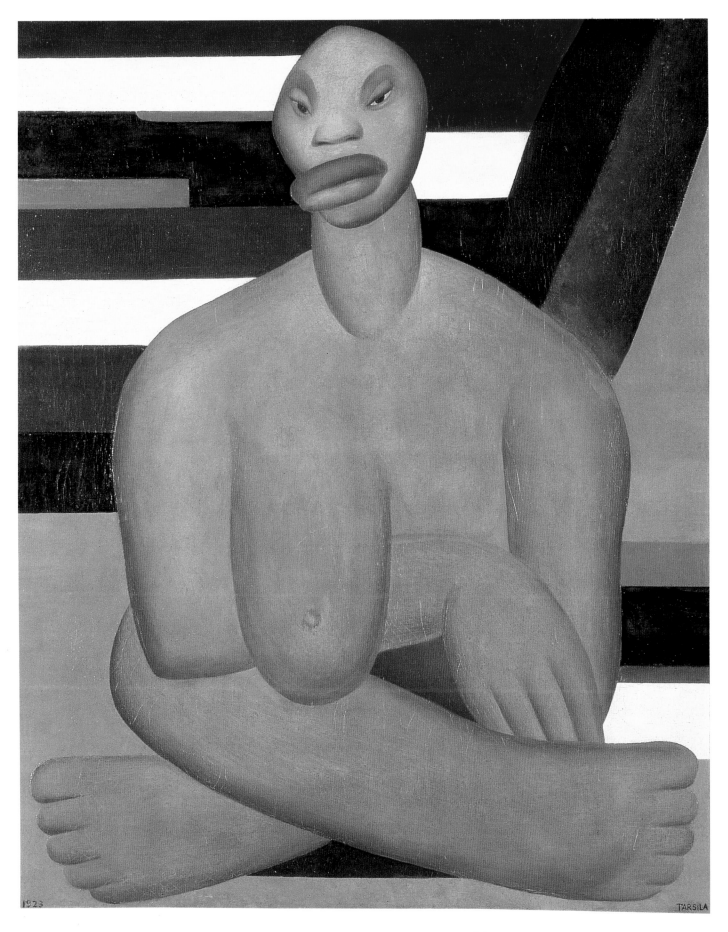

218. TARSILA DO AMARAL *Black Woman*, 1923. Oil on canvas, 100 x 80 cm. Museu de Arte Contemporânea da Universidade de São Paulo

219. VICTOR BRECHERET *Painful Sorrow*, 1919. Marble, 50 x 18 x 37.5 cm. Zellmeister Collection, São Paulo

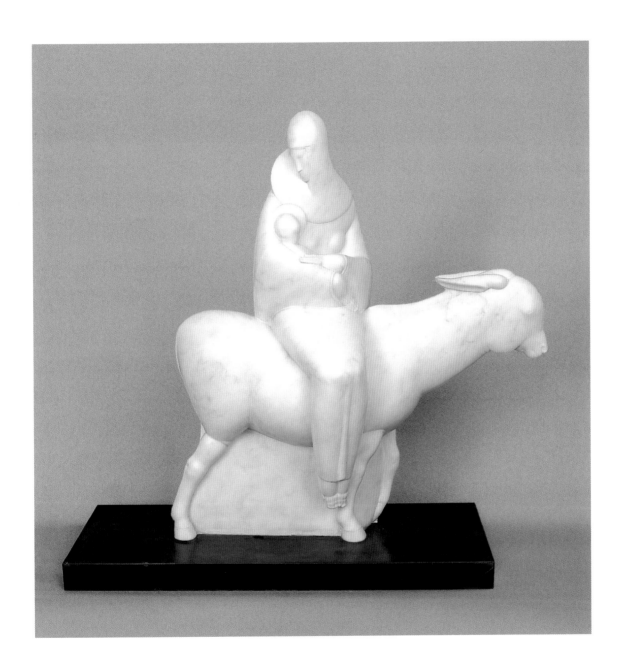

220. VICTOR BRECHERET *Flight into Egypt*, 1928. Marble, 73 x 68 x 23 cm. Private collection

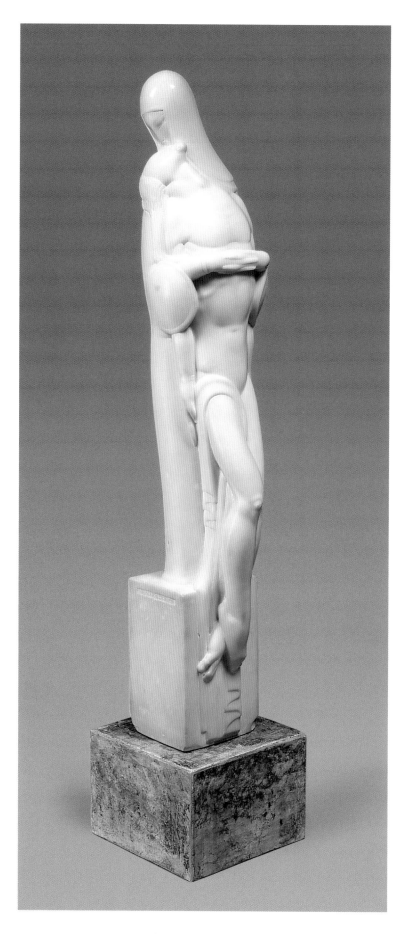

221. VICTOR BRECHERET *Pietà*, 1930s. Marble, 89 x 22 x 14 cm. Collection of Mr. and Mrs. Luis Antônio de Almeida Braga, Rio de Janeiro

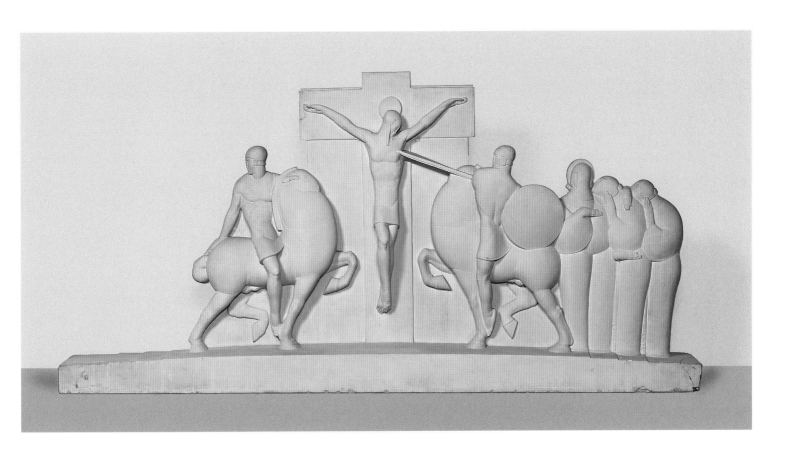

222. VICTOR BRECHERET *Crucifixion of Christ*, 1923–24. Stone, 83.5 x 171.5 x 17 cm. Museu de Arte
Brasileira–Fundação Armando Alvares Penteado, São Paulo

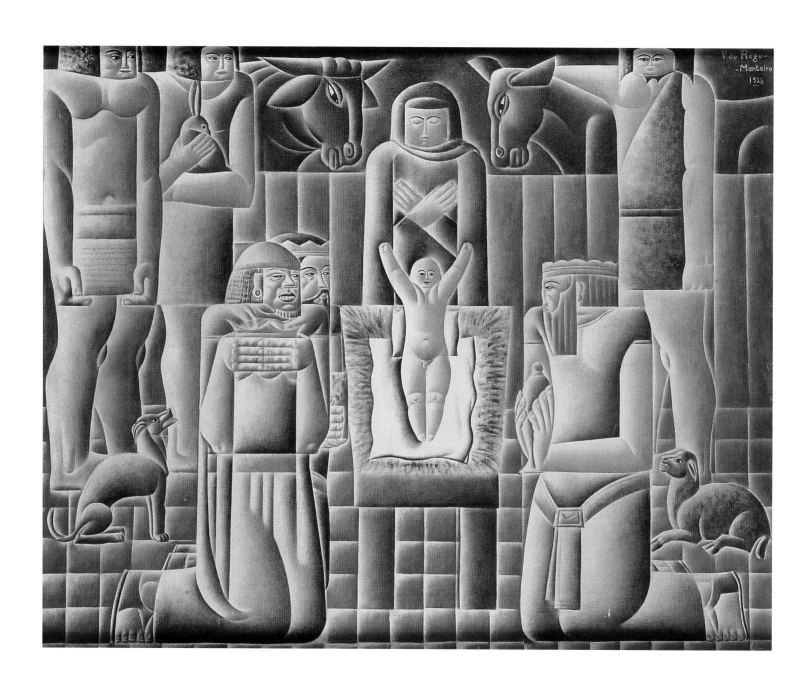

223. VICENTE DO RÊGO MONTEIRO *The Adoration of the Magi*, 1925. Oil on canvas, 81 x 100 cm.

Museu de Arte Moderna do Rio de Janeiro, Gilberto Chateaubriand Collection

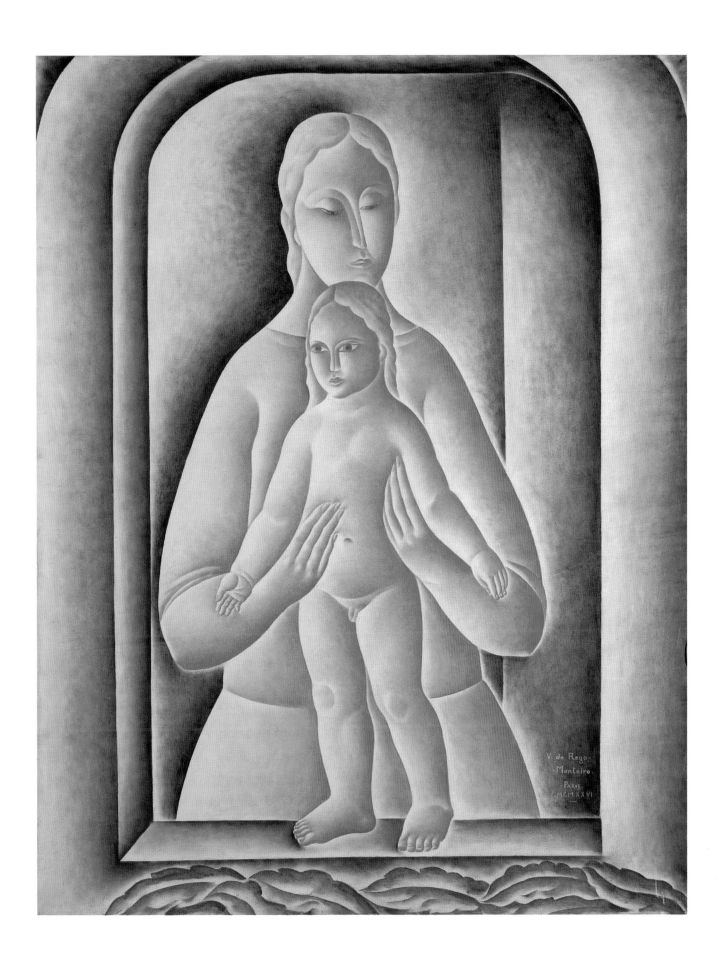

224. VICENTE DO RÊGO MONTEIRO *Madonna and Child*, 1926. Oil on canvas, 92 x 73 cm.

The Metropolitan Museum of Art, New York, Robert Lehman Collection, 1975

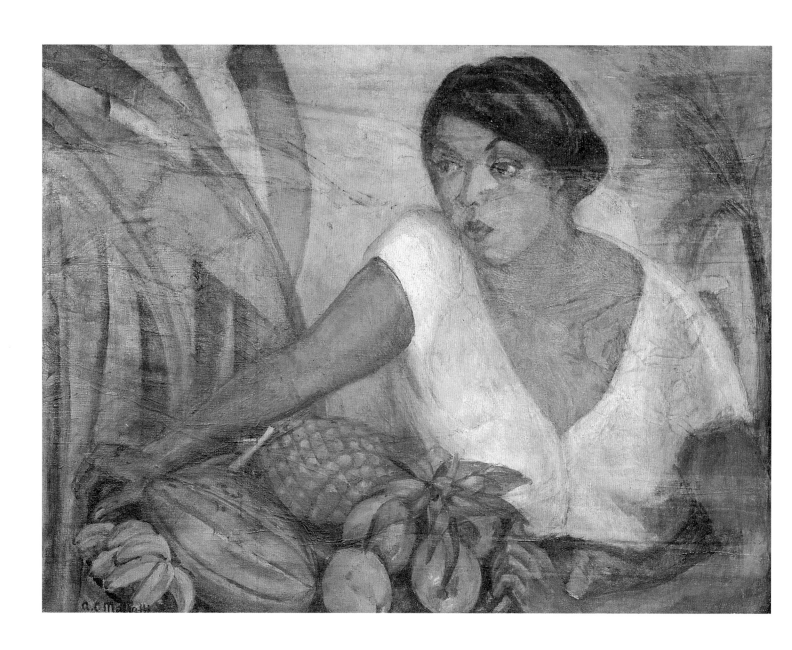

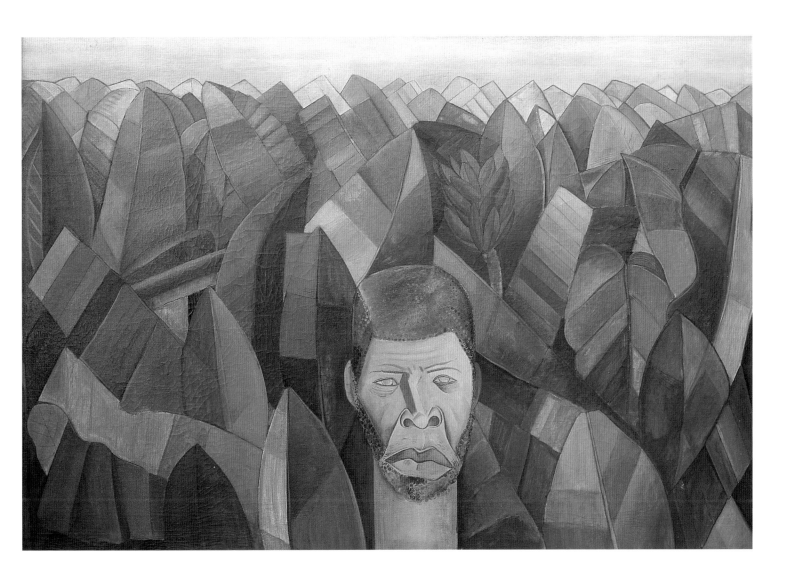

226. LASAR SEGALL *The Banana Grove*, 1927. Oil on canvas, 87 x 127 cm. Pinacoteca do Estado de São Paulo

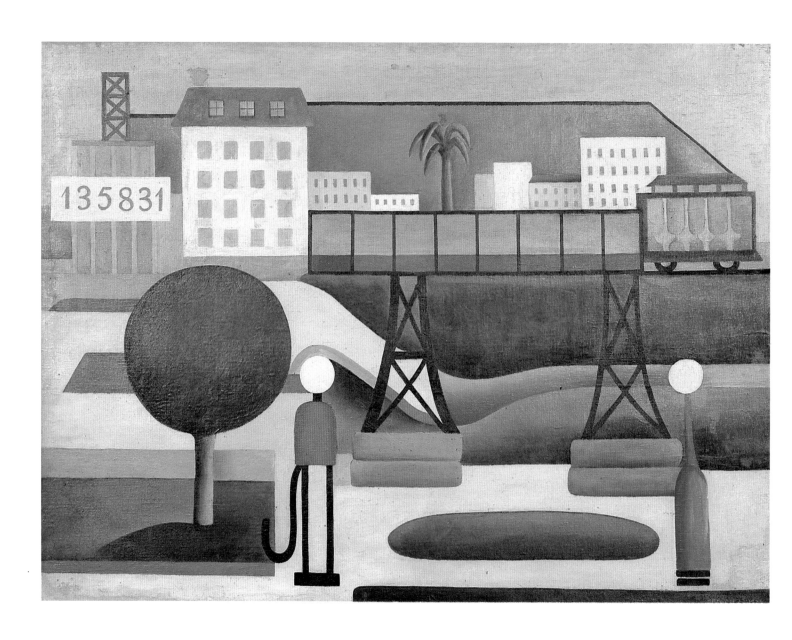

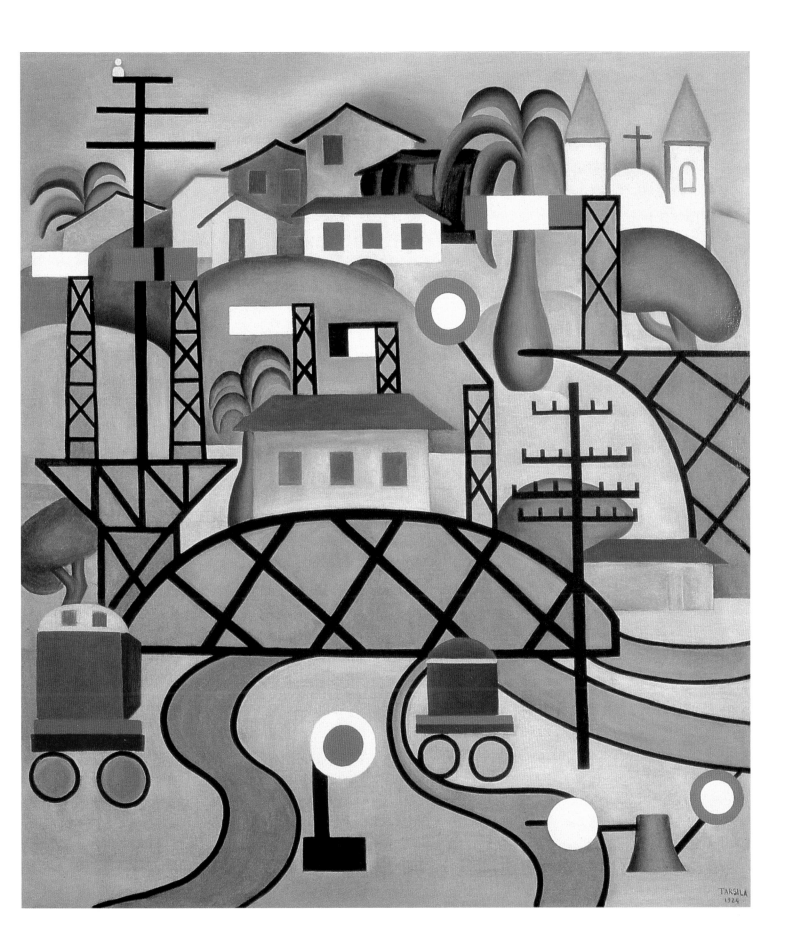

228. TARSILA DO AMARAL *E.F.C.B.*, 1924. Oil on canvas, 142 x 126.8 cm. Museu de Arte Contemporânea
da Universidade de São Paulo

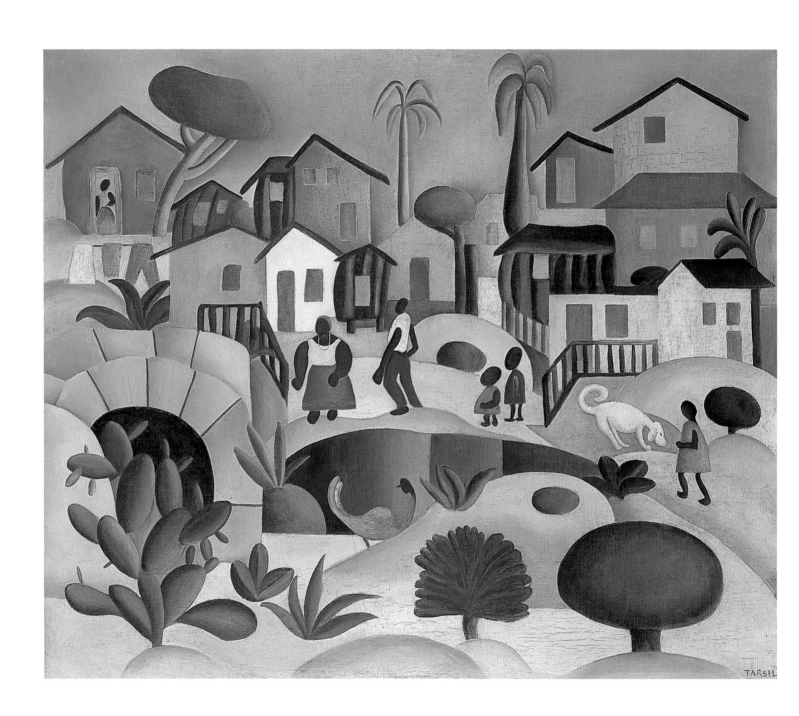

229. TARSILA DO AMARAL *Shantytown Hill*, 1924. Oil on canvas, 64.5 x 76 cm. Collection of Sérgio Sahione Fadel, Rio de Janeiro

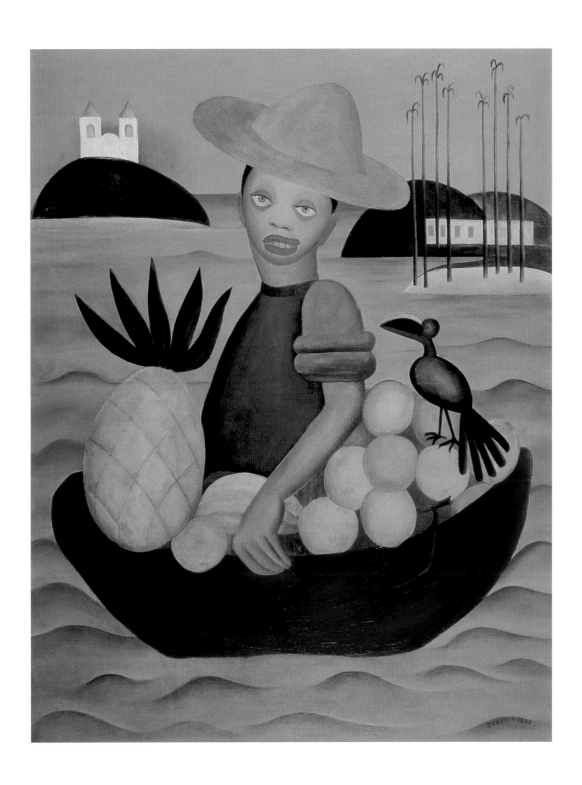

230. TARSILA DO AMARAL *The Fruit Seller*, 1925. Oil on canvas, 108.5 x 84.5 cm. Museu de Arte Moderna do Rio de Janeiro, Gilberto Chateaubriand Collection

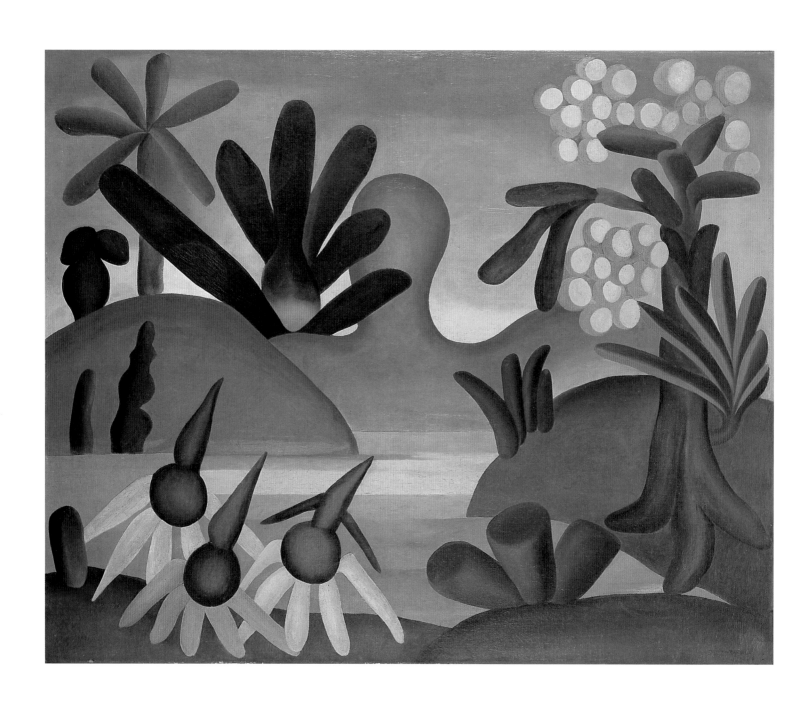

231. TARSILA DO AMARAL *The Lake*, 1928. Oil on canvas, 75.5 x 93 cm. Collection of Sérgio Sahione Fadel, Rio de Janeiro

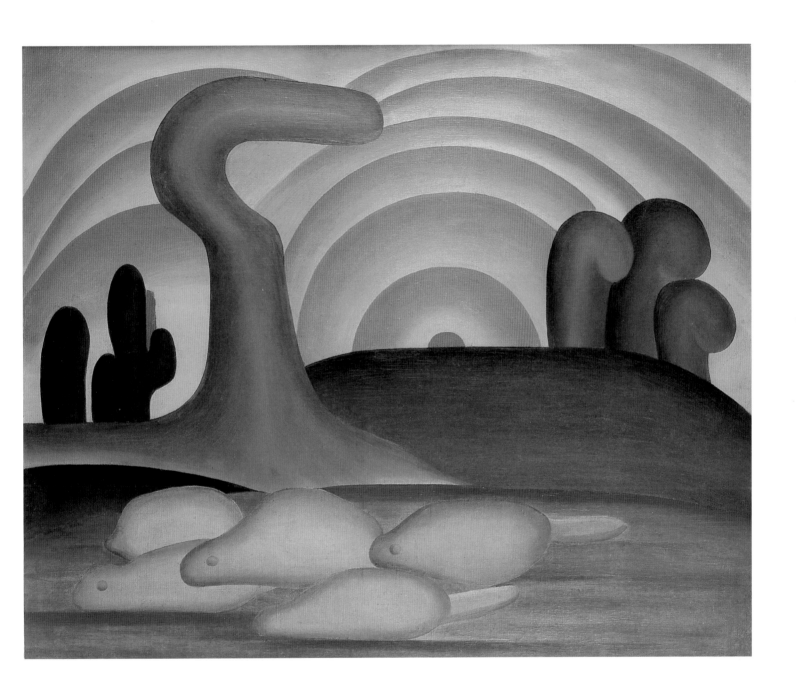

232. TARSILA DO AMARAL *Setting Sun*, 1929. Oil on paper, 54 x 65 cm. Collection of Genviève and Jean Boghici,
Rio de Janeiro

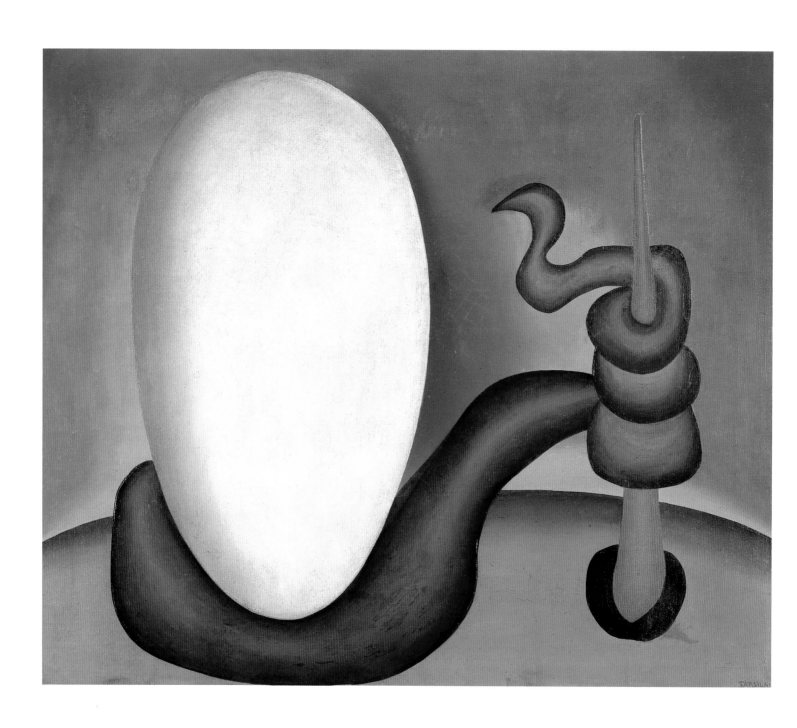

233. TARSILA DO AMARAL *The Egg*, 1928. Oil on canvas, 60.5 x 72.5 cm. Museu de Arte Moderna do Rio de Janeiro, Gilberto Chateaubriand Collection

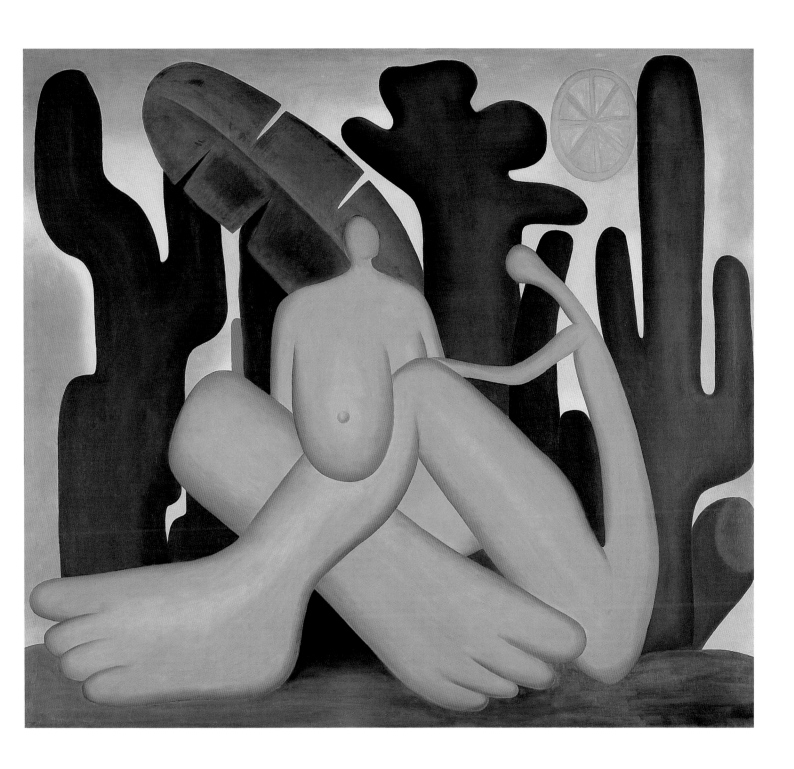

234. **TARSILA DO AMARAL** *Anthropophagy*, 1929. Oil on canvas, 126 x 142 cm. Fundação José e Paulina
Nemirovsky, São Paulo

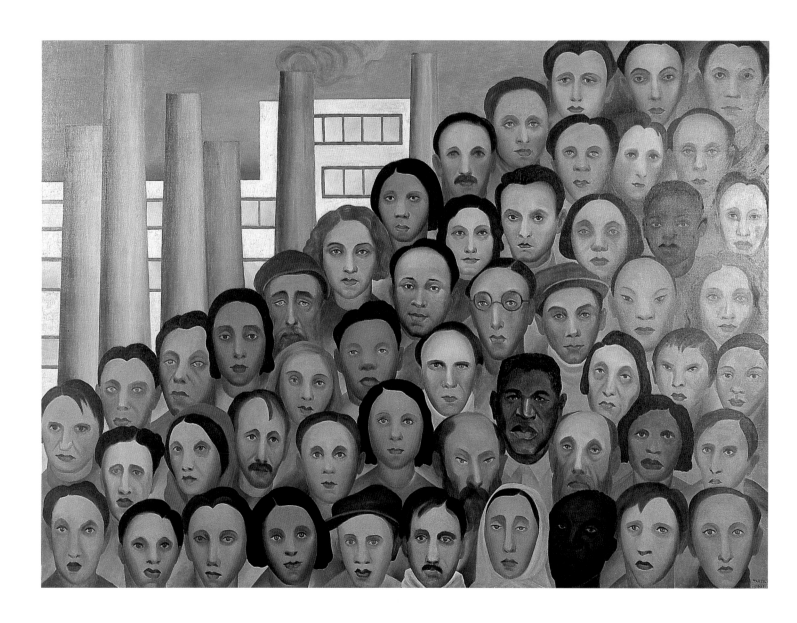

235. TARSILA DO AMARAL *Workers*, 1933. Oil on canvas, 150 x 205 cm. Acervo Artístico/Cultural dos Palácios do Governo do Estado de São Paulo

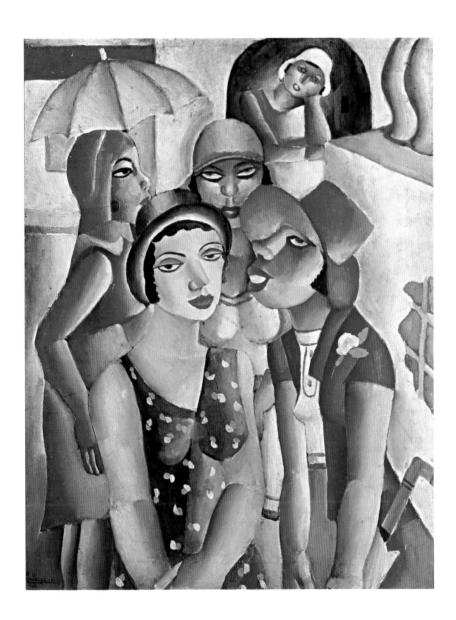

236. EMILIANO DI CAVALCANTI *Five Girls from Guaratinguetá*, 1930. Oil on canvas, 91 x 71 cm.
Museu de Arte de São Paulo Assis Chateaubriand, São Paulo

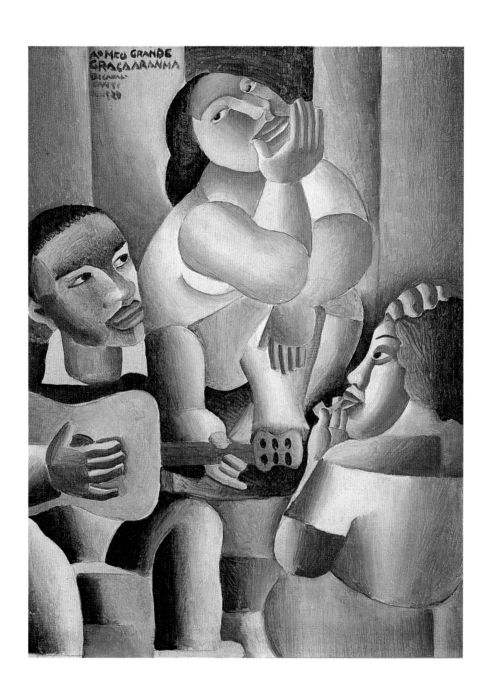

237. EMILIANO DI CAVALCANTI *Samba Group*, 1928. Oil on canvas, 63 x 48 cm. Collection of Sérgio Sahione Fadel, Rio de Janeiro

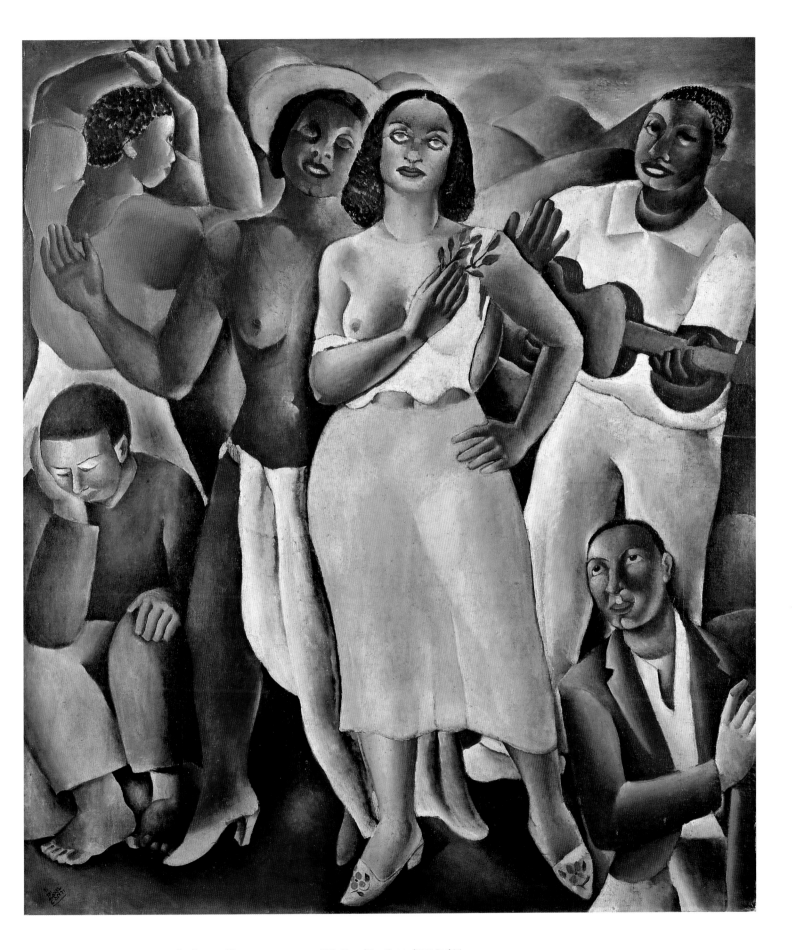

238. EMILIANO DI CAVALCANTI *Samba*, 1925. Oil on canvas, 175 x 154 cm. Collection of Genviève and Jean Boghici,
Rio de Janeiro

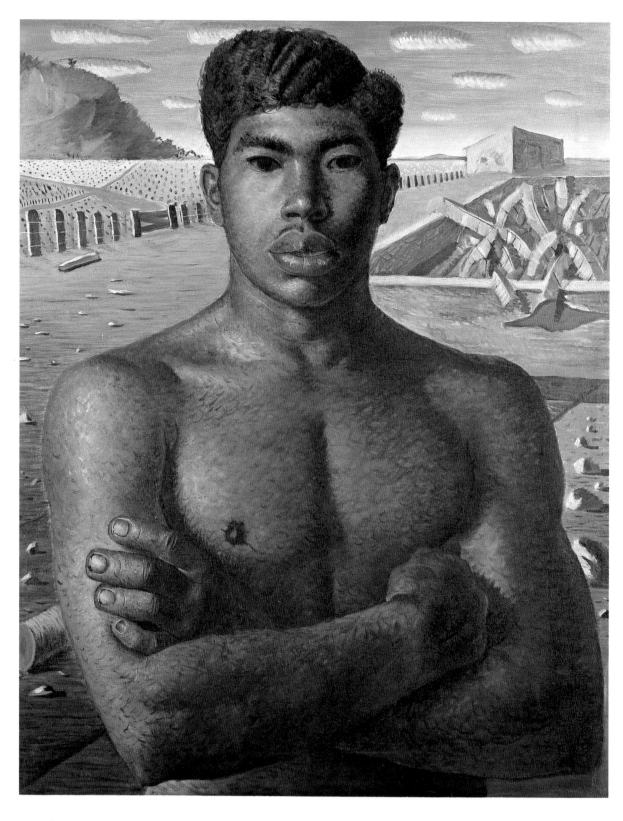

239. CÂNDIDO PORTINARI *Mestizo*, 1934. Oil on canvas, 81 x 65.5 cm. Pinacoteca do Estado de São Paulo

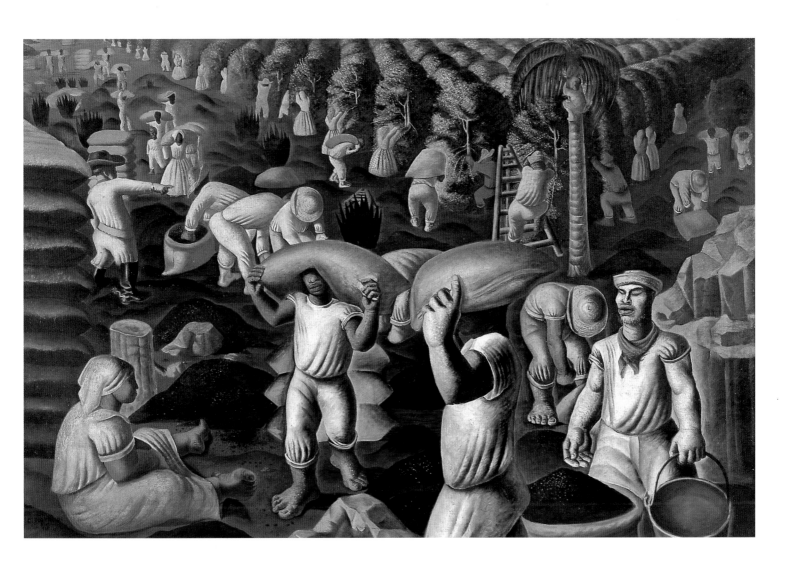

240. CÂNDIDO PORTINARI *Coffee*, 1935. Oil on canvas, 130 x 195.4 cm. Museu Nacional de Belas Artes, Rio de Janeiro

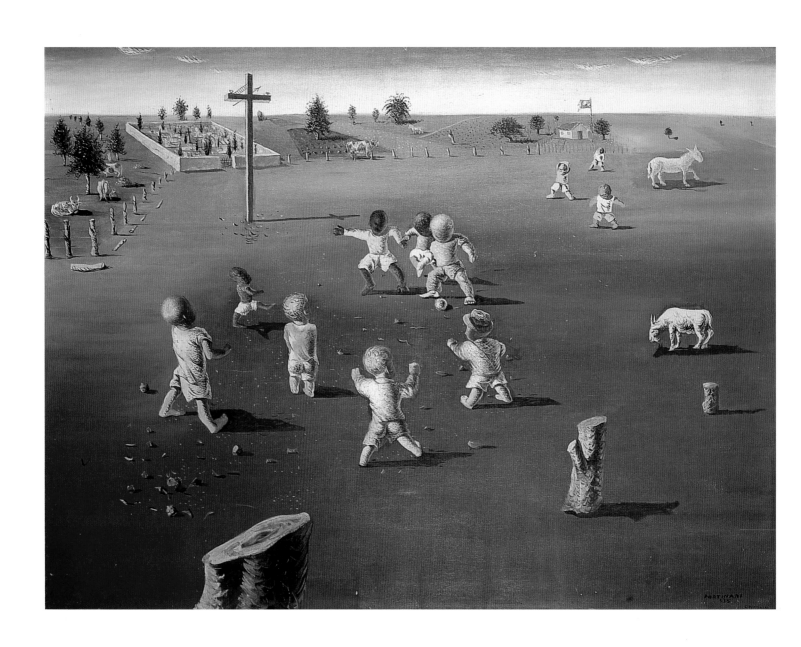

241. **CÂNDIDO PORTINARI** *Soccer*, 1935. Oil on canvas, 97 x 130 cm. Collection of Sérgio Sahione Fadel, Rio de Janeiro

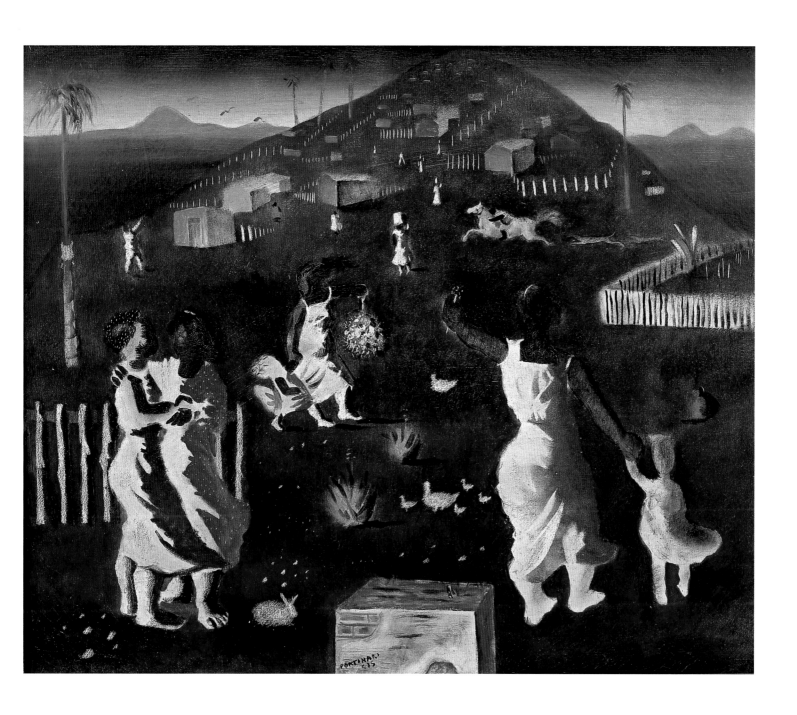

242. CÂNDIDO PORTINARI *Shantytown Hill*, 1935. Oil on canvas, 60.5 x 73 cm. Collection of Beatriz and Mário Pimenta
Camargo, São Paulo

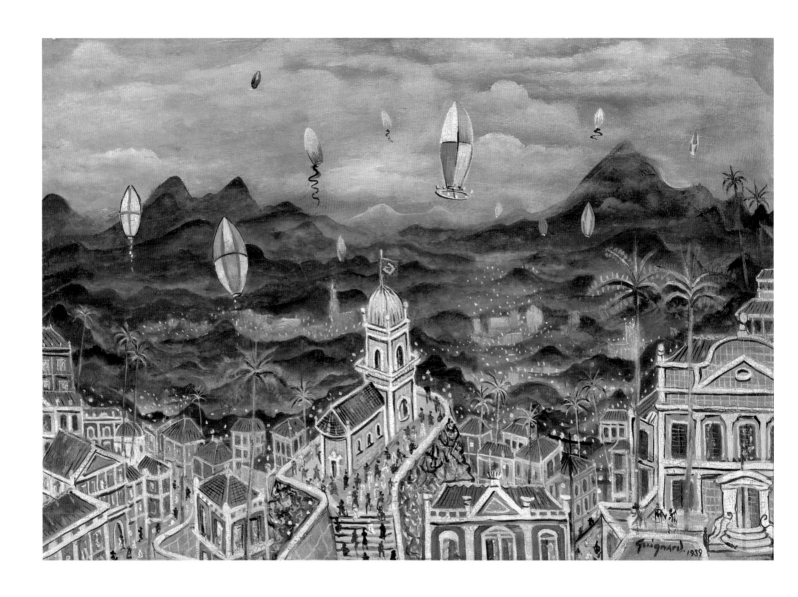

243. ALBERTO DA VEIGA GUIGNARD *Saint John's Day Celebration*, 1939. Oil on wood, 54.5 x 80 cm. Collection of
Ricard Akagawa, São Paulo

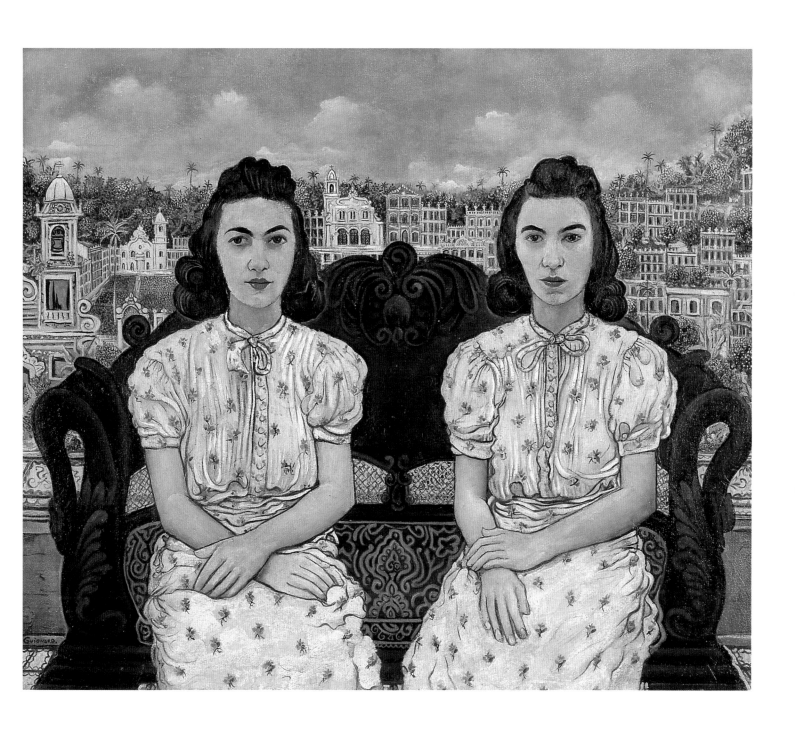

244. ALBERTO DA VEIGA GUIGNARD *Léa and Maura*, 1940. Oil on wood, 110 x 135 cm. Museu Nacional de Belas Artes, Rio de Janeiro

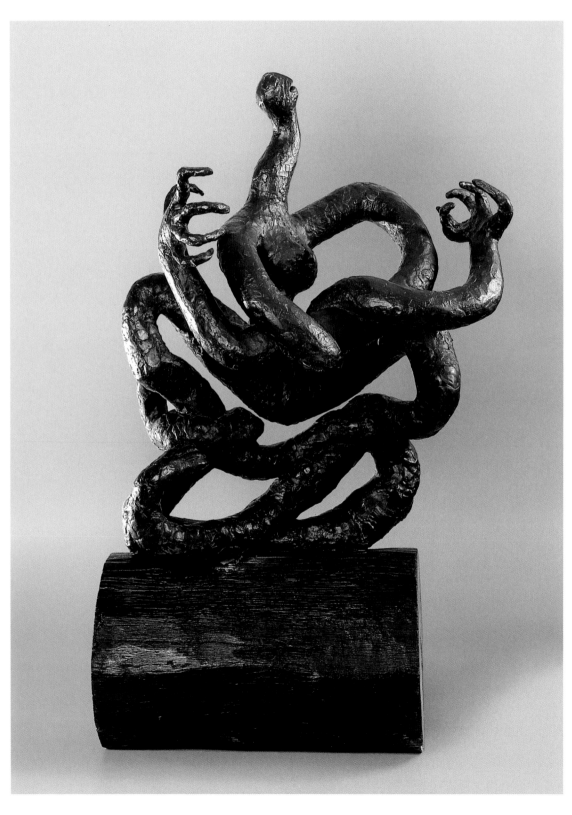

245. MARIA MARTINS *Without Echo*, 1943. Bronze, 64 x 53 x 33 cm. Collection of Genviève and Jean Boghici, Rio de Janeiro

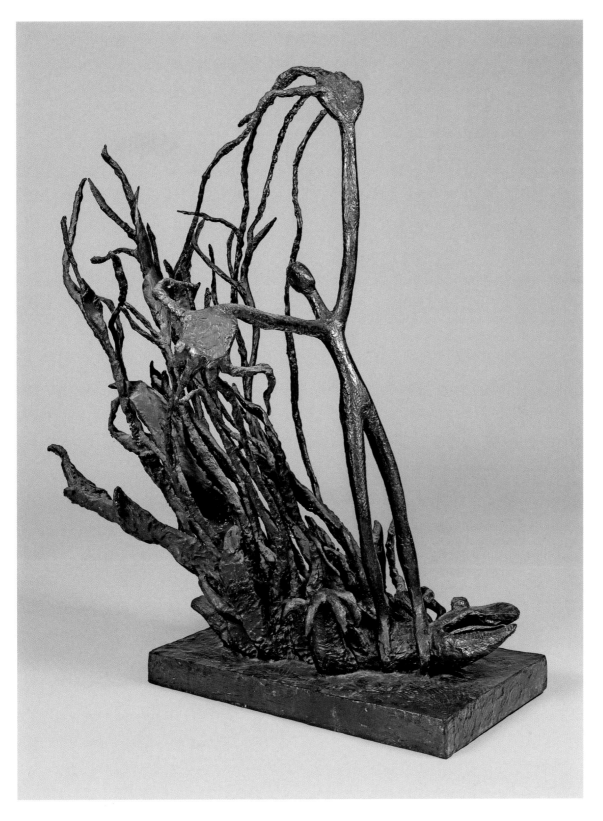

246. MARIA MARTINS *Prometheus*, 1949. Bronze, 104.5 x 57.3 x 94 cm. Collection of Genviève and Jean Boghici, Rio de Janeiro

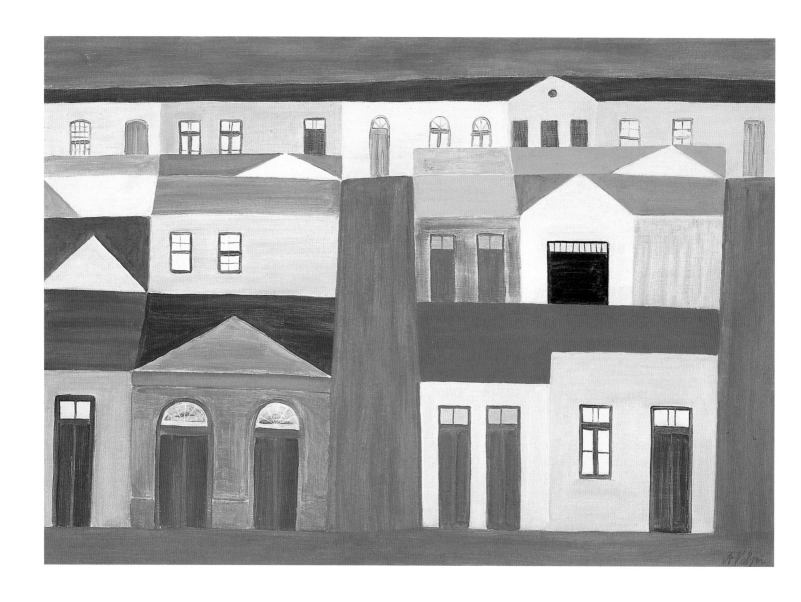

247. ALFREDO VOLPI *Facades*, early 1950s. Tempera on canvas, 81.5 x 116 cm. Collection of Marta and Paulo Kuczynski, São Paulo

248. ALFREDO VOLPI *Houses in Santos*, 1952. Tempera on canvas, 116.3 x 73.4 cm. Private collection

249. ALFREDO VOLPI *Facade*, 1950s. Tempera on canvas, 155 x 102 cm. Collection of Marta and Paulo Kuczynski, São Paulo

250. ALFREDO VOLPI *Facade*, 1950s. Tempera on canvas, 105 x 70 cm. Private collection

251. ALFREDO VOLPI *Concrete Forms*, 1950s. Tempera on canvas, 100.5 x 65.6 cm. Collection of Mr. and Mrs. Luiz Antonio de Almeida Braga, Rio de Janeiro

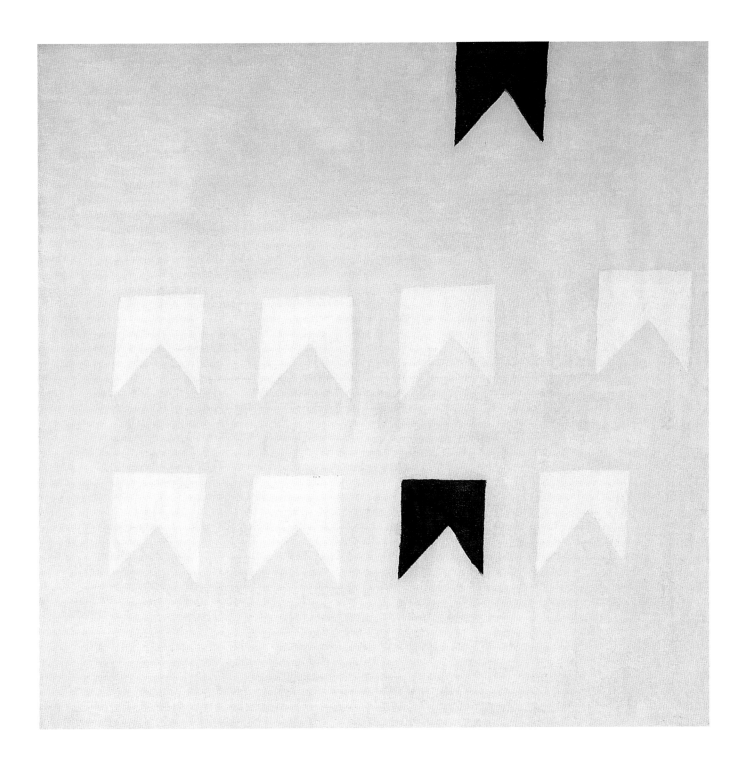

252. **ALFREDO VOLPI** *Black and White Flags*, 1959. Tempera on canvas, 72 x 72 cm. Mastrobuono Collection, São Paulo

Concrete Art

The 1950s, which saw the construction of Brazil's new utopian capital, Brasília, and the formation of the *São Paulo Bienal*, was a period of democracy and relative economic prosperity in the country. It was within a climate of increased internationalism that the distinctive form of geometrically based painting and sculpture called Concrete art was established. In Europe, Russian Constructivism, De Stijl, Neo-Plasticism, and the Bauhaus school had all nourished a taste for rational nonobjectivity, and artists such as the Uruguayan Joaquín Torres-Garciá, who in 1934 had returned from an extended European residency, had imported this tendency to Latin America. Swiss artist Max Bill, who had exhibited his work at the Museu de Arte de São Paulo in 1950 and returned the following year to win a major prize at the first *São Paulo Bienal*, had inspired many younger artists in Brazil to work in a style related to his.

Waldemar Cordeiro's *Manifesto ruptura*, one of the most important documents in the rise of Concrete art, appeared in 1952, accompanying an exhibition at the Museu de Arte Moderna de São Paulo. Along with Cordeiro, other artists who formed the initial Concrete group included Lothar Charoux, Geraldo de Barros, Luis Sacilotto, and Mary Vieira. Among the aims of Concrete art was the distancing of visual expression from figurative art, which had played such a strong role in the past. Through the years, Concrete artists in Brazil would also be attuned to contemporary theories of cybernetics and Gestalt psychology, and to the optical experiments of international artists such as Victor Vasarely and Bridget Riley.

While Concrete art first found expression in São Paulo, Rio de Janeiro was the site of some important innovations in the late 1950s. The Grupo Frente artists, including Lygia Clark, Hélio Oiticica, and Lygia Pape, held their first exhibition at the Galería IBEU in Rio de Janeiro in 1954. In 1956, the first *Exposição nacional de arte concreta* was held at the Museu de Arte Moderna do Rio de Janeiro. The artists who had belonged to the first wave of Concretism were dismayed to see a lessening in the rigor of color and form in the works displayed. Artists from Rio de Janeiro became more and more interested in experimenting with a wide range of color and inserting a greater sensuality or poetic feeling into their art.

In 1959, poet Ferreira Gullar's *Manifesto neoconcreto* expressed a need to break away from the "dangers of excessive rationalism and scientific positivism." Artists such as Clark, Oiticica, Pape, and Franz Weissmann thus began to create work that was predicated on the involvement of the viewer. Ultimately, some of the members of the Neo-Concrete group, especially Clark and Oiticica, went on to develop methods of creating art that embraced notions of performative interactivity between the art object and the spectator. —E. J. S.

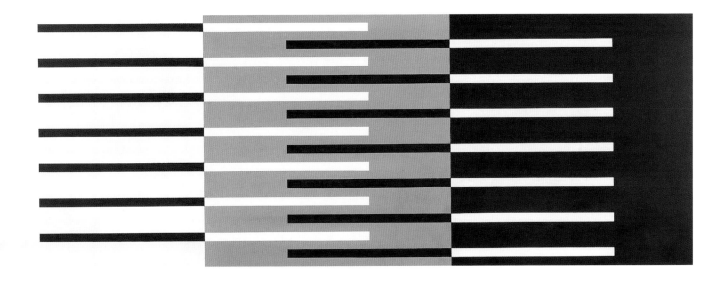

253. **LUIS SACILOTTO** *Concretion 5521*, 1955. Enamel on wood, 30 x 90 cm. Collection of Adolpho Leirner, São Paulo

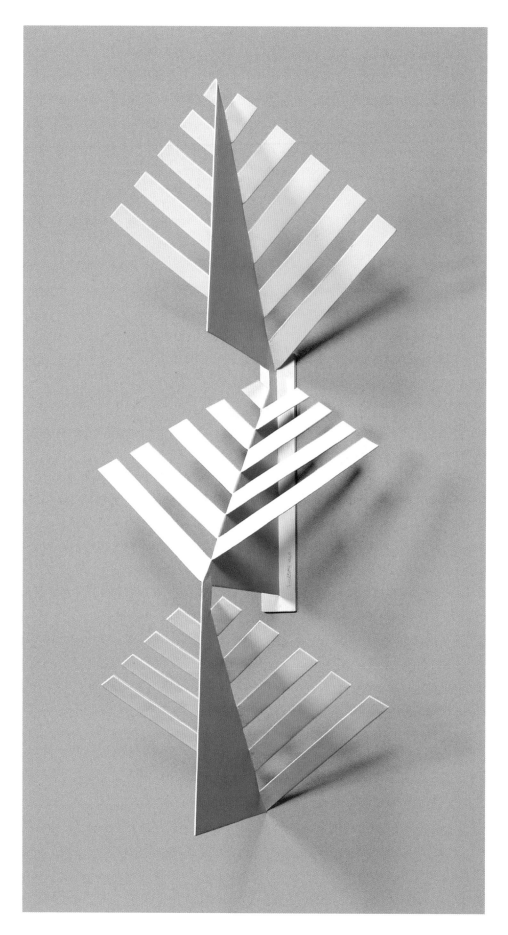

254. LUIS SACILOTTO *Concretion 6045*, 1955. Iron, 90 x 50 x 31 cm. Collection of Adolpho Leirner, São Paulo

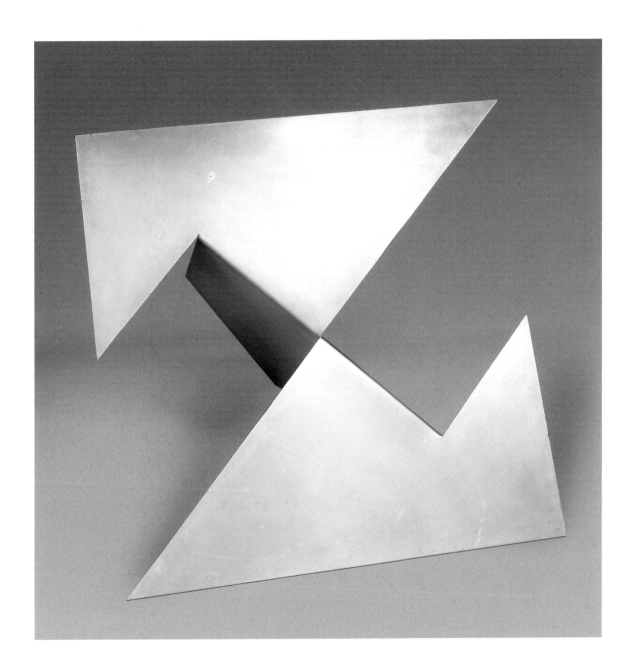

255. **LUIS SACILOTTO** *Concretion 5730*, 1957. Aluminum, 50 x 50 x 35 cm. Collection of Adolpho Leirner, São Paulo

256. FRANZ WEISSMANN *Column*, 1952–53. Painted iron, 200 x 38.5 x 38.5 cm. Collection of the artist

257. FRANZ WEISSMANN *Tower*, 1958. Painted iron, 140 x 55 x 55 cm. Museu Nacional de Belas Artes, Rio de Janeiro

258. **MARY VIEIRA** *Polyvolume: Plastic Disc*, 1953–62. Anodized aluminum and wood, 46 x 37 x 21 cm.
Museu de Arte Contemporânea da Universidade de São Paulo

450

259. LYGIA PAPE *Book of Time*, 1961. Acrylic on wood, dimensions variable. Collection of the artist

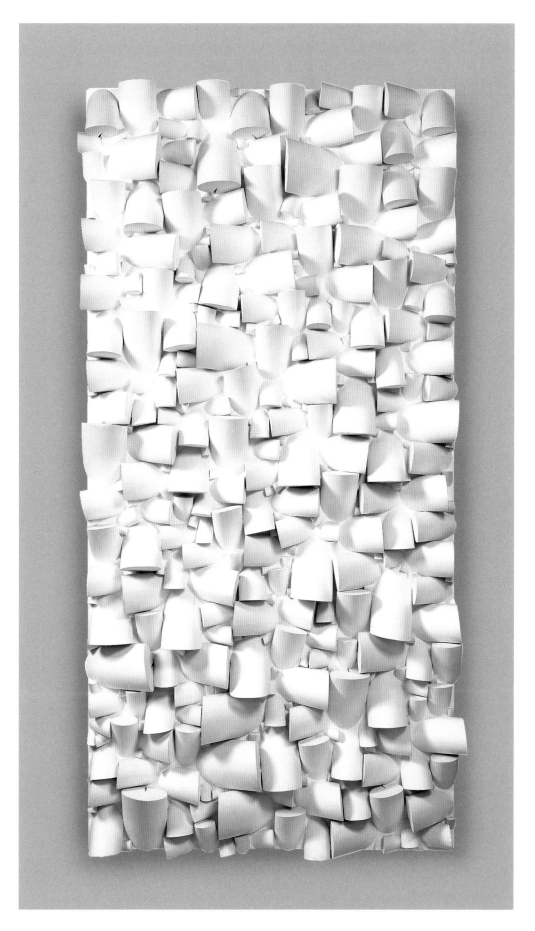

260. SÉRGIO CAMARGO *No. 104*, 1966. Painted wood, 205.5 x 100.5 x 25 cm. Collection of Gerard Loeb, São Paulo

Lygia Clark and Hélio Oiticica

Lygia Clark and Hélio Oiticica are the two best-known representatives of the Neo-Concrete movement in Brazil. Clark's early training took place in Rio de Janeiro with the noted landscape architect and painter Roberto Burle Marx, whose intense involvement with natural forms undoubtedly inspired her. She constantly struggled to integrate the energy of life forces in her art, and a tension between rigid abstraction and organic growth is evident in her work. After creating a series of hard-edge abstract paintings, such as *Egg* (1959, cat. no. 261), Clark moved on to produce three-dimensional metallic sculptures. In her *Trepantes* of the 1960s (e.g., cat. nos. 270–72), she combined metal and wood, setting up a series of correlations between the two surfaces and textures. Also from the 1960s, *Bichos* (e.g., cat. nos. 263–65)—free-form objects that may be installed anywhere and in any configuration chosen by the viewer/participant—combine hints of living, breathing beings with the coolness of metal. Clark's later work reflects her practice as a psychotherapist. For example, she created articles of clothing that could be worn and used to temporarily alter the personality of the wearer. In participatory works such as these, Clark reached far beyond conventional definitions of art.

Clark both collaborated with and had strong affinities with Oiticica, who holds a position in Brazil analogous to that maintained by Andy Warhol in the United States and Joseph Beuys in Western Europe. "Creator," "shaman," "rebel": these are among the many terms that could be used to describe his significance. Before Oiticica's untimely death at the age of forty-three, he had rarely exhibited in conventional galleries or museums and did not conceive of his work in the orthodox sense, as art that could be commodified and put on display for viewers' pleasure.

After early study with the painter Ivan Serpa, Oiticica created a series of *Metaschemes* in the late 1950s (e.g., cat. nos. 273–75), composed of geometrical forms painted in oil on canvas. In 1959, he made the transition from two to three dimensions. He showed a series of reliefs in the first *Exposição neoconcreta*, held at the Museu de Arte Moderna do Rio de Janeiro in 1959, as well as at *Konkrete Kunst*, presented in Zurich in 1960. Oiticica's *Parangolés*, which he began making in 1964, represent a critical turning point in his career. Taking the form of a cape or a voluminous garment worn by a participant in an "action," his use of these *Parangolés* is related to the genres of experimental, performative art that were developing internationally in the 1960s, yet they are an innately Brazilian form of this phenomenon. Oiticica's performances using the *Parangolés* were in part stimulated by the artist's interest in dance and Carnival. By this time, he had gained the rank of *passista* (principal dancer) in the samba school of Mangueira, one of Rio de Janeiro's oldest *favelas* (slums). —E. J. S.

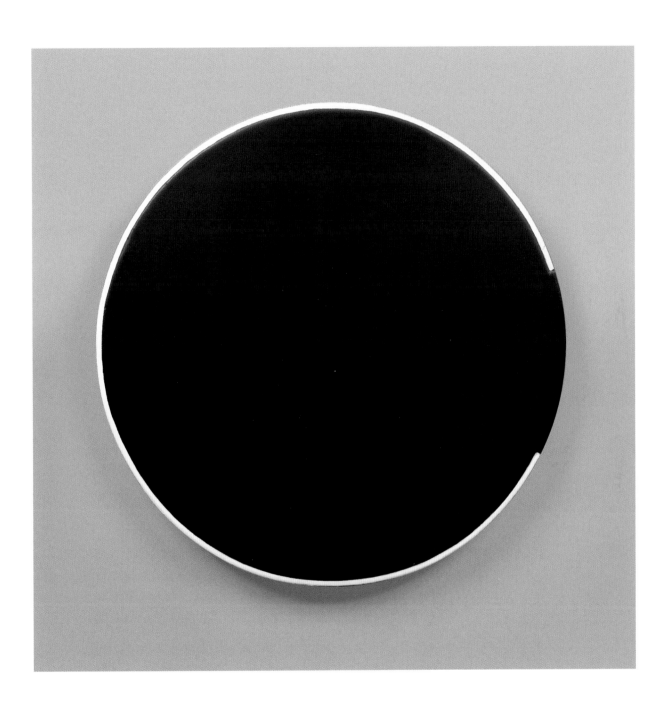

261. LYGIA CLARK *Egg*, 1959. Industrial paint on wood, 33 x 33 x 2.5 cm. Collection of Adolpho Leirner, São Paulo

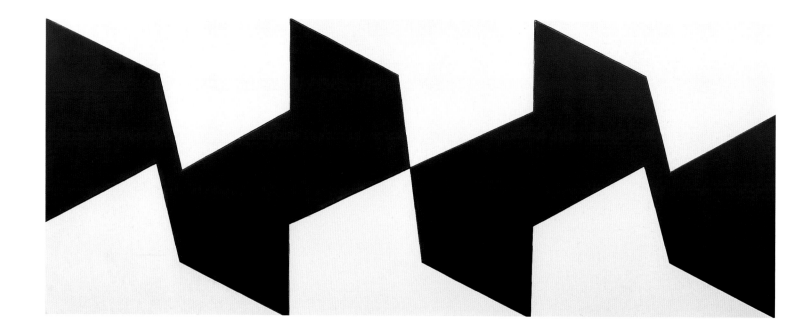

262. LYGIA CLARK *Modulated Space Number 3*, 1957. Industrial paint on wood, 47 x 120 cm. Collection of
Marta and Paulo Kuczynski, São Paulo

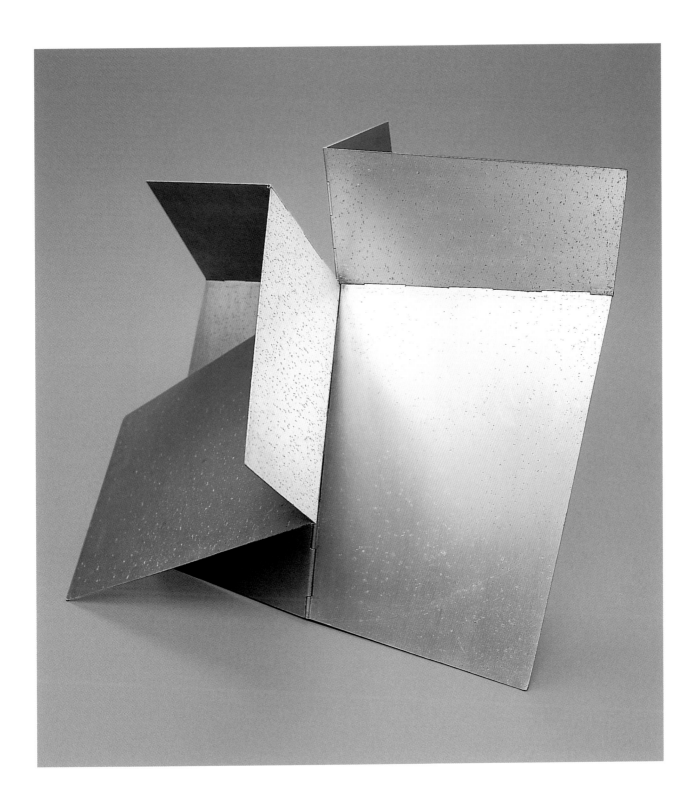

263. **LYGIA CLARK** *Bicho*, 1960s. Aluminum, 8 x 91 x 61 cm. Collection of Luiz Buarque de Hollanda, Rio de Janeiro

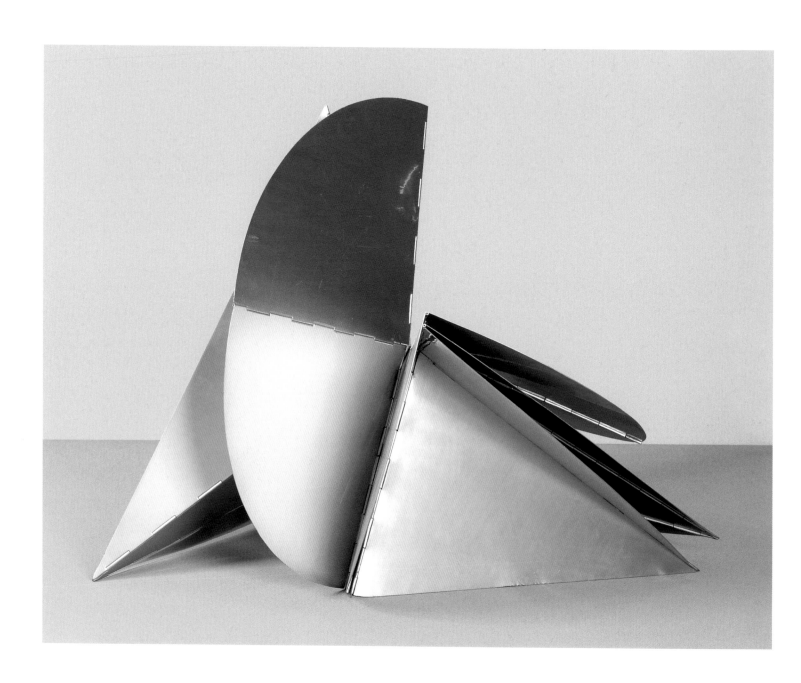

264. LYGIA CLARK *Bicho*, 1960. Aluminum, 100 x 100 x 100 cm. Collection of Eugênio Pacelli Pires dos Santos, Rio de Janeiro

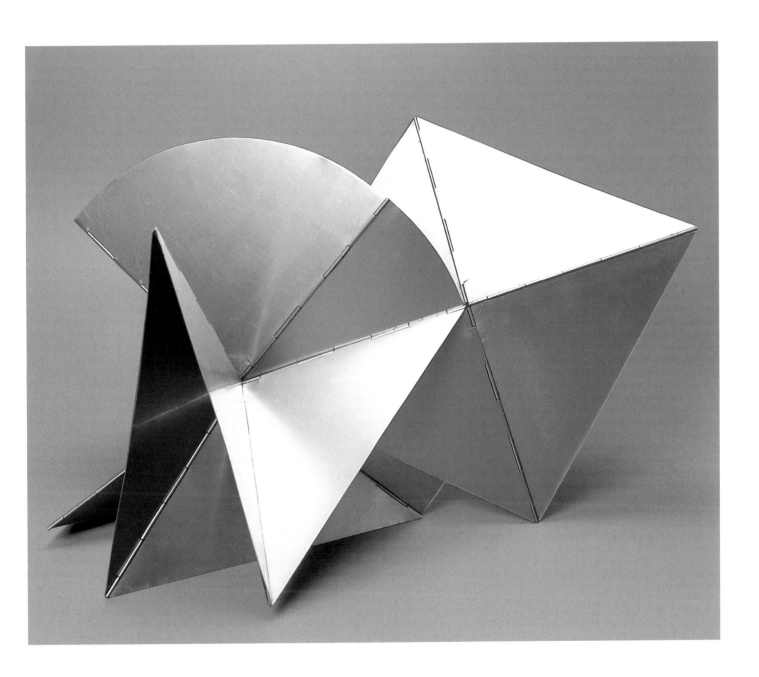

265. **LYGIA CLARK** *Bicho*, 1960s. Aluminum, 8 x 91 x 61 cm. Collection of Luiz Buarque de Hollanda, Rio de Janeiro

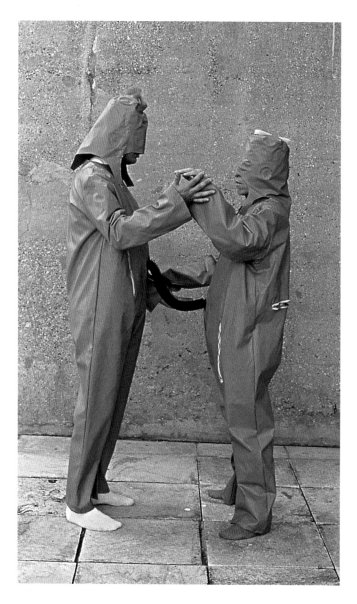 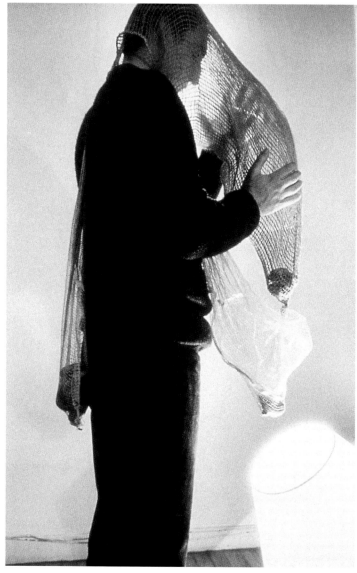

LEFT: 266. LYGIA CLARK *The I and the You: Clothing-Body-Clothing Series*, 1967. Interactive objects. Museu de Arte Moderna do Rio de Janeiro, Clark Family Collection. RIGHT: 267. LYGIA CLARK *Abysmal Mask*, 1968. Interactive object. Museu de Arte Moderna do Rio de Janeiro, Clark Family Collection.

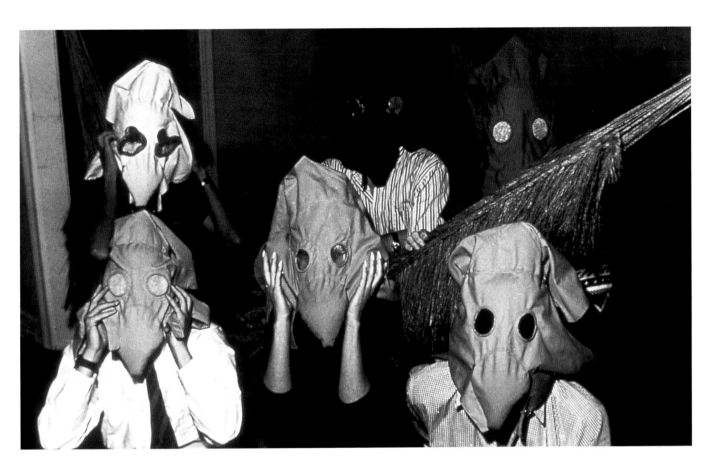

TOP: **268. LYGIA CLARK** *Sensorial Masks*, 1967. Interactive objects. Museu de Arte Moderna do Rio de Janeiro, Clark Family Collection. BOTTOM: **269. LYGIA CLARK** *Dialogue with Glasses*, 1968. Interactive objects. Museu de Arte Moderna do Rio de Janeiro, Clark Family Collection

TOP: **270. LYGIA CLARK** *Trepante*, 1969. Copper and wood, 150 x 240 x 95 cm. Collection of Mr. and Mrs. Luiz Antonio de Almeida Braga, Rio de Janeiro. BOTTOM: **271. LYGIA CLARK** *Trepantes*, 1964/1987. Rubber, 144 x 44 x 0.5 cm. Museu de Arte Moderna do Rio de Janeiro

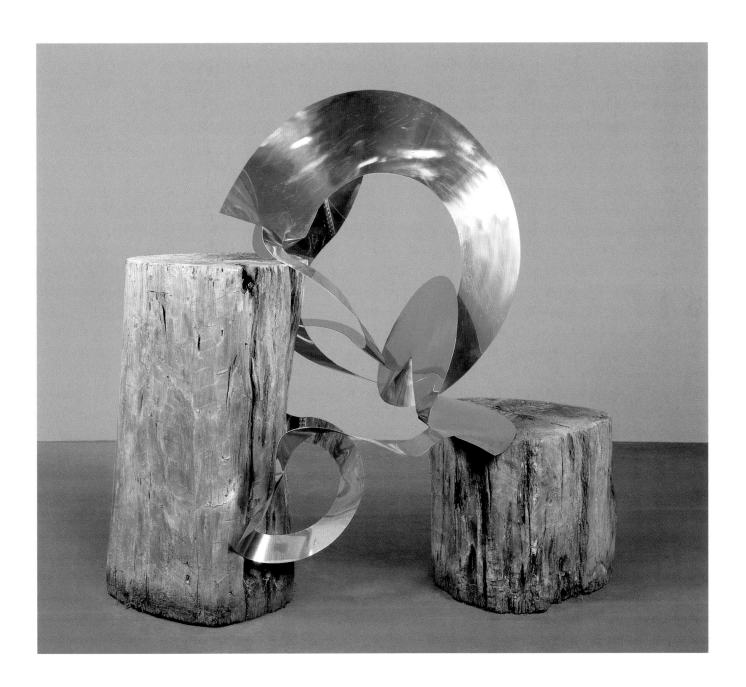

272. **LYGIA CLARK** *Trepante*, 1969. Stainless steel and wood, 152 x 160 x 95 cm. Collection of
Mr. and Mrs. Luiz Antonio de Almeida Braga, Rio de Janeiro

273. **HÉLIO OITICICA** *Metascheme*, 1959. Oil on canvas, 54 x 65 cm. Collection of Luiz Buarque de Hollanda, Rio de Janeiro

274. **HÉLIO OITICICA** *Metascheme Red and White*, 1950s. Oil on canvas, 80 x 100 cm. Private collection, São Paulo

275. HÉLIO OITICICA *Metascheme,* 1959. Oil on canvas, 54 x 65 cm. Collection of Luiz Buarque de Hollanda, Rio de Janeiro

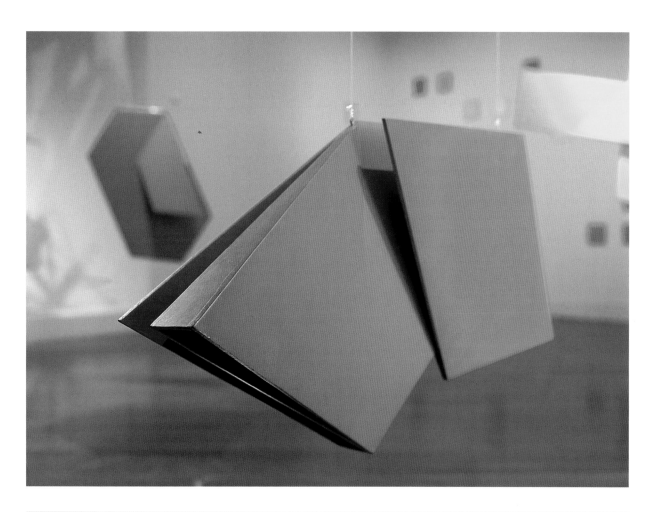

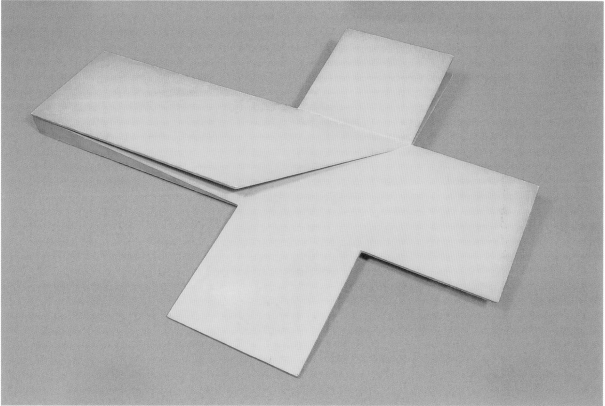

TOP: **276. HÉLIO OITICICA** *Spatial Relief*, 1959. Acrylic on wood, 16 x 63 x 150 cm. Hélio Oiticica Collection, Projeto Hélio Oiticica, Rio de Janeiro. BOTTOM: **277. HÉLIO OITICICA** *Spatial Relief*, n.d. Acrylic on wood, 154 x 116 x 10 cm. Collection of Luiz Buarque de Hollanda, Rio de Janeiro

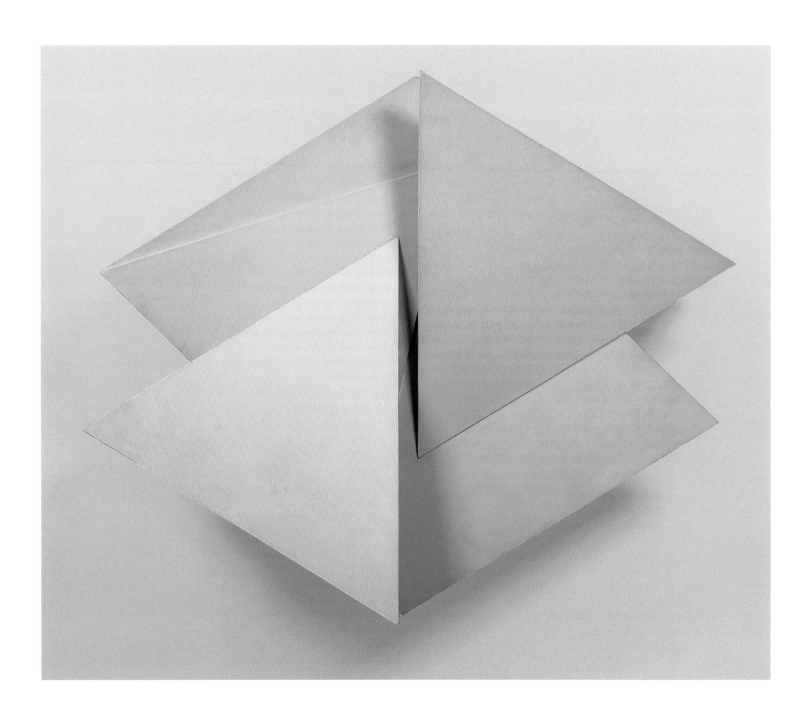

278. HÉLIO OITICICA *Spatial Relief*, 1959. Acrylic on wood, 15 x 100 x 125 cm. Hélio Oiticica Collection,
Projeto Hélio Oiticica, Rio de Janeiro

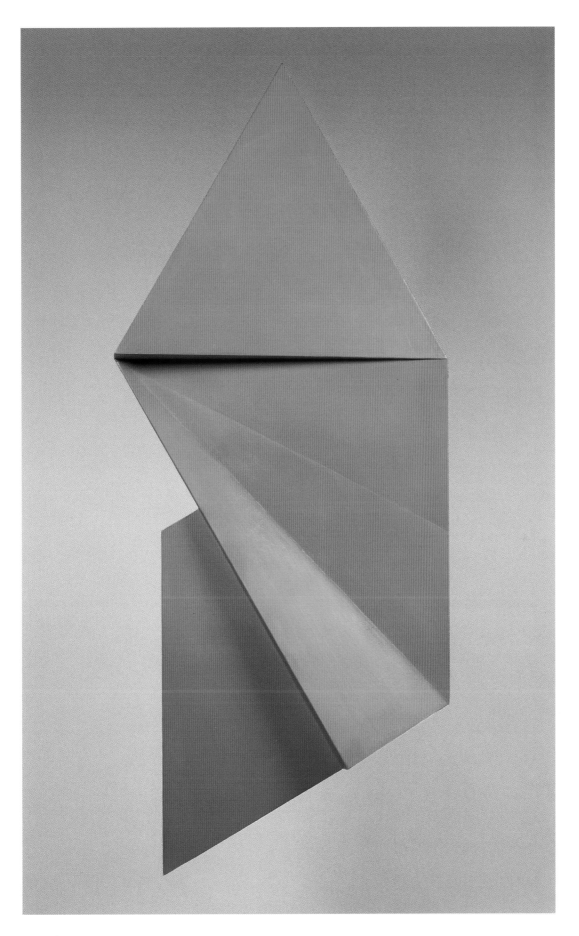

279. HÉLIO OITICICA *Spatial Relief,* 1959. Acrylic on wood, 150 x 62.5 x 15.5 cm. Hélio Oiticica Collection,
Projeto Hélio Oiticica, Rio de Janeiro

CLOCKWISE FROM TOP LEFT: 280. HÉLIO OITICICA *Parangolé "I am Possessed,"* 1964. Cloth cape. Hélio Oiticica Collection, Projeto Hélio Oiticica, Rio de Janeiro. 281. HÉLIO OITICICA *Parangolé "xoxóba,"* 1964. Cloth cape. Hélio Oiticica Collection, Projeto Hélio Oiticica, Rio de Janeiro. 282. HÉLIO OITICICA *Parangolé P16 Cape 12 "From the Adversity We Live In,"* 1964. Cloth cape. Hélio Oiticica Collection, Projeto Hélio Oiticica, Rio de Janeiro. 283. HÉLIO OITICICA *Parangolé "Mangueira,"* 1964. Cloth cape. Hélio Oiticica Collection, Projeto Hélio Oiticica, Rio de Janeiro

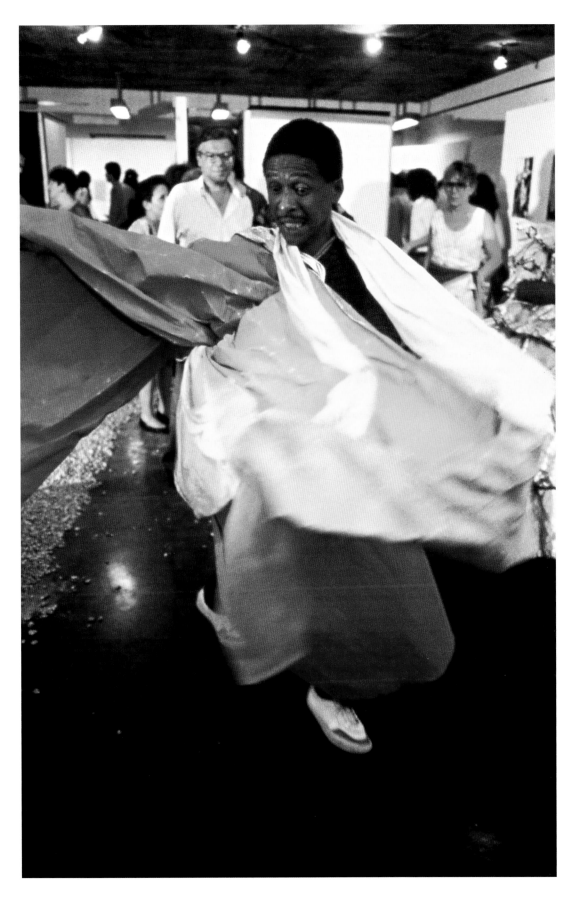

284. HÉLIO OITICICA *Parangolé P4 Cape 1*, 1964. Cloth cape. Hélio Oiticica Collection,
Projeto Hélio Oiticica, Rio de Janeiro

Arthur Bispo do Rosario

Arthur Bispo do Rosario is one of the most intriguing and enigmatic figures in the history of twentieth-century Brazilian art. His work—most of which he made using found objects—comprises a wide variety of pieces, including model ships, carts with toy cars, a ship-bed for Romeo and Juliet that he conceived of for use in his own ascent to heaven, and racks of bottles filled with confetti. However, it is for his extraordinary textile works that he is best known. His most outstanding creation is the great *Presentation Mantle* (n.d., cat. no. 286), which he intended to wear while standing before God on Judgment Day.

Bispo do Rosario was born in the town of Japaratuba in the northern state of Sergipe in 1911. He held a variety of jobs in his early years, then entered the navy, where he became a championship boxer. After leaving the military in 1933, he went to Rio de Janeiro, where he worked as a security guard and a housekeeper, among other occupations. In 1938, Bispo do Rosario was arrested and committed to a series of mental asylums, finally being transferred to the institution where he spent the rest of his life, the Colônia Juliano Moreira in Rio de Janeiro. Shortly after his arrival there, he began to create embroideries featuring intensely worked patterns of words and iconic symbols. Some of these embroideries refer to sports, others to ecstatic religious experiences. He also created a series of sashes for participants in imaginary beauty pageants.

In 1995, Bispo do Rosario's work was exhibited at the Brazilian pavilion of the Venice *Biennale*. Curator Nelson Aguilar described *Presentation Mantle* in the exhibition catalogue: "In the lining there are embroidered the names of hundreds of acquaintances. Bispo was to stand before the Creator in proxy for many compatriots. On the outside surface, glittering on the red fabric, burn the yellow threads with the power to obfuscate the divine court. The greatest designer of Christian art at the end of the millennium, this artist is also pagan for the carnivalesque liberty in which he weaves his raiment. He intends to crash the gates of Paradise dressed as an admiral of a seafaring power on the day of a big party." The cloak is reminiscent not only of the richly decorated ecclesiastical garments of the Baroque but also of Lygia Clark's interactive clothing (e.g., cat. nos. 266–69), Hélio Oiticica's *Parangolés* (e.g., cat. nos. 280–84), and Lygia Pape's *Tupinambá Cloak* (2000, cat. no. 305). Yet Bispo do Rosario most likely would not have accepted the designation of "artist," thinking of himself in more transcendental terms. Bispo do Rosario died in 1989. —E. J. S.

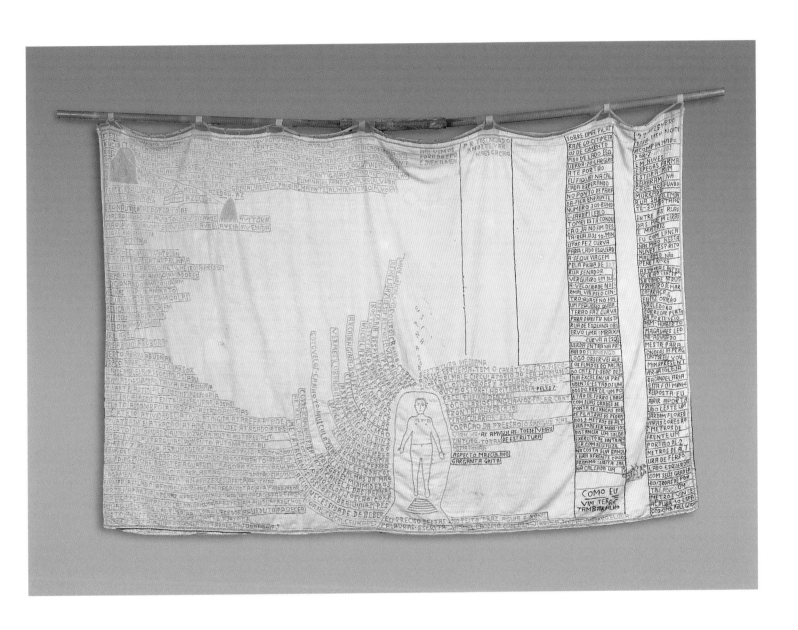

285. ARTHUR BISPO DO ROSARIO *I Need These Words (Writing)*, n.d. Thread, fabric, wood and plastic, 130 x 200 x 3 cm.
Museu Bispo do Rosario/Instituto Municipal, Colônia Juliano Moreira, Prefeitura Rio de Janeiro

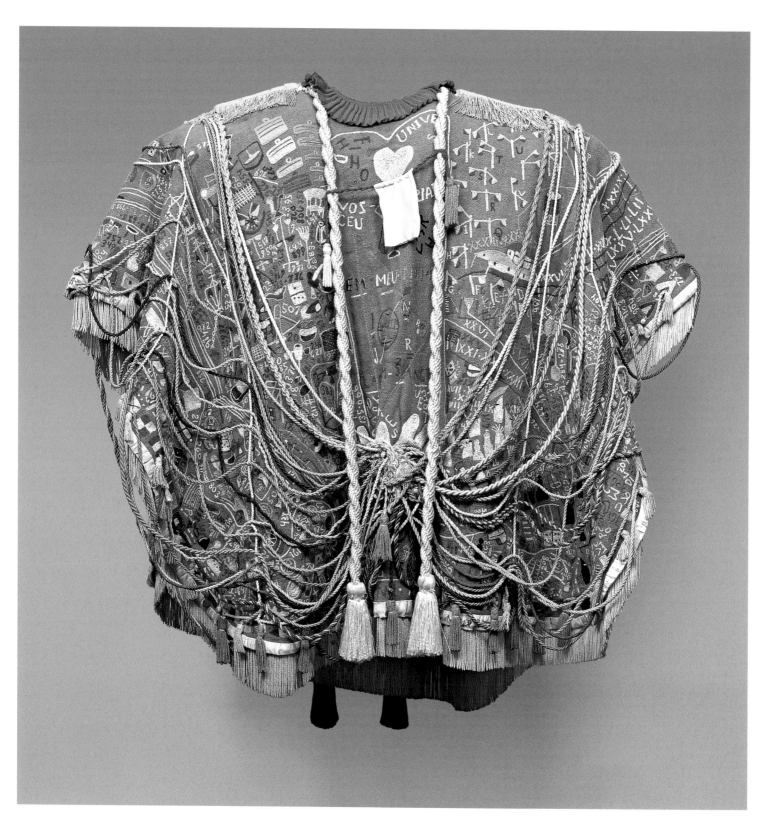

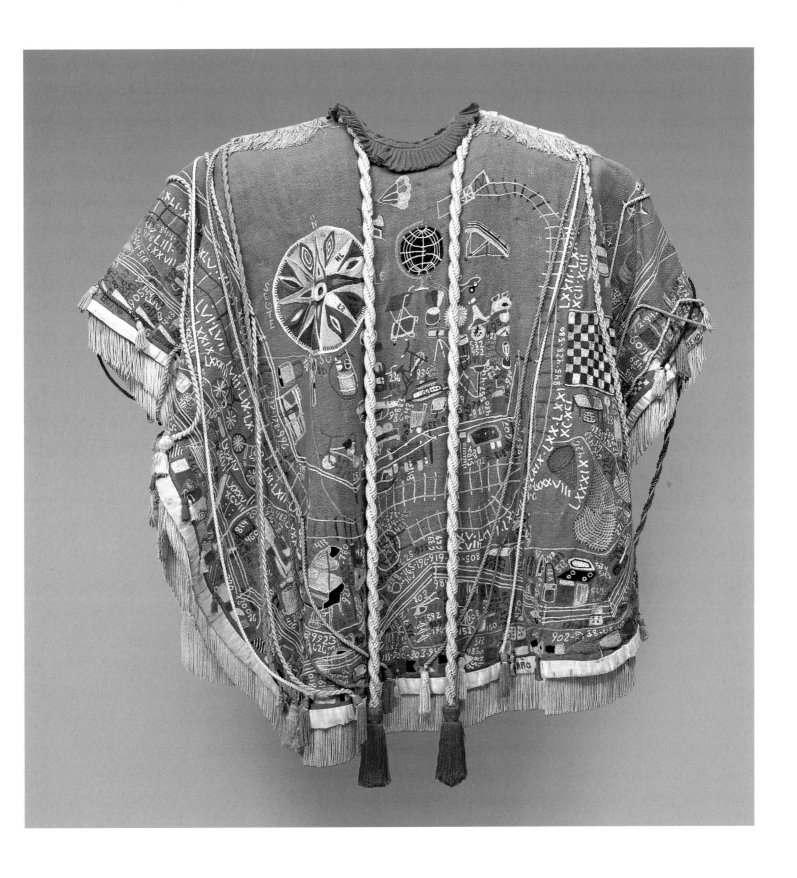

TOP TO BOTTOM: **287. ARTHUR BISPO DO ROSARIO** *Miss Amazon*, n.d. Fabric, thread, and plastic, 116 x 26 x 22 cm. Museu Bispo do Rosario/Instituto Municipal, Colônia Juliano Moreira, Prefeitura do Rio de Janeiro. **288. ARTHUR BISPO DO ROSARIO** *Miss Brazil*, n.d. Fabric, thread, plastic, and metal, 116 x 23 x 20 cm. Museu Bispo do Rosario/Instituto Municipal, Colônia Juliano Moreira, Prefeitura do Rio de Janeiro. **289. ARTHUR BISPO DO ROSARIO** *Miss France*, n.d. Sash: fabric, thread, and aluminum tube; scepter: wood, thread, and metal, sash h. 72 cm; scepter h. 70 cm. Museu Bispo de Rosario/Instituto Municipal, Colônia Juliano Moreira, Prefeitura do Rio de Janeiro

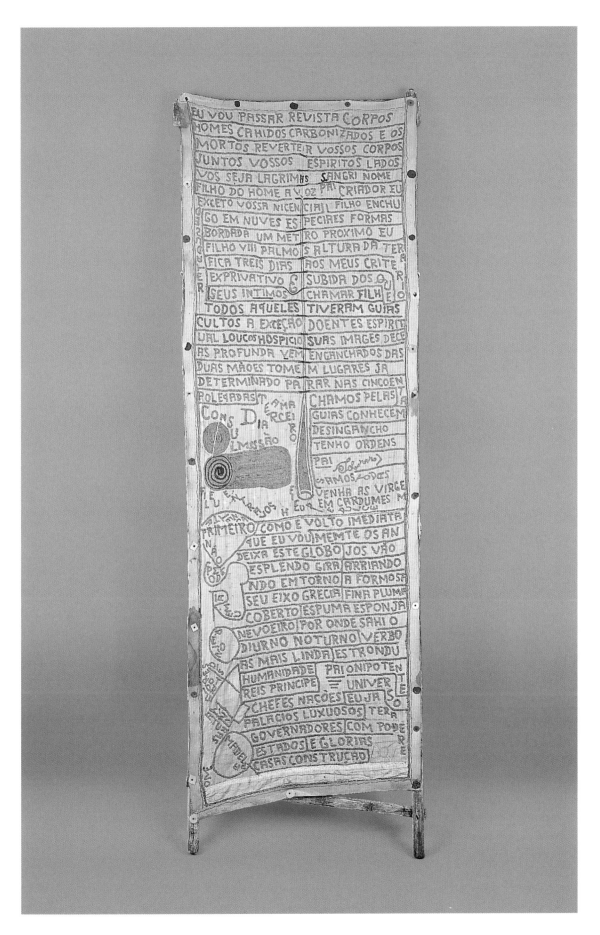

290. ARTHUR BISPO DO ROSARIO *Come Virgins in Shoals*, n.d. Wood, fabric, plastic, and thread, 153 x 51.5 cm.

Museu Bispo do Rosario/Instituto Municipal, Colônia Juliano Moreira, Prefeitura do Rio de Janeiro

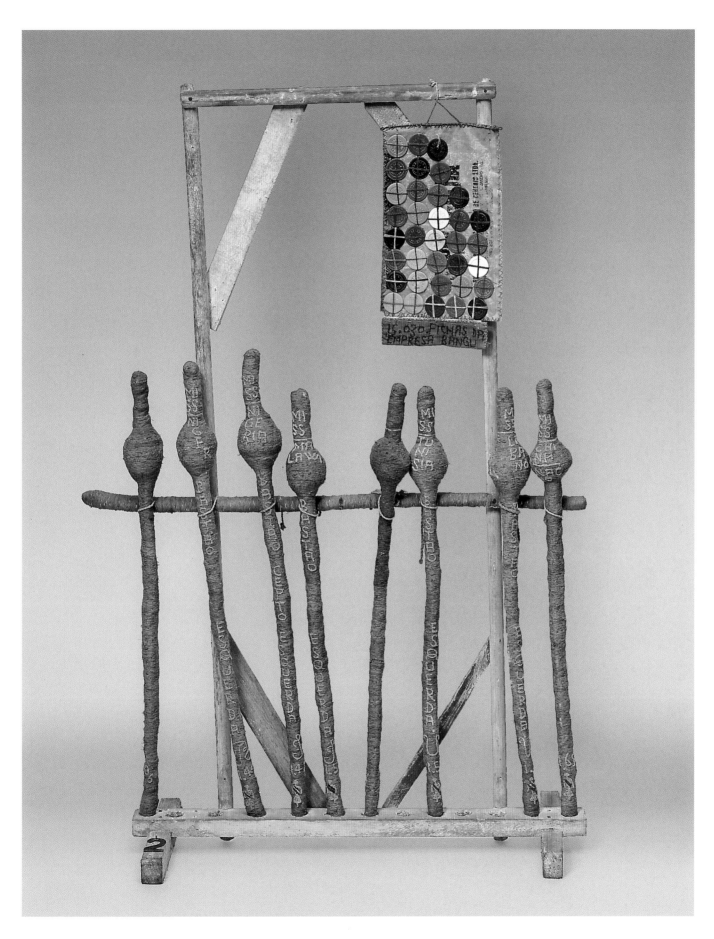

291. ARTHUR BISPO DO ROSARIO *Eight Scepters*, n.d. Wood, cardboard, plastic, and thread, 101 x 76 x 22.7 cm.

Museu Bispo do Rosario/Instituto Municipal, Colônia Juliano Moreira, Prefeitura do Rio de Janeiro

Ex-Votos and Mastheads

The fervor of popular faith in Brazil is captured in the sculpture tradition of ex-votos. "Ex-voto," from the Latin, means something offered or performed in fulfillment of a vow. In Brazil, ex-votos are called *milagres* (miracles). Most are made of wood (and some of ceramic) in the *sertão*, the arid backlands of the Northeast. *Milagres* often take the form of body parts—heads, hands, legs, feet, stomachs, breasts—which signify that the person for whom the *milagre* was made had been cured of a malady specific to that area of the body. Ex-votos are donated to churches or chapels, or deposited in the "houses of miracles" found in some of the country's great pilgrimage centers. These sites—some of which are sanctioned by the Catholic church—are dedicated to saints or pious people known for their healing powers. Among the most outstanding pilgrimage centers in the Northeast of Brazil are São Francisco das Chagas in Canindé in the state of Cearà, Bom Jesús de Lapa in Bahia, and Nosso Senhor dos Passos in São Cristovão in the state of Sergipe.

The making and use of ex-votos has been a common practice in many world cultures, but the particular forms taken by those from Brazil have roots in several of the visual traditions of the country. In one sense, these images may be affiliated with the sort of popular religious carvings characteristic of the Baroque. However, as art historian Lélia Coelho Frota has stated, "Indigenous Brazilians as well as those of African origin, both from societies skilled in woodworking, surely exerted great influence in establishing norms for the portrayal of human figures in the *milagres* of northeastern Brazil." These images represent the convergence of multiple visual traditions and serve as receptacles of the pious zeal of the people who make and use them.

Another popular wood-carving tradition is that of mastheads, or *carrancas*, created for the most part during the nineteenth and early twentieth centuries for use on the *barcas* that plied the waters of the São Francisco river in northeastern Brazil. Many societies have made such symbolic sculptures for boats, but few match the expressive power and intensely dramatic quality of the Brazilian mastheads. Invariably, they represent the upper bodies and heads of animals, with lions being the most common form as their strength and ferocity were believed to protect the ship and its cargo from bad weather or robbery. The most famous sculptor of mastheads was Francisco Biquiba Lafuente Guarany (1882–1985). Because the boats for which such sculptures provided protection have been replaced by smaller, lighter vessels, mastheads no longer have a practical use and have become a genre of tourist art. —E. J. S.

292. Ex-votos (hands), n.d. Wood, 16–25 cm long. Atração Escritório de Arte, São Paulo

480

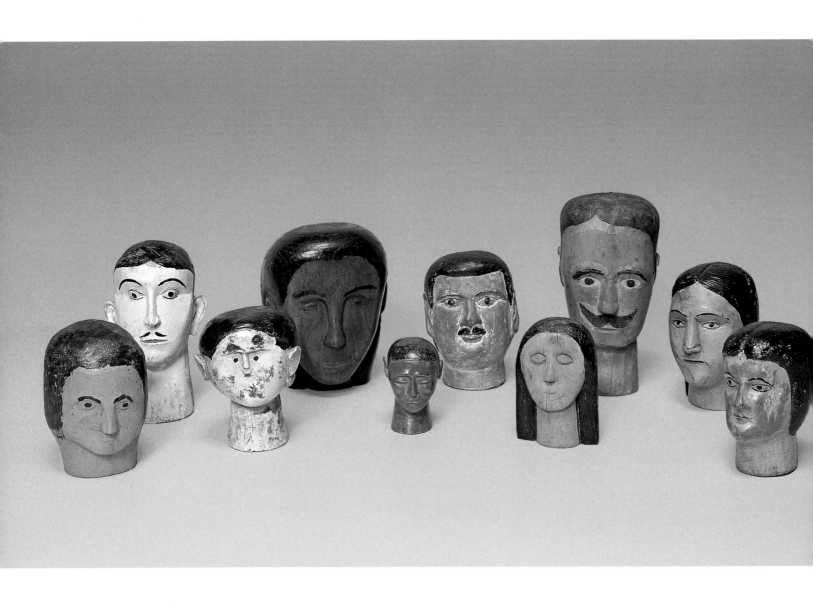

293. Ex-votos (heads), n.d. Wood, 7–19 cm high. Collection of Marcelo de Medeiros, São Paulo

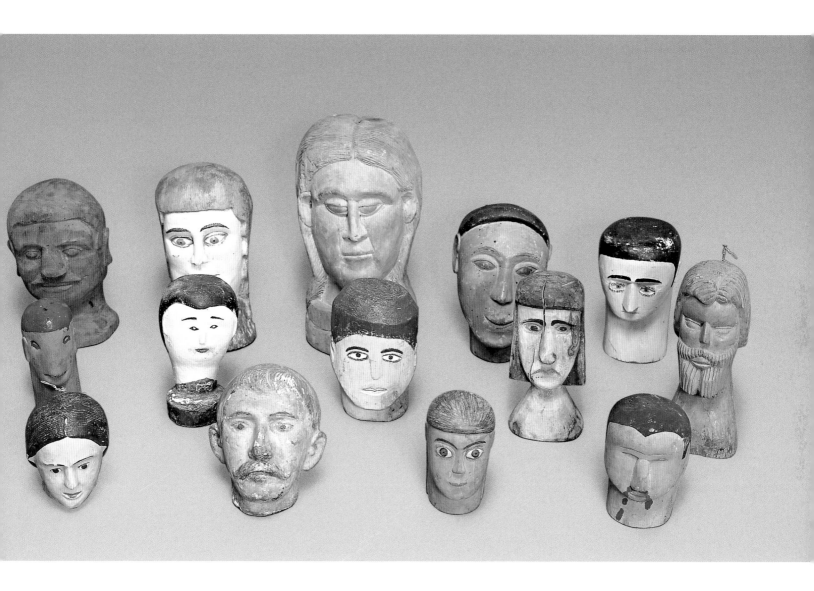

294. Ex-votos (heads), n.d. Wood, 7–19 cm high. Collection of Marcelo de Medeiros, São Paulo

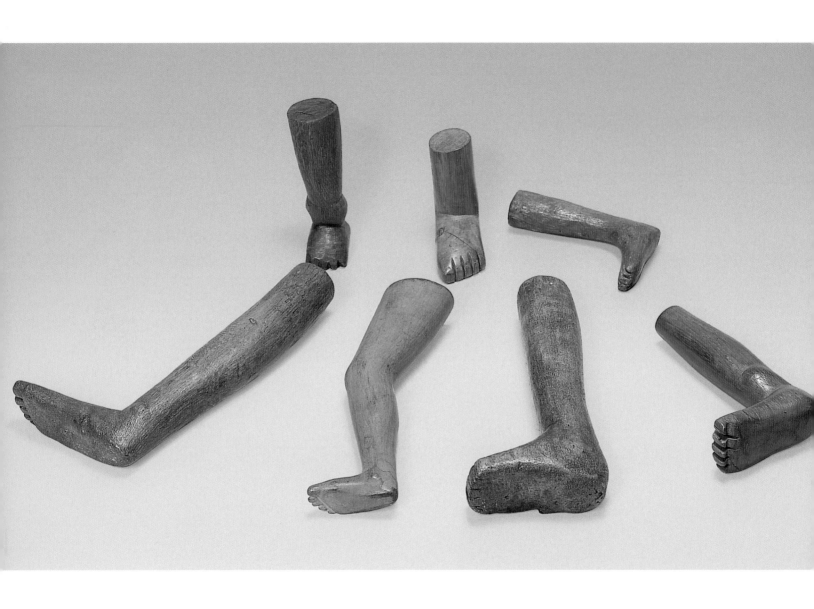

295. Ex-votos (legs), n.d. Wood, 15–28 cm high. Atração Escritório de Arte, São Paulo

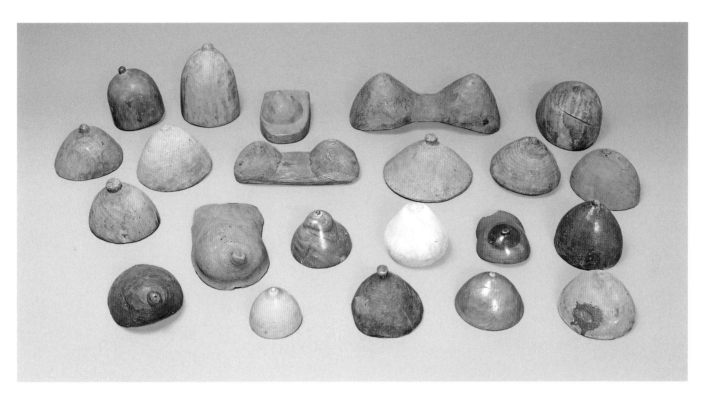

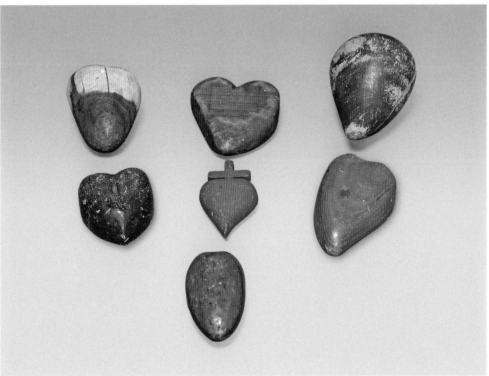

TOP: 296. Ex-votos (breasts), n.d. Wood, dimensions unknown. Atração Escritório de Arte, São Paulo.

BOTTOM: 297. Ex-votos (hearts), n.d. Wood, dimensions unknown. Atração Escritório de Arte, São Paulo

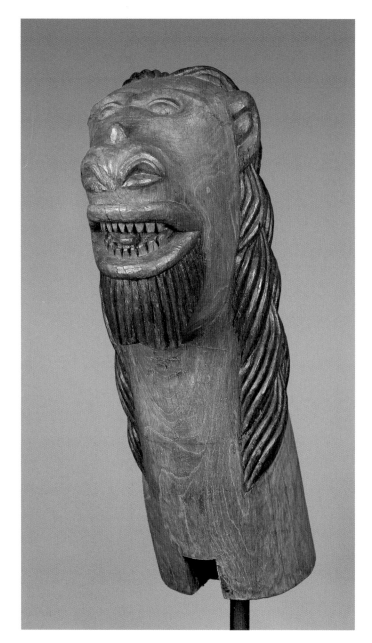 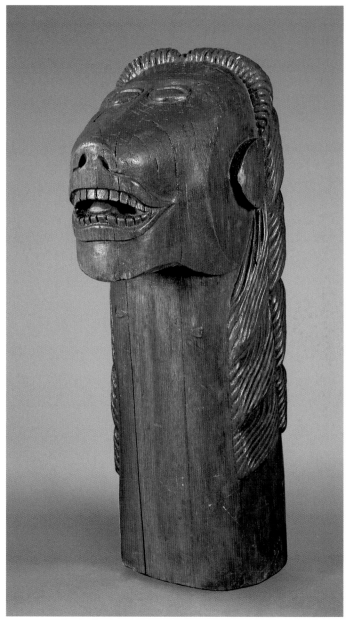

LEFT: **298. ANONYMOUS** *Masthead,* 20th century. Wood, 82 x 26 x 64 cm. Collection of Pedro Ramos Carvalho, Rio de Janeiro.
RIGHT: **299. ANONYMOUS** *Masthead,* 20th century. Wood, 85 x 25 x 40 cm. Collection of Pedro Ramos Carvalho, Rio de Janeiro

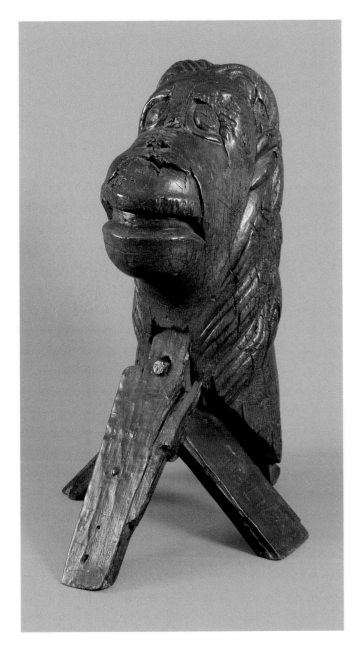

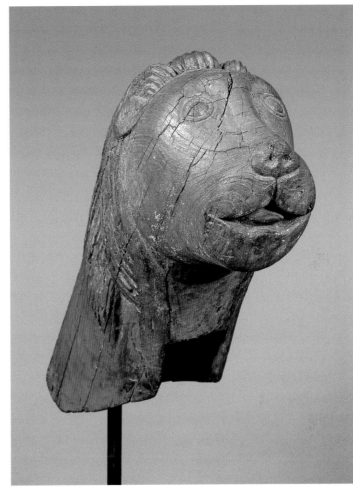

LEFT: **300. ANONYMOUS** *Masthead*, 20th century. Wood, 70 x 19 x 35 cm. Collection of Pedro Ramos Carvalho, Rio de Janeiro.

RIGHT: **301. ANONYMOUS** *Masthead*, 20th century. Wood, 44 x 21 x 61 cm. Collection of Pedro Ramos Carvalho, Rio de Janeiro

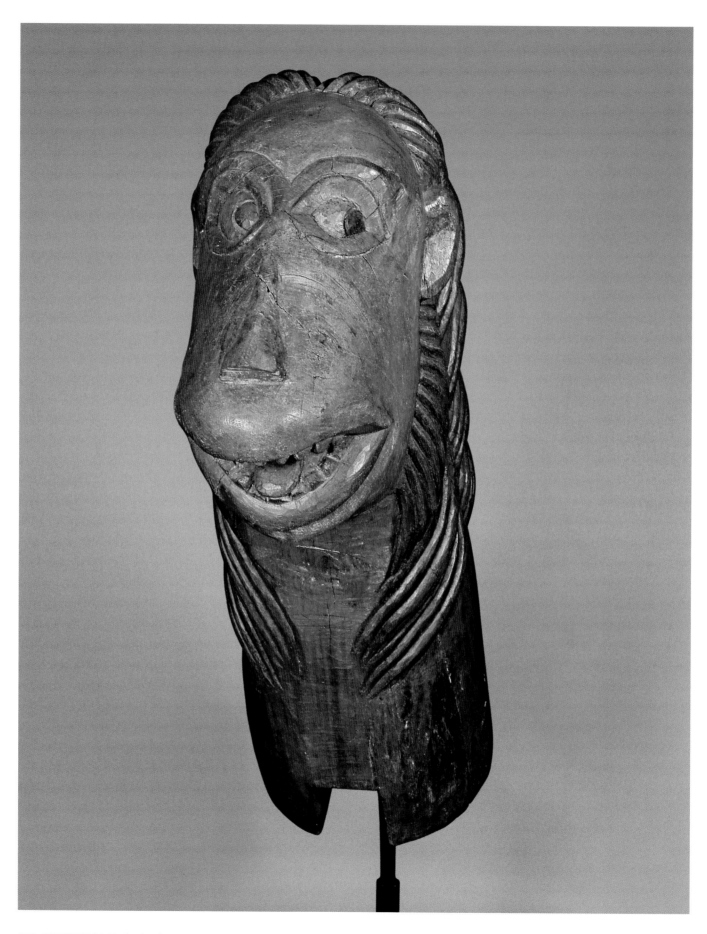

302. ANONYMOUS *Masthead*, 20th century. Wood, 80 x 28 x 56 cm. Collection of Pedro Ramos Carvalho, Rio de Janeiro

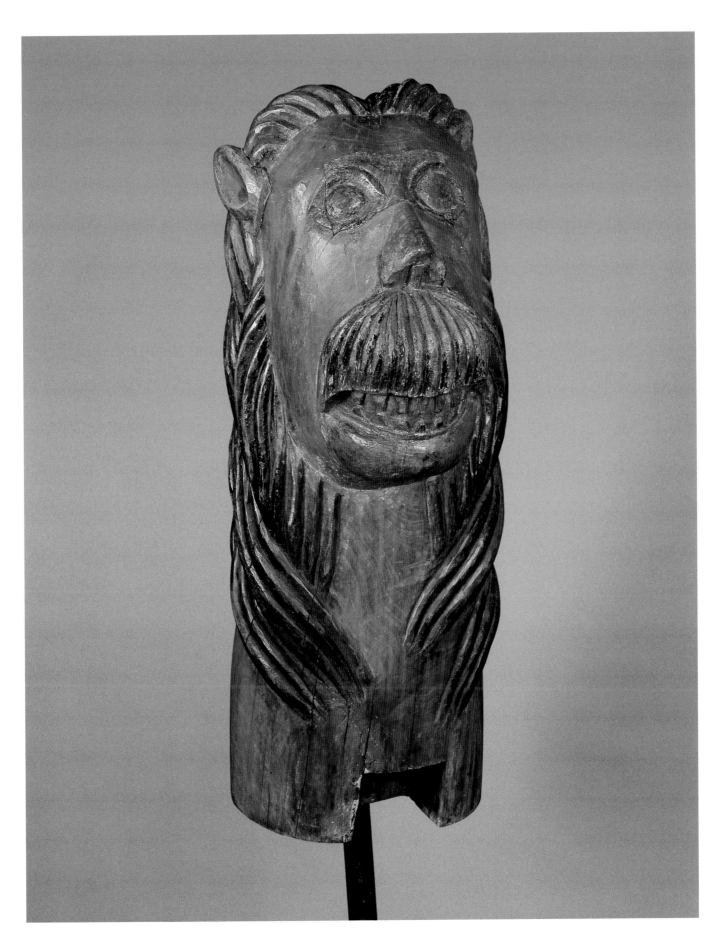

303. ANONYMOUS *Masthead*, 20th century. Polychromed wood and iron, 76 x 39 x 94 cm.

Collection of Pedro Ramos Carvalho, Rio de Janeiro

Contempor

ary Brazil

Nine Times Brazil

Nelson Aguilar

In the 1960s, Brazilian art abandoned its compulsive search for foreign models and began to reference itself. The mythical horizon and focal point of all energies was Brasília, the new capital in central Brazil, created as the incarnation of the utopian promise offered by modern architecture to end the underdevelopment of the nation. The Constructivist generation took its aesthetics to the extreme. Geometrical abstraction offered a clean and uncomplicated look. Although the Expressionist group remained active, the new radicals escaped its influence and drew straight lines that reflected the technological profile of a civilization in tune with the future.

The Constructivist experience in Brazil, known as Concretism, produced works that went beyond the rigorous premises of geometric abstraction as practiced by the Swiss artist Max Bill, who had a strong influence over Brazilian artists during the 1950s. The shift from plane to space, from canvas to object, proclaimed

the autonomy and confidence in transposing drawing to reality. The talented geometricians from the 1950s—Lygia Clark, Hélio Oiticica, and Lygia Pape—came to call themselves Neo-Concretists and affirmed that the world should not only be interpreted but also changed. Their goals are continued today by a number of contemporary Brazilian artists—nine of whom will be considered here.

The aesthetic quality of artworks from the late 1950s and the 1960s, such as Oiticica's *Spatial Reliefs* (e.g., cat. nos. 276–79), Clark's *Bichos* (e.g., cat. nos. 263–65), and Lygia Pape's *Book of Creation* (1959–60) place the viewer alongside the artist at the center of the work. The traditional way of looking at art discouraged direct participation. Museums sought to hypnotize viewers and lock them in luxury prisons. These new artistic objects, however, could not be merely contemplated; they required the use of all the senses. Clark's *The House and the Body* (1968)

allows the viewer to enter inside and offers various types of sensorial experiences. The struggle to create alternative exhibition spaces began during the early 1960s. Cultural manifestations, with their humanist and idealist inclinations, took on a political and defiant tone as the military dictatorship gained power; the work of art wanted to be accessible to all. Brazil's failure to achieve a socialist government in 1964, and the succeeding political repression, created bitterness similar to that which swept Europe in 1848 after the defeat of the republican revolutions. In both cases, the political arena shifted from the collective to the individual. In their respective historical moments, Charles Baudelaire's *Les Fleurs du mal* and Clark's relational objects attempt to save the fallen body, forgotten by its own self, the body in search of sensory exchange.

In 1968, Lygia Pape created *Divisor*, a work consisting of a sheet of cotton fabric measuring thirty square meters and pierced with multiple holes into which viewers could stick their heads, thereby forming a single body. The work was a device to transform the masses into a community and sparked a sense of solidarity that had been curtailed by the authoritarian regime. Pape saw Brazil as a dismembered body, in which different parts were isolated from one another. This also applied to the indigenous peoples, with whom the artist identified. In 1978, she and art critic and curator Mário Pedrosa went to the Museu Nacional de Belas Artes, Rio de Janeiro, with the objective of selecting indigenous objects for the upcoming exhibition *Alegria de viver, alegria de criar* to be held at the Museu de Arte Moderna do Rio de Janeiro. The show was intended to draw attention to a segment of the Brazilian population that had no civil rights, as well as to the curator, who had been denounced and forced into a long exile for speaking out against the torture of political prisoners.

Pedrosa intended to juxtapose present and past expressions of the creativity of indigenous peoples. By grouping objects made by different societies who had been decimated by colonizers the exhibition would function like a mirror through which to analyze current social conditions in Brazil. Alongside contemporary objects for example, Pedrosa planned to show a feathered sixteenth or seventeenth-century cape (cat. no. 1) of the Tupinambá people. A tragic fire in the Museu de Arte Moderna prevented the realization of the exhibition; had the show happened, Pape would have included a work that she based on the indigenous cape. In a recent version, *Tupinambá Cloak* (2000, cat. no. 305), she envisioned her garment as a red cloud, formed by a cloth stretched out a few feet above the floor and held up by wires attached to nearby beams. The surface holds spheres covered with red ibis feathers (like the Tupinambá, the artist loves birds). Extruding hands, feet, and bones suggest that the spheres have a voracious appetite for human flesh. Beneath the tentlike fabric are other, darker spheres filled with cockroaches.

The story of Hans Staden, the first European to escape the cannibalistic practices of the indigenous Brazilians, becomes a necessary reference to Pape's cloak. In the early sixteenth century, the German traveler spent nine months as a prisoner of the Tupinambás and in 1557 published an account of his experience. In his description of the cannibalistic ritual, he noted that some of the participants were dressed in feathers. Engraved illustrations of the story have become ingrained in the Western imagination. The strength of Pape's piece lies in its direct connection to this literary source, as well as the artist's childhood spent in the Cabo Frio region, which had been the habitat of the Tupinambá until their extermination by the Portuguese colonial army at the end of the seventeenth century. When Brazil achieved its independence, Tupinambá bravery became a symbol of resistance. The invitation to exhibit this work in 2000 at the *Mostra do redescobrimento* in São Paulo

underscored its importance as one of the most profound statements in Brazilian art. In modern times, cannibalism came to represent the assimilation of certain aspects of dominant cultures in the formation of a national identity, and the process of going outside oneself without losing one's individuality. Pape offers a different interpretation. The flight of the cloak, propelled by the red plastic and the feathers in her piece, lands on heavy dark balls spread out on the floor and surrounded by insects: While the country strives to reach the stature of a mythical bird, the everyday reality of the lives of the indigenous peoples is no better than that of insects.

Antonio Manuel is the youngest of the group formed by Clark, Oiticica, and Pape. He continues their project, extending into the 1990s an aesthetics that began in the 1960s. The results are often surprising. Sudden changes from cosmos to chaos are constant in his work. *Phantom* (1995, cat. no. 304) presents a space filled with hundreds of pieces of charcoal suspended from the ceiling. The work is like a dematerialized cave illuminated by lanterns, engaging the public by creating an oracular setting where the words of the gods are revealed to humans. It imposes boundaries and asks the neophyte to succumb to the experience of being lost inside a labyrinth. The viewer is brought back to the present by a startling photographic image (affixed to one wall of the installation), which originally appeared on the first page of various newspapers in Brazil. The photograph depicts a hooded witness to the infamous massacre in the atrium of the Candelária church in Rio de Janeiro, when nine children were executed by policemen and a tenth survived by pretending to be dead.

The influence of Pop art on Manuel's early work is apparent. He was interested in Andy Warhol's silkscreens of car accidents and electric chairs, and Robert Rauschenberg was also an influence. However, Manuel uses the mass media to create other possibilities of expression.

He re-creates the newspaper page; alternating photographs, headings, and text, the newspaper layout serves to attract the viewer. As a descendant of Neo-Concretism, the artist understands formal problems. To compose the headlines and body of the news, one needs a geometrical imagination—like Piet Mondrian's way of organizing forms—to successfully arrange visual and textual elements.

His references are often dictated by current events. We see street demonstrations contained by the police or images of mourning covered by a black cloth, visible only when the viewer pulls some strings to reveal the front page of a newspaper, stained in red, with prominent headlines and photos depicting a student killed at a demonstration. Manuel's *Hot Urns* (1968) are as powerful as a newspaper proclaiming the latest headlines. Composed of hermetically sealed boxes containing information that can be seen only when the strong containers are destroyed, the urns, or *urnas*, were part of an event at the Aterro do Flamengo, in Rio de Janeiro, where hammers were provided so that the public could smash them. ("*Urna*" in Portuguese also means ballot box, an object that was not in use at the time since general elections in Brazil had been abolished.) One urn contained an image of a starving child from Biafra. The message has been sent, but, as in Franz Kafka's allegory, it can only reach its destination if the emperor's messenger can overcome infinite obstacles. Subjectivity itself multiplies the distance between messenger and recipient.

The work of Regina Silveira challenges another allegory, that of the cave as presented by Plato in the *Republic*. Humans, according to the philosopher, are condemned to having their backs to the world and seeing only the shadows projected on the walls of the cave. We can only access representations, never the true essence of beings and things. In the artist's interventions the opposite occurs. Shadows have no limits and their projec-

tions constitute forms that are more significant than the bodies that cast them. This principle is fully realized in the installation *The Saint's Paradox* (cat. no. 306), first shown in 1994 at El Museo del Barrio in New York. The goal of this museum is to awaken interest in Latin American art among its constituents; Silveira makes this her goal as well. She chose a piece from the museum's collection to incorporate into her work: a small wooden statue of Saint James, a popular saint in Latin America. This simple wood carving has moving arms, common in handmade toys. A shadow of the miniature was projected on the walls. Riding on his white horse, Saint James is the protector of both the colonized and colonizers. Two elements of the crude figure invite a reflection on the conquest of the New World: the horse, brought to the Americas by the colonizers, and the religious commander's multicultural features.

The saint's portentous shadow projected on the museum wall corresponds to another equestrian fantasy, one built according to classical norms. Silveira's inspiration is the monument in São Paulo to the Duque de Caxias (1803–1880), a hero of Brazil's armed forces who rose to prominence during the war against Paraguay. The Modernist sculptor Victor Brecheret was commissioned to create the sculpture in 1941 after winning a public competition, and the statue was completed posthumously in 1960. Silveira, however, is only interested in the shadow cast by the warrior. Brecheret's statue has the sword in an upright position, on alert. In Silveira's installation the shadow cast by the sword is horizontal, as if ordering an attack. The interplay between shadow and figure shows, both conceptually and aesthetically, that religion, even when depicted at its most austere, can still serve the purpose of political domination.

In his early paintings, photographer Miguel Rio Branco worked with a plethora of colors. Some appeared aged and darkened, taking on a purplish, poisonous hue.

While he now works exclusively in photography, painting always lingers as a dormant coal ready to burst into flames. The perfect translation between the two mediums occurs in the *Barroco* polyptych (1993, cat. no. 321), which includes an image of the toxic remains of a burned tire, its form oscillating between that of a serpent and a wreath, like an Abstract Expressionist composition that captures the mutating identities of shapes.

To understand more recent Brazilian art, one must consider the country's forgotten dreams, belonging to another space and time. During the dark years of Brazil's dictatorship, everything became merchandise. Megalomania proceeded while the cost of labor shrank to nothing. Workers were displaced and mandated to build the ideal country while suffering horrible hardships. Fifteen years after the creation of Brasília, Rio Branco made a series of photographs for the magazine *Malasartes* depicting the communities that had sprung up around the new capital. The work is not photojournalism even though it touches upon burning issues. The article describes the vicissitudes of the living conditions of workers who live near the monuments they help erect. The developers created wooden cottages that could be transported on trucks. Mobile living guaranteed the separation between different social classes and precipitated urban satellite zones. In *Brasília: Banking Sector: Workers Waiting to Depart*, we see a vehicle filled with caged humans parked under a sign with the name of one of the most well-known Brazilian architects, João Filgueiras Lima, who, like them, became a victim of the system.

Rio Branco's *Blue Tango* (1984, cat. no. 322) portrays the atmosphere of Salvador da Bahia, the largest black city outside of Africa. In twenty photographs, two young male bodies move to create vignettes against a concrete background; the bluish light around their darker, shadowed bodies expresses the coexistence of land and sea. A rectangle painted

on the wall suggests a ballet barre. The boys' various poses pay homage to Eadweard Muybridge, and the elegant figures they cut reference *capoeira*, a dance accompanied by the sound of the *berimbau*, which over time has become more ornamental than the violent martial art practiced by the slaves who came from Angola. Their movements suggest a metaphor for the ardent cultural resistance of the Afro-Brazilian community.

The wonder of Tunga's artworks comes from the convergence of extremely disparate aspects of the avant-garde. Unexpectedly, Vladimir Tatlin's culture of materials is united with the Surrealism of André Breton and Philippe Soupault, assuming that these artists were able to develop such a spatial cosmology. Within this poetics, nature is not passive; on the contrary, it has a power that is as active as culture itself. Minerals, plants, and animals become elements of the work. From the beginning, Tunga kept his distance from those artists obsessed with the latest fashion. His use of materials offers a way for those who oppose idealized interpretations of an artwork and the fetish of beauty.

Aware that titles are an active element of an artwork, early in his career Tunga showed a rubber circle, with a faltering lightbulb in its center, over a low stool also covered in rubber. The title, *Saint John the Baptist*, mirrors the simplicity of the work. For *Beetle Treasures* (1992), the artist guided three dung beetles to sculpt spheres from organic matter. *Milky Fallings* (1994) is meant to evoke Edgar Allan Poe's "The Bells." In this large-scale installation, shown at the São Paulo *Bienal* in 1994, Tunga interprets the ode by the American poet as a downpour of bells, itself an unimaginable and cosmic event. The poem is about the relation between time and matter and about capturing the unique sensibility of each season. In the installation, gel, iron, steel, and also air—which moves through the sinuous spaces between the chalices and bells—work to the temporal fluidity. The paraphernalia is

eventually reunited in performances in which men and women partake in a solemn ritual to inaugurate a sacred space.

The work of Arthur Bispo do Rosario was first noticed around 1980 when a television network did a piece about the Côlonia Juliano Moreira, an insane asylum in Rio de Janeiro. In this destitute setting, Bispo do Rosario, a longtime resident of the asylum, transformed his space by filling it with colorful and surprising art that was created using whatever he could find. He shredded his hospital uniform and separated the blue threads to be sewn on sheets to create banners. The embroidered images of naval destroyers, names of ports, and maps are the work of an old sailor, the words sewn on the cloth preserve memories of travels, itineraries, and geographical details. The artist embroidered a testament on a garment, *Presentation Mantle* (n.d., cat. no. 286), to be worn on Judgment Day. Inspired by naval dress attire and resembling a poncho, passages of the user's life are annotated on the garment like tattoos of the soul. Ribbons and naval signs are set against Roman and Arabic numbers, wind roses, hearts, games, the terrestrial globe, and a boxing ring (the artist gained notoriety as a Latin-American lightweight champion). Hundreds of names, mostly those of women, are inscribed on the inside of the garment, concealed by a sense of propriety that guards the names in secret. These are the people on whose behalf he would advocate with the Creator.

Bispo do Rosario also made scepters and ribbons for contestants of fantasy beauty pageants. He considered many states and countries in his search for beauty, and invented prizes to honor the winners of his imaginary contests. When asked by a reporter to comment on the insignia he created for Miss Afghanistan, he displayed remarkable political insight: "I read the newspapers every day, I take notes, register the actions of all countries, and then separate the piles of paper and make ribbons on which I write the

sayings. I know that Russia invaded that country. I too feel the same way."

Bispo do Rosario never parted with his works, despite persistent invitations to exhibit. After his death in 1989 his work became known and gained prominence in the Brazilian art world, as demonstrated by his impact on contemporary artists. The artist refused to take medication in the hospital because he believed it hindered his creativity. His creations captured details of the human carousel that surrounds illness, poverty, and exclusion. The patients of the Colônia Juliano Moreira, totaling over three thousand, suffered because their individuality was treated with indifference. In this confinement, daily objects attain a hyperbolic value and are forever recycled. Bispo do Rosario collected discarded objects from the hospital and changed their function, lining them up like soldiers: mugs, drainers, bottles, vases, jugs, all in brightly colored plastic, emerge from the drab background. To some, they may look like Nouveaux Réaliste accumulations, but those who overcome this impression enter the fragile world of people transformed into objects and always at the mercy of the system.

Adriana Varejão breaks away from the steady evolution in Brazilian art that marked the smooth transition from Concretistism to Neo-Concretism and also from site-specific to Conceptual art. In her paintings, the artist incorporates and goes beyond the generation that fought for free expression, and she does not accept intellect as an extrinsic factor of the work of art. This sense is the result of a Minimalist aesthetic where even delirium occurs within an impeccably formal decorum. She views the surface of the canvas as a field on which not just to apply but to plant colors.

This return to painting, however, is not a mere revival. She incorporates the advances of installations that challenged the traditional support that for centuries had been associated with art. Varejão reflects on the abandonment of walls and

pedestals, and on the inclusion of the public on the inside of the work. The return to the canvas introduced a new grandeur where proportion is subject to inversions. Her oil paintings of the 1980s resemble cutouts of larger paintings and exhibit a prolific figuration of an expanding nature. These works have a Baroque feel, resembling rotating wreaths, where the ornamental outweighs the sculptural, and the periphery is more vital than the center. Revealing a deep knowledge of iconography and classical antiquity—Icarus falling, Sardanapalus dying, the wounded Cythera—these works became references for a refertilized historical moment.

Beginning in the 1990s, Varejão's work underwent a radical change: the authorial character represented by her sinuous brushstrokes gave way to the exploration of a legacy infused with various historical prototypes. We see paintings that reproduce narrative panels of glazed tiles, where the passage of time is suggested by faithfully reconstructed cracks and gaps. From these bucolic, restful scenes emerge sadomasochist or perverse motifs that startle the viewer. Images of severed bodies bring together many aspects of early Modernism, which had already anticipated the forces of globalization in many respects. The ripped, wounded, and gutted canvasses explode with red pigment. A simulacrum of the Baroque, Varejão's work shows different space-times within a single theme: the domination of the colonial by the metropolis.

Vik Muniz's photographic works focusing on temporal experience gained prominence in the 1990s. His works are the result of a process of reconstitution of existing images or even substances such as dirt, sugar, and pencil lead. The series *The Best of "Life"* (1988–90) consists of drawings of famous photographs from the magazine, which are ingrained in our collective memory, such as the first moon landing and the cold-blooded execution of a Vietcong, among others. This graphic exercise is not mere copying but amounts

to a reconstruction of the artist's memory. When he sensed that his recollections of the famous works lacked something, he would ask other people for their descriptions, but he never revisited the original photographs himself. The titles of works in the series *Pictures of Thread* (1995–98) reveal how much thread was necessary to re-create well-known, iconic works of art that, for the most part, belong to the public domain. In this manner we are informed that 20,000 yards of thread were required to recreate a Jakob van Ruisdael, 4,000 for a Gerhard Richter, 17,500 for a Claude Lorrain landscape, and so on.

At a moment when the artist might be considered as reclusive as Saint Jerome, there are indications that he is at the forefront of the art world; Muniz's innovative photographic series *Aftermath* (1998, e.g., cat. nos. 315–19) conclusively proves this. The title alludes to the time after Carnival or a celebration when the floor is covered in confetti and shredded paper. The children appear tremulous, almost as apparitions. The garbage, in contrast, is rendered in almost hyperreal detail, in which the texture, color, and shape of each fragment is legible. The protagonists of these photographs are street kids from São Paulo, where the artist was born. Turning to children is a significant recourse for someone who is searching for lost time. Far from the body and close to the spirit of Marcel Proust, Muniz finds abandoned youth. These children—Emerson, Aparecida, Socrates, Angélica, and Madalena, among others—escape detection. They disappear in the permanent gray of the city, in the buildings tinged with pollution, in the garbage belt that surrounds the shanty-towns at the edges of more affluent urban territory. In order not to feed or incite false expectations, these children live in a psychological void, in keeping with their surroundings. Muniz gave them reproductions of Van Dyck, El Greco, and Velasquez portraits of royalty, soldiers, and historical figures. The opportunity to identify themselves with these rulers and commanders

transformed the kids from a state of indifference to one of expressiveness and confidence. They playfully mimicked the poses and attitudes of the subjects in the classic portraits, inspiring a positive rivalry with the seventeenth-century heroes. In doing this, the children recovered their self-esteem and overcame issues of abandonment. This was Muniz's means for distinguishing the zone occupied by these street heroes from the one overtaken by garbage.

Childhood is prominent elsewhere in Muniz's oeuvre, such as his series *The Sugar Children* (1996), which depicts youths working on sugar plantations on the Caribbean island of Saint Kitts, and *Every Day Life, Contemporary Art and Projeto Axé* (1999–2000), portraying kids taken off the streets by authorities in Salvador da Bahia. These photographic series, together with the images in *Aftermath*, address not only social exclusion but also the emotional potential that allows the transformation of reality.

Ernesto Neto is so deeply immersed in art as experience that he was married at the Museu de Arte Moderna do Rio de Janeiro amid a setting comprised of a room-sized installation of his work. He uses spandex as an expandable filter that contains varied substances, such as aromatic spices, or simply air. This material gradually became more important in his production, growing exponentially and now occupying vast areas of his artworks. Neto walks in paradise, happy in the knowledge that exudes from scientific conquests. His contemporary sensibility makes it unnecessary to cleanse his sins. He instinctively breaks with visual history, retrieving sensory elements from the streets of Rio de Janeiro, with its varied scents and streets markets, its old railroad station, the noise of its people coming and going, and the gentle sea breeze that permeates his own studio.

The acceleration precipitated by science and technology produces changes in behavior, creating new business and political centers and generating new

means of knowledge. All the qualities that Italo Calvino predicted for the new millennium—lightness, quickness, exactitude, visibility, multiplicity and consistency—are present in Neto's work, which perhaps accounts for its wide acceptance. The textured surfaces and evocative scents of his pieces stimulate associations with the subatomic universe and, above all, with the bodily and the biological. Neto's existence inhabits these connections. His art is not the case of showing something but of living something.

Translated from the Portuguese by Michael Reade.

A Sensual Metaphysics: Miguel Rio Branco and Vik Muniz

Germano Celant

Brazil is a melting pot that blends, on the one hand, the intensity of its powerful aggregate of historical and ethnic entities that seem forever to be on the verge of breaking into myriad fragments, and, on the other, the felicitous tension and spontaneity with which the passionate and sensuous richness of its being and existence express themselves. These two apparently contrasting and divergent polarities create a state of suspension, a fragile, friable equilibrium that arises from a common way of feeling, a belief that no thought exists separate from life, that thought is not confined to a sphere where physical laws apply. All is understood as vital plenitude, flux and flow, movement and fecundity; all carries a sensual, positive meaning free of dross.

Every creative product made in Brazil takes part in this oscillation between looming explosion and sensory tactility. There is thus no such thing as an immutable identity enclosed in an envelope of reassuring imperturbability. On the contrary, every element is ready to overflow and take on the appearance of another. A fragmentation tending to support the contingent and the temporary—which lead reactively to a consciousness of the spiritual and the eternal—coexists with the inanimate materiality of the force of gravity that pins human beings to the earth, and from this interaction arises a pulsation of the blood that is a spark of the divine. Holding together the disconnected social and cultural mass of this vast body of land, this duality, combined with the fire of an individualism continuously fed by passion and carnal energy, informs all of Brazil's art and literature, music and cinema, architecture and photography, producing a sparkling, single whole, a "living thought" springing from the conjunction of spirit and matter.

The plenitude of Brazilian culture derives its sustenance from that mystical point where subject and object cease to be

opposite categories and recognize themselves in each other, their mutual aspects assuming the dual connotations of material spirit and spiritual matter. In such osmotic significations, the material core serves as support for the spirit, in the absence of which there can be no thought or life. As a result, all the arts in Brazil tend to strengthen the bond between these entities; they reintegrate the soul, the source of nervous vitality and receptor of spiritual forces, and they accept the mediation of flesh and sensuality as an irrational, intuitive knowledge that, in representing the lower powers, bespeaks a salutary energy.

In tracing the history of Brazilian creativity from the eighteenth century to the present day, one readily finds this continual grafting of matter and spirit in religious and secular sculpture and painting, in sound and graphic constructions, in the design of objects and buildings, which are all the product of a tangle of opposites agitated by an orgy of moods inconceivable to the staid European or North American mind. There is a metaphysics of the whole, which since 1920, with the Anthropofagia movement headed by Tarsila do Amaral and Oswald de Andrade, has derived sustenance, again in a dialectical key, from mystical tendencies in which Surrealist experience is injected into the heart of the Baroque. The interest of this meeting of extremes lies above all in the attempt to interpret a duality whose roots lie deep in the dramatic and mystical ceremonies of the eighteenth century, and which is expressed in the continual restlessness of a physical and sensual dynamism surging up from below. From this blend of sanctity and asceticism, with its negation of life and its awareness of bodily existence, springs a passage into the reconciliation of extremes between life and death, between ritual and an organically whole culture that sees the human body as a transmitter of energy, a kind of cauldron capable of receiving the breath of natural powers and giving it back in purified form.

Everywhere—from Modernist art to Concrete poetry, from the architecture of Brasília to Cinema Novo—one finds this same search for a life force that is the spiritual and intellectual yardstick for evaluating every cultural organism; and one finds as well the formation of a psychophysical aggregate of forms and volumes, materials and images, held together by fiery or icy threads that carry with them the purifying presence of the past as well as the sensual modality of the present. All Brazilian art results from this fusion, this descent into history and into the lower regions of the life of the body, in its search for an elsewhere in which metaphysics is not an aspiration to the divine but an integral part of everyday life. There is no separation between the lower and higher powers; emanations of the same energy, they blend together, enabling the sacred and the profane, the spiritual and the physical, to immerse themselves together in the flow of existence.

In the sphere of photography, from the 1940s on, this vital metaphysics has manifested itself in a documentary attitude, almost scientific in nature, toward certain aspects of Brazilian society that transcend its limits. In a first instance, photographers such as Pierre Verger turned their gaze to the country's anthropological weave. They bore witness to its character as a unique, wondrous thing with a particular vitality and magnetism, and they created images that function by virtue of reality's magic. There is no attempt at refinement or mental absorption. The persons and ethnic groups, the rites and ceremonies, the subterranean existence of secret, pagan gestures typical of a land that is a crossroads of energies—Afro-Euro-Brazilian—are etched onto their film, the surface of which fixes the object's identity and magnitude, allowing the photograph to become a form of poetry made up of bodies and buildings, passages and gestures.

In a second instance, photographers such as Geraldo de Barros and Mário Cravo

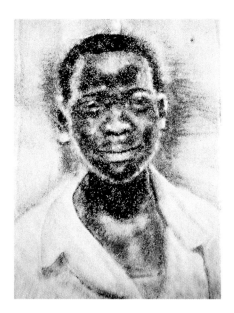 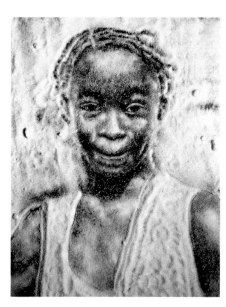

LEFT: **VIK MUNIZ** *The Sugar Children: Little Calist Can't Swim*, 1996. Gelatin-silver print, 35.6 x 28 cm. Courtesy of Brent Sikkema Gallery. RIGHT: **VIK MUNIZ** *The Sugar Children: Valentina, The Fastest*, 1996. Gelatin-silver print, 33 x 27 cm. Courtesy of Brent Sikkema Gallery

Neto defined photography as an expressive genre that is not only documentary but also artistic and suited to melding with other languages of visual art, a tool of communication that seeks to break out of the simulacrum of representation and assert itself as an autonomous language. Their photographs convey the impression of an unusual energy belonging both to the realm of testimony and the creative interpretation of the subject. There is something mystical here, in the state of interchange between the photographer and the thing photographed. A ritualized language is created that tends to translate the power of the image into an entity accessible to the general public.

The magic of the image—the fruit of a moment of grace and naturalness in the human condition—is the notion informing the work of Miguel Rio Branco, who seeks continuity between existence and photography. His work does not subject the furies of life to a purifying bath; rather, it presents the viewer with life's outer texture, capturing its dark, obscure side, where all the conflicts of human and inhuman reality fall together, and in whose flow every form is reduced at once to detritus and to primitive, pure energy.

In Rio Branco's early informalist paintings from 1964 on, materials arranged themselves as drips of color and form, in a duality of self and non-self, interior and exterior. In them, one sees the echo of both the gesture and the energy of things; the action of the artist and a contemplative vision of the world shine through. The same process of unifying inner power and quotidian inertia appeared in Rio Branco's photographs and films beginning in 1970. Here, poetry is born of the scene of an animal or human body in the urban landscape. The photographic moment, captured in black and white or sepia, is a whirlpool of energy feeding on the contrast between existence and the city: an urban stage where what matters is the idea of an elsewhere that is as indefinite as the smoke enveloping a human presence in the streets of New York in *Smoke Man* (1970), or the sensual gesture enveloping the female body in Rio de Janeiro in *My Hand* (1970).

From the very beginning of his career, Rio Branco's sense of creation has stemmed from a sensual, physical immersion in reality. Every action captured is subjected to the emanations of the surrounding world. It awakens as a passage through the world of the positive as well as the negative. His portraits of 1975 on are immersions into the blackness and cruelty of male and female prostitution. They are the dark manifestation of society's other face, an infernal labyrinth infested by human matter and density yet possessing a subtle, hidden power of illumination.

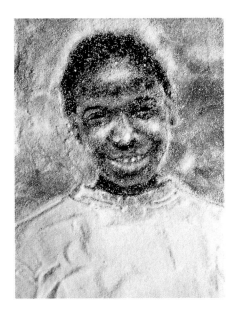

Like his photographs of Brazilian bordellos, Rio Branco's images of the Amazon forest individuate a core of burning existences, though they are formulated in different terms.

Rio Branco's photography is a play of antagonistic polarities, a representation of Eros and Thanatos. His black-and-white and color images of the 1970s depicting details of everyday life in Brazil show a flux of life seeming to transform itself into its opposite, into a deadly nullification that is the abyss into which the shattered body falls and becomes inert, a simulacrum. By 1976, the inert in Rio Branco's work became fecund. It recovered a lost fullness, and life's details recovered their impetus, perhaps due to the artist's travels to Europe and North America. Indeed, these details were reformulated through the regenerative charge of photography in chromatic metaphors of dazzling brightness. The abyss marking the life of the striptease as well as the opacity of the simple gesture was plunged into a cauldron of color that returned power and energy to the image. Here, the artist's Brazilian matrix wavers between the poles of sensuality and banality, documenting a continuous back-and-forth between the body marked by familiar happinesses and that marked by the ecstasy of drugs or the negativity of prostitution. In these images, Rio Branco sought to reappropriate the ener-

gies of life in all its manifestations, immersing himself inside the dark vortex where everything filthy, degrading, and abject gathers, but hurling himself equally into naturalness and simplicity, into the pure vigor of a force renewed by light.

Rio Branco's entire oeuvre is an endeavor to document the pulsating magma that characterizes the double profile of brute nature and redeemed nature. Whether in Cuba or Paris, Rio de Janeiro or Santiago de Compostela, his camera points magnetically to the destiny of things and people, of animals and cities, not to accept this fate passively, but to measure itself against it. Every photograph, whether portraying the body of a dog or a man lying on the ground, a slithering snake or a bull's horn, a boxer training or a prostitute making herself up, bears witness to an attentiveness, an alertness to the errant power of cruelty and the sensual fever that comes over the human being in all acts. Indeed, Rio Branco's gaze catches fire. It transforms itself into a crackling of reds and violent hues that devour human figures and gestures. The intense reds compose and break up the photograph's forms, as if hell existed to give life and meaning to the image.

In the 1990s, this hallucinatory, ecstatic phase took the form of installations and multiple projections accompanied by sound. Here, his photographs work by means of mutual suggestion and interdependence. Light spills over into music, and shadows flow into a luminous consciousness in which the identities of the subjects moving about between spirit and nature construct a narrative that is the antithesis of conscious and unconscious, social and private, public and intimate, high and low. The passage through this space involves the viewer down to his deepest fibers, immersing him in the mazes that run underneath cities and houses, labyrinths swollen with sinister yet joyous life. Here, devastation and horror, obscenity and sweat, death and poverty, are the necessary signs of a drama

of disintegration that must pass through suffering in order to achieve reabsorption and self-transformation. This is the meaning of Rio Branco's photographic ritual, which has roots that lie deep in shadow and impurity, but which in the end is luminous and purificatory.

The itinerary of Vik Muniz is similarly linked to the fermentation of a double principle, here involving the gravitational element of matter and the radiant fire of the photographic image. Since 1989, the complexity of his vision has manifested itself in the coexistence of object and image. In earlier works, object and image are antagonistic, though complementary in as much as they are bound to a single narrative. In *Tug of War* (1988), for example, which depicts two figures pulling on a rope, the figures are photographic representations whereas the interval between them is defined by a three-dimensional segment of rope, and in *Two Nails* (1987), the fixity of a silver-print image is undermined by two three-dimensional nails. Indeed, for Muniz, photography must not be satisfied with imitating life, registering only its surface movements, where only a pale echo of the force of things and actions survives; rather, it must be a "real" moment, a triumph of the material that nourishes it. Photography must present the throbbing of a vital, phantasmatical existence. Indeed, in 1990, wishing to capture the force that reality (the personal and sensual reality of his own memory as well as that of the things around him) pours into the reproduced representation, Muniz began working with the relationship between the form and formlessness of photography. The former is represented by the historic icons that the photographers of Magnum and other agencies have left in our collective memory, while the latter is derived from the open use of materials such as graphite, which is placed at the whim of the hand's randomness to reconstruct memorized figures. It is another passage into the dialectic between reality and representation, with the difference

that, whereas in the early works they were complementary and parallel, here they overlap and are integrated into one another. They offer themselves as an interpretive filigree, the construction of which is founded on the common social memory of a culture based on media information. The snapshot capturing an instant of history—the young John F. Kennedy, Jr,. saluting his father's passing bier, Neil Armstrong taking the first steps on the moon—coincides with the immediacy of the action of the artist representing, by means of blots or shapeless applications of material, the form of an historic event *in fieri*, as it comes into being. In other words, a short circuit is established between the photographic impulse and the vision traced, both of them being unpremeditated "sketches" of a consciousness of sight.

Muniz's endeavor to introduce a physical quotient linked to his dexterity, which allows the hardness of the event, the softness of the flesh, or the texture of the object to combine with, for example, the velvety sweetness of sugar in *The Sugar Children* (1996) or the rigidity and compactness of iron wire in *Pictures of Wire* (1995), is the basis of a photography that remains, undeniably, a simulacrum of reality, but that is permeated by a desire to involve the physical presence of the world in its process. In this sense, the materiality serves to overcome artifice and the mechanical expedient, attempting to call into question photography's ambiguity and deception, which are fundamentally linked to the mystery enclosed in the contours of objects. This is why Muniz has measured himself against the compositional structures that give shape to figures and landscapes, and why he has returned to the eighteenth-century pictorial and sculptural tradition of cloud figures. In 1993, he began working with "equivalents," photographing pieces of cotton that manage to form the image of a cloud. More recently, he has attempted to give form and figuration to smoke dissolving in the sky, recalling the Impressionist idea of giv-

ing form to the formless. Using the contents of formlessness—cotton or smoke—Muniz analyzes photography's formal mutations and rate of optical efficacy, its index of monumentality and variability.

Muniz's recourse to such materials as wire, cotton, sugar, chocolate, dust, and dirt arises from an analysis focused on the act of photographing, on the unconditioned, passive manifestation of the phenomenon photographed. He investigates with a critical but personal edge, giving expression to a materiality that is hard or soft, open or closed, depending on the subject, laying the foundation for a photographic and phenomenal unruliness capable of circumnavigating the stumbling blocks of the fixed snapshot, the restrictions of technique, and the limitations of form. His method involves a reconnaissance of the elements that potentially make up the spirit of representation; it is a renewed movement toward a sensuality of sight, conducted through a domestic, affable vivacity recognizable in small and simple things. In this way, Muniz attains the visually generic quality of such artistic icons as the works of Jackson Pollock and Joseph Beuys or of details of bodies and faces of children, and reanimates them through the formlessness of a personal chronicle made up of pleasure and memory, and of materials belonging to a given place, such as the dust of the Whitney Museum of American Art, New York, or trash from the streets of Rio de Janiero. The result never strays from the rigid methods of photographic surveying; it is just that Muniz is looking for an interlocutory phase in which the photograph exists and entrusts itself to the finished form but also lives on the energy of the matter and formlessness that belong to the universe of the ungraspable everyday.

In this sense, one might say that, like the classic English landscapists, Muniz tends to confer beauty on the incorporeal or the immaterial, imbuing it with a sensation or feeling that is psychic and personal. He seeks to capture the power of preexisting images, from iconic photographs of historic moments to Leonardo's *Last Supper* and Vincent van Gogh's *Sunflowers* to configurations of the stars at the time of certain exceptional events such as the discovery of America and the explosion of the atom bomb. But he sucks it all back into his universe of materials, which are intimate and subjective, gratuitous and fragile, making it possible to bind the simulacrum to reality while placing it on a terrain above reality, that of artistic manipulation. Here, then, is a new reality subjected to a metamorphosis that determines at once the essence of an idea and a physical factuality: a sensual metaphysics.

Translated from the Italian by Stephen Sartarelli.

Contemporary Projects

This selection of contemporary work suggests the multiplicity of artistic strategies employed today, much of which sets up vital parallels with the art of Brazil's past. Lygia Pape serves as an important link between the Neo-Concrete generation of the 1950s and 1960s and contemporary artists. Her *Tupinambá Cloak* (2000, cat. no. 305) recalls the beginnings of Brazil's recorded visual history, paraphrasing the sixteenth or seventeenth-century red feather Tupinambá cape (cat. no. 1). Regina Silveira considers the themes of the mutability of appearances, power, control, and disenfranchisement. In *The Saint's Paradox* (1994–98, cat. no. 306), a small wood carving of Saint James the Apostle rests on a pedestal in the center of the exhibition space. The enormous shadow that he appears to cast is not his, but an ironic distortion of the shadow that would be cast by a military monument by Modernist Victor Brecheret, which is located in a public square in São Paulo. In Antonio Manuel's *Phantom* (1995, cat. no. 304), large and small pieces of carbon hang from strings throughout the exhibition space, creating a universe of floating black elements. Within this threatening maze an image of a hooded individual, a witness photographed while describing a massacre of street children by the police in Rio de Janeiro, is affixed to a wall.

Accumulation, juxtapositions of materials and surfaces, and magnetic tensions are all elements of Tunga's work. In several pieces, he refashions a Baroque aggregation of constituent parts, conveying intimations of the sacred. While his large-scale installations suggest inexorable mass, they also imply profound sensuality; indeed, references to body parts, skin, and hair are intrinsic to Tunga's visual vocabulary. Literal interaction between the viewer and the work of art is a quintessential element in the environments created by Ernesto Neto. His most ambitious works embrace the spectator in total environments made of nylon netting or flesh-colored Lycra and infused by odorous substances such as aromatic spices. Neto continues the tradition of experiential art as represented by Lygia Clark and Hélio Oiticica. In an ironic commentary on the past, Adriana Varejão has employed visual quotations of architectural elements such as tile decorations from Brazil's colonial period. An urgent sense of corporeality is also conveyed by the body fragments and extrusions of flesh that often punctuate her work. While Miguel Rio Branco and Vik Muniz are worlds apart in their sensibilities, both artists' photography-based works demonstrate a concern for fragmentary appearances, the fleeting view, and chance occurrences. Rio Branco's light-saturated photographs are often shocking, both in their intensity and subject matter. Muniz creates elaborate scenarios with ephemeral materials, such as dust, thread, and sugar, which he then photographs; the process and the fugitive quality of the materials are emphasized, as if to suggest organic growth and decay. —Edward J. Sullivan

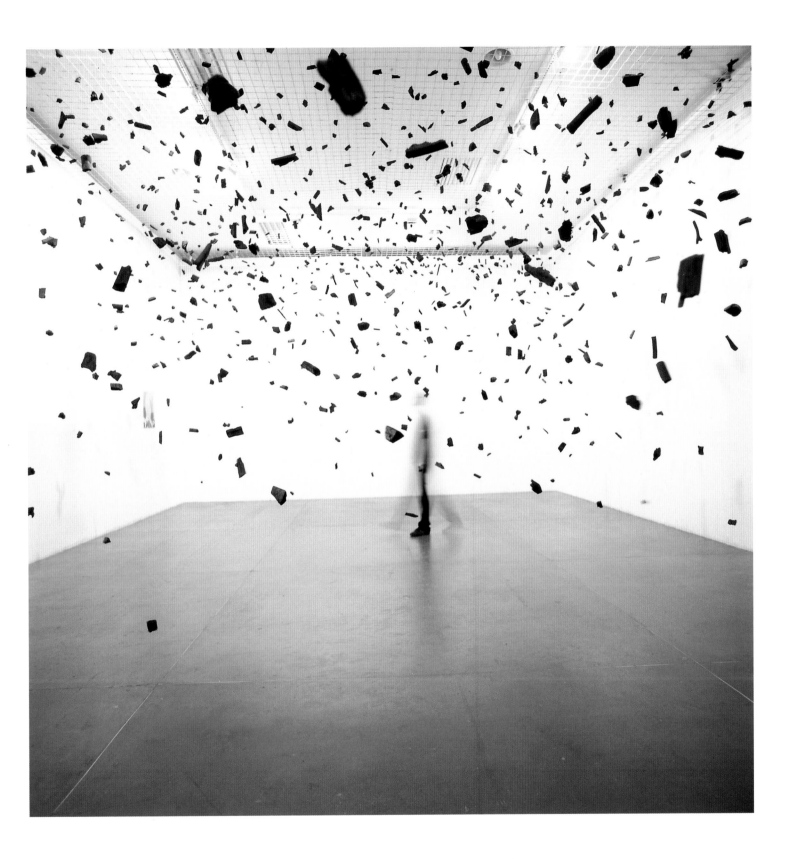

304. ANTONIO MANUEL *Phantom*, 1995. Mixed-media installation. Collection of the artist

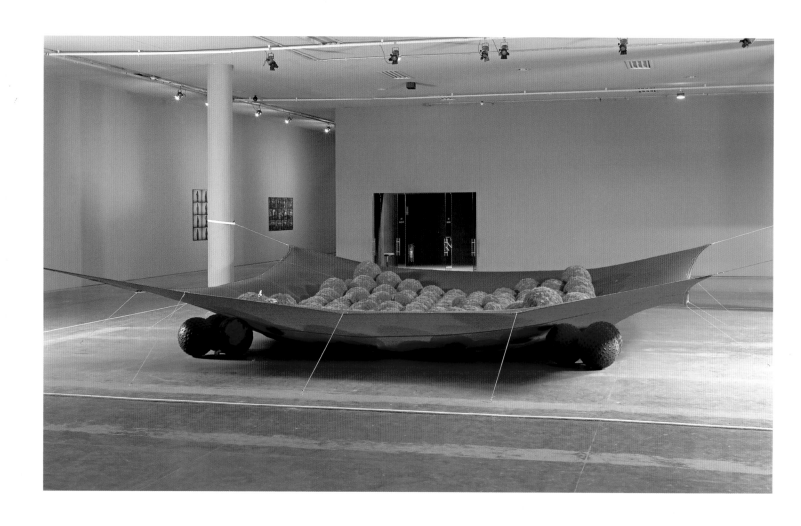

ABOVE AND FACING PAGE: **305. LYGIA PAPE** *Tupinambá Cloak*, 2000. Mixed media, 150 x 800 x 800 cm.

Collection of the artist

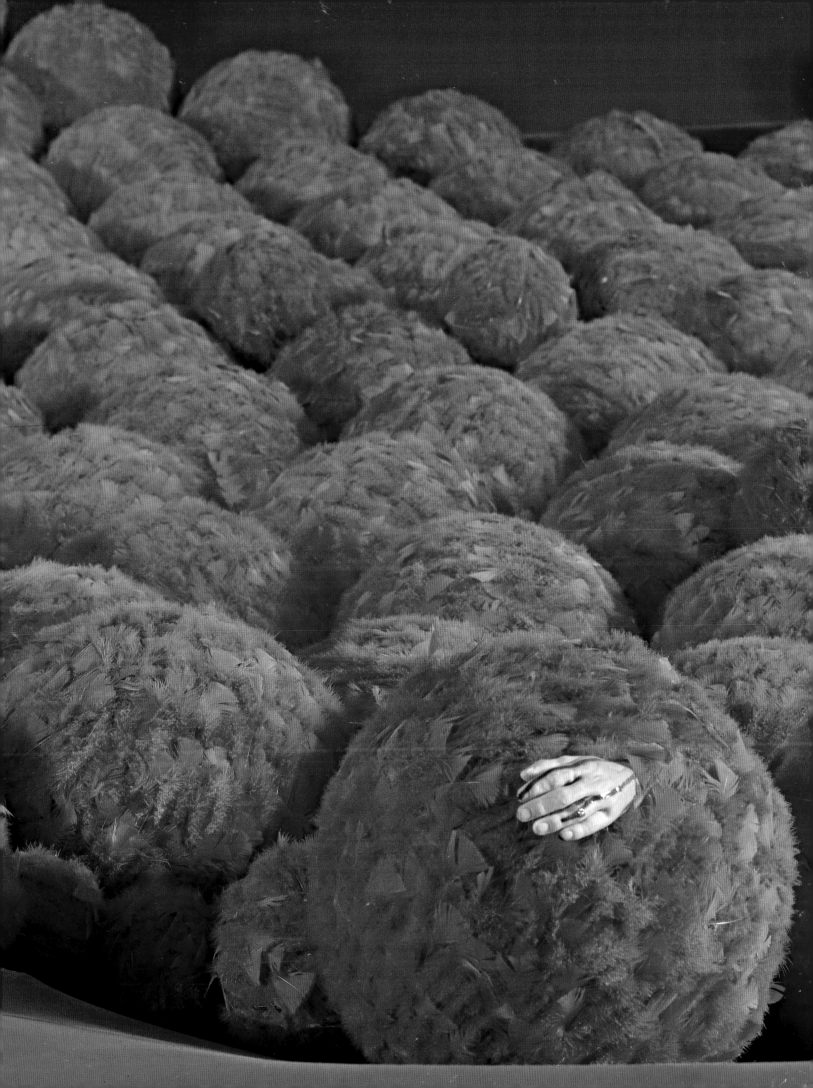

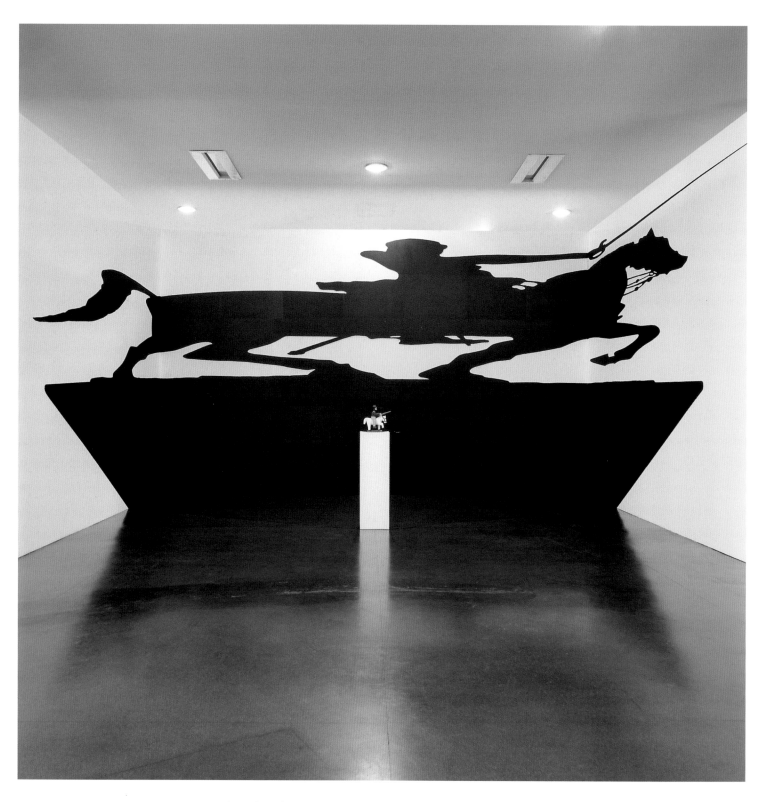

ABOVE AND FACING PAGE: **306. REGINA SILVEIRA** *The Saint's Paradox*, 1994–98. Mixed-media installation. Museu de Arte
Contemporânea da Universidade de São Paulo

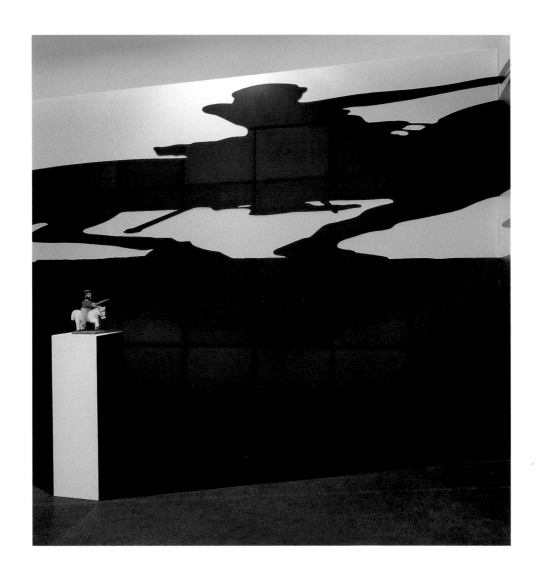

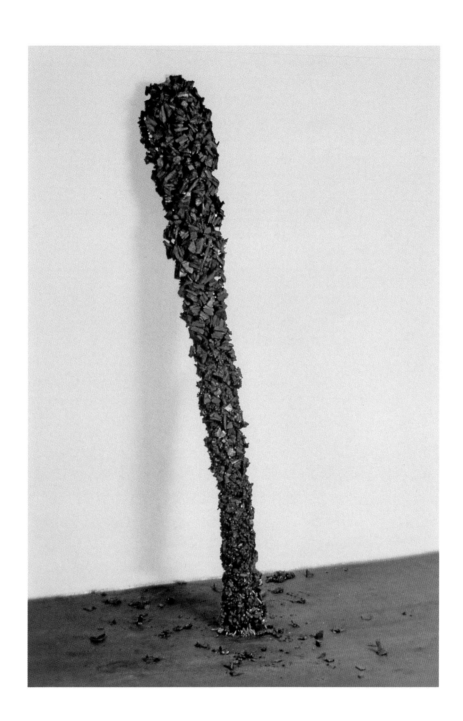

307. **TUNGA** *Takape (Club)*, 1986–97. Iron, magnets, and iron fillings. Private collection

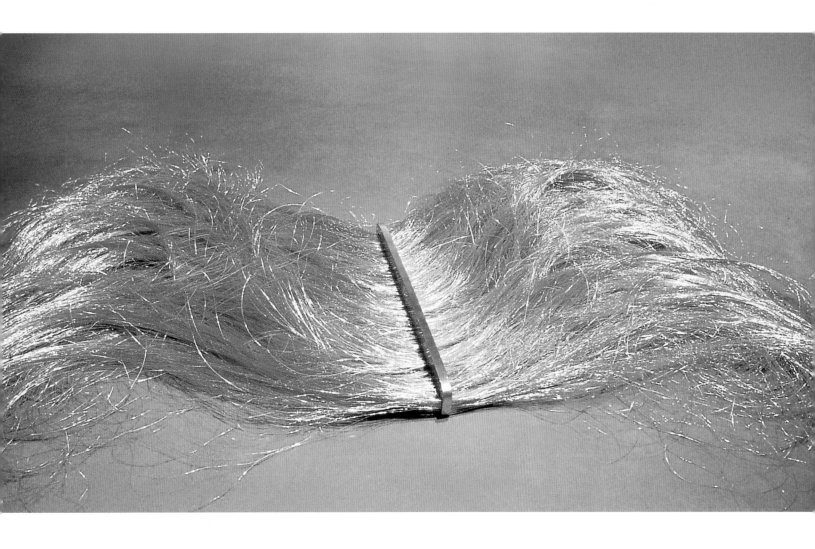

308. TUNGA *Comb (Scalp)*, 1984–97. Brass, 157.5 x 78.7 cm. Collection of Marieluise Hessel, on permanent loan to the Center for Curatorial Studies, Bard College, Annandale-on-Hudson, New York

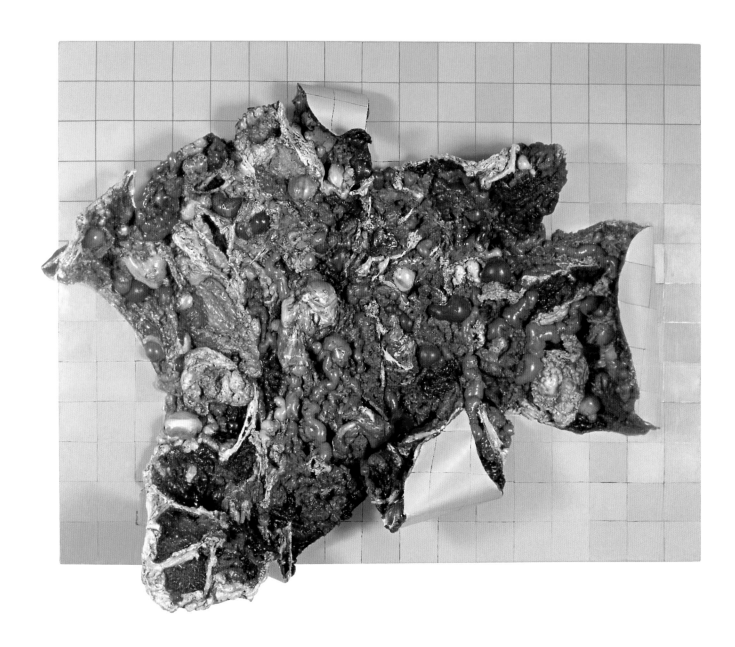

309. ADRIANA VAREJÃO *Folds*, 2000–01. Oil, foam, aluminum, wood, and canvas, 195 x 250 x 66 cm. Private collection, courtesy of Lehmann Maupin Gallery, New York

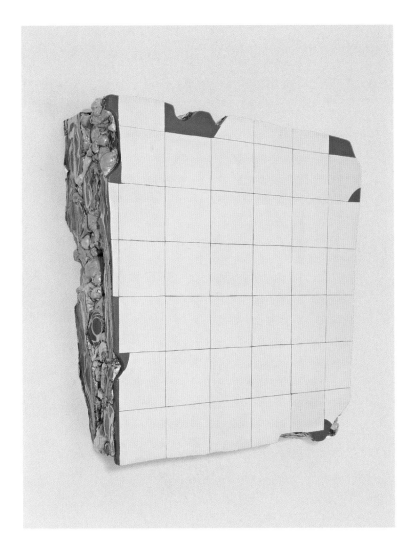

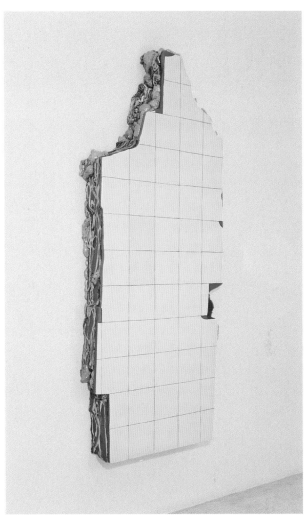

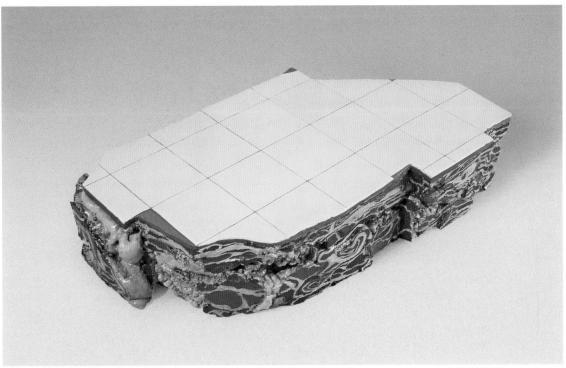

CLOCKWISE FROM TOP LEFT: 310. ADRIANA VAREJÃO *Chacahua Jerked-Beef Ruin*, 2000. Oil, polyurethane, and oil ink, 91 x 88 x 34 cm. Collection of Ricard Akagawa, São Paulo. 311. ADRIANA VAREJÃO *São Paulo Jerked-Beef Ruin*, 2000. Oil, polyurethane, and oil ink, 168 x 69.5 x 14 cm. Collection of Simone Fontana, São Paulo. 312. ADRIANA VAREJÃO *Caruaru Jerked-Beef Ruin*, 2000. Oil, polyurethane, and oil ink, 89 x 52 x 21 cm. Collection of Raquel Silveira, São Paulo

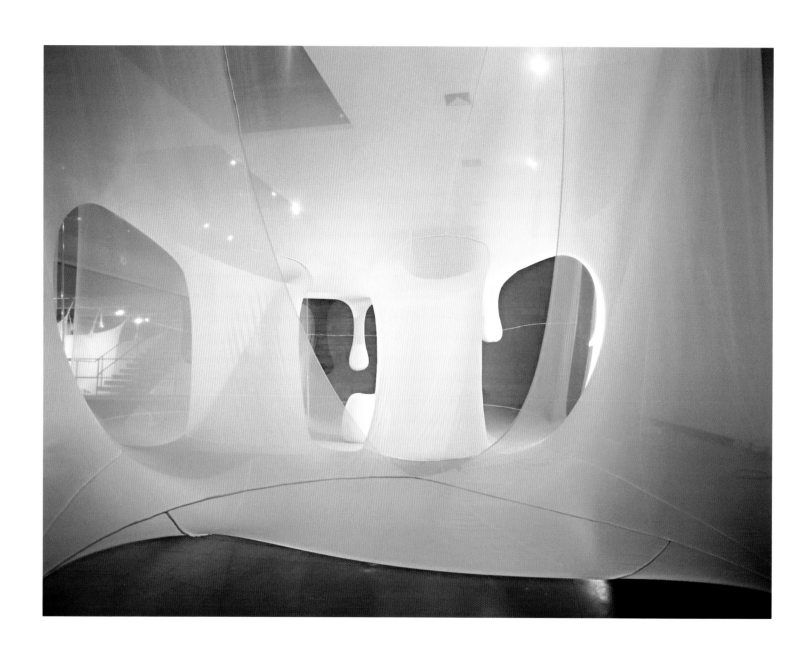

313. **ERNESTO NETO** *Womb Chapel*, 2001. Lycra, tulle, polyamide tubes and stockings, sand, Styrofoam, and aluminum tubes,
6 x 14 x 20 m. Courtesy of Tanya Bonakdar Gallery, New York, and Galeria Fortes Vilaça, São Paulo

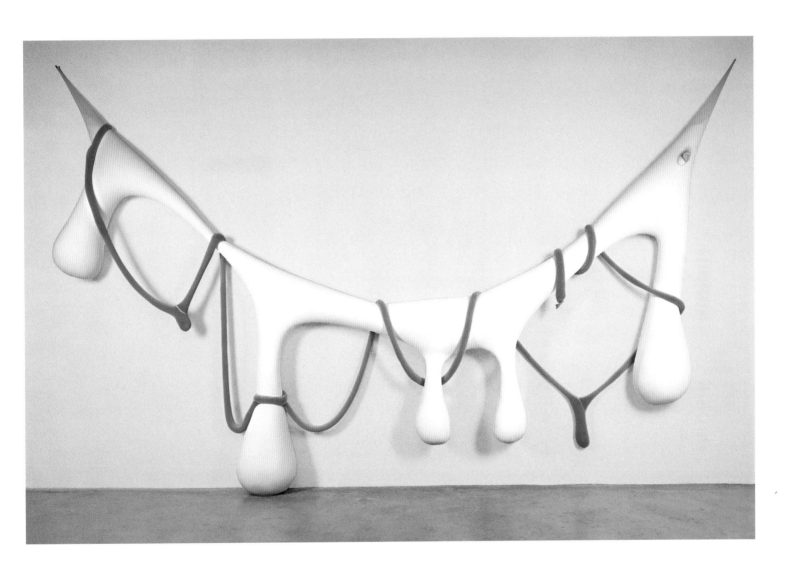

314. **ERNESTO NETO** *We Live in a Symbiotic Love*, 2001. Styrofoam, stockings, and lavender, 148 x 244 x 16 cm.
Solomon R. Guggenheim Museum, New York, purchased with funds contributed by the International Director's Council and
Executive Committee Members: Ann Ames, Edythe Broad, Henry Buhl, Elaine Terner Cooper, Dimitris Daskalopoulos, Harry
David, Gail May Engelberg, Ronnie Heyman, Dakis Joannou, Cindy Johnson, Barbara Lane, Linda Macklowe, Peter Norton,
Willem Peppler, Denise Rich, Simonetta Seragnoli, David Teiger, Ginny Williams, and Elliot K. Wolk 2001.25

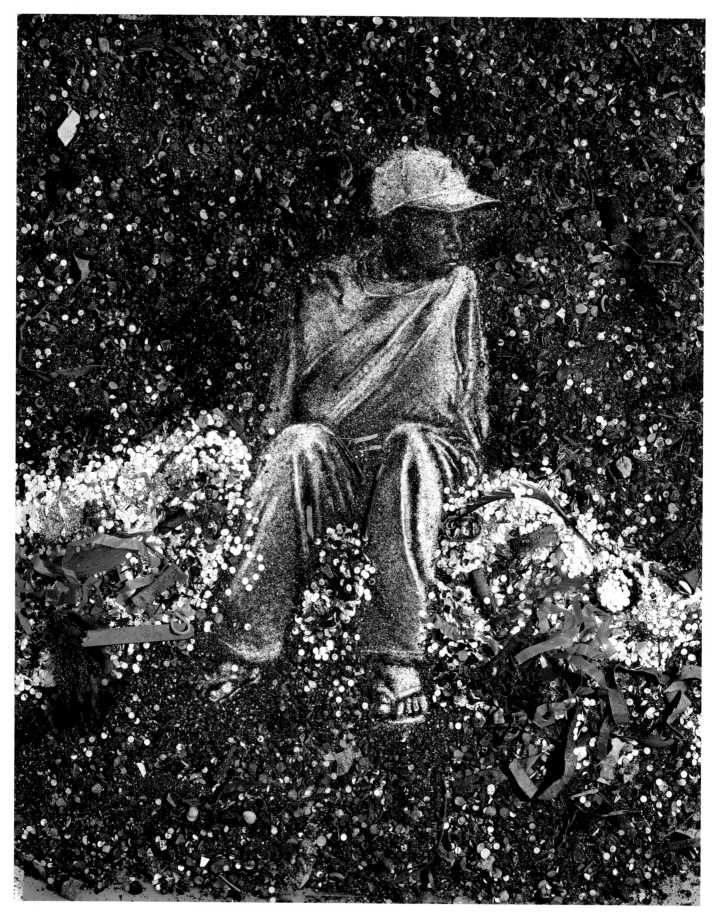

315. **VIK MUNIZ** *Aftermath (Angélica)*, 1998. Cibachrome print, 180 x 120 cm. Collection of the artist, courtesy of Galeria Fortes Vilaça, São Paulo

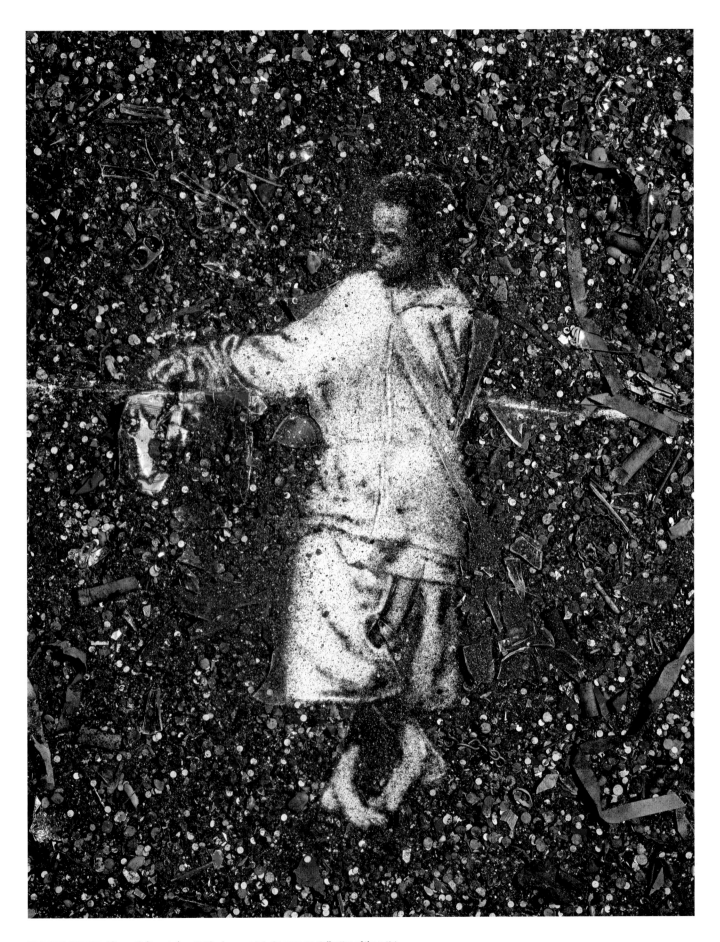

316. VIK MUNIZ *Aftermath (Socrates)*, 1998. Cibachrome print, 180 x 120 cm. Collection of the artist, courtesy of Galeria Fortes Vilaça, São Paulo

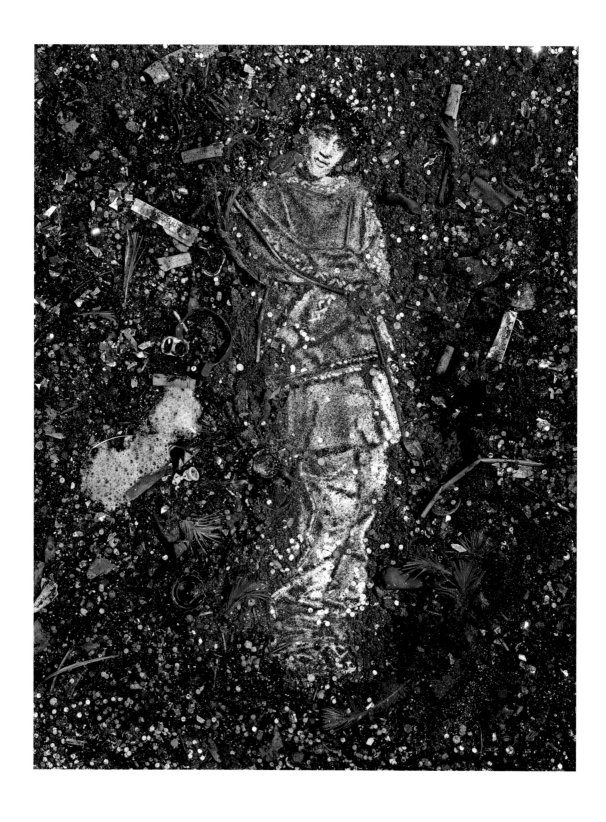

317. VIK MUNIZ *Aftermath (Madalena)*, 1998. Cibachrome print, 210 x 120 cm. Collection of the artist, courtesy of Galeria Fortes Vilaça, São Paulo

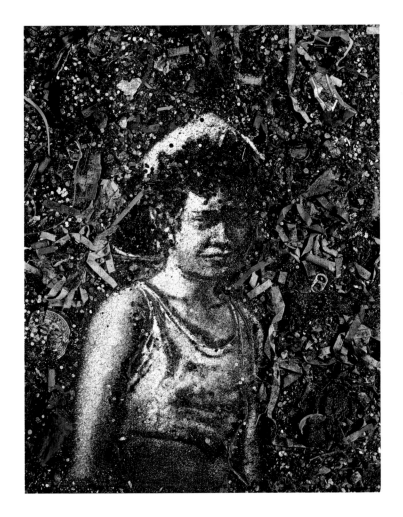 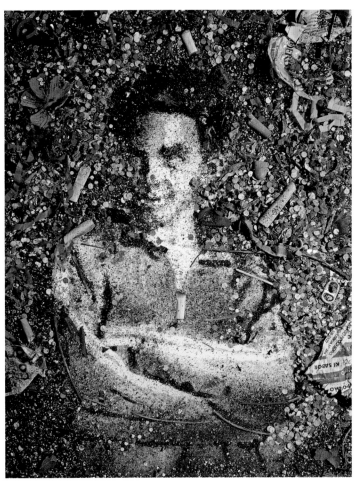

318. VIK MUNIZ *Aftermath (Aparecida)*, 1998. Cibachrome print, 150 x 120 cm. Collection of the artist, courtesy of Galeria Fortes Vilaça, São Paulo. 319. VIK MUNIZ *Aftermath (Emerson)*, 1998. Cibachrome print, 150 x 120 cm. Collection of the artist, courtesy of Galeria Fortes Vilaça, São Paulo

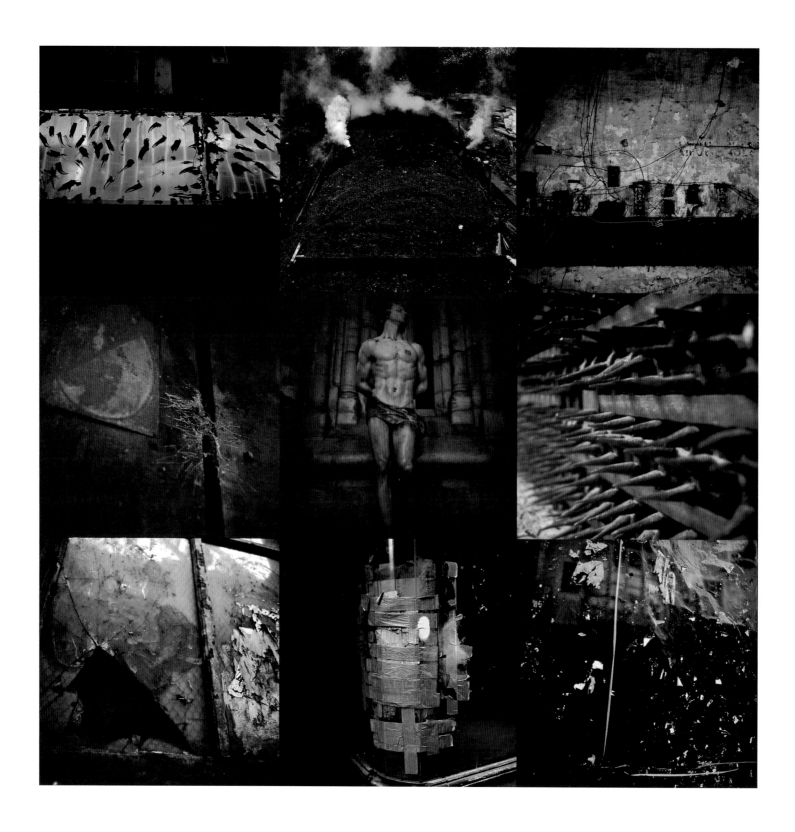

320. **MIGUEL RIO BRANCO** *Heartless Black Saint Sebastian*, 2000. Cibachrome prints, 243.8 x 243.8 cm overall. Courtesy of the artist; D'Amelio Terras Gallery, New York; Galeria Oliva Arauna, Madrid; Galeria André Milan, Rio de Janeiro; Galeria Fortes Vilaça, São Paulo

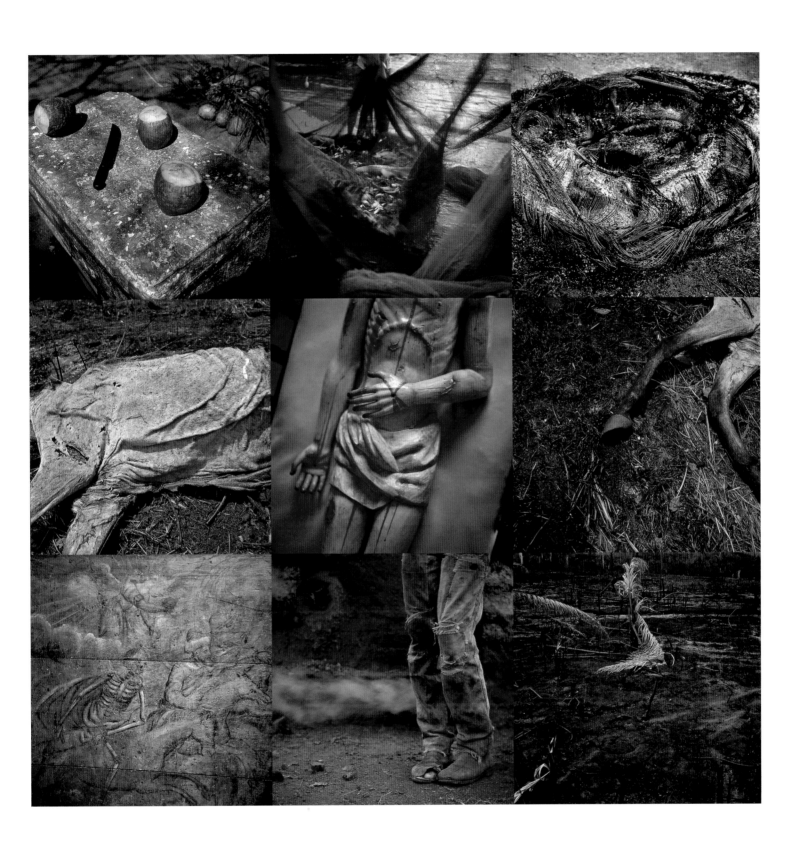

321. MIGUEL RIO BRANCO *Barroco*, 1993. Cibachrome prints, 243.8 x 243.8 cm overall. Collection of Claudio Cesar and Lynn Steiner Cesar, Phoenix, courtesy of Galería Oliva Arauna, Madrid; the artist; D'Amelio Terras Gallery, New York; Galeria André Milan, Rio de Janeiro; Galeria Fortes Vilaça, São Paulo

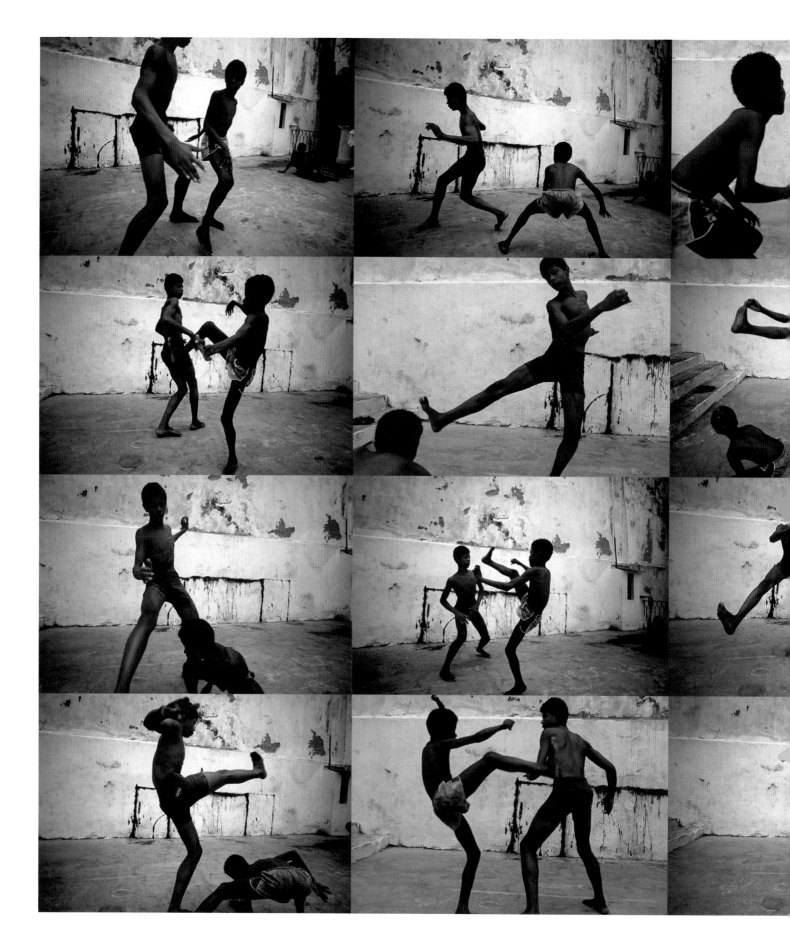

322. MIGUEL RIO BRANCO *Blue Tango*, 1984. Cibachrome prints, 200 x 300 cm overall. Courtesy of the artist, D'Amelio
Terras Gallery, New York; Galería Oliva Arauna, Madrid; Galeria André Milan, Rio de Janeiro; Galeria Fortes Vilaça, São Paulo

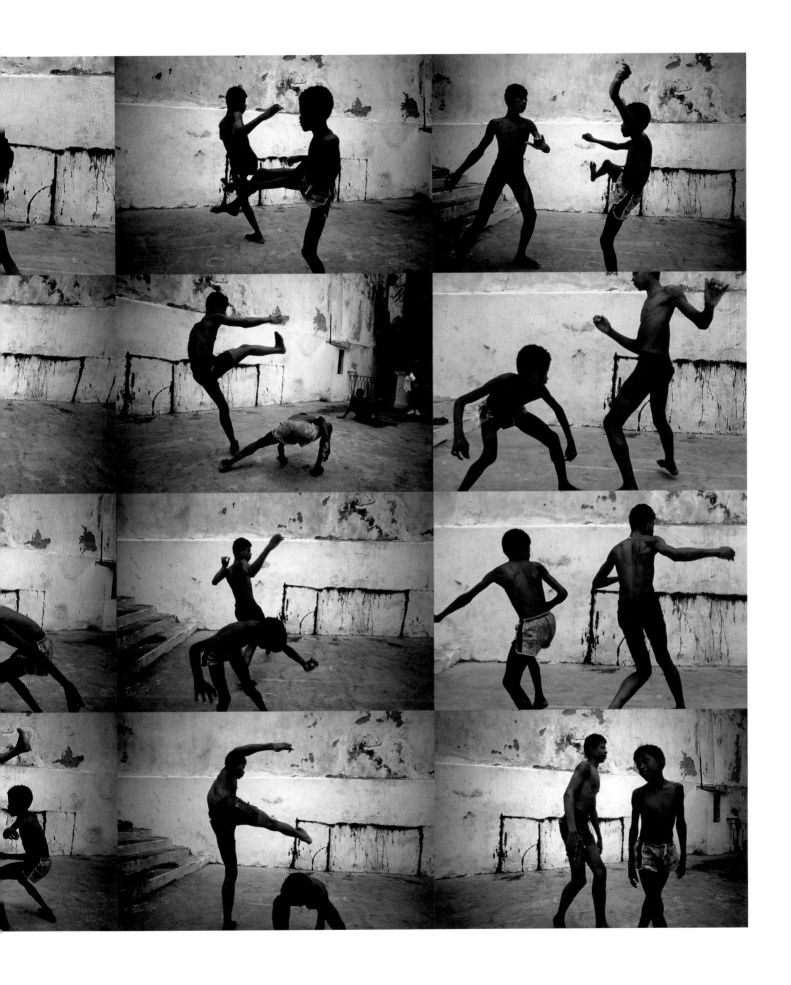

Architectu

Toward a Phenomenology of Brazil's Baroque Modernism

David K. Underwood

The milieu in which Brazilian life
began was one of sexual intoxication.
—Gilberto Freyre, *Casa grande e senzala*

The Baroque and the Rococo are
admirably adapted to the Brazilian
landscape. . . . The country is so
Baroque that one has the impression
that the style was born here.
—Roberto Burle Marx, *Arte e paisagem*

We do not conceive of a work of art
as a "machine" or as an "object,"
but as a "quasi-corpus" [quasi-body],
that is to say, something that
amounts to more than the sum of
its constituent elements; something
that can only be understood phenom-
enologically.
—Ferreira Gullar, *Manifesto neoconcreto*

Where are we to put the limit
between the body and the world,
since the world is flesh . . . [since]

visible things are the secret folds of
our flesh.
—Maurice Merleau-Ponty, *The Visible
and the Invisible*

Brazilian Modernism was born of a
spiritual quest for cultural identity rooted
in an aesthetic exploration of the tropical
landscape and the colonial Baroque condi-
tion. An important dimension of this
quest—the search for a Baroque unity of
body and soul—is evident not only in
much Brazilian painting and sculpture but
also in the work of Brazil's great Modernist
architects: Lúcio Costa, Roberto Burle
Marx, and especially Oscar Niemeyer. Each
in his own way has contributed to the
definition of a Brazilian ethos through an
architectural exploration of the tropical
Baroque and the Modernist strategy of
antropofagia (cannibalism). Architecture,
the monumental extension of the flesh of
the body into the flesh of the world, has
been for Niemeyer a means to incorporate

(literally and metaphorically) a vision of the Brazilian soul and achieve a sense of cultural identity and intimacy with the divine. His work is thus important for understanding Modern Brazilian art because it has forged a conceptual and historical link between the colonial Baroque and Modernism, and in particular between the cosmic organicism of *antropofagia* and the phenomenological concerns of Neo-Concrete and contemporary art. His work has addressed not only the formal and ritual qualities of the Baroque but also the erotic primitivism of the Antropofagia movement, its rites of communion with nature and the body, and its attempts to return to a primordial world of spiritual meaning and intimate contact with the landscape before the conquest. The development of an architectural expression of Brazil's "Baroque Modernist" identity is best revealed through several important buildings and projects: the Brazilian Pavilion (1939) at the New York World's Fair; the project (1948) for a theater adjoining the Ministry of Education and Health Building in Rio de Janeiro; the Chapel of Saint Francis (1940–43) and related buildings at Pampulha; the Cathedral of Brasília (1958–62) and palaces in the capital; the Memorial da America Latina (1989) in São Paulo; and the Museu de Arte Contemporânea (1991–96) in Niterói.

The Baroque in Brazil

"Baroque" has been defined in many ways. What interests us here, especially in light of the epigraph by Burle Marx at the beginning of this essay, is the relation between the Baroque and Brazil, and the extent to which the concept in this case encompasses much more than a style. One of the most important English-language statements in this regard was Leopoldo Castedo's book *The Baroque Prevalence in Brazilian Art*.[1] Drawing on the observations of Brazilian anthropologists, writers, and artists (among them Gilberto Freyre, Jorge Amado, Sergio Buarque de Holanda, and Oscar Niemeyer), Castedo explored the plastic feeling, theatricality, and lyricism of Brazilian cultural forms as varied as the *capoeira* and the music of Heitor Villa-Lobos. Characterizing Brazil's Baroque ethos in philosophical and comparative visual terms by juxtaposing images of O Aleijadinho's architecture and sculpture with Niemeyer's buildings and spaces in Brasília, Castedo defined the Baroque in Brazil in terms of an intuitive nature comprising four attributes he found in the art and psychological profile of the people: universality, intimacy with the divine, sensuality, and audacity. To these he added several formal qualities "found especially in the Brazilian expression": the breaking up of outlines, the obsessive predominance of the curve, and an almost frenzied dynamism. While these are defining characteristics in all the arts, they are especially evident in architecture, "traditionally the head of the hierarchy."[2] In this connection, he adds, the most salient attribute of the Baroque is that of the multimedia expression—the *Gesamtkunstwerk*—"the tendency to intermingle the fine arts" in a "reciprocal subjection of architecture, sculpture, painting, music, poetry, drama, and the dance to the advancement of a common ideal." This fusion of the arts and the "yearning to achieve a community of form and expression" occurred "possibly nowhere more unmistakably than in the art of Brazil." Moreover, he adds that "if the Baroque means depth," open form, spatial feeling, and even scenographic value, then Hispano-American Baroque "is not Baroque at all."[3] Whereas Spanish art exhibited "an abiding devotion to the ascetic," Brazilian Baroque delighted in the "tumescence of carnal forms," in the provocative swelling of the flesh.[4]

This sensuality and audacity of the Brazilian Baroque are in harmony with a universal quest for infinity and intimacy with the divine. In the introduction to the catalogue of his important exhibition *O universo magico do barroco brasileiro*, Emanoel Araújo equates the

Brazilian soul with the Baroque spirit of "contagious emotion" and "collective ecstasy."[5] The cultural resonance of Brazil's "mestiço spirit" results in a "syncretism that playfully incorporates body and soul."[6] The seductive quality of Baroque art—its ability to enchant the depths of the soul and inspire the faith of the masses—is emphasized. So too is the experiential dimension. Germain Bazin and others observe that understanding the poetry of the Baroque requires that we experience the ceremony.[7] Nicolau Sevcenko suggests that no Baroque work can be appreciated in isolation from its ritual context or outside the "intense emotional atmosphere" of myth, faith, divine intervention, and miracles: "Baroque art has to be seen with the eyes of the soul."[8] For him, the Baroque in Brazil was not a passing artistic style, but a "profound dimension of the country's entire history"—the "basic stuff of a totally new cultural synthesis"—a dimension that is best seen in Brazil's festival celebrations: Carnival, Corpus Christi, and the Triumph of the Eucharist.[9]

The Baroque Festival and the World In-Between

According to Maria Lúcia Montes, the earliest Baroque festivals in Brazil served to "seduce and attract the savage natives" who continued to practice cannibalism after being converted and whose "inconstant souls" therefore demanded more and more of the festival celebration to conquer them for the Christian faith.[10] The Baroque festival has a synthesizing and playful quality that resolves or incorporates contradictions, thereby demonstrating the impossibility of separating the sacred and the profane: "Festivals are ambiguous zones of the 'in-between' that permit the negotiation of a full range of mediations between extremes," and in so doing reveal the extraordinary profusion of spiritual elements materialized in sensory experiences or aesthetic performance.[11] As Octavio Paz observes, in provid-

OSCAR NIEMEYER Cathedral of Brasília, 1958–62

ing a means to seek out and achieve some sort of primordial reconciliation with the universe, the festival "opens the doors of communion" and "prefigures the advent of the day of redemption [when] society will return to its original freedom, and man to his primitive purity."[12]

Montes sees the monumental celebration of the Triumph of the Eucharist in colonial Minas Gerais as a paradigm for the festival in Brazil's Baroque culture. The Triumph of the Eucharist had two levels of "text," or meaning, the first of which was the written narrative published in 1734. Montes emphasizes the importance of the subtext beyond the narrative, that of the performance and experience of the festival itself.[13] The essential Baroque quality of the festival celebration is not in the initial or literal level of text or narration, but in the deeper, performative level where the language of images and sounds is integrated into an experience of the simultaneous and the momentary, something which the text alone cannot capture. The most characteristically Baroque quality of the festival is its use of multimedia experiences to elevate the masses to a spiritual plane, using metaphors and allegories in which the concrete and literal take on indirect meanings. Herein lies the essential connection between the Triumph of the Eucharist and the celebration of Carnival. Both involve an allegorical level that expresses meaning only through the totality of its elements and the simultaneous integration of its multiple languages.[14]

But it is not just the modern-day Carnival celebration that illustrates the continuing presence of Brazil's Baroque heritage. Without essentializing modern

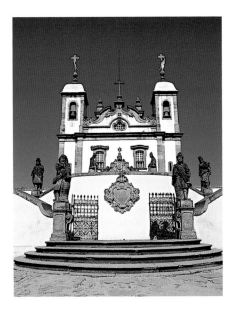

O ALEIJADINHO Terrace of the Prophets, ca. 1800, the sanctuary of Bom Jesus de Matozinhos, Congonhas do Campo, Minas Gerais

Brazil in terms of a Baroque derivation, we can see this heritage in a variety of modern forms, as Montes explains: "A single Baroque *matriz* [matrix, source, mold, womb] of the festival impregnates these cultural forms, which assimilate and re-create, fold and unfold back, and recombine in an infinite process of variation, thanks to the very dynamic of culture."[15] Montes's use of the birthing metaphor and notion of culture as a continuous process of folding and unfolding bring to mind the phenomenology of Maurice Merleau-Ponty. In its concern for finding ultimate origins, so too does her final question: What was the ultimate *matriz* of the corporeal language of the Baroque festival? The Indian? The African? The European? The mestizo or mulatto? Niemeyer searched for more primordial origins.

Merleau-Ponty: Theorist of the Baroque, Philosopher of Ambiguity

The philosophical writings of the French existential phenomenologist Merleau-Ponty are specifically referenced in the *Manifesto neoconcreto* (1959) by Ferreira Gullar, but the full implications of his search for a deeper understanding of Brazilian Modernism as a whole have yet to be brought out. These writings suggest an especially fruitful line of inquiry into the nature of the "Baroque world" as it relates to a modern Brazilian *Lebenswelt*

that Araújo has characterized as "an experience of ambiguity."[16] Mauro Carbone and Christine Buci-Glucksman comment upon the relation between Merleau-Ponty's aesthetic ontology (aesthetic approach to Being) and the Baroque's ontological aesthetics (preoccupation with Being in aesthetics).[17] More fundamental, Merleau-Ponty's philosophical project was aimed at revealing the limitations of the traditional rationalist dichotomy between the mind and the body as two separate entities and formulating instead a holistic experiential philosophy with a Baroque sensitivity to the primordial realm of corporeality, aesthetic perception, and the "in-between" ("*l'entre-deux*"): the "intertwining," or "chiasm," of the "flesh" and the "polymorphous wild-world" of which it is an extension.[18] Samuel Malin defines "chiasm" as "a grouping, a gathering or assemblage wherein the members are related sinuously or flexuously by means of bending themselves to each other."[19] In Merleau-Ponty's philosophy, the "flesh" of the incarnate "body-subject" mediates between the exteriority of the physical facts of the world and the interiority or "intentional projects" of psychic and spiritual states, of emotional and instinctual impulses. This mediation—this synthesis of body and soul—takes the ambiguous form of an "intertwining" of the perceived and the perceiver, of the hand that both touches and is touched, of imagination and expression, of body and art. As Merleau-Ponty puts it, "He who sees cannot possess the visible unless he is possessed by it, unless he is of it."[20] This chiasmic state of reversibility is also characterized by a "synesthetic spatiality" in which different media or substances, "coextensive" with the body, can be "transubstantiated" into one another or into new artistic forms, without losing their depth, thickness, or meaning: "The thickness of the body is . . . the sole means I have to go to the heart of things, by making myself a world and by

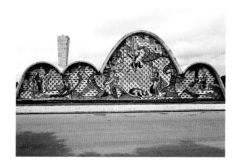 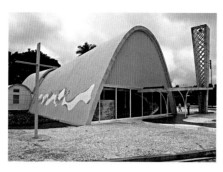

LEFT: **OSCAR NIEMEYER** Chapel of Saint Francis, 1940–43, Pampulha, Belo Horizonte, facade with *azulejo* panels by Cândido Portinari. RIGHT: **OSCAR NIEMEYER** Chapel of Saint Francis, waterfront facade

making them flesh."[21] Merleau-Ponty's "Baroque" sensitivity to the multisensorial dimensions of perceptual experience is announced in his phenomenological description of the high-school building to which he returns thirty years later: "It is not so much an object which it would be useful or possible to describe by its characteristics, as it is a certain odor, a certain affective texture which holds sway over a certain vicinity of space."[22]

What is particularly illuminating about this philosophy for an understanding of the Brazilian body and soul is the ethical dimension of Merleau-Ponty's view of "carnality." He describes the openness of the body's "slippery hold on things" as a place of "communion" and "primordial faith" that enables the body-subject to "transcend" itself at the same time that it makes the soul incarnate, enabling the body-subject to both feel and believe.[23] Moreover, as Evans and Lawlor note, "both 'flesh' and 'chiasm' are terms that carry Christian connotations (the mystery of the incarnation and the cross)."[24] It is precisely this return to both the primordial physicality of the body and its inherent spirituality that we find at the heart of the Antropofagia movement—the manifesto of Brazilian Modernism—as well as at the heart of Niemeyer's best architecture.

Antropofagia as Modernist Chiasm
What relates Brazil's Modernist strategy to the Baroque spirit is the ritual synthesis of opposites—the ability to explore the liminal zones of the in-between, to find the layering, overlapping, and intertwining of the sacred and the profane. What unites the Christian communion with

cannibalism is the ritual and symbolic consumption of the flesh as a means to a new spiritual identity in which one body eats another in order to possess its soul.[25]

The Antropofagia movement was a Modernist quest for cultural identity rooted in the possibility of a guilt-free "cosmic sexuality" and a "redeeming spirituality," what Paz calls "true erotic communion."[26] As Eduardo Subirats observes, it remains a "central leitmotiv" of Brazilian Modernism, "the expression of a permanent, creative, and vital nucleus of Brazilian civilization without which it would be difficult to understand the culminating expressions of its poetry, its music, or its architecture."[27] Antropofagia fostered an appreciation of a Baroque sense of the "total work of art," a sense of the integration of all of the arts under a common perspective that combined a critique of modern civilization and an idealization of a tropical utopia, the ideological basis of which was a "critical rehabilitation of a great matriarchal mythology."[28] This mythos combined a focus on the vital cycles of nature, the body, and erotic desire with a humanized view of technology—a synthesis that would poetically reconnect or chiasmically bend modern civilization toward a fantasy rooted in nature, eroticism, reproduction, and poetic creation. According to Subirats, Antropofagia's "orgiastic ritual of artistic creation" involved the discovery of a "free poetic language historically prior to the arrival of the European colonizers."[29] The movement explored "a poetry of paradise regained and the nostalgia for a resexualized community, deeply rooted in a matriarchal conception

of nature," the restoration of a "sacred nudity," and a "shamanic sacralization of the body."[30]

The values and goals of the Antropofagia movement were reflected and reinforced by the trip taken by Oswald de Andrade, Tarsila do Amaral, and the Swiss poet Blaise Cendrars to the ancestral (colonial Baroque) homeland of Minas Gerais. There they rediscovered firsthand the "situated" Brazilian body in a variety of spiritual settings and landscapes—in the buildings, sculptures, and festivals of the Barroco Mineiro. This trip was a quest for origins that went back to the premodern world of Brazil's colonial Baroque "wild being."

The central image of Antropofagia and of Brazilian Modernism in general is Tarsila do Amaral's *Anthropophagy* (1929, cat. no. 234)—the visual counterpart to Oswald de Andrade's *Manifesto antropófago* (1928). It is an image of both explicit and implicit intertwining. Shown are two primitive bodies, one male, one female, their fleshy, swelling limbs interlocked in a primordial statement of sexual union and fertility. Fertility and connection to the earth—to Mother Nature—are emphasized by the centrality of the breast and the size of the feet. The two figures reflect an explicitly sexual rite of cannibalistic consumption/communion—one that implies a "resurrection" of Brazilian culture—in a momentary and timeless intertwining of past, present, and future. This is a chiasmic image that intertwines body and landscape, male and female, European Modernism and Brazil, primitive and modern, primordial past and imagined identity for the future, sacred and profane. Antropofagia was a nostalgic longing for a mythical connection with primordial origins, a longing to reconnect with the body from which Brazilian culture was born.

Modern Architecture as Flesh: The Baroque-Modernist Chiasm

For Castedo, Brazil's Baroque was something "best epitomized by that country's unique contribution to Modern art—its architecture: more specifically, that exciting conjunction of audacity and unfettered imagination, of richness and variety, of lyricism and love of the curve—Brasília."[31] The chiasmic intermingling of the Baroque spirit and Modernism in Brazil can be best seen in the architectural masterpieces of Niemeyer. The groundwork for his achievement was laid by the Antropofagia movement and the work of his mentor Costa, who proposed a new Modernist curriculum for Rio de Janeiro's architecture school and a cosmic theory of the origins of Brazilian architecture. More than this, Costa promoted a new appreciation of the colonial Baroque and upheld it as the basis for a sort of Brazilian *Kunstwollen* (will to form).[32] His plan for Brasília intertwined Christianity and the Conquest in the image of the Cross, at the same time that it, along with Niemeyer's architecture, sought to embody the perceived aspirations of the national soul.

Antropofagia and Costa's work also laid the foundation for the achievement of landscape architect Burle Marx, whose major contribution was to develop through his garden art the full implications of Brazil's tropical Baroque situation, and to explore as the basis for Brazilian identity the combination of the aesthetic and natural, as well as the colonial and modern. His exploration of Brazil's tropical milieu was both scientific and aesthetic, but the brilliance of his work lay in his ability to find a spiritual zone between the two, one that harmonized a botanical and Modernist ecology of form. The actual experience of the artist's intertwining of the natural landscape and the man-made garden was the chief means of knowing and establishing a tropical Baroque ethos for Brazilian Modernism.[33]

It was through his frequent collaborations with Burle Marx and numerous other artists (including some very gifted structural engineers) that Niemeyer's best works came to express an integrated "Baroque" vision that brought together

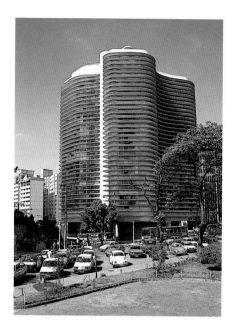

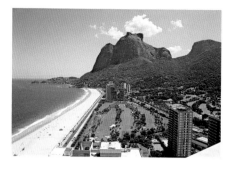

space, structure, landscaping, sculpture, painting, and the decorative arts, including panels of native wood and *azulejo* (blue-and-white ceramic tile), into a dazzling spectacle of colorful, curvilinear form.[34] The most celebrated achievement in this regard was the Chapel of Saint Francis (1940–43) at Pampulha, with surrounding landscaping by Burle Marx, *azulejo* panels by Cândido Portinari, and parabolic vault structures calculated by Joaquim Cardoso. In Niemeyer's projects for Pampulha, the creation of an artificial place in the midst of a lush natural setting continued to reflect the priorities of Modernist identity politics and diffusionist modernization. The ambitions of the mayor, Juscelino Kubitschek, who sought political backing from a nouveau-riche industrial elite in search of a weekend playground and a place in which to indulge the body, were addressed through an entertainment complex including a yacht and swimming club, a gambling casino with a dance hall, and an open-air restaurant and dance club for the "popular classes." Niemeyer's response reflected the flashy innovation of a young architect striving to find an appropriate expression of Brazilian identity through the creation of an architectural festival that was both a statement of revolt and a project of transcendence in the native landscape. In Niemeyer's words, "the

intended protest arose from the environment where I lived, with its white beaches, huge mountains, old Baroque churches, and beautiful tanned women."[35] Conceived as a sort of a architectural fairground that would be conducive to the "opening out" of the "overworked" elite, the complex would focus visually on Niemeyer's personal ritual of innovation: the redemptive image of a chapel dedicated to Saint Francis. For Niemeyer, the essence of this new Brazilian identity was to be reduced, in a grand poetic gesture, to what Merleau-Ponty calls the "logos of the line": the free-flowing and sensual curve.

The stated basis of Niemeyer's emerging aesthetic at Pampulha, and, consequently, of his version of Brazilian cultural identity, was the free and sensual curve that he found in the tropical landscape and bodies of his native Rio de Janeiro.[36] This aesthetic inspiration led him to explore the origins of Brazilian architecture—before the conquest of Brazil—in terms of a pre-Baroque emphasis on the landscape itself. Niemeyer's architecture can thus be experienced and understood as an architectural phenomenology of the Brazilian landscape, one that also reflects a cannibalist intentionality, a gobbling up of the Modernist discourse of Le Corbusier.[37] Niemeyer is fond of recounting one of Le Corbusier's observations about his work: "Oscar, you always have the mountains of Rio in your eyes; you do Baroque in reinforced concrete, but you do it very well." A comparison of Niemeyer's Praça da Liberdade Apartment Building in Belo Horizonte with the mountainous landscape of Rio suggests that Niemeyer was indeed doing phenomenology in rein-

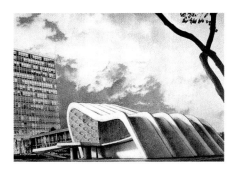

forced concrete, just as Merleau-Ponty observes that Paul Cézanne, when he painted Mont Ste.-Victoire, was illustrating the phenomenological approach in painting. Both artists were doing more than painting a picture or designing a building; they were using their special mediums and the "logos of the line" to "make a piece of nature."[38]

Niemeyer's 1948 project for a curvilinear theater with twin auditoriums adjoining the Ministry of Education and Health Building in Rio de Janeiro was an important statement of Modernist intertwining in Brazilian architecture, one that recalls Antropofagia's evocation of the primitive, sexualized, and matriarchal universe of the "wild-world" before the conquest. The unexecuted project was presented as a photomontage that deliberately contrasts (yet binds together) the mechanized, rectilinear slab of the Corbusian Ministry Building with a dramatically plastic and biomorphic form that stresses organic fluidity and curving sensuality: masculine versus feminine form. In Niemeyer's "Poem of the Curve," written about this time as a response to Le Corbusier's "Poem of the Right Angle," he states, "It is not the right angle that attracts me, nor the straight line—hard and inflexible—created by man. What attracts me is the free and sensual curve, the curve that I find in the mountains of my country, in the sinuous course of its rivers, in the body of the beloved woman." His architectural mythos is in harmony with the idea of fertility based in a matriarchal nature found in Antropofagia. It also reflects the intertwining of male and female form, of European and Brazilian, and of rational and sensual.

Here, the identity problematic of a young Communist architect overshadowed by the European system of Le Corbusier was addressed through a ritual combination of revolt and innovation. The idea of a Brazilian place and culture was essentialized through a dramatically curving body-structure reflecting Niemeyer's quest for the same evocation of "primitive purity" and primordial connection with a pre-rational consciousness celebrated by Antropofagia, Paz, and phenomenologists like Merleau-Ponty. This mythos would find its most mature expression in the 1953 Canoas House, where Niemeyer's labyrinth of solitude finds redemptive connection with Mother Nature through a ritual synthesis of architecture, curving lines, and landscape.

The Brazilian Pavilion at the 1939 New York World's Fair was the first building in which we find an authentic intuition of a phenomenology of Brazilian Modernism. This is evident on several levels. First, because the fair's program privileged a blending of futuristic and nationalistic marketing criteria, the building had to express from the very start the intentionality of bringing out for an international audience what a "Modern Brazilian" building wanted to be. This meant that the collaborating partners, Costa and Niemeyer, had to not only "bend" their own ideas and forms but also had to accommodate those of Le Corbusier, the International Style, Brazil's colonial Baroque heritage, and the new materials and structures of modern technology. This implied a phenomenological/eidetic reduction of the building's elements and its essentialization in terms of the most basic Brazilian qualities that could be brought out using an inflected variant of the formal language of the International Style. This involved as well the replacement of rigid Cartesian visual perspectives by a more fluid "promenade architecturale" in which the architecture is experienced by body-subjects that move through and perceive a multimedia and multisensorial spatiality,

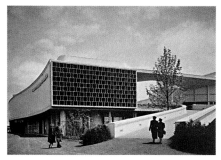

LEFT: **OSCAR NIEMEYER** Canoas House, 1953, Rio de Janeiro. RIGHT: **LÚCIO COSTA AND OSCAR NIEMEYER** Brazilian Pavilion, 1939, New York World's Fair

as in a Baroque ritual procession. Like Baroque festivals, the Brazilian Pavilion was intended to be experienced synesthetically: on several sensory levels simultaneously. As he or she navigated the shifting visual perspectives of a Modern, graceful composition of curving contours, textured surfaces, native plantings, and interesting audiovisual presentations and wall displays, the visitor heard the sounds of popular Brazilian music and tropical birds, smelled the aroma of Brazilian coffee and the fragrance of native orchids, tasted the food prepared in the restaurant, and perhaps even danced to the rhythm of the background music coming from the orchestra pit. Through the experience of moving through the pavilion, the visitor was to intuit the essence of the *Lebenswelt* (lived world) of modern Brazilian culture in all its tropical lushness and exotic sensuality. Using the flexuous curve as a sensual counterpoint to the rectangle, the building's forms "opened up" to the world of experience, making space for the nonrational experience of ambiguity, reversibility, and inversion. Probably the most compelling of these reversibilities was the experience of "entering" the building by "exiting" it, via a curving ramp that led to an open-air terrace, or ship's deck, with a splendid view of a tropical pool and garden below, the centerpiece of the whole composition. Both the exterior ramps and the interior gallery space were conceived as a fluid "nave" through which flowed a steady stream of visitors who, like Baroque pilgrims in search of festival relics, found themselves transported into another world.

The grandest poetic gesture in the

Baroque-Modernist spirit was Brasília, where the utopian rituals of colonial conquest and magical form produced almost overnight an image of a futuristic place in the middle of no place. The functional aspects mattered less than the symbolic imagery. The international marketing of an image of modernity was paramount. The creation of a universalist mythology was to ensure the erasure of the underdevelopment of the past. Formal innovation and universal spiritual redemption symbolized above all by the Cathedral of Brasília (1958–62), the Alvorada Palace (1956–58), and the Planalto Palace (1958) on the Plaza of the Three Powers. In all of these, Niemeyer extended his architectural body-language into the realm of pure and elemental form. Exoskeletons of sculptural wraps and bonelike structural frameworks echoing the Surrealist images of Yves Tanguy reflect the coming forth or pulling out of the architectural body to create a space for the spiritual itinerary of national redemption within.

Niemeyer's more recent work continues to reflect the ritual appropriation of the Brazilian body and its imagery to project a Baroque-Modernist identity to an international audience. In Rio de Janeiro's Samba Stadium (1984), the spiritual transcendence of Brazilian bodies through the ritual of Carnival was appropriated by Niemeyer and his state patrons as a symbol of the nation and showcased in a new permanent structure. Now even the grandest of rituals and its space were aestheticized and commodified for tourist consumption. Carnival is again the theme in Niemeyer's Memorial da America Latina (1989) in São Paulo, in which the physical

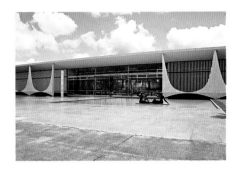

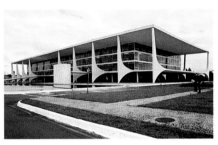

and linguistic isolation of Brazil from the rest of Latin America was addressed through a ritual of aesthetic unification, via the casting of an abstract and primitivist body-language of reinforced concrete sculptures that was intended to project an image of Latin American unity but in fact presents a forced, whitewashed view of it. Niemeyer's apparently subversive festival of surreal forms culminates in a concrete spectacle that is rooted in the Brazilian enchantment of the body politic with the body physical, a spectacle that ends up reifying the lived world of bodily interaction and human sensuality into abstract essences, sprawling concrete sculptures and spaces that obscure the rich and intimate details of Latin American culture. The memorial thus expresses both the triumph of the culture-constructing elite and the unresolved dilemma of Latin American development, for here we have the form of a monumentally severed hand from which trickles down not capital for development but the blood of the working class. It is their blood, as symbolized in the bleeding hand of Christ, that defines the map and experience of the region. Niemeyer's chiasmic intertwining of Modernist, Communist, and Christian meaning (the stigmata, sacrificial blood, etc.) is unmistakable here.

In the Museu de Arte Contemporânea (1991–96) in Niterói, Niemeyer's most recent ritual structure, the cultural isolation of a city with an inferiority complex vis-à-vis Rio de Janiero was addressed through the municipal government's attempt to create a new pilgrimage destination for "mass consumption" by tourists—a museum that would showcase the utopian redemption of Brazil's Modernist heritage. It is perhaps the definitive architectural festival in Niemeyer's career and his most eloquent, metaphorical, and Baroque statement to date about the redemptive role of abstract art in a society that he feels he cannot otherwise change.

The Niterói museum takes the form of a bulging white "spaceship" ("*aero-nave espacial*"), a baptismal font, or a ritual chalice of redemption, containing not the Eucharistic wine symbolizing the blood of Christ but the sacramental objects of a different, Modernist communion: 1,500 works of Brazilian abstract art. The museum can thus be read as an expression of the architect's continuing faith in the sacred power of abstract art and poetic form to lift humankind out of its dismal existence and into a nebulous spiritual realm as otherworldly as this spaceship chalice. It expresses Modernist dialectics of ritual and redemption, rupture and transcendence, withdrawal and return, being rooted and being free. For if it is a spaceship (as the popular press would have it) or a bird taking flight (as the architect himself prefers), it may also be seen as a body-place: a huge uterine form connected to the landscape via a coiling red-white umbilical chord carrying the lifeblood of Mother Earth into the fleshy, white, swelling form above.[39] Just as baptism gives birth to the spiritual Christian body, so the Eucharistic exercise enables it to be fed and grow, since the Eucharist aims ultimately for "something like an infinite swelling of the body" in both time and space.[40] Niemeyer's building projects the fertile swelling of the primordial body into the landscape as the basis, like

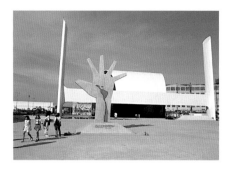 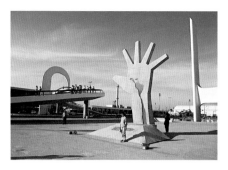

LEFT: **OSCAR NIEMEYER** Memorial da America Latina, São Paulo, 1989. RIGHT: **OSCAR NIEMEYER** Bleeding Hand, Memorial da America Latina, 1989

Antropofagia, of a utopian identity for the future. An architectural embodiment of Brazil's Baroque Modernism, the imagery of Niemeyer's museum intertwines Christian and cannibalist ideals of redemption in terms of Paz's "true erotic communion" and of fertility: the "*Mysterium unitatis*" via the "*Unitas Corporis.*" The beauty of architecture, as Niemeyer's "Poem of the Curve" reminds us, is to be found in the body of the beloved woman.

The Museu de Arte Contemporânea is an architectural festival that finds what Paz has called the "navel of the universe" and the "mythical place of origin" in Niterói.[41] The site chosen for the museum is historically "sedimented" (to use Merleau-Ponty's terminology) in another kind of communion, one that is profane: with its scenic view of Guanabara Bay, it was originally a lover's lane. The multiple meanings of Niemeyer's futuristic spaceship reside in waters that run at least as deep as these. The connections with the fluid, navelike pilgrimage/gallery space of the Brazilian Pavilion at the New York World's Fair, and with works by contemporary artist Ernesto Neto come to mind. Neto's *Ovulo-Nave* is another spaceship, a vessel conceived as a flowing setting for a collection of objects that appear phenomenologically to come into being as we move through the fluid space, inviting us to consider the cosmic time-space relationships among primordial beginnings, colonial past, momentary present, and imagined future, and to explore the experiences of birthing and growing, the metaphors of embodiment, the fleshy swelling of form, and the bulging of the *matriz*, "pregnant"

with multiple meanings, interpretations, and many other visions besides our own.[42]

The semantic complexity of Niemeyer's museum and the many compelling artworks of Brazilian Modernism resides in their Baroque openness to the experiential dimension of body and soul, to multiple perspectives of vision and interpretation, and to the sedimentation and dense layering of intertwined meanings. These qualities connect Niemeyer's architecture and the works of Modern and contemporary Brazilian artists to the concerns of Gullar's *Manifesto neoconcreto* and the achievements of artists who felt its influence, especially Lygia Clark, Hélio Oiticica, Tunga, and Cildo Meireles. Neo-Concretism promoted a phenomenological openness to sensory experience and viewer involvement, and saw the body as its artistic metaphor. In her *Casulos*, *Trepantes* (e.g., cat. nos. 270–72), and *Bichos* (e.g., cat. nos. 263–65), Clark developed a poetics of the body that relies on spectator participation to shape flat surfaces into three-dimensional objects through a perpetual process of re-creation and unfolding. Oiticica's *Bólides* and *Parangolés* (e.g., cat. nos. 280–84) invite the public to touch objects and move through space with the whole body.[43] Tunga's works examine the metaphor of the whole body as a "field for the continuous interaction of processes," drawing a parallel between sculptural energies and the body's sexual energies, and exploring relationships in which one body is immersed in another, with the eroticism of space suggested through repeated use of the metaphor of swallowing. Tunga's works are always "woven together into an intricate, quasi-mythical,

TOP TO BOTTOM: **OSCAR NIEMEYER** Museu de Arte
Contemporânea, Niterói, 1991–96

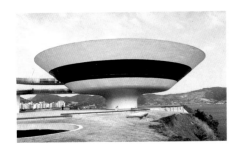

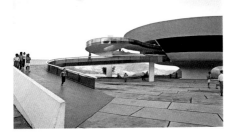

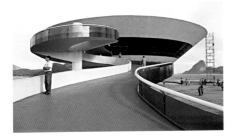

existential realm."[44] We see these tendencies as well in the work of Meireles, whose 1987 installation *Missao/Missoes (How to Build Cathedrals)* uses bones and communion wafers to evoke associations with indigenous rituals, the sacred space of the church, and miraculous redemption through the Eucharist—in a circular space that is "dark, primordial, shrouded in ambiguity; a reminder of death, like an enormous Catholic reliquary."[45] These images remind us once again of some of the thematic and spiritual connections between the Baroque and Modernism in Brazilian art and architecture.

Notes

1. Leopoldo Castedo, *The Baroque Prevalence in Brazilian Art* (New York: Charles Frank, 1964).
2. Ibid., p. 23.
3. Ibid., p. 19.
4. Ibid., p. 10.
5. Emanoel Araújo et al., *O universo magico do barroco brasileiro* (São Paulo: Serviço Cultural da Indústria, 1998), pp. 15, 18.
6. Ibid., p. 22.
7. Ibid., p. 27.
8. Nicolau Sevcenko, "Barroco: A arte da fantasia," in *O universo magico do barroco brasileiro* (São Paulo: Serviço Cultural da Indústria, 1998), p. 60.
9. Ibid.
10. Maria Lúcia Montes, "Entre a vida comum e a arte: A festa barroca," in *O universo magico do barroco brasileiro*, p. 374.
11. Ibid., p. 377.
12. Octavio Paz, *The Labyrinth of Solitude* (New York: Grove Press, 1985), pp. 51–52, 211.
13. Montes, "Entre a vida comume a arte," p. 372.
14. Ibid., p. 378.
15. Ibid., pp. 379–80.
16. Emanoel Araújo in conversation with the author, Salvador da Bahia, June 2000. For Araújo, the ambiguity of Brazilian experience relates above all to the dilemma of race relations: that the colonial plantation was both the nexus of an unequal power relationship between white master and African slave, as well as a setting for racial hybridization and cultural blending.
17. Mauro Carbone, "The Thinking of the Sensible," in Fred Evans and Leonard Lawlor, eds., *Chiasms: Merleau-Ponty's Notion of Flesh*, (Albany: SUNY Press, 2000), p. 126; and Christine Buci-Glucksmann, *La Folie du voir: De L'Esthetique Baroque* (Paris: Galilee, 1986), pp. 73, 85–86.
18. For a recent discussion of Merleau-Ponty and his ideas, see Evans and Lawlor, *Chiasms: Merleau-Ponty's Notion of Flesh.*
19. Samuel Malin, "Chiasm, Line, and Art" in Henry Pietersma, ed., *Merleau-Ponty: Critical Essays*, (Lanham, Md.: University Press of America, 1989), p. 220.
20. Maurice Merleau-Ponty, *The Visible and the Invisible* (Evanston, Ill.: Northwestern University Press, 1968), pp. 134–35.
21. Ibid.
22. Ibid.
23. Evans and Lawlor, *Chiasms: Merleau-Ponty's Notion of Flesh*, pp. 4, 11.
24. Ibid., pp. 1 and 17, n. 2.
25. In Brazilian Portuguese, the verb *"comer"* means "to eat" but also has the connotation of sexually possessing the body of the other.
26. Eduardo Subirats, *Del surrealismo a la antropofagia* (Valencia, Spain: IVAM Centre Julio González, 2000), pp. 18, 10–12; and Paz, *The Labyrinth of Solitude*, p. 202.
27. Eduardo Subirats, *La penultima vision del Paraiso*, p. 13.
28. Ibid., pp. 13–15.
29. Ibid., pp. 5–6, 15, and Subirats, *Del surrealismo a la antropofagia*, p. 18.

30. Ibid., p. 7.

31. Castedo, *The Baroque Prevalence in Brazilian Art*, p. 16.

32. See Hugo Segawa, "Um malcomportado aluno de racionalismo," *Novos estudos CEBRAP* 32 (March 1992), p. 214.

33. For a recent analysis of Burle Marx and his Anthropophagic appropriation of Corbusian forms and ideas, see Valerie Fraser, "Cannibalizing Le Corbusier: the MES Gardens of Roberto Burle Marx," *Journal of the Society of Architectural Historians* 59 (June 2000), pp. 180–93.

34. Gillo Dorfles has used the label "*neobarroca*" to describe Modern Brazilian architecture. See Segawa, "Um malcomportado aluno de racionalismo," p. 210.

35. Niemeyer, *Meu sosia e eu* (Rio de Janeiro: Editora Revan, 1992), p. 34.

36. See David Underwood, *Oscar Niemeyer and the Architecture of Brazil* (New York: Rizzoli, 1994); and Underwood, *Oscar Niemeyer and Brazilian Free-Form Modernism* (New York: George Braziller, 1994).

37. Subirats has observed a basic similarity in intentions between Antropofagia and Niemeyer's work, noting the liberty of formal language and the erotic relation with nature. See Subirats, *La penultima vision del Paraiso*, p. 7.

38. Maurice Merleau-Ponty, "Cézanne's Doubt," in Galen Johnson, ed., *The Merleau-Ponty Aesthetics Reader: Philosophy and Painting* (Evanston, Ill.: Northwestern University Press, 1993), p. 62.

39. This is not the first uterine image in Niemeyer's work. Consider the pear-shaped plan of the dance hall in the Casino in Pampulha.

40. Georges Didi-Huberman, "Disparate Thoughts on Voracity," *XXIV Bienal* (São Paulo: Fundacao Bienal, 1999), p. 201.

41. Paz, *The Labyrinth of Solitude*, p. 208.

42. Merleau-Ponty, *The Visible and the Invisible*, p. 441.

43. Ivo Mesquita, "Brazil," in Edward J. Sullivan, ed., *Latin American Art in the Twentieth Century* (London: Phaidon Press, 1996), p. 215.

44. *Body to Earth: Three Artists from Brazil* (Los Angeles: University of Southern California, Fisher Gallery, 1993), pp. 26–28, 34.

45. Ibid., p. 12.

The Spirit of Brasília: Modernity as Experiment and Risk

James Holston

Travelers usually experience Brasília as a city removed from the rest of Brazil. This sense of separation derives in part from Brasília's great distance from the Atlantic coast, to which Brazilians have for centuries "clung like crabs," as Frei Vicente do Salvador put it.[1] By road or by air, travelers must cross this distance to reach the city. They traverse a limbo not of jungle, as outsiders sometimes imagine, but of two million square kilometers of highland *cerrado*, dry and stunted, that is the desolate Central Plateau of Brazil. At the approximate center of this flatland, Brasília comes into view as an exclamation mark on the horizon, like an idea, heroic and romantic, the acropolis of an enormous empty expanse. Once swept inside the city on its superspeedways, travelers confront a more complex separation, that of Modernist Brasília from the familiar Brazil: they encounter an entire city of detached rectangular boxes, the transparencies of a world of glass facades, automobile traffic

flowing uninhibited in all directions, vast spaces seemingly empty without the social life of streets and squares, and serial order, clean, quiet, and efficient. In short, they find modernity, regulation, and progress on display.

Yet if this urbanism appears incongruously Brazilian, for those who know Brazil, Brasília's history expresses at the same time a remarkably Brazilian way of doing things. By history, I refer to the processes of building the city and structuring its society. Although their result may appear the opposite today, these processes also exemplify that knack for improvisation for which Brazil is famous. I mean that sense of invention found in so many facets of Brazilian life, from soccer and samba to *telenovelas*, from theories of modernity (such as *Antropofagia*) to everyday race mixing, from "autoconstructed" (self-built) housing in the urban peripheries to federal initiatives in the treatment of AIDS. It is improvisation by design, a

desire to overcome by leaping, an instinct for the advantages of play. It is the need to be modern that views a lack of resources as an opportunity for innovation. After all, Brazilians built Brasília in just three and a half years. They turned a spot in the middle of nowhere, marked by an "x" on the ground, not only into an inhabitable city in record time but also into one that presented to the whole world of 1960 the most modern form of urbanism. To do so, they employed the tactics of bricolage, and they experimented in all fields. Thus, they reproduced in pioneering Brasília Brazil's distinctive style of inventing its own modernity.

In specific ways, therefore, Brasília is both radically separate from and part of the "rest of Brazil." Examples of this contradiction abound. For example, Brasília's Master Plan prohibited the development of an urban periphery for the city's poor, typical of other Brazilian cities. As the national capital, Brasília had to be different, and its planners aimed to preclude unwanted characteristics of the rest of Brazil. Yet, as I explain later, government policy created an impoverished periphery of Satellite Cities even before the capital's inauguration in 1960, "Brazilianizing" its foundations. Therefore both the Plano Piloto (as the privileged Modernist city is called) and the Satellite Cities constitute Brasília, which must be understood as a regional city from the beginning. The city that resulted, however, does not simply reproduce the rest of Brazil around it that planners wanted to deny. In its combination of the radically new and the familiar, Brasília remains distinct in the constellation of Brazilian cities.

This special quality derives not so much from the city's identity as a capital of capitals, but from Brasília's founding conception as an experiment in urbanism to risk something new. It is precisely this daring to embrace the modern as a field for experiment and risk that the city's pioneers called the "spirit of Brasília." This spirit of innovation structured Brasília at many levels. It motivated planners to make Brasília different, not for the sake of exoticism but to establish an arena of experimentation in which to solve important national problems. In some aspects, Brasília's experiments succeeded; in others they failed. But both successes and failures derive from the same source, as both possibilities accompany genuine experiments.

If the spirit of Brasília is, therefore, that of experiment, is it not strange that this city of total design and improvisation, of innovation and contradiction, is now frozen in time? That is, the entire urban area of the Plano Piloto is legally preserved—entombed or *tombado*, as Brazilians call this preservation of patrimony—by local, national, and international layers of legal protection. If this experimental city has thus become a memorial, what memory does it record? To memorialize is never to tell the whole story. It is rather to select certain conditions that the memorializers want to preserve and ignore others. Thus, the spirit of a place—what the Romans called its *genius loci*—consists of what is both emplaced and displaced in memoriam. In these terms, what is the genius of Brasília, constructed in the backlands of Brazil in the late 1950s, and has its spirit been compromised by preservation? In what follows, I address these questions in turn.

Statecraft and Stagecraft

The Plano Piloto's basic residential units are all equal: same facade, same height, same facilities, all constructed on *pilotis* (columns), all provided with garages and constructed of the same material—which prevents the hateful differentiation of social classes; that is, all families share the same life together, the upper-echelon public functionary, the middle, and the lower.

As for the apartments themselves, some are larger and some are smaller in number of rooms. They are distributed, respectively, to families on the basis of the number of dependents they have. And because of this distribution and the

nonexistence of social class discrimination, the residents of a superquadra are forced to live as if in the sphere of one big family, in perfect social coexistence, which results in benefits for the children who grow up, play, and study in the same environment of sincere camaraderie, friendship, and wholesome upbringing. Since Brasília is the glorious cradle of a new civilization, the children raised on the plateau will construct the Brazil of tomorrow.[2]

This description of "perfect social coexistence" comes neither from the pages of a utopian novel, nor from the new world annals of Fourierite socialism. Rather, it is taken from the periodical of the state corporation (Novacap) that planned, built, and administered Brasília—from a "report" on living conditions in the new capital three years after its inauguration. Nevertheless, it presents the fundamentally utopian premise that the design and organization of Brasília were meant to transform Brazilian society. Moreover, it does so according to conventions of utopian discourse: by an implicit comparison with and negation of existing social conditions. In this case, the subtext is the rest of Brazil, where society is perniciously stratified into social classes, where access to city services and facilities is differentially distributed by wealth and race, and where residential organization and architecture are primary markers of social standing. Brasília is put forth not merely as the antithesis of this stratification, but also as its antidote, as the "cradle of a new civilization." Furthermore, planners assume what they wish to prove, namely, that the unequal distribution of advantage that orders urban life elsewhere in Brazil is already negated in Brasília.

This thesis of negation and invention is the premise that structures Brasília's foundation. It is at the core of what Brazilians meant when they referred to the spirit or idea of Brasília, epithets widely used during the pioneering phase of the city. As such, this idea crystallizes an important paradigm of Modernity. It pro-

The crossing of Brasília's Monumental and Residential Axes, under construction in 1957, marks the location of the future capital in the wilderness of the Central Plateau.

poses that the state, as a national government, can change society and manage the social by imposing an alternative future embodied in plans—in effect, that it can make a new people according to plan. Moreover, as a Modernist plan, this idea is millenarian. It proposes to transform an unwanted present (the rest of Brazil) by means of a future imagined as radically different. This millenarian modern exemplifies a kind of stagecraft that has come to define the statecraft of modern nation-building: modern states use planned public works to promote new forms of collective association and personal habit that constitute their projected nation.[3]

Brasília's Modernism is exemplary of this statecraft. As the city's founder, President Juscelino Kubitschek, affirms:

I have long been aware that modern architecture in Brazil is more than a mere aesthetic trend, and above all more than the projection into our culture of a universal movement. It has in fact put at our service the means with which to find the best possible solution of our city planning and housing problems. . . . It is, furthermore, a strong affirmative expression of our culture, perhaps the most original and precise expression of the creative intelligence of modern Brazil.[4]

Kubitschek's "affirmative relation" between modern architecture and modern Brazil lies precisely in using the former to stage the latter, as he demonstrated so effectively in his many city-building projects. Moreover, in explaining the selection

Aerial view of Brasília's South Wing, showing residential superquadras and row houses in 1981

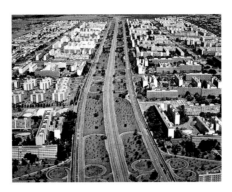

of Lúcio Costa's Modernist Master Plan for Brasília, Kubitschek justifies both the utopian and the millenarian character of this stagecraft-as-statecraft: "Owing to the need to constitute a base of radiation of a pioneering system [of development] that would bring to civilization an unrevealed universe, [Brasília] had to be, perforce, a metropolis with different characteristics that would ignore the contemporary reality and would be turned, with all of its constitutive elements, toward the future."[5] Thus, Brasília's founders envisioned it as more than the symbol of a new age. They also intended Brasília's Modernist design and construction as the means to create that new age by transforming Brazilian society. They saw it as the means to invent a new nation for a new capital—a new nation to which this radically different city would then "logically belong" as Costa claimed.[6]

This project of transformation redefines Brazilian society according to the assumptions of a particular narrative of the Modern, that of the Modernist city proposed in the manifestos of CIAM (Congrès Internationaux d'Architecture Moderne). In Brasília, this model is most clearly expressed in Costa's Master Plan and in the architecture of Oscar Niemeyer, the city's principal architect. But it is also embodied in many other aspects of the city's organization. From the 1920s until the 1970s (and in many places, until today), CIAM established a worldwide consensus among architects and planners on problems confronting the modern city. This consensus was especially shaped by the visionary architect Le Corbusier, whose writing framed its themes and whose

urban design became its dominant grammar. As interpreted with world-renowned clarity by Costa and Niemeyer in the 1950s, Brasília is the most complete example of CIAM tenets ever constructed.

In subsequent sections, I discuss these tenets specifically in relation to Brasília's design; here, I want to examine their reproduction in Brazil. As is universally acknowledged, the project of Brasília is a blueprint-perfect embodiment of the CIAM model city. Moreover, its design is a brilliant reproduction of Le Corbusier's version of that model.[7] The point I want to make, however, is not that Brasília is merely a copy. Rather, it is that as a Brazilian rendition of CIAM's global Modernism, its copy is generative and original. Kubitschek argued precisely this point in the citation above. Brasília is a CIAM city inserted into what was the margins of modernity in the 1950s, inserted into the Modernist ambitions of a postcolony. In this context, the very purpose of the project was to capture the spirit of the modern by means of its likeness, its copy. It is this homeopathic relation to the model, brilliantly executed to be sure, that gives the copy its transformative power. In other words, its power resides precisely in the display of likeness. This display of an "original copy" constitutes the stagecraft that I referred to earlier as statecraft. It is the state in its theatrical form, in the sense of constructing itself by putting on spectacular public works. Under Kubitschek, Brazil showed itself to be modern by staging it. As the centers of decisive political, economic, and cultural power remained elsewhere in Brazil for at least a decade, Brasília's initial mission was above all gestural: to display modern architecture as the index of Brazil's own modernity as a new nation, establishing an elective affinity between the two.

Thus, Brasília's modernity is spectacular in the sense of being a staging of the state in its charismatic form. It is charismatic not only because Brasília is an animating center of nation-state building and state-directed modernizing and innova-

tion. It is also charismatic because Brasília's project proposes an equation between the condition of the ruler—in the form, metonymically, of his seat, the capital—and the state of rule. It proposes, in other words, to lead the rest of Brazil into a new era by example. This charismatic notion of statecraft is an ancient proposition, as historians and anthropologists of the state have shown.[8] It depends on establishing a correspondence between the good state of the ruler (the majesty of majesty) and the good state of the realm, in which the first becomes a prerequisite of the second. This relationship is homeopathic, one of establishing a likeness between two conditions. What makes this link plausible is the display of state—its public works, as I have called them—in which the stateliness of power is itself an ordering force. With Brasília, this charismatic conception of state finds a Modernist incarnation.

Innovation by Design

Brasília was designed to mirror to the rest of Brazil the modern nation it would become. At this scale of statecraft, Brasília is a charismatic center in doubly mimetic terms. On the one hand, it conveys its aura as an animating center of the modern by embodying in its own organization the CIAM plan of a radiant future. On the other, it animates by relaying to the national realm its idea of innovation. In this radiation, Brasília is a civilizing agent, the missionary of a new sense of national space, time, and purpose, colonizing the whole into which it has been inserted. This civilizing project is concisely represented in countless maps of Brazil produced in the 1950s and 1960s, showing the radiating network of highways that the government intended to construct between Brasília and state capitals. As a project of national development, it is a map of pure intention, since almost none of these roads existed at the time. As such, it represents the intended integration of the new nationalized space Brasília would generate.

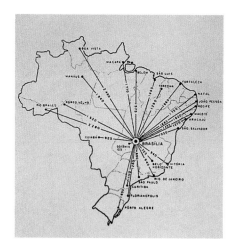

Map from an elementary school textbook (Perugine et al. 1980) used to illustrate the idea of Brasília as the hub of national development

Corresponding to this new dimension of national space, Brasília implemented a new sense of national time. To build the city is just three and a half years, Novacap instituted a regime of round-the-clock construction. This regime of hard work became known throughout Brazil as the "rhythm of Brasília," "fifty years of progress in five." Breaking with the Portuguese meter of colonialism, this is a new rhythm, defined as 36 hours of nation-building a day—"12 during daylight, 12 at night, and 12 for enthusiasm." It expresses precisely the new space-time consciousness of Brasília's modernity, one that posits the possibility of accelerating time and of propelling Brazil into a radiant future.

The rhythm of Brasília thus reveals the development of a new kind of agency, confident that it can change the course of history through willful intervention, that it can abbreviate the path to the future by skipping over undesired stages of development. This Modernist agency expressed itself in a drive to innovate in all domains of Brasília's construction and organization. As I examine later, we find it not only in the city's architecture and planning, but also in its schools, hospitals, traffic system, community organization, property distribution, bureaucratic administration, music, theater, and more. We find this new sense of national agency, of rupture and innovation, concisely conveyed in newspaper and magazine advertisements of the period that celebrate the participation of

Brazil's industries in the capital's construction: "Here begins a new Brazil!—Rupturita Explosives Incorporated (a pioneer in the explosives industry)"; "Brasília: the dawn of a new era—Bimetal Incorporated"; "Brasília: the decisive mark of national progress—Mercedes Benz of Brazil."[9]

Thus, Brasília's Modernism signified Brazil's emergence as a modern nation because it simultaneously broke with the colonial legacies of underdevelopment as it posited an industrial modernity. The new architecture and planning attacked the styles of the past—the Iberian Baroque and the Neoclassical—that constituted one of the most visible symbols of a legacy the government sought to supersede. Literally, Modernism stripped these styles from building facades and city plans, demanding instead industrial-age building materials and an industrial aesthetic appropriate to "the new age." In planning, it privileged the automobile and the aesthetic of speed at a time when Brazil was embarking on a program of industrialization especially focused on the automobile industry. It also required centralized planning and the exercise of state power that appealed to the statist interests of the political elite.

In these terms of erasure and reinscription, the idea of Brasília proposes the possibility of an inversion in development: a radically new city would produce a new society to which it would then belong. The first premise of this inversion is that the plan for a new city can create a social order based on the values that motivate its design. The second premise projects the first as a blueprint for change in the context of national development. Both premises promised a new and modern agency of innovation for Brazil, and both motivated the building of Brasília. In what follows, I suggest that these premises generated two modes of planning and design in Brasília, and that these modes are fundamentally at odds. One is total design and master planning; the other is contingency design and improvisation. The latter is experimental by nature; the former was an experiment when tried in Brasília that soon overwhelmed and negated the other. Moreover, it engendered a set of social processes that paradoxically subverted the planners' utopian intentions.

Total Design

To create a new kind of society, Brasília redefines what its Master Plan calls the key functions of urban life, namely work, residence, recreation, and traffic. It directs this redefinition according to the tenets of the CIAM model city. CIAM manifestos call for national states to assert the priority of collective interests over private. They promote state planning over what they call the "ruthless rule of capitalism," by imposing on the chaos of existing cities a new type of urbanism based on CIAM master plans. CIAM's overarching strategy for change is totalization: CIAM its model city imposes a totality of new urban conditions that dissolves any conflict between the imagined new society and the existing one in the imposed coherence of total order. Precisely because of its emphasis on the state as supreme planning power, state-building elites of every political persuasion have embraced the CIAM model of urban development, as its phenomenal spread around the world attests.

One of the principle ways by which CIAM design achieves its totalization of city life is to organize the entire cityscape in terms of a new kind of spatial logic. It is not the only way, but I use it to illustrate both the nature of total design and one of its basic objectives: the subversion of premodern and especially Baroque urbanism. Visitors to Brasília often observe that they are disoriented because the city has no street corners. Their absence is but one indication of a distinctive and radical feature of Brasília's CIAM modernity, namely, the absence of streets themselves. In place of street corners and their intersections, Brasília substitutes the traffic circle; in place of streets, high-speed avenues and residential cul-de-sacs; in place of sidewalk pedestrians, the automobile; and in place

of the system of public spaces that streets traditionally support, the structure of a completely different urbanism. At the scale of an entire city, Brasília thus realizes the objective of CIAM planning to redefine the urban function of traffic. It does so by eliminating what it calls the corridor street, the street edged with continuous building facades. Although one might not imagine the importance of traffic planning in these terms, this elimination has overwhelming consequences for urbanism: It subverts the system of space-building (or solid-void) relations that structures premodern urbanism and replaces it with another.

In its critique of the cities and society of European capitalism, CIAM Modernism proposed the elimination of the corridor street as a prerequisite for modern urban organization—a plan of attack Le Corbusier labeled "the death of the street" in 1929. CIAM vilifies the street as a place of disease and criminality and as a structure of private property that impedes modern development. More consequentially, however, Modernist architecture attacks the street because it constitutes an architectural organization of the public and private domains of social life that it seeks to overturn.

The corridor street is the architectural context of the outdoor public life of preindustrial cities, common to both Brazil and Europe. This context is constituted in terms of a contrast between the street system of public spaces (voids) and the residential system of private buildings (solids). Traditionally, architects are trained to structure this contrast in terms of an organization of its solids and voids into figure and ground relations. Generally, in premodern urbanism, streets and squares are framed by facades built edge-to-edge and perceived as having the shape these frames make. Thus, streets and squares are spaces that have form, usually perceived as a figure of rectangular volume. This figural perception creates the impression that the continuous building facades are the interi-

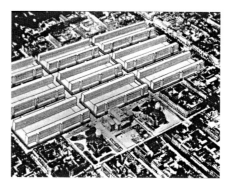

Unrealized project for central Berlin by architect Ludwig Hilberseimer, 1927

or walls of outdoor rooms, the public rooms of the city. The street-walls are, accordingly, ornamented, and the street-rooms furnished with benches, sculpture, fountains, and so forth. The spatial principle of this urbanism is, therefore, that streets and squares are figural voids in contrast to the ground of the solids around them.

This elemental organization of solids and voids has dominated Occidental urbanism for 2,500 years. It developed its recognizable character in ancient Greece and its fullest elaboration in the Baroque cities of Europe. It must suffice here to observe that in this preindustrial urbanism, both space and building are reversibly both figure and ground.[10] Although space is consistently figural and building is ground, these relations are easily reversed to signify public monuments and civic institutions. This reversal is the key rhetorical principle of the preindustrial architectural ordering of public and private.

Modernism breaks decisively with this traditional system of architectural signification. Whereas preindustrial Baroque cities (such as Ouro Prêto in Brazil) provide an order of public and private values by juxtaposing architectural conventions of repetition (ground) and exception (figure), the Modernist city (such as Brasília) is conceived as the antithesis both of this mode of representation and of its represented sociopolitical order. In the Modernist city, vast areas of continuous space without exception form the perceptual ground against which the solids of buildings emerge as sculptural figures. There is no relief from this

Figure ground plan of an east-west section of Brasília's South Wing, showing residential superquadras and commercial sectors around 1960.

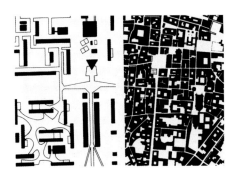

absolute division of architectural labor: Space is always treated as continuous and never as figural; buildings always as sculptural and never as background. The consequences of this total inversion are profound. By asserting the primacy of open space, volumetric clarity, pure form, and geometric abstraction, Modernism not only initiates a new vocabulary of form. More radically, it inverts the entire mode of perceiving architecture, turning it inside out—as if the figural solids of the Modernist city have been produced in the mold of the figural voids of preindustrial urbanism. Furthermore, the Modernist city negates the reversals of the traditional code by insisting on the immutability of the terms: By establishing the absolute supremacy of continuous nonfigural void, it transforms the ambivalence of Baroque planning into a monolithic spatial order. Reversals are now impossible. Modernism has imposed a total and totalizing new urban order.[11]

Complementing its theory of objective change, the CIAM model also proposes a subjective transformation of existing conditions. Borrowing from other avant-garde movements of the early twentieth century, it uses techniques of shock to force a subjective appropriation of the new social order inherent in its plans. These techniques emphasize decontextualization, defamiliarization, and dehistoricization. Their central premise of transformation is that the new architecture/urban design creates set pieces of radically different experience that destabilize, subvert, and then regenerate the surrounding fabric of social life. It is a viral notion of revolution, a theory of decontextualization in which the radical qualities of something totally out of context infect and colonize that which surrounds it. This something may be a single building conceived as a fragment of the total plan. Or, it may be an entire city designed as an exemplar, as in the case of Brasília. Either way, the radical fragment is supposed to create new forms of social experience, collective association, personal habit, and perception. At the same time, it is supposed to preclude those forms deemed undesirable by negating previous social and architectural expectations about urban life. As the Novacap "report" cited above asserts, "residents of a superquadra are *forced* to live as if. . . ."

Brasília's design implements the CIAM premises of objective and subjective transformation by both architectural and social means. On the one hand, its Master Plan displaces institutions traditionally centered in a private sphere of social life to a new state-sponsored public sphere of residence and work. On the other, its new architecture renders illegible the taken-for-granted representation of these institutions. Its strategy of total design is thus a double defamiliarization. As a result, for example, the functions of work and residence in Brasília lose their traditional separation when the latter is assigned on the basis of work affiliation, as it was generally until 1965 and still is in some sectors. Hence, Bank of Brazil employees reside in one superquadra, those of the Air Force Ministry in another, those of Congress in yet another, and so forth. In addition, these functions become architecturally indistinguishable as the buildings of work and residence receive similar massing and fenestration and thereby lose their traditional symbolic differentiation.

Brasília's Modernist Master Planning is a comprehensive approach to restructuring urban life precisely because it advances proposals aimed at both the public and the private domains of society. Its proposal for the private realm centers on a new type of domestic architecture and

Left: Rua Tiradentes in Ouro Prêto. Right: Superquadra apartment block, SQS 108-Block E, in Brasília

residential unit that organizes residence into homogeneous sectors, structured by a concept of "collective" dwelling. This plan is best embodied in the superquadras of the Plano Piloto, a type called the Collective Dwelling. The word "collective" refers to the sharing of common facilities, such as schools, administration buildings, social clubs, green areas, and commercial structures. As one might expect, such an experiment in living receives mixed evaluations from residents. My study of the model superquadras (South 108, for example) concluded that especially residents with younger children find them compelling.[12] However, many other residents complain that the elimination of informal social spaces traditionally found in Brazilian homes—the *copa*, balcony, and veranda—defamiliarizes the superquadra apartments. Moreover, people frequently complained that their gridded glass facades negate expressions of individual status and personality in an attempt to communicate an egalitarian, rational social order. For many, the outcome of this design is both a sense of isolation inside the apartments and yet an abandonment of the superquadra's green areas.[13]

In sum, Brasília's Modernist design achieves a similar kind of defamiliarization of public and private values in both the civic and the residential realms. On the one hand, it restructures the city's public life by eliminating the street. On the other, it restructures the residential by reducing the social space of the private apartment in favor of a new type of residential collectivity in which the role of the individual is symbolically minimized. Together, these strategies constitute a profound estrangement of residential life as Brazilians know it.

These intended defamiliarizations are brutally effective. Most people who move to Brasília experience them with trauma. In fact, the first generation of inhabitants coined a special expression for this shock of total design, *brasilite* or "Brasília-itis." As one resident told me, "Everything in Brasília was different. It was a shock, an illusion, because you didn't understand where people lived, or shopped, or worked, or socialized." Another said, "even the tombstones are standardized." Another common instance of disorientation is the sense of exposure residents experience inside the transparent glass facades of their Modernist apartment buildings. With considerable irony, they nicknamed these glass boxes "the *candango*'s television set"—meaning that a poor man (the *candango*, Brasília's pioneering construction worker) can find nightly entertainment by standing in front of an apartment block to watch the interior drama of middle-class life revealed on the big screen of the illuminated facade. In response to this perceived assault on their privacy, which some link to the moralizing gaze of a new state-sponsored public sphere, residents resist by putting up every kind of visual barrier—curtains, blinds, potted plants, even birdcages. Yet the sense, if not the fact, of transparency remains. Thus, Brasília's

Modernism also works its intended subversion at an intimate scale of daily life. Harmonized in plan and elevation, Brasília's total design created a radically new world, giving it a form that possessed its own agenda of social change.

Contingency Design

I suggested earlier that the project of Brasília generated two modes of design and planning. Although both were experimental and innovative, they were fundamentally at odds. One is Modernist total design. As I have shown, this mode attempts to overcome the contingency of modern experience by totalizing it, that is, by fixing the present as a totally conceived plan based on an imagined future. This kind of design is always already preserved by the very completeness of the plans themselves, which have a statute-like character as a set of instructions. In the case of Brasília, Costa's Master Plan actually became law with the inauguration of the capital. Establishing the city's inaugural legal and administrative organization, its first Organic Law declared that "any alteration in the Plano Piloto . . . depends on authorization in federal law."[14]

The second mode of design and planning is based on contingency itself. It improvises and experiments as a means of dealing with the uncertainty of present conditions. Contingency design works with plans that are always incomplete. Its means are suggested by present possibilities for an alternative future, not by an imagined and already scripted future. It is a mode of design based on imperfect knowledge, incomplete control, and lack of resources, which incorporates ongoing conflict and contradiction as constitutive elements. In this sense, it has a significant insurgent aspect. I will illustrate contingency planning with three examples from the construction period of Brasília. The first concerns the worker himself as *bricoleur*; the second, the contrast between the totally regulated construction zone and the market city that developed on its

fringes; and the third, the development of illegal settlements as a reaction to the government's planned occupation.

In late 1956, Novacap divided the area of the future Federal District into two zones of planned but temporary occupation based on a spatial organization of work. One zone was reserved for construction camps that would build the city and one for commercial establishments that would provide services and supplies to the work force. The need to build Brasília quickly and the lack of skilled labor created a work regime of improvisation and ingenuity in both zones. In this regime, Brasília's workers became famous as *quebra-galhos* ("trouble-shooters, handymen"), a type of *bricoleur* ready to tackle any job with great ingenuity but limited resources; or, as one *candango* joked, "ready to undertake tasks for which he has not been sufficiently prepared." Moreover, the shortage of skilled laborers meant that unskilled workers could move into a category of skilled labor and higher pay with relative ease. Nearly every *candango* I interviewed told the same story of unlimited hours of work, rapid advancement based on audacity, and learning on the job.[15]

As Novacap was constructing the Plano Piloto to accommodate the government and its civil servants transferred from Rio de Janeiro, it wanted to preclude the possibility that this labor force might take root in shanties on the site. Therefore, with statelike authority and its own security force, Novacap strictly controlled access to and accommodations within the construction zone. However, if the construction zone was marshaled like a boot camp, Novacap established a commercial zone for private initiative at its edge that grew as its opposite under a laissez-faire policy. This site became known as the Free City (Cidade Livre), though officially called the Provisional Pioneer Nucleus or Núcleo Bandeirante. The government encouraged entrepreneurs to supply the construction effort at their own risk and profit, and, after the city's inauguration, to become its

commercial and service population. To that end, it offered entrepreneurs two incentives: free land and no taxes for four years. The combination of laissez-faire governance and temporary wooden buildings turned the Free City into a veritable frontier town of abundant cash and ambition. However, Novacap's commercial contracts stipulated that at the end of the four-year period it had the right to raze the entire city to the ground. With a turn of phrase still famous in the Free City, the president of Novacap declared, "In April 1960, I will send the tractors to flatten everything."

Thus, in classic imperial fashion, Novacap created a kind of bazaar at the gates of its noncommercial capital. On the one hand, those whom it recruited for jobs in construction were billeted in regimented camps as the work crews of a public building project. On the other, those recruited for their capital investments in all activities except construction populated the Free City and dominated its capitalist economy. It was called a Free City precisely because it grew in an area free of regulations that applied elsewhere. In contrast to the construction zone, it was immediately accessible to all: to those just off the bus, to those awaiting documentation for construction work, to those rags-to-riches dreamers seeking their frontier Eldorado, to those whose husbands and fathers were laboring in the camps. All could enter the Free City freely to find a place to live and work—freely meaning, of course, in accordance with individual means. The Free City was thus a capitalist city, organized around contingency and risk, on the fringes of a totally planned economy.

Another crucial difference between the Free City and the construction zone was that the latter was overwhelmingly male and occupied mostly by men who lived in barracks without families. Ultimately, the consequences of this difference fundamentally altered the planned organization of the Federal District. The two encampments for Novacap employees

were exceptions, as both officials and manual workers had the privilege of family residence. As a result, 89 percent of Novacap officials and 82 percent of its workers brought their families to Brasília by 1959. For the rest of the almost 17,000 men lodged in the private sector construction camps, 91 percent lived without families, although 34 percent of them were married. In all, there were only about 1,450 families in these camps, mostly those of the managers and a few skilled workers.[16] To be sure, the rest of the married workers were not less likely to want to live with their families. For them, there were only two options: to rent accommodations in the Free City for their families, or to build unauthorized dwellings for them somewhere in the countryside around the construction camps.

Of the two, the latter became the more common, and, after 1958, the only viable option. The tenuous balance between housing supply and demand in the Free City ruptured that year, when a massive influx of drought victims from the northeast of Brazil overwhelmed the limited supply of accommodations. Rents and overcrowding soared. Both migrants and speculators responded by building huge numbers of unauthorized shacks. Rather than allow this uncontrolled growth, Novacap prohibited additional expansion of the Free City after December 1959. It even attempted to slow migration by erecting what turned out to be an ineffective police cordon around the city. As a result of this housing crisis, workers who wanted to bring families to Brasília had little choice but to become squatters by seizing land on which to build illegal houses. Most seizures were multifamily occupations. The larger ones were called *vilas*, the most important being Vila Sara Kubitschek (named after the president's wife), Vila Amaury, Vila Planalto, and Vila do IAPI.[17] Improvised by *candangos* to lodge their families, these illegal *vilas* were so important in the settlement of the Federal District that by May 1959 they contained

over 28 percent of its population. Moreover, as we will see, these insurgent settlements soon became legalized as precisely the kind of a poor periphery around the Plano Piloto that the Master Plan prohibited (as in Article 17).

The *candangos* were not the only ones to risk illegal settlement in response to the government's planned occupation. In this regard, the fate of Novacap's officials is especially significant. These administrators, architects, and engineers were the supreme commanders in Brasília. They formed an elite cadre of pioneers, zealously dedicated to its spirit as a mission of national development. Nevertheless, although they combined nearly absolute power, they lacked an essential component. According to the state's plan to transfer the federal bureaucracy—elaborated by the Grupo de Trabalho de Brasília (GTB) in Rio de Janeiro—Novacap officials had no predetermined rights to reside in the city, as most had been recruited for the preinaugural construction and not for the postinaugural bureaucracy. Thus, they found themselves without inaugural rights to the city they built and ruled and to which 89 percent had already brought families.

In August 1958, however, a "corrective measure" presented itself. The Popular

Housing Foundation completed 500 row houses located between W-3 and W-4 in the South Wing, based on a Niemeyer design. In the GTB's original distribution plan, these houses were designated for lower-echelon functionaries (e.g., drivers, janitors, typists) transferred with large families. Although their design expresses a middle-class social organization, these row houses were thus intended as *casas populares* (popular-class houses) for the lower-income residents. Indeed, at their inaugural ceremonies in August, President Kubitschek affirmed that "what we call popular houses in other places, housing for people of few resources, in Brasília constitute palaces contested for by all the residents and workers as a prize for their efforts."[18] In fact, so prized were these completed houses that 500 of Novacap's elite families immediately and illegitimately occupied all of them, usurping transferee rights. Ultimately, no one disputed Novacap's usurpation. There was, in any case, no one to evict them.

This "official seizure" had profound consequences for Brasília's social structure. It forced the GTB to scuttle its planned social stratification of residence in which the superquadras in the 100–300 bands were reserved for middle- and upper-echelon officials, and the W-3 houses and 400 band superquadras for those in the lower ranks. With the W-3 houses occupied, the GTB had to change its housing assignments and distribution criteria. Instead of a stratified distribution, it had to adopt an egalitarian one based on criteria of need and a pool of recipients now including all levels of functionaries. Out of this distribution emerged the famous superquadra blocks of Brasília's postinaugural years in which the upper and lower classes lived side by side. This distribution lasted only five years, until the government sold the apartments on the open market. Ironically, however, through an unintended concordance of contingencies, the initial distribution

created a radical social structure more in keeping with the one originally envisioned by the utopian architects.[19]

Brazilianization

Built Brasília thus resulted from the interaction of both modes of planning: the total and totalizing, the contingent and insurgent. In most cases, however, the former soon overwhelmed the latter. I will use the example of the illegal periphery to demonstrate. The government planned to recruit a labor force to build the capital, but to deny it residential rights in the city it built for the civil servants from Rio. By 1958, however, it became clear that many workers intended to remain and that almost 30 percent of them had already rebelled against their planned exclusion by becoming squatters in illegal settlements. Yet the government did not incorporate the *candangos* into the Plano Piloto, even though it was nearly empty at inauguration. The government found this solution unacceptable because inclusion would have violated the preconceived model that Brasília's "essential purpose [was to be] an administrative city with an absolute predominance of the interests of public servants."[20] Rather, under mounting pressure of the *candango* rebellion, and in contradiction of the Master Plan, the administration decided to create legal Satellite Cities, in which *candangos* of modest means would have the right to acquire lots and to which Novacap would remove all squatters. In rapid succession, the government founded Taguatinga (1958), Sobradinho (1960), and Gama (1960), and legalized the permanent status of the Free City in situ, under the name Núcleo Bandeirante (1961). In authorizing the creation of these Satellite Cities, the government was in each case giving legal foundation to what had in fact already been usurped: the initially denied residential rights that *candangos* appropriated by forming squatter settlements. Thus, Brasília's legal periphery has a subversive origin in land seizures and contingency planning.

To remain faithful to their model, the planners could not let the legal periphery develop autonomously. They had to counter contingency, in other words, by organizing the periphery on the model of the center. To do so, they adopted what we might call a strategy of retotalization, especially with regard to the periphery's urban planning, political-administrative structure, and recruitment of settlers. That model had two principal objectives: to keep civil servants in the center and others in the periphery, and to maintain a "climate of tranquillity" that eliminated the turbulence of political mobilization.[21] Given these objectives, the planners had little choice but to use the mechanisms of social stratification and repression that are constitutive of the rest of Brazil they sought to exclude. First, they devised a recruitment policy that preselected who would go to either the center or the periphery and that would give bureaucrats preferential access to the Plano Piloto. Second, in organizing administrative relations between center and periphery, planners denied the Satellite Cities political representation. Through this combination of political subordination and preferential recruitment, of disenfranchisement and disprivilege, planners created a dual social order that was both legally and spatially segregated. Ironically, it was this stratification and repression and not the illegal actions of the squatters that more profoundly Brazilianized Brasília.

As we might guess, the reiteration of the orders of the center in the periphery created similar housing problems there. These problems led, inevitably, to new land seizures and to the formation of new illegal peripheries—in the plural because now each satellite spawned its own fringe of illegal settlements. Moreover, by the same processes, some of these seizures are legitimated, leading to the creation of yet additional Satellite Cities. These cycles of rebellion and legitimation, illegal action and legalization, contingency planning and retotalization, continue to this day.

Vila Chaparral, a squatter settlement near the Satellite
City of Taguatinga

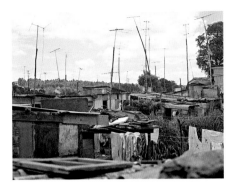

A striking illustration of the perpetuation
of Brasília's contradictory development is
that, even today, the Plano Piloto remains
more than half empty while only contain-
ing 14 percent of the Federal District's
total population. This comparison strong-
ly suggests that the government continues
to expand the legal periphery rather
than incorporate poor migrants into the
Plano Piloto.[22]

When we consider the Plano Piloto
itself, the terms of its Brazilianization are
somewhat different. Especially among the
first generation, residents tried two strate-
gies to overcome their sense of estrange-
ment in Brasília's new world. Some tried
to reassert the familiar values and conven-
tions of a more heterogeneous outdoor
public urbanity. For example, in a few of
the local commercial sectors of the South
Wing, residents rejected the lack of street
life by repudiating the antistreet design.
They put store entrances back on the curb
rather than on the proposed superquadra
(non-street) side of the buildings. In so
doing, they tried to reconstitute the life
of the market street where it had been
architecturally and legally denied.
However, their success was limited. In the
absence of a continuous system of streets
and sidewalks, the front-back reversals
were isolated. In any case, the government
precluded this "deformation" of the Plan
when it later built the local commercial
sectors of the North Wing. Similarly, resi-
dents rejected the transparency of glass
facades not merely by putting up barriers
but by demanding an architecture of
opaque walls and balconies in later
superquadras.

Most accepted privatization, however,
as the means to create new and more
selective social groupings. An example of
this second strategy is that rather than try
to reform the Master Plan, many among
Brasília's elite (including city planners and
officials) rejected the residential concept of
the superquadra altogether. They moved
out of their Plano Piloto apartments and
created their own neighborhoods of indi-
vidual houses and private clubs on the
other side of the lake. In so doing, they
contradicted Article 20 of the Master Plan,
which stipulated that the lake area remain
free of "residential neighborhoods." The
existence of these elite neighborhoods
repudiates the aims of the Master Plan to
achieve social change by instituting a new
type of residential organization. Whereas
the superquadra concretizes a set of egali-
tarian prescriptions, especially through
standardization, the houses of these elite
neighborhoods often compete with each
other in ostentation, using a bricolage of
historical styles. While significant in its
own right as a counterstyle, this display
fractures every tenet of the Modernist aes-
thetic and social program of the Master
Plan. By building exclusive neighborhoods
and clubs, these elites contradicted the
intentions of Brasília's residential organi-
zation. Without their support, important
aspects of its proposed collective structure
collapsed.

Entombment

We have seen that the history of Brasília's
development is one of interaction between
its total and contingent planning. Mostly,
however, the total overwhelmed the con-
tingent, as planners insist on reiterating
the original model in the face of insurgent
developments. In a few cases, such as the
front/back reversal of stores and the settle-
ment of the periphery, contingency plan-
ning made lasting changes to the Master
Plan. However, even these insurgent alter-
natives were retotalized, as planners either
neutralized their significance by isolating
them (the first case) or subsumed them

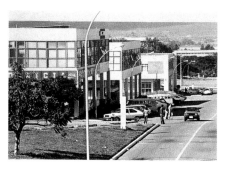

into the whole by organizing their development according to original principles and objectives (the second).

With these conclusions in mind, we can return to a question posed at the beginning: If the spirit of Brasília is that of innovation, experiment, and risk, is this insistence on totalizing the contingent—that is, on perpetuating one experimental moment at the expense of all others—a betrayal of that spirit? Even though planners may think they are furthering the project of Brasília through this insistence, are they misguided in imposing one model that was experimental in the 1950s but that now prevents subsequent generations of Brazilians from using Brasília as *their* field of experimentation? After all, the spirit of Brasília inspired Costa's and Niemeyer's particular expressions of it and, therefore, predates them. If so, then the idea of Brasília cannot be subsumed and completed by those particular embodiments. Must it not, as well, continue to inspire others?

Brasília is today preserved by various levels of law. What is "entombed" is the original urban conception of Costa's Master Plan (1957), including the Plano Piloto and the Lake Districts but not the periphery. Indeed, Brasília was born preserved when the Master Plan became law with the city's inauguration (Article 38 of Law 3751, April 1960). Since then, it has been protected by three additional levels of law. In 1987, the local government of the Federal District regulated Article 38 through Decree 10,829, giving that article new specificity and application. Also in 1987, Brasília received unprecedented international protection: UNESCO guaranteed its preservation by inscribing the Plano Piloto (including the Lake Districts) in its List of World Cultural and Natural Heritage. It is the largest urban area in the world and the only contemporary living city so preserved. Moreover, it one of the few twentieth-century sites selected for the list, along with Auschwitz, Hiroshima's Peace Memorial, and the Bauhaus at Weimar and Dessau. Finally, the Brazilian federal government declared Brasília *tombada* in 1990, inscribing it in the Book of Historical Preservation (entry 532), an inscription regulated by acts of the Secretariat of National Historical and Artistic Patrimony (SPHN) and the Brazilian Institute of Cultural Patrimony (IBPC). In the words of the official publication of the IBPC, Brasília's preservation means that:

> Any alteration in the height of buildings, in the layout of roads, avenues, and lots, in the use and function of lots, in the unbuilt green areas, within the perimeter preserved, should, on principle, be avoided. Necessary alterations should be profoundly studied and carefully executed to guarantee the preservation of the essential characteristics of the Plano Piloto and its quality of life.[23]

To disagree, one could reasonably argue that the exceptional "quality of life" of Brasília is rooted in a history of extraordinary inequality and stratification (exceptional even by Brazilian standards), that it is based on exclusive privileges, and that it costs the nation an inordinate amount to maintain for the benefit of a half-empty

TOP: Second generation superquadras revealing the rejection of glass facades in favor of opaque walls and balconies. BOTTOM: House in Brasília's South Lake district

Plano Piloto in relation to an increasingly populous and poor periphery. One could claim that legislation that fixes such a "quality of life" is but a means to preserve the privilege of elites at the expense of others—indeed, that it establishes a tyranny of elites through law and planning councils, and that it empowers a gerontocracy of founders to maintain their vision while depriving younger generations of citizens the opportunity to define their own. One could argue the pros and cons of these assertions at great length with respect to Brasília, without necessarily reaching a completely satisfactory conclusion.

I prefer to conclude by noting that there is no mention in the pronouncements about Brasília's preservation of what is to my mind the most important of its "essential characteristics," namely, its spirit of invention. If that spirit is essential, and if preservation is intended to protect the essential, then at the very least *tombamento* should preserve Brasília as a field of experimentation, indeed of continuous innovation. It should preserve the city as special place in Brazil where that kind of risk is possible. Freezing Brasília at one moment betrays that spirit and turns it into a ghost.

This suggestion does not in any way mean "letting market forces take over" from government planning in Brasília. Though privatizing certain urban issues would be an important experiment, "the market" can never be a blanket solution to urban problems. Rather, my suggestion means sponsoring controlled experiments in urbanism in all aspects, from housing to governance to transportation, that will out of necessity respond to Costa's Master Plan but that may also depart from it in considering new problems. In this way, planners could preserve many aspects of the CIAM Modernist city, while allowing Brasília to become a city layered with other kinds of urbanisms. In fact, what makes cities like Rome, Paris, and New York most interesting is that they are not based on one model but are layered with the visions of each generation that lived them. This juxtaposition makes visible the vitality of city life as debates about urbanism itself. The density of this record produces cities rich in experience and rewards those who know them. The vast and empty spaces of Brasília need to contain such juxtapositions, whose frisson is the best means not only to nurture the founding idea of Brasília as experiment, but also to perpetuate the importance of its initial experiment, its Costa/Niemeyer/CIAM Modernist urbanism.

At the very least, memorializing Brasília must mean re-presenting its premises as they developed through both total and contingent/insurgent modes of design. Presenting that dialogue between the modes of Brasília's design is a challenge worthy of a memorial to the real history of the city. It would also provide an important educational project for all concerned with urbanism. As it is now, Brasília's preservation tells only part of the story, that of the elite planners and architects but not that of the workers who built the city but who rebelled against their exclusion. It also neglects the story of the officials who developed new but not architectural proposals for urban life. And it preserves an exaggerated, state-sponsored social and spatial stratification.

Furthermore, Brasília's preservation laws are in practice often circumvented by negligence or corruption, a common fate of administration by statute. Thus, reliance on these laws fails to protect the city from the ills of misuse and speculation. For example, growth in the North Hotel Sector neither conforms to the Master Plan, nor follows the logic of market competition, nor constitutes a new experiment in planning. Rather, it is a chaotic and corrupted development. If in theory entombment compromises Brasília's spirit, in practice it does not effectively prevent the corruption of its body.

In the 1950s, Brasília dared to be an innovation in urbanism. Like most significant experiments, it took the risk of submitting itself to public evaluation. That I criticize aspects of its development does not diminish my admiration for its foundation. To the contrary, I have argued that it is important to commemorate the particular experiment of its founders, but only in the context of memorializing that greater idea of modernity as experiment and risk that is the spirit of Brasília.

Notes

1. Frei Vicente do Salvador, *História do Brasil, 1500–1627* (São Paulo: Cia. Melhoramentos, 1931), p. 19.

2. *Brasília* (Journal of Companhia Urbanizadora da Nova Capital do Brasil—Novacap) (1963), p. 15.

3. For an extensive discussion of this Modernist political and planning project, see my study of Brasília, on which I rely for various passages of this essay. This study was based on several years of fieldwork in Brasília. James Holston, *The Modernist City: An Anthropological Critique of Brasília* (Chicago: University of Chicago Press, 1989).

4. Stamo Papadaki, *Oscar Niemeyer* (New York: George Braziller, 1960), p. 7.

5. Juscelino Kubitschek, *Por Que Construí Brasília* (Rio de Janeiro: Bloch Editores, 1975), pp. 62–63.

6. Lúcio Costa, "Razões da nova arquitetura," *Arte em Revista* 4 (1980), p. 15.

7. See Holston, *The Modernist City*, pp. 31–58 for proof and discussion of the Le Corbusian derivation.

8. For example, see Quentin Skinner, "The State," *Political Innovation and Conceptual Change*, Terence Ball, James Farr, and Russell L. Hanson, eds., (Cambridge, England: Cambridge University Press, 1989) for an analysis of the conceptual foundations of the modern European state, in part inspired by Clifford Geertz, *Negara: The Theatre State in Nineteenth-Century Bali* (Princeton, N.J.: Princeton University Press, 1980).

9. These citations come from media material in the personal archive of the author.

10. Holston, *The Modernist City*, pp. 101–44.

11. Although I argue that Modernist urban planning is antithetical of Baroque planning in theory, and eliminates it in practice, some observers suggest that Niemeyer's architecture has a Baroque aspect. In particular, they point to the curving and "lyrical" lines of his massing and to the iconic quality of some of his forms. The Cathedral in Brasília is a good example of the latter, readily recognizable as a "crown of thorns" or "two hands in prayer," as many people describe it. I would only argue that in theory all Modernist buildings are figural and that most Baroque buildings are not iconic. That some of Niemeyer's are especially iconic says more about their ability to communicate quickly and effectively as "one-liners" than about any deeper Baroque sensibility.

12. Holston, *The Modernist City*, pp. 163–87.

13. The reduction of family social space and expression of individuality is consistent with Modernist objectives to reduce the role of private apartments in the lives of residents and, correspondingly, to encourage the use of collective facilities. As Le Corbusier argued, "The problem was no longer that of the family cell itself, but that of the group; it was no longer that of the individual lot but that of development." Charles-Edouard Jeanneret Le Corbusier, *La Charte d'Athenes* (Paris: Editions de Minuit, 1957), p. 16.

14. As in Article 38. The first Organic Law of Brasília, Law 3751 of April 13, 1960, is also known as the Lei Santiago Dantas after its principle sponsor in Congress.

15. I should also stress that the need to build Brasília at breakneck speed also created serious job hazards. The combination of exceptionally long work hours,

deadline pressures, and lack of adequate training made work-related accidents and deaths progressively more common.

16. These and subsequent demographic data come from IBGE (Instituto Brasileiro de Geografia e Estatística), *Censo Experimental de Brasília* (Rio de Janeiro: IBGE, 1959). It was officially called the Experimental Census because, like so much in Brasília, it was designed to test new methods and concepts that would be developed as national guidelines.

17. That these land seizures were the only viable places of residence near the construction sites for poor families is indicated in the demographic profile of the only *vila* surveyed in the 1959 census: over 99 percent of the population of Vila Amaury lived in family households, the highest incidence of family residence in any of the new settlements in the Federal District and comparable only to that of the preexisting cities of Planaltina (97 percent) and Brazlândia (100 percent). IBGE 1959, p. 103.

18. *Arquitetura e Engenharia, Brasília*, special edition (July–August 1960), p. 148.

19. In addition to Novacap, other federal institutions had the task of constructing the superquadras. The officials of these institutes were, like Novacap's elite, dedicated pioneers who were deprived of postinaugural residential rights. However, they had much less power. After the inauguration, they continued to live in the wooden shacks of the construction camps, while the transferred civil servants got the apartments they had built. Finally, they too carried out an illegal occupation to gain what they thought they deserved. In a dramatic raid, IPASE officials seized the last apartment blocks the institutes would build in Brasília, just before they were distributed to others.

20. Ministry of Justice (Minister Carlos Cyrillo, Jr., Jayme de Assis Almeida, et al.), *Brasília: Medidas Legislativas Sugeridas à Comissão Mista pelo Ministro da Justiça e Negócios Interiores* (Rio de Janeiro: Departamento de Imprensa Nacional, 1959), p. 9.

21. Ibid.

22. The Plano Piloto was planned for a maximum population of 500,000. As of 1996, the date of the most recent findings, it has a population of 199,000. If we include the Lake districts, we add another 54,000 residents, for a total that is still just half Brasília's planned population. Moreover, the demographic imbalance between center and periphery has only worsened with time. At inauguration, the Plano Piloto had 48 percent of the total District population and the periphery (both Satellite Cities and rural settlements) had 52 percent. In 1970, the distribution was 29 percent to 71 percent; in 1980, 25 percent to 75 percent; in 1990, 16 percent to 84 percent; and in 1996, 14 percent to 86 percent. IBGE 1996.

23. IBPC (Instituto Brasileiro do Patrimônio Cultural), Patrimônio Cultural (Boletim Informativo Bimestral da 14ª Coordenção Regional do IBPC), special edition (November–December 1992), p. 10.

After the Miracle: Brazilian Architecture 1960–2000

Hugo Segawa

It might not be easy for a foreigner to understand what the creators of Brasília intended to represent in their audacious project of transferring the country's capital from the place where it had been since the eighteenth century—the coastal city of Rio de Janeiro—to Brazil's central plateau. We may be able to reduce the subject's complexity, however, if we examine the discourse of that period by considering excerpts from various sources.

Brasília in its epic dimensions was described as the "capital of the future and of hope," in the discourse propagated by the government and disseminated throughout the world. In the words of a native ideologue, the philosopher Roland Corbisier (b. 1914), the new capital was a matter of national development:

This task . . .of development, of national integration, of building a Brazilian Nation . . . while having an economic and social content, is fundamentally political and ideological in nature. The forces of the market, surrendered to spontaneity, to their own free will, will not be what enable us to correct the international and domestic imbalances and thereby promote the harmonious and stable development of the country according to our own schedule. The task is an urgent one, in the short term, since it is a question of reducing the discrepancy between our backwardness, our poverty, and the progress and wealth of the highly developed world. It is a question of recovering lost time, of converting space into time and geography into history. [1]

President Juscelino Kubitschek (1902–1976)—the mastermind behind the concept of development through industrialization during his administration between 1956 and 1960, promoted the public competition for the Master Plan of the new capital, which was won by Lúcio Costa

(1902–1998). Kubitschek inaugurated the new capital on April 21, 1960, and termed its construction a priority that was symbolic in nature. In Corbisier's view,

> The speed at which it is being built corresponds to the need to regain lost time, to scorch through historic periods and achieve the rhythm of urgency that should characterize our development. If it were not built in such a way, spurred on with implacable determination, it might never be completed or completed too late.[2]

Presented as an allegory, Brasília would capitalize on the international prestige that Brazilian art and architecture had secured since the end of World War II,[3] and showcase the unique creative capacity of a nation manifesting its cultural emancipation and affirming its new status as a developing country.

> The construction of the capital attests to the ability to create the supreme pedagogical moment—the city would contain works of art per se, but would itself be a work of art. From this time forward, when it is seen that the country is capable of creating a Metropolis as an authentic expression of itself and of its vision of the world, the Brazilian people truly affirm its creative power in the field of culture. . . .

> The audacity and originality of both the city plan, as presented in the exemplary work of Lúcio Costa's initial proposal, and the architectural work realized by Oscar Niemeyer, perhaps the greatest Brazilian artist, are eloquent proof that we are no longer condemned to merely translate, imitate or copy, but that we have now become capable of freely asserting our own genius and creative power.[4]

The preceding text, prepared in 1960 at the Instituto Superior de Estudos Brasileiros—

a branch of the Ministry of Education and Culture established by Corbisier—gives the official opinion of the time, which, to some extent, characterizes a worldview feeding the national-development euphoria that was almost unanimously pursued in the country. We can say "almost," since also at the same time another important analyst of Brazilian identity and culture, the sociologist Gilberto Freyre (1900–1987), was denouncing the "oblique censure" of his critical positions regarding the new capital in the book *Brasis, Brasil, Brasília*,[5] which was initially published in Portugal. According to Freyre,

> [Corbisier] was invited by then president Juscelino Kubitschek, his personal friend, to provide his opinion on how, even at mid-stage, the construction of Brasília was proceeding, and so he did. He stated that in many ways the work seemed satisfactory; that the architecture, from a sculptural point of view, would cause an international sensation as an original creation from an aesthetic point of view. But from the social perspective this work was entirely unsatisfactory. Ecologists had not been listened to, nor had social scientists, geographers, educators, or urban planners. No one had been listened to aside from the two architects responsible for this purely aesthetic, and in some regards, purely abstract architecture of Brasília.[6]

Freyre was not the only dissenting voice, since Brasília was to become the subject of systematic criticism. On the domestic level, many reactions were the result of divergent political and ideological viewpoints, especially with the change in perspective that followed Kubitschek's administration, and with the military coup of 1964. International assessments tended to settle somewhere between admiration and unease. How could a relatively peripheral country dare to confront the challenge of the contemporary city by employing

theoretical precepts on modern urbanism that had been conceived during the first decades of the twentieth century? Brasília gained worldwide attention for its novelty and as a phenomena of civic initiative.

The chasm between the redemptive discourse on urban creation and the actual implementation of such aspirations, given the confluence of political events of 1964 and thereafter, made the new capital a target for discrediting the doctrines of urbanism, as extolled by the CIAM (Congrès Internationaux d'Architecture Moderne) and other agents of Modernism. Epithets such as "fantasy-city" or "urban chimera" fed the mythology, or antimythology, of a city viewed with mistrust and even prejudice, as if it were some presumed utopia.

The international literature, as seen in textbooks on architecture and urbanism, such as those by Manfredo Tafuri and Francesco Dal Co,[7] Kenneth Frampton,[8] and William Curtis,[9] generated stereotypical visions of Brasília by disseminating images of an arid urban complex through photographs of the newly constructed city (which is quite different today, decades after it was inaugurated), and, in some cases, by providing serious informational errors—which leads one to view such opinions with skepticism.[10] On the other hand, more in-depth studies have posited concrete questions, and the words most frequently crowding their titles—"segregation," "exclusion," "social control," "political participation," "citizenship," "crisis"—suggest analyses that might lead to an understanding of the political and social processes that have shaped the urban space; in some cases, these studies deflate the specific, symbolically charged understanding of architecture and urbanism.[11] At the other extreme, the exacerbation of this bias has led the pure autonomy of architecture and urbanism to contextual constraints.

Forty years after its inauguration, Brazil's capital is a synthesis of the paradoxes of a nation that is at once hyperdeveloped and underdeveloped. Brasília has

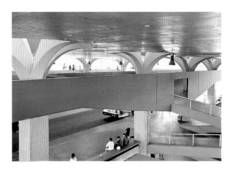

JOÃO BATISTA VILANOVA ARTIGAS Jaú bus station, Jaú, 1973

matured with its own symbolic territorialities. Its spaces are the setting for popular rituals with a monumental backdrop. The permeability between public space and political place establishes a relationship that creates and reinforces social identities and notions of citizenship. The cityscape of the Plano Piloto seems immutable, yet the city itself is in constant motion.[12] The urban memory of the capital is situated somewhere between the formal exuberance of the monuments Oscar Niemeyer (b. 1907) created and the social effervescence of its satellite cities. This memory is also shaped by UNESCO recognition, which granted the city the status of a World Heritage Monument: the first work realized in accordance with the modern principles of the twentieth century to be registered on the organization's list.

Modern Brazilian architecture as it had developed from the experiences of architects from Rio de Janeiro since the 1930s had its corollary in Brasília. The architecture of certain luminaries, such as Costa,[13] Niemeyer,[14] Affonso Eduardo Reidy (1909–1964),[15] the brothers Marcelo Roberto (1908–1964) and Milton Roberto (1914–1953), Jorge Moreira (1904–1992),[16] Álvaro Vital Brazil (1909–1997),[17] and Robert Burle Marx (1909–1994),[18] became the country's current and accepted architectural language. It influenced the training and careers of new architects—who believed in the transformational perspectives of this architecture—as well as, with less pretension and true ingenuity, in the formalism that was assimilated by the real-estate market and other popular constructions and became fashionable. The 1960s brought a consolidation of this

PAULO MENDES DA ROCHA Brazilian Museum of
Sculpture, São Paulo, 1988–95

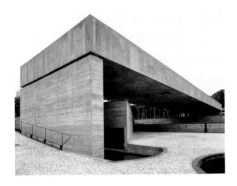

hegemony as well as a dilution of an architectural ideal through its formal appropriation devoid of the content established by its pioneers. Ultimately, twilight came to the heroic period in modern Brazilian architecture.

The Avant-Garde in São Paulo

In a decade of evident hopes, which was initiated in Brazil with the inauguration of Brasília, São Paulo was considered to be the country's industrial metropolis and the main center of technological development. With its great economic dynamism and cultural effervescence, the city became consolidated as the principal center for the circulation of wealth. The major figures on the São Paulo architectural scene were Rino Levi (1901–1965)[19] and Oswaldo Arthur Bratke (1907–1997).[20] Although they were contemporaries of the masters from Rio de Janeiro, their mature creations diverged from the Rio models, which had been influenced by Le Corbusier. In São Paulo, aside from the natural tribute to the masters from Rio de Janeiro, information was circulating about architecture in the United States: the work of Frank Lloyd Wright, Richard Neutra, and Mies van der Rohe and the Case Study Houses were frequently discussed by architects and students at Mackenzie University and the University of São Paulo, the city's only schools of architecture. It was in this environment that João Batista Vilanova Artigas (1915–1985),[21] the most outstanding Brazilian architect of the tumultuous 1960s and 1970s, began to gain prominence.

A natural leader, an eloquent and articulate professor, and a leftist militant,

Artigas was responsible for the conceptual clarity, systemization of ideas, and curricular reorganization of the Faculty of Architecture of the University of São Paulo, whose edifice represents a symbol of this inconclusive effort. He was the theorist for a so-called "progressive" architecture, one with a strong nativist sentiment but who also took part in the developments of the period. Promoting the notion of *desenho*[22] as a demonstration of national sovereignty, an instrument of political and ideological emancipation, Artigas established a conceptual framework that was soon assimilated and discussed by his peers and the students with the real thrust of nationalistic and developmental idealism, molding an architecture program that educated several generations of São Paulo architects, and that would also have a strong influence on academic curricula throughout the country during the 1970s.

The theoretical and ideological formulations of Artigas and his followers sought to lay the foundation for utopian theses, which, although far from corresponding to traditional architectural theories, elevated the subject to a new dimension of political and social ethics. Never before in Brazil had there been such a clear effort to correlate a series of theories with concrete applications as was evident with the many projects planned by Artigas and his younger colleagues. Ethics and aesthetics were never so much in evidence. Ethics with aesthetics and aesthetics with ethics: this was a play on words that permeated the discussions and the practice of architecture in São Paulo during 1960s and 1970s.[23]

Aside from highly articulate theoretical discourse, the most expressive creations of this architecture had a tremendous impact—charged as they were with the iconoclasm and extremism of the turbulent 1960s—and even today seem polemical and not easily assimilable. This architecture might best be implemented as a model space for a free and democratic society. For its most experimental practitioners,

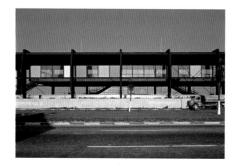

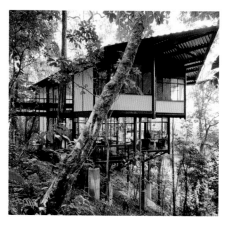

Brasília was conceived as a collective space for coexistence and mutual encounters. The urban environment should be for everyone, and this is how it was planned, with the abolition of all traditional urban structures. Brasília was fundamentally the paradigm of a city as model for the logic of the edifice. Many of these individual architectural works can be examined through the relationship they articulate with the city itself, either in establishing a simulation of urban continuity, even without the alteration of the intransigent parceling of land by the landowning structure (in practice, resulting in an innocuous paradox), or, on the other hand, through the supposed hostility of the environment, the sense of self-absorption that lends an introspective and austere aspect to the buildings, which in turn contain magnificently open and integrated interiors, featuring a microspace of freedom as a negation to the fragmented exterior.

Formally, the basic expression of this architecture was its geometric purism and the dominance of a particular system of construction: reinforced and exposed concrete. It was a construction system that was readily available, in contrast to the steel frame structures, typical in the United States, which at the time were not accessible for building purposes in Brazil. Evidently, in Latin America, the influence of Le Corbusier's postwar creations resulted in the widespread use of concrete, as can be seen in the works of architects such as the Venezuelan Carlos Raúl Villanueva (1900–1972),[24] the Chilean Emilio Duhart (b. 1917),[25] and the Brazilians in particular, among others. While still far from being considered merely a construction element

with an expressive aesthetic, reinforced concrete was the most advanced technological frontline available to the Brazilian architects. As a result Brazilian structural engineering is considered among the most sophisticated in the world. Thanks to the deference of Niemeyer and his belief that concrete was an ideal support material for his elaborate creations, the formal and technical exploration of its characteristics became a metaphor for the technological self-affirmation in architecture and design engineering among the São Paulo architects. Furthermore, the explicit use of structure as the dominant element in Niemeyer's architecture did not clash with the Miesian principle of the valorization of the structure. The São Paulo architects wisely appropriated these lessons.

It is common to identify buildings rendered in exposed concrete as products or derivations of the so-called "Paulista School" of architecture—a designation that seems to cover a lot of territory without revealing anything. In reality, this simplification does not take into account that the works that can be identified or associated with the "Paulista" trend should be seen as part of a continuum in Modern architecture stretching from the Rio de Janeiro architectural output of the 1940s and 1950s, whose major exponent was Niemeyer. After its reinterpretation in São Paulo, it was transformed into something quite different, without having lost the essence and exuberant characteristics of the architecture from which it was derived. Architects such as Paulo Mendes

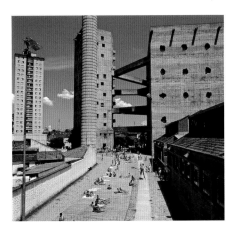

da Rocha (b. 1928),[26] Fábio Penteado (b. 1928),[27] Carlos Millan (1927–1964), Júlio Katinsky (b. 1932), João Walter Toscano (b. 1933), Eduardo de Almeida (b. 1933), Abrahão Sanovicz (1934–1999), Siegbert Zanettini (b. 1934), Décio Tozzi (b. 1936), Paulo Bastos (b. 1936), Ruy Ohtake (b. 1938),[28] Marcos Acayaba (b. 1944), and others—although following trajectories marked by their own personal styles and traits—may be seen as part of this tendency. It is only by highlighting this that we can understand the position of other equally notable architects on the São Paulo scene, such as Lina Bo Bardi (1914–1992),[29] Joaquim Guedes (b. 1932),[30] Sérgio Ferro (b. 1938), and Rodrigo Lefèvre (1938–1984).

The forms of this tendency in architecture, less than its ideas, were diffused throughout the country as a counter-legitimization of a concept. Taken as a substitute for the heroic works of 1930 to 1960, and for a time reputed to be the reference for Brazilian architecture identity, the content established by this architectural avant-garde was appropriated in a bureaucratic manner. The architectural practice of the São Paulo current in the 1960s—despite the military coup of 1964—did not entirely evidence an abandonment of the positivist utopian idealism of building an economically and socially evolved country. While still far from enacting any redeeming transformation of Brazilian society, the acritical persistence and/or reproduction of certain attitudes manifested in the São Paulo architecture accentuated the contra-diction between the ideal and the real. The mere transposition of formal models that had been divested of ideological conviction reinforced the banalization of utopia. In the 1980s, Brazil was no longer the country of the future, as symbolized by the construction of Brasília. Architects were deluded by the possibilities of transforming Brazil through progress and by attending to the country's social needs. Dreams of development from the 1950s and 1960s collapsed. In European and North American architecture, postmodernism hailed the death of Modern architecture and all of the redemptive intentions that the Modern movement had hoped to achieve. Vilanova Artigas died in 1985, and with him the entire architectural utopia of a transformed Brazil symbolically vanished.

Ideal City versus Real City

The cover of the January 11, 1993, issue of *Time* was devoted to "megacities." The magazine announced, "By the year 2000, more than 50 percent of humankind will live in cities, including 21 megacities of more than 10 million people. A few are coping with the exploding conditions. Elsewhere, chaos looms." *Time* introduced the subject by contrasting two models: the disaster of Kinshasa, Zaire, and the quality of life of Curitiba, Brazil.

Since the 1960s Brazil has been a country with more than half of its population living in cities; by the 1980s, 75 percent lived in urban areas. According to United Nation's statistics, the second and eleventh largest metropolitan areas on the planet are São Paulo, with 19.2 million inhabitants, and Rio de Janeiro, which has 11.3 million inhabitants.

Far from these megastatistics, Curitiba, the capital of the state of Paraná, has much more modest dimensions: it is a city of 1.4 million inhabitants (1990). It celebrated its tercentenary in 1993; twenty years earlier, this discreet metropolis was home to 500,000. Between 1970 and 1985, Curitiba, along with other islands of prosperity in Paraná, assimilated the immigra-

tion of 1.5 million rural workers—victims of the substitution of coffee cultivation with the mechanized labor of soybeans and wheat—along its peripheries. Despite this massive rural influx, Curitiba has been considered the Brazilian city with the best quality of life. Since the late 1980s, recognition in the form of awards and laudatory reports from publications throughout the world has increased the city's sense of self-esteem, responsibility, and solidarity, and intensified its charisma as an urban paradise.

The initial structures for this policy of urban administration date from 1965, when the architect Jorge Wilheim (b. 1928) developed the basis for Curitiba's guiding plan. Emphasizing the organization of a local planning group, the Instituto de Pesquisa e Planejamento Urbano de Curbita (Curitiba Institute for Urban Research and Planning [IPPUC]), established a strategic plan for integrated development, with interdisciplinary groups working in the areas of sanitation, public transportation, traffic, education, recreation, and industry. In 1970, the appointment of the then-president of the institute, Jaime Lerner (b. 1937), as mayor, initiated the application of solutions that had been formulated by the IPPUC—ideas that Lerner knew how to convert into reality. An equitable continuity in administrative philosophy ensured the gradual implementation of goals established in these plans, consolidating a group of integrated proposals for the streamlining of resources, resolving chronic urban problems and improving the quality of life. Lerner served as mayor for two more terms, the last of which ended in 1992. Since that time, he has managed to have successors elected who were connected with the IPPUC, while he currently continues in his second term as governor of the state of Paraná.

The statistics speak for themselves: in 1970, the city had .46 square meters of open space per inhabitant; today this figure is close to 54 square meters for each resident of Curitiba. The World Health

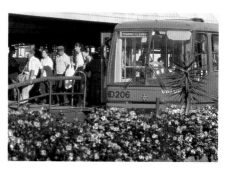

Organization recommends an index of 16 square meters per inhabitant. The city boasts approximately 17 square kilometers of parkland, gardens, forests, sports centers, and city squares, which comprise 4 percent of the total urban area of 430 square kilometers. A significant portion of these open spaces arose through the creation of linear parks that run alongside the rivers bisecting the city. A proposal for redeveloping the riverbanks, which were previously covered with overgrown structures and refuse, was put into operation. With the reforestation, clearing, rectification, and deepening of these waterways, natural drainage basins were formed, which over the past twenty years have eliminated the continual flooding that once plagued the city.

Curitiba's urban transportation system is considered one of the most efficient in the world. City buses are used by 75 percent of the population, transporting approximately 1.3 million passengers each day. At the same time, almost 28 percent of the city's 500,000 privately owned cars remain parked at home, given the efficient option of public transit. The system's cost-effectiveness allows for a rate of fuel usage that is 20 percent lower than mass transit systems in operation in similar cities, and also results in lower air pollution rates from vehicle exhaust.

Recycling, reuse, and revitalization are concepts that have also been embraced by the culture of Curitiba. For example, a former powder magazine from the early-twentieth century was transformed into a theater. A glue factory was made into a cultural center in São Lourenço Park. Three abandoned stone-quarries—eyesores in

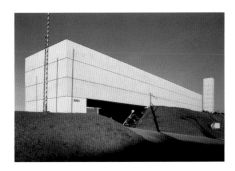

GUSTAVO PENNA Bandeirantes Television and Radio Network, Belo Horizonte, Minas Gerais, 1984–85

the landscape surrounding Curitiba—have been occupied by public establishments: the Paulo Leminski Cultural Space (an open-air theater for large rock concerts and musical presentations), the Ópera do Arame (a metallic-structure auditorium seating 2,400) and the Universidade Livre do Meio Ambiente (Open University of the Environment), a building dedicated to developing the exchange of ideas based on Curitiba's environmental experiences. The traditional center of the city was transformed with pedestrian malls, the preservation and restoration of old buildings and installation of new attractions, such as the Rua 24 Horas, a shopping and recreational facility in the style of the old European shopping galleries, which is open day and night. During the 1990s, works such as the Faróis do Saber, the Memorial da Cidade, the Ruas da Cidadania, as well as the memorials to various ethnic groups, provide architecture that is often visually compelling, spectacular, highly appealing to the public, and of polemically architectonic density.

"Ecological capital," "model city," and "experimental city" are some of the epithets garnered by Curitiba. This is an excellent marketing strategy for a city that either anticipated or followed many of the global concerns of the past decades such as ecology, sustainable development, recycling, and revitalization.

Brazil is the country that built Brasília—the most fascinating and polemical experience in modern urban planning of the twentieth century—and it is also the country of São Paulo, the wealthiest city in South America and one of the world's five great metropolises. Between the completely

planned city and the virtually ungovernable one many ordinary elements can be found. Brazil is a country of counterpoints and extremes: the ideal city—Brasília; the gargantuan city—São Paulo; and the possible city, Curitiba, an alternative, manageable urban center. Brasília, São Paulo, and Curitiba represent laboratories in which to observe the disparities between Modernist city, extrapolated city, and traditional city.

Renewed and New Paradigms

Curitiba demonstrates that recent architecture in Brazil is not restricted to the cultural and economic initiatives on the Rio de Janeiro–São Paulo axis. It is undeniable that the international discussion concerning postmodernism contributed to the airing of debates in Brazil. Nevertheless it is important to determine what impact this discussion really had during the 1970s and 1980s. These debates, intense in the developed countries but rather tepid in Brazil, did not foster changes in and of themselves, nor do they explain the transformations witnessed in Brazilian architecture during the 1980s. The postmodern question opened up sensibilities and tolerance for a diversity of viewpoints, with the understanding that there were other ways of thinking through and implementing a given project. Phenomena perceived on a global level filtered down to Brazilian architects: the fallacy of architectural panaceas (solutions that were allegedly valid for all realities), increased dialogue between the urban context and the natural environment in the construction of buildings, historical recognition as a project reference point, reassessment of the recycling of buildings as a means of cultural preservation, the creation of space through the collaboration between architects and users, and an approach that is less hieratic, dictatorial, determinist, and synthetic replaced by practices that are more analytic, symbolic, and accepting of ambiguity. These values can be seen in a variety of works and theoretical implementations, in particular after the mid-1980s among

younger architects, and with deft and subtle acknowledgment among older professionals.

The recognition of diversity—one of the benefits derived from the postmodern condition—justified taking another look at works executed in other Brazilian regions without the preconceived notion that Brazilian architecture was an easily definable entity centered in the two main cities of the country. On the contrary, architectural approaches with many nuances—even those derived from the Rio de Janeiro and São Paulo mainstream—displayed a sense of vitality that was only hampered by economic limitations (the so-called lost decades in Latin America, the 1980s and 1990s), which constricted the possibilities of developing great architecture given the continental dimensions of the country. Furthermore, the historical relationship between the architectural avant-garde and the state began to change. Public funding supported the classic works of the heroic period of Brazilian Modernism, Brasília, and countless architectural examples in São Paulo and Curitiba. In view of the crisis of the last two decades, the government is no longer a great Maecenas, and private enterprises have become the major contractors, without necessarily encouraging proposals that are conscious of architecture's cultural responsibilities.

During the 1980s, many architects, such as the group from Minas Gerais who came into association through the periodical *Pampulha* in Belo Horizonte in 1979: Éolo Maia (b. 1942) and Jô Vasconcellos (b. 1947),[31] Sylvio de Podestá (b. 1952),[32] Álvaro "Veveco" Hardy (b. 1942), Joel Campolina (b. 1947), among others. These architects were geared toward work that was independent of the Rio de Janeiro–São Paulo mainstream, were sparked by the postmodern dialogue of the period. Of this group, Gustavo Penna (b. 1950),[33] was the one to gain the greatest prestige during the 1990s. Architects of an intensely regional nature, but drawn together by

TOP: **FERNANDO CHACEL** Gleba E Park, Lagoa de Tijuca, Rio de Janeiro, 1986–88. BOTTOM: **PAULO ZIMBRES AND LUIS ANTONIO REIS** Federal University of Uberlândia Library, Uberlândia, Minas Gerais, 1990–91

their interest in ecological and bioclimatic architecture in the Amazon region, Severiano Porto (b. 1930) and Mário Emílio Ribeiro (b. 1930) garnered international recognition. João Castro Filho (b. 1950), is a follower of this tendency.

There is a generation of architects now in their seventies—trained during the full-blown euphoria of surrounding Brasília, or slightly before—whose works deserve our attention: Acácio Gil Borsói (b. 1924), Giancarlo Gasperini (b. 1926), Carlos Fayet (b. 1928), and Cláudio Araújo (b. 1931). In the same age range, we find the landscape architect Fernando Chacel (b. 1931), whose brilliant work can be seen as an heir of Burle Marx. Slightly younger— in the sixty-year age range—are architects such as Paulo Zimbres (b. 1933), Vital Pessoa de Mello (b. 1936), Paulo Bruna (b. 1938), Carlos Bratke (b. 1942),[34] and Joan Villà (b. 1944). Architects trained during the 1970s suffered from the effects of the military dictatorship and the stagnation in work during the "lost decades." Of this generation, we can cite a number of significant architects such as Mauro Neves Nogueira (b. 1952), Marco Antônio Borsoi (b. 1954), the Königsberger/Vannucchi team, who regularly turned out high-quality work in the São Paulo commercial real-estate sector, and Brasil Arquitetura, orginally comprised of Marcelo Ferraz

LEFT: **PAULO BRUNA AND ROBERTO CERQUEIRA CESAR** Ática Shopping Cultural, 1995–97. RIGHT: **JOÃO FILGUEIRAS LIMA (LELÉ)** Sara Kubitschek Hospital, Fortaleza, 1994–2001

(b. 1955), Francisco Fanucci (b. 1952) and Marcelo Suzuki (b. 1956).

The figure of Luiz Paulo Conde (b. 1934)[35] also stands out. This architect emerged on the Rio de Janeiro scene in the 1980s with work that distinguished itself from the modern Rio de Janeiro trends, and who conceived—first as municipal secretary of urban planning, and then as mayor of Rio de Janeiro between 1993 and 1999—of energetic actions such as the remodeling and recycling of urban areas with the Rio-Cidade project,[36] and interventions in the city's poor districts with the Favela-Bairro project,[37] whose activities in the Fernão Cardim *favela* (conceived of by the architect Jorge Mário Jáuregui) won such recognition as the Veronica Green Prize from Harvard University and the Prince Claus Fund from the Netherlands.

After overcoming the idiosyncrasies of postmodern architecture, the 1990s were marked by the late but deserving reappraisal of Lina Bo Bardi, thanks to a monograph[38] and a traveling exhibition, along with the international recognition of Paul Mendes da Rocha, the growing prestige of João Filgueiras Lima (b. 1942),[39] known as Lelé, a disciple of Niemeyer, who in some instances surpassed his master. And the master himself, now in his nineties and fully active, enjoys ever-increasing admiration from young people. These four architects—all related to the "tradition" established with Brasília—show a persistent yearning for utopia.

We may ask ourselves, what is the common denominator among all these architects? In principle, not much. Among the paradigmatic works that previously marked the trends in Rio de Janeiro and São Paulo, it is possible to discern a few common links, and this is evidence of a different reality not very far in the past. In a country of the proportions of Brazil, it is no longer possible to imagine a single, unifying architectural output, as local and international criticism once did in characterizing the Brazilian works produced more than forty years ago.

While in the 1960s there were seven schools of architecture in the major state capitals, whose curricula leaned toward some of the common values derived from the Rio de Janeiro–São Paulo hegemony, there are now 139 programs spread across the country, and little can be said about the quality of most of these schools. In this sense, young Brazilian architecture is an enigma in terms of its potential to create a new architecture for Brazil, which once again seems to recapture the promise of development. In this regard, and if we reconsider the past, we can say that there was a subtle difference among the young architects working in the 1950s, such as Mendes da Rocha, Porto, and Filgueiras Lima, in their expectations for a confident and hopeful Brazil as a nation in transformation, on the road to development. They had a project for utopia. Nowadays there is an understanding among the young of the limits of architecture as a transformational tool, of the uncertainties regarding the ways to achieve such transformation, despite some repressed optimism and the desire for change. Young people have a utopia without a project.

Is Brazil's modern legacy, in postmodern times, an achievable goal? I don't believe that this legacy has become fallow, that it has ceased to show promising

Cinema

The Baroque, the Modern, and Brazilian Cinema

Robert Stam and Ismail Xavier

As a vast New World country, similar to the United States in its historical formation and ethnic diversity, Brazil constitutes a kind of southern twin whose strong affinities with the United States have been obscured by ethnocentric assumptions and media stereotypes, making Brazil both reassuringly familiar and disconcertingly alien to North Americans. While in no way identical, the two countries are eminently comparable. After millennia of indigenous habitation and culture, Brazil and the United States were both "discovered" as part of Europe's search for a trade route to India. Both countries began their official histories as European colonies, one of Portugal, the other of Great Britain. In both countries, colonization led to the occupation of vast territories and the dispossession of indigenous peoples. Through the massive importation of Africans, the two countries formed the largest slave societies of modern times, until slavery was abolished with the Emancipation

Proclamation of 1863 in the United States and the Golden Law of 1888 in Brazil. Both countries received parallel waves of immigration from all over the world, ultimately forming multicultural societies with substantial indigenous, African, Italian, German, Slavic, Japanese, Arab, and Jewish (Ashkenazi and Sephardi) populations and influences.

The complex national culture of Brazil is richly expressed in the history of its cinema, from the earliest cinematic "views" of the 1890s, through the *bela epoca* of 1908–11, during which Brazilian cinema dominated its own market, through the studio musical comedies, or *chanchadas*, of the 1930s to 1950s, through the just-like-Hollywood-style ambitions of the Vera Cruz Studio of 1949–54, through the various phases of the Cinema Novo movement beginning in the late 1950s, and on to the stylistic pluralism of the present day, a period that has seen not only a resurgence of cinema within Brazil itself,

O Pagador de Promessas (*The Given Word*, 1962),
Anselmo Duarte

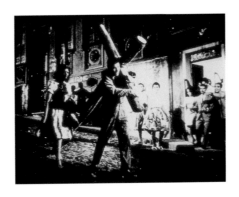

but also Oscar nominations for Brazilian films like Fábio Barreto's *O Quatrilho* (1996) and Walter Salles's *Central do Brasil* (*Central Station*, 1998). More recently, audio-visual mediums like video and television have also given expression to Brazilian national identity.

Many of the works discussed here were selected for inclusion in the film and video program of the *Brazil: Body and Soul* exhibition. On one level, this selection treats Brazilian Baroque and Modernism in a relatively narrow sense as cultural categories and historical periods. But in a broader sense, it addresses the intertextual relationships that have arisen from Brazil's status as a multicultural nation emerging from the processes of European colonization and North American neocolonization. This Brazil is deeply marked by the ethnocide of its indigenous population and the legacy of slavery; by large-scale migration; by Jesuit hegemony in formal education and the formation of a deeply syncretic religious experience; and by the colonial process and the official preference for a predominantly European immigration. All have contributed to the mix that is Brazilian culture.

Among the films that touch directly on the Baroque are two documentaries that treat the work of noted eighteenth-century sculptor O Aleijadinho (Francisco Antônio Lisboa): Lima Barreto's *Santuário* (1951) and Joaquim Pedro de Andrade's *Aleijadinho* (1978). Arthur Omar's *Musica Barroca Mineira* (1981) is an avant-gardist meditation on the work of the eighteenth-century black composers of Baroque music known as the Orfeus Morenos (mestizo, or

mixed-race, Orpheuses), among them Joaquim José Americo Lobo Mesquita. Carlos Diegues's *Xica da Silva* (1976), Walter Lima, Jr.'s *Chico Rei* (1982), and Joaquim Pedro de Andrade's *Os Inconfidentes* (*The Conspirators*, 1972) are historical costume dramas that exploit the Baroque architecture of Minas Gerais as both theme and decor.

The films that directly treat or exemplify literary and artistic Modernism include Mário Peixoto's two-hour masterpiece *Limite* (1930), an example of the filmic Modernism of the historical avant-garde. *Limite* is Modernist in its sound track (Erik Satie, Igor Stravinsky, Maurice Ravel), in its visual influences (Impressionism, German Expressionism, Soviet montage, and Surrealism), and in its partial inspiration, in formal terms, by the writings of Virginia Woolf. Joaquim Pedro de Andrade's *Macunaíma* (1969) brilliantly updates Mário de Andrade's 1928 Modernist novel of the same name. Written long before the boom of Latin American fiction, the novel was not only the forebear of all Magic Realist novels but also anticipated theories of postcolonial hybridity. The film adaptation turns the novel into the springboard for a critique of repressive military rule and of the predatory capitalist model of the short-lived Brazilian "economic miracle" of the early 1970s.

Other films reference the Baroque and the Modern, not as specific periods and movements within Brazil's artistic history, but in a more indirect, metaphoric, and transhistorical fashion, as perennial tendencies within Brazilian art. It has long been commonplace to speak of the Baroque as a cultural dominant in Brazilian art and society. Roger Bastide, Otto Maria Carpeaux, Leopoldo Castedo, Afránio Coutinho, Affonso Romano de Sant'Anna, and Nicolau Sevcenko are among the cultural critics who have spoken of the multi-faceted "Baroqueness" of Brazil. The Baroque has often been defined as a loose constellation of traits and concepts—the irregular, the asymmetrical, the excessive,

574

the grotesque, the sensual, the melan-
choly, the frenetic, the transrealist—that
are also highly evocative of Brazilian cul-
tural practices. The Baroque evokes volup-
tuous religiosity, labyrinthian structures,
architectonic decentering, the cohabitation
of contraries, the spectacularization of
faith, the melding of sacred and profane,
messianic aspiration, and the exaltation of
the senses, all of which are evident in
abundance in Brazilian cinema.

Cultural theorists such as Walter
Benjamin have noted the affinity between
the Baroque and the literary device of alle-
gory, while Fredric Jameson has argued
that all third-world texts are "necessarily
allegorical," in that "even those texts
invested with an apparently private or
libidinal dynamic . . . necessarily project a
political dimension in the form of national
allegory; the story of the private individual
destiny is always an allegory of the embat-
tled situation of the public third-world cul-
ture and society."[1] Brazilian intellectuals
were working with something like the con-
cept of national allegory long before
Jameson, at least since the debates revolv-
ing around the Tropicália movement of
the late 1960s, and arguably even since the
debates concerning the national character
conducted by the Brazilian Modernists in
the 1920s.[2]

While it is problematic to posit any
single artistic strategy as uniquely appro-
priate to the cultural productions of an
entity as heterogeneous as the "third world,"
one could easily argue that Brazilian films,
even the most frivolous, have often had an
allegorical dimension, with allegory here
conceived in a broad sense as any kind of
oblique or indirect utterance soliciting
hermeneutic completion or deciphering
on the part of the reader or spectator, as a
way of addressing one topic while ostensi-
bly addressing another: past for present,
elsewhere for here. Some of the Brazilian
films of the 1950s, in this perspective, can
be seen as parodying successful Hollywood
films of the period in order to allegorize
both the "inferiority" of Brazilian cinema

TOP: *Os Inconfidentes* (*The Conspirators*, 1972), Joaquim
Pedro de Andrade. BOTTOM: *Matar ou Correr* (*To Kill or to
Run*, 1954), Carlos Manga

vis-à-vis the dominant model and the
impulse to transcend the conditions
imposed by economic dependency. The
films of the first phase of Cinema Novo,
similarly, constitute allegories of underde-
velopment, where history is shown as the
unfolding of a progressive teleological
design and where an aesthetics of hunger
turns scarcity itself into a signifier, trans-
forming a poverty of means into a badge
of honor.

Much Brazilian art has managed to
transvalue the negative by forging an aes-
thetics of hunger, an aesthetics of *cafonice*
(tackiness) or of *lixo* (garbage). Here we
find a transfiguration of the very codes of
good taste, a capacity to find beauty in the
imperfect and the *desafinado* (out of tune).
These aesthetics share the jujitsu trait of
turning strategic weakness into tactical
strength, deploying the force of the domi-
nant against domination. What could be
more baroquely excessive, than the con-
junction of sex, death, and sacrilege to be
found in the films of Brazil's only horror
director, José Mojica Marins (affectionately
known as Coffin Joe), as in his classic fea-
ture *À Meia-Noite Levarei Sua Alma* (*At
Midnight I'll Take Your Soul*, 1964).

Brazil's *udigrudi* (underground)
filmmakers of the late 1960s were the first,

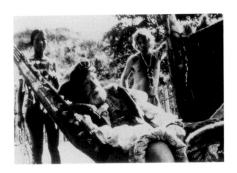

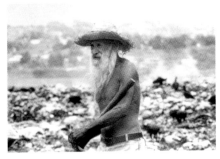

to our knowledge, to speak of the aesthetics of garbage. The valorization of "sleaze, punk, trash, and garbage" that Jameson posits as characteristic of first-world postmodernism was already present in the palpably grubby "dirty screens" of the 1960s Brazilian underground movement. (This historical priority confirms the notion that Latin America, as a marginalized society caught in a peculiar realm of irony imposed by its neocolonial position, was in many ways postmodern *avant la lettre*.) As the quintessence of the negative and the excessive, and an image appropriate to a third-world country picking through the detritus of an international system dominated by first-world monopoly capitalism, garbage served as an object of ironic reappropriation. In aesthetic terms, garbage can be seen as an aleatory collage or surrealistic enumeration, a case of the definitive by chance, a random pile of objets trouvés and papiers collés, a place of violent, surprising juxtapositions.[3] Grossly material, garbage is society's id; it steams and smells below the threshold of ideological rationalization and sublimation. The garbage movement's film manifesto, Rogério Sganzerla's *O Bandido da Luz Vermelha* (*Red Light Bandit*, 1968), which treats Brazil itself as a realm of garbage, begins with a shot of young *favelados* dancing on burning garbage piles. Like other avant-garde films of the late 1960s and early 1970s, *O Bandido da Luz Vermelha* is allegorical in another sense: as a fragmentary discourse expressing a crisis in representation in which the very notion of historical and cinematic teleology is suspect.[4]

The films of the garbage movement were made in the São Paulo neighborhood called *boca de lixo* (mouth of garbage), a red-light district named in opposition to the high-class red-light district known as *boca de luxo* (mouth of luxury).[5] Eduardo Coutinho's documentary *Boca de Lixo* (*The Scavengers*, 1992), evokes this district in its title, centers on impoverished Brazilians who survive on their finds from a garbage dump outside Rio de Janeiro, where they toil against the backdrop of the outstretched arms of the Christ of Corcovado. Jorge Furtado's short *Ilha das Flores* (*Isle of Flowers*, 1990) brings the garbage aesthetic into the postmodern era, using garbage as both theme and formal strategy. It draws on Monty Python–style animation, archival footage, and parodic documentary techniques to indict the distribution of wealth and food around the world.

Similarly, the trope of cannibalism was made the basis of an insurgent aesthetic by the Brazilian Modernists, who called for the anthropophagic devouring of the techniques and information of the developed countries in order better to struggle against domination. Just as the aboriginal Tupinambá Indians reportedly devoured their enemies to appropriate their strength, so Brazilian artists and intellectuals, the Modernists argued, should digest imported cultural products and exploit them as raw material for a new synthesis, thus turning the imposed culture back, transformed, against the colonizer. Oswald de Andrade, the dynamic guru of the Modernist movement, pointed the way to an artistic practice at once nationalist, Modern, multicultural, and pleasurable.[6] In his manifesto of *Pau-Brasil* poetry in 1924, he called for an "export-quality" poetry that would not borrow imported

European models but would find its roots in everyday life and popular culture. Where colonialist discourse had posited the Carib as a ferocious cannibal, as diacritical index of Europe's moral superiority, the his *Manifesto antropofágo* (1928) called for a revolution infinitely "greater than the French revolution," the "Carib revolution," without which "Europe wouldn't even have its meager declaration of the rights of man."[7] De Andrade proposed the anthropophagic "digestion" of modern technology and the Modernist avant-garde of Futurism and Surrealism. Although the cannibalist metaphor also circulated among European avant-gardists,[8] cannibalism in Europe, as Augusto de Campos points out, never constituted a cultural movement, never defined an ideology, and never enjoyed the profound resonances within the culture that it did in Brazil.[9] Radicalizing the Enlightenment valorization of indigenous Amerindian freedom by such writers as Michel de Montaigne and Jean-Jacques Rousseau, Brazilian Modernism highlighted aboriginal matriarchy and communalism as a utopian model and a trampoline for a future inspired by the values of the "high-tech Indian," the Indian who selectively appropriates "Western" technologies. Synthesizing insights from Montaigne, Friedrich Nietzsche, Karl Marx, and Sigmund Freud, along with what he knew of native Brazilian societies, de Andrade portrayed indigenous culture as offering a more adequate social model than the European one.[10]

Latin America in general and Brazil in particular have been fecund in neologistic aesthetics in the literary, painterly, and cinematic realms, most of which have revalorized by inversion what was formerly seen as negative, especially within colonialist discourse. Even Magic Realism, for example, inverts the colonial view of magic as irrational superstition. The rich history of aesthetic innovation in Brazilian cinema, however, derives not only from reaction against the dominant colonialist model but also, we would argue, from a

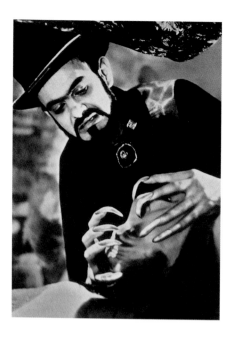

Esta Noite Encarnarei no Teu Cadaver (This Night I'll Possess Your Corpse, 1966), José Mojica Marins

number of the salient historical features of Brazilian culture itself, including its multicultural and multiracial character. Within Brazilian culture, at least three major constellations of cultural practices are superimposed: those of indigenous cultures (Tupi, Bororo), those of African cultures (Bantu, Yoruba, Hausa), and those of European and extra-European immigrant cultures. Thus syncretism and hybridity were the hallmarks of Brazilian art and culture long before they became fashionable buzzwords for the postcolonial theories of the 1980s. Indeed, the beginnings of Brazilian syncretism can be traced to Africa in the sixteenth century, with the intertwining of Portuguese and Bantu religious symbolism, whereby the signs and figures of European culture were "read" through signs and figures from Africa.

Since that time, all of the world's cultures have set down roots in Brazil. What triggers artistic optimism even in crisis-ridden periods for Brazilian cinema is the constitutive multiculturalism of Brazil, its artistic *disponibilité*, its structural and affective openness to Europe, Africa, and indigenous America—indeed, to the entire globe. No culture, ultimately, is completely alien to Brazil; or, as Paulo Emilio Salles Gomes stated, "Nothing is foreign to us, since everything is."[11] Although the country's social structures sometimes seem

Macunaíma (1969), Joaquim Pedro de Andrade

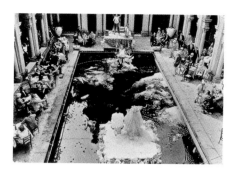

ossified and sclerotic, its cultural structures are open and porous. In Brazil, the conflictual mingling of so many histories and traditions almost necessarily gives rise to the innovative and surprising.[12]

The indigenous presence has been a perennial theme in Brazilian cinema, from Humberto Mauro's *O Descrobrimento do Brasil* (*The Discovery of Brazil*, 1937), through Joaquim Pedro de Andrade's *Macunaíma* and Nelson Pereira dos Santos's *Como Era Gostoso o Meu Francês* (*How Tasty Was My Little Frenchman*, 1971), an irreverent film rooted in the historical relations between Europe and the indigenous peoples in the sixteenth century, partly based on the diaries of European travelers like Hans Staden and Jean de Léry. The theme emerges again with the "indigenous media" of the 1980s and 1990s, where native Brazilians used Camcorders to shape their own image and destiny, and in the television miniseries *A Invenção do Brasil* (*The Invention of Brazil*, 2000), made to commemorate the quincentennial anniversary of Pedro Álvares Cabral's "discovery" of Brazil in 1500. It also appears in contemporary feature films like Lúcia Murat's *Brava Gente Brasileira* (*Brave Brazilian People*, 2000), a historical study of native peoples' struggles against colonial domination.

The African presence has pervaded all moments of Brazil's history and all areas of its culture. Many of the greatest Brazilian literary figures, whose works have frequently been adapted for the cinema, have been black or mulatto. Machado de Assis, for example, wrote the novels adapted in Paulo Cesar Saraceni's *Capitu* (1968; based on *Dom Casmurro*), Nelson Pereira dos Santos's *Azyllo Muito Louco* (*The Alienist*, 1970; based on *O Alienista*), and Júlio Bressane's *Brás Cubas* (1985; based on *Memórias Póstumas de Brás Cubas*). Filmmaker Lima Barreto, actor Jorge de Lima, and novelist Mário de Andrade had partial African ancestry. In the realm of popular culture, many of the most prized symbols of Brazilian nationhood are Afro-Brazilian in origin. The national dish is *feijoada*, the black-bean stew improvised by slaves, and the national music is samba, whose Africanized polyrhythms have long thrown down the basic beat of Brazilian music. In the privileged moments of Brazilian life, as we see in films like Diegues's *Xica da Silva*, Brazil might be said to celebrate its own blackness.

Africa also influenced Brazilian religiosity irrevocably, engendering a symbolic crisscrossing of pantheons and forms of worship. The architecture of the Afro-Brazilian religion of Candomblé—the temples, the groves of sacred trees, the spring of Oxalá—represents a "reconstruction of the lost Africa."[13] Africa not only sent religions like Candomblé to Brazil; its religions also syncretized with popular Catholicism and European spiritism to form such religions as Umbanda. The African influence, furthermore, shaped Catholic practice in Brazil, making what began as a rather harsh and inquisitorial religion more humane, affective, and sentimental rather than dogmatic and formalist. Anselmo Duarte's film *O Pagador de Promessas* (*The Given Word*, 1962), winner of the Palme d'Or at the Cannes Film Festival, revolves around this kind of encounter, depicting a peasant's attempt to fulfill his vow—proffered in an Afro-Brazilian religious shrine—to carry a cross into the Baroque church of Saint Barbara in Salvador da Bahia.

The Baroque, in both Europe and Brazil, has also demonstrated a vocation for the theatrical and the performative, having been linked to festivals, processions, and celebrations as part of the spectacularization of faith. This theatricalizing vocation is strikingly present in many

Brazilian films. Bia Lessa's *Crede-Mi* (Believe Me, 1997) links popular Brazilian festivals to an adaptation of Thomas Mann's *The Magic Mountain*. Gael Arraes's *O Auto da Compadecida* (*A Dog's Will*, 2000) invokes, as its title suggests, archaic theatrical forms (the word *auto* evokes old Iberian plays), here reinvested with the energy of contemporary Brazilian rural culture.

In Brazil, Baroque processions merged with African celebrations to shape the protean vitality of Brazilian Carnival, making it more dynamic than the relatively petrified forms of European carnivals. The Carnival floats, like those of Baroque religious pageants, are still called *allegorias* (allegories). Afro-Brazilians brought to Carnival their traditions of totems (*ranchos* in Bahia) and royal pageants (*maracatu* in Recife), turning it into a secularized religion characterized by visual apotheosis and collective *jouissance*. Indeed, Carnival and Afro-Brazilian religious practice display metonymic as well as metaphoric links. In metonymic terms, Afro-Brazilian religious groups have actively shaped Carnival's style of pageantry, music, dance, and costume, and in metaphoric terms, Carnival and the West African trance religions share a comparable play with identity, in the *fantasias* of Carnival (the *favelada* costumed as an aristocrat, a man in drag) and in the trances of Candomblé (a man possessed by a female saint, a young white person by an old black man).

Descriptions of the Baroque as sensual and erotic and characterized by a love of the curve uncannily evoke the voluptuous polyrhythms of carnival's samba pageant. With its ambitious orchestration of narrative, music, dance, and costume, this pageant promotes a spectacular interplay not only of diverse arts but also of the Dionysian and the Apollonian. Static equilibrium becomes dynamized into a delicious curvilinear frenzy. Diegues's *Xica da Silva* treats a theme presented as a samba pageant by the Salgueiro Samba School in 1962: the legendary story of a former slave woman who became extremely powerful

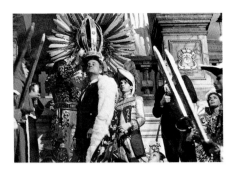

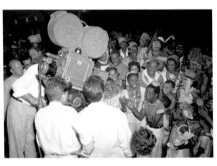

through her liaison with a Portuguese official. The film not only features the samba-style music of Jorge Bem but also corresponds to the protocols of a samba-school aesthetic, mingling the love of costume and dance and music with the Baroque decors of Minas Gerais. Carnival and Afro-Brazilian religion also meet in Vera de Figueiredo's *Samba da Criação do Mundo* (1978), in which the Beija Flor Samba School stages Yoruba cosmology in what might be called an Afro-Baroque aesthetic. Under the overarching spirituality of Olorum (presiding deity of the Yoruba pantheon), Obatala, the masculine principle, and Odudua, the feminine principle, collaborate to create the world, while also giving birth to the various *orixás* (gods or spirits). The film is punctuated by cosmological poems and danced poetic tributes to the *orixás*: Nana, *orixá* of fertility; Oxum, *orixá* of waterfalls and rivers; and Ogum, warrior god and hunter.

The gregarious mysticism of Afro-Brazilian religious expression is symbiotically linked both to Carnival and to black performance in general. Performance and the arts, dance and song and spectacle, are at the very core of African trance religions. If the drums don't play, the gods don't come. As Robert Farris Thompson has pointed out, art participates in the ritual

process not only by honoring the deities but also by calling them into presence and action. Sacred objects incarnate *axé* (energy) and ritual efficacy.[14] The arts—costume, dance, poetry, music—create the appropriate atmosphere for worship. Olodumare, creator of the Universe, can be seen as the greatest artist, and the *orixás* are artists who have artistic tastes in clothing, decoration, and so on. As poetic figures, the *orixás* now play an artistic role in Africa and the diaspora akin to the role of the classical deities of the Greek pantheon within literature, painting, and sculpture. For Henry Louis Gates, Jr., the Yoruba trickster figure Exu-Legba provides the germ of the deconstructive "signifying" aesthetic of African-American literary narrative.[15] The *orixás* permeate the sculpture of Mestre Didi, the photography of Pierre Verger, the painting of Carybe, and the music of Olodum, Ile Aiyé, and Timbalada (not to mention Paul Simon and David Byrne). Indeed, Arturo Lindsay speaks of a "neo-Yoruba" genre of contemporary art.[16]

The innovative quality that derives from the multicultural character of the country also has to do with Brazil being a place where European ideas and forms are, to use Roberto Schwarz's felicitous phrase, "out of place."[17] (And we might add "out-of-time," in that the zenith of the Brazilian Baroque coincided with the decadence of the movement in Europe.) This out-of-placeness has triggered the necessary transformation and indigenization of European forms, summed up in Paulo Emilio Salles Gomes's pithy formulation, "the creative Brazilian *incapacity* for copying."[18] The absence of certain building materials and of specialized artisans led to changes in Brazilian architecture, for example, and pictorial content also became miscegenated. Thus a chapel in Ouro Prêto features a mulatto Virgin Mary surrounded by mestizo angels; the Baroque music produced in Minas Gerais during the eighteenth century shows the influence of the Afro-Brazilian heritage of its composers

and performers; and a Baroque church in Salvador da Bahia, is Islamicized and Africanized because its artisans and architects were Arabic-speaking Muslims from West Africa. Indeed, Emanoel Araújo argued that almost all of the art produced in the first three centuries after Cabral was the product of *mestizo* artists.[19]

In the Modernist era there was, of course, a good deal of concrete interanimation among the Brazilian and European avant-gardes. Blaise Cendrars, Le Corbusier, Filippo Tommaso Marinetti, Darius Milhaud, and Benjamin Peret all went to Brazil, just as Oswald de Andrade, Anita Malfatti, Sergio Millet, Paulo Prado, Heitor Villa-Lobos, and other key figures in the Brazilian Modernist movement made frequent trips to Europe. The Brazilian Modernist painter Tarsila do Amaral studied with Fernand Léger, and she and her husband, Oswald de Andrade, counted Léger, as well as Constantin Brancusi, André Breton, Jean Cocteau, Milhaud, Satie, and Stravinsky among their close friends. Nonetheless, the Modernism that arose in Brazil had distinct differences from European Modernism. In Brazil, the Modernist movement mingled hommages to indigenous culture with aesthetic Modernism, melding political nationalism with stylistic internationalism. The Antropofagia movement "set its face against the Occident," though it warmly "embrace[d] the discontented European, the European nauseated by the farce of Europe."[20] De Andrade saluted Surrealism, in a self-mockingly patronizing manner, as one of the richest "pre-anthropophagic" movements. "After Surrealism," he proclaimed in the *Manifesto antropofágo*, "only Antropofagia."

The exoticizing metaphors of the European primitivist avant-garde had a strange way of taking flesh in the Latin American context, resulting in a kind of ironic echo effect between European and Latin American Modernism. Thus Alfred Jarry's "neglected branch of anthropophagy" came to refer in Brazil to the

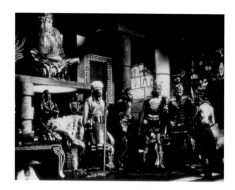

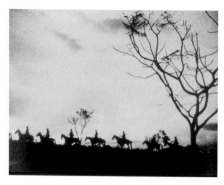

LEFT: *Nem Sansão Nem Dalila* (1954), Carlos Manga.
RIGHT: *O Cangaceiro* (1953), Lima Barreto

actual cannibalism of the Tupinambá, and Surrealist automatic writing metamorphosed into the collective trance of Afro-Brazilian religions like Candomblé. While Parisian Surrealists had to seek out the exoticist delights of African masks and La Revue Nègre, Tarsila, in her painting *Black Woman* (1923, cat. no. 218), had only to evoke the memory of her Afro-Brazilian nanny, thus making exoticism quotidian and familiar. Brazilian familiarity with the "madness" of Carnival and with African-derived trance religions made it easy for Brazilian artists to assimilate and transform artistic procedures that in Europe represented a more dramatic rupture with ambient values and spiritual traditions.

Brazilian cinema shares in this sense of out-of-placeness. Since the early twentieth century, Brazilian cinema has had a sense of being a latecomer in the international arena of market competition, carrying the image of a marginal cinema even for its own national audience. Filmmakers see their works as inherently disadvantaged, mired in a situation where foreign (especially North American) cinema is favored as the privileged interlocutor for both exhibitors and spectators. Underfunded and underprotected, Brazilian cinema has had to struggle against not only foreign domination of exhibition circuits but also the Brazilian public's internalization of entertainment norms borrowed from Europe and the United States. Brazilian filmmakers have thus been reflexively aware of a massive intertextual game played across cultures and cinemas. For all these intersecting reasons, Brazilian cinema is marked by mixture, hybridity,

exchange, and impurity. In a film market organized since the 1920s to exhibit an internationally dominant American cinema, some filmmakers, perhaps inevitably, have taken Hollywood as an industrial and stylistic model, or at least as a central point of reference. From the 1930s through the 1950s, there were many attempts to construct a film industry along Hollywood lines. Some of these attempts were fairly successful—for example, the longlasting Atlântida and Cinedia studios in Rio de Janeiro. And some were relatively unsuccessful, such as the short-lived Vera Cruz Studio, in existence from just 1949 to 1953. The aesthetic of Hollywood led to the passive mimicry of the dominant colonizer, although even here there are exceptions such as the Vera Cruz film *O Cangaceiro* (1953), directed by Lima Barreto, with its mélange of nationalist rhetoric and Hollywood Western–style representations of the Northeast's social bandits. The *chanchadas*, the most popular film genre in Brazil from the late 1940s to the 1950s, simultaneously mimicked and mocked Hollywood. In José Carlos Burle's *Carnaval Atlântida* (1953), a Brazilian director symptomatically named Cecilio B. de Milho (Cecil B. of the Corn) wants to direct a Hollywood-style blockbuster based on the Helen of Troy story, only to be mocked by more popular characters who prefer a carnivalesque approach. In Carlos Manga's *Matar ou Correr* (*To Kill or to Run*, 1954), a parody of Fred Zinnemann's *High Noon* (1952), the Portuguese title of which was *Matar ou Morrer* (meaning "to kill or to die"), the sheriff played by Gary Cooper becomes a charlatan named Kid Bubble and his side-

TOP: *Limite* (1930), Mário Peixoto. BOTTOM: *Terra em Transe* (*Land in Anguish*, 1967), Glauber Rocha

kick is Ciscocada. Joaquim Pedro de Andrade's more recent *Vereda Tropical* (1980) is an acerbic parody of the soft-core *pornochanchada*, in which the object of desire takes the form of a watermelon that the protagonist literally loves.

Apart from the parodic *chanchadas*, critical intertextuality has formed part of Brazilian cinema since its very beginnings, precisely because of the filmmakers' consciousness of multiple aesthetic models drawn from Brazil, Europe, and the United States. It is as if the filmmakers, conscious of working with issues having a long history of formulation in a body of filmic and extrafilmic texts, had become necessarily reflexive, directly or indirectly discussing the cinema within their works. Each movie is a methodological sample of a possible approach to filmmaking, at once about a subject and itself. Here Brazilian cinema is in step, of course, with international cinema, with its everincreasing tendency to reflexivity, whether Modernist (early Jean-Luc Godard), Brechtian (late Godard, Jean-Marie Straub), or postmodernist (Atom Egoyan) in approach.

The 1960s film movement known as Cinema Novo, led by Glauber Rocha, Nelson Pereira dos Santos, Joaquim Pedro de Andrade, Carlos Diegues, and Leon Hirszman, was profoundly intertextual,

drawing on a wide range of influences. Although all of these directors subscribed on one level to the cinema of Italian Neorealism with its concern for social realism, as well as to a politicicized version of the French New Wave notion of auteurism, they were also deeply impacted by Brazilian Modernism. Indeed, Cinema Novo must be understood against the dual backdrops of Brazilian popular culture and its high-Modernist literary canon. Literary figures of the 1920s such as Mário de Andrade and Oswald de Andrade were important, as was the midcentury figure of João Guimarães Rosa, whose complex, esoteric, and Baroque-Modernist texts were taken as a decisive source for key figures of Cinema Novo. Rosa's influence sometimes took the form of adaptation—as in Roberto Santos's *A Hora e a Vez de Augusto Matraga* (1965), Nelson Pereira dos Santos's *A Terceira Margem do Rio* (*The Third Bank of the River*, 1997), and Pedro Bial's *Outras Estórias* (*Other Stories*, 1999), as well as in *Diadorim* (1985), a television series based on Rosa's *Grande Sertão: Veredas* (1955). But at times Rosa's influence was more diffuse and subtle, for example in the way his *Grande Sertão: Veredas* hovers over the symbology and solemnity of Rocha's backlands epic *Deus e o Diabo na Terra do Sol* (*Black God, White Devil*, 1964), the author's labyrinthian literary techniques turning into the director's winding camera movements and an exasperated sound track.

Each of the filmmakers of Cinema Novo moved toward his or her own form of dialogue with other cinemas and with specific trends within Brazilian culture. Rocha had created an excessive Modernist cinema that mingled popular Brazilian culture—Candomblé in *Barravento* (*The Turning Wind*, 1962), popular pamphlets and *cangaceiros* (backlands bandits) in *Deus e o Diabo na Terra do Sol*—with the erudite culture of Rosa and Villa-Lobos. Rocha's mode of intertextuality was forged out of film quotations, ambiguous forms of incorporating religious language and images, and a theatricalization of politics drawn from

William Shakespeare, Sergei Eisenstein, and Bertolt Brecht, which led many critics to qualify his work as Baroque. Rocha's *Terra em Transe* (*Land in Anguish*, 1967), for example, is the apotheosis of the Baroque. Explicitly allegorical, it constitutes a kind of Benjaminian *Trauerspiel* about what Rocha referred to in interviews as the "tragic carnival of Brazilian politics." Here, Rocha translocated the ideas and strategies of Brecht, Africanizing, tropicalizing, and carnivalizing them through an anachronist strategy, rendering a contemporary coup d'état, for example, as if it were a Shakespearean coronation.

Terra em Transe was a key influence on the late-1960s multi-art movement called Tropicália, named after a provocative 1967 installation by Hélio Oiticica. In the debates surrounding Tropicália, there was a renewed interest in Oswald de Andrade's ideas about *antropofagia*, and specifically in his *Manifesto antropofágo*. Transcultural intertextuality, metaphorized by the cannibalistic devouring of alien texts, became a radical poetic program. The question of identity was treated in terms not of purity and fidelity to origins but of a struggle for hegemony in a context of inevitable conflicts and interactions among cultures. Sganzerla's *Bandido da Luz Vermelha*, Nelson Pereira dos Santos's *Como Era Gostoso Meu Francês*, Arthur Omar's *Triste Trópico* (1974), and Paulo Caldas and Lírio Ferreira's *Baile Perfumado* (*Perfumed Ball*, 1997) are all examples of this cannibalistic intertextual strategy inherited from 1920s Modernism.

Perhaps more than most cinemas, Brazilian cinema exhibits a tendency toward formal eclecticism and the systematic mixture of styles. This stylistic hybridity is partly derived from the cultural heterogeneity of Brazil, as well as from the awareness of the multiple styles available from abroad and from a sense that the peripheral condition of Brazilian cinema could serve as a point of departure for innovative production strategies and stylistic choices. This heterogeneity characterized the parody *chanchadas*, which often

mocked their own poverty of means when compared with Hollywood films, and Cinema Novo's aesthetics of hunger, which turned the stigma of poverty and scarcity within Brazilian film into a proud badge of honor, a token of aesthetic confidence and political audacity. But stylistic eclecticism also derived from strong cultural traditions in Brazil. The *chanchadas*, for example, must be seen against the backdrop of Rio de Janeiro's Carnival as well as of the tradition of *malandragem*, or quick-witted street-smart hustlerism.

What is striking in Brazilian cinema and culture is the extraordinary originality of the Brazilian aesthetic contribution. Rather than seeing Brazilian art as "tainted" by its excess and disharmony, as somehow compromised by its contradictory mixture of melancholy and euphoria, by its careening between the performative joys of Carnival and the melancholy evocations of the ephemeral nature of happiness, we can see such "imperfections" as the key to its creativity. The very term "baroque," after all, was first used to refer to a pearl despised for its distorted form, its excrescences and irregularities. Brazilian cinema gives voice both to ecstatic hopes for liberation and to the hangover of cyclical disenchantments rooted in the horrors of endemic violence, including even religious violence. The poet Mário Faustino summed up this dialectic of misery and utopia in the phrase "*quanta violencia, mas quanta ternura*" (so much violence, but so much tenderness). We see this violence in Sérgio Bianchi's *Cronicamente Inviável* (*Chronically Unfeasible*, 1999), with its disenchanted portrait of contemporary Brazilian society, seen as a wholesale exercise in social hierarchy and sadomasochism. Brazilian cinema displays a paradoxical mixture of cultural pride and resentment, mimicry and audacity, austerity and excess, that in sum gives voice to the body and soul of Brazilian culture.

Notes

1. See Fredric Jameson, "Third World Literature in the Era of Multinational Capitalism," *Social Text* 15 (fall 1986).

2. See, for example, Roberto Schwarz, "Cultura e politica 1964–1969" (1970), in *Pai de familia e outros ensaios* (Rio de Janeiro: Paz e Terra, 1977); O. C. Louzado Filho, "O contexto tropicalista," *Aparte*, no. 2 (1968); Gilberto Vasconcelos, *De olho na fresta* (Rio de Janeiro: Graal, 1977); Celso Favanetto, *Tropicalia, alegoria, alegria* (São Paulo: Kairos, 1979); and Ismail Xavier, *Alegoria, modernidade, nacionalismo* (Sao Paulo: Editora Funarte, 1985).

3. For a survey of recycled art from around the world, see Charlene Cerny and Suzanne Seriff, *Recycled, Reseen: Folk Art from the Global Scrap Heap* (New York: Harry N. Abrams; Santa Fe: Museum of International Folk Art, 1996).

4. These concepts are debated in Ismail Xavier, *Allegories of Underdevelopment: From the Aesthetics of Hunger to the Aesthetics of Garbage* (Minneapolis: University of Minnesota Press, 1997).

5. Brazilian plastic artist Regina Vater played on these references in her mid-1970s work *Luxo/Lixo*, in which she photographically documented the quite different trash found in neighborhoods representing the different social classes.

6. Oswald de Andrade's various manifestos are collected in *Do pau-brasil a antropofagia as utopias* (Rio de Janeiro: Civilizacao Brasileira, 1972). (Author ranslations.)

7. See Leslie Bary's excellent introduction to and translation of the *Manifesto antropofágo* in *Latin American Literary Review* 19, no. 38 (July–December 1991).

8. In "Anthropophagie" (1902), Alfred Jarry spoke of the *"branche trop negligée de l'anthropophagie,"* and in "L'Almanach du Père Ubu," he addressed himself to "amateur cannibals." In 1920, Francis Picabia issued the "Manifeste Cannibale Dada."

9. Augusto de Campos, *Poesia, antipoesia, antropofagia* (São Paulo: Cortez e Moraes, 1978), p. 121.

10. The Modernist rehabilitation of non-European culture, as David Brookshaw points out, was essentially artistic. The Modernists did not intervene politically on behalf of the black masses or in favor of tribes threatened with extinction. See David Brookshaw, *Raca e cor na literatura brasileira* (Porto Alegre: Mercado Aberto, 1983), p. 96.

11. Paulo Emilio Salles Gomes, "Cinema: A Trajectory within Underdevelopment," in Randal Johnson and Robert Stam, eds., *Brazilian Cinema* (New York: Columbia University Press, 1995), p. 245.

12. For an expanded discussion of multiculturalism within Brazilian cinema, see Robert Stam, *Tropical Multiculturalism: A Comparative History of Race in Brazilian Cinema and Culture* (Durham, NC: Duke University Press, 1997).

13. Roger Bastide, *African Religions of Brazil* (Baltimore: Johns Hopkins University Press, 1978), pp. 247–348.

14. Robert Farris Thompson, *Flash of the Spirit: African and Afro-American Art and Philosophy* (New York: Random House, 1983), pp. 5–7.

15. See Henry Louis Gates, Jr., *The Signifying Monkey* (New York: Oxford University Press, 1988).

16. Arturo Lindsay, *Santeria Aesthetics in Contemporary Latin American Art* (Washington, D.C., and London: Smithsonian Institution Press, 1996), p. xx.

17. See Roberto Schwarz, *Misplaced Ideas: Essays on Brazilian Culture* (New York: Verso, 1992).

18. Salles Gomes, "Cinema: A Trajectory within Underdevelopment," p. 245.

19. See Emanuel Araújo, *A mao afro-brasileira: Significado da contribuiçao artistica e historica* (São Paulo: Tenenge, Odebrecht, 1988).

20. Maria Eugenia Boaventura, *A Vanguarda Antropofágica* (São Paulo: Attica, 1985), p. 114.